PRE-COLUMBIAN ART AND THE POST-COLUMBIA

PRE-COLUMBIAN ART *and the*

BARBARA BRAUN

POST-COLUMBIAN WORLD

Ancient American Sources of Modern Art

HARRY N. ABRAMS, INC.

Publishers

PROJECT MANAGER: *Harriet Whelchel*
COPY EDITOR: *Nancy Moore*
DESIGNER: *Judith Michael*
PHOTO RESEARCH: *Jennifer Bright, assisted by Colin Scott*

LIBRARY OF CONGRESS CATALOGING-IN-PUBLICATION DATA
Braun, Barbara, 1939–
Pre-Columbian art and the post-Columbian world : ancient American sources
of modern art / by Barbara Braun.
p. cm.
Includes bibliographical references and index.
ISBN 0–8109–3723–9
1. Art, Comparative. 2. Art, Modern—20th century. 3. Indians—
Art—Influence. I. Title.
N7428.5.B73 1993
709′.04—dc20 92–29047
CIP

Published in 1993 by Harry N. Abrams, Incorporated, New York
A Times Mirror Company

Printed in Italy

CONTENTS

ACKNOWLEDGMENTS

I arrived at my interest in the question of Pre-Columbian art and the post-Columbian world by a circuitous route. After preparing for a career as a historian of modern art, I inadvertently became involved in Pre-Columbian studies when I accepted a position as an assistant in the Pre-Columbian Collection at Dumbarton Oaks, one of the first museums to treat this material aesthetically and probably the finest of its kind in the United States. Here I was exposed to objects of surpassing beauty and to many of the important scholars in the field. I also had the opportunity to travel to Mexico and Central America to see sites and collections. I was immediately drawn to these alien objects by their plastic vitality and exotic attractiveness, but they also represented an alternative vision of art as an integral expression of a culture, in contrast to its marginal position in contemporary society. Many of these objects were actually used by indigenous peoples, not only as totems, icons, fetishes, and architectural ornaments, but also as vessels, masks, tools, clothing, and jewelry that at the same time embodied the thoughts, feelings, beliefs, and social structures of ancient Pre-Columbian cultures.

I soon began to address iconographic questions about the meaning of these objects in the Pre-Columbian universe and went on to earn a doctorate in Pre-Columbian art history and archaeology at Columbia University. I wrote my dissertation on the monumental sculpture of Cotzumalhuapa, a striking assemblage of reliefs and rock carvings in southern Guatemala that fuses the severe conceptual art of Teotihuacán and the elegant realism of the Maya in the same period (A.D. 250–900). Although there are tantalizing hints of ceremonial, mythological, and ideological systems embodied in such sculptures, and archaeology can provide information about their chronology and context, there is a paucity of firm data to use for interpretative purposes. The absence of contemporary written records to help interpret the meaning of Pre-Columbian images is conducive to speculation and a projection of the preoccupations of the beholder on the ancient creators of these images. I therefore concluded that the most meaningful way for me to approach this material was through an examination of its reception in the West and began looking at modern art with this in mind. Here was a situation where a subjective response was called for and where documentation was readily available.

There are many individuals who have assisted me along this route and deserve my thanks. They include the late Robert Goldwater, my graduate advisor at New York University's Institute of Fine Arts, whose approach to art historical scholarship, breadth of knowledge, and literate explication of art has been an inspiration for many years; Elizabeth Benson, formerly curator of the Pre-Columbian collection at Dumbarton Oaks, for introducing me to the Pre-Columbian world and generously encouraging my interest in many ways; and especially Esther Pasztory, professor of art history and archaeology at Columbia University, for stimulating guidance in the questions of Pre-Columbian art history, supervision of my doctoral work, and sponsorship of the requisite research and travel grants to Mexico, Central America, and Europe.

In 1977 Joseph Masheck, then editor of *Artforum* magazine, asked me to write an article about an exhibition of Peruvian textiles; the result was my first articulation of the linkage between Pre-Columbian and modern artists, and the germ of the conception of this book. The idea for a book had taken firmer shape by the time William Rubin, formerly director of the Department of Painting and Sculpture at the Museum of Modern Art, hired me in 1982 as a consultant to his massive Primitivism show and catalogue. Even though Pre-Columbian art was eventually eliminated from the exhibition program and my expertise was never fully utilized, my participation in this project served to validate my intentions and clarify my own approach to the question of primitivism.

When, finally, with a book contract in hand, I fully engaged this project, many individuals assisted my necessarily wide-ranging research, to whom I am grateful. Johanna Hecht, associate curator at the Metropolitan Museum of Art, showed me Paul Gauguin's decorative arts objects in storage and provided information about them. Holly Barnet-Sanchez and Marcos Sanchez Tranquilino kindly escorted me on a tour of Frank Lloyd Wright's houses and Maya revival architecture in Los Angeles and gave me a thoroughgoing introduction to Chicano art in East Los Angeles. Jeanette Peterson was a fine companion on a visit to some of Wright's Los Angeles buildings. Professor David Gebhard of the University of California at Santa Barbara imparted some of his extensive knowledge of Wright, his son Lloyd Wright, and the Maya Revival style in a discussion in his home. Lauren Bricker, curator of the architectural drawing collection, Department of Art, the University of California at Santa Barbara, was particularly helpful with regard to information concerning Robert Stacy Judd's activities. With great generosity Cecelia Buzio de Torres acquainted me with the life and work of her father-in-law, Joaquín Torres-García. She shared information from family archives, hard-to-obtain books, journals, catalogues, photographs, and documents concerning Torres-García, permitted me to see stored paintings by Torres-García, and conveyed manifold insights about his activity. Elizabeth Fonseca asked me to write the catalogue for a retrospective of the painting of Augusto Torres that she organized, offering entree to privileged information about the Torres-García family and access to Augusto Torres himself, who conveyed firsthand knowledge about his father's life and work. In stimulating discussions and published articles, César Paternosto imparted his devotion to Andean tectonic art and Torres-García's work and involvement with it. Others who offered encouragement and information for which I am grateful include Sally Sloan, Berthe Small, Alva Millian, Phyllis Freeman, Fran Ames, Lisl Cade, Frederick Field, Jeanette Pepper Bello, Brian Nissen, Charles Campbell, Terry Kirk, and Regina Jensen.

My thanks also go to the members of the graduate seminar on "Primitivism in Modern Art, Some Unexplored Issues," in which I presented some of the ideas for this book in preliminary form at the State University of New York at Stony Brook. Students there who helped me to refine my thoughts include Jaimes Contreras, Nancy Dugan, Aaliyah Gupta, Thomas McSwane, Dianne Parker, and especially Paul Werner, whose presentation on the ideology of primitive hieroglyphs opened my eyes to the extent of nineteenth-century interest in that subject.

I am especially grateful to the individuals who encouraged my ongoing work on this project by inviting me to present talks, symposium papers, or articles on aspects of it, occasions that invariably served to crystallize my thoughts on the topic at hand. They include Donald Kuspit and the late Lawrence Alloway, editors of *Art Criticism*; Suzanne Blier of the Columbia University Seminar on the Arts of Africa, Oceania, and the Americas; George Kubler and Mary Miller of the Yale University Art History Department; John Onians, former editor of *Art History*; Cecelia Klein, organizer of a panel on "Institutions and the Aestheticization of Primitive Art" at the College Art Association; Francesco Pellizi, editor of the journal *Res*; Elizabeth Boone, who organized the Dumbarton Oaks Conference on "Collecting the Pre-Columbian Past"; and Mari Carmen Ramirez, organizer of a symposium on "The Inverted Map: School of the South (Post) Modernist Issues" at the University of Texas at Austin.

I am most grateful to the people who have had an active role in putting this complex book together: photographer Jeffrey Jay Foxx for his fine photographs of Mexican and Central American monuments and sites, and for making every effort to

meet my exacting specifications. Accomplishing this task not only required extensive travel to many out-of-the way places but also special efforts to gain access and permissions to photograph under difficult circumstances. For picture research extraordinaire I thank Abrams photo editor Jennifer Bright and her assistant, Colin Scott. For assistance in gathering illustrations I am especially grateful to Alan Sawyer; Cecelia Buzio de Torres; Gloria Groom; Deborah Nagao, who acted as liaison in Mexico for the photography of Pre-Columbian objects and especially of Anahuacalli; Elizabeth Benson; Justin and Barbara Kerr; and the staff of the Goldwater Library at the Metropolitan Museum of Art, including Ross Day and Virginia Webb, all of whom went out of their way to be helpful and to locate difficult-to-find reproductions. Others who helped in this respect include César Paternosto, Richard Todd, Anthony Perez, Elizabeth Boone, Christopher Donnan, and Richard Brettell. Designer Judith Michael was unfailingly creative and flexible in organizing the large quantity of images from many different sources.

Above all I wish to to extend my thanks to my editor Harriet Whelchel, always alert, who kept on top of a very complex project with smooth efficiency, keen intelligence, and good cheer; Nancy Moore, for diligent copy editing of the manuscript and offering useful challenges to some of my thoughts; and Nanice Lund, who keyboarded the manuscript and was always pleasantly responsive to my requests.

My greatest debt of gratitude is to my husband, John F. Baker, for his unwavering encouragement, generous moral support, and practiced editorial eye from the earliest stages and throughout the long process of this project's realization. He also made possible and often good-naturedly shared research excursions in Mexico, California, and other locales. Without his stalwart presence this book would not have been accomplished.

For my beloved husband, John F. Baker,
whose unstinting encouragement, good-natured support,
editorial acumen, and remarkable patience
made this book possible

PREFACE

enry Moore's *Reclining Figure*, in a dozen variations, adorns museum galleries, corporate headquarters, and public malls throughout the United States, yet how many people are aware that its acknowledged source is the Toltec-Maya chacmool, a Mesoamerican temple guardian and repository of sacrificial offerings? Or that the foundation of Paul Gauguin's style owes as much to ancient Peruvian plastic and pictorial formulas as to Impressionism? Or that Frank Lloyd Wright, America's premier modern architect, learned as much about structural design and ornamentation from a close study of Maya temples and Mixtec palaces as he did from Japanese structures? Or that a quarter of a century later Louise Nevelson tapped these same sources in her huge wooden wall reliefs? Or that graphic and painterly artists as diverse as Joaquín Torres-García, Paul Klee, and Josef Albers sought inspiration in the linear strain of Pre-Columbian art encoded in pictographic representations in Peruvian weavings and pottery and Mexican codices and murals? Or that the more recent work of Color Field painter Alfred Jensen, minimalist sculptor Tony Smith, earth artist Robert Smithson, and ceramists Ken Price and David Gilhooly is also deeply indebted to ancient American forms and ideas?

It is not hard to locate the reason why these artists' keen interest in Pre-Columbian art remains obscure while Pablo Picasso's enthusiasm for African sculpture, the German Expressionists' infatuation with Oceanic art, and the Surrealists' romance with the American Indian have been widely trumpeted. Most accounts of modern art still trace a linear development from School of Paris Impressionism to Abstract Expressionism while ignoring deviant expressions. In this scheme, for example, Realist painting after the 1910–1920 Mexican Revolution or 1930s Uruguayan Constructivism have no place. They are considered marginal, provincial episodes and their revival of Pre-Columbian forms of negligible interest.

Robert Goldwater's pathbreaking *Primitivism in Modern Painting* in 1938 was the first book to tackle the subject in comprehensive terms and set the standard for later studies. Goldwater covered modern (mainly French) painters' attraction to the arts of Africa, Oceania, and to some extent North America but failed to include Pre-Columbian art—except for a few pages on Henry Moore in a 1967 revised edition that added sculpture. He maintained that Pre-Columbian art was neither primitive nor influential, arguing disingenuously that the earlier date of Latin American colonialism made it less relevant to modern artists. This bias, and another against ceramics—which he relegated to a lesser category of decorative art—accounts for his neglect of Gauguin's keen interest in ancient Peruvian ceramics in an otherwise thorough discussion of the artist's primitivizing.

An influential French study, Jean Laude's *La Peinture française (1905–14) et "l'art nègre"* in 1968 followed Goldwater's lead by focusing almost entirely on the School of Paris and on African models (while condemning German Expressionist primitivism). Laude's "Arts primitifs dans les ateliers d'artistes" the year before was also one of the first shows to document links between modern artists and primitive art; it even included a few Pre-Columbian pieces. But among Western scholars, Germans were the first to credit Pre-Columbian art's contribution to modernism. *World Cultures and Modern Art: The Encounter of 19th and 20th Century European Art and Music with*

Asia, Africa, Oceania, and Afro- and Indo-America, a big exhibition catalogue by Manfred Schneckenburger et al. published in conjunction with the 1972 Munich Olympics, is a stimulating, if impressionistic and formalist, survey of modernist primitivism that includes Pre-Columbian art. Also unusual is its provision of a context for primitive art in brief essays on masks, myth, and magic in ethnographic societies. More recently, Alan Wilkinson's catalogue for a 1982 Toronto show, "Gauguin to Moore: Primitivism in Modern Sculpture," covered Pre-Columbian material in a well-documented but plodding discussion of primitive influences on Gauguin and Moore.

The most up-to-date, large-scale examination of this topic is the massive, two-volume catalogue for the 1984 exhibition "Primitivism in 20th Century Art: Affinity of Tribal and Modern" organized by William Rubin for the Museum of Modern Art. Despite radically altered perspectives on art practices and relationships between developed and developing worlds, Rubin's study reaffirmed Goldwater's fifty-year-old version of modernist primitivism with some new twists. Once again, Rubin concentrated on the reception of primitive art in the West, disregarding primitive contexts entirely, and featured the School of Paris (starring Picasso) and its preference for African, Oceanic, and North American Indian art, while ignoring Pre-Columbian material (except in one out of a dozen catalogue essays—on Alberto Giacometti). Rubin credited primitive art with greater formal influence on modernism than had Goldwater, presenting fresh documentary support while at the same time promoting a notion of affinities (similarities without direct links) between the two.

Rubin rationalized his decision to exclude Pre-Columbian art by subscribing to largely discredited categories of tribal and court societies. African, Oceanic, and North American Indian polities were deemed "tribal," and Pre-Columbian a "court" or archaic society, that is, an avowedly higher, yet not fully high, culture, akin to Egypt, Persia, or Cambodia. Yet in a long footnote to his introduction, Rubin acknowledged that the history of Pre-Columbian influence on modern art needs to be written, citing my work.

I want to reject these long-standing assertions about the lack of importance of Pre-Columbian art to modernists and to fill an important gap in critical attention concerning primitivism in modern art. Pre-Columbian art is also part of this story, and modern artists themselves did not make such academic distinctions in their search for new means to revitalize outmoded Western forms. They had equal access to Pre-Columbian art, regarded it in the same light as other alien traditions, and were likewise influenced by it. This can be proved by looking closely at the production of modern artists that reflects this influence to a greater or lesser extent. Though expressed aesthetically, this process also involved specific historical, sociopolitical, and ideological conditions that are essential to its appreciation and analysis. Thus, for instance, Gauguin's turning to Pre-Columbian art related to the larger social and political context in which he practiced his art as well as to his personal circumstances and preferences.

The other half of this story involves an aesthetic and contextual examination of the Pre-Columbian artifacts that affected these artists. Unlike modern works intended for decoration or contemplation, they cannot so easily be severed from contingencies of origin, connotation, and use without losing their meaning. Offered here is up-to-date archaeological and ethnographic information about their cultural affiliations, dates, religious, mythological, and sociopolitical functions. The idea is to make the reader aware of the ancient people who made and used them and to clarify essential distinctions between Pre-Columbian and modern art.

A word is in order here about what is meant by Pre-Columbian, also called pre-Hispanic, art. Although the term encompasses all the indigenous arts of the Americas before Columbus, it commonly refers to the cultures of Mesoamerica (Mexico and Guatemala) and the Central Andes (Peru and Bolivia), as well as Central America and the Northern Andes (Ecuador and Colombia) from roughly 1200 B.C. to the time of the Spanish Conquest about A.D. 1500. Except for Maya hieroglyphic writing and sixteenth-century Spanish eye-witness accounts of the Aztecs and Inkas, Pre-Columbian art is mainly known through archaeological excavations.

The large-scale, complex, theocratic societies of the Maya, Toltec, and Aztec civilizations in Mesoamerica and the Inka in the Central Andes, which are popularly

identified with Pre-Columbian art in the West, were characterized by a state and even imperial form of government, a high degree of social, economic, and political specialization, urban centers, and monumental architecture. But the cultures of Central America and the Northern Andean area were simpler sociopolitical entities organized into independent, small-scale "chiefdoms," which generally lacked urban centers and monumental public works.

Within the two "high-culture" areas of Mesoamerica and the Central Andes various distinctive regional art styles were integrated in a unified, continuous cultural tradition and time frame. In Mesoamerica the early, middle, and late time periods are designated preclassic or formative (c. 1500 B.C. to A.D. 250), classic (c. A.D. 250–900), and postclassic (c. A.D. 900–1521). (This awkward Eurocentric classification is attributable to the fact that the Maya culture, with its naturalistic figurative imagery and hieroglyphic writing system, was favored in the West. Since the Maya flourished in the middle period, this became known as the classic, and the terminology has stuck.) The most important style of the Mesoamerican formative period is associated with the Olmec culture on the Gulf Coast of Mexico, which formed the basis of many later styles. The art of western Mexico also belongs to the (late) formative period. During the classic period the dominant styles in Mesoamerica were the contrasting abstract, geometric Teotihuacán style in highland Mexico and the floridly naturalistic Maya in lowland Guatemala and Yucatán. The art of Oaxaca, classic Veracruz, and Cotzumalhuapa also flourished at this time. In the postclassic period the Toltec, Mixteca Puebla, and Aztec were the dominant styles.

For the Central Andes the chronological markers are the early, intermediate, and late periods divided by "horizons" that define the geographic spread of an art style. The earliest civilization in the Central Andes was that of the Chavín in the early horizon (c. 900–200 B.C.). Like that of the Olmec in Mesoamerica, the Chavín style was the precursor of many later styles. The two great styles of the early intermediate period (c. 200 B.C.–A.D. 600) were the contrasting realistic Moche and emblematic Paracas/Nazca, respectively on the north and south coasts of Peru. In the middle horizon (c. A.D. 600–1000) the Wari-Tiwanaku style spread from the southern highlands throughout Peru and Bolivia, while a major style in the late intermediate period (c. A.D. 1000–1470) was that of the Chimú on the north coast of Peru. Finally, in the late horizon (1470–1534), the Inka style of the southern highlands of Peru extended all the way from Ecuador to northern Chile.

It is important to understand that Pre-Columbian art was made under a very different system from our own. In the pre-Hispanic world, art and architecture played a religious and social role in daily rituals, major ceremonies, and deity and funerary cults; they also served as a major means of communicating dynastic history, ethnicity, and power relations. In modern society, on the other hand, art is an individualistic pursuit as well as a commodity.

A cross-cultural approach to the problem of primitivism in modern art is unique. In relating scholarly developments in the Pre-Columbian field to creative activities and criticism in modern art, and addressing questions of style and context in both, my aim is to bring closer two specialized discourses that are farther apart than they should be. As presently constituted, they are expressed either in popular or hermetic language. Pre-Hispanic art is evoked in dated romantic stereotypes of lost continents, buried treasure, and virgin sacrifice or, alternatively, in social scientific jargon (see, for instance, *American Antiquity*, the official journal of the Society for American Archaeology). Even without having to contend with a remote time, place, or epistemology, writings on modern art exhibit a parallel split.

I recognize at least some of the difficulties inherent in such an integrative goal, which amounts to joining scientific and artistic practice and their opposed frames of reference. Archaeology views pre-Hispanic culture instrumentally, while modernism's basic tenet is a humanistic belief in individual creativity and consciousness. So far as we know, Pre-Columbian art was a collective effort, the result not of spontaneous personal innovation but of a slow process of communal inventiveness in which specialized skills were applied to well-honed formulas. Individual biographies, psychologies, and points of view intrinsic to an understanding of modern art are irrelevant in relation to anonymous artisans.

The issue of authorship rather than levels of social development is one of the factors aligning pre-Hispanic with other ethnographic arts vis-à-vis modernism. Artists regarded it in the same way they did African, Oceanic, or North American Indian forms—as the handiwork of anonymous craftsmen and -women. They perceived these artisans as being fully integrated into these cultures, as opposed to their own sense of marginality. In our own time, a comparable opposition between the conventions of individual art production and anonymous utilitarian practice seems to translate into a dichotomy between high and low, avant-garde and mass culture.

Since modern artists by no means confined their interests in non-Western art to one tradition, it is not always easy to distinguish pre-Hispanic from other ethnographic influences. In the age of André Malraux's "museum without walls," they were eclectic in their gleanings, culling and mixing forms from a variety of sources—exotic styles, popular arts, and the storehouse of Western art history—in a syncretist stew. But a study of these artists' production and, in most cases, personal testimony makes it clear that Pre-Columbian art was a major influence.

In approaching the question of Pre-Columbian sources of modern art, I have elected to examine closely the work of five acknowledged and seminal masters: French Symbolist Paul Gauguin, English sculptor Henry Moore, American architect Frank Lloyd Wright, Mexican muralist Diego Rivera, and Uruguayan Constructivist Joaquín Torres-García. They represent diverse, international currents of modern art, not just the French tradition so often construed as the only progressive modernist line. Each searched out and used a certain facet of the pre-Hispanic visual tradition— architecture, earthworks, monumental sculpture, paintings, ceramics, textiles, lapidary and metal work—for either formal or expressive purposes. An examination of the distinctive ways in which they incorporated the ancient plastic and pictorial formulas should reveal the scope of this primitivizing tendency. By singling out these individuals I have regrettably neglected other important artists whose work is significantly indebted to Pre-Columbian art, such as the Guatemalan painter Carlos Mérida, the Austrian sculptor Fritz Wotruba, and the Danish sculptor Robert Jacobsen.

But it seems to me that these five individuals best exemplify the modernist relation to different aspects of the Pre-Columbian visual tradition. Gauguin focused on ancient Peruvian ceramics, which are among the most extraordinary of any world culture; Moore looked to the imposing monumental stone sculpture of Mesoamerica; Rivera was mainly inspired by ancient West Mexican terra-cottas and small-scale Aztec sculptures; Wright's reliance on Mesoamerican architectonic form and decoration provides an opportunity to examine closely perhaps the greatest Pre-Columbian aesthetic achievement—its remarkable architecture; and Torres-García tapped the impressive graphic and woven geometric designs of ancient Peru. In every case these artists carefully worked out their relation to Pre-Columbian models over long periods of time, usually going back to their early years, in a great corpus of work. And some of them left behind a voluminous body of writing pertaining to their interest in Pre-Columbiana.

The careers of these artists, furthermore, occupy a specific time frame in the history of modern art. With the exception of Gauguin, who was the great precursor of this tendency in the late nineteenth century, their achievements belong to the second and third decades of the twentieth century, the heyday of modernism. This period, spanning roughly the end of the first World War to the beginning of the second, was also the time when pre-Hispanic art became generally recognized as aesthetically worthy and, not coincidentally, when Pre-Columbian archaeological investigations intensified. Without denying these men's genius it is possible to see them as interested in, aware of, and influenced by the well-publicized art and archaeology of their time.

The story of these five great masters' explorations of pre-Hispanic art forms part of a larger narrative that traces the history of the reception of Pre-Columbian artifacts in the West since the Conquest as well as the ways in which the relations of later generations of artists to Pre-Columbian art have altered and developed in the second half of the twentieth century. The end result offers a clear picture of the Pre-Columbian visual qualities that have most appealed to Western eyes, a measure of the preoccupations of vanguard artists in our era, and an appreciation of the seriousness of the cross-cultural transaction: a complex, multidimensional interpretation of art since the late nineteenth century through the prism of one of its important sources.

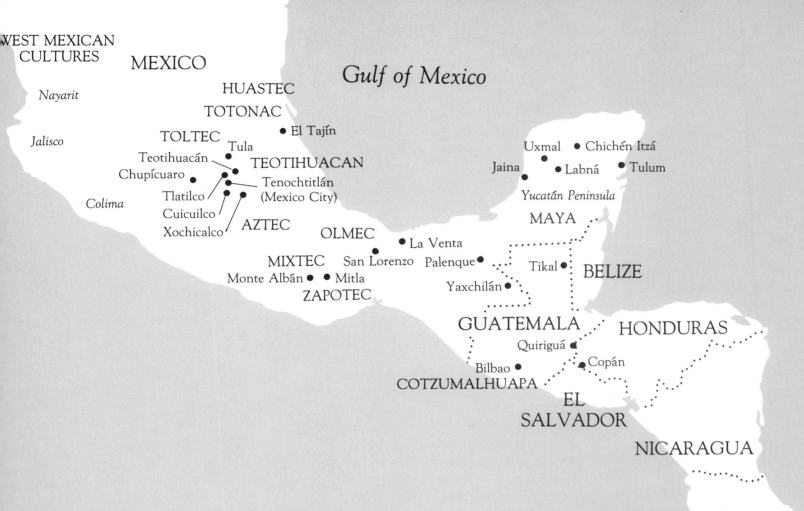

WEST MEXICAN
CULTURES

MEXICO

Nayarit

Jalisco

Colima

HUASTEC

TOTONAC

• El Tajín

TOLTEC

Tula

Teotihuacán

TEOTIHUACAN

Chupícuaro •

Tenochtitlán
(Mexico City)

Tlatilco •

Cuicuilco

Xochicalco

AZTEC

OLMEC

MIXTEC

San Lorenzo

Monte Albán • • Mitla

ZAPOTEC

Gulf of Mexico

Uxmal
•

• Chichén Itzá

Jaina
•

• Labná

• Tulum

Yucatán Peninsula

MAYA

•

La Venta
•

Palenque •

Tikal •

BELIZE

Yaxchilán •

GUATEMALA

HONDURAS

Quiriguá •

• Copán

Bilbao •

COTZUMALHUAPA

EL
SALVADOR

NICARAGUA

Pacific Ocean

Pre–Columbian Regions

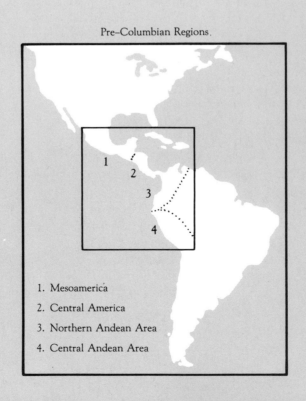

1. Mesoamerica

2. Central America

3. Northern Andean Area

4. Central Andean Area

COLOMBIA

ECUADOR

PERU

BRAZIL

LAMBAYEQUE
● Lambayeque CHIMU *North Highlands*

Huaca Prieta ● ● Cupisnique
Chan Chan ●● MOCHE
● Moche
CHAVIN
● Chavín de Huántar
Central Highlands

Chancay ● WARI
 ● Wari
Lima ● Machu Picchu ●
 ● Pachacamac ● Pisak
PARACAS ● Cuzco
 South Highlands INKA
Paracas ●
Ocucaje ● ● Nazca
 Lake Titicaca
 NAZCA

 BOLIVIA

 Tiwanaku ●

TIWANAKU

CHILE

0 200 400 Miles

0 200 400 Kilometers

TIME CHART

MESOAMERICA

< >< >

1500 B.C.	1000 B.C.	500 B.C.	0	A.D. 500	A.D. 1000–1521

PRECLASSIC OR FORMATIVE			CLASSIC		POSTCLASSIC	
Early 1500–900 B.C.	Middle 900–250 B.C.	Late 250 B.C.–A.D. 250	Early 250–600	Late 600–900	Early 900–1200	Late 1200–1521

OLMEC
1200–600 B.C.
 Tres Zapotes
 900–600 B.C.
 San Lorenzo
 900–600 B.C.
 La Venta
 900–600 B.C.
 Tlatilco
 1000–500 B.C.

WEST MEXICAN CULTURES
250 B.C.–A.D. 250

TEOTIHUACAN 150 B.C.–A.D. 750
Teotihuacán 150 B.C.–A.D. 750

ZAPOTEC 400–800
Monte Albán 400–800

TOTONAC 500–1521
El Tajín 500–900

TOLTEC 900–1200
Tula 900–1200

MIXTEC 1200–1521
Mitla 1200–1521

HUASTEC 1200–1521

AZTEC 1350–1521
Tenochtitlán 1350–1521

MAYA 250 B.C.–A.D. 1000
 Uxmal 700–1000
 Labná 700–900
 Palenque 600–800
 Yaxchilán 300–800
 Piedras Negras 300–800
Tikal 200 B.C.–A.D. 800
 Copán 600–800
 Quiriguá 600–800

COTZUMALHUAPA 500–900

TOLTEC-MAYA 1000–1200
Chichén Itzá 1000–1200
Tulum 1000–1300

CENTRAL ANDES

< > < >

1500 B.C.	1000 B.C.	500 B.C.	0	A.D. 500	A.D. 1000	1534

INITIAL PERIOD	EARLY HORIZON	EARLY INTERMEDIATE	MIDDLE HORIZON	LATE INTERMEDIATE	LATE HORIZON
1500–900 B.C.	900–200 B.C.	200 B.C.–A.D. 600	600–1000	1000–1470	1470–1534

North Coast

Cupisnique
900–200 B.C.

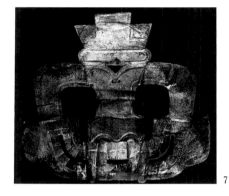

MOCHE 1–700
Moche 1–700

LAMBAYEQUE 900–1250

CHIMU 900–1470
Chan Chan 900–1470

Central Coast

Pachacamac 100–1534

Chancay 900–1534

South Coast

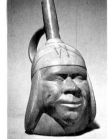

PARACAS 700 B.C.–A.D. 200
Ocucaje 300–100 B.C.

NAZCA 200 B.C.–A.D. 600
Cahuachi 200–500

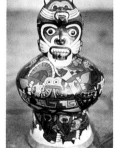

Highlands

CHAVIN
900–200 B.C.
Chavín de Huántar
900–200 B.C.

TIWANAKU 300 B.C.–A.D. 1000
Tiwanaku 300 B.C.–A.D. 1000

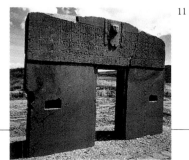

WARI 500–800
Wari 500–800

INKA 1400–1534
Cuzco 1400–1534
Machu Picchu 1450–1550

PRE-COLUMBIAN ART IN THE POST-COLUMBIAN WORLD

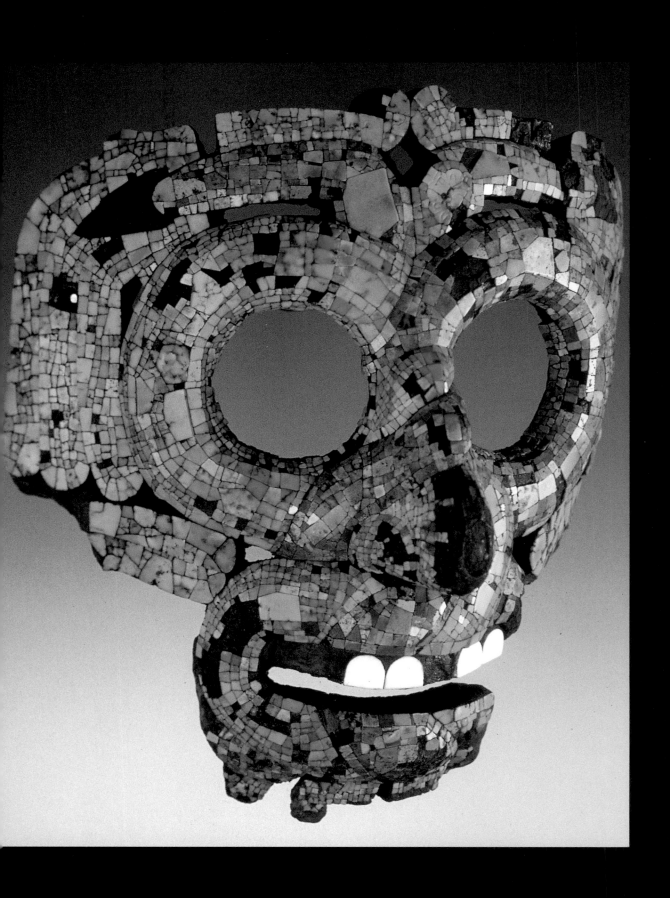

It is important to analyze how powerful discriminations made at particular moments constitute the general system of objects within which valued artifacts circulate and make sense.

JAMES CLIFFORD, *The Predicament of Culture* (1988)

Though the artifacts of pre-Columbian civilization created a stir from the very first European contacts with the New World in the sixteenth century, it was only in the latter half of the nineteenth century that they inspired Western designers, artists, and craftspersons to incorporate and imitate them in their own work. The character of that aesthetic embrace was, however, heavily conditioned by well-established conventions for approaching Pre-Columbiana. This chapter is an effort to trace the history of the reception of pre-Hispanic objects in the West by examining "powerful discriminations" made about them at particular moments by individuals and institutions in France, England, the United States, and Mexico. It focuses on what ancient American material they chose to preserve, value, and exchange[1] and on the treatment, collection, and display of Native American artifacts from the sixteenth century to the present. It monitors their trajectory in the West from ethnographic curiosity and golden lure in the sixteenth century, to objects of disdain in the seventeenth and eighteenth centuries and of romantic and naturalistic attachment in the nineteenth century, and, finally, in the late nineteenth and first half of the twentieth centuries, to the aesthetic appreciation and appropriation of pre-Hispanic forms and ideas.

Most sixteenth-century European beholders of Native American artifacts were highly impressed by them. Hernán Cortés declared of the Mexican buildings, "It cannot be believed that any princes of this world, of whom we know, possess any things of such high quality. . . . They are so well constructed . . . that there can be none better."[2] Above all he admired the exquisite turquoise mosaic masks and shields of the Aztecs, commenting in a letter, "As for the stones, there is no imagination which can divine the instruments with which they were so perfectly executed."[3] In the same tone of wonderment, Bernal Díaz del Castillo compared Indian craftsmen in the Aztec capital to Alonso Berrugnete and Michelangelo and framed his description of the city in terms of the chivalric romances: "These great towns and *cues* [temples] and buildings rising from the water, all made of stone, seemed like an enchanted vision from the tale of Amadis. Indeed, some of our soldiers asked whether it was not all a dream."[4]

Cortés collected samples of the exotic things he found in the conquered country to send back to the Spanish court and the pope. These representations of the New World included birds and animals—jaguars, opossums, armadillos—silver, gold jewels, amber, balsam, oil, even human specimens—jugglers who tossed sticks with their feet, skillful dancers who seemed to fly in the air, hunchbacks, Indian chiefs. Among his inventory of Mexican objects were a modeled gold animal head, a gold sun (probably an Aztec calendar), much featherwork, embroidered cotton, and two codices. After seeing the objects Cortés sent to the Queen of Spain and her son Charles V, Albrecht Dürer, writing in his diary on August 27, 1520, commented: "I saw the things which have been brought to the King from the new golden land. . . . All the days of my life I

21

have seen nothing that has gladdened my heart so much as these things, for I saw among them wonderful works of art, and I marvelled at the subtle ingenia of men in foreign lands."[5] Peter Martyr also expressed amazement with the same hoard and marveled especially at the codices and the featherwork, noting that "the cleverness of the artist and the workmanship exceeded the value of the material."[6]

It is difficult to determine whether the admiring reactions of these witnesses signify an aesthetic appreciation of Pre-Columbian artifacts. Their observations mainly address the strangeness, the rarity of the materials, and the technical skill of these objects. Dürer marveled at the intricacy and craftsmanship of the Indian objects that Cortés had sent to the royal court, but he did not, as far as we know, sketch them or try to make anything like them.[7] The human meaning of these artifacts—how Indians used them and interpreted their symbols—was entirely lost on Europeans. What they seized upon were the things they could fathom—the materials with which the objects were made and the technical skills of their makers. The Spanish conquerors and missionaries immediately put these materials and skills to work for their own purposes, providing native craftspersons with European designs of a mainly religious nature—for featherwork priests' vestments, manuscript and mural paintings, and corn-pith sculptures of Christ and the saints—that were intended for use in the colonies and for export.[8]

Charles V and his ministers failed completely to appreciate, aesthetically or otherwise, the Native American artifacts Cortés sent home. They had all the Mexican and Peruvian gold and silver melted down and precious stones extracted from objects. However, among the hoards of New World booty sent to Europe in the following decades, many objects were preserved in royal cabinets of curiosities (Wunderkammer) as trophies of conquest and specimens of a strange, richly endowed New World. In Vienna, Emperor Ferdinand I, younger brother of Charles V, established the first curiosity or wonder cabinet containing Mexican objects. His sons, Archduke Karl of Steiermark and Archduke Ferdinand II of the Austrian Tyrol, continued to preserve Mexican curiosities (a few of which survive in the Vienna Völkerkunde Museum).[9] The most avid collectors were the Medici in Florence—partly owing to their close relationship with the Hapsburgs.

Wonder cabinets were humanist counterparts of medieval treasuries of holy relics, displaying rare, magical, and marvelous artifacts that illustrated the range of human custom, ritual, and ceremony, with each object representing a whole region or population.[10] They included items made of precious material, which exhibited great virtuosity; natural objects believed to possess benign or dangerous powers—walrus tusks, rhinoceros horns, crystals, exotic stuffed birds and animals—and (sacred) figurines and small paintings. New World hammocks and canoes, Brazilian clubs and rattles, Mexican featherwork fans, headdresses, shields, hardstone carvings, mosaic-encrusted masks, and codices were much sought after (see pages 24–25, 28). By the 1550s Cosimo I, for example, had assembled as many as forty-four pieces of Mexican featherwork, including various garments, and several wooden turquoise mosaic masks and animal heads carved from semiprecious stones.[11]

These objects were displayed in a random, nonhierarchical fashion, without direct concern for their aesthetic qualities. Large curiosities were mounted on walls and suspended from the ceilings of halls; small items were stored in cabinets and cupboards. Before the end of the sixteenth century, private citizens had also begun to form cabinets of curiosities that also contained Native American artifacts. One of the most notable was assembled by a Bolognese naturalist, Ulisse Aldrovandi, who was passionately interested in the New World. His collection included several Aztec and Mixtec objects—a turquoise mosaic mask (now in the Museo Pigorini in Rome), a knife with an obsidian blade in the form of a bird of prey, a mask of an old god, a deity head and figure, a labret, and a spindle whorl.

Europeans felt obliged to come to moral, philosophical, theological, and practical terms with the makers of these artifacts, but they experienced difficulty in locating American Indians and their culture within familiar social and religious hierarchies and in correlating their existence with long-held notions about the origins of civilization in the ancient Near East and Greece. A great ecclesiastical debate about how to regard the Indians—whether as Christians, subjects of the crown, slaves, or even human beings—raged throughout the sixteenth and seventeenth centuries.[12] Early impressions

of New World Indians had been mainly favorable, but familiarity soon bred contempt. Thus, in 1532 Indians were seen to have spiritual capacity, in 1555 as inconstant and vice-ridden (at a time when they were already degenerating as a result of colonization), and in 1585 as savages who practiced scarification, human sacrifice, trophy-head hunting, and cannibalism.[13] These antithetical views were exemplified on early maps of the New World in which the Indian was invariably pictured as either a simple gatherer of brazilwood or a cannibal chopping up another Indian.[14]

Despite later revisions of these views, the basic Western response to the Pre-Columbian world continued to fluctuate between ancient America as a prelapsarian golden age or as a spectacle of savagery,[15] reflecting, at any given time, the West's major internal preoccupations and external involvements with that hemisphere. In the seventeenth century the prevailing image of the American Indian was of a backward and degenerate creature; the eighteenth-century Enlightenment condemned the Indians as uncivilized, while the followers of Rousseau commended them for their naturalness and romanticized them as Noble Savages—intuitive, irrational, childlike creatures living in harmony with nature. In the nineteenth century, after the French Revolution and the Napoleonic wars, the dominant construction of the Indian was once again couched in terms of disillusionment and intolerance of inferior races, mirroring changed political and social realities.

Wonder cabinets began to disappear by the mid-seventeenth century and were obsolete by the eighteenth century, as a more serious concern for classification developed. The museum as an institution arose from the ashes of the *Wunderkammer*, using its objects as raw material for scientific collections of natural history and ethnography, which were expanding with a developing capitalism and colonialism. The creators of the first museums broke down the wonder cabinet and analyzed it, systematically regrouping the random and strange into discrete and exemplary categories, such as food, clothing, tools, and weapons. By the end of the nineteenth century, evolutionism was the theme that dictated the arrangement of most exotic artifacts. Whether presented as antiquities, arranged geographically, by society, or in realistic dioramas, objects were made to tell a story of human development. No longer primarily an exotic curiosity, the object had become a source of information entirely integrated in the universe of Western humanity.[16]

THE NINETEENTH CENTURY: NATIONALISM, COLONIALISM, AND THE NEW INTEREST IN PRE-COLUMBIANA

The new kind of interest in Pre-Columbian artifacts that emerged in the nineteenth century went hand in hand with the construction of new national identities on the part of the new nation-states and older empires. The industrial powers among them needed to revise their narratives of themselves—for example, they could no longer represent themselves as divine monarchies—and of the world, to mobilize new forms of activity and support. An important element of their new strategy was to project themselves as masters of world culture and patrimony by mounting scientific expeditions to study colonial outposts and bring back collections of specimens. The removal of these objects to metropolitan centers served to legitimize colonizing ventures all over the world. These expeditions also served as agencies of business and politics and reinforced Western domination of nonwhite peoples.

The amassing of collections of pre-Hispanic artifacts was an intrinsic part of this global European enterprise. And, like other samples of resources from the colonial periphery, these artifacts were preserved and recontextualized in newly created national museums and world's fairs, which became sites for entertaining metropolitan audiences and instructing them in the glories of the nation and its projects of industrialization and colonization.[17] The constant theme of world's fairs—or universal expositions, as they were commonly called—was Progress, which was demonstrated by a graphic comparison between civilized and uncivilized cultures: displays of the latest technological feats of the imperial nation were juxtaposed with the backward technology and habitations of primitive and colonized people.

The expansion of natural history, ethnography, and other fields of knowledge was

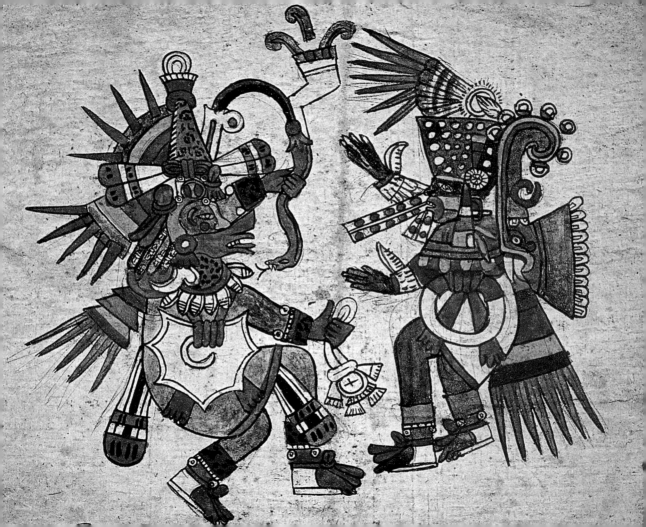

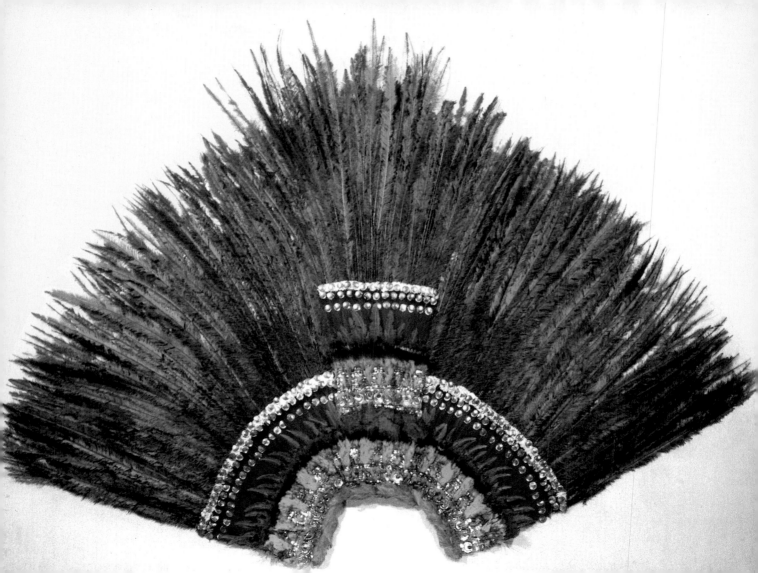

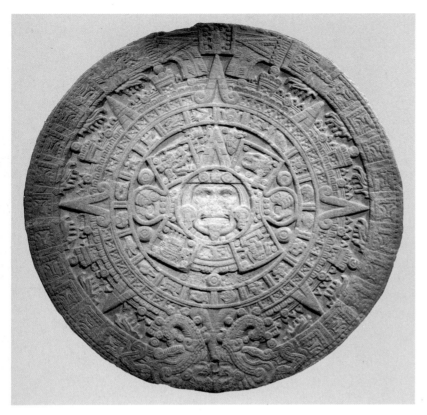

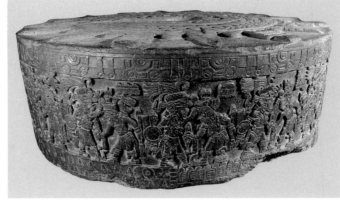

presented invariably through the eyes of an intrepid male explorer. In the forefront of this activity was Prussian scientist Alexander von Humboldt, whose five-year mission in the Americas was to investigate the natural history, geography, and culture of the Western Hemisphere and to report on its mineral resources and how they could be best exploited. During the year he spent in New Spain, in 1803, Humboldt's interest in Mexican archaeology was excited by three extraordinary Aztec monuments, unearthed in 1790 and 1791 in the great central square of Mexico City, whose complex iconography was thought to encapsulate the cosmological and calendric wisdom of the ancient Mexicans. They were the colossal and terrifying Coatlicue, mother of the Aztecs' patron deity, Huitzilopochtli; the gigantic image of the solar disk known as the Calendar Stone; and the great circular Stone of Tizoc, associated with the Aztec emperor Moctezuma's predecessor. Humboldt studied these and other Pre-Columbian monuments in the Mexican capital, reviewed the literature on the subject, and brought back a collection of Aztec objects. His documentation of Pre-Columbian monuments, architecture, and codices in *Vues des cordillères et monuments des peuples indigènes de l'Amérique*, a large album of annotated plates (and part of his thirty-volume magnum opus on America), helped reshape the European vision of ancient Mexico and stimulated further explorations.

Different metropolitan powers went about exploring and collecting the Pre-Columbian past in different ways. In France, following the precedent of Napoleon's scientific expeditions to Egypt, it was government policy to provide generous financial support for these activities[18]—though, of course, there were individuals who undertook them independently, for example, J.M.A. Aubin, who accumulated a treasure trove of manuscripts and documents from 1830 on. As early as 1860 the Ministry of Public Instruction purchased Jean-Frédéric Waldeck's drawings of Palenque and other sites (made in the 1830s) and subvented the researches and travels of the eccentric abbot Charles Etienne Brasseur de Bourbourg.[19] The French government also financed Brasseur's preparation and publication of two enormously important literary sources of information about Pre-Columbian civilization, which he had recovered on his travels to Mexico and Central America during the 1840s and 1850s: Bishop Diego de Landa's sixteenth-century account of the Yucatán, *Relación de las cosas de Yucatán*, and the *Popol Vuh*, the great epic of the Quiché Maya people. On the occasion of the French invasion of Mexico in 1864, Napoleon III established an elaborate scientific expedition to explore, study, and collect Pre-Columbian antiquities, appointing Brasseur as one of its mainstays. Even after Emperor Maximilian's assassination and the collapse of the

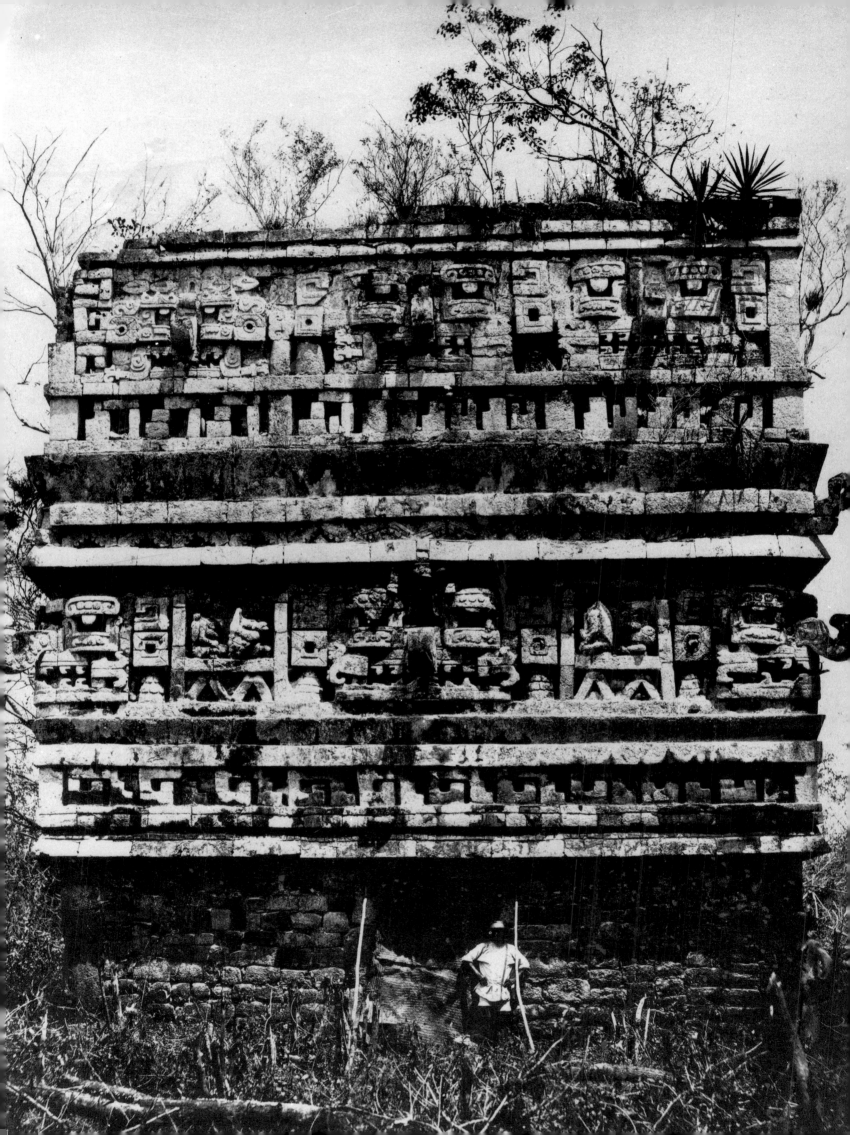

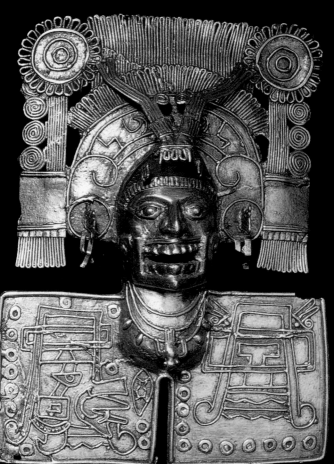

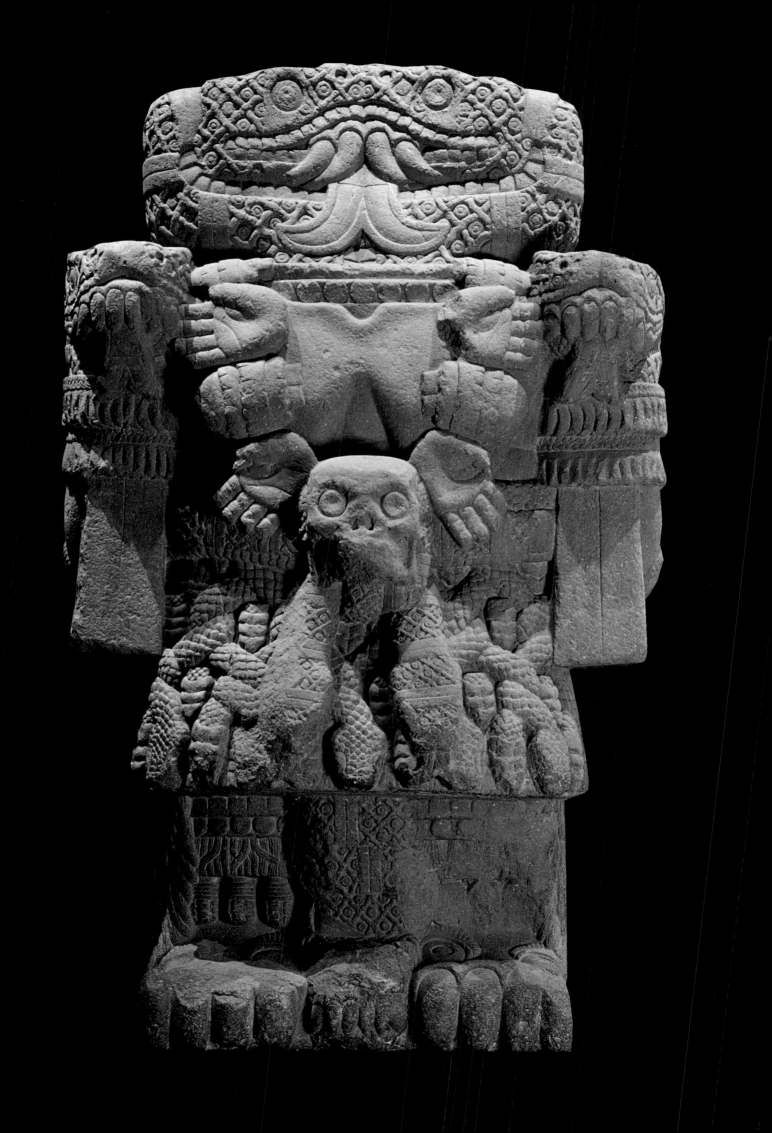

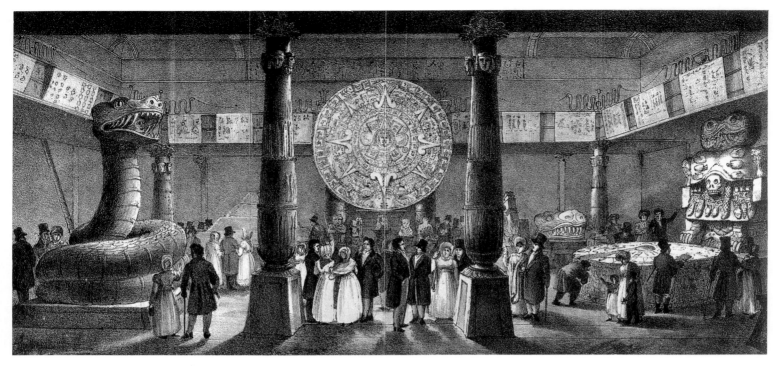

Illustration from William Bullock's A Description of the Unique Exhibition Called Ancient Mexico: Collected on the Spot in 1823 by the Assistance of the Mexican Government and Now Open to Public Inspection at the Egyptian Hall, Piccadilly. *1823. Engraving. The British Museum, London. Shown in the engraving are the Calendar Stone, Coatlicue, and the Stone of Tizoc.*

French intervention in Mexico, the government continued to subsidize missions to the Americas, including Charles Wiener's 1875 expedition to Peru, which yielded some four thousand objects, and Alphonse Pinart's five-year sojourn in Mexico, Central America, and the United States, from 1878 to 1883.[20]

A central figure in the imperial collection and appreciation of the Pre-Columbian past was Désiré Charnay, whose photographic expeditions produced remarkable visual results for domestic consumption at the same time as they celebrated the intrepid lone male explorer/scientist (à la Humboldt). His first tour of highland Mexico and the Maya area in 1857 and 1858, which included the sites of Mitla, Izamal, Chichén Itzá, Uxmal, and Palenque, was a pioneering effort in archaeological photography. He traveled with a huge camera, which took large plates that had to be prepared by hand before each exposure, developed in the field, and printed later on albumen-silver paper. The result was *Cités et ruines américaines*, an album of photographs of ruins and a volume of text (written mainly by French architectural historian Eugène Viollet-le-Duc). On subsequent trips to Mexico and Central America (sponsored by the French Scientific Commission and the Ministry of Public Instruction) he also pioneered the use of papier-mâché for making molds and casts of monuments. As Curtis Hinsley points out, Charnay's drawings, daguerreotypes, photographs, molds, and casts of pre-Hispanic ruins played a vital role in the constantly improving processes of technological conquest and consumption that characterized the colonizing enterprise. Moreover, his publications, particularly the popular *Ancient Cities of the New World: Being the Voyages and Explorations in Mexico and Central America of 1857–1882*, which emphasized the urban dimension of Pre-Columbian sites and framed Mexico and Central America as a unified high civilization comparable to the lost civilizations of the Old World, were instrumental in the late-nineteenth-century elevation of Pre-Columbian culture from the realm of the savage to that of socially defined meaning.[21]

In contrast to France, there was almost a total lack of British public support for the exploration and collection of Pre-Columbian artifacts. In England privately sponsored expeditions and collections were the rule—though of course the apparatus of the huge British colonial establishment greatly abetted them, and artifacts collected by English adventurers eventually found their way into state museums. William Bullock, a collector of natural and ethnographic curiosities and a showman, provided the earliest British exposure to Pre-Columbiana. After traveling to Mexico for six months in 1822, he staged the first big exhibition of Mexican antiquities in an Egyptian-style hall he had built in London's Piccadilly to display exotica to the paying public. It included casts (which he had painstakingly made himself) of the Aztec Calendar Stone, Coatlicue, and Stone of Tizoc that had so aroused Humboldt's interest, as well as several original pre-Hispanic carvings and manuscripts that he had collected, along with botanical and zoological specimens and modern artifacts. Bullock's highly

successful show introduced Lord Edward Kingsborough, a frequent visitor, to Pre-Columbian manuscripts and thus became the genesis of Kingsborough's lavish nine-volume encyclopedia, *Antiquities of Mexico*—for which he commissioned facsimiles of all the known Mexican codices (and many documents and chronicles). This enormous undertaking, which ultimately landed Kingsborough in debtors' prison, was an inestimable contribution to Pre-Columbian studies—even though it was initiated in the hopes of proving that Mexico had been colonized by the lost tribes of Israel.

The two greatest British Pre-Columbian collections were accumulated by Henry Christy, an ethnologist who had traveled to Mexico with the historian Edward B. Tylor, and Alfred P. Maudslay, an independently wealthy explorer whose activities in the Maya area accelerated the process of representing, reproducing, and removing artifacts begun by Charnay. Maudslay first visited Central America as a student in 1872, and after a brief career in the colonial service in Trinidad and the southwestern Pacific (Tonga), he returned to Guatemala to dedicate himself to the systematic study of Maya antiquities. Between 1881 and 1894 he made seven forays into the Maya area, laboriously transporting photographic equipment and plaster-casting supplies (in the event photographs would be impossible) over very difficult terrain. His meticulous research—photographs (technically improved since Charnay's expeditions), accurate site plans, detailed architectural data, careful records of sculptures, and drawings of hieroglyphic inscriptions—were published in five lavish volumes by Frederick Godman and Osbert Salvin in the *Biologia Centrali-Americana*. Without Maudslay's work much of the ongoing decipherment of Maya glyphs and calendrics could not have taken place.

The French and English went about preserving and displaying Pre-Columbian material in different ways, often competing with one another in terms of national pride. The capital cities of both countries had the most important exhibitions; however, many port cities that were trading with South America also mounted Pre-Columbian objects in municipal museums. From the late eighteenth century on, isolated Pre-Columbian artifacts found their way into the Louvre from the king's collection at the time of the French Revolution; and into the British Museum from Sir Hans Sloane's bequest, and from William Bullock's exhibition of Aztec sculptures in Piccadilly.[22] The first ethnographic galleries, in which Pre-Columbian material was incorporated with artifacts from around the world, were installed between 1820 and 1850 in both Paris and London. Then, in 1850 the Louvre held its first exclusively Americanist exhibition, including some nine hundred Pre-Columbian pieces, but it was moved around repeatedly and finally dismantled.[23]

It was only in the 1860s and 1870s that the first permanent, distinctively Pre-Columbian exhibits emerged. In 1865 the British Museum acquired Henry Christy's collection by bequest and opened it to the public once a week in his house; twenty years later, it transferred the collection to Bloomsbury and mounted the striking Aztec mosaics and other objects in its ethnographical gallery. Toward the end of the century, the museum acquired Maudslay's collection, which consisted of a small number of original Maya steles and sculptures and a large number of casts that he had made. But once again, the museum failed to put it on display for some thirty years, shifting it instead to the basement of the South Kensington Museum, a national museum of design (now the Victoria and Albert Museum).

In France, artifacts from the scientific expedition that accompanied Napoleon III's invasion of Mexico, especially from the large-scale excavations at Mitla, entered public and private collections, but there was no major institutional exhibition as a result. The spoils of Charles Wiener's state-supported expedition to Peru in 1875, however, were exhibited in the Palais de l'Industrie as part of the 1878 Paris Universal Exposition, in conjunction with a series of staged vignettes of Peruvian daily life. The show was a great popular success, and the French ethnographical community seized the opportunity to press for a full-scale, state-supported ethnographical museum. (Their cause was aided by the German government's establishment in 1873 of the Museum für Völkerkunde in Berlin.) The government responded by converting the exhibition in an eclectic Gothic-Byzantine-Moorish structure that overlooked the Champ de Mars into a permanent venue. Thus the new Musée d'Ethnographie du Trocadéro (now the Musée de l'Homme) became the acknowledged focus of interest for ancient American artifacts and French Americanist studies, surpassing the British collection in scientific and scholarly terms.[24]

In the United States there was a similar, though differently inflected, project of Pre-Columbian exploration, appropriation, and preservation, which was also driven by nationalist as well as political and economic imperatives.[25] During the nineteenth century the United States was engaged in its own westward expansion and consolidation, including the annexation of parts of northern Mexico. At the same time, the notion of Manifest Destiny was extended to encompass the wish for hemispheric unity, and an obsession with an isthmian canal was translated into a generalized preoccupation with the Central American region. With the close of the frontier and the maturation of North American industrial capitalism toward the end of the century, special economic interests in the United States also began to challenge the English and German investors in Latin America.

Coincident with this heightened interest in Central America, North American adventurers began visiting the region. The first important American explorer in Central America was the writer John Lloyd Stephens. Together with Frederick Catherwood, an English architect who had been a draftsman in the Middle East, he traveled throughout the Maya area in Yucatán and Central America from 1839 to 1842. Combining accurate archaeological descriptions and travelogue, Stephens's four engaging and immensely popular volumes about his travels, *Incidents of Travel in Central America, Chiapas, and Yucatan* and *Incidents of Travel in Yucatan*, communicated his keen admiration of the achievements of the Maya and his assessment (unusual at the time) that they were an indigenous development. Catherwood's accompanying illustrations of the ruins, engravings made with the aid of a camera lucida and—for the second book—the newly invented daguerreotype process, are the most famous depictions of them, in part because William Prescott praised them highly in his *History of the Conquest of Mexico*. He captured the visual details of buildings and monuments at Copán, Palenque, and Uxmal with great accuracy and sensitively conveyed the surrounding landscape, foliage, and general atmosphere of the ruins. A later volume published by Catherwood alone, *Views of Ancient Monuments in Central America, Chiapas, and Yucatan*, was a series of images that rendered the ruins and the landscape in a more romanticized vein. Maya carvings are dramatically framed by the dark, mysterious jungle, and picturesquely posed and costumed natives occupy the foregrounds.

Like many North American explorers of the region, Stephens traveled with various objectives. He had an official diplomatic mission, scouted for investment opportunities—he even tried unsuccessfully to buy Copán, Quirigua, and Palenque—and at the same time studied and collected Central American antiquities, which he planned to exhibit with a Catherwood panorama in New York and in a great new national museum of American antiquities. In the following decades Ephraim George Squier explored Nicaragua, Honduras, El Salvador, and later Peru with similar diplomatic, commercial, and scientific intentions and shipped Pre-Columbian monuments back to Washington for a proposed new national archaeology museum. Important publications that resulted from Squier's travels included *Nicaragua: Its People, Scenery, Monuments, and the Proposed Interoceanic Canal* and *Peru: Incidents of Travel and Exploration in the Land of the Incas*.

Another explorer of Central America on the same diplomatic-archaeological-commercial circuit was Edward Thompson. As consul to Mérida he spent much of his time exploring Maya ruins in Yucatán and shipping back artifacts to Harvard University's Peabody Museum of American Archaeology and Ethnology, his patron institution. His archaeological efforts culminated in the dredging of the famous well of sacrifice at Chichén Itzá—a site he in fact was able to purchase and live on with the help of a rich benefactor. The acquisition and removal of buried items that occupied all these men functioned as a form of claimstaking for the United States, a country that was perennially uncertain about its legitimate right to land, and Pre-Columbian collecting became symbolic capital for both cosmopolitan status and confirmation of a national culture tied to the land.

Before the Civil War, American elites defined high culture Eurocentrically and saw no reason to study and collect inferior, primitive civilizations. Even well-informed travelers such as Stephens and Squier regarded Mesoamerican artifacts mainly as curiosities. After the war, however, the cultural establishment in Boston, New York, and Washington began to rethink the Pre-Columbian past and revalue Pre-Columbian

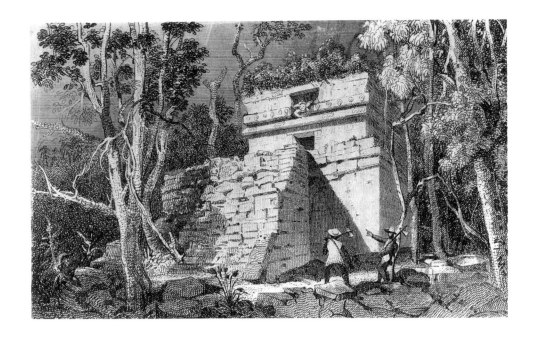

Frederick Catherwood. Temple at Tulum, Yucatán, Mexico. From Views of Ancient Monuments in Central America, Chiapas, and Tulum. 1844. Engraving. Rare Books and Manuscripts Division, The New York Public Library, Astor, Lenox and Tilden Foundations

objects as antiquities; and once their great age was recognized, these artifacts could be recovered as embodiments of beauty, knowledge, and the origins of civilization.[26]

Harvard's Peabody Museum, endowed in the 1860s, was the first specifically anthropological museum in the United States. Caught amid a heated debate over Darwinian evolution, the Peabody faced opposition in genteel Boston circles, which deemed primitive peoples and their artifacts unworthy subjects for the moral education of civilized nations.[27] For their self-appointed task of socializing and enlightening the threatening new immigrant masses, prominent Boston patrons such as Charles Eliot Norton required a morally uplifting subject matter that conflicted with anthropology's stress on the mundane and imperfect—for example, Indian shell-heaps—that was the result of evolutionary thought.

The Peabody reconciled the two ideologies in the late nineteenth century by establishing a hierarchy within the Pre-Columbian world, which eventually had enormous ramifications for the twentieth-century aesthetic approach to Pre-Columbian artifacts. As possessors of mathematics and calendrics, the Maya were classified as rational, literate, peaceful, and cultivated, that is, most conforming to Western ideals, while less refined cultures of ancient America were consigned to a lower level of the hierarchy. The upshot was a late-nineteenth-century academic construction of the ancient Mesoamerican world as a dichotomous split between the humanist and civilized Maya civilization and the brutal and bloodthirsty Aztec savages.

As the premier center of Pre-Columbian studies, the Peabody financed the activities and published the reports of Maudslay and Teobert Maler, an Austrian who traveled for many years in Mexico and Central America photographing ruins, which added greatly to Maudslay's documentation of Maya-area sites. And it organized and provided the intellectual scaffolding—exhibits, advice, classifications—for the influential display of pre-Hispanic artifacts at the Chicago Exposition in 1893.

Frederick Putnam, the director of the Peabody Museum, took charge of the anthropology exhibits at the Chicago fair. He organized a major show of Maudslay's and Maler's photographs of Maya sites as well as actual Maya monuments inside the anthropology hall and a mammoth display of life-size casts of Maya buildings and sculpture from Yucatán sites outside the hall. The casts of these evocative monuments, which were made to order for the occasion by Thompson and Maudslay and surrounded with tropical foliage to simulate their natural setting, greatly impressed the fair-going public with their strangeness and grandeur and piqued popular interest in Pre-Columbian archaeology.

Immediately after the fair, Chicago's cultural barons established the Field Columbian Museum to institutionalize the anthropological exhibits from the exposition. One of its first curators of American archaeology was William Henry Holmes, whose Archaeological Studies among the Ancient Cities of Mexico was a pioneering investigation of the materials, techniques, styles, and aesthetic of ancient Mexican art and architecture. The decade between 1895 and 1905 also witnessed the

Life-size casts of Maya buildings, World's Columbian Exposition, Chicago, 1893. Photograph in Bancroft, The Book of the Fair, 1893, vol. 7, p. 636. Miriam and Ira D. Wallach Division of Art, Prints and Photographs, The New York Public Library, Astor, Lenox and Tilden Foundations

growth of the Smithsonian Institution (where Holmes was a director of the Bureau of American Ethnology) and the American Museum of Natural History (where Franz Boas later became chief anthropologist) as centers for the systematic field study, acquisition, and display of Pre-Columbian material—just one aspect of their increasingly far-flung anthropological investigations. World's fairs continued to be held well into the twentieth century in the United States, when political and industrial leaders in various sections of the country wanted to present Americans with visions of progress and cultural unity in regional terms, and they often included a section devoted to Pre-Columbian civilization. Because the fairs were usually managed by the same prominent scientists and experts who were connected with both the government and major museums, there was a continuity between them and their treatment of Pre-Columbian cultures.

But the Pre-Columbian world eluded easy categorization within the post-Darwinian evolutionist scale of civilizations. Was it an archaic civilization like Mesopotamia or a more primitive social organization aligned with human origins? Pre-Hispanic civilization was technologically backward and presented clear evidence of cannibalism and human sacrifice. At the same time, however, Pre-Columbian civilization had a courtly and statist tradition whose remains included monumental architecture and sculpture—most prominently associated with the literate Maya. This evidence of traditional and religious societies in the Pre-Columbian world aligned it with Orientals and Asiatics in the human hierarchy of the West—that is, below white races, but not so far below as tribal societies, which did not have densely populated cities, great temples and palaces, and calendrics. Thus, it was usually classified as barbarian—a stage above savagery and below true civilization—but its problematic placement in the evolutionist scheme has always conditioned its treatment as art.[28] (Contemporary art history surveys, which alternately group it with the primitive, with art's mystical, magical beginnings in caves, or with the archaic civilizations of the Mediterranean world, demonstrate the lack of agreement about its position.)

Universal expositions, with their kaleidoscopic spectacles, were an effort to present a unified account of the past and present at a time of disjunction and uncertainty encompassing the rise of cities, industrialization, modernity, corporate forms of business, dramatically altered social relations of advanced capitalism, and disinherited masses threatening the higher orders.[29] The process of secularization in the late nineteenth century, coupled with the determinism of Darwinian evolutionism, exacerbated the cultural turmoil, producing, in Jackson Lears's phrase, a "crisis of cultural authority" and promoting a widespread sense of dislocation and of moral and spiritual malaise among the bourgeoisie. One result was an insistent flight from modernity, which was characterized by a longing for the reconstruction of a coherent sense of identity and for the restoration of the lost innocence and the authentic experience of bygone eras. An activist version of antimodernism preached regeneration through preindustrial craftsmanship and a simple pastoral life. A more inner-directed antimodernism often substituted occultism for a lost sense of a coherent universe.[30]

Popular interest in Pre-Columbian cultures incorporated many of these antimodernist responses to the profound disjunctions of the late nineteenth century. There was an especially strong strain that associated pre-Hispanic civilization with occult and supernatural phenomena, including Pythagorean number mysticism, esoteric investigations of originary or "natural" languages, and transoceanic diffusionism—the notion of a common origin for wildly disparate cultural traits—often attached to questions about ancient Americans that were ignored by rationalist and positivist science. These were questions involving the strangeness and mystery of the Indian world that had surfaced in its first contacts with Western culture in the sixteenth century and resurfaced in the debates of the post-Darwinian period: Where did the Indians come from? What happened to them? How could their existence be reconciled with a belief in the Bible, or with evolutionary or racial theories?

A broad public seized on the notion of Atlantis as a means of answering some of these questions and of reconciling the apparent great age and sophistication of Pre-Columbian ruins with the baser existence of the surviving indigenous population. As it was recast by Brasseur de Bourbourg, the idea of Atlantis, a mythical continent that was conceived as the cradle of world culture in Plato's time, became an explanation of all the missing links in the prehistory of Mesoamerica. It extended from Central

America to the Canary Islands and Africa and was destroyed in a volcanic cataclysm six thousand to seven thousand years ago, but some of its surviving inhabitants (who were white) settled on the Lesser Antilles and eventually came to the mainland of Central America, bringing culture to the Maya. Thus the Toltecs and their king Quetzalcoatl were descendants of the surviving remnants of Atlantis. As evidence of this bizarre history, Brasseur offered legendary meanings derived from his study of Maya hieroglyphic inscriptions, etymology, mystical signs, rites, and symbols that represented the powers of nature.[31] The assertion that the inhabitants of Atlantis, rather than indigenous Indians, were responsible for the high culture of the Mayas dovetailed neatly with the officially sanctioned racism that was politically motivated. It also served to confirm the idea that the Maya civilization was midway between the primitive and the civilized on the evolutionist scale, while managing at the same time to envision it as a prelapsarian embodiment of an alternative social order.[32]

During much of the nineteenth century, mystical notions about Pre-Columbian culture had a very wide currency, and even purportedly scientific investigations of ancient America were often saturated with them. Augustus Le Plongeon, a weird figure who spent long years in Yucatán and excavated at Chichén Itzá, where he uncovered the famous chacmool statue, popularized Brasseur's ideas in his widely read books.[33] Edward Thompson, whose expeditions in the Yucatán were sponsored by the Peabody, was a believer in Atlantis, and Le Plongeon for a time received the support of respectable antiquarian societies in Boston. Many reputable European scholars upheld diffusionist speculations about the Asiatic origins of Pre-Columbian civilization, including British anthropologists Grafton Elliot Smith and Edward B. Tylor, and the founding curator of the Trocadéro, E. T. Hamy, who devoted decades of minute scholarship to amassing evidence of, say, the presence of the yin-yang symbol at Chichén Itzá.[34] Pre-Columbian codices and glyphs, which were studied as scientific evidence of early writing systems, were also investigated for the light they shed on the connections between the religious beliefs of ancient Mexicans and Egyptians and for insights into pagan cults and occult lore since Plato and Pythagoras—with similar arguments often advanced in both cases.

It was only with the consolidation of twentieth-century anthropology as an academic discipline and the ascendancy of the culturally specific and developmental anthropological paradigms in the early twentieth century that these entangled strands of science and pseudoscience began to be separated. Nevertheless, fantastical interpretations of Pre-Columbiana have persisted in the popular imagination until the present, proving themselves immune to the strenuous efforts of professional anthropologists to disparage them.[35] A direct line can be traced, for example, from Le Plongeon's predictions of cataclysm through his readings of Maya glyphs to the recent calculation in 1989 of a "harmonic convergence" marking the beginning of a "period of shake up," which José Arguelles of Boulder, Colorado, promoted on the basis of his interpretation of Maya and Aztec calendrics. Mystical explanations of enigmatic Pre-Columbian myths and symbols like these have found greatest favor during the waves of popular occultism that have periodically washed over the cultural landscape in the United States and abroad. And many idealistic modernist artists who appropriated Pre-Columbian forms as a resource for their work also embraced the magical and mystical notions associated with them as a means of satisfying their spiritual yearning in a desanctified universe.

FROM ETHNOGRAPHY TO ART

It is generally agreed that Pre-Columbian artifacts did not enter Western art history until around 1920, moving from the ethnographic to the fine-art category more than a decade after Boas introduced the notion of contextualizing anthropological artifacts in an effort to recreate the total life of a culture and Pablo Picasso, André Derain, and other Parisian artists had begun to regard the tribal objects from Africa and Oceania in the Trocadéro as aesthetic fodder.[36] But it would be wrong to conclude, as most authorities do, that there was little or no aesthetic appreciation of Pre-Columbian objects before that time.[37] Since the Conquest, there has indeed been aesthetic interest in pre-Hispanic artifacts that has been overlooked, mainly because it was usually directed to architectural ornamentation and the decorative arts, rather than to

painting and sculpture. As inferior forms within the Western artistic hierarchy, the decorative arts are relatively unconstrained by conflicts with religious and political ideologies, though more subject to the exigencies of fashion.

Sporadic instances of European artisans incorporating Pre-Columbian forms in their work are known from the sixteenth through the eighteenth centuries. Examples include "Indian" faces with feathered headdresses carved on capitals in a Liège episcopal palace and on a tomb in Rouen cathedral in the late sixteenth century that may have been inspired by Mixtec goldwork masks, and actual artifacts used to embellish fanciful bibelots in the manner of the eighteenth-century fashion for chinoiserie: an Olmec greenstone mask (given arms and an ornate metalwork setting) set in a lavish reliquary and a pair of giant seventeenth-century Guadalajara ceramic vases with Pre-Columbian motifs supported by elaborate gilt statues of Indians.[38] However, it was only in the second half of the nineteenth century that the aesthetic interest in Pre-Columbian forms moved from the margins to the center of consciousness in the West, after the decorative arts were elevated to the status of fine arts as a result of the crusades of John Ruskin and William Morris.

Perhaps equally important in the reevaluation of Pre-Columbian artifacts as fine art was the increasing association after about 1860 of the pre-Hispanic world with exotic, lost, high civilizations of proto-urban dimensions.[39] The great architecture and monumental sculpture documented in Charnay's, and later Maudslay's, books and photographs, the Peabody's elevation of the Maya into the Greeks of the New World, and Holmes's aesthetic valuation of Mexican antiquities were instrumental in bringing about this change. Curtis Hinsley points out that a further sign of this transformation was the portrayal of the imagined Pre-Columbian artisan: "While still anonymous, his art moved from the intuitive impulses of savagery into a realm of socially defined meaning, combining the instructions of a presumed priestly order and communal needs with individual expression."[40] Once the pottery and textiles of pre-Hispanic culture were seen to be created by individuals, an aesthetic appreciation of these goods was at hand; the Pre-Columbian world became morally worthwhile and eminently collectible.

Nineteenth-century architects and designers who were concerned with principles that would improve design in the industrial age sought new models in historical and exotic styles of all kinds. Viollet-le-Duc was a leading light of the French Gothic revival; he also advocated the use of Pre-Columbian architectural decoration as a new means of embellishing functional buildings—not surprisingly, since he wrote the introduction to Charnay's *Ancient Cities of the New World*. In his extremely influential *The Grammar of Ornament*, architect and ornamentalist Owen Jones codified the principles of architecture and design and supported them with a compendium of conventionalized designs from a wide variety of historical periods and cultures: Persian, Moorish, Egyptian, Japanese, Chinese, Greek, and Pre-Columbian. Christopher Dresser, who succeeded Jones as the leading ornamentalist and industrial designer in England, created designs for nearly every decorative medium. As director of the Linthorpe Pottery in Yorkshire, he used the unusual shapes of Nazca and Moche ceramics (which he had probably seen on display at the Paris Universal Exposition of 1878) as sources for his own pottery designs, declaring that they represented new possibilities for "intelligent and imaginative eclecticism."[41]

Dresser's writings and designs were a major influence on the British, and especially the American, Aesthetic movement, a revival of interest in the decorative arts that introduced principles emphasizing art in the production of furniture, metalwork, ceramics, stained glass, textiles, wallpapers, and books. During its height in the mid-1870s and the 1880s, the movement advanced a mélange of exotic forms as surface decorative elements for consumption on all levels of society and promoted innovative approaches to domestic decoration through a proliferation of art and design magazines, books, societies, clubs, and exhibitions.[42] In this context, the decorative and design qualities of Pre-Columbian ceramics, textiles, and architectural ornaments were viewed as counterparts of Japanese or Islamic elements and were equally prized as embodiments of exotic, mysterious, and picturesque civilizations like those of the Near and Far East. One of the great monuments of the American Aesthetic movement exemplifies this tendency. It is a flamboyantly decorated Near-Eastern style mansion called Olana overlooking the Hudson River in upstate New York, which the illustrious nineteenth-century landscape painter Frederick Church designed as a showcase for his highly

Carved Olmecoid mask set in a European reliquary. Mask: 100 B.C.–A.D. 250, recarved by an Aztec lapidary 1440–1521; greenstone, height 4⅜". Reliquary: Guillaume de Groff, 1720; mixed materials, height 23⅝". Schatzkammer der Residenz, Munich

Two relief slabs showing an eagle devouring a human heart, said to be from Veracruz, near Tampico, Mexico. 1000–1200. Limestone, 27½ × 29½". The Metropolitan Museum of Art, New York, Gift of Frederick E. Church, 1893 (93.27.1,2)

eclectic collection of old and new oriental rugs, Moorish metalwork, Chinese and Japanese porcelain, Venetian glass, Asiatic sculptures, Mexican textiles, and paintings (including of course his own).

Church traveled widely in Mexico and South America, painting and sketching nature in its sublime and picturesque guises. In the course of his travels he acquired a sizable number of Pre-Columbian-style objects, which he displayed at Olana in a room with a Mexican and South American motif. The collection consists mainly of Aztec-style pottery and some stone sculptures but also includes Maya, as well as various ancient Central and South American-style ceramics and sculptures—and is almost entirely fake.[43] If Church was aware of this, he probably would not have cared, since his only interest was in the way these pieces blended into the interior decor and in their exoticism, not in their authenticity or intrinsic meaning. The most important objects in the collection were undoubtedly (an apparently authentic) pair of Toltec reliefs representing an eagle devouring a heart. Church bequeathed them to the Metropolitan Museum of Art, of which he was an early trustee, and they are now on display in the Michael Rockefeller wing of primitive art.

The fact that large numbers of Pre-Columbian forgeries were manufactured in the late nineteenth century[44]—especially of Colombian goldwork, Aztec stone idols and masks, as well as ancient Mexican and Peruvian pottery—attests that there was already an art market developed enough to support them. While it is true that forgery of Pre-Columbian artifacts had begun in early colonial times on a modest scale, presumably to supplement a limited European supply of curiosities,[45] the exquisite refinement of many late-nineteenth-century fakes—some of which were considered masterpieces of their genre until modern technology and art-historical detective work ferreted them out[46]—argues for a primarily aesthetic motivation in their manufacture.

As Pre-Columbian forms were achieving the status of fine art in the late nineteenth century, they were simultaneously valorized as both high and low, civilized and savage aesthetic expressions, a contradiction licensed by the shifting position of ancient American civilization within the classification systems of evolutionism. On the one hand, the Aesthetic movement upheld these objects as emblems of the great good taste and worldly sophistication of progressive individuals in step with modern life. On the other hand, the Arts and Crafts movement in England and America, which was a critique of modern culture, projected "Red Indian Art"[47]—a term subsuming Pre-Columbian and North American Indian artifacts—as a natural or primitive aesthetic expression and a means of recovering primal authenticity of thought, feeling, and action, that is, of revitalizing modern life.

Arts and Crafts doctrines shared the Aesthetic movement's exaltation of craftsmanship, natural materials, and the integrated interior but rejected machine production and emphasized form and structure rather than surface ornament.[48]

Inspired by William Morris's critique of the deadening effects and overrationalization of capitalist work, they envisioned an alternative culture to capitalism, which advanced craftsmanship—and socialism—as a cure for modern overorganization and extolled preindustrial work as a model of joyous labor in a community.[49] Primitivizing begins here: the artisan was instructed to project himself into the place of the ancient worker and to do the thing as it was done in the beginning, pursuing the primal instinct for art, without its sophistication.

This is where Paul Gauguin enters the story of the Western reception of Pre-Columbian objects. Like many other late-nineteenth-century painters, such as James Abbott McNeill Whistler, Gauguin actively participated in the decorative arts. From the onset of his career he did not confine his artwork to the canvas but instead applied his talents to needlework, the decoration, design, and construction of furniture, chests, and other household items, the painting and carving of walls, doors, and wooden objects, and the making and decoration of pottery. For the rest of his life he continued to embellish every interior that he occupied. His initial forays in this area were largely inspired by the Pre-Columbian artifacts he encountered at the Paris Universal Expositions of 1878 and 1889. During the latter he sketched Aztec monuments, studied Maya glyphs (in an exhibit of the history of writing), and admired the Pre-Columbian pottery on display as products of an authentic experience of a premodern past. His childhood in Peru and his mother's partly Peruvian identity heightened his experience of ancient Peruvian pottery, which markedly influenced his own ceramics from 1888 on and also affected his painting, even after he had gone to Tahiti. From Gauguin's primitivizing relation to Pre-Columbiana we are only half a step away from the high-modernist embrace of Pre-Columbian art in the twentieth century.

Taking their cue from Gauguin, whose work was on view in a retrospective exhibition in Paris in 1908, vanguard modernist artists became enchanted with *arts primitifs* and began haunting the jumbled display of exotica at the Trocadéro for inspiration in the years before World War I.[50] Like Gauguin, they appropriated primitive art with the intention of subverting the established aesthetic order, while at the same time conceiving of themselves as creative geniuses expressing the highest aspirations of their culture—and recognizing the value of the primitive as a resource for their material forms. Pre-Columbian artifacts were never central to the "primitivist revolution"; unlike African objects, they played no important role in Picasso's generation of Cubism. However, they did have a significant impact on several individuals in Picasso's circle in the prewar period, including André Derain, who modeled his early sculptures after Aztec forms; Diego Rivera and David Alfaro Siqueiros, who were already formulating the notion of a return to indigenous forms as a basis for a new Mexican art; Henri Rousseau, who claimed to have spent many years in Mexico and credited it with inspiring the jungle settings in his work; and the influential poet and critic Guillaume Apollinaire, whose extensive involvement with Pre-Columbiana has generally been overlooked.

As one of the first critics to acknowledge the greatness of African sculpture and elevate it to the level of medieval and even Greek art, Apollinaire was also one of the first to admire the aesthetic quality of Pre-Columbian and American Indian forms, but they engaged his attention more keenly as a manifestation of primitive ritual, magic, and language. He was particularly fascinated by ancient Mexican codices and hieroglyphic inscriptions and often characterized them as examples of originary writing and esoteric language in essays and reviews written between 1912 and 1918. He also used Mexican ideograms as models for his own "calligrammes."[51] Thus, Apollinaire carried forward into the twentieth century the mystically inflected nineteenth-century relation to Pre-Columbiana, and in the following decades this tendency was to find its apotheosis in Surrealist researches into ancient American arcana, such as those of Antonin Artaud, Georges Bataille, and contributors to the journal *Documents*.

THE 1920S: PRE-COLUMBIAN ART AND ARCHAEOLOGY ARRIVE

During the 1920s the European enthusiasm for primitive art was stimulated further by postwar disillusionment with Western civilization and a new fascination with the

colonies. In Paris, as James Clifford points out, the term *nègre* embraced modern American jazz, African tribal masks, and voodoo as well as Oceanic and Pre-Columbian artifacts and immediately evoked a world of dreams and possibilities—passionate, rhythmic, concrete, mystical, unchained.[52] The explosion of popular interest in exotic and primitive forms was also marked by new developments in architectural design and the decorative arts, which seemed to pick up where the Aesthetic movement of the 1880s had left off. In 1925, a highly influential Parisian exhibition, "Exposition internationale des arts décoratifs et industriels modernes," promoted as the essential experimental design form of the machine age a stylizing attitude known as Art Deco, which encouraged designers to produce elegant architectural and decorative forms out of shiny new materials and to ornament them with geometricized forms derived from an eclectic assortment of primitive and Pre-Columbian sources.

Sectors of the elite cultural establishment in London and Paris also began to acknowledge the modernist primitivist revolution of the preceding decade. And in reevaluating Pre-Columbian artifacts as fine art, art institutions invariably strove to incorporate them within the high-culture canon, in the category of archaic, court, or theocratic art.[53] The first officially sanctioned "artistic" exhibition of Pre-Columbian artifacts took place in 1920 at the Burlington Fine Arts Club in London. The immediate context was Bloomsbury critic Roger Fry's just-published *Vision and Design*, which provided a new theoretical basis for constituting Pre-Columbian objects as art by articulating, for the first time in English, the formalist and universalist credo of modernist art—that art need only have formal meaning and that form was a universal medium of vision. The book contained chapters on ancient American, African, Bushman, and Islamic art alongside ones on Giotto, Cézanne, and Renoir. The club's "Exhibition of Objects of Indigenous American Art" was an extensive display of ancient American objects from local private collections and small museums (the Pitt-Rivers Museum, the Cambridge Museum of Ethnology and Archaeology, and the municipal museum of Liverpool). Thomas Athol Joyce, curator of American antiquities in the British Museum and primary shaper and disseminator of information about its voluminous Pre-Columbian holdings, which Henry Moore was scouring at that very moment for sculptural models, wrote the catalogue.

Eight years later the first French exhibition of Pre-Columbian material as fine art was held in the Louvre's Pavillon du Marsan and included almost a thousand objects from Mexico and Central and South America. The catalogue, *Les Arts anciens de l'Amérique*, was prepared by the exhibit's organizers, Alfred Metraux and Georges Henri Rivière, who selected pieces for their high quality and made every effort to illuminate artistic developments by grouping objects according to form and decoration and stressing the style of each epoch or region, so that the play of neighboring influences would be apparent.[54] The show inspired a number of artists and writers in Surrealist circles to explore Pre-Columbian art. Prominent among them was the Uruguayan Joaquín Torres-García, who, after intensively studying ancient Peruvian art and architecture, made it a linchpin of his theory of Universal Constructivism.

The 1920s also witnessed a great surge of interest in Pre-Columbian art and culture in the Western Hemisphere. In Mexico, in the aftermath of the Revolution of 1910 to 1920, a reformist government strove to incorporate a previously despised indigenous population into the new nation-state, which had been struggling for existence since the departure of the Spanish in 1821. From that year forward the construction of the ancient past was inseparable from this struggle.[55] In 1825 the first National Museum of Archaeology had been established, though a suitable facility to house the vast collection of Aztec monuments (including the three great monoliths that had been unearthed in 1790–91) was not opened to the public until the 1880s.

The late nineteenth century was a time when the Aztecs were first integrated into the national identity; their Republican virtue was hailed as the first stage of the progressive evolution of the Mexican state, followed by the Conquest, the Viceregal period, Independence, Reform, and the optimistic Porfirian present. After the Revolution, the Mexican Renaissance fleshed out a mythic past that would inspire the Mexican masses in the creation of a new nation. Indigenist ideology venerated the Aztecs (now renamed the *México*) as the great ethnic group from which all Mexicans descended. It celebrated them as spreaders of a trading civilization whose communally

held agricultural lands provided a historical basis for Emiliano Zapata's land reform and lionized their fierceness and military might to embolden an Indian population known for its docility and passivity. This construction of the Aztec period as a golden age of Mexico glossed over the powerful elements of control, domination, and exploitation in Aztec society and downplayed its widespread practice of human sacrifice and cannibalism. It also posed an anti-imperialist challenge to the Anglo-Americans who had imagined an ostensibly kinder and gentler—an essentially feminized—Maya civilization as the pinnacle of Mesoamerican culture history.

As a means of unifying the national consciousness, philosopher José Vasconcelos and archaeologist Manuel Gamio spearheaded this ideological campaign to rediscover and revive native art and culture, which included a mural program celebrating the national heritage, educational outreach to encourage indigenous crafts, and archaeological excavation and preservation of pre-Hispanic ruins. Diego Rivera's nationalist mural projects of the 1920s epitomize these aims.

After he had completed his great nationalist mural cycle of the 1920s (and had become a national hero), Rivera embraced with a similar indigenist zeal the task of promoting and collecting Pre-Columbian artifacts as art. In the process he accumulated nearly sixty thousand objects, which he eventually donated to the state with a museum that he designed and built to house them.[56] Among his circle of friends, Moisés Sáenz, artists Miguel Covarrubias and Roberto Montenegro, and the American expatriate designer William Spratling also accumulated extensive Pre-Columbian holdings, many of which eventually found their way into the great National Museum of Anthropology in Mexico City (dedicated in 1964) and a few university and provincial museums.

In the United States during the first decades of the century, capital was invested in Latin America in growing volume, especially in mineral and agricultural products. By the end of World War I, the United States had supplanted Britain as the dominant trader and investor in the region, and it consolidated this position in the 1920s as unprecedented amounts of its capital flowed into Latin America in the form of direct and indirect investments.[57] Within this geopolitical and economic framework, the overlapping nineteenth-century anthropological, aesthetic, modernist, and antimodernist strains of appreciation of Pre-Columbian material in the United States came together to form a wellspring of interest in the subject, which was supported by corporate, nationalist, and regionalist imperatives and conditioned by a provincial, self-consciously American response to the challenge of European modernist culture. A general awareness of the nationalist revolution and cultural revival in neighboring Mexico—of both a sympathetic and critical complexion—and a new wave of occultism fueled this interest further.

In architecture, industrial design, and the decorative arts, a Maya Revival style that emphasized smooth planes punctuated with geometric ornament derived from Pre-Columbian forms was applied to everything from skyscrapers to ashtrays.[58] It took hold most effectively in southern California, where a Spanish colonial presence and the ruins of an earlier Indian culture were still in evidence. Surfacing as early as 1915 at the Panama-California International Exposition in San Diego, the style was a more exotic offshoot of efforts to establish a regional vernacular for the residences of the new entrepreneurial elite by using architectural forms and motifs of the old aristocratic Spanish social order. Local designers such as Francisco Cornejo and Henry Lovins also began incorporating within it Egyptian, Moorish, and especially Pre-Columbian motifs and colors as elements of interior decor, furniture, tiling, and graphic design. Cornejo even designed the sets and costumes of choreographer Ted Shawn's Toltec-inspired 1920 ballet, Xochitl.[59] In the ambience of this regional Hispanic revival style, Frank Lloyd Wright's long-term interest in Pre-Columbian architecture (dating to his early career in Chicago) took flight in residential designs of the late 1910s and early 1920s in Los Angeles, especially his textile-block houses, which were indebted to both Mixtec and Maya sources. And from the mid-1920s to mid-1930s, the facades and interiors of hotels, theaters, mansions, civic centers, and unconventional churches in the newly thriving capital of the motion-picture and tourist industries were ornamented with often playful and frequently garish stylizations of Maya and Mexican forms, architect Robert Stacy Judd being the chief practitioner and publicist of the style.

The Maya Revival style ultimately extended beyond the West Coast and was applied to the effort of creating a modern all-American style during the late 1920s and early

1930s.[60] In this sense it was systematized and synthesized for adaptation to modern buildings, particularly movie theaters and skyscrapers, throughout the country. In the popular imagination, Maya pyramids, with their setback plans, verticality, and planarity, were indigenous precedents of modern American skyscrapers, and their exterior and interior (lobby) surface decoration was often Maya-derived. During the early years of the Depression, elaborate Maya Revival buildings were also erected as the grand centerpieces of world's fairs; the Maya Building at the 1933 Chicago Century of Progress World's Fair replicated a portion of the Uxmal Nunnery; and the Federal Building at the 1935 California Pacific International Exposition in San Diego was a reconstruction of the Governor's Palace at Uxmal.

The 1920s were the heyday of Pre-Columbian archaeological research and exploration in the United States, focusing primarily on the study of the Maya that the Peabody Museum had initiated in the previous century. Herbert Spinden, the leading figure in the field, continued Maudslay's initiatives by conducting a *New York Times*–financed expedition in a largely unmapped area of Yucatán and by deciphering Maya inscriptions. His pathbreaking *A Study of Maya Art* was an effort to establish a serial chronology of Maya art on the basis of the evolution of stylistic traits and dated monuments. He also published other important studies of ancient American civilization in 1917 and 1933, when he was associated first with the American Museum of Natural History and then with the Brooklyn Museum as curator of Primitive and New World Cultures.

Several centers for Pre-Columbian studies were among the many (newly tax-exempt)

James Miller and Timothy Pflueger. Exterior view, 450 Sutter Street (The Medical Building), San Francisco, California. 1930

41

cultural institutions established in the United States during the economically expansive 1910s and 1920s, with the most important being the Carnegie Institution of Washington, directed by Sylvanus G. Morley. Its large-scale excavations concentrated on the documentation of elite monumental architecture and sculpture of such major Maya sites as Uaxactún in Guatemala and Chichén Itzá in Yucatán, setting the standard for Maya archaeology for the next forty years. Archaeologist Frans Blom worked for the Carnegie at Uaxactún in 1923 but carried out his major research and exploration under the auspices of Tulane University's new Middle American Research Center. On one expedition to Mexico's Gulf Coast region in 1925, he and Oliver La Farge unearthed a number of spectacular monuments—colossal heads, monolithic altars, anthropomorphic figures—which they attributed to an important pre-Maya culture (incorrectly labeled the Olmec) and published in a highly readable account, *Tribes and Temples*. The 1920s were also the salad days of the Museum of the American Indian. Founded in 1918 in New York by George Heye as a center for the study and collection of Indian material of the entire Western Hemisphere, it supported extensive field research in Mexico and Central and South America. (The museum virtually collapsed during the Depression and, after decades of neglect and scandal, is currently being resuscitated by the Smithsonian Institution as the new National Museum of the American Indian.)[61]

Many of the leading Pre-Columbian scholars of the day worked for the government and actively fostered a chauvinist construction of Pre-Columbian culture; they also facilitated the spread of the Maya Revival style by serving as consultants to industrial designers and architects.[62] During World War I, as an official of the American Museum of Natural History and a government agent, Spinden toured Central America to collect ancient American designs for U.S. textile manufacturers (whose European sources were cut off), while simultaneously searching for mahogany for U.S. airplane propellers. During the Depression, he directed a federal project to construct models of Maya buildings (which were installed in the Brooklyn Museum's Pre-Columbian exhibit) and hailed the Maya Indians as good Americans because they had "skyscraper instinct." He also devised educational outreach programs, employing the museum's native American collection as an instrument for the socialization and assimilation of its large (Eastern European) immigrant constituency. Like Spinden, Morley and Blom promoted the uses of the Maya beyond the confines of the academy; the former by authenticating the Maya detailing of the interior decor of the Fisher Theater in Detroit in 1928; the latter by conducting an elaborate government-supported expedition in Yucatán to document the Nunnery quadrangle at Uxmal for reproduction at the 1933 Chicago fair. (For many years, Blom attempted without success to have Tulane erect a full-size replica of the Uxmal Nunnery or the Castillo at Chichén Itzá as the new headquarters of its Middle American Research Institute and collection.)

During the 1930s and 1940s, in pursuit of a policy of hemispheric unity called Pan-Americanism (as a strategic defense against the incursion of European fascism into the American continent), the U.S. government escalated the campaign to promote Pre-Columbian art as an all-American heritage by actively encouraging its collection and dissemination.[63] In 1933 President Franklin Roosevelt articulated a Good Neighbor Policy that stimulated a flurry of cultural activities designed to enhance hemispheric understanding. In 1939 he appointed Nelson Rockefeller, then president of the Museum of Modern Art's board of directors, to implement the policy as Coordinator of the Office of Inter-American Affairs. With his successful family business and artistic links with Latin America, Rockefeller was eminently suited to the task.

In his capacity as coordinator of Inter-American Affairs, Rockefeller and his aides, principally René d'Harnoncourt, developed numerous exhibitions of ancient and modern Latin American art that were publicly committed to the enhancement of hemispheric understanding. Between 1940 and 1945 there were eight such exhibitions at the Museum of Modern Art, including the extensive "Twenty Centuries of Mexican Art" (1940), jointly sponsored by Mexico and directed by its leading archaeologist, Alfonso Caso. These were coordinated with a large number of exhibitions of Pre-Columbian art (variously presented as ethnography, as high, and as primitive art) organized in prominent venues, including the 1939–40 Golden Gate International Exposition in San Francisco (for which Rivera painted a mural on the theme of Pan-Americanism); the Brooklyn Museum; Harvard University's Fogg and Peabody

museums; the American Museum of Natural History, linked with the New York World's Fair; the Wakefield Gallery; and the National Gallery of Art.[64]

All these exhibitions interpreted Pre-Columbian objects as belonging to a common American heritage, and, with the exception of "Twenty Centuries of Mexican Art," drew exclusively on U.S. expertise, analysis, and collections.[65] Fifty years later, the same scenario was reenacted on an even grander scale. In the fall of 1990, a staggering array of highly coordinated and slickly marketed exhibitions of ancient and modern Mexican art (trumpeted in the New York media as "Mexico, a Work of Art"), whose centerpiece was "Mexico, Splendors of Thirty Centuries," an extravaganza organized by the Metropolitan Museum of Art, served as cultural harbinger of another U.S. government hemispheric policy: free trade with Latin America, only this time Mexican corporations interested in hastening the policy's implementation picked up the tab.[66]

The history of Nelson Rockefeller's personal collection of Pre-Columbian art is instructive with regard to the vicissitudes of this material within the U.S. art establishment and its changing attitude toward this material. As an aficionado of modern art, Rockefeller began collecting Pre-Columbian art on a Mexican sojourn in 1933 when Diego Rivera—whom he had commissioned to paint a mural in the newly erected Rockefeller Center—and Miguel Covarrubias impressed upon him its profound impact on their work.[67] In the same year the Rockefeller-supported Museum of Modern Art mounted the exhibition "American Sources of Modern Art," curated by Holger Cahill, which attempted to demonstrate the influence of Pre-Columbian art on modern American artists, including Rivera, Siqueiros, Carlos Mérida, John Flannagan, and William Zorach.[68] During the 1930s Rockefeller tried to sponsor the inclusion of Pre-Columbian art at the Metropolitan Museum, but the museum turned him down flat, referring him instead to the American Museum of Natural History, where the Met had been shunting bequests of this material since 1882, though it sporadically presented such objects in temporary exhibitions. Undeterred, Rockefeller continued to acquire Pre-Columbian as well as primitive art and to knock at the Metropolitan's door, eventually founding his own Museum of Primitive Art in 1954 as a repository for his growing collection. His chief advisor was René d'Harnoncourt, director of the Museum of Modern Art, who had an abiding personal interest in Pre-Columbian art and had organized a number of exhibitions of primitive art at the Modern. Still desirous of a more prominent venue for his collection, Rockefeller continued to try to interest the Metropolitan in it, but the museum steadfastly refused to acknowledge its aesthetic nature. In the late 1960s, however, Rockefeller finally prevailed when the Met, as a means of fulfilling an expansive building drive, accepted the collection with his donation of a primitive-art wing honoring his son Michael (who died in 1961 while on a collecting expedition among the Asmat people of New Guinea).[69]

In the Rockefeller wing, which opened to the public in 1982, Pre-Columbian and primitive material is displayed in formalist aesthetic terms; isolated, rarefied ceremonial objects are dramatically lighted and placed on pedestals and in vitrines, without ethnographic information. Until recently, anthropology museums in the United States treated Pre-Columbian objects very differently, displaying them not as sculpture or paintings but in proximity to objects from the same cultural group, including utilitarian artifacts such as grinders, bowls, or spears. A mask or a statue was grouped with formally dissimilar objects and explained as part of a ritual or institutional complex. Thus the object in an ethnographic museum was culturally or humanly "interesting"; in the art museum, it was primarily "beautiful" or "original."[70]

Museums were the major institutional setting for ethnography and archaeology in the English-speaking world until around 1930, when developments within and outside these disciplines contributed to a decline in their importance and their replacement by universities. New anthropological paradigms—behaviorism in the 1930s, New Archaeology and "cultural process" in the late 1960s—discouraged archaeologists from gathering and studying large collections.[71] At about the same time, a highly active international art market in Pre-Columbian antiquities, often allied with the burgeoning field of Maya epigraphy, was competing with anthropology for dominion over the same artifacts, while Third World nationalist movements laid claim to them as cultural patrimony.

Perhaps in response to these challenges, many ethnographic museums and

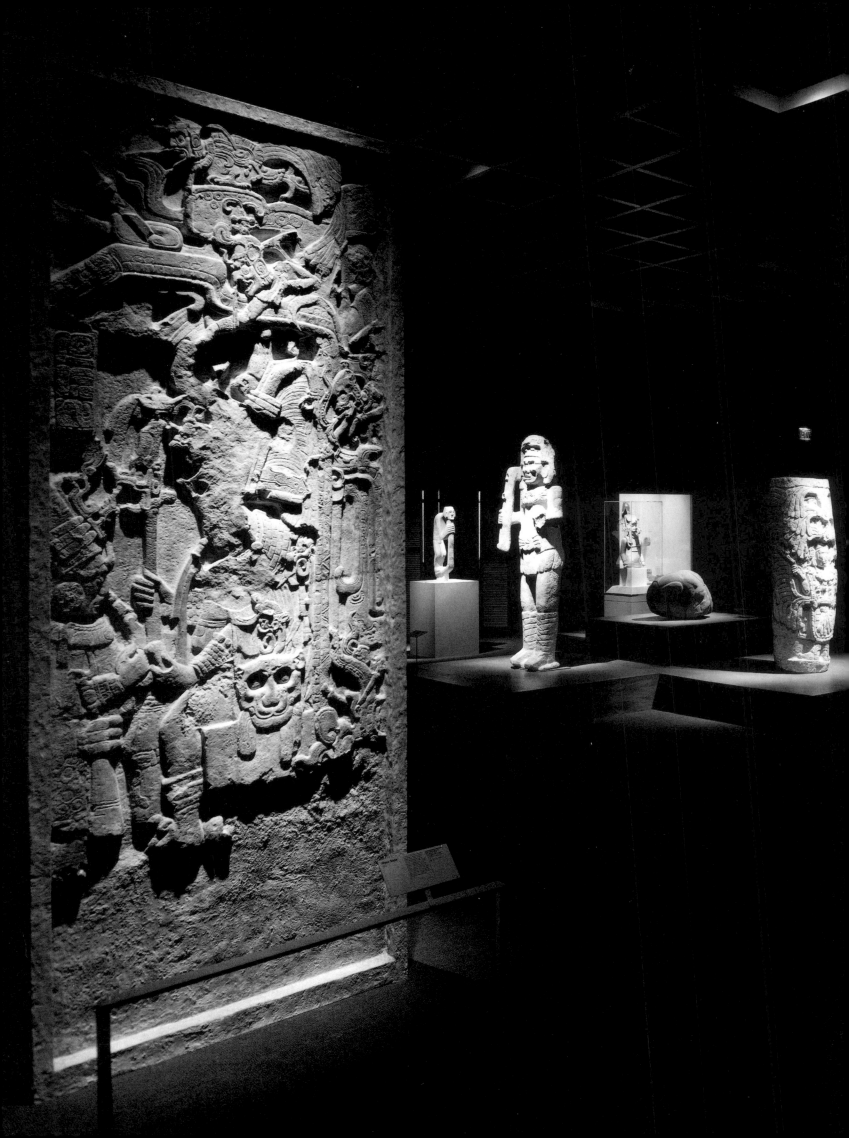

Gallery of Mesoamerican stone
sculpture. The Michael C.
Rockefeller Memorial Wing, The
Metropolitan Museum of Art,
New York

archaeologists have recently combined the aesthetic formalist and ethnographic cultural approaches in both their permanent and temporary exhibitions of Pre-Columbian artifacts, while some fine-art museums have shown signs of incorporating cultural information in their displays of Pre-Columbian art. More often than not, however, the mixture of scientific and artistic approaches to this material is an uneasy one. A recent major traveling exhibition, "Maya Treasures of an Ancient Civilization," organized in 1986 by the Albuquerque Museum, provided a striking example of their irreconcilability. Its title and installation connoted a fine-art perspective, even as its ample textual paraphernalia insisted on an anthropologically grounded perception and condemned a purely aesthetic contemplation of the objects on display.[72]

The tension between the two approaches to Pre-Columbian artifacts is deep seated indeed, recalling the problematic status of this material in Western eyes since the Conquest. Old debates about the nature of Pre-Columbian civilization have been transmuted into a contemporary conflict between aesthetic and scientific approaches to the subject. The touchstone of the present debate, however, is not savagism or civility but looting. The aestheticization of Pre-Columbian artifacts licensed their wrenching from their sites of origin and freed them to be treated as circulating commodities in the art market. The contrasting scientific approach insists on their primary role as evidence of the cultural evolution of the societies that created them and as a means of their reconstruction. For the modern archaeologist the artifact is a component of a site and is valued primarily for the information that can be gleaned from a careful investigation of its original context, that is, its association with other artifacts and particular location. Looting destroys this context and makes information gathering impossible. A demand for these objects in the international antiquities market also encourages forging, which further compounds the task of archaeologists, and according to them, throws into question the iconographic interpretations on which epigraphers and art historians often depend.

These contending aesthetic and scientific approaches both tend to occlude the historical role of power in the acquisition of objects and to deny that the presence of these objects, in private collections or in museums of any kind, is the result of the colonial subjugation and exploitation of the indigenous populations that are the rightful heirs to them. A variety of notable artists in the past century have also exploited Pre-Columbian works in their own way, by absorbing and appropriating their forms and themes. In the chapters that follow we will explore how, why, when, and under what circumstances they made use of these objects.

NOTES

1. See James Clifford, *The Predicament of Culture: Twentieth Century Ethnography, Literature, and Art* (Cambridge, Mass., 1988), p. 221. Clifford's chapter, "On Collecting Art and Culture," inspired many of my thoughts in this one. I am also indebted to the presentations in a symposium on "Collecting the Pre-Columbian Past" held at Dumbarton Oaks in Washington, D.C., in October 1990, published in Elizabeth H. Boone, ed., *Collecting the Pre-Columbian Past* (Washington, D.C., 1993), for many of the points made here, particularly to Curtis Hinsley's contribution, "In Search of the New World Classical," pp. 105–22. Hugh Honour's pathbreaking *The New Golden Land: European Images of America from the Discoveries to the Present Time* (New York, 1975); Benjamin Keen's *The Aztec Images in Western Thought* (New Brunswick, N.J., 1971); and Marianna Torgovnick, *Gone Primitive: Savage Intellects, Modern Lives* (Chicago and London, 1990) were also important sources.

2. Tzvetan Todorov, *The Conquest of America* (New York, 1984), pp. 128–29, citing Cortés's observations of Mexico.

3. *Ibid.*

4. *Ibid.* Honour, *op. cit.*, p. 21, points out that this description falls in line with previous descriptions of Islam and the Orient as the "fabulous East."

5. Honour, *ibid.*, p. 28.

6. *Ibid.*

7. Todorov, *op. cit.*, p. 132. If Dürer's remarks about the Pre-Columbian objects he saw in Brussels should not be interpreted as aesthetic appreciation because he failed to model images after them, some scholars suggest that he did just that in a plan he made for an ideal city in 1527, which may be based on a widely circulated (in the 1524 edition of Cortés's letters) plan of Tenochtitlán. The central square dominating the residential area in Dürer's plan resembles the sacred precinct, surrounded by a serpent wall, in the map of Tenochtitlán. See Keen, *op. cit.*, p. 69; Peter Streider, *Dürer* (New York, 1982), pp. 45–64; and Erwin Walter Palm, "Tenochtitlán y la ciudad ideal de Dürer," *Journal de la Société des Américanistes*, n.s. 40 (1951), pp. 59–66. The evidence is inconclusive, but if this influence is admitted, then it represents the first

instance of the impact of Pre-Columbian architecture on Western art.

8. Until recently scholars have neglected the question of the continuation of Indian arts and crafts after the Conquest. But the degree to which Indian artisans retained their own techniques, symbols, and aesthetic sensibilities is currently being debated. See The Metropolitan Museum of Art, Mexico: *Splendors of Thirty Centuries* (New York, 1990), p. 248.

9. Honour, *op. cit.*, p. 30. A magnificent feather headdress in Vienna is often identified as Moctezuma's crown, which was presented to Cortés as a propitiatory gift.

10. Clifford, *op. cit.*, p. 227.

11. A few of the more striking objects were later exhibited in the Tribuna of the Uffizi, and the rest with the hoard of weapons, exotic costumes, and natural-history specimens in the adjacent armory (whose ceiling was frescoed with Indian warriors and American birds in 1588). See Honour, *op. cit.*, pp. 29–30, and n., p. 274; Detlef Heikamp, *Mexico and the Medici* (Florence, 1972); and Heikamp, "American Objects in Collections of the Renaissance and Baroque." in Fredi Chiappelli, ed., *First Images of America: The Impact of the New World on the Old* (Berkeley, Los Angeles, and London, 1976), pp. 455–82.

12. See Honour, *op. cit.*, pp. 56–59; and Brian Fagan, *Clash of Cultures* (New York, 1984), pp. 43–45.

13. See John Elliott, "Renaissance Europe and America: A Blunted Impact?" in Chiappelli, *op. cit.*, pp. 15–16; and Todorov, *op. cit.*, pp. 33–36.

14. Honour, *op. cit.*, p. 57.

15. Hal Foster, "The 'Primitive' Unconscious of Modern Art," *October* 34 (Fall 1985), p. 62. Since the Enlightenment, Foster points out, the primitive has served as a subordinate term in Europe's imaginary set of oppositions: light/dark, rational/irrational, civilized/savage. It has been domesticated in these terms, as a fixed structural opposite or dialectical other to be incorporated and has assisted in the establishment of a Western identity and limits.

16. Clifford, *op. cit.*, pp. 227–28.

17. Shelly Errington, "Progressivist Stories and the Pre-Columbian Past: Notes on Mexico and the United States," in Boone, *op. cit.*, pp. 211–13 and *passim*.

18. Elizabeth A. Williams has documented the history of collecting and exhibiting Pre-Columbiana in France and England in two articles, which I draw on heavily for this discussion: "Collecting and Exhibiting Pre-Columbiana in France and England, 1870–1930," in Boone, *op. cit.*, pp. 123–40; and "Art and Artifact at the Trocadéro: *Ars Americana* and the Primitivist Revolution," in George Stocking, Jr., ed., *Objects and Others: Essays on Museums and Material Culture* (Madison, Wis., 1985), pp. 146–66. See also Ian Graham, "Three Early Collectors in Mesoamerica." in Boone, *ibid.*, pp. 49–80, and Ignacio Bernal, *A History of Mexican Archaeology: The Vanished Civilizations of Middle America* (London, 1980), pp. 107–8.

19. See J. F. Waldeck, *Monuments anciens du Mexique* (Paris, 1866), with a commentary by Brasseur; and Brasseur de Bourbourg, *Histoire des nations civilisées du Mexique et de l'Amérique Centrale*, 4 vols. (Paris, 1859). See also the documentary-sources section of the selected bibliography at the back of this book.

20. See Charles Wiener, *Pérou et Bolivie: Récit de voyage suivi d'études archéologiques et ethnographique et des langues des populations indiennes* (Paris, 1880); and Ross Parmenter, *Explorer, Linguist, and Ethnologist: A Descriptive Bibliography of the Published Works of Alphonse Louis Pinart, with Notes on His Life* (Los Angeles, 1966).

21. Hinsley, *op. cit.*, pp. 112–13.

22. Graham, *op. cit.*, p. 63, recounts that a patron bought Bullock's material for the museum when he heard they would be sold and exported to France. The items that came to the museum included a stone serpent (Xiucoatl) weighing over 500 pounds, a jade representation of Quetzalcoatl, a stone reclining deity (Chacmool), numerous stone and ceramic figures, an obsidian mirror, and various smaller artifacts. See also H. J. Braunholtz, "History of Ethnography in the Museum after 1753," *British Museum Quarterly* 18 (1953), pp. 90–93.

23. According to Williams, 1985, *op. cit.*, p. 149, the first American artifacts in French collections were sent from South America in the 1780s and installed in the Cabinet du Roi. Between 1800 and 1850, there were two important private collections in Paris, owned by M. Allier, a parliamentarian, and M. Jomard, an ethnographer. But the Louvre had the most extensive collection, which was based on donations and the purchase of a collection owned by an antiquarian named H. de Longperier, including some major pieces published in Kingsborough's *Antiquities of Mexico*. Longperier wrote the catalogue of the 1850 exhibition, *Notice des monuments exposés dans la salle des antiquités américaines au Musée du Louvre* (Paris, 1850), which contained stone and terra-cotta sculptures and reliefs, jewelry, and utensils from a variety of sites in ancient America. After this exhibit, however, the status of these artifacts was uncertain; they migrated between the Louvre, the Bibliothèque Nationale, the Musée Guimet, and were finally deposited in the Trocadéro in 1878.

24. Williams, 1993, *op. cit.*, pp. 131–33. The collection was used in conjunction with French scholarship that was published in two French-language journals and within a division of the Société d'Ethnographie entirely devoted to Americanist studies. The Trocadéro's first director, Theodore Hamy, was one of the major authorities on the subject.

25. For this discussion, I am indebted to Hinsley, *op. cit.*, pp. 106–12; William Roseberry, *Anthropologies and Histories* (New Brunswick, N.J., and London, 1989), p. 98; and Robert L. Brunhouse, *In Search of the Maya* (New York, 1973), pp. 102–3 and *passim*.

26. Clifford, *op. cit.*, p. 222.

27. Curtis Hinsley, "From Shell-Heaps to Steles: Early Anthropology at the Peabody Museum," in George Stocking, Jr., ed., *Objects and Others: Essays on Museums and Material Culture* (Madison, Wis., 1985), pp. 50–58.

28. See Errington, *op. cit.*, pp. 212–13, 222–23.

29. See Alan Trachtenburg, *The Incorporation of America: Culture and Society in the Gilded Age* (New York, 1982), pp. 15–16.

30. T. J. Jackson Lears, *No Place of Grace: Antimodernism and the Transformation of American Culture, 1880–1920* (New York, 1981), pp. 56, 58, 142, 173, 309, and *passim*.

31. See Bernal, *op. cit.*, p. 108, who characterizes Brasseur's work as a mixture of sound sense, great learning, absurd theories, groundless fantasies, and proof that is no proof, conducted in a spirit that is very remote from the scientific.

Brasseur picked up on the speculations of Carlos de Sigüenza y Góngora, an early-seventeenth-century Spanish priest and mathematician, who tried to explain the existence of a race that preceded the Toltecs with the notion of Atlantis. He also believed that Bishop Landa's explanation of Maya hieroglyphs was the key to deciphering them.

32. Cf. Torgovnick, *op. cit.*, pp. 60–62, 160, who discusses the literary notion of Atlantis in relation to Africa.

33. *Queen Moo and the Egyptian Sphinx* (New York, 1896) was a summary statement of Brasseur's mystical theories employing hieroglyphs and numeration as evidence and linking notions of the possibility of predicting cataclysms to the glyphs and the fantasy about Atlantis and its destruction. Ignatius Donnelly's best-selling *Atlantis: the Antediluvian World* (New York, 1880, first of many editions) brought these ideas to the attention of an even wider public. Le Plongeon also put forward Brasseur's favorite notion of transoceanic diffusionism (which was implicit in his idea of Atlantis). Following Brasseur's lead, Le Plongeon attempted to prove it etymologically in his "Ancient Maya Hieratic Alphabet Accompanied by an Egyptian Counterpart" (1885), which evoked Masonic rites and sacred mysteries at Uxmal as the source of Egyptian rites and mysteries and asserted a common origin for the Mayas, Phoenicians, and Egyptians. See Lawrence G. Desmond and Phyllis M. Messenger, *A Dream of Maya: Augustus and Alice Le Plongeon in Nineteenth-Century Yucatan* (Albuquerque, 1988).

34. Williams, 1993, *op. cit.*, p. 129. Elliot Smith's book *Elephants and Ethnologists* (New York, 1924) contended that decorative motifs at Copán represented Indian elephants and thus proved the Asian origin of Pre-Columbian civilization.

35. See, for example, Jeremy Sabloff, ed., *Archaeology: Myth and Reality. Readings from Scientific American* (San Francisco, 1982). Part of the problem may reside in the specialized jargon and general inaccessibility of much anthropological and archaeological writing.

36. See Clifford, *op. cit.*, p. 228; and William Rubin, ed., *"Primitivism" in 20th Century Art*, 2 vols. (Museum of Modern Art, New York, 1984).

37. See, for example, Honour, *op. cit.*, p. 168 and *passim*, who maintains this position while identifying some exceptions to the rule from the sixteenth through the nineteenth centuries; and Todorov, *op. cit.*

38. See Honour, *op. cit.*, pp. 60–61, 168 and notes, pp. 275, 279; and Elizabeth Easby and John Scott, *Before Cortés: Sculpture of Middle America* (Metropolitan Museum of Art, New York, 1970), no. 307. Pre-Columbian motifs were also used in masques and theatrical fêtes. A careful examination of European textile and wallpaper designs in the eighteenth century might also yield further instances of Pre-Columbian sources.

39. Hinsley, 1993, *op. cit.*, pp. 112–13.

40. *Ibid.*, p. 113.

41. Honour, *op. cit.*, p. 185. See *ibid.*, figs. 187–88, for renderings of some of the items on view.

42. See Doreen Burke et al., *In Pursuit of Beauty: Americans and the Aesthetic Movement* (Metropolitan Museum of Art, New York, 1986), pp. 19–21 and *passim*.

43. In September 1987, at the request of Olana's director, I personally examined the collection to determine the cultural identity and authenticity of its contents. The Central and South American-style artifacts include ceramics and stone sculptures imitating Nicoya, Chiriqui, Quimbaya, Moche, and Chimú objects.

44. See William Holmes, "On Some Spurious Mexican Antiquities and Their Relation to Ancient Art," *Annual Report of the Board of Regents of the Smithsonian Institution* (Washington, D.C., 1886), part 1, pp. 319–34, for evidence of Pre-Columbian forgeries as early as the 1820s; Leopold Batres, *Antiguedadas majicanas falsificacion y falsificadores* (Mexico, 1910); and Elizabeth Boone, ed., *Falsifications and Misreconstructions of Pre-Columbian Art* (Washington, D.C., 1980).

45. See Donald Robertson, "Mexican Indian Art and the Atlantic Filter," in Chiappelli, *op. cit.*, p. 494, n. 25.

46. See Joseph Alsop, "The Faker's Art," *New York Review of Books* 33 (October 23, 1986), pp. 25–26ff. Alsop mentions a giant Quimbaya gold figure, which was recently removed from the Pre-Columbian exhibit at Dumbarton Oaks after conservator Robert Sonin established that it was the work of a nineteenth-century master forger whom Sonin has compared with the Cellini gold-cup forger.

47. "Red Indian art" was a favorite theme of Gustav Stickley's magazine, *The Craftsman* (1901–16), which covered all the decorative arts, Morris, Ruskin, medieval guilds, Lalique, etc. See Lionel Lambourne, *Utopian Craftsmen: The Arts and Crafts Movement from the Cotswolds to Chicago* (Salt Lake City, 1980), p.152.

48. Burke et al., *op. cit.*, p. 21.

49. Lears, *op. cit.*, pp. 62–64, 91–92, and *passim*. I would like to credit Lears's discussion of the Arts and Crafts movement for stimulating my thoughts on this subject. He stresses that American Arts and Crafts ideology, like other manifestations of what he calls the antimodern impulse, ultimately served to revitalize rather than transform bourgeois culture: what began as a critique ended (through cooptation and compromise) as an affirmation.

50. See Clifford, *op. cit.*, pp. 135–38, 147–48; and William Rubin, "Picasso" in Rubin, *op. cit.*, vol. 1, pp. 268–336.

51. See Katia Samaltanos, *Apollinaire, Catalyst for Primitivism, Picabia and Duchamp* (Ann Arbor, Michigan 1984), pp. 3–6, 38–42. From 1903 to 1918, in poems, articles, reviews, and a novel, Apollinaire extolled

Pre-Columbian and North American Indian art, ritual, and signs. For example, in a 1915 issue of *Mercure de France* he wrote: "In Mexico, the Aztec, Toltec or Chichimec gods are resurrected. Blessed idolatry, if only it could revive the sense of this noble plastic beauty that the Mexican stone carvers once possessed to such an elevated degree and which almost all other peoples have lost."

52. Clifford, *op. cit.*, pp. 197–98 and *passim*.

53. See Williams, 1985, *op. cit.*, p. 163; and William Rubin, "Modernist Primitivism, An Introduction," in Rubin, *op cit.*, vol. 1, pp. 3, 74–75.

54. Williams, *ibid.*, pp. 146–47.

55. See Enrique Florescano, "The Creation of the Museo Nacional de Antropología of Mexico and Its Scientific, Educational, and Political Purposes," in Boone, *op. cit.*, pp. 81–104. For an account of a parallel development in Peru, see Elizabeth H. Boone, "Collecting the Pre-Columbian Past: Historical Trends and the Process of Reception and Use," in Boone, *ibid.*, pp. 323–25.

56. See Barbara Braun, "Diego Rivera's Collection: Pre-Columbian Art as a Political and Artistic Legacy," in Boone, *op. cit.*, pp. 251–70.

57. Roseberry, *op. cit.*, p. 99. U.S. agricultural and mineral interests were focused on sugar in Cuba and Puerto Rico, bananas in Central America and Colombia, copper in Mexico and Chile, and petroleum in Mexico and Venezuela. By the 1920s the United States was setting up public banks and making loans to national and provincial governments in Latin America.

58. See Marjorie Ingle, *The Mayan Revival Style* (Salt Lake City, 1984). Ingle's study is a pioneering account of this phenomenon, which also effectively brings out its kooky and playful dimension. See also Bevis Hillier, *Art Deco of the 1920s and 1930s* (London, 1968) and Hillier, *Style of the Century* (New York, 1983).

59. Ingle, *op. cit.*, pp. 9–10.

60. *Ibid.*, pp. 51, 66, 76, and *passim*.

61. See Barbara Braun, "Cowboys and Indians, the History and Fate of the Museum of the American Indian," *The Village Voice* (April 8, 1986), pp. 30–40, for an account of the complex and unsavory history of this institution; and Braun, "Art from the Land of the Savages, or Surrealists in the New World," *The Boston Review* (October 1988), pp. 5–6. 18–19, for an account of Surrealist emigrés collecting American Indian art at the Museum of the American Indian and elsewhere in 1940s New York.

62. Ingle, *op. cit.*, pp. 8–9, 47, 51, 75.

63. See Holly Barnet-Sanchez, "The Necessity of Pre-Columbian Art in the United States: Appropriations and Transformations of Heritage, 1933–1945," in Boone, *op. cit.*, pp. 177–208. The concept of Pan-Americanism was originally developed by Latin American heads of state in the 1920s to further political and economic relations between Spanish and Portuguese nations. See also Eva Cockcroft, "The United States and Socially Concerned Latin American Art," in Luis Cancel et al., *The Latin American Spirit: Art and Artists in the United States, 1920–1970* (Bronx Museum of Arts, New York, 1989).

64. The Brooklyn Museum organized a series of traveling shows of Pre-Columbian, colonial, and modern Latin American art designed for smaller museums; Harvard University's Fogg and Peabody museums jointly presented "Pre-Columbian Art" (1940); the American Museum of Natural History, "Masterpieces of Primitive Sculpture" (1940); the Wakefield Gallery, "Pre-Columbian Stone Sculpture" (1944), curated by painter Barnett Newman and reflecting the Abstract Expressionists' intense interest in primitive forms and myths; and the National Gallery of Art, "The Figure of Man in Ancient American Art" (1944–45), curated by George Kubler.

65. Barnet-Sanchez, *op. cit.*, p. 186.

66. The calendar of events for the citywide celebration was twenty-five pages long, and a twenty-four-hour, seven-day-a-week telephone hotline provided detailed computerized information about the schedule. The offerings included a film retrospective of contemporary Mexican directors at the Museum of Modern Art; major exhibitions of contemporary Mexican painting and folk art in prominent venues; art, photography, and ethnography shows in smaller museums and private galleries; musical, ballet, and theatrical performances; as well as miscellaneous lectures, seminars, readings, and round-table discussions.

67. See his own account in the introduction to Douglas Newton et al., *Masterpieces of Primitive Art: The Nelson A. Rockefeller Collection* (New York, 1978), p. 20.

68. Another noteworthy early collector of Pre-Columbian art in the United States was Robert Woods Bliss, foreign service officer and ambassador to Argentina, whose collection was originally housed in the National Gallery in Washington, D.C., and then, in 1963, transferred to Dumbarton Oaks and given in trust to Harvard University.

69. See Barbara Braun, "The Michael C. Rockefeller Wing: Art Not Anthropology," *Art News* 81, no. 3 (March 1982), pp. 78–82.

70. Clifford, *op. cit.*, pp. 226–28. However, in the sense that both the ethnographic and aesthetic approaches posited a stable reality and an equality of subject and object, when in fact the subject was always in control, they were similar. See Torgovnick, *op. cit.*, p. 114.

71. See Elizabeth Boone, "Collecting the Pre-Columbian Past: Historical Trends," in Boone, *op. cit.*, pp. 329–31, 336–37.

72. See Barbara Braun, "Chac's Revenge," *Art in America* (January 1986), pp. 88–97, which is a review of this show; and Braun, "Letters: Maya Show Debated," *Art in America* (September 1986), pp. 13, 165.

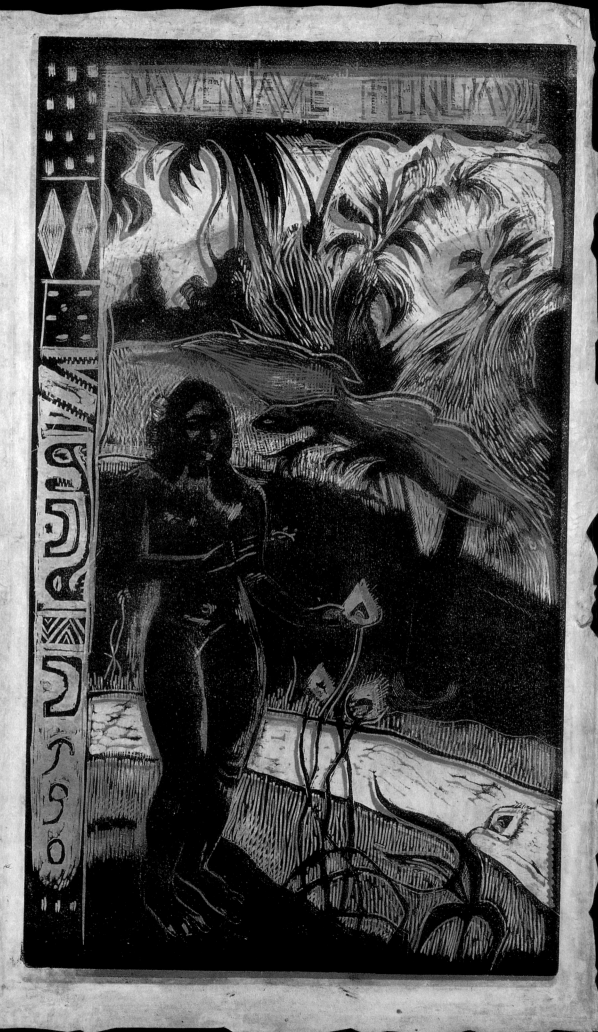

PAUL GAUGUIN: SEARCHING FOR ANCESTORS

Vous trouverez toujours le lait nourricier dans les arts primitifs, dans les arts de pleine civilisation j'en doute (*You will always find nourishment in the primitive arts, in the arts of "high" civilization I have my doubts*).

PAUL GAUGUIN, *Cahiers pour Aline*, 1892

S ince the late nineteenth century, artists have been looking closely, appreciatively—and often imitatively—at so-called primitive, archaic, and ethnographic art, that is, art that originates outside the mainstream of Western culture in technologically backward societies. Perhaps the most familiar example of this attraction of the primitives for the moderns is Paul Gauguin. His flight to Tahiti and exploration of Maori art are legendary. And his use of Japanese, Persian, Egyptian, and Cambodian models has also been thoroughly documented. But Gauguin's debt to Pre-Columbian art, especially ancient Peruvian art, the foundation of his inclination to the exotic, has been sorely overlooked.[1]

It is often forgotten that Gauguin had Peruvian ancestry and spent his formative years in that country. In fact, he remained fascinated with this "Indian" side of his identity all his life. In his earlier crafts, particularly his little-known ceramic pieces, but also in his paintings, right to the end he empathized strongly with his exotic origins. This sense of identification informs his personality and attitudes to life, as well as the practice of his art.

"You must remember that two natures dwell within me: the Indian and the sensitive man," Gauguin wrote to his wife, Mette, in February 1888, adding, "The sensitive being has disappeared and the Indian now goes straight ahead."[2] Later that same year he wrote to his chief benefactor during this period, a fellow former-stockbroker-turned-artist, Emile Schuffenecker: "Also I have done some nudes, which ought to please you. And not all in the Degas style. The last is a fight between two boys near a river, quite Japanese, by a Peruvian Indian."[3] The references that dot Gauguin's journals and correspondence to, variously, his "Indian," "savage," "Peruvian," and "Inkan" nature were not just fanciful. They are, to be sure, a symbol of his alienation from bourgeois society and his need to experience himself as "other" in relation to it.[4] But they are also rooted in fact.

Gauguin's maternal grandmother, Flora Tristan, a famous flamboyant agitator in behalf of workers' and women's rights, was born in Peru, daughter of Don Mariano Tristan y Moscoso, a Spanish colonel serving in Lima, and niece of a viceroy.[5] In 1849, when Gauguin was a year old, his family emigrated to Lima—his father died en route—where he lived with his widowed mother and sister in his great-uncle's aristocratic household until 1855. Thus, from ages one to six Gauguin actually lived in Peru.[6] Gauguin also revisited Peru sometime in 1866, during his stint as an officer in the merchant marine.

When they returned to France, his mother brought along her cherished collection of ancient Peruvian artifacts. "My mother," he wrote in his journal *Avant et Après*, "kept a few Peruvian vases and . . . quite a number of figures made out of solid silver, just as it comes out of the mine. Everything disappeared in the Saint Cloud fire." (The fire was in 1871, when Gauguin was twenty-three years old. Unfortunately, no record of the contents of the collection survives.) In the same place, he also recalls ancient Peruvian art in the Paris home of an old French industrialist who had made a fortune in Lima: "In Paris I saw Maury again, a very old man. . . . He owned a very beautiful collection of vases (Inka pottery) and many pieces of pure gold jewelry made by the Indians."[7]

Paul Gauguin. Nave nave fenua (Delightful Land). c. 1894. Woodcut, 14 × 8". Collection Edward McCormick Blair

But surely the most important link between Gauguin and Pre-Columbian art was Gustave Arosa, a wealthy French businessman and art patron, who became his guardian after his mother's death. It was Arosa who found Gauguin a job as a stockbroker's agent on the Paris stock exchange, encouraged him as an amateur artist, and helped shape his artistic development. Alongside impressionist paintings, Arosa collected a wide variety of ceramics of all periods and cultures, including Pre-Columbian.[8] We can safely assume that Gauguin was acquainted with pieces belonging to Arosa. An additional important source of exotic models for Gauguin's art came from Arosa's business. He was an early manufacturer of photolithographs and supplied illustrations for many publications during the 1860s and 1870s, including volumes on ceramics, art, and architecture.[9]

French books on Pre-Columbian art and archaeology by Brasseur de Bourbourg, Aubin, Viollet-le-Duc, Waldeck, Charnay, and Wiener[10] were another likely means for Gauguin to become acquainted with this material—especially since we know that Gauguin's working methods entailed the intensive use of reproductions as models for his work, such as the well-documented borrowing of specific poses from photographs of Borobudur and Egyptian reliefs in his Tahitian paintings. During and after Napoleon III's Mexican intervention in the 1860s, the already well established French scholarly interest in ancient America received further impetus. Under the auspices of government-sponsored commissions set up to study all facets of native America, adventurer-scholars like Charnay, Wiener, and Alphonse Pinart explored Mexico and Central and South America, photographed ruins, made huge casts of major monuments for exhibition in Paris, studied native American languages and inscriptions, and published heavily illustrated reports, such as Charnay's popular *Ancient Cities of the New World*, Wiener's *Pérou et Bolivie*, and Pinart's numerous articles in scholarly and popular journals.[11]

Most French and English nineteenth-century studies of ancient New World cultures share a diffusionist orientation; they are preoccupied with the origins of pristine civilizations and usually try to demonstrate, through comparative studies of motifs, myths, and languages, that Old World civilizations influenced New World cultures. They stress similarities, rather than differences, between cultures widely separated in time and space, as well as single points of origin for common traits, instead of independent, parallel inventions. Such an approach blurs distinctions between diverse cultures and encourages the artist, craftsperson, or scholar to fuse motifs and blend concepts from distant sources. What we might judge as an eclectic pastiche of say, Maya, Japanese, and Egyptian motifs, was to nineteenth-century eyes, more often, a natural consequence of the ultimate linkage of these motifs.[12] Formal correspondences among such styles, particularly their use of flat, stylized, heavily outlined forms and lack of perspective, reinforced these notions. Thus Gauguin was probably prepared by the critical discourse of his day to perceive the images of remote preindustrial cultures through diffusionist lenses.

Yet another significant source of information about Pre-Columbian material available to Gauguin was the Musée d'Ethnographie du Trocadéro in Paris, which opened to the public as part of the Paris Universal Exposition of 1878. The American collection drew on several sources, including the transfer of American antiquities from the Louvre, the Natural History Museum, and the Bibliothèque Nationale, and many private donations by individuals. Career diplomats who had served in Peru, such as Léonce Angrand, French consul in Lima, were extremely generous—perhaps because Peru's export laws were weaker than Mexico's. But most of the pieces came from state-sponsored missions, such as Wiener's vast Peruvian collection, along with a display of artifacts and natural-history specimens from Colombia, Ecuador, and Bolivia, and Pinart's donation of hundreds of Central American and Andean pieces (some fakes). Other explorers who sent material back from Peru included Jules Crevaux and Léon Cessac.[13] The catalogue of the Trocadéro's American Gallery provides a good idea of the items on view. The introduction identifies its sixty annotated plates (174 figures) as "a minute portion of the thousands of objects from both Americas that the Trocadéro possesses."[14] *Decades Americanae*, the illustrated memoirs of the gallery's curator, E. T. Hamy, fills out the picture of the Trocadéro's ancient American collection.[15]

The Paris Universal Exposition of 1889 was a major opportunity for Gauguin to learn more about Native American culture. He spent a lot of time at the fair, partly

because he was exhibiting paintings and graphics at the Volpini Café in the company of the Synthetists and Impressionists. According to his letters and contemporary accounts, he was captivated by the Javanese Village, which was part of a vast display of the entire gamut of French tropical possessions put on by the Colonial Department to promote its activities, frequented an exhibit of the history of writing, which included inscriptions from Palenque and Easter Island pictographs, and sketched material from Mexico, which a contemporary identified as casts of Aztec sculpture.[16] Buffalo Bill's Wild West show, with North American Indians, was also a particular hit with Gauguin, who—in keeping with his self-identification with the "savage"—sported a cowboy hat around Paris and later practiced with a bow and arrow on Brittany beaches.[17]

The year 1883 was decisive in Gauguin's career: He quit his job in order to dedicate himself to his art. Almost immediately he had to confront the enormous difficulties involved in practicing art as a profession at a time when—as a result of the societal transformation brought about by the Industrial Revolution—old forms of patronage no longer obtained. He needed to develop the skills of his craft, establish his professional credentials, and, at the same time, compete for attention in the marketplace by offering his audience something new.[18] Having begun to sculpt as early as 1877, Gauguin decided to try his hand at making ceramics, which he viewed as an extension of his sculpture, as a means of earning a regular income to support his painting. He was aware of the growing market for ceramics, and he was acquainted with fellow artists who supplemented their income in this way, including his friend the sculptor Paul Aube, and the etcher Félix Bracquemond, a friend of both Edgar Degas and Camille Pissarro.[19] And even though he did not for whatever reason imitate commercially successful ware, Gauguin still hoped that his ceramics would sell.[20] But he sold very few. Most were purchased or stored by his accommodating friend Schuffenecker, remained in the hands of his family in Copenhagen, or were given away (to Vincent van Gogh, Odilon Redon, and Madeleine Bernard) or exchanged for other artworks.[21]

Gauguin's turn to ceramics followed naturally from his well-developed interest in the decorative arts. Already in 1873 he and his wife had collaborated on an embroidery for their home;[22] in 1881 he carved wooden panels (with small portrait heads of his children and with foliage) for his dining-room cupboard; and in 1883 "his interest in crafts had led him to suggest a revival of tapestry weaving."[23] His activity in this realm continued throughout his life; he carved and decorated canes, boxes, shoes, barrels, doors, furniture, walls, house facades, and interiors everywhere he lived. Indeed, many of Gauguin's characteristic painting procedures correspond to—may, in fact, stem from—typical craft practices: the borrowing and reshuffling of decorative elements; exploitation of a repertoire of motifs over and over again in different mediums; and the fluid transitions from two to three dimensions and back. What is more, this craft orientation seems to have colored not only his techniques but also his attitudes toward his art. Many of his most cherished notions, especially his enchantment with the preindustrial world and his dream of a community of artists living and working together, are echoed in the tenets of the Arts and Crafts movement, the intensive craft revival of the mid- and late nineteenth century that was a response to the mass fabrication and soullessness of the Industrial Revolution.[24]

Through Bracquemond, Gauguin was introduced to Ernst Chaplet, a ceramist who had attracted considerable attention with decorative stoneware (previously used in France only for utilitarian purposes) and emerged as a preeminent artist-craftsman seeking to revitalize ceramics with natural forms. His stoneware, fired at Havilland Studios, leaned heavily on Japanese formulas and older traditions of ultilitarian ware. When Gauguin began working with Chaplet, his characteristic pots frankly accepted the texture of stoneware, called attention to their container function, and were decorated with zones of ornamental forms emphasizing the pot structure—lip, base, handle—and naturalistic plants in the neutral areas. (Decorative techniques included high and low relief, incision, colored slip or glaze, and gold accents.)

As might be imagined, Gauguin was heavily dependent on Chaplet's technical expertise at this stage. A few of Gauguin's pots from 1886 to 1887 bear Chaplet's mark, suggesting that Gauguin decorated with modeled or painted botanical and figural forms pots thrown by Chaplet. But Gauguin also made pots in which the body and decoration were his while the firing and glaze were Chaplet's.[25] Most of Gauguin's pots

Paul Gauguin. Pot decorated by Gauguin, thrown by Ernst Chaplet. 1886–87. Stoneware, height 11⅝". Musées Royaux d'Art et d'Histoire, Brussels

were very different from Chaplet's rather conventional pieces. Indeed, by 1888 they had parted company artistically (though Chaplet continued to fire and glaze Gauguin's pots). Chaplet abandoned stoneware for the production of more refined porcelain and oriental glazes, while Gauguin continued to use rough stoneware clay and to experiment with glazes for his own expressive purposes.

Gauguin objected to the mechanical forms of pots thrown on the wheel and to conventional styles of decoration.[26] Of the pots he made for himself, none were thrown on the wheel; all were modeled by hand like "primitive" pottery, using coiling and hollowing-out techniques. "My aim," he wrote in an article in *Le Soir* in 1895, "is to transform the eternal Greek vase and replace the potter's wheel by an intelligent hand able to infuse it with the life of a work of art."[27] (In the nineteenth century most fine artists who worked on ceramics restricted their activity to ornamentation or to wax models, which would be realized in clay by a craftsperson; they did not manipulate the clay directly.) In his insistence on directly manipulating the clay—on making pottery in the same way that the primitives made it—and in his renunciation of the classical formulas of the Western tradition in favor of primitive models, Gauguin had already asserted a principle that would govern his entire artistic career: his rejection of the modern industrial world in favor of a retreat to an unspoiled past.

Out of an estimated total of one hundred ceramic objects that Gauguin made, sixty-odd survive. The majority belong to private collectors, and the few that are in public institutions belong to museums in Copenhagen, Reunion, Paris (including the Musée d'Orsay), Dallas, Washington, D.C., and Nassau County, New York.[28] Gauguin's ceramics are best studied as a whole in two authoritative catalogues raisonnés: Christopher Gray's *Sculpture and Ceramics of Paul Gauguin* and Merete Bodelsen's *Gauguin's Ceramics: A Study in the Development of His Art.* The ceramics have no date marks, but Bodelsen has assigned four well-defined chronological groups on the basis of style, subject, and technique, as well as external data. Roughly, Gauguin began by producing smallish jugs and jars decorated with human, animal, landscape, or ornamental designs, which were either modeled, executed in relief, or incised. As he progressed, the pots became more plastic and highly modeled until, in the final stage, they were pure sculptures.

Most of the so-called rustic pots of the first phase, 1886–87, were moderate-sized, coarse, brown stoneware with slip-painted or glazed decorative elements, sometimes also accented in gold. The dominant theme of these early pots is one of "back to nature," with many motifs relating to the seasons and stars and deriving from his Breton paintings of 1886, which picture a rustic idyll of peasant girls, shepherd boys, geese, and sheep. Early specimens include rectangular-shaped pots and double and triple pots joined by a big handle. One glazed pot is shaped like a hollow tree stump and adorned with a woman's head in front and animal-head appendages on its surface.[29] Such a transference of his figural repertoire from one medium to another was Gauguin's normal practice. But he probably also saw this mating of coarse, rustic material with coarse, rustic theme—preindustrial technique with preindustrial subject—as a perfect congruence of form and content. Some other decorative motifs are quotes from recent French paintings by artists Gauguin admired, including Eugène Delacroix and Degas. In using such motifs, the artist probably intended to extend the aesthetic limits of the medium and to challenge contemporary standards of taste.

The derivation of many of the motifs is clear, but the genesis of these weird and fantastic shapes, peculiar handles, little faces, and animal heads, as well as of the notion of joining two or even three pots together, is more obscure. In his review of the ceramics shown at the Universal Exposition of 1889, in which he criticized conventional ceramics, Gauguin acknowledged his sources: "Ceramics are not futile things. In the remotest times among the American Indians the art of pottery was always popular. God made man out of a little clay," he wrote.[30] Previously, when Pre-Columbian, especially Peruvian, sources for Gauguin's ceramics have been cited,[31] they have invariably been identified as Inkan, in accord with Gauguin's diaristic comments about his Inkan Indian nature. But a glance at a typical Inkan pot, called an *aryballos,* shows that there is little correspondence between these almost classically shaped, austere, and elegant globular jars with conical bases (whose name, in fact, derives from the classical Greek vases they resemble), with their schematic decoration and conventionalized form, and Gauguin's fanciful ceramics.

OPPOSITE, CLOCKWISE FROM TOP:
Paul Gauguin. Pot decorated with Breton shepherdess. 1886–87. Stoneware, unglazed and decorated with colored slip, length 9½". Whereabouts unknown. Courtesy Milton S. Eisenhower Library, The Johns Hopkins University

Paul Gauguin. Vase decorated with half-length figure of a woman (probably based on a Degas drawing of a ballet dancer). 1886–87. Brown unglazed stoneware, height 8½". Kunstindustrimuseet, Copenhagen

Paul Gauguin. Pot in the form of a tree stump with face on front. 1886. Brown stoneware, glazed in mottled green, brown, and red with touches of gold, height 7⅝". Whereabouts unknown. Courtesy Milton S. Eisenhower Library, The Johns Hopkins University

Visual evidence indicates, instead, that Gauguin was inspired mainly by the ancient Andean North Coast ceramic tradition, which originated in the Chorrera culture of southern Ecuador, sometime between 1200 and 900 B.C., was fully realized from about 900 B.C. until the late fifteenth century in the Peruvian cultures of Cupisnique, Salinar, Vicús, Moche, Chimú, and Lambayeque and is epitomized by the Moche (c. 100 B.C.–A.D. 700) and Chimú (c. A.D. 900–1470) styles. This is a plastic and sculptural strain of Peruvian ceramics, very different from the more pictorial tradition of the south and the highlands. Using rich volumes, balanced masses, and a high degree of formal simplification, it combined the methods of sculptor and molder to represent figures. Like all Pre-Columbian pottery, these forms were built up by hand via direct modeling, coiling, stamping, and mold-making techniques. Glazes were not used, but pot surfaces were frequently burnished, giving them a glazed aspect. The preferred form for North Coast ceramics is a spherical, flat-bottomed, stirrup-spout bottle (designed for liquid storage), the container being surmounted by a hollow vent consisting of two curved branches that join a vertical tubular mouth. The way this curious spout is attached to the vessel varies from culture to culture, so that, for example, Moche and Chimú stirrup spouts are consistently affixed at different angles to the top and back of the container.

Moche and Chimú pots are easily distinguished on many counts (although as recently as thirty years ago Moche ware was often subsumed under the Chimú heading). Moche ware is highly sculptural; many pots are human, animal, plant, or house effigies; others are modeled in high and low relief, incised or painted. Sometimes one vessel combines these different kinds of ornamentation—usually without a smooth transition between them. Above all, Moche pottery is distinguished by its realistic representation of human figures—really a kind of geometricized naturalism—and by its sensitively modeled, individualized portrait vessels. Predominant paste colors after firing are reddish brown, beige, or a gray-black, often slip-painted with white or a combination of red and white.

After a gap of about two hundred years, Chimú ceramics revived the Moche style (in a renaissance or archaizing tendency). But unlike the earlier sculptures, Chimú pots were designed to be mass-produced with molds, so that their modeling and ornamentation is much simpler. The Chimú vessel body is often decorated with low-relief pressed figures, while miniature human or animal figures or heads adorn the bottle and spout juncture. Bulk manufacture often led to a marked deterioration in quality, though many Chimú pots are well made and well fired. Their surfaces are limited to a uniform metallic black or reddish-brown color and are rarely painted after firing.

A comparison between illustrations of Gauguin's early ceramics and examples of Moche and Chimú ware reveals some striking structural similarities, though the surfaces and motifs on Gauguin's vessels are very different. Since many of his ceramics also recall pottery styles of other cultures, the North Coast Andean ceramic tradition was by no means Gauguin's exclusive source of inspiration. He was, for example, clearly aware of Oriental pottery traditions, in terms of shape and glaze, as were many potters of his day. However, this strain of Pre-Columbian ceramics seems to have been a major stimulus for the fantastic shapes and handles and small appliquéd figures of Gauguin's pots.

Nor was Gauguin alone in modeling his ceramics after ancient Peruvian forms at this time. In the 1860s and 1870s Christopher Dresser, a renowned English theoretician and popular writer on design and a leading designer of metalwork, glass, textiles, and pottery, greatly admired Egyptian, Chinese, but especially Japanese and Pre-Columbian ceramics. In 1879 he established the Linthorpe Pottery in Yorkshire, using common brick clay for his hand-thrown and -decorated pots, deriving his forms mainly from Peruvian and Japanese ceramics and his figure glazes from Chinese models.[32]

In the spring of 1887, after trying very hard and failing to establish himself as a potter, Gauguin took flight from his desperate financial and social situation in France by traveling to Panama and Martinique—the first of many such voyages to the tropics. As early as the spring of 1885 he had entertained thoughts of going to the colonies[33] but had instead gone to Brittany, which was more accessible and also promised to provide picturesque subject matter, an affordable life-style, and a community of artists.

Arryballos *Inka, 1450–1533. Terra-cotta, height 15". Musées Royaux d'Art et d'Histoire, Brussels*

RIGHT:
*House effigy pot. Moche, North Coast, Peru,
1–700. Terra-cotta, height 7". Linden-Museum,
Stuttgart, Germany*

BELOW:
*Paul Gauguin. Rectilinear pot. 1886–87.
Stoneware glazed with a blackish-brown mottled
glaze with accents of gold, height 5⅞".
Whereabouts unknown. Courtesy Milton S.
Eisenhower Library, The Johns Hopkins University*

OPPOSITE, CLOCKWISE FROM TOP:
*Blackware pot. Chimú, North Coast, Peru,
1000–1500. Terra-cotta, 9 × 7¼".
The Brooklyn Museum, Gift from the Collection
of Eugene Schaefer (36.314)*

*Paul Gauguin. Tall bottle with stopper. 1886.
Brown stoneware with a mottled glaze of gray,
black, and reddish-brown and gold outlines, height
7⅞". Whereabouts unknown. Courtesy Milton S.
Eisenhower Library, The Johns Hopkins University*

*Paul Gauguin. Gourd effigy pot (vase in the shape
of three gourds). c. 1886–87. Stoneware with a
dark variegated glaze accented with touches of gold,
height 6⅞". Whereabouts unknown. Courtesy
Milton S. Eisenhower Library, The Johns Hopkins
University*

PAGES 62–63, CLOCKWISE FROM
TOP LEFT:
*Paul Gauguin. Double pot with bridge (fantastic
pot decorated with a Breton figure). c. 1886–87.
Brown stoneware, height 5⅜". Whereabouts
unknown. Courtesy Milton S. Eisenhower Library,
The Johns Hopkins University*

*Double-spout and bridge pot. South Coast, Peru,
Middle Horizon, 600–1000. Coiled polychrome
ceramic, 5⅜ × 5⅞ × 5½". Herbert L. Lucas, Jr.,
Collection*

*Paul Gauguin. Double-spout and bridge pot.
c. 1886. Unglazed stoneware decorated with
Breton motifs, height 5⅞". Private Collection*

*Double-chamber vessel depicting a warrior. Vicús,
North Coast, Peru. Modeled ceramic with slip,
9¼ × 11¼ × 4¾". Herbert L. Lucas, Jr.,
Collection
This site was discovered in the 1960s; vessels of
similar form existed in late-nineteenth-century
collections.*

But he found Brittany no longer remote and exotic, less rural than urban in appearance and manners, already shaped by industrialization (intensive fishing, kelping, and tourism) into a ruined resort.[34]

Gauguin next tried more promising locales in the colonies. He told Mette that he was going to Panama and Martinique "to live like a savage."[35] But he gave the painter Emile Bernard, with whom he shared many professional concerns at the time, a more pointed motivation for his trip, in a letter datelined Pont Aven, October 1888: "I rather agree with Vincent, the future belongs to the painters of the tropics, which have not yet been painted, and new subjects always have to be found for the public, that stupid buyer."[36] Thus, it is not surprising that Gauguin invariably linked the dream of an exotic, tropical locale with the utopian notion of a community of like-minded artists. "And if I could get a larger sum of money together," he wrote Bernard in the same letter, "I'd buy a house there in Martinique so that I could establish a studio where my friends would find everything ready for them and they could live on almost nothing."[37]

Gauguin's primitivizing impulse was directly keyed to French colonialism. Every destination he considered was a French colony—not only Panama and Martinique, his first ports of call, but subsequently Indochina and Madagascar, which he never reached, and Tahiti and the Marquesas, where he finally settled. The reasons why are not hard to come by. The Société de Colonisation encouraged recruits for the colonies, even holding out the promise of free passage;[38] and there was also the prospect of protection and even sustaining employment by the colonial administration, in case all else failed.

Official French rhetoric promoted colonization as a means of restoring national vitality and avoiding decadence, echoing in much the same terms Gauguin's own feelings on the matter.[39] Colonization thus provided the artist with a handy retreat from the Parisian world he despised while also permitting his maintenance of a lifeline to it; he could still negotiate with his real social world, even if only by long-distance mail boats. Above all, it was imperative that Gauguin retain contact with his audience, the Parisian avant-garde, art-buying public, in whom colonialism had also fostered a taste for exotica.

In the colonies Gauguin sought an unspoiled preindustrial landscape free of economic and social constraints. What he found instead, in each locale, were the same contradictions that he had experienced in Brittany: Panama and Martinique, and then Tahiti and the Marquesas, proved a disappointment. To earn enough money to leave Panama to go to Martinique island, Gauguin and his companion, the painter Charles Laval, became ditchdiggers on the Panama Canal excavations, and both became severely ill in the process. Later in Tahiti and finally in the Marquesas, between 1895 to his death in 1903, Gauguin confronted similar contradictions: The incursions of foreign capital had wrought changes that had fatally contaminated the island paradise. By then, however, he had come to direct his gaze entirely inward in his art. He used as his subject matter an imaginary landscape (reconstructed from J. A. Moerenhout's *Voyages aux îles du Grand Océan*, an early-nineteenth-century account of the culture and mythology of Tahiti), thereby effectively denying the obsolescence of the old Tahitian culture. And, perhaps because he avoided dealing with these contradictions in his art, he felt compelled to fulminate against them in other ways. During his last years in Oceania (when he was too ill to paint very much), Gauguin conducted an extraordinary one-man campaign against the colonial authorities, both civil and religious, for their mistreatment of the natives and destruction of their culture.

By all accounts, the Martinique sojourn, from spring 1887 to January 1888, represents a turning point for Gauguin's psychic and artistic life. There is a marked shift in his internal balance, evident in his more forceful projection of himself as a rebel in retreat from his society; this was when he wrote to Mette about the ascendency of his Indian over his sensitive nature. He appears also to have experienced a profound sexual or emotional awakening in Martinique. These changes are reflected in his art as he begins to switch his attention from perceptual to conceptual concerns. This trip also surely heightened his awareness of Pre-Columbian material, which he must have seen on its home ground on his extensive travels through Central America.

The ceramics Gauguin made during the winter of 1887 through 1888 mark a

considerable change from his earlier efforts. The rustic mode with its Breton motifs was abandoned in favor of a deeper expression in both emotional and formal terms. Where his first group of pots showed Gauguin picking up on certain aspects of Peruvian ceramic forms—especially their peculiar shapes, handles, and appliquéd figures—he now came to terms with the plastic and sculptural dimensions of these objects: their compact silhouettes, severe simplification of realistic form that omits nonessentials, use of the container as a frame for the figure, and overall synthetic tendency. One example is a jar modeled with a Martinique female head that recalls North Coast Peruvian stirrup-spout vessels. This head is integrated into the pot's structure, where it would simply have been added at the top or side in the previous phase. Moreover, Gauguin apparently began to explore the content as well as the form of Pre-Columbian imagery and to study the way in which the two are joined.

A comparison between a vase thought to represent Madame Schuffenecker and a typical Moche figural vessel shows Gauguin's more skillful adaptation of ancient Peruvian plastic formulas. Like the Moche figure, Madame Schuffenecker's head is enlarged and her body abbreviated to coincide with the swelling form of the vessel; the shape and proportion of the vase merges with that of the figure's ample body. Using a similar schematization of the human figure, Gauguin has, like the Moche potters, made a ceramic container that is equally valid as a sculpture. Additional resemblances between Gauguin's portrait of Madame Schuffenecker and Moche ware include the perpendicular attachment of the handle to the pot's rear, the uniform (chocolate brown) color of the vase, and the use of a few telling costume and physiognomic details—necklace, belt, eyelashes, brows, headdress—highlighted in a contrasting slip to succinctly suggest the presence of both clothing and body beneath the ambiguously shaped pot.

BELOW LEFT:
Seated, bound prisoner. Moche, North Coast, Peru, 1–700. Ceramic. Whereabouts unknown

BELOW RIGHT:
Paul Gauguin. Vase representing Madame Schuffenecker. c. 1887–88. Chocolate-colored stoneware, height 10¼". Whereabouts unknown. Courtesy Milton S. Eisenhower Library, The Johns Hopkins University

The belt in the form of a serpent on this pot indicates Gauguin's new attention to Pre-Columbian symbolic motifs. In the Moche and Chimú canons, the serpent belt is an attribute of the deity Ai Aipec that asserts his mythic supernatural status.[40] Gauguin's use of a serpent belt on this vase to suggest the erotic and demonic power of Madame Schuffenecker (who apparently rebuffed his advances) anticipates the theme of Eve and the Serpent, or the eternal mystery of woman, that was to figure repeatedly in his later sculpture, paintings, and prints.[41] Serpent imagery abounds in Pre-Columbian art of all periods and cultures, not only in Peru. The usual connotation is one of fertility—Earth's surface, water, regeneration—never of temptation or evil. In Veracruz and Aztec art of Mesoamerica, female deities, for example, the goddess Cihuateteo,[42] are sometimes represented with serpent belts, so perhaps Gauguin found a precedent for this motif there.[43] The modeling of the face on Gauguin's pot also recalls Veracruz ceramic figures.

Another outstanding second-phase ceramic in the shape of the head and shoulders of a young girl demonstrates Gauguin's mimicry of the complex presentation of narrative on certain Peruvian North Coast ceramics, particularly the way realistic elements are organized in conceptual rather than perceptual terms. Like the portrait vase of Madame Schuffenecker, this female is modeled in coarse, dark-brown clay that is left unglazed, though the hair and eyes are slip-painted black. The pot's handle is formed by the head and neck of a goose. Geese are engraved on the chamber of the vase, which is covered in a pale green slip. The lip is incised with painted plant forms, while a group of incised geese on the base is glazed in yellow.

Specific details of this vase seem derived from Pre-Columbian art. The geese on the chamber are stylized into fluent contours in a way that the geese in the early Breton paintings are not. Representations of birds on Chimú pressed-ware pots are simplified in a similar manner, and one such image appears in a page of Gauguin's notebook. Curiously, however, the drawing is inscribed with the word "Palenque." This suggests that Gauguin had already examined Maya hieroglyphs (whose figural components include many animals), probably through the agency of Count Waldeck's famous reports of the inscriptions at Palenque or Brasseur de Bourbourg's studies of Maya manuscripts, and that in true diffusionist fashion he assumed the ancient Peruvian and Mexican styles to be related. Later, in Tahiti, Gauguin would more fully develop this incipient interest in the decorative and symbolic properties of primitive writing forms in several sculptures, paintings, and woodcuts.

The mixture in this vase of relief, modeling, painting, and incising techniques, the disproportionate scale of the various images, and the absence of a smooth transition between them recall the formal composition of Moche bottles that represent mountain scenes. These combine an outscale modeled figure of a deity with highly stylized landscape and figural elements that are painted, engraved, or modeled in low relief on the chamber. A story of a myth or ritual based on one doubtless unifies this jumble of images. A Moche observer would have known the myth and recognized the symbolic meaning of the images, which we can only infer, in the absence of a written record in ancient Peru. He or she probably experienced this imagery as a ratification of the regnant social-spiritual order.

Gauguin seems to have intuited what the ancient potter was doing and imitated it in his own terms. His point of departure for this vessel is the Greek myth of Leda and the Swan, but he has injected his private associations—his psychological state—into the imagery, making the piece as mysterious to the modern viewer who lacks a knowledge of Gauguin's personal history as the Moche vessel. Gauguin used a similar disjunctive organization to great effect in such paintings as the *Yellow Christ* and *Green Calvary* of the following year—not to ratify but to stress contradictions in the social-spiritual order of his time.

The new coupling of the erotic and the exotic female so evident in these ceramics, which link seductive women with "otherness" in the form of animals, may be a consequence not only of Gauguin's sensual excitement in the tropics but of his enhanced appreciation of one of the most striking and notorious facets of Moche ware: the explicit representation of sexual encounters of all kinds (including the conjunction of humans and animals).[44] A number of Pre-Columbian styles are characterized by the frank expression of male and female sexual prowess, but Moche ceramic art leads the list.

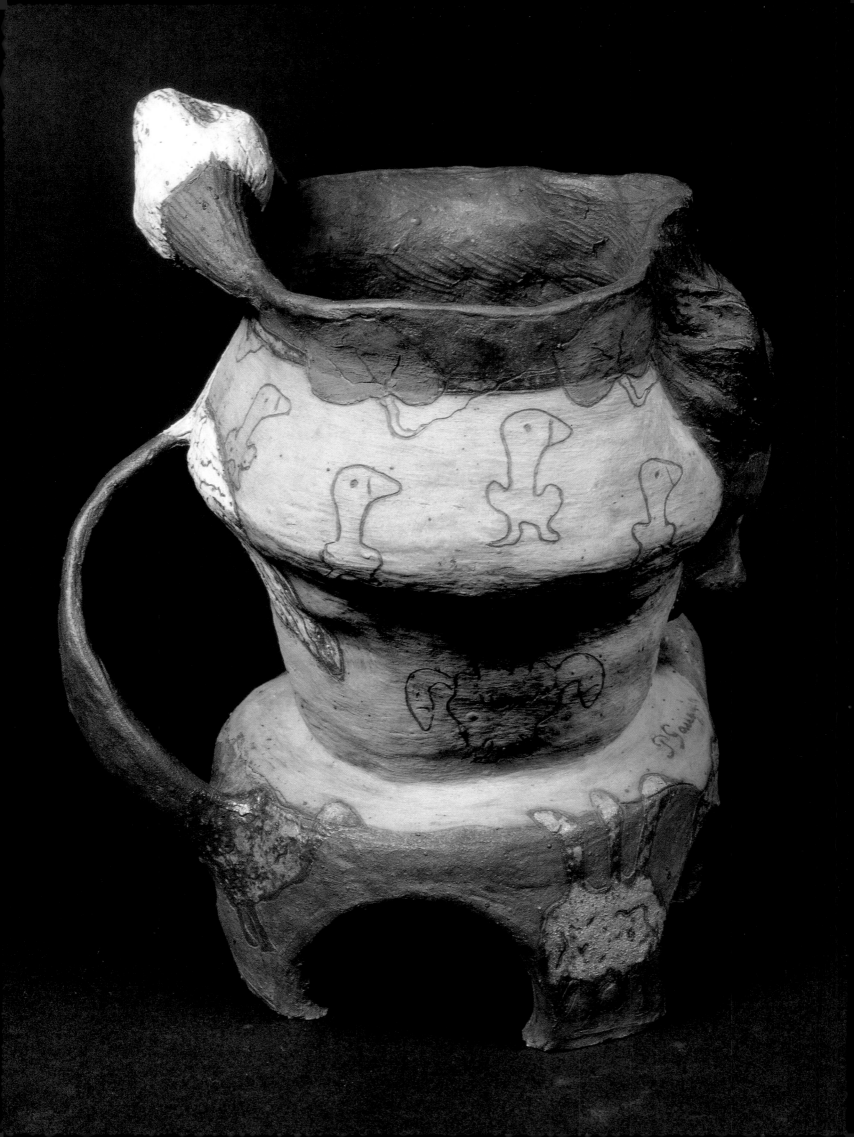

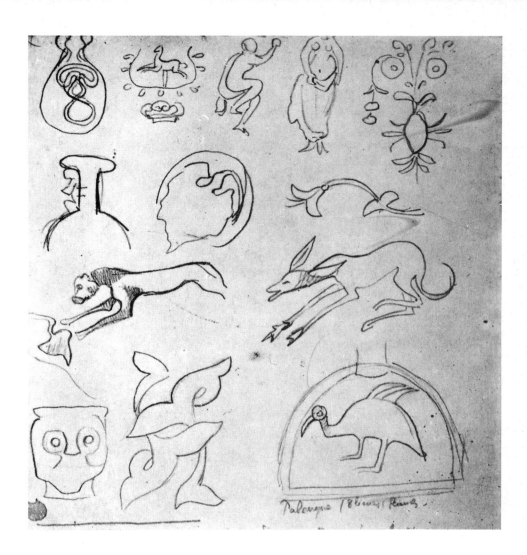

Finally, two anomalous pots attributed to the second phase of Gauguin's ceramic production dramatically suggest the extent of Gauguin's interest in Pre-Columbian pictorial formulas that bear directly on visual problems he was currently exploring in his art. A cylindrical vase in the form of a tree trunk depicts two modeled heads that seem to be looking down at a crouching nude female holding a mirror (incised on the pot wall, together with birds and fishes), suggesting a female seductress and male onlookers.[45] Differences in the surface texture of the pot encourage a reading of it as one large image representing a monster face, with knothole eyes, a maw formed by grooves, and a nose formed by the female figure. In a similar manner, another vessel—with a double spout, round basket-like handle, and painted and incised profile felines above crescent forms—can be read in profile as a feline whose head, mouth, and ears are formed by the left-hand spout, and forepaws by grooves in its square feet.[46] Feline imagery abounds in ancient American art, most especially on Peruvian artifacts. One of many possible examples is a Cupisnique feline effigy pot with a similar profile. Moreover, a profile animal on a crescent, a foxlike creature with lunar associations, appears frequently on Recuay as well as Moche-style pottery.

In both vessels Gauguin seems to be playing with a form of simultaneous or split imagery—a combinative technique employed in many Pre-Columbian (as well as early dynastic Chinese) symbolic styles that stress symmetry and puzzle imagery—which often takes the form of a frontal monster mask that also reads as two converging profile serpent, feline, or bird heads. Gauguin's apparent use of this Pre-Columbian convention on these ceramics parallels his use of spatially and psychologically ambiguous images in many paintings of 1888, such as the Museum of Modern Art's *Still Life with Three Puppies*, where the puppies of the title read simultaneously as real dogs and porcelain objects, as three-dimensional forms and flat patterns on the surface. It also suggests his close reading of Pre-Columbian art and even perhaps a desire to show off his mastery of it by doing it one better himself. After all, Parisian vanguard artists often quoted a chosen model—an admired painting by a colleague, a Japanese print—in order to surpass it.[47]

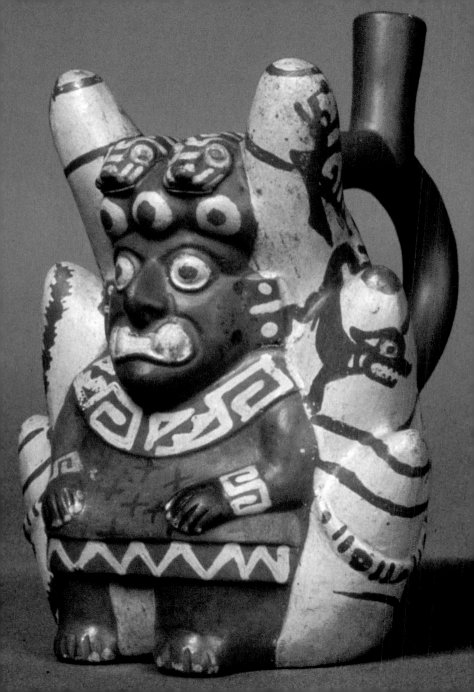

Paul Gauguin. Double-spout vessel in the shape of a cat, with basket-like handle and painted decoration of profile felines. c. 1887–88. Unglazed medium-brown stoneware decorated with black slip and incised animals and foliage, length 9⅞". Whereabouts unknown. Courtesy Milton S. Eisenhower Library, The Johns Hopkins University

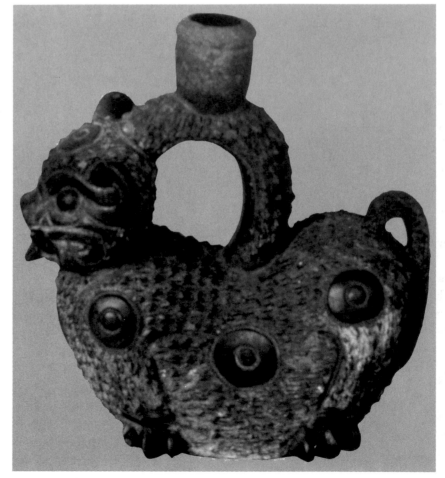

Feline effigy bottle. Chongoyape-Chavín, North Coast, Peru, 1200–500 B.C. Ceramic. Whereabouts unknown

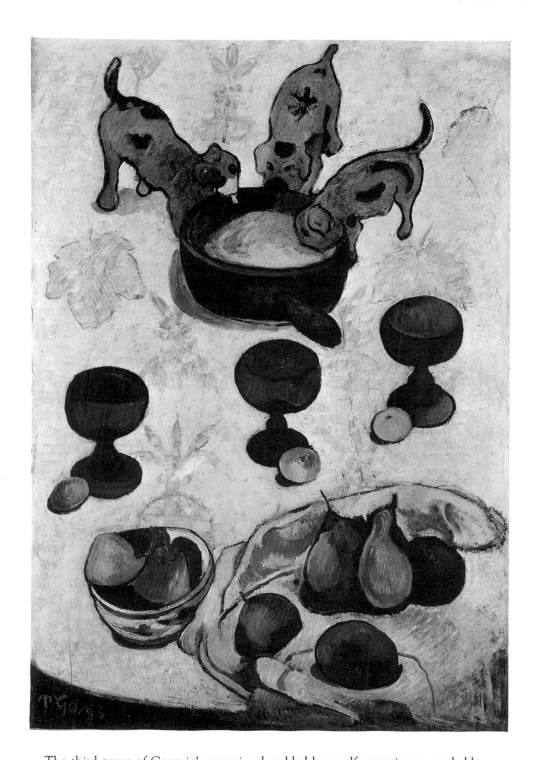

Paul Gauguin. Still Life with Three Puppies. 1888. Oil on wood, 35⅛ × 24⅝". Collection, The Museum of Modern Art, New York, Mrs. Simon Guggenheim Fund

The third group of Gauguin's ceramics, heralded by a self-portrait vase probably made in late 1888 or early 1889, is far more sculptural than previous efforts. In addition, the glaze takes on greater importance, and the entire object achieves a new symbolic intensity. The influence of ancient Peruvian ceramics is stronger than ever. A comparison between the self-portrait vase and a Moche portrait bottle, a hallmark of classical Moche art, shows its unmistakable prototype, even down to details of physiognomy, facial expression, and the head's angle of inclination. Many Moche portrait bottles sensitively record the individuality of the sitter, usually an important official, including his age, mood, attitude, and accoutrements of rank (turban, headdress, face paint, ear ornament). Most show thoughtful men of noble bearing, at the peak of maturity, with mainly serious but sometimes humorous expressions.

Gauguin's vase unmistakably reproduces his own features, testifying to his by now complete identification with the "other" in the guise of an ancient Peruvian Indian. It demonstrates not only his grasp of the essential features of the Moche model but also his transformation of it into a statement of his new Symbolist credo. "A word of advice; don't copy nature too much," he wrote to Schuffenecker in 1888, adding, "Art is an abstraction; derive this abstraction from nature while dreaming before it, and think more of the creation which will result than of the model."[48] He portrayed

PAGE 74:
Paul Gauguin. Self-portrait pot, profile. 1888–89. Stoneware glazed in olive green, gray, and red, height 7⅝". Kunstindustrimuseet, Copenhagen

PAGE 75:
Portrait pot, profile. Moche, North Coast, Peru, 1–700. Ceramic. Museum für Völkerkunde, Staatliches Museen Preussischer Kulturbesitz, Berlin

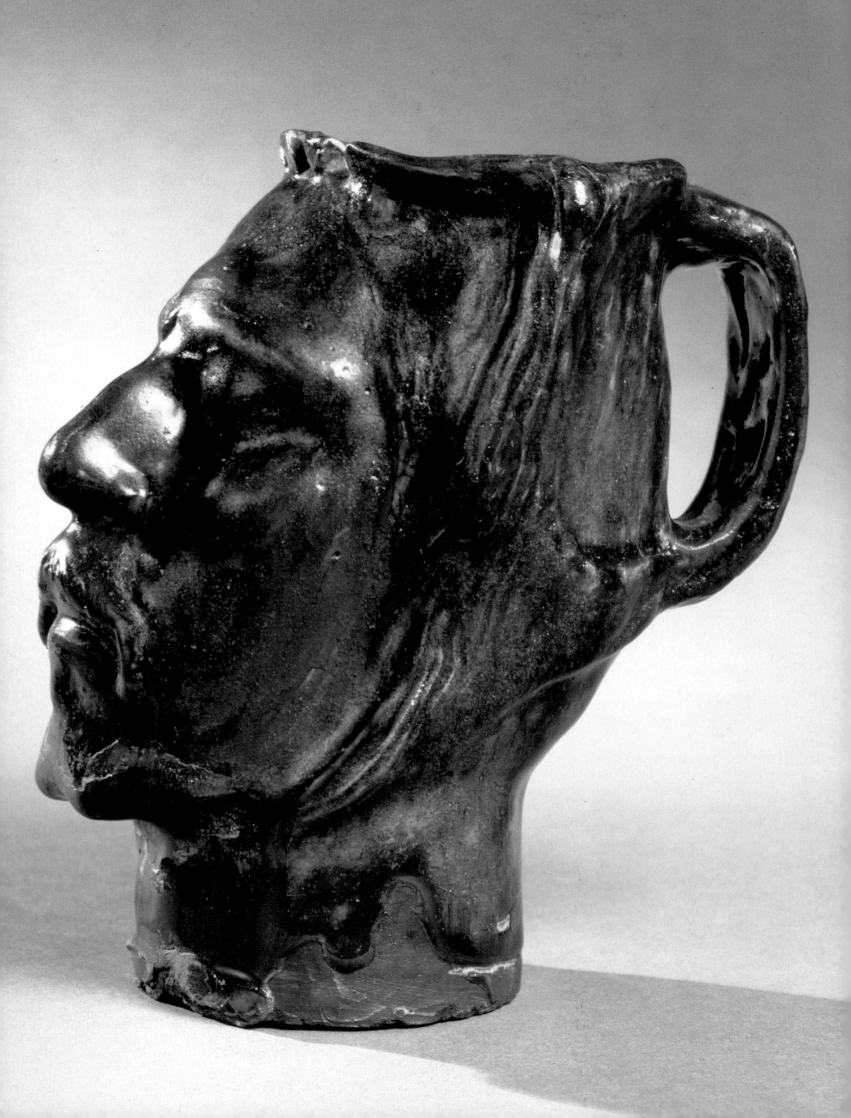

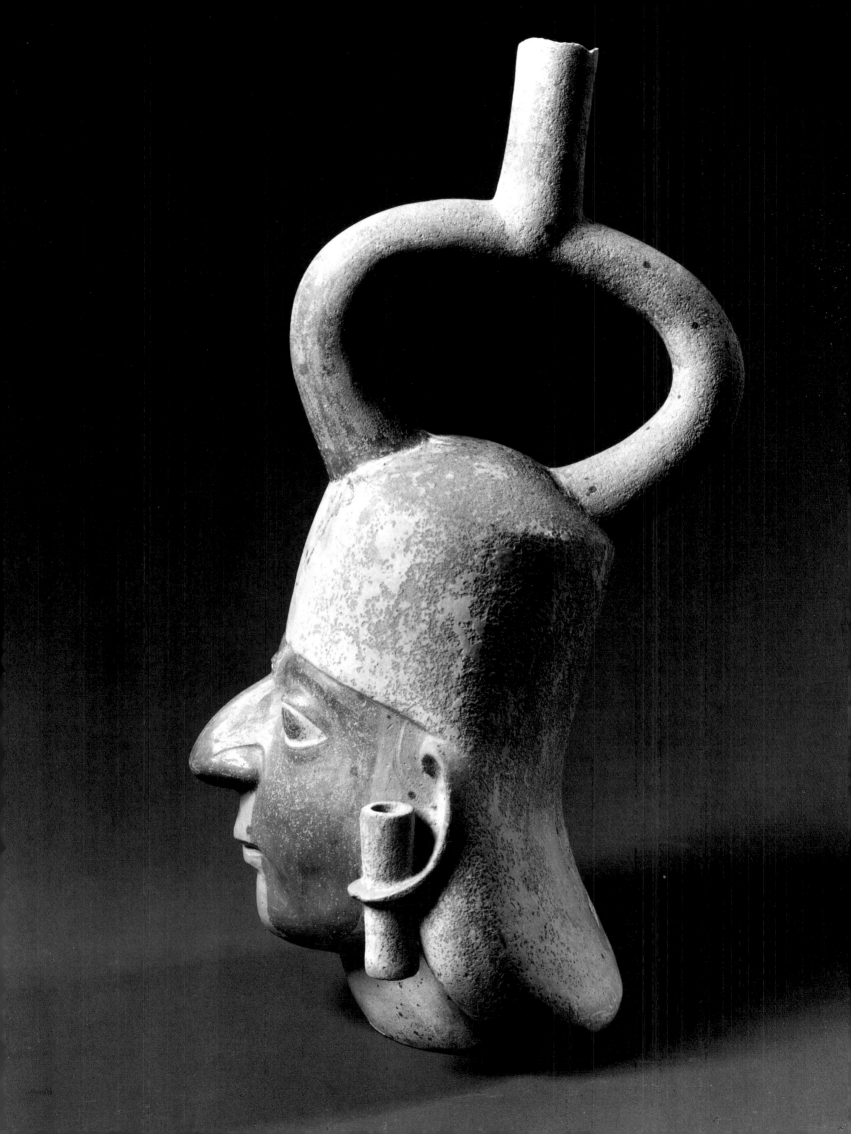

Paul Gauguin. Self-portrait pot, front view. 1888–89. Stoneware glazed in olive green, gray, and red, height 7⅝". Kunstindustrimuseet, Copenhagen

Straight-spout head jar. Moche, North Coast, Peru, 1–700. Ceramic. Amano Museum, Peru

himself with his eyes closed, not unlike many Moche portraits or effigies—as if to symbolize his renunciation of the outside world and retreat into the subjective realm.[49] This new attitude embracing the antinaturalist and literary aesthetic of the Symbolist movement is epitomized in his landmark painting, *The Vision after the Sermon* of 1889, which emphasizes the inner vision of the Breton peasants over their external reality. Gauguin had decided that the artist must strive to represent essences rather than appearances, dreams and fantasies instead of objective conditions.[50]

The gravity of this self-portrait is heightened by the dark olive-green and brown glaze, which has been daubed with a blood-red overglaze on the forehead and eyes, stressing their crucial importance to the artist's visions, and allowed to run down over the mouth and collect at the throat. A bloody, severed head was a recurrent emblem in the work of Gustave Moreau, Stéphane Mallarmé, Redon, and other proponents of Symbolism. In portraying his own head in this fashion, Gauguin was both alluding to their work and identifying himself as a sacrificial victim.

In his earlier glazed ceramics, Gauguin touched up the color modulations with paint and gold accents. But in this new style he has left the glaze alone to produce its own chromatic and textural effects. This experimentation with the color effects of the glaze had immediate repercussions on the color harmony of his pictures.[51] One of the first paintings to show a change in palette is an 1888 *Self-Portrait* dedicated to Van Gogh, which is virtually identical in conception to the self-portrait vase. Gauguin described this painting to Schuffenecker in a letter dated October 1888, comparing its colors to his ceramic glazes, but he might as well have been describing the vase itself:

I did a portrait of myself for Vincent . . . a bandit's head at first glance, a Jean Valjean, also personifying an Impressionist painter who is frowned upon and, in the eyes of the world always carries a ball and chain. . . . The colors are colors remote from nature; just picture a vague memory of pottery twisted by a fierce fire! All the reds, the purples, streaked by flashes of fire, like a furnace blazing before the painter's eyes, where the struggle among his thoughts takes place.[52]

In accord with Symbolist theory, Gauguin was deeply attracted not only to the colors that resulted from fired glazes but also to the romance and mystery of the ceramic firing process itself. The highest heat possible is the most desirable for firing pots, he noted in his review of the ceramics on view at the Universal Exposition of 1889; he likened the firing process to a transformative passage through hell, which releases the beauty in the material, as well as the harmony of the colors.[53]

The self-portrait vase's importance to Gauguin also can be seen by its inclusion in his *Still Life with Japanese Woodcut*, and some of the meaning he attached to ancient Peruvian ceramics can be construed from this painting. The juxtaposition of his Moche-style pot with a Japanese print and a typical Impressionist vase of flowers represents a statement of his major artistic influences at the time, which would have been understood as such by Parisian vanguard artists and critics. Both exotic elements—the print and the pot—invoke the artist's longing for and efforts to retrieve the more natural conditions he imagined for a remote preindustrial world. In the late nineteenth century, Japanese art was consistently linked with the primitive and Japanese life envisioned as Edenic in its simplicity, even in the face of growing evidence to the contrary.[54] There can be little doubt that Gauguin perceived ancient Pre-Columbian art and culture in parallel terms. The strange effect of the flowers emerging from the head of the self-portrait vase signals a symbolic intention—a reference, perhaps, to the creativity of the artist in his savage guise, to the notion of life emerging from death, or even to the fruitfulness of Pre-Columbian sources for his art—especially since he repeated this conceit in other works of this period. A similar self-portrait head with, in this case, a lotus plant growing out of the neck appears on the lap of *Black Venus*, a ceramic statue of 1889, and the earliest representation of an exotic, dark-skinned female as a primitive goddess in Gauguin's art.[55]

For all its symbolic trappings, *Still Life with Japanese Woodcut* is still an Impressionist painting. By comparison, Gauguin's *Symbolist Self-Portrait with Halo* of 1889 is a full-fledged Symbolist work and quite abstract: Perspective is entirely abandoned, form is more rudimentary, decorative line is dominant, color is in a new key, owing in part to the modulation of tone and artistry derived from the stoneware glazes. And, of course,

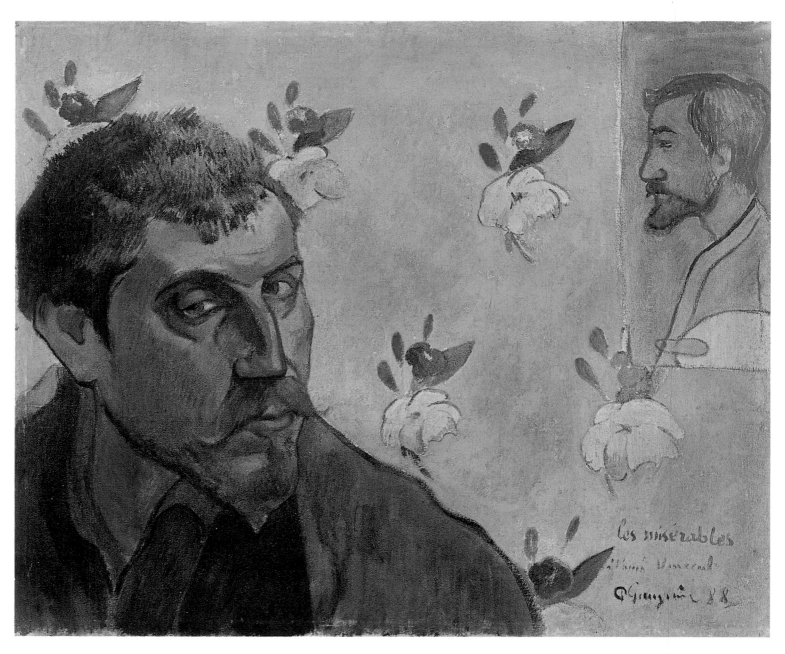

*Paul Gauguin. Self-Portrait (Les Misérables).
1888. Oil on canvas. 17¾ × 21⅝". Collection
Vincent van Gogh Foundation, Vincent van Gogh
Museum, Amsterdam*

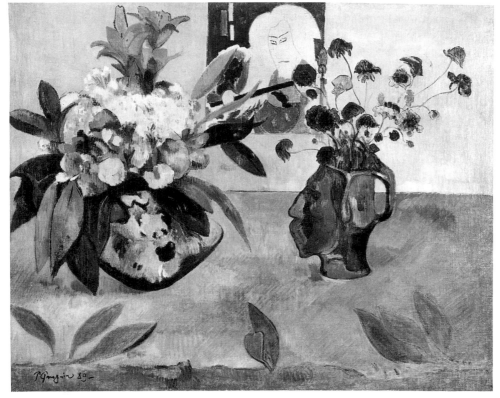

*Paul Gauguin. Still Life with Japanese Woodcut.
1889. Oil on canvas, 28½ × 36½". The Teheran
Museum of Contemporary Art, Iran*

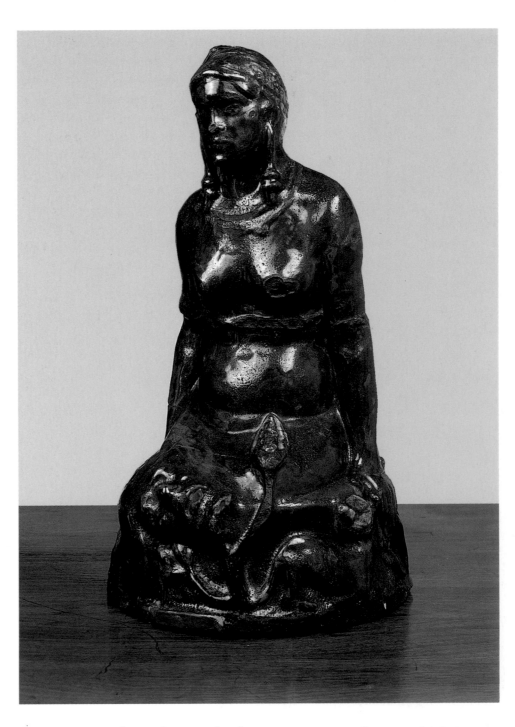

Paul Gauguin. Black Venus. 1889. Glazed stoneware, 19⅝". Nassau County Museum. Museum Services Division. Department of Recreation and Parks

the painting is replete with personal and esoteric associations. In a way, this image seems a flattened and abstracted version of his self-portrait vase.

Yet another important stoneware self-portrait, executed in 1889, derives from a Moche prototype. Gauguin apparently deemed it one of his best pieces, since he sent it to Emile Bernard's sister Madeleine as a love offering and incorporated it into his work in other mediums. The jar is peculiarly shaped, bears an indistinct image, and has a thick, dark-gray glaze. In the artist's words, "It represents vaguely a head of Gauguin the savage."[56] This time, however, the artist has portrayed himself as a grotesque, with his thumb over his mouth, a motif he said signified the stifling of a great cry of pain and loneliness. "All this bile," he wrote Bernard, "this gall which I am amassing because of the redoubled blows of misfortune. . . . Such is Gauguin of the pot, his hand is suffocating in the furnace, the cry which wants to escape."[57] He further noted that the character of the jar derived from its ordeal of high firing—its emergence from a Dantesque inferno—once more invoking the ideas he expressed in his article on the ceramics at the 1889 exposition.[58]

Moche models for this pot might include any number of distorted heads fused with plant forms, such as the anthropomorphic potatoes so common to the style. But the most likely source is a stirrup-spout effigy of a fantastic head of a grimacing supernatural being—an almost abstract collage of images. The bizarre, twisted form of

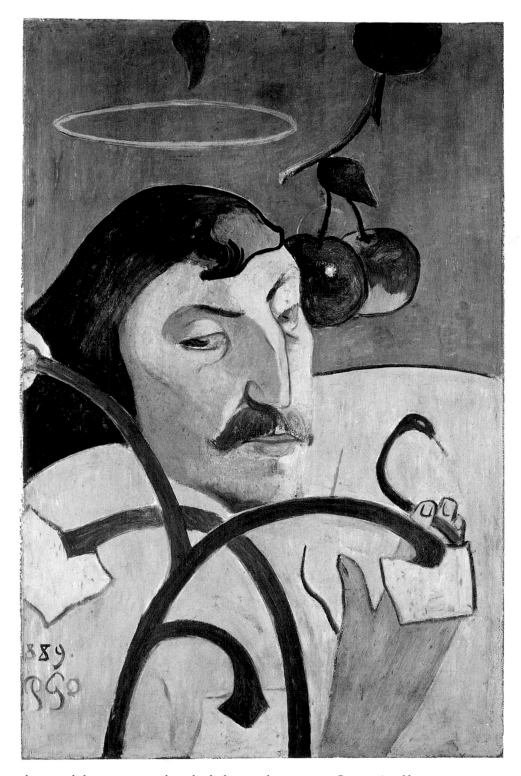

this weird deity corresponds in both form and content to Gauguin's self-portrait jar. (Since most Moche pots were mold-made, duplicates of this very pot are likely to have existed in museum or private collections in France.)

This self-portrait pot is quoted on the upper right of Gauguin's *Self-Portrait with Yellow Christ* of 1889–90 and juxtaposed with a straightforward self-portrait in the center and a quotation of his painting *Yellow Christ*, 1889, on the left. These quotations function as representations of the artist's state of mind. In placing himself in between these images, Gauguin seems to equate his own suffering, represented by the distorted self-portrait pot, with Christ's sorrows, and to see himself as encompassing both savage outcast and redeeming savior, reconciling in his person these opposite roles. On another level, he seems to suggest that the artist's mediation can bring about a syncretist fusion of pagan and Christian beliefs and cultures. But the rough-hewn quality and crude color of the Christian icon underscore Gauguin's alienation from contemporary society and his insistence on the need to return to a primitive, preindustrial state of grace. Moreover, the disjunctive nature of these twice- and thrice-removed images—their distanced relation to the viewer—serves as a metaphor

Paul Gauguin. Oviri. 1894. Stoneware, partially glazed, 29½ × 7½ × 10⅝". Musée d'Orsay, Paris

Effigy vessel surmounted by skeletal figure. Moche, North Coast, Peru, 1–700. Ceramic, height 8⅝". Rautenstrauch-Joest-Museum, Cologne

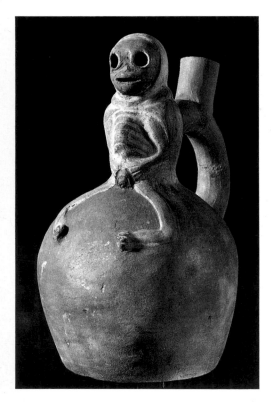

OPPOSITE:
Pot depicting a mountain-sacrifice scene. Moche, North Coast, Peru, 1–700. Modeled and painted ceramic. Museum für Völkerkunde, Staatliche Museen Preussischer Kulturbesitz, Berlin

for the painful contradictions that Gauguin was experiencing at this time.

The year 1889 was a critical juncture in Gauguin's art and life, marking the cresting of his creative powers and the low ebb of his fortunes. This was the point at which he exchanged the outer for the inner world in his art, displacing physical appearances by imagination, the moment of transition from an Impressionist to a Symbolist style. This was also the year of the Universal Exposition, which provided the artist with a wealth of stimulating information about exotic arts, crafts, cultures, and customs related to French colonial possessions in the tropics. It was also, curiously, the time when Pre-Columbian forms exerted the stongest impact on his work, as evidenced by the crystallization of his craft practice in the third phase of his ceramics and the paintings and sculptures that incorporated the lessons and images of the ceramics. Gauguin produced his finest works in the years 1888 to 1889, but he was also deeply despondent. He was ignored by society, unable to eke out a living, and desperately poor. In 1891 he departed Paris and sailed from Marseilles to Tahiti, the first of his two trips there.

The artist's subsequent ceramic production is of little interest with regard to Pre-Columbian influence. Most of the pieces of this last phase of ceramics—from 1890 to 1895—are no longer containers but are full-fledged sculptures. An example is the strange statue called Oviri, Gauguin's largest and most important stoneware figure, which he made during a brief stay in France from 1893 to 1895, an interval between his two trips to Tahiti. Like some of the ceramic containers of 1889, Oviri is self-referential and meant to represent a savage; the title means "wild" or "savage" in Tahitian. It had great significance to Gauguin, who wanted but failed to have it placed over his grave. (In 1973, however, a bronze cast of the sculpture was erected on his tomb on the Marquesan island of Hivoa.) When he returned to Tahiti for the last time in 1895, his ceramic work came to an end; the island lacked suitable clay for pottery making.

Finally, turning from Gauguin's ceramics directly to his paintings, woodcarvings, and graphics, it is important to note a recurrent female image, which Wayne Andersen has shown to be related to ancient Peru.[59] She first appears as a young, crouching, tormented girl in a pastel of 1889 called Breton Eve, and again in the important wood relief called Soyez amoureuses (Be in Love and You Will Be Happy), also of 1889, in which the self-portrait pot quoted in Self-Portrait with Yellow Christ is once again represented (on the upper right). She also appears in a woodcut of the same title (Soyez amoureuses) and year but in the guise of a withdrawn figure of death. In all versions, Eve is derived from a Peruvian mummy that was on view at the Trocadéro during the 1880s. A comparison between the mummy in the museum and Gauguin's images, especially the withered figure in the relief, leaves no doubt that he was inspired by the mummy. The mummy's legs and arms are drawn inward and bound, feet crossed, and head tilted and couched in its hands, in an approximation of a fetal position, which was the customary burial position in Peru.

Gauguin used this figure as a symbol of life, death, and rebirth, as well as of seduction, lust, and fatal knowledge. Andersen has linked this image—particularly the Breton Eve, with a serpent behind her—with the vase that represents Madame Schuffenecker wearing a serpent belt (and a related ceramic that portrays a serpent in her hair) and with Gauguin's Martinique representation of his mother as Eve. He has also drawn attention to its associations with the artist's Peruvian "mummy" and his childhood in Peru.[60]

Another, quite different representation of Eve in an important early Tahitian painting also contains elements that may well have been inspired by Gauguin's interest in Pre-Columbiana. Te nave nave fenua (The Delightful Land) of 1892 and numerous reworkings of it in woodcuts, watercolors, and transfer drawings of 1893–94 depict the theme of Eve's temptation by the serpent in a tropical setting (p. 50).[61] An erotic figure based on a reproduction of a Borobudur sculpture, Eve is accompanied by a chimerical feathered serpent and, in the graphic versions of the image, by an added vertical panel of primitive signs, which presumably represent the Maori language. The serpent's fantastical guise has never been satisfactorily explained. However, since Gauguin actually discussed Mexican deities in his unpublished treatise, L'Esprit moderne et le catholicisme, it is quite possible that he arrived at this form by drawing on his knowledge of the ancient Mexican creator god Quetzalcoatl, who was usually

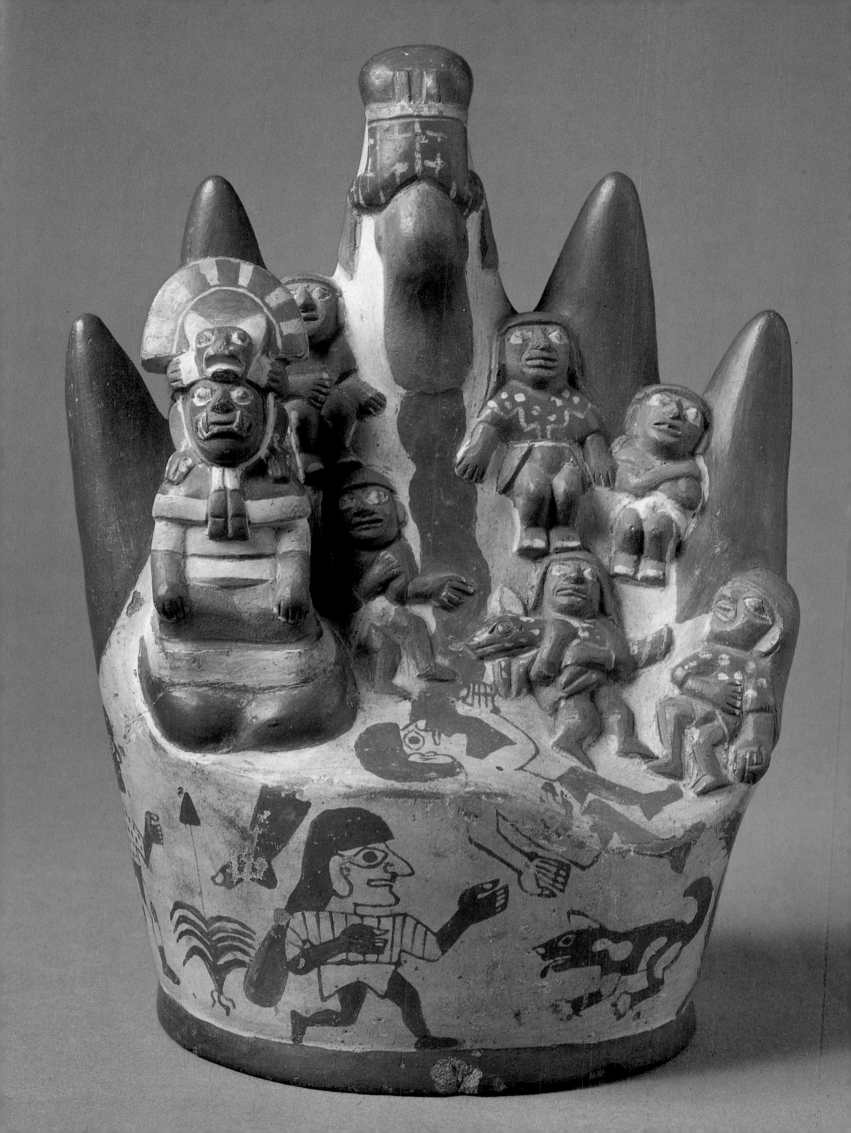

OPPOSITE:
Paul Gauguin. Soyez amoureuses, vous serez heureuses *(Be in Love and You Will Be Happy).* 1889. *Painted linden wood, 47⅛ × 38⅛″ with frame. Courtesy, Museum of Fine Arts, Boston, Arthur Tracy Cabot Fund*

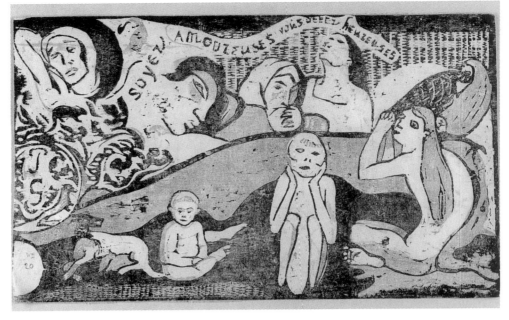

Paul Gauguin. Soyez amoureuses, vous serez heureuses *(Be in Love and You Will Be Happy).* 1898. *Woodcut, 6⅜ × 10⅞″. The Art Institute of Chicago, Joseph Brooks Fair Collection, 1949.932*

Paul Gauguin. Breton Eve. *1889. Watercolor and pastel on paper, 13¼ × 12½″. Bequest of Marion Koogler McNay, Marion Koogler McNay Art Museum, San Antonio, Texas*

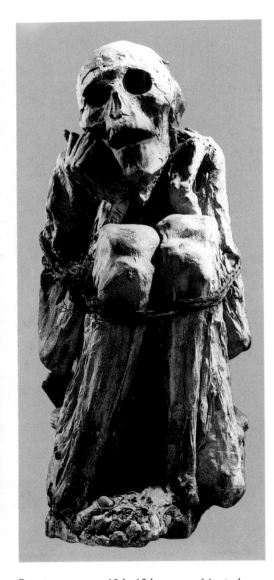

Peruvian mummy. 12th–15th century. Musée de l'Homme, Paris

PAGES 86–87:
Paul Gauguin. D'où venons-nous? Que sommes-nous? Où allons-nous? *(Where Do We Come From? What Are We? Where Are We Going?).* 1897. *Oil on canvas, 4′6″ × 12′3½″. Museum of Fine Arts, Boston, Tompkins Collection*

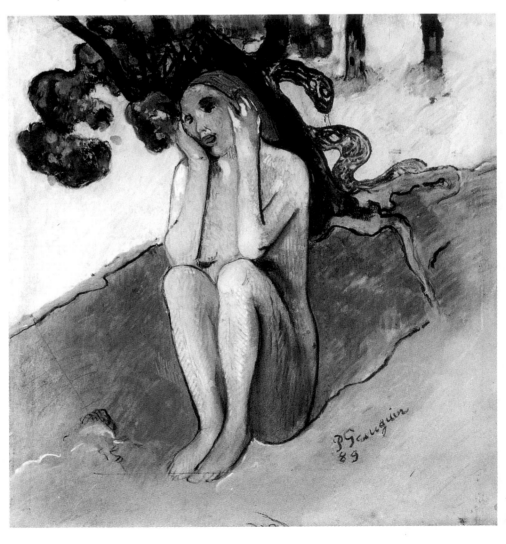

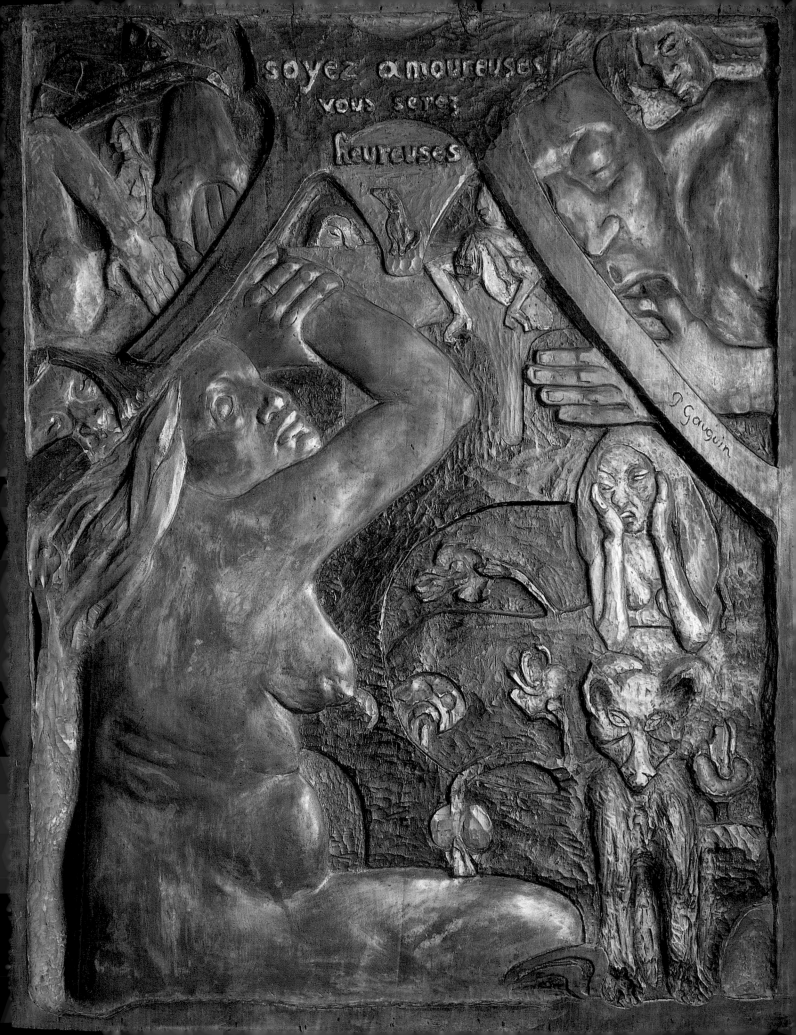

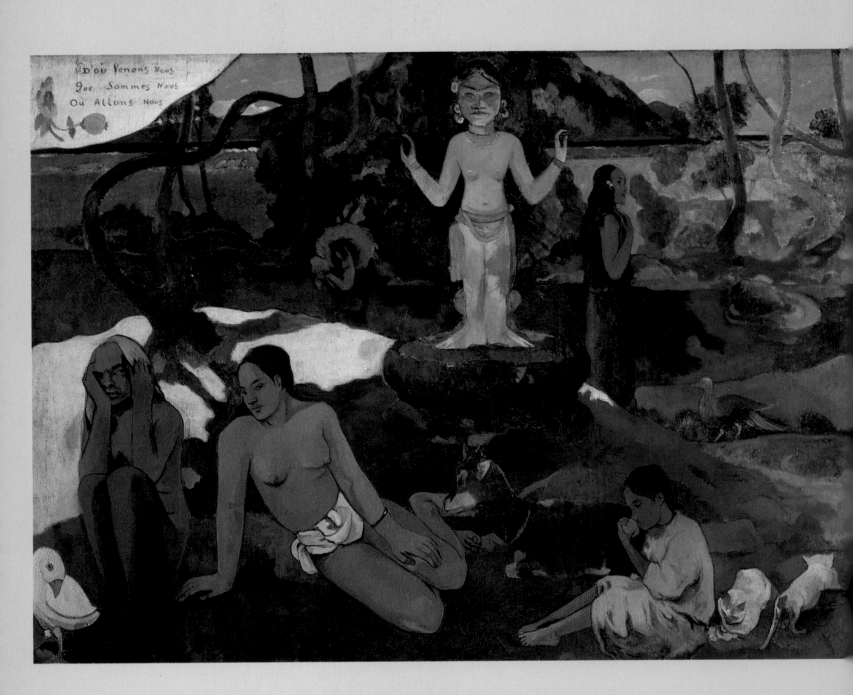

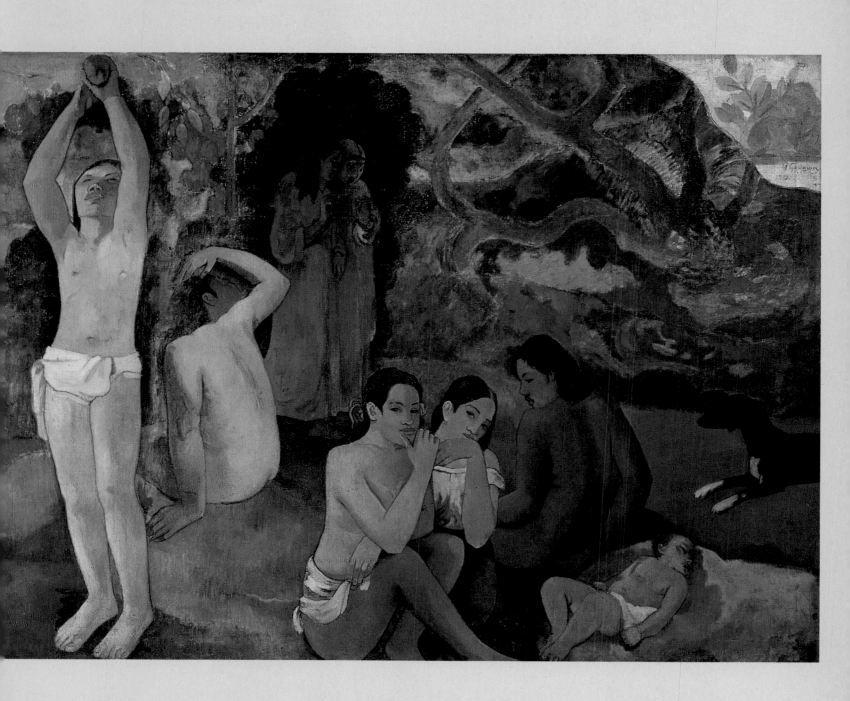

represented as a feathered serpent.[62] It is also likely that the artist derived the idea of a panel of primitive signs accompanying a figure from his recollection of Pre-Columbian art, since both its format and position resemble typical hieroglyphic text panels on classic Maya reliefs from such sites as Palenque and Yaxchilán.[63]

The earlier figure of Eve, which was derived from a Peruvian mummy, recurs in Gauguin's great Polynesian painting (completed in 1898 just before an attempted suicide and meant to stand as a summation of his life's work) *Where Do We Come From? What Are We? Where Are We Going?* Here, the figure functions as a symbol of old age in a representation of the life cycle and brings to mind not only the mummy but also many shrouded skeletal figures on Moche vessels. It is worth pondering whether Gauguin was aware of the frequency of depictions of youth, old age, and death on Moche ceramics, or of the centrality of the notion of the cycle of life, death, and rebirth in Moche iconography and its linkage with sex in that system. Additional portions of this painting recall Pre-Columbian pictorial formulas, especially the way Gauguin has represented the mountains in the background in a manner reminiscent of Moche mountain-sacrifice-scene pots, just as some of his other Polynesian paintings seem to incorporate memories of Moche motifs.[64] In any event, this figure's presence in this testamentary painting, with its associations to the theme of mother, birth, death, and return, shows the influence of ancient Peruvian art extending from the beginning to the end of Gauguin's artistic career and demonstrates his everlasting preoccupation with his Peruvian origins and his savage nature.

Gauguin's Moche- and Chimú-influenced ceramics thus represented not just an incidental, early episode in his art, as has previously been supposed, but an important foundation for everything that followed. His primitivizing stylistic explorations began in his pottery and were keyed to the repudiation of modern industrial society and rejection of outworn classical formulas that were first manifested in the decorative arts. He appropriated Pre-Columbian ceramic forms and techniques, invoked and reworked them in this medium, as part of an attempt to retrieve the meaning, and indirectly the conditions, of social life before industrial capitalism.

Gauguin was not the only artist-potter of the period to admire ancient Peruvian ceramics, but his personal, highly charged connection with Peru encouraged him to give Peruvian ceramics great weight in his art. He became personally identified with his ceramics, creating radical images of himself in stoneware and using them as important elements in his paintings and reliefs. In making pottery as the primitives made it, Gauguin learned to simplify his shapes, experiment with color harmonies, and articulate a conceptual image by using symbolic form and disjunctive composition. Only after he established these terms in his ceramics did he develop them further in painting and sculpture, adapting the craftsperson's procedure of borrowing themes and reshuffling motifs in the same and different mediums. But, where a Pre-Columbian artisan communicated commonly held ideas in an accepted language of forms, Gauguin's conceptions remained private, apprehensible by only a handful of intimates in the Parisian aesthetic vanguard.

The artist's identification with his Indian origins and nature and his interest in Pre-Columbiana should also be acknowledged as having an impact on important aspects of his mature art practice. Many of the most cherished themes and obsessive preoccupations of the Tahitian and Marquesan years found preliminary expression in his little-known ceramics. The seductive stoneware female figures entangled with animals and plants are the prototypes for the dark-skinned primitive enchantresses that populate his Tahitian universe. These same ceramic pieces are the earliest manifestation of the fascination with ancient myths and mysterious writing systems that permeates the late work. Indeed, Gauguin's very decision to live permanently in Oceania seems to follow inexorably from his profound attachment to his exotic origins in Peru. He perhaps imagined that in so doing he was returning to the land of his golden childhood, Peru—which had nourished his art for so long—as the recurrent themes of mother, birth, death, and return in the Polynesian paintings affirm. And since, according to diffusionist theory, the inhabitants of Oceania had originally come from Peru, he may even have been convinced that he was rejoining his Inka ancestors.[65]

NOTES

1. This chapter was originally published in a different form as "Paul Gauguin's Indian Identity: How Ancient Peruvian Pottery Inspired His Art," *Art History* 9, no. 1 (March 1986), pp. 36–54.

Research into the connection between Gauguin and Pre-Columbiana has been discouraged by at least two factors. Robert Goldwater's pioneering *Primitivism in Modern Art* (1938, rev. ed., New York, 1967) asserted that Pre-Columbian material was not within the purview of modern artists. In addition, the art historical media hierarchy has relegated Gauguin's ceramics to an inferior position in his oeuvre.

2. In Maurice Malingue, ed., *Paul Gauguin: Letters to His Wife and Friends*, trans. by H. J. Stenning (London, 1946), p. 23.

3. *Ibid.*, p. 99 (July 8, 1888).

4. In "Les Données Brentonannte: La Prairie de la Représentation," in *Modern Art and Modernism: A Critical Anthology* (Francis Frascina and Charles Harrison, eds., London, 1982, pp. 285–304), Fred Orton and Griselda Pollock discuss the frequent use of the terms "savage, primitive, rustic, simple and remote" by Parisian painters (including Gauguin) referring to Brittany (p. 295). They point out that these terms partake of the "ideological baggage carried by artistic tourists," who judged anything deviating from urban bourgeois norms accordingly.

5. By any standards, Flora Tristan was a remarkable woman for her time and place. "She was connected with all sorts of socialist affairs, among them the worker's union. The grateful workers set up a monument to her in the cemetery of Bordeaux. It is probable that she did not know how to cook. A socialist-anarchist blue-stocking," recalled Gauguin in *Avant et Après*, trans. by Van Wyck Brooks in *Paul Gauguin's Intimate Journals* (Bloomington, Ind., 1958), p. 153. She was, he adds, a "very pretty and noble lady. . . . I also know that she spent her whole fortune in the workers' cause, traveling ceaselessly. Between whiles she went to Peru to see her uncle Citizen Don Pio Tristan de Moscoso (of an Aragonese family)."

6. The artist's evocation of his Lima childhood in *Avant et Après* (Brooks, *op. cit.*, pp. 152–54) reveals his emotional ties to Peru: "I have a remarkable visual memory and I recall this time of my life, our house and ever so many things that happened . . . in that delicious country where it never rained." He lived like a little prince, he recalls, and was exposed to exotic people (especially servants of different races) and customs (madmen chained to roofs, for example). His memories of his beloved mother, whom he conjures up in colonial costume, are largely confined to this period.

7. Daniel Guerin, ed., *The Writings of a Savage: Paul Gauguin* (New York, 1978), p. 237, and Brooks, *op. cit.*, p. 194. I have been unable to trace this collection.

8. Hotel Drouot auction catalogues reveal the scope of his collection, cited in Christopher Gray, *Sculpture and Ceramics of Paul Gauguin* (Baltimore. 1963; reprint New York, 1980), p. 22, n. 57.

A record of some of Arosa's Pre-Columbian holdings can be found in Auguste Demmin's encyclopedic *Histoire de la céramique* (Paris, 1875). Plate xxxv illustrates Aztec and Mixtec pots owned by Demmin and three Peruvian bottles and an Aztec jar in Arosa's collection. Demmin's book also provides a notion of the way Pre-Columbian ceramics were regarded and classified at the time in France. His typology includes five classes of ancient American pottery—four from Mesoamerica and one from Peru. He considered Peruvian pottery fabrication superior because there was no use of the potter's wheel, while believing (erroneously) that the Mexicans used the wheel. Although the dating of this material is sketchy, the author's bias is distinctly in favor of more ancient material. Also of interest are the references to various contemporary Parisian collections of Pre-Columbian ceramics and to the extent of the holdings of this material in French, British, and German museums. In an earlier volume, *Guide de l'amateur faiences et porcelaines* (Paris, 1867), Demmin cites a M. Lefèvre, who owns fifty "Aymara" (Moche and Chimú) pots, and a M. Pingret who has a collection of two thousand Mexican pots.

9. Gray, *op. cit.*, p. 22, n. 57; and Richard Field, "Gauguin's Woodcuts: Some Sources and Meanings," n. 36, in University Museum, *Gauguin and Exotic Art* (Philadelphia, 1969).

10. The two most frequently cited Pre-Columbian authorities by Demmin, 1875, *op. cit.*, are Brasseur de Bourbourg and Count Waldeck, both New World explorer-adventurers and proponents of diffusionist theory. Waldeck is highly praised for his expeditions to Palenque and Yucatán and for the magnificent reproductions in his *Monuments anciens du Mexique et du Yucatan* (Paris, 1986). Many motif correspondences between Greek, Etruscan, and Peruvian pots are indicated, e.g., grecas and "Hercules" struggling with a fish.

11. Although Pinart did not write an encompassing account of his far-flung travels thoughout the Americas and Oceania, he published numerous reports and studies and left behind a great deal of unpublished material. An exact contemporary of Gauguin, Pinart was highly regarded in France as an accomplished linguist and ethnologist, especially in his youth. Early on, he had been inspired by Brasseur to study native American languages and compare them with Far Eastern languages to prove that Indians originally came from Asia. Traveling in pursuit of evidence to support this theory, he even ventured to Easter Island, returning to France to serve as commissioner for the Paris Exposition of 1878. Just before Gauguin's arrival in Panama, Pinart had spent three years there studying ancient inscriptions, local dialects, and ethnological collections, which became the subject matter of most of his subsequent work.

12. The well-known explorer Thor Heyerdahl is a present-day proponent of diffusionism. His famous Kon Tiki expedition set out to demonstrate that simple boats could have made vast sea-going voyages, in this case crossing the Pacific east to west from Peru to Polynesia. To buttress his theory that Polynesian culture was derived from South America, he also compared linquistic, physical-anthropological, and ethnological traits. See Thor Heyerdahl, *American Indians in the Pacific* (London, 1952); and *Sea Routes to Polynesia* (London, 1968).

13. Elizabeth A. Williams, "Art and Artifact at the Trocadéro," in George Stocking, Jr., ed., *Objects and Others: Essays on Museums and Material Culture* (Madison, Wis., 1985), p. 156.

14. E. T. Hamy, *La Galerie Américaine de Musée d'Ethnographie du Trocadéro* (Paris, 1897). There are

marked affinities between several objects illustrated in the plates and a number of Gauguin's ceramics and sculptures.

15. Both Hamy's catalogue and memoirs (*Decades Americanae: Mémoires d'archéologie et d'ethnographie américaines* [Paris, 1898]) are saturated with diffusionist notions.

16. See Gray, *op. cit.*, p. 52, citing Paul Serusier; B. Danielsson, "Exotic Sources of Gauguin's Art," in University Museum, *op. cit.*; and Merete Bodelson, *Gauguin Ceramics in Danish Collections* (Copenhagen, 1960), p. 36, n. 42.

I suspect, but have been unable to verify, that these were casts of Maya relief monuments from southern Guatemala that were exhibited in the Madrid Exposition of 1892 and probably also in the 1889 Paris Exposition. Gauguin might also have seen businessman and assiduous *américaniste* Eugene Goupil's personal collection of ancient Mexican statuettes and diverse "industrial productions," which was displayed in conjunction with the exposition. See Williams, *op. cit.*, p. 156.

17. See Gauguin's letters to Bernard of February 1889 (in Malingue, *op. cit.*, p. 118); and August 1890 (in M. A. Bernard-Fort, ed., *Lettres de Paul Gauguin, à Emile Bernard* [Geneva, 1954], p. 117).

18. See Griselda Pollock, "Stark Encounters: Modern Life and Urban Work in Van Gogh's Drawings of The Hague 1881–3," *Art History* 6, no. 3 (September 1983), p. 331. I am indebted to Pollock's article on Van Gogh for enlarging my view of art practice in this period.

19. Gray, *op. cit.*, p. 5; Guerin, *op. cit.*, p. 17, a letter of late June 1886: "I'll take a small studio . . . and I'll work at ceramics, sculpturing pots the way Aube used to do. M. Bracquemond, who has been friendly with me because of my talent, has found me this work and told me it could become lucrative."

20. In a letter to Mette of December 1886 (Guerin, *op. cit.*, p. 18), he wrote: "I am making ceramic sculpture. Schuffenecker says they are masterpieces, as does the ceramicist, but it's probably too artistic to sell. Yet he says that within a given period of time at the industrial arts exhibition, this idea will be wildly successful."

21. Theo van Gogh, brother of Vincent, held a sale of Gauguin's ceramics and sold a few pieces, which helped to finance the artist's trip to join Vincent in Arles. Purchasers of the artist's ceramics included Pietro Krohn, future director of the Museum of Decorative Arts, Copenhagen, who bought Gauguin's self-portrait jug from Schuffenecker in 1893, and Gustav Fayet, a great admirer of Gauguin, who bought several of his ceramics from Schuffenecker and the artist's family around the turn of the century. See National Gallery of Art, *The Art of Paul Gauguin* (Washington, D.C., 1988), pp. 59, 63, 127, and *passim*.

22. Bodelsen in *Gauguin's Ceramics: A Study in the Development of His Art* (London, 1964), fig. 140, reproduces the sketch for it and says that the designs bear a Peruvian motif. I am unclear what she means by this and cannot discover more from the illustration.

23. Gray, *op. cit.*, p. 5, citing a letter from Pissarro to his son.

24. William Morris crystallized these sentiments in the 1860s by positing an ideal of close collaboration between artists and craftspersons and setting an example with his London Red House, a free association of artists who worked together in the manner of medieval guilds. By the 1870s, the Arts and Crafts movement had inspired a large number of British art potteries to produce wares thrown and decorated by hand. These ideas quickly spread to the continent, receiving official endorsement in France through the formation of the Union Central des Beaux Arts Appliqués, which sponsored new decorative arts museums and exhibitions. See A. W. Coysh, *British Art Pottery, 1870–1940* (Rutland, Vt., 1976); and Lionel Lambourne, *Utopian Craftsmen: The Arts and Crafts Movement from the Cotswolds to Chicago* (New York, 1980).

25. Gray, *op. cit.*, pp. 23–26.

26. In his review of the ceramics on view at the Universal Exposition of 1889 in *Le Moderniste* (June 4 and 11, 1889), Gauguin praised Chaplet but also criticized the familiar shapes of his pots, saying that he ought instead to associate himself with an artist-sculptor. See Guerin, *op. cit.*, p. 34.

27. Cited in Bodelsen, 1960, *op. cit.*, pp. 9–10.

28. Most of those in private collections have never been on exhibit, and no separate exhibition of his ceramics has been held, except for Bodelsen's exhibition, *ibid.*

29. Bodelsen and Gray dispute the dating of this pot; Gray claims it is early, while Bodelsen places it later, in 1888 or 1889, on the basis of the *flamme* glaze. See Gray, *op. cit.*, cat. no. 10, p. 123. I have largely followed Bodelsen's sequencing but concur with Gray in this case.

30. Guerin, *op. cit.*, p. 32.

31. According to Gray, *op. cit.*, p. 22, n. 58, the first person to point out the similarity between some of Gauguin's pottery and Pre-Columbian ceramics was René Huyghe in his commentary on Gauguin's *Ancien culte mahorie* (Paris, 1951), p. 20.

32. See J. F. Blacker, *Nineteenth Century English Ceramic Art* (Boston, 1911), pp. 404–14; and Fine Arts Society, *Christopher Dresser (1834–1904): Pottery, Glass, Metalwork* (London, 1972).

Since Dresser's pots were exhibited in London in the early 1880s to great acclaim, Gauguin might have been aware of them—through his association with Arosa, the ceramic collector, if not his own three-week sojourn in England in 1885. At any rate, they show someone else pursuing a similar course at a slightly earlier time.

33. Gray, *op. cit.*, p. 24.

34. Orton and Pollock, *op. cit.*, p. 299.

35. Guerin, *op. cit.*, p. 19.

36. *Ibid.*, p. 26.

37. *Ibid.*, p. 26. Gauguin's experience of the Paris Universal Exposition of 1889 fueled these impulses, as his letter of 1890 to Bernard (in which he hoped to convince the latter to join him) indicates: "What I want to do is to set up a studio in the tropics. With the money I shall have I can buy a hut of the kind you saw at the Universal Exhibition. An affair of wood and clay, thatched, near the town but in the country." In M. Malingue, ed., *Lettres de Gauguin: à sa femme et ses amis* (Paris, 1946), p. 191.

38. Gray, *op. cit.*, p. 49, quotes Gauguin in a letter mentioning this society and free transportation to Tahiti.

39. Kirk Varnedoe, "Gauguin," in William Rubin, ed., *Primitivism in 20th Century Art* (Museum of Modern Art, New York, 1984), p. 186.

40. He can be seen in this guise on any number of Moche mythological relief and painted pots (including one in the Trocadéro, cat. no. 21261) or Chimú pressed-ware decorated pots.

41. See Gray, *op. cit.*, p. 29. Another vase from this period in the form of a woman's head, which is securely identified as Madame Schuffenecker, shows her wearing a serpent headdress (see Gray, *ibid.*, cat. no. 67, and National Gallery of Art, *op. cit.*, p. 122).

42. See, for a ceramic example (not necessarily known in Gauguin's time), a middle classic Veracruz effigy of the goddess Cihuateteo from El Cocuite, which bears a striking resemblance to Gauguin's vase, in Edward H. Merrin Gallery, *Works of Art from Pre-Columbian Mexico and Guatemala* (New York, 1971), fig. 10.

43. Another example of Gauguin's use of serpent imagery associated with Eve that seems to be derived from Pre-Columbian prototypes is on a carved wooden cane in the Metropolitan Museum collection (inv. no. 67.187.45) from the same period (see Gray, *op. cit.*, cat. no. 80, p. 199). A serpent coils around the cane's shaft, and just above it, at the top of the cane, is a naked female figure in a caryatid position whose head is enveloped in a sabot that resembles a Pre-Columbian headdress. On the other end of the design, the serpent issues out of the mouth of a frog in standard Pre-Columbian fashion. Gray, *ibid.*, points out that this creature resembles a lizard on a Peruvian pot that was in Gustave Arosa's collection (as pictured in Demmin, 1867, *op. cit.*, fig. 4, p. 1067).

44. Moche erotic art encompasses oral intercourse, fellation, masturbation, breast fondling, and kissing. According to Christopher Donnan in *Moche Art of Peru* (Los Angeles, 1978), pp. 133–34, all these activities and postures preclude insemination, and the absence of any activity that would lead to childbirth argues against an interpretation of Moche art as fertility-oriented.

45. Gray, *op. cit.*, p. 168, compares this pot to a wooden relief by Gauguin called *Martinique*, in which two heads emerge from tree trunks on either side of a nude female. In both cases the image features a female seductress and male onlookers, as do many of Gauguin's representations of this period.

This curious imagery evokes a central episode in the Quiché Maya *Popol Vuh*, the late Pre-Columbian epic incorporating very ancient and widely distributed Mesoamerican myths, involving a young women and a head suspended from a tree limb. Miraculously impregnated by the head's spittle, she becomes the mother of the hero twins in the myth. Brasseur de Bourbourg had recently translated this myth into French, and it is possible that Gauguin was acquainted with it.

46. Bodelsen, 1964, *op. cit.*, p. 104.

47. See Orton and Pollock, *op. cit.*, p. 300.

48. Malingue, *op. cit.* (n. 37, above), p. 134.

49. See Bodelsen, 1964, *op. cit.*, pp. 182, 188.

50. This was also the reason that Gauguin admired "primitive" art and thought it superior to the Western tradition: "It proceeds from the spirit and makes use of nature," but avoids the error of naturalism and is rendered with all the simplicity that the medium permits. Cited in Robert Goldwater, *Gauguin* (1957 ed., reprinted New York, 1983), p. 38.

51. Bodelsen, 1964, *op. cit.*, pp. 112, 191.

52. Cited in Guerin, *op. cit.*, pp. 24–25.

53. *Ibid.*, p. 33.

54. See Elisa Evett, "The Late Nineteenth-Century European Critical Response to Japanese Art: Primitivist Leanings," *Art History* 6, no. 1 (March 1983), pp. 104–5.

55. It may be more than coincidental that a plant form, usually a lotus, is often shown emerging from a sacrificed human head in Maya art and hieroglyphs.

56. Gray, *op. cit.*, p. 30, citing Gauguin's letter to Madeleine Bernard.

57. *Ibid.*, pp. 30–31, citing Gauguin's letter to Emile Bernard that mentions this pot. Yet another symbolic dimension of the jar alludes to his dependency on tobacco. See National Gallery of Art, *op. cit.*, p. 178.

58. *Ibid.*, citing a second letter to Bernard that mentions the pot.

59. Wayne V. Andersen, "Gauguin and a Peruvian Mummy," *Burlington Magazine* 109 (January–June 1967), pp. 238–42; and Andersen, *Gauguin's Paradise Lost* (New York, 1971), pp. 112–27.

60. See Andersen, 1971, *op. cit.*, for a determinedly Freudian interpretation of this image, which stresses the notion of regression and return in the Polynesian work.

61. See National Gallery of Art, *op. cit.*, cat. nos. 148, 149, 172, 177–180, and 182. The first translation of the woodblock version of the subject into a drawing is inscribed in pidgin French, "Don't listen to the liar." Gauguin had placed and then, after criticism, erased the identical inscription on the version of *Breton Eve* that was shown in the Volpini exhibition of 1889. See *ibid.*, p. 332.

62. Gauguin's serpent resembles a winged lizard, while Quetzalcoatl is most often represented as a feathered snake in ancient Mexican art. (The 1902 manuscript of this treatise is in the St. Louis Art Museum.)

63. Gauguin incorporated glyphlike signs on other Polynesian period work, including *Wood Cylinder with Christ on a Cross* and the painting *Te amana*. These signs are usually interpreted as his transcriptions of an Easter Island script known as "Rongorongo."

64. For example, the wraithlike profile figure in the left background of *Spirit of the Dead Watching*, 1892, seems derived from shrouded skeletal figures on many Moche pots. Varnedoe, *op. cit.*, p. 199, and fig., p. 200, on the other hand, sees a derivation "most likely from Egyptian sources." Frontal views of the same figure in, for example, Gauguin's study for this painting, *Words of the Devil* (see *ibid.*, p. 201), appear to confirm this resemblance to Peruvian images.

65. Perhaps he recalled the legendary raft voyage of the Inkas from Peru to Polynesia, which Thor Heyerdahl demonstrated in 1947 could have taken place, when he sailed on a balsa raft, the Kon Tiki, from Peru and landed 101 days later on the island of Raroia in Polynesia. See n. 12, above.

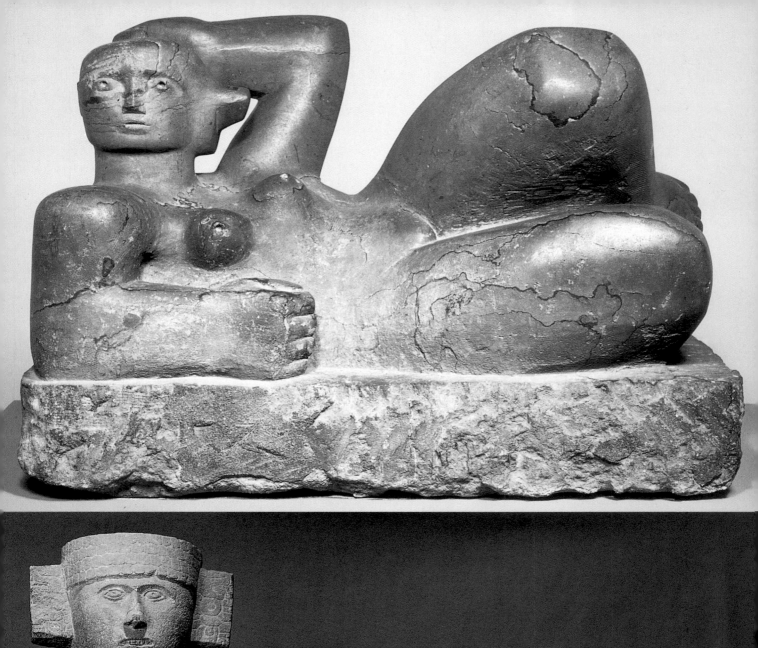

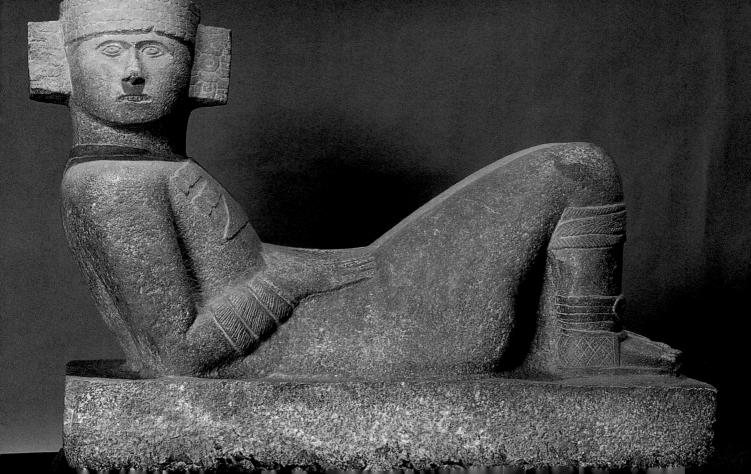

HENRY MOORE: THE CHACMOOL IN THE GARDEN

Among the many non-Western influences that Henry Moore assimilated, Pre-Columbian sculpture stands out as seminal.[1] Moore is also the modern artist most closely identified with Pre-Columbian sculpture, having often extolled its "stoniness, truth to material and full three-dimensional conception of form." Although the comparison between his reclining figures of 1929 and 1930 and the Toltec-Maya chacmool is familiar, his persistent reference to Pre-Columbian art is less well known. He first encountered Pre-Columbian art while a student in a provincial art school, almost immediately began using it as a model for his work, and continued to refer to it in every phase of his long and illustrious career as Britain's and then as the Western world's premier modernist sculptor and monument maker. Today we can see that he used this alien tradition, especially highland Mexican plastic formulas, to popularize still another—modernism—which is defined here as the notion of artistic progress through formal and technical innovation informed by styles of the past.[2]

Moore emerged as a sculptor in the early 1920s at a time when the devastation of World War I and the eruption of the Russian Revolution had shattered the coherence of established sculptural tradition. In England the prewar experimentation of Jacob Epstein, Henry Gaudier-Brzeska, and Constantin Brancusi was available as a model for a new kind of sculpture. Perhaps even more important was a new theoretical basis for the modern practice of sculpture articulated by Bloomsbury critics Roger Fry in *Vision and Design* (1920) and Clive Bell in *Art* (1914).[3]

Fry's book, with its chapters on African, Ancient American, Bushman, and Islamic art alongside those on Giotto, Cézanne, and Renoir, asserted that art all over the world could be scanned for authentic aesthetic experience and that the Western classical artistic tradition was imbued with the conservativism of authority. Bell's concept of "significant form," stressing the autonomy and disinterestedness of art, also endorsed this view by admitting a whole range of experiences into its practice—not only primitive, non-Western models, but also, say, a devotion to the memory of a Yorkshire landscape, an interest in the shapes of stones and bones, departures from anatomical accuracy, and, finally, abstraction.[4] Here were the basic precepts for modernist sculpture: a commitment to the unity of all aesthetic experience; the notion, advanced by Bell, that a work of art need only have sculptural meaning; and permission to range all over the world's sculpture in search of models, as Epstein, Gaudier-Brzeska, and Brancusi had done.

Moore, too, embraced these tenets at the outset of his career, having discovered Fry's *Vision and Design* while he was attending Leeds School of Art from 1919 to 1921. "Once you'd read Roger Fry the whole thing was there," he declared, adding, "Fry opened the way to other books and to the realization of the British Museum."[5] It was all quite straightforward, he said. Even his working-class origins meshed perfectly with modernism's implicit oppositional stance.

He was born in 1898, seventh of eight children, in Castleford, a grim industrial town in northern England just outside Leeds, and raised in an environment dominated by coal mines, chemical plants, and potteries. His coal-miner father was a forceful and ambitious man with socialist convictions and intellectual interests, who managed (by dint of scholarships) to send three of his children, including Henry, to Castleford Secondary School—intended for the children of the petit bourgeoisie—so that they could better themselves by becoming schoolteachers. Moore favored his gentler mother, who encouraged his artistic inclinations, which were further reinforced by his high school art teacher. Miss Alice Gostick took him under her wing until he enlisted in the army in 1917 and saw to it that he studied sculpture on a veteran's grant-in-aid upon his return.

As an older and more disciplined student, Moore flourished at Leeds School of Art, becoming the sole beneficiary of its new sculpture department (academically out of favor until this time) and carefully preparing for his next career move, a scholarship at London's Royal College of Art. At Leeds he connected with Sir Michael Sadler, then vice chancellor of the Leeds University, the first of many prominent, progressive cognoscenti who became his lifelong patrons. In the early years, they provided

94

opportunities for advancement and deflected hostile criticism, and in later years, promoted him to national prominence. As a modern-art enthusiast, Sadler collected paintings by Turner, Constable, Cézanne, Van Gogh, Gauguin, Picasso, and Kandinsky, befriended important artists like Aristide Maillol, and even translated Kandinsky's *Art of Spiritual Harmony* (1914).

Once Moore was ensconced at the Royal College of Art, its newly appointed principal (later Sir) William Rothenstein (who had known Degas, Monet, and Rodin in Paris) became Moore's champion. He got Moore an appointment as a teacher at the college, from 1925 to 1929, and his brother, Charles Rutherston, began collecting Moore's sculpture as early as 1922. Another mentor of this period was Bradford printer and publisher E. C. Gregory, who, beginning in the late 1940s, published the five-volume catalogue raisonné of Moore's work, which is known as Lund-Humphries. By the mid-1950s, Gregory, Moore, and Herbert Read were sitting on the same committee of the Institute of Contemporary Art, promoting public sculpture. Thus, from the start, Moore's course was remarkably smooth, combining exceptional talents, extraordinary dedication, and great good luck. From humble beginnings in the Yorkshire working class, he moved swiftly to embrace new ideas and establishment benefactors in his steady climb to success.

As a scholarship student at the Royal College of Art, Moore accommodated the demands of the very traditional coursework, such as modeling figures after casts, but he pursued his real education elsewhere, seeking alternatives to the classical humanist tradition. "There was a period when I tried to avoid looking at Greek sculpture of any kind," he later recalled. "When I thought that the Greek and Renaissance were the enemy, and that one had to throw all that over and start again from the beginning of primitive art."[6] Reading Fry had led Moore directly to the British Museum, a vast repository of centuries of colonial plunder, to find what he was looking for. Immediately, he began a dedicated study of archaic Greek, Egyptian, Cycladic, Austral islands, African, Sumerian, and, particularly, Mexican art on regular biweekly visits. "One room after another in the British Museum took my enthusiasm a new world at every turn. . . . And after the first excitement it was the art of ancient Mexico that spoke to me most, except perhaps Romanesque or early Norman. And I admit clearly and frankly that early Mexican art formed my views of carving as much as anything I could do."[7]

Ancient Mexican art was especially well represented in the British Museum, which had acquired its first pieces in the 1820s and gradually augmented its collection throughout the nineteenth century—depending mainly on the generosity of colonial officials, travelers, and explorers who brought curiosities home.[8] The most notable Pre-Columbian accessions were items collected by ethnologist Henry Christy during his Mexican travels in 1856 and 1857.

During the first three decades of the twentieth century, Thomas Athol Joyce was the key figure in shaping and disseminating information about the British Museum's American Antiquities collection.[9] In 1923 Joyce transferred eminent Maya epigrapher Alfred P. Maudslay's extraordinary collection of ancient Maya sculptures and casts from the basement of the Victoria and Albert Museum to the British Museum (which had originally declined to take it in 1893). He set it up with great fanfare in a "Maudslay Room"—the first time the museum had ever devoted an entire room to the activity of a living person—and prepared for the occasion a *Guide to the Maudslay Collection of Maya Sculptures from Central America*, which appeared in 1923. Joyce's own archaeological excavations in British Honduras (now Belize), from 1926 to 1931, and additional major purchases filled out the Maya collection. At the same time, the British Museum was acquiring extensive holdings of South American material, especially Peruvian pottery.[10]

Even though many more of its specimens were in storage than on exhibit, then as now, the museum's ethnographic display still contained, in Moore's words, an "inexhaustible wealth and variety of sculptural achievement (Negro, Oceanic Islands, and North and South America), but overcrowded and jumbled together like junk in a marine store, so that after hundreds of visits I would still find carvings not discovered there before."[11]

Outside the precincts of the British Museum, there was an equally intensive flurry of professional activity and public interest in New World archaeology, coinciding with

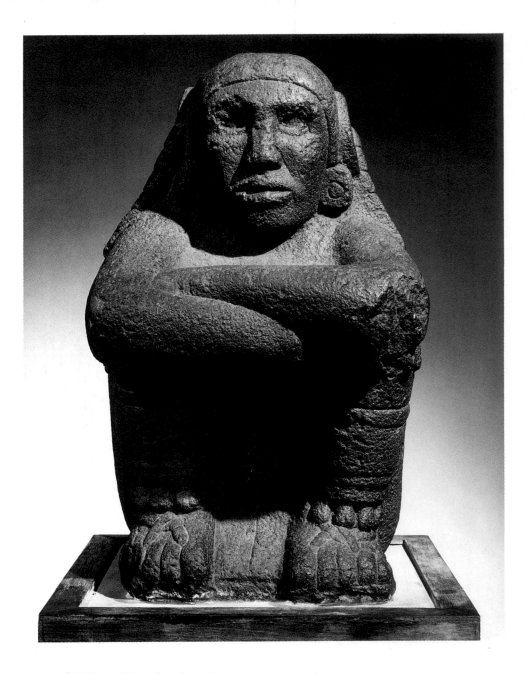

Seated man. Aztec, c. 1400–1500. Stone, height 21¼". The British Museum, London (The Bullock Collection)

renewed U.S. and British colonial interest in Central America. Following up on Maudslay's Maya initiatives was Herbert Spinden, who, together with Gregory Mason, conducted a *New York Times*–financed archaeological expedition in a largely unmapped part of the Yucatán peninsula.[12] At the same time, Sylvanus Morley, Frans Blom, and Thomas Gann explored the still partly unmapped Mexican, Guatemalan, and British Honduras rain forests and coastal areas in search of unreported Maya ruins, while Edward Thompson dredged the famous sacred well (*cenote*) at Chichén Itzá for archaeological treasure. Each wrote about his explorations in both popular and scholarly journals. Gann, a port doctor in Belize City and a fluent writer, was an inveterate bush traveler and explorer who wrote six popular books about his expeditions in Maya land, including *Mystery Cities* in 1925. His accounts also appeared on a regular basis in the weekly *London Illustrated News*, which, beginning in 1923, gave extensive coverage to New World archaeological discoveries.[13] This widespread English-language coverage of American archaeology appealed to a public whose fascination with lost cities, unknown civilizations, and ancient origins rivals that of today.

Moore was certainly not the first modern sculptor to look closely at Pre-Columbian forms; Gauguin, Derain, and Brancusi had already paved the way before 1908. Derain's *Crouching Figure* of 1907 is a rough-hewn, compact, orthogonal, stone image of a man hugging his doubled-up legs. It is clearly based on a standard type of Aztec lithic sculpture: a static, hieratic, blocky, bilaterally symmetrical seated male figure with flexed legs and crossed arms resting on knees.[14] These figures, which have been found in great numbers, were set up in open-air, household, and temple shrines throughout

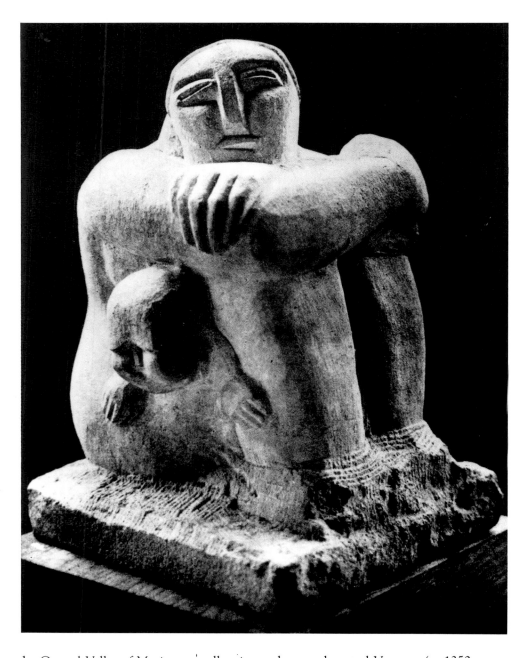

Henry Moore. Mother and Child. *1922. Portland stone, height 11". Whereabouts unknown*

the Central Valley of Mexico, as well as in northern and central Veracruz (c. 1350–1521). As if alive, they were offered prayers, food, and drink. Aztec sculptures retain a unitary, cubic shape—heightened in this pose by the framing-arm position. The blocky mass is subdivided into large curving planes that subsume all unnecessary detail. Everything incidental—anatomical features, decoration, protruding parts—is eliminated or subordinated to the whole; symbolic information is conveyed through incision or low relief; chin, nose, eyes, ears, hair are carved with little depth so as not to disturb the compact outline of the mass. The heavy, hard, solid character of the block of stone is a dominant feature of these sculptures, and it is heightened by the bareness of their surfaces, whether raw and textured or smooth and highly polished.[15]

Derain's *Crouching Figure* was exhibited at Daniel Kahnweiler's gallery in 1907 and seen by Brancusi and other Parisian vanguard artists. Sydney Geist has demonstrated the impact of its vigorous carving, blocky proportions, symmetrical design, assertion of material, and retention of mass on Brancusi's *The Kiss* of 1907–8.[16] Brancusi's stone seated female, *La Sagesse*, 1908, though more smoothly finished and rounded, shares a similar posture, symmetricality, and compactness.

Moore—from the start antagonistic to the classical ideal—studied Pre-Columbian art far more assiduously than did these prewar modernists. He turned to it as a primary model, becoming something of a scholar of ancient Mexican sculpture.[17] Fry's *Vision and Design* had sent him not only to museums but also to books to study primitive and Pre-Columbian material; as they had been for Gauguin, reproductions were an important resource. Until he could afford to buy many books, Moore was an inveterate library-goer.[18] He fondly recalled the many evenings spent during his first year at the

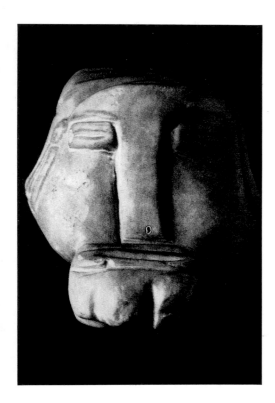

Mask. Mezcala, Guerrero, Mexico, 1200–1521.
From Ernst Fuhrmann, Mexiko III, *Darmstadt,
Germany, 1923*

Royal College of Art, "when I could spread out the books I'd got out of the library and know that I had the chance of learning about all the sculptures that had ever been made in the world."[19] His notebook jottings further reveal the extent of these researches.[20]

In the 1920s Moore undoubtedly was familiar with Fry's citations in his *Vision and Design* chapter on Ancient American Art, including Walter Lehmann's *Altmexikanische Kunstgeschichte*, from which he made drawings, and Thomas Joyce's three volumes on ancient Mexican, Central, and South American art. There also can be no question that he knew Joyce's *Short Guide to the American Antiquities Collections in the British Museum*. Moore also owned and copied plates from Lehmann's *Kunstgeschichtes das Alten Peru (The Art of Old Peru)*, and Ernst Fuhrmann's *Mexiko III* as well as his *Reich der Inka*, which he bought in 1923.[21] Another, slightly later, source of reproductions was *L'Art précolombien* by Adolphe Basler and Ernst Brummer, which Moore purchased in 1928. It would be difficult to overestimate the importance of these publications to Moore's creation; in effect, they became sculptural pattern books, providing him with a repertory of images during the formative decade of his art.

Moore began drawing ideas for sculpture in 1921; by 1928 he had filled many loose sheets and at least six notebooks with hundreds of preparatory drawings for sculptures, as well as exercises that were not translated into sculpture or that were reserved for future use. Among them were many copies of Pre-Columbian and primitive sculptures.[22] They provide an excellent index to the wide range of art that interested Moore during this formative period as well as clues to specific sources of his sculptures.[23] Moore later explained the necessity for all these drawings: "When one is young, one has lots of influences mixed up in one's mind so that drawing was a means of generating ideas and also of sorting them out."[24] Concurrently with his notebook sketches, Moore continued his series of highly accomplished life drawings, which had started as an important part of his rigorous art school training—honing his skills in observing and rendering three-dimensional images on a flat surface—and which culminated in his remarkable World War II shelter drawings.

This process of working from reproductions, which had also been Gauguin's practice, affected Moore's sculpture in important ways, particularly in terms of its scale and unilateral view. When Gauguin used photographs as models, he usually translated two-dimensional images of three-dimensional artifacts into a two-dimensional painting format, readjusting the scale of his depicted figure to the landscape or still life depicted. Moore, on the other hand, in translating the same type of reproductions into three-dimensional objects, often failed to account for the immediate relation between their material presence and the human scale of the viewer. He frequently shifted from a monumental into a miniature format without adjustment and even conceived of some of these large sculptures as capable of being held in the hand. Later on, he had no compunction about modeling small maquettes to be translated into gigantic sculptures without making a corresponding alteration in the nature or complexity of the image. The result is a frequently skewed scale.[25] Moore's use of photographs as sculptural models also seems to have affected the singular orientation of much of his work, which often looks more like high relief than freestanding plastic form.

Moore's first modernist carvings were executed between 1922 and 1924. In addition to the example of Derain and Brancusi, his major stimulus undoubtedly was what he later termed the "simple, monumental grandeur [and] . . . massive weightiness" of Aztec carvings,[26] as well as other Pre-Columbian sculptural styles—Olmec, Mezcala, Teotihuacán, Toltec, and Huastec—which have many of the same characteristics. His first fully three-dimensional sculpture, the 1922 *Mother and Child*, combines an awareness of the *Crouching Figure* and the British Museum's Xochipilli, patron deity of the cult of pleasure, or a similar seated Aztec figure.[27] The choice of rough Portland stone as material, the unfinished stone base, orthogonal projection of the cubic mass, severe full forms, emphatic hand gestures, and absence of anecdotal elements—except for the typically Aztec sandal fastening etched on the figure's ankles—point to the basalt Xochipilli as Moore's major source of inspiration. In preliterate ancient Mexico, such geometric simplification, muting of incidental detail, and overall formal clarity, in combination with precise symbols and broad hand gestures, were the predominant means of expressing a particular deity's identity.

Certain crucial elements of Moore's sculpture deviate from this Aztec model. For one

thing, the mother's face derives not from Aztec but from Mezcala-style stone carving, product of an as yet little understood ancient Mexican culture in Guerrero. Mezcala masks, made of hard, polished stone, typically have flat planes and schematic features indicated by raised welts, sharp edges, and concavities symmetrically distributed in a square or trapezoidal face. Moore probably found the source of the mother's face in Fuhrmann's *Mexiko III*, an alabaster head of a man in Vienna's natural history museum; there is a striking correspondence between their raised rectangular eyes, long, flattened noses, and straight mouths. A Moore drawing in a notebook of 1926 of a head inscribed *Head of Christ in Alabaster/Mexican*, which presumably postdates *Mother and Child*, resembles both the mother's and the Mezcala heads.

In this, his earliest appropriation of Pre-Columbian art, Moore had already established a working formula for the future. In the interest of a reductivist aesthetic, he adapted the plastic conventions of Aztec figural sculpture, as well as certain of its expressive traits: the head turned at an angle to the major axis (subtly altering the essential symmetry), gestural hands, attached base. At the same time he ignored their native meaning, most conspicuously by transforming the image's gender from male to female and articulating a favorite personal theme: the protective mother with her child. And, by piecing together a mosaic of diverse sources—experienced both first- and second-hand—he arrived at his sculptural image via a process of synthetic bricolage once more reminiscent of Gauguin.[28]

But because *Mother and Child* is an immature work, the composite image is still imperfectly fused, and the disparate sources can be readily identified. Another alien element involves the baby figure, whose peculiar configuration and conjunction with its mother was also inspired by previously unidentified Pre-Columbian sources. In

Henry Moore. Head. 1923. Alabaster, height 5½". Whereabouts unknown

Henry Moore. Head of Christ in Alabaster/ Mexican. Page 97 from the artist's notebook no. 6. 1926. Pencil on paper, 9½ × 6¾". The Henry Moore Foundation, Much Hadham, Hertfordshire, England

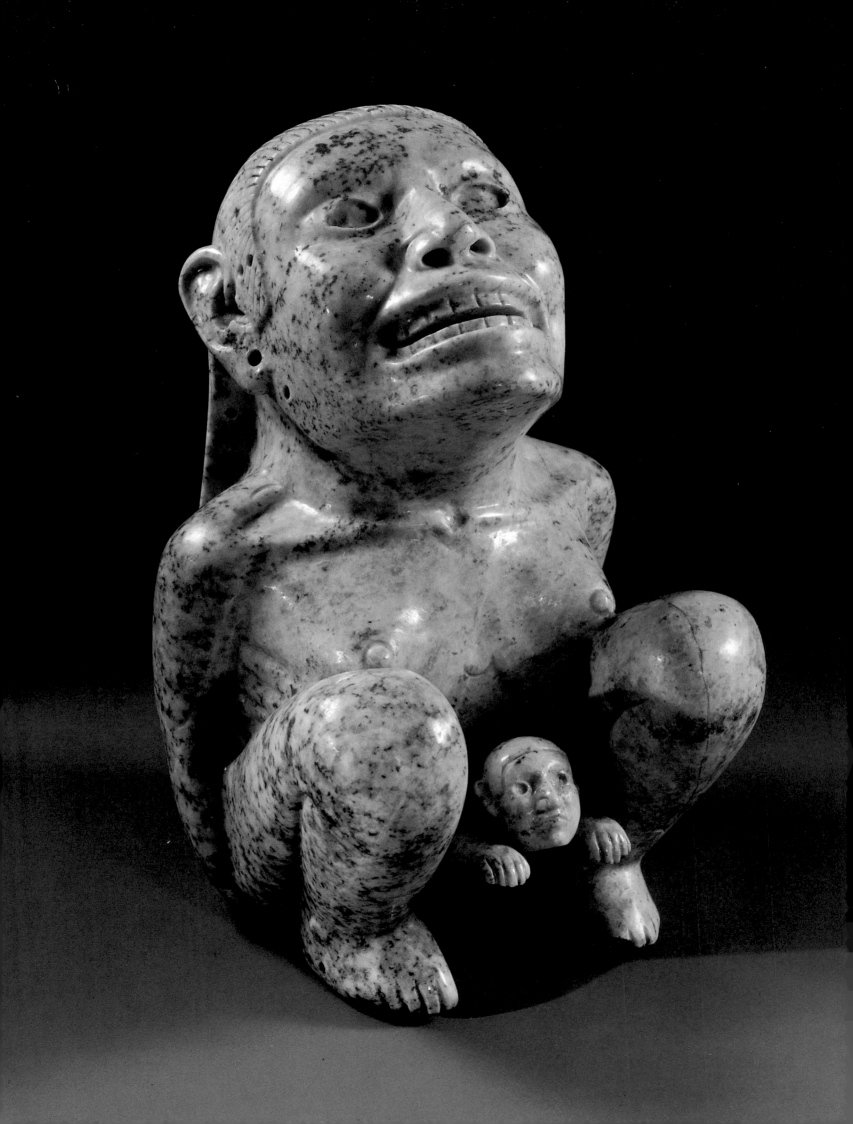

conforming his image to the lithic block, Moore squeezed the baby between the mother's torso and flexed legs so that its head and arms emerge from her side. In the Aztec canon, mother and child images, serving domestic rather than public purposes, were commonly made of clay rather than of stone, and these images usually show the mother stiffly clutching an inanimate, doll-like child. But an unusual aplite representation of Tlazolteotl, Aztec goddess of childbirth, confession, and absolution, now at Dumbarton Oaks, probably inspired Moore's conceit. It shows her giving birth Indian-style, delivering her baby in a squatting position.[29] Moore would have seen a reproduction of this striking sculpture, which was published by E. T. Hamy in Paris in 1906, or a replica of it in the Trocadéro Museum on his biannual trips to Paris, which he began in 1922.[30] He adapted this image of the emergent baby to the needs of his sculpture by shifting it to another part of the female anatomy and turning it on its side.

Still another Pre-Columbian model, visible in books Moore knew at this time, furnished the baby's head.[31] Enigmatic infantile representations known as "were-jaguar" babies are a hallmark of the Olmec style that flourished on the Gulf Coast of Mexico in southern Veracruz and western Tabasco around 1200 to 600 B.C. They were made of highly polished hard stone or ceramic, mostly on a small scale, sometimes in the form of votive axes, and are characterized by a pear-shaped head, either bald or covered with a tight-fitting cap, a tall cleft forehead, a flat, snub nose, puffy cheeks, and, especially, a peculiar mouth that seems to combine the attributes of a wailing baby and a snarling jaguar. All these figures give an impression of power and monumentality regardless of their size, because they are so self-contained.

The most conspicuous instance of Moore's reliance on Olmec sculpture is his 1926 *Baby's Head*,[32] but in fact it is only one of several carvings of the 1920s reflecting this source. Although they essentially resemble Aztec sculptures, Olmec figures are more robust, weighty, and imposing, yet at the same time tauter and more animated, as if imploding with energy. Their proportions, internal spatial rhythms, and fragmentary state (reflecting great age and ancient mutilation) further differentiate them from the Aztec. Moore's 1924 *Seated Figure*, which appears monumental though it measures only ten inches high, resembles an Olmec monument from Misantla and Olmecoid boulder and pedestal sculptures from Tiquisate, on the south coast of Guatemala.

Two half-length mother and child carvings of 1924 are indebted to the same sources; like Olmec monuments, their muscular physiques and smooth, slowly curving volumes evoke a mythic race of giants. *Maternity*'s close-fitting, caplike hair clearly derives from the distinctive helmets worn by Olmec colossal heads and were-jaguar babies, which were illustrated in books Moore knew,[33] and her dour, impersonal expression and thick elbow, wrist, and neck joints recall those of many Olmec figures. Moore once commented that these early carvings had no necks because he was afraid to weaken the stone by undercutting, but an equally plausible explanation is the neckless condition of his Olmec models.

The peculiar half length, the manner in which mother holds child, and the unilateral conception of *Maternity* suggest a derivation from either figural reliefs on Olmec "altars," which were reproduced in magazine articles announcing their discovery,[34] or from smaller three-dimensional images of a figure holding a child, such as an elegant Mezcala-style specimen illustrated in Lehmann.[35] While to us they may recall Christian madonnas, such images probably had dynastic meaning, heralding the birth, confirmation, or presentation of the chief's heir.

Mother and Child, the more compelling and larger of the two sculptures, was begun in 1924 and completed in 1925, after Moore had returned from a trip to Italy. The work reverses Moore's usual enclosing-mother motif by having the child in turn envelop the mother's head and thereby recalls were-jaguar-baby headdresses worn by Olmec figures. At the same time, it evokes totemic images from African and Northwest Coast Indian cultures,[36] as well as Michelangelo's *Doni Madonna*—all of which Moore undoubtedly knew. Upon completing this *Mother and Child*, Moore abandoned the theme for five years. He took it up again in 1929, returning to the same Olmec models. Some of these new sculptures recall the lateral figures on La Venta altars; others with taut contours, repetitive curving internal planes, and glossy surfaces seem kin to the Mezcala example.

In 1925 archaeologists Frans Blom and Oliver La Farge discovered a spectacular Olmec monolith on the summit of a volcano in the Tuxtla mountains representing a

Baby. Olmec, Veracruz, Mexico, c. 1100 B.C. From Walter Lehmann, Altmexicanische Kunstgeschichte, *Berlin, 1922*

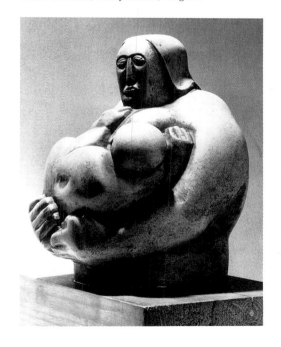

Henry Moore. Maternity. *1924. Hopton Wood stone, height 9″. The Henry Moore Foundation, Much Hadham, Hertfordshire, England*

OPPOSITE:
The goddess Tlazolteotl in the act of childbirth. Aztec, 1350–1521. Aplite with garnet inclusions, height 8″, width 4¾″, depth 5⅞″. Dumbarton Oaks Pre-Columbian Collection, Washington, D.C.

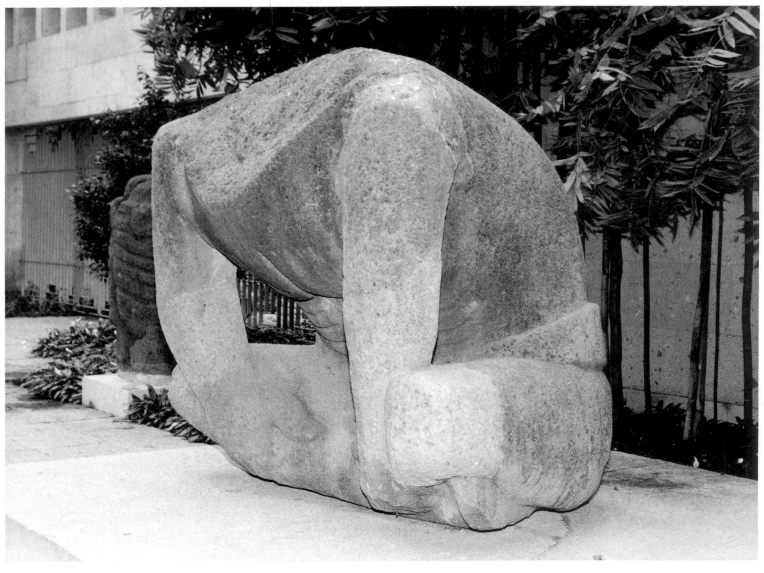

Monolith. Olmec, 1200–600 B.C. Stone. Museo
Etnográfico y Arqueológico, Jalapa, Veracruz,
Mexico

RIGHT:
Henry Moore. Seated Figure. 1924. Hopton
Wood stone, height 10″. The Henry Moore
Foundation, Much Hadham, Hertsfordshire,
England

FAR RIGHT:
Altar 5, La Venta. Olmec, Tabasco, Mexico,
1200–600 B.C. Basalt, height 37″, Parque La
Venta, Villahermosa, Mexico. Courtesy of the Pre-
Columbian Art Research Institute, San Francisco

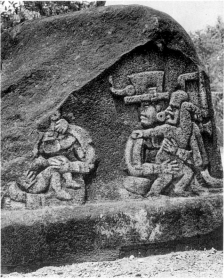

OPPOSITE:
Henry Moore. Mother and Child. 1924–25.
Hornton stone, height 25″. Manchester City Art
Galleries

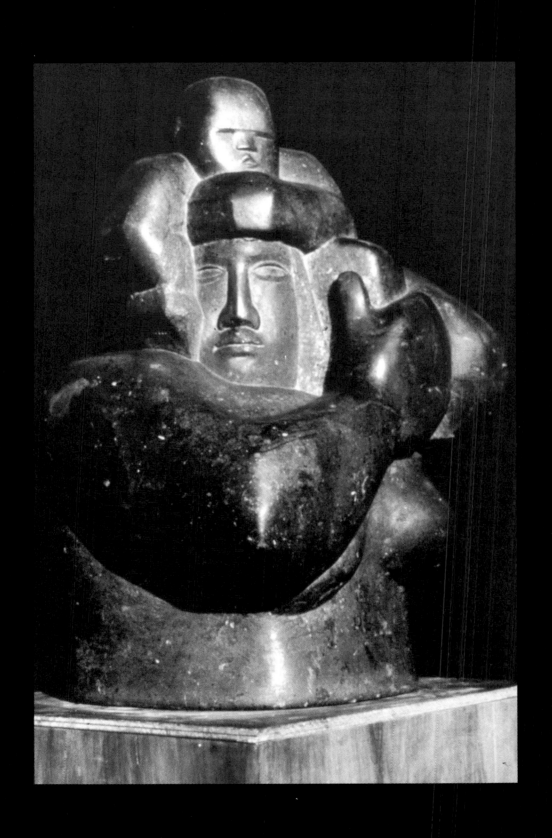

seated human figure wearing as a headdress a face of a were-jaguar baby. At the nearby site of La Venta they cleared and photographed another half-dozen Olmec monuments, including a colossal head and several so-called altars. The highly readable account of the Blom-La Farge expedition, *Tribes and Temples*, was published in 1926. Public fascination with a mysterious culture that could produce such powerful and evocative monuments, and the rapid exchange of information within the close-knit international community of Americanists via professional journals and explorers clubs,[37] virtually ensured Moore's awareness of these monuments at this time.

Nor was Moore the only English sculptor to be stimulated by Olmec monumental sculpture. Frank Dobson, twelve years Moore's senior and a cherished colleague, whom Bell, Fry, and other critics championed as bearer of Gaudier-Brzeska's torch and Epstein's rival, was also an avowed student of primitive art.[38] His *Baby's Head, Man-Child,* and *Seated Torso,* all exhibited between 1921 and 1924, show that he too was examining Olmec colossal heads, were-jaguar babies, and seated figures at this time, and he may have encouraged Moore to do the same.[39]

During the same period, Moore experimented with another kind of sculptural form: smooth, stylized animal representations. Once again Roger Fry, in his *Vision and Design* chapter extolling prehistoric cave painting, must have provided the initial impetus. More direct sources included works by Brancusi, Gaudier-Brzeska, and Moore's contemporary Leon Underwood. One of Moore's earliest carvings, the marble *Dog* of 1922, is abstracted into a compact mass of uniform, smoothly rounded volumes and jagged planes, resembling both Gaudier's cubist-vorticist animal sculptures, such as the Museum of Modern Art's *Birds Erect* of 1914, and Underwood's *Nucleus,* which treats mass as a complex series of smooth-textured planes and angles.[40] Underwood, Moore's life-drawing teacher during the 1920s, was a serious student and collector of primitive and prehistoric art who traveled widely in its pursuit at this time, making trips to the Dordogne and Altamira caves in France to study animal paintings,[41] and to Central Mexico and Yucatán to see Maya and Aztec art *in situ.*

Gaudier and Underwood pointed the way, but Moore's own scrutiny of the Aztecs' synthetically simplified natural forms—stone representations of serpents, coyotes, dogs, and jaguars—provided the means. He appears to have been attracted to their tense poise and feral vitality, as his later comment about an Aztec rattlesnake in the British Museum makes clear: "Although the snake is coiled into a most solid form, it has a real air of menace, as if it could strike at any moment."[42] He characteristically lifted certain features of these representations, mixing and matching them into his own composite figures. *Dog's* schematic, squared-off features, cubic shape, muscular curves, and crouching stance suggest a combination of the almost caricatural paws, eyes, and ears of a small onyx ocelot from Teotihuacán in the British Museum, or of a similar huge stone Aztec jaguar (a container for sacrificed hearts called a *cuauhxicalli*) or the stylizations of an Aztec descending fire serpent in the British Museum and a Colima ceramic dog—respectively reproduced in Lehmann, Joyce, and Kuhn. The flat polished planes, taut interlocking curves, and multiple views of Moore's *Snake,* 1924, imitate Aztec coiled serpents, particularly as illustrated in Kuhn, while *Head of a Serpent,* 1927—modeled after the ubiquitous tenoned serpent heads on Aztec architectural facades and stairway balustrades, and made to be mounted on a wall like a gargoyle or hunting trophy—seems to pick up the notion of menacing nature by isolating the creature's blunt head and mouth.[43]

During these formative years Moore exploited yet another category of ancient Mexican sculpture: He carved more than a dozen masks and heads between 1921 and 1930. The rounded forms, highly polished surface, and unusual shape of Moore's verde di prato *Mask* of 1924 derive from Mezcala-style masks. Most of them, however, are based on stone masks of the Teotihuacán and Aztec cultures. Like the latter, and primitive-inspired heads by Brancusi and Amedeo Modigliani, Moore's masks are unindividuated—ageless, sexless, expressionless—never suggesting portraits. The form of the earliest work, preceded only by a slate relief of a head inspired by Gauguin carvings, a small alabaster head of 1923 (page 99) mirrors the standard trapezoidal shape, broad face, flattened planes, half-opened thin lips, and horizontally truncated forehead of stone masks associated with Teotihuacán in the classic period, c. 150 B.C. to A.D. 750. The preeminent Mexican archaeologist Manuel Gamio's publication of his major excavations at Teotihuacán in the monumental *La Población del Valle de*

Mother and child. Mezcala, Guerrero, Mexico, 1200–1521. From Walter Lehmann, Altmexicanische Kunstgeschichte, *Berlin, 1922*

OPPOSITE:

Henry Moore. Mother and Child. *1932. Green Hornton stone, height 35". Robert and Lisa Sainsbury Collection, University of East Anglia, Norwich, England*

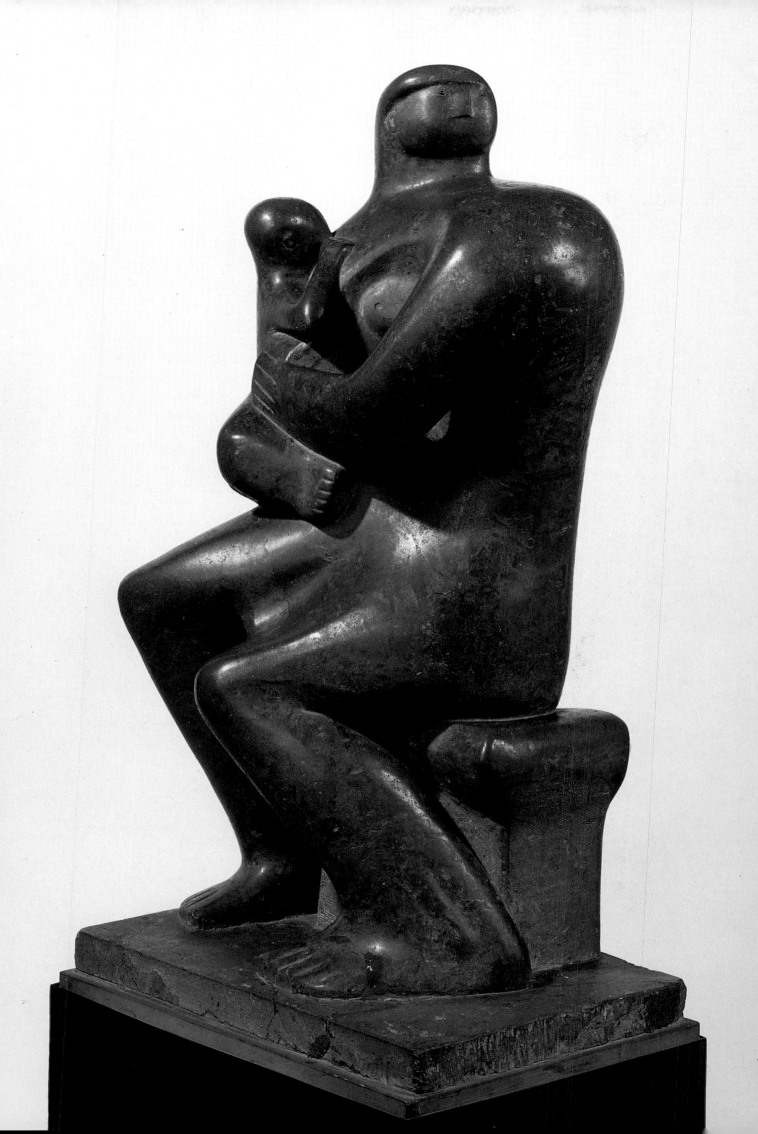

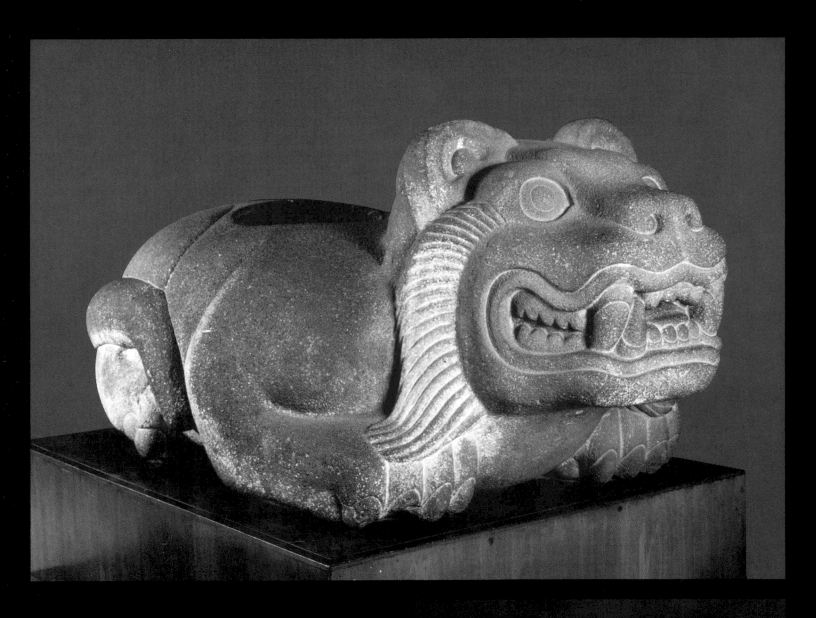

Teotihuacán (1922) stimulated public interest in this material at precisely the time Moore began examining it.

Toward the end of this period, between 1927 and 1930, Moore carved more than half a dozen masks based mainly on Aztec models, which resemble earlier Valley of Mexico masks but are more realistic and rounded in format. His sources were the usual British Museum Pre-Columbian collection and book reproductions, particularly Joyce's 1927 *Mexican and Maya Art* and Basler and Brummer's *L'Art précolombien* (1928: the flyleaf of Moore's copy is inscribed "Henry Moore 1928"), which contained more than thirty plates of ancient Mexican masks in the British Museum and Musée de l'Homme. A number of Moore's masks seem almost direct translations of images in these volumes, including these striking (but hardly exhaustive) correspondences: *Mask* of 1927, owned by his daughter Mary, which originally had inlaid eyes, and an obsidian "Aztec-period" mask in the British Museum; *Skull Mask*, 1928, and the mask of Xipe Totec, Aztec god of spring renewal and grisly patron of human sacrifice by flaying, as well as the Aztec mosaic-encrusted, stone, and rock-crystal skulls, all in the British Museum. While experts have recently questioned the authenticity of several of these Xipe Totec masks, as well as of the rock-crystal skulls,[44] in the 1920s they were still esteemed as prize specimens of Aztec refinement and savagery.

A few *Masks* of 1929 appear to be informed by similar Aztec models combined with still others.[45] Perhaps the most striking example, a mask in the Leeds City Art Gallery, resembles both the Xipe Totec mask and Picasso heads of the late 1920s. As will be seen below, a number of these masks are nearly identical to the heads of the reclining figures that Moore was developing at this time. For example, the 1927 *Mask* correlates with the head of *West Wind*, and the Leeds *Mask* with that of a *Reclining Figure* also in Leeds.

Moore's repertory of Pre-Columbian models during the 1920s thus derived from an assortment of ancient Mexican cultures widely separated in time and space, yet it is as if Moore had distilled from the art of these disparate cultures certain shared basic formal traits, which gives them a broad stylistic unity. They are characterized by an architectonic discipline and symmetrical order; their mass enfolds as a cubic unit, subdivided into large planes that absorb all detail unnecessary to the effect of the whole.[46] The heavy, solid character and masterful working of the (usually volcanic) stone material also unites these sculptures. This highland tradition stands apart from the more elaborate Maya tradition in the lowlands of Mesoamerica.[47] Predominantly a narrative art of refinement and flamboyance, expressed in nuanced reliefs, carved in porous limestone or modeled in plaster, Maya monumental sculpture is altogether at odds with the highland norm of robust three-dimensionality, geometric stylization, self-containment, and hard stone materials. While Moore had equal access to Maya art— through the British Museum's newly installed Maudslay room and book and journal reproductions—and could hardly have failed to admire the technical skill of Maya stone carving so evident in the museum's magnificent Yaxchilán lintels, he did not emulate it, because he saw it as visually far too similar to some of the forms favored by the discredited Western classical tradition. Thus, it can be seen that Moore's intensive eclecticism during the 1920s operated within certain well-defined stylistic parameters, insofar as his principal non-Western sources were concerned.

Why, when other primitive or archaic carving traditions were equally available as models—Gaudier had looked to Easter Island, Epstein to Africa, Brancusi to Rumanian carving—did Moore turn to this ancient Mexican highland tradition so consistently?[48] In 1941, Moore himself offered an answer: "Mexican art as soon as I found it seemed to me true and right, partly because I at once hit on similarities in it with some 11th century carvings I had seen as a boy on Yorkshire churches. Its stoniness, by which I mean its truth to material, its tremendous power without loss of sensitiveness, its astonishing variety and fertility of form-invention and its approach to a full three-dimensional conception of form, make it unsurpassed, in my opinion, by any other period of stone sculpture."[49] Much of this statement is self-explanatory: The ancient Mexican stone-carving tradition was especially highly developed, exhibiting a surpassing formal vitality and plastic invention and a greater variety of models than any other. Moreover, it struck a familiar chord, tapping, even validating, his youthful experiences in Yorkshire and reconfirming Fry's and Bell's dicta that authentic aesthetic experience could be found anywhere.

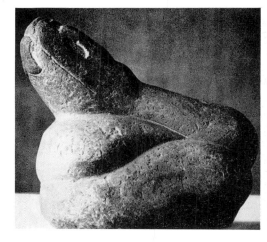

Coiled serpent. Aztec, 1350–1521. Stone. From Herbert Kuhn, Die Kunst der Primitiven, *Munich, 1923*

OPPOSITE, CLOCKWISE FROM TOP:
Giant jaguar (cuauhxicalli, *"vessel for human hearts"*). *Aztec, c. 1502–20. Andesite, 36⅝ × 89". Museo Nacional de Antropología, Mexico City*

Henry Moore. Snake. 1924. Marble, height 6¾". Courtesy of The Henry Moore Foundation

Henry Moore. Dog. 1922. Marble, height 7". Courtesy of The Henry Moore Foundation

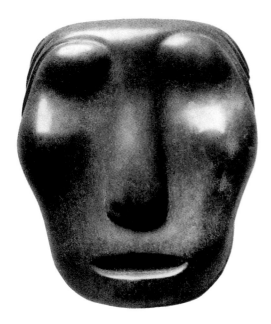

Henry Moore. Mask. 1924. Verde di prato, height 7". Whereabouts unknown

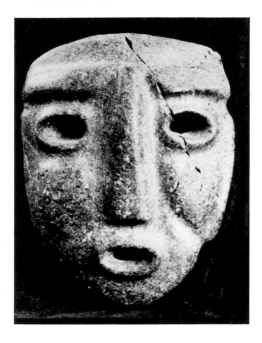

Mask. Mezcala, Guerrero, Mexico, 1200–1521. From Herbert Kuhn, Die Kunst der Primitiven, *Munich, 1923*

RIGHT:
Henry Moore. Skull Mask. 1928. Stone, height 8½". Whereabouts unknown

FAR RIGHT:
Henry Moore. Mask. 1929. Cast concrete, height 8½". The Henry Moore Foundation, The Henry Moore Centre for the Study of Sculpture, Leeds City Art Gallery

Less obvious, however, is Moore's statement concerning Mexican sculpture's "stoniness," its "truth to material" and "power without loss of sensitiveness." Often reiterated, it provides a clue to his complex attitudes toward ancient Mexican art. By "stoniness," the single word he used most frequently to characterize Mexican art, he meant formal qualities of density, hardness, gravity: "[Sculpture should be] hard and concentrated and should not be falsified to look like soft flesh [but] should keep its hard tense stoniness," he had said elsewhere.[50] "Stoniness" also referred to technical features. It implied a carver's keen understanding of and intuitive response to the inherent peculiarities and expressive possibilities of material: "Every material has its own individual qualities. It is only when the sculptor works direct, when there is an active relationship with his material, that the material can take its part in the shaping of an idea."[51] "Stoniness" was thereby conflated with "truth to materials" and "direct carving." Moore's experimentation during the 1920s with a wide variety of stones— Portland, Mansfield, Hornton, Hopton Wood, alabaster, verde di prato, serpentine, African wonderstone, marble, slate—appears to have been an attempt to explore their special properties in these terms.

Moore's desire for direct engagement with material reflects the Arts and Crafts movement's theories about the expressive possibilities of each medium. Gauguin had insisted on making pottery as the ancient Peruvians made it, manipulating the clay without recourse to a mechanical (and hence somehow unnatural) wheel. In the early twentieth century, Brancusi was the chief exponent of "direct carving," which was also championed by Gaudier, and later by Moore, Dobson, Underwood, and many of their contemporaries, becoming a sort of battle cry of modernism, a moral imperative to reject an "effete" nineteenth-century academic art practice. Technically, this also meant refusing to copy from a plaster model with a traditional pointing machine or calipers; aesthetically, it meant upholding a virtuous new kind of form determined by the creative process itself.[52]

But the ideology of direct carving was also tinged with romantic and condescending notions about the production of primitive art. Moore derived the linked notions of direct carving, truth to material, and a return to the primitive from Gaudier, whose 1916 biography by Ezra Pound greatly influenced him.[53] Gaudier had identified the modern sculptor as a man who considers "light voluptuous modeling" as insipid, whose "work is nothing more or less than the abstraction of his intense feeling . . . and has no relation to classic Greek, but . . . is continuing the tradition of the barbaric peoples of the earth (for whom we have sympathy and admiration)."[54] As an instinctual expression of raw, unmediated feelings, barbaric art was, in this view, purificatory and revitalizing, a means of redeeming an overly rational, desiccated civilization. Primitive peoples, by implication, had no capacity for conceptual expression, since their art was not a result of conscious aesthetic decisions.

Moore's comments about Mexican sculpture suggest that he embraced it in precisely these terms. In 1924, for example, he told Rothenstein that "Donatello was a modeller and it seems to me that [it is] modelling that has sapped the manhood out of Western

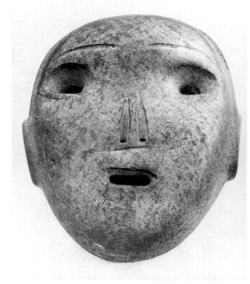

Henry Moore. Mask. 1927. Stone, height 8¼".
Estate of Mrs. Irina Moore

Mask. Teotihuacán, Mexico, 150 B.C.–A.D. 750.
Green serpentine. Dumbarton Oaks Pre-
Columbian Collection, Washington, D.C.
This mask exemplifies, in an earlier period, the
Mexican highland style Moore admired.

sculpture."[55] In 1941 he wrote, "[Primitive art] makes a straightforward statement, its primary concern is with the elemental, and its simplicity comes from direct and strong feeling. . . . The most striking quality common to all primitive art is its intense vitality. It is something made by people with a direct and immediate response to life."[56] To Moore, Mexican sculpture was an originary, primitive art. Its aggressive qualities presented a manly aesthetic counter to a Western tradition gone effeminate and soft.

Though Moore focused primarily on the formal and technical aspects of ancient Mexican art, his interest in it was by no means confined to these qualities, though the Moore literature insists that this was the case. His attentiveness to a number of the more grisly and macabre Aztec representations—deities embodying death, flaying, and decapitation—suggests that he was interested in their content as well as form. The language he used to describe Mexican sculpture, for example, "Mexican sculptures have a cruel hardness that is the opposite of other qualities I like in European art,"[57] and the models he chose to imitate—menacing Aztec animals, gruesome Xipe heads, Olmec were-jaguar babies—implicitly refer to its savage content. And it is this perceived correspondence of form and content that is the key to his sustained attraction to Pre-Columbian art.

Another Englishman of similar background, D. H. Lawrence, shared this affinity for Mexico. Both were working-class sons of miners from Yorkshire and were highly emotional artists. Since Moore avowed that "it's been novelists if anything who have had the biggest influence on me . . . in coloring one's outloook, one's growth,"[58] and since he greatly admired Lawrence, it is likely that his notions about Mexico resembled, perhaps even derived from, those of Lawrence.

Lawrence was obsessed with Mexico as a counter to the sterile modern European industrial society alienated from its natural roots. "The Indian, the Aztec, old Mexico—all that fascinates me and has fascinated me for years," he wrote in a 1921 letter. "*There* is glamour and magic for me. Not Buddha . . . so finished, perfected and fulfilled. . . ."[59] At first Lawrence turned to Italy and Sardinia, and then to Australia, to escape the Europe he despised. But it was in New Mexico and Mexico that he felt most at home and in touch with the primordial. "I like it here," he wrote after arriving in Mexico, "I don't know how, but it gives me strength, this black country. It is full of man's strength."[60]

As the subject of much of his writing during the twenties, Mexico seemed both to fascinate and repel Lawrence, representing a possibility of renewal and at the same time a return to the savage, what he called the dark currents of the blood. Many of his Mexican-period works focus on brutal Aztec sacrificial rites. The 1922 Taos poems are evocations of Mexican ferocity, associating the New Mexican eagle with Aztec heart sacrifice. *The Plumed Serpent*, a novel of 1926, is about substituting for an effete Christianity a revivified ancient sacrificial cult of Quetzalcoatl—an indigenous renaissance. The short story called *The Woman Who Rode Away* also invokes Aztec human sacrifice in sexual terms.[61]

Lawrence's attitude toward Mexican Indians mirrors his ambivalent feelings toward women (he had been, like Moore, deeply attached to his mother): He both despised and idealized them, seeing them as embodiments of a primordial sensuousness tinged with sadomasochism. Embracing Edward Tylor's evolutionary (and racist) cultural scheme—from savage to barbaric to civilized social levels—he saw the Indians as "a black savage mass. . . . They are half civilized, half wild," he wrote in a 1923 letter.[62] He embraced a fantasy, not a reality, of Mexico, which harked back both to romantic nineteenth-century notions of the noble savage and to colonial prejudices about savagery.

Lawrence responded to the relics of Mexico's past with the same mixed attraction and repulsion. In *The Plumed Serpent* he spoke of the "fascination . . . fear and repellence" of the "hard, four-square, sharpedged, cutting, zigzagging [carved mosaic facades of] Mitla, like continual blows of a stone axe." In the same place, he described the stone serpents in the National Museum as "snakes coiled like excrement, snakes fanged and feathered beyond all dreams of dread," and those on the temple of Quetzalcoatl at Teotihuacán as "all-enwreathing dragon[s] of the horror of Mexico." The Aztec rattlesnake was for Lawrence a fitting emblem of the Mexican nation: "It's got a rattlesnake coiled in its heart, has this democracy of the New World. It's a

dangerous animal, once it lifts its head again . . . the stone coiled rattlesnake of Aztec eternity."[63] Compare this with Moore's notebook notation beside his drawing of an Aztec coiled serpent: "eternal grinding and interlacing of forms,"[64] and his references to menacing Aztec serpents.

The point is that, though dissimilar in temperament, Moore and Lawrence shared many things, including outsider origins and modernist rebellion against established norms, together with their keen interest in Mexican forms. Lawrence was adventurous, restless, peripatetic, also violent, intractable, and antiformalist; Moore, accommodating, gentle, insular, and focused on artistic form.[65] Yet they gravitated to Mexican things at the same time, finding in them rawness, ferocity, brutality, but also some sort of constructive virility, jagged energy, and concise clarity.

Moore's pronouncements about the stoniness, fertility of invention, plastic force, and cruel hardness of Mexican art, and his reference to its "power without loss of sensitiveness," seem to echo Lawrentian as well as late-nineteenth-century characterizations of Aztec art as both savage and elegant. They suggest that he conceived of Mexico in a timeless, static state, locus of a barbarism still unpolluted by civilization, notwithstanding the enormous changes evidently taking place there. Moore also apparently believed that the inherent primordial vitality of Mexico's archaic forms could miraculously infuse new life into modern art.

The ideology of "truth to materials" and "direct carving" has since been thoroughly discredited. It is now clear that material properties influence an image's final form in only minor ways; that style is governed mainly by the attitude that the sculptor brings to the material, and that this in turn is conditioned by its economic, social, and political context. It is also recognized that no matter how materially impoverished a people's life may be, it is never primordial, nor is its artistic expression unmediated.[66] "Primitive" people also create what they think of as "art" and make aesthetic judgments. Moore himself renounced the ideology of "truth to materials" in the thirties, as his working methods plainly began to diverge from its imperatives: He penetrated the stone mass with deep holes and spaces; turned to bronze casting of plaster models; allowed his sculptures to be copied by others and finally to be executed entirely from maquettes by assistants. "Nowadays I feel it is the artist's vision that matters more than the material used," he explained, adding, "If the idea is good, it can actually be reproduced in many materials."[67] But visual examples have shown that Moore's theories about art never completely shaped his sculptural practice. Far from being an unmediated expression of his response to a particular material, his carving was from the beginning a highly calculated process, self-consciously contrived through elaborate preparatory drawings and an eclectic assortment of Pre-Columbian and primitive models.

Unlike Lawrence, who knew Italy before seeking the primordial in Mexico, Moore came to Mexico and the primitive without direct experience of the classical tradition. Thus, when the opportunity arose for him to travel to the heartland of this tradition, he at first resisted it, accepting a traveling fellowship to Italy only after unsuccessfully trying to change the venue to Paris.[68] In Italy in the spring of 1925 (he visited Paris and the Guimet and Trocadéro museums on both legs of his journey), he experienced a painful conflict between his convictions about primitive art and his new awareness of great proto-Renaissance masters, especially Giotto, Masaccio, and Giovanni Pisano. "It's dangerous for young people to stop doing their own work and concentrate for a long period on other people's. In Italy there was just too much richness, too much to sort out all at once. I knew even then that it had to be done. . . . But at that time . . . it was an ordeal," he recalled in the late 1960s.[69] For a time after his trip Moore was paralyzed by this crisis. Unable to reconcile the rigid dichotomy he had set up between the classical tradition and modeling on the one hand and the primitive and direct carving on the other, he pursued both tracks separately.

Around 1920, as part of a pervasive postwar retrospective tendency in painting and sculpture, Picasso had initiated a vogue for Neoclassical female nudes of Michelangelesque stature characterized by huge thighs, thick torsos, round breasts, stocky necks, clumsy fingers, oval faces, and hair in a bun; the figures usually recline, propped on an elbow, or are seated.[70] Parisian sculptors who participated in this trend included Gaston Lachaise and Henri Laurens, while outside France Maillol, the premier prewar sculptural exponent of "ordered classicism" in female guise, was coming

into his own; in the estimation of both Clive Bell and Thomas Craven, he was then the greatest living sculptor. Perhaps not coincidentally, this fashion took shape at precisely the time when middle-class women were challenging their traditional roles in favor of greater self-sufficiency, and the flapper image flaunting female rebellion was in full gear.

In England, inspired by Renoir and Picasso, the painters of the Bloomsbury circle—Duncan Grant, Matthew Smith, Dodd Proctor, and Vanessa Bell—were the first to express the Neoclassical nude female theme, followed by sculptors such as Dobson and Moore. It is likely, for example, that Moore saw Grant's 1919 painting *Venus and Adonis*, which was owned by Sir Michael Sadler. Reflecting both Neoclassical style and classical myth, it may well have set a precedent for Moore's series of reclining females. An outstanding early example is the naturalistic 1927 *Reclining Woman* in cast concrete, a voluptuous and tranquil female.[71] Other English artists producing similar work at this juncture included Mark Gertler, J. D. Fergusson, Bernard Meninsky, Underwood, and a bit later, Stephen Tomlin.

The year 1928 marks a major turning point in Moore's work, bringing about a synthesis of these discrepant Neoclassical and primitivizing currents. It was sparked by a commission for a relief figure of the *West Wind* atop London's new Underground Headquarters office building. As his first effort to make public art—to conceive a gigantic symbolic image in a prominent open-air context—this commission spurred Moore to rethink the idea of a reclining nude in monumental terms, whereas previously his work had been intimate and modest in size (even when inspired by Pre-Columbian monoliths), and led to his breakthrough work, *Reclining Figure* (page 92), completed in 1929 and now in Leeds.

The Underground building was intended to be a symbol of energetic optimism befitting a machine-age transport system, although its design mixes traditional and modernist elements and the classical theme of its decorative carvings—eight allegorical flying figures of the four winds—is unrelated to underground transport.[72] The eight-foot-long figures are situated on the seventh story, eighty feet above the pavement, on a band of stone that girds the building to mark the setback of its wings; they are not very visible from below. Architect Charles Holden commissioned seven sculptors to carve decorations for this project. Eric Gill, the best known of the seven, was put in charge and given three figures to do. Moore and four others were given one figure apiece, so that each "wind" was represented twice. Jacob Epstein was also hired to create freestanding sculpture for the building.[73]

Moore set about his task by making hundreds of preparatory sketches, filling an entire *Underground Relief Sketchbook* in 1928. Drawings in the first pages of the sketchbook show that his starting point for the project repeated the static pose and naturalistic demeanor of the previous year's *Reclining Figure* in concrete. But these soon gave way in his efforts to represent flying motion, to flatten and monumentalize the figure, and to relate it to its architectural setting.[74] It is not surprising, given Moore's orientation, that at a certain point in the figure's conception he turned to Pre-Columbian sculpture for inspiration, focusing on the Toltec-Maya chacmool from Chichén Itzá (page 92), a colossal recumbent figure associated with temple doorways and seats of authority, which was designed to be seen from a distance. This chacmool was once a conspicuous architectural ornamentation on a broad terrace at the top of the Temple of the Tables (now called the Temple of the Warriors). For the first time the function of a Moore figure and that of its ancient source were congruent: Both were monumental reclining spirit personifications at the apex of imposing structures, and both in different ways proclaim the individual's prostration before authority.

The Moore literature is unclear as to exactly how and when the artist first encountered the chacmool, since Moore's own accounts have varied. In 1946 he said it occurred in 1925, after his trip to Italy, as he was working his way out of the violent internal conflict Italy had engendered: "I came back to ancient Mexican art in the British Museum. I came across an illustration of the chacmool discovered in Chichén Itzá in a German publication—and its curious reclining posture attracted me—not lying on its side, but on its back with its head twisted around."[75] At other times, he claimed 1923 and 1927 as the critical juncture. But the date must be at least as early as 1922, since there are two thumbnail sketches of what is undoubtedly the

Henry Moore. Ideas for West Wind Relief. *1928.*
Pen on paper, 14⅜ × 8⅞". Art Gallery of
Ontario, Toronto

chacmool—a figure reclining on its back, head at right angle to body, legs drawn up,
rectangular base—in Moore's notebook number 2, dated 1921–22.[76] The most likely
vehicle of transmission was a plaster cast in the Trocadéro of the chacmool from
Chichén Itzá; a likely source for this first drawing of it was a plate in Lehmann's
Altmexikanische Kunstgeschichte, which we know was in Moore's possession in 1922.
Moore was also no doubt aware of the less prepossessing Aztec chacmool in the British
Museum ethnographic collection.

Nor was the chacmool an obscure object at the time. The French adventurer
Augustus Le Plongeon originally brought it to light in 1884, giving it a Yucatecan
Maya name meaning "red or great jaguar paw" and weaving fantastical tales around it
in his *Sacred Mysteries among the Mayas and Quiches* (1886), *Queen Moo and the
Egyptian Sphinx* (1896), and *Queen Moo II* (1900). The cast in the Trocadéro was

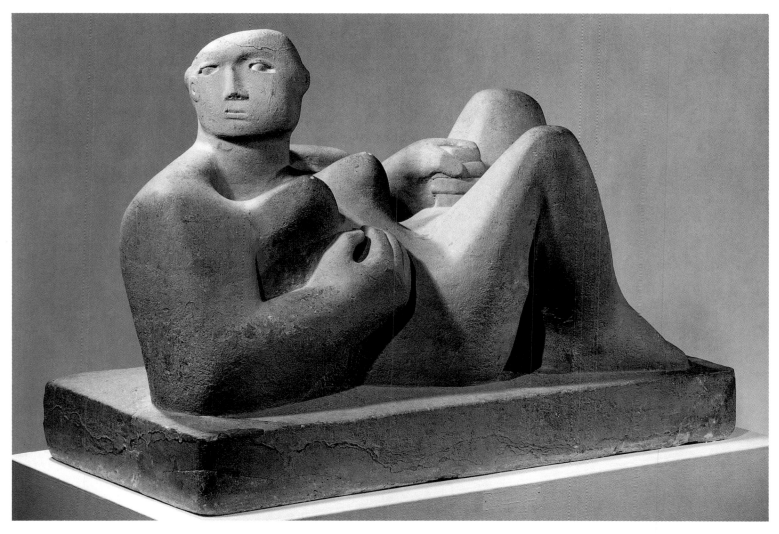

taken from the limestone sculpture Le Plongeon uncovered. Now located in the National Anthropology Museum in Mexico, this chacmool is mentioned and illustrated in nearly every early-twentieth-century account of Mesoamerican art and archaeology. Journalistic coverage in the 1920s included features in the *London Magazine* and the *London Illustrated News*, which devoted two articles to Thomas Gann's discovery of a Yucatecan site he named Chacmool after he found a version of the Chichén figure there.[77]

Evidence of Moore's continuing interest in the chacmool after the initial sketches includes three studies of reclining figures in notebook number 3 of 1922–24.[78] (One wonders as well whether the unique *Recumbent Male Figure* that Moore carved out of Mansfield stone in 1924, since destroyed, may have been based on the Mexican prototype.) However, the artist's renewed interest in the chacmool at the time of his *West Wind* commission in 1928 may have been stimulated by the activity of his mentor, Leon Underwood, who had traveled extensively in Mexico during the previous year and also had executed a painting called *Chacmool's Destiny*.[79]

The chacmool's distinctive horizontal posture is its salient characteristic. It is a male figure reclining flat on his back, body raised at either end by bent knees and elbows that support a slightly lifted torso, as in a classical yoga position of equilibrium. The symmetrical body has a single axis from neck to toes, the hands meet on the thorax and support a vessel resting on the stomach. The primary view is a relief-like profile, with the head rotated 90 degrees from the body axis to present a frontal face. The figure's proportions—an overly large head in relation to a short torso and elongated limbs—are markedly unnaturalistic. Its costume often includes a pillbox-style headdress with jutting square ear ornaments, an elaborate breast ornament or collar, a breechcloth, bracelets, armlets, sandals, and leg ornaments, but these elements are subsumed within a clearcut angular silhouette. Like most Pre-Columbian highland art, it is ponderous and austere, its expression solemn, lacking lightness or humor. Yet its upraised head turned toward the viewer conveys an alert watchfulness, a tension between its parts.

Henry Moore. Reclining Woman. 1930. Green Hornton stone, 23½ × 36½ × 16¼″. National Gallery of Canada, Ottawa

PAGE 116:
Henry Moore. Seated Figure. 1930. Alabaster, height 15″. Art Gallery of Ontario, Toronto

PAGE 117:
Standard Bearer. Toltec-Maya, Chichén Itzá, Yucatán, Mexico, 1000–1200. Stone. Museo Nacional de Antropología, Mexico City

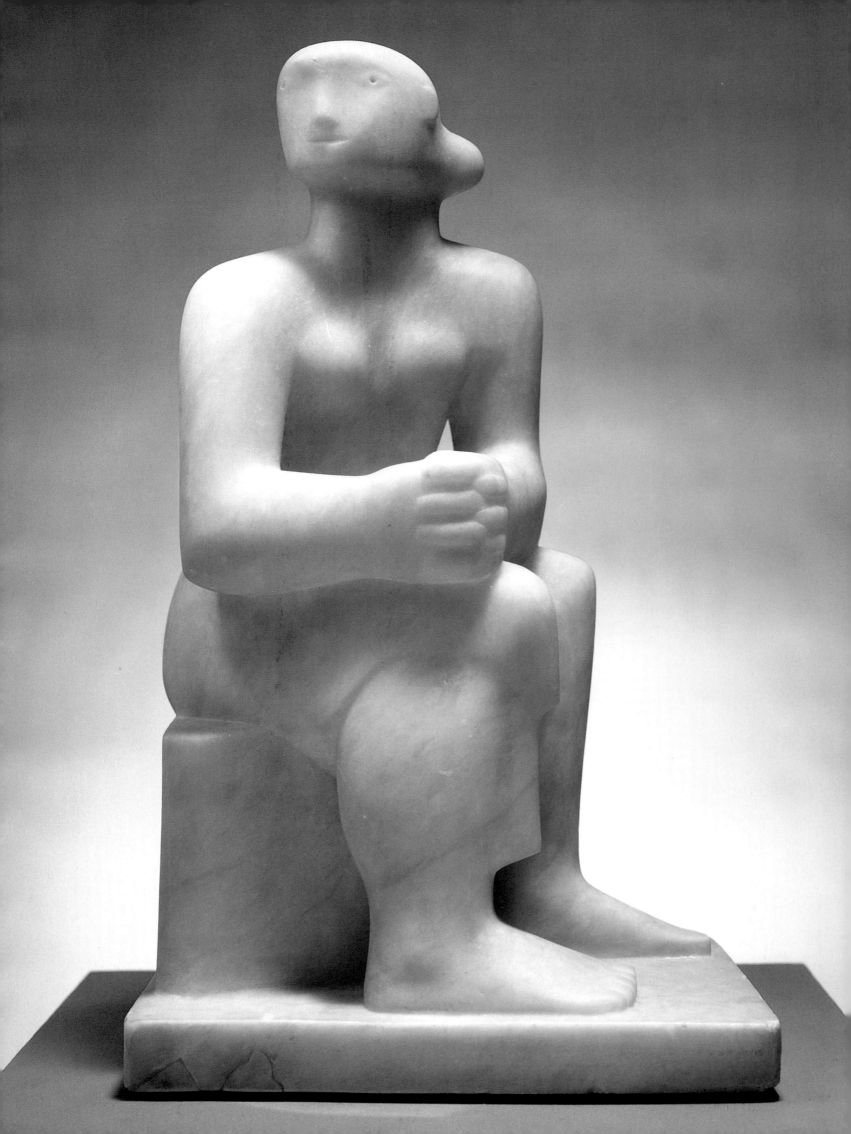

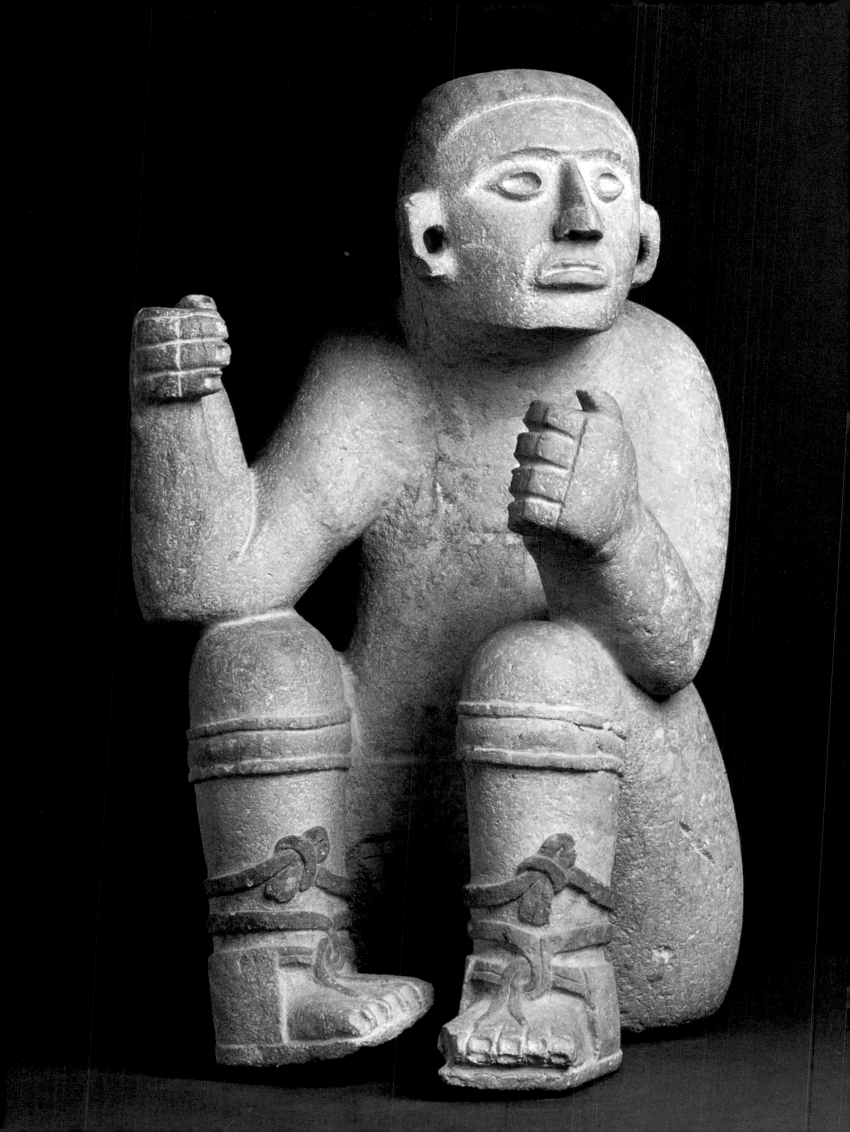

The chacmool's direct appearance in the conceptual process of the Underground project occurs after many pages of preparatory sketches for *West Wind*, as the figure progressively stiffens, assuming a blocky, angular form, and is surrounded by stylized geometric notations of its architectural context.[80] At the bottom of this sheet, the chacmool's rectangular bent elbow and masklike face emerge. The general stability and severity of *West Wind*'s final form also owes much to the chacmool: The figure's simultaneously volumetric and flattened character, blocky shape (sans wrists and ankles), bold formal simplification (the outline subsumes incised details), and rhythmic equilibrium of parts are particularly indebted to the ancient prototype, as is its twisted head. But its caplike hair, deeply shadowed eyes, and air of brooding seriousness reflect the typical traits and feature distortions of the Aztec-style masks Moore had studied previously. Its face, in fact, corresponds closely to his asymmetrical 1927 *Mask*, which was derived from an Aztec obsidian head.

Toward the end of the *Underground Relief Sketchbook* appears a study for a reclining figure relief on the back of a garden bench; this sketch is the genesis of the Leeds piece. Like *West Wind*, the figure reclines sideways, but the right angles formed at the elbow and raised knee link it even more closely to the chacmool. And in the definitive study for the Leeds carving—an enlarged version of the bench-relief study—Moore has added three blocky protuberances beside the head that echo the rectangular ear ornaments of the Chichén chacmool.[81]

The raised legs of the chacmool, "coming down like columns," together with the "stillness and alertness, a sense of readiness, and the whole presence of it" were, Moore said, the features he most admired in the chacmool.[82] The upright, vigilant head, with staring, widely separated eyes, juxtaposed with the reclining form at rest; the enclosing crooked elbow and raised knees; and the ear ornaments transformed into a cubic bun are incorporated in the Leeds figure and hundreds of its successors. Another constant is the Mexican figure's massive, inert, blocklike character—underlined by an attached base whose coarse surface refers to the shape and texture of the stone from which it was carved—and unnaturalistic figural proportions.

In addition to the obvious sex change, however, the Leeds figure differs from the chacmool in important ways. By tilting the body on its side and shifting the weight, contrapposto-like, from both hips to one[83] (while maintaining a low center of gravity), by stacking and opening up an irregular space between the legs and lifting and releasing the left arm from the block, Moore has made his figure more supple, asserting an asymmetry and contrast between the masses. The *Reclining Woman* of the following year (now in Ottawa) is closer in pose to the chacmool: weight resting firmly on the buttocks, both bent knees upright, feet parallel, and both arms lowered. But its less masklike head, its torso, and its limbs are subtly twisted out of direct alignment with one another, each one operating independently and bringing about a looser and more complex interpenetration of volumes. By overriding the symmetricality of the chacmool, Moore achieved for the first time forms that "really existed and worked against each other and with each other rather than [being] one solid mass that was all crushed and stuck together," as he later noted.[84]

As in his previous Mexican-inspired sculptures, Moore emphasized the faces and hands of the reclining figures, which he based on separate Pre-Columbian prototypes. The face of the Leeds figure is based primarily on the round face, open mouth, and blank stare of the mask of Xipe Totec that had inspired one of a series of masks from 1928 and 1929. Its cubistic, flattened nose and broken plane from nose to chin may also refer to Olmec or Veracruz dualistic heads.[85]

The clenched fist of the Ottawa figure echoes those of many Toltec and Aztec standard-bearer and guardian figures—once displayed on pyramid terraces—which were intended for the insertion of banners. Moore used similar hands on a series of semiabstract seated females with clasped hands, produced from 1928 to 1931, which in fact resemble these ancient standard bearers while also sharing the twisted head, contrapposto torso, and cubic bun of his contemporaneous reclining figures.

The formal strategies of Moore's reclining figures and their relation to the chacmool and other ancient prototypes are now clear. Less clear is the manner in which Moore responded to and transformed the chacmool's iconographic content in his own work.

The cultural identification and significance of the chacmool in ancient America is clouded, though not for lack of efforts to unravel them by scholars. The chacmool is

generally regarded as Toltec in origin and as evidence of that culture's penetration of the Maya area (although some experts argue the reverse). Its iconographic interpretation is still more problematic. Its common placement in or near temple entrances and its watchful, outwardly turned head suggest a guardian function. Aztec-period examples are associated with the rain god—they wear the traditional mask of the Mexican rain deity Tlaloc—and sacrifice: The vessel they hold is a *cuauhxicalli* for the hearts of sacrificial victims. However, the Toltec-Maya version, five centuries earlier, lacks the clear deity insignia of the Aztec. It is generally thought to be a fertility deity associated with the harvest and drunkenness—its vessel to accommodate an intoxicating drink—though Mary Miller has recently argued for its linkage variously with the Maya rain god Chac and/or with war, sacrifice, and captive imagery commemorating a defeated enemy.[86]

America. German, Meissen (Model by J.F. Eberlein, P. Reinicke, and J. J. Kaendler). c. 1760. Hard-paste porcelain, height 10¾". Wadsworth Atheneum, Hartford, Connecticut, J. Pierpont Morgan Collection

Moore apparently was unconcerned with the historical, cultural, and mythological underpinnings of the icon. He converted the chacmool's gender from male to female, thereby substituting a nude woman for a masculine guardian figure probably associated with warfare and conquest. In this sense his reclining figure curiously echoes that of the first image of the "Indian savage" to enter the corpus of European art: the recumbent female personification of America adorning sixteenth-century maps as an allegory of one of the four continents. America is invariably a naked female, but her feathered headdress and bow and arrow in these maps are attributes of male warriors. Her other accoutrements are a severed head (a reference to cannibalism) or an alligator (denizen of a watery continent). And for the next two centuries she is frequently represented as such in European painting, sculpture, murals, and decorative arts.[87]

From a feminist perspective both the early allegorical and the Moore representations construct a telling equation between lesser race and lesser gender—and imply that both are on a lower evolutionary rung than the colonizing white male. There existed no monumental tradition of a supine nude female in ancient America,[88] but there was, as we have seen, a strong Neoclassical one in Europe that had recently been revived by Picasso, Maillol, and others. It is the old idealization of the female as a passive object of desire, available to the determining male gaze as a symbolic release for lust, anxiety, and terror. This image may have been reconstituted as a reassertion of female subjugation at a time when large numbers of middle-class women were actively resisting their traditional role. More broadly, it could also have functioned as "cultural legitimation of social repression," as Benjamin Buchloh has suggested.[89] Moore's fulsome reclining females seem to carry this connotation, and the occasional eruptions of overt aggressivity towards the female in his work, exemplified in images from 1927, 1930,[90] and 1952 of infants aggressively sucking a mother's breast (see below) appears to confirm this interpretation.

Moore also exalted women's biological role by encouraging a metaphorical reading of his recumbent females in geological terms, thus equating them with earth-mother figures. At the artist's suggestion, the Ottawa figure was given the title *Mountains*, when it was published in R. H. Wilenski's *Meaning of Modern Sculpture* in 1932.[91] This accorded with a then fashionable surrealist penchant for animistic representations of the female as landscape, her rising and falling contours suggesting hills and valleys, as, for example, in the paintings of British Surrealist Paul Nash.

What distinguishes Moore's figures from similar conceptions by Nash, Dobson, and other contemporaries is the chacmool-like vigilance that nearly every one of his recurrent reclining females shares. By comparison, Dobson's nudes in a similar pose are flaccid, evoking tranquillity and repose. In Moore's work, what remains of the ancient source is precisely an impression of the aggressive vitality that the artist saw in it. Quite literally, he has used the intrusive watchful head—together with the hard, rectangular propped elbow and overall blocky form—as a means of infusing a primitive energy, breathing life into a Western art tradition gone soft. Where D. H. Lawrence wanted to primitivize Western culture, it could be said that Moore's instinct was to domesticate the primitive to Western culture by fusing its raw vitality, gravity, and mystery with familiar, acceptable content, such as the female figure, and conventional (sexist) attitudes towards it. In this sense he appropriated what he deemed to be savage masculine power to construct a reassertion of male supremacy over claims to power from threatening new quarters, while denying the native culture its own meaning.

In explicit terms, however, the conversion of the chacmool's gender was primarily a

formal decision; the female simply offered the best example of a well-built form with which he could seek different plastic effects. He said the reclining female was important because it allowed him "to try out all kinds of formal ideas. . . . The subject matter is *given*. It's settled for you, and you know it and like it, so that within it, within the subject you've done a dozen times before, you are free to invent a completely new form-idea."[92] If pressed about meaning, he would speak vaguely about the female body as an expression of nature elevated to a symbol of universal order.

By adapting the Mexican formula to a European format, Moore could skirt conventional realism, while still referring to the familiar, and at the same time he could call attention to the artist's formal gestures with his material. This idealization was based on a tension between the objective female form and primitivist-derived stylistic perceptions. In this way the chacmool became, in Moore's words, "undoubtedly the one sculpture which most influenced my early work."[93]

The creation of these first fully realized, large-scale, independent sculptures signaled an end to Moore's apprenticeship and the beginning of his self-sufficiency as an artist. Though still deeply dependent on ancient and modern models, his work now seemed formed of an independent consciousness, and he began to exert an influence on others. The Leeds figure had an immediate impact on Barbara Hepworth and other artists in Moore's Hampstead circle, and there was even a curious correspondence between the work of Epstein and Moore—the older artist turned in the early thirties to Pre-Columbian models—suggesting a possible reversal in the direction of influence.[94] As Epstein had before him, Moore even began to collect primitive art, including African and Mexican pieces.[95] In the catalogue of Moore's highly successful, second one-man show at Leicester Galleries in April 1931, Epstein hailed his colleague as the future of English sculpture. New critics associated with abstraction and Surrealism, including R. H. Wilenski and Herbert Read, also took up his cause. From this point on, he was regarded as the central figure in the development of modern art in England.

From the late 1920s Moore was continually preoccupied with the theme of the reclining figure, which eventually encompassed two-thirds of his entire oeuvre. The prototype for all these images is the chacmool-derived conception of a stereometric horizontal volume with a low center of gravity enclosing a cavity at its center. He elaborated and refined this formula over the next fifty years, variously balancing masses and voids, stressing negative or positive spaces, and breaking, piercing, and eroding the solitary form into two, three, and four parts as he became more involved with abstraction. But nearly always he retained some reference to the blocky enveloping form of a reclining human figure and an upright head that had originally been inspired by the chacmool.

Nothing in the way of Pre-Columbian influences on Moore's work compares in importance to the chacmool. Nevertheless, noteworthy appropriations of pre-Hispanic forms continue in his work of the 1930s, 1940s, and 1950s, although most critics contend that his more radical 1930s sculptures mark a break with Mexican models. Until 1932 he produced clearly recognizable figures in the semiabstract, modernist style of the Leeds and Ottawa figures. But beginning with *Composition*, 1931, and for the next four years, Moore experimented with a more aggressively abstract modernist style keyed to a Surrealist emphasis on the unconscious and modeled on the expressive distortions of Picasso's bathers, Arp's biomorphic forms, and Giacometti's metaphorical "gameboard" pieces of the late 1920s and early 1930s.

The most abstract works of this phase—representing a profound departure from prior efforts, which Moore would not pursue again for another twenty-five years—are an evocative, disquieting series of mothers and children and reclining females from 1934 and 1935. Their dislocated or dismembered parts are linked together by a common rectangular base, which bridges the spaces between them. Outstanding examples include *Head and Ball, Composition, Reclining Figure* in Corsehill stone, and *Four Piece Composition: Reclining Figure*. The hollowed-out and incised fragments provide clues to their anatomical identity through organic reference, as for example in *Four Piece Composition: Reclining Figure*, where a small ball signifies a navel. But at the same time they correspond to other natural shapes—pebbles, bones, stones, shells. Moore's use of such metaphorical analogies and biomorphic distortions shows him sharing the Surrealists' preoccupation with the antirational and animistic. They also recall a corresponding Surrealist interest in the fantastic shapes and disjunctions of Oceanic

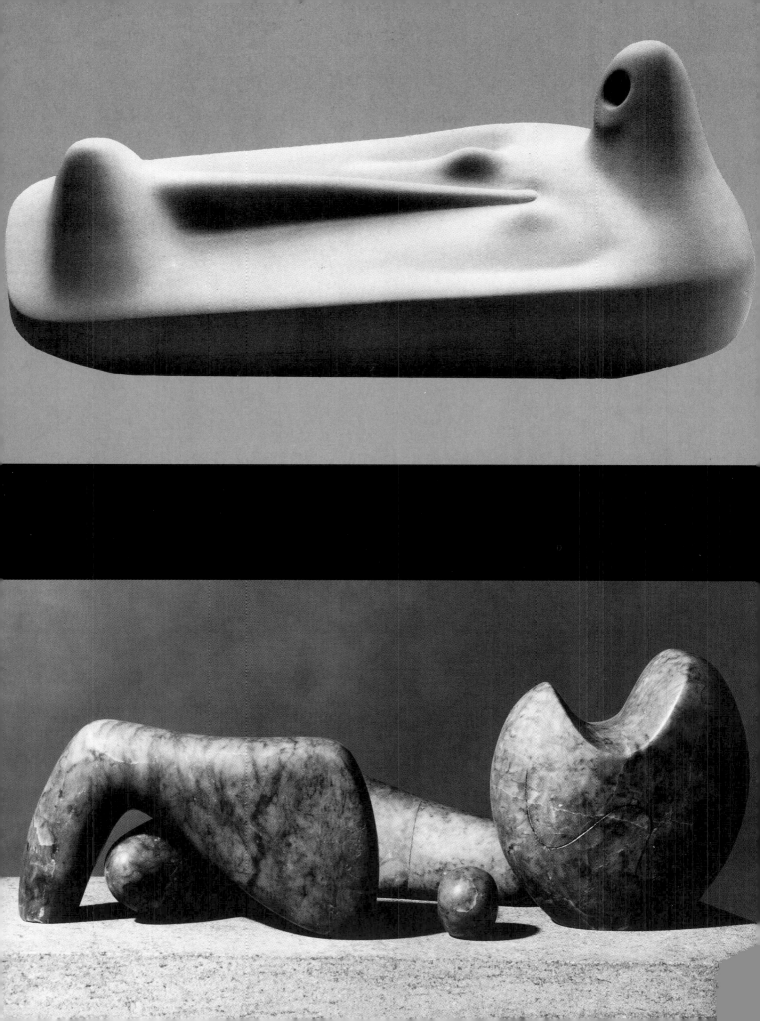

Hacha. Veracruz, Mexico, 300–900. From Ernst
Fuhrmann, Mexiko III, Darmstadt, Germany,
1923

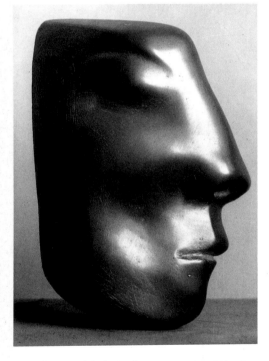

Henry Moore. Mask (no longer extant). 1929.
Rock salt, height 8½"

OPPOSITE, ABOVE:
Parrot-head hacha. Xochicalco, Morelos, Mexico,
550–950. Gray volcanic stone with traces of
stucco and red paint, height 21⅝". Museo
Nacional de Antropología, Mexico City

OPPOSITE, BELOW:
Henry Moore. Head with Notch. 1937–38.
Green serpentine, height 13¼". The Henry Moore
Foundation, Much Hadham, Hertfordshire,
England

art, which are so different from Moore's monolithic, Mexican-inspired mode.[96] Yet a previously unacknowledged (though possibly indirect) Pre-Columbian influence is also at work here.

There can be no doubt that these abstract, metaphorical pieces owe a special debt to Giacometti's innovative works of 1930 through 1933, such as *Woman with Her Throat Cut*, *Project for a Square*, *Head/Landscape*, *Circuit*, and *No More Play*, which involve similar (though more complex) formal and analogical strategies.[97] As early as 1930 Giacometti was associated with a dissident Surrealist group led by Georges Bataille. Its major vehicle was the journal *Documents*, which was committed to the study of primitive and Pre-Columbian sculpture—in-depth articles on Aztec art and sacrifice were published in 1930—and to combining ethnographic analysis with modern thematic interests. At the heart of Bataille's theory lay his appreciation of Pre-Columbian art, expressed in an essay from 1928 called "L'Amérique disparue," in which he wrote approvingly of Maya self-mutilation, Aztec cannibalism and blood lust, and the sacrificial rites of the Pre-Columbian ball game.[98] Scholars have documented parallels between the form and content of a number of Giacometti's pieces of the early 1930s and Bataille's notions.[99]

Even if Moore was aware through his association with Giacometti—whom he had met by 1933[100]—of Bataille's determinedly perverse celebration of Aztec sadism and ball-game-related sacrifice, it is unlikely, in view of the primacy of his formalist concerns and his commonsensical outlook, that he would have fully embraced this demonic aspect of Pre-Columbian culture. On the other hand, the uncharacteristically erotic, antirational, and abstract nature of his 1934–35 production and its obvious dependence on Giacometti's works of the preceding years suggest that at that moment he may have been receptive to these extreme views.

Be that as it may, there can be no doubt that Moore was aware of the Pre-Columbian ball game and interested in its associated paraphernalia. Quite possibly he was acquainted with the Surrealists' major source of information about it, Frans Blom's *The Maya Ball Game: Pok-ta-pok*. As early as 1928, and again in 1930, he used as models for his heads the axe-shaped *hachas* associated with the players. One even seems equipped, like so many ball-game-associated heads, with a rear tenon (for attachment to another surface). His use of the title *Head and Ball* for one work of this period may also allude to the ball game.

The *hachas*' surfaces are activated through stepped forms, openwork breaks, and small holes. In a Guatemalan variant a calculated use of perforations as both positive and negative space suggests a metamorphic shifting between human and animal image within the same form.[101] Moore might have found the examples of Guatemalan *hachas* in the British Museum collection particularly attractive when he was exploring notions of metamorphic expansion in a series of "transformation drawings" during the first half of the 1930s. In them he transformed found objects—lobster claws, pieces of bone, pebbles—into drawings for sculptures of reclining figures and mothers and children for his *Composition* and *Square-Form* series. Moore himself once attributed the piercing of his sculptures of the late 1930s to the Mexican stimulus, citing as inspiration a giant perforated parrot head (a ball-court marker) from Xochicalco, in which positive and negative spaces have equal value. Perforated and notched *hachas* clearly played a determining role in shaping images of flat, sharp-edged profile heads, such as *Square Form*, 1936, *Head*, 1937, and *Head with Notch*, 1937–38, which also mark a return to his blocky format.

Through his involvement with Surrealist notions of the transgressive nature of the unconscious, Moore pushed his previous assimilation of Pre-Columbian models to another level. His first drawings of figures in a landscape setting, during the second half of the 1930s, seem to be another outgrowth of Surrealist conceptions of ambient space. Their aura of eroded natural boulders or archaic monuments situated in remote, mysterious archaeological contexts[102] was probably inspired by the Surrealists' keen interest in archaeology, as exemplified in Max Ernst's 1934 painting *Garden Airplane Trap*, which is based on photographs of Machu Picchu.[103] In addition, they may reflect Moore's awareness through photographs of Pre-Columbian monuments *in situ*.

This placement of figures in a specific environment reaches maximum force in his 1940–41 drawings of the London Underground during the blitz, in which shrouded reclining figures are confined in cavernous dark spaces. Executed in his capacity as

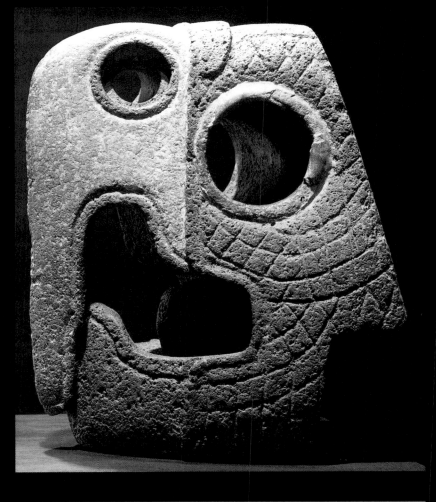

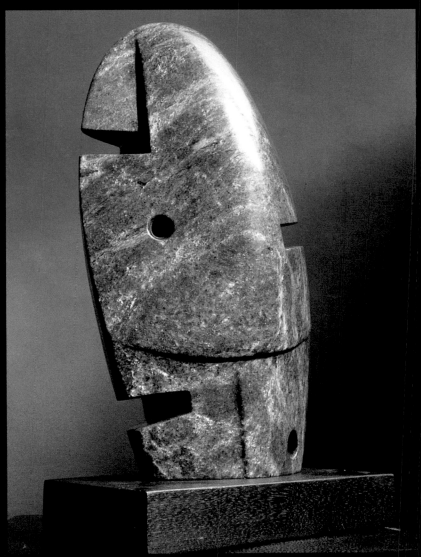

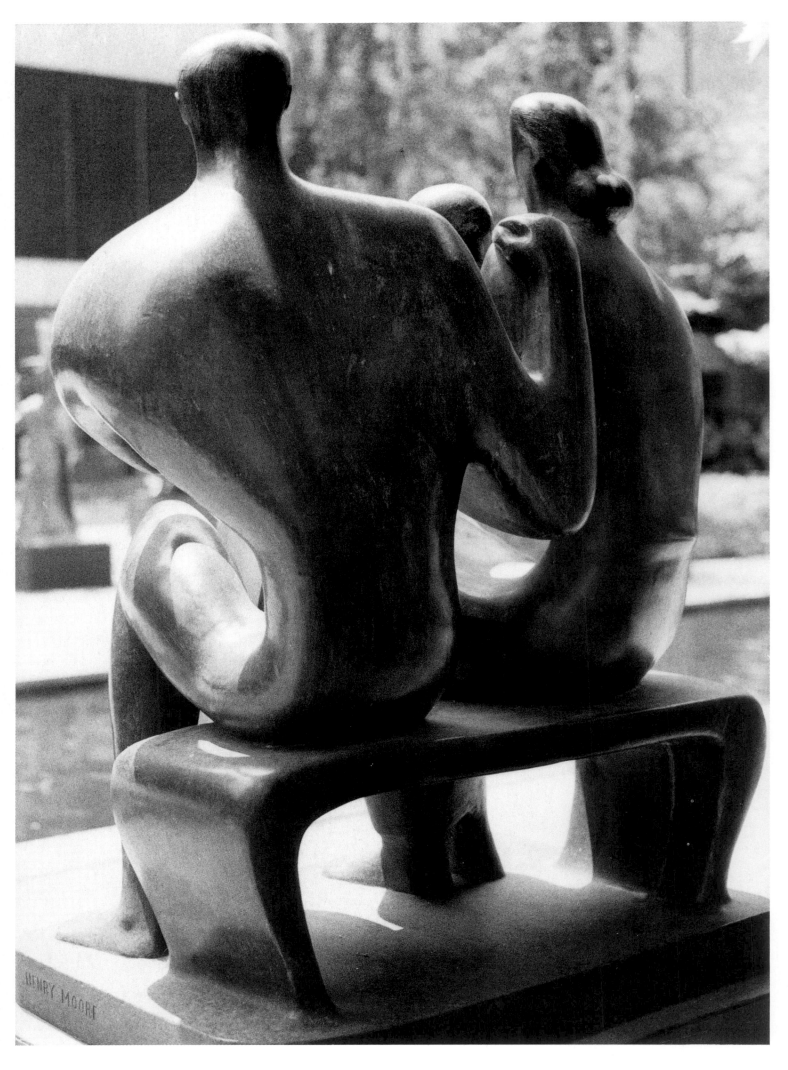

official war artist, they are among Moore's finest achievements. In them Pre-Columbian, Renaissance, and modern models cohere with his experience of dramatic contemporary events into a deeply moving vision of human dignity in the face of fear and suffering.

After the shelter drawings were exhibited in the National Gallery in the early 1940s, Moore achieved wide-scale public acceptance and was the recipient of numerous official honors and commissions. Besides the famous *Northampton Madonna*, commissioned in 1943 by the Reverend Walter Hussey for the Church of St. Matthew, there were further commissions from institutions for which he turned out sculptures ratifying established values. These included a series of family groups, a theme Moore began to explore around the time of the birth of his daughter Mary. They consist of two adult figures holding one, or sometimes two, children and suggest that he was turning both to Renaissance images of the Holy Family and to Pre-Columbian art for solutions to this new formal problem. In particular, the numerous small terra-cotta maquettes for these mother-father-child groups in the mid-1940s point to ancient West Mexican (Nayarit, Jalisco, and Colima) ceramic representations as models.

These Mexican terra-cottas were widely admired at this time, and many artists took their cue from Diego Rivera, who had amassed a huge collection of them, which he published in 1941.[104] A comparison between Moore's *Family Group*, 1947, and a Jalisco couple—one of many similar ceramic sculptures in contemporary public and private European collections—reveals striking similarities in figural proportions and attitudes. The exaggerated gestures and anatomical distortions, including the broad, flat, concave upper torsos, long tubular curving arms, truncated hands and feet, and blurred features, are especially revealing of this connection. The rhythmic alternation of masses and spaces, the smooth, highly burnished surfaces, and even specific details of Moore's figures, such as protruding vertebrae and slouching posture, are directly traceable to West Mexican models. Compare, for example, the male in the 1947 family group and a seated man from Colima.

Increasingly in the 1950s Moore was asked to sculpt state or corporate symbols. One such occasion was his commission in 1952 to make a carved screen for the balustrade

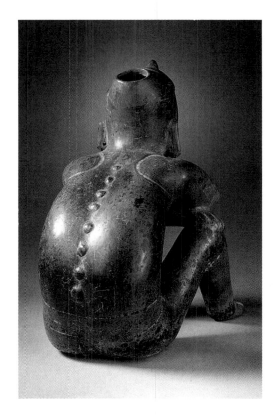

Seated male figure with horn headdress. Colima, Mexico, 300 B.C.–A.D. 300. Clay with dark red slip, 12 × 7 × 10". Los Angeles County Museum of Art, The Proctor Stafford Collection, Purchased with funds provided by Mr. and Mrs. Allan C. Balch (M.86.296.113)

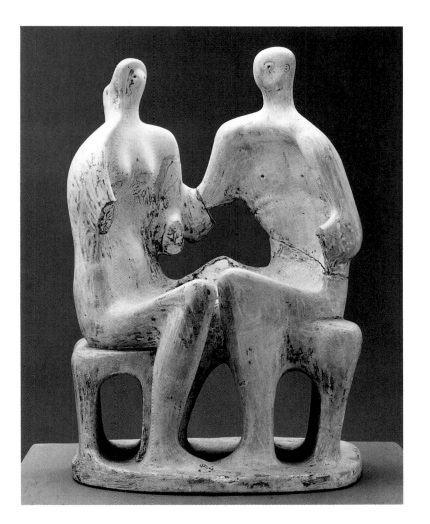

Henry Moore. Family Group. 1947. Plaster, height 16". Art Gallery of Ontario, Toronto, Gift of Henry Moore, 1974

PAGE 126:
Joined couple. Jalisco, Mexico, 200 B.C.–A.D. 500. Clay with dark red-brown slip, 15 × 16 × 13". Los Angeles County Museum of Art, the Proctor Stafford Collection, purchased with funds provided by Mr. and Mrs. Allan C. Balch (M.86.296.75)

OPPOSITE AND PAGE 127:
Henry Moore. Family Group. 1948–49. Bronze (cast 1950), 59¼ × 46½ × 29⅞", including base. Collection, The Museum of Modern Art, New York, A. Conger Goodyear Fund

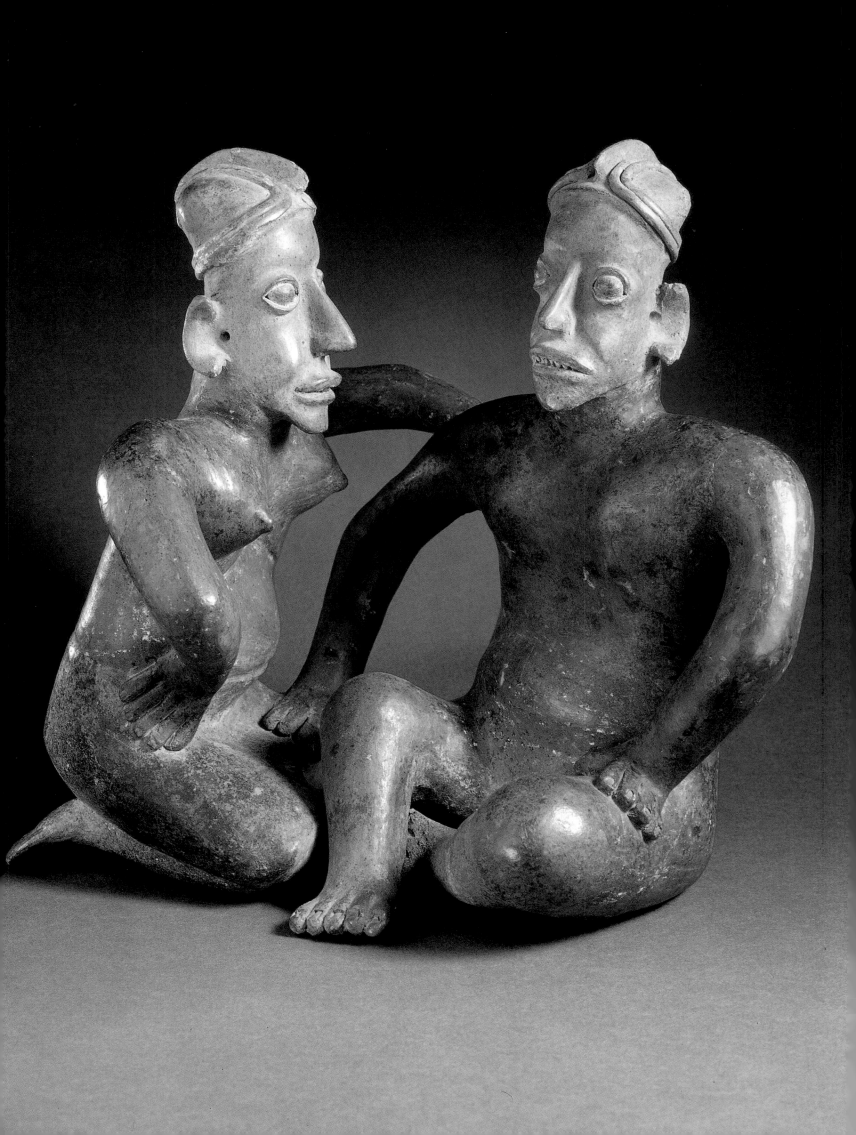

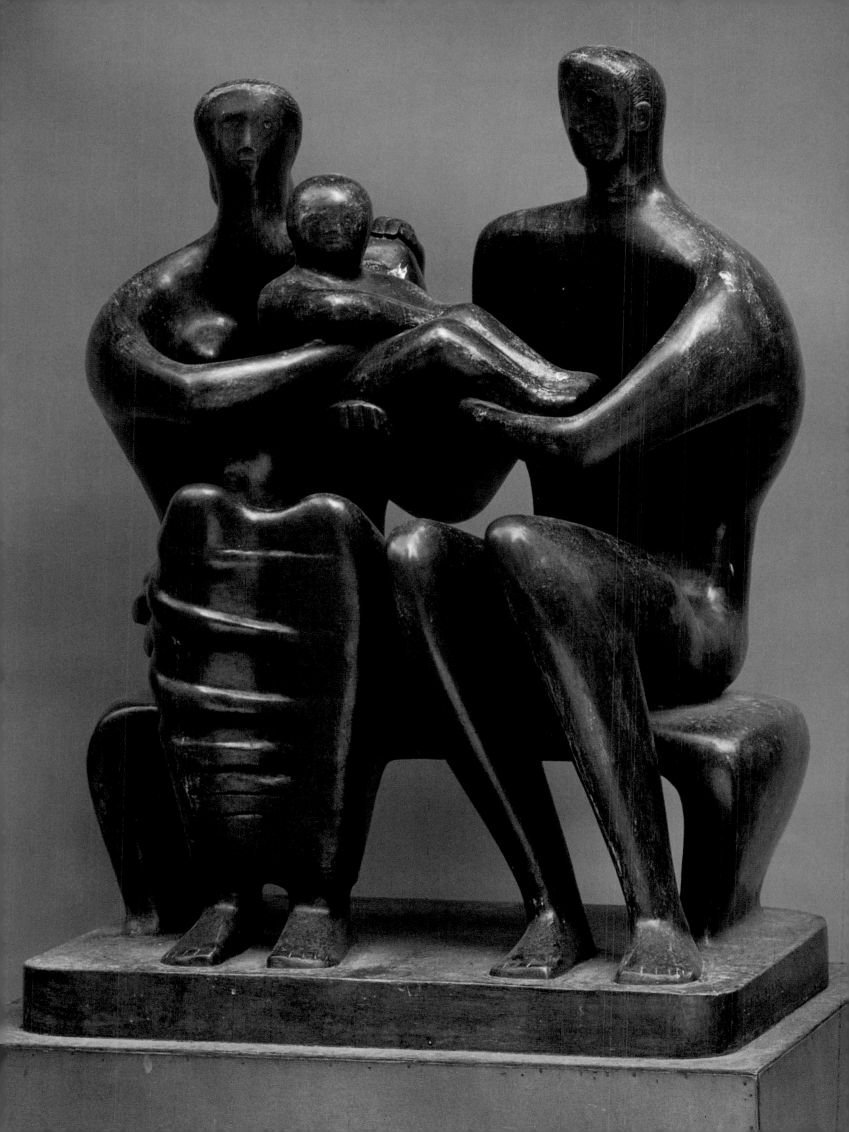

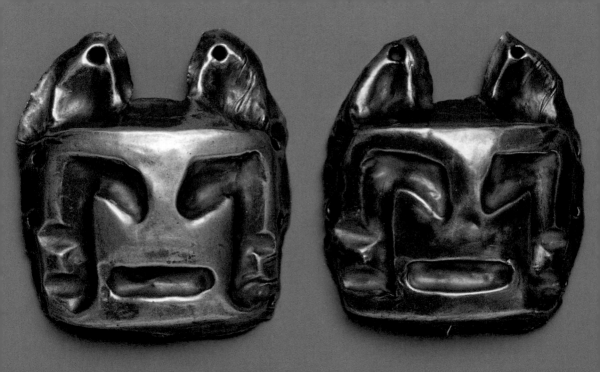

of the terrace of the Time-Life Building on Bond Street, along with a *Draped Reclining Figure* for the terrace itself. As in his previous architectural sculpture commission for *West Wind*, also poised above the street on a corporate building, he turned to blocky Pre-Columbian forms for inspiration in creating monumental imagery, but he shifted his attention from ancient Mexico to Peru. This was precisely the time when Peruvian antiquities, whose aesthetic appreciation had lagged behind those of Mesoamerica, were coming into their own in museum collections.[105] On this occasion, however, without benefit of a given symbolic motif, Moore resorted to semiabstract figurative monoliths quite devoid of thematic content. He collaborated with architect Michael Rosenauer in conceiving of a massive stone screen that would be pierced and carved on both sides and divided into four open panels, each containing a slightly projecting anthropomorphic upright figure continuous with the geometrical facade of the building. (Originally, he thought of them as revolving on a turntable in individual frames so that they could be seen in the round, but this proved impracticable.)

The rectangular forms of the screen figures hark back to those of Moore's blocky, semiabstract carvings of heads and square forms of 1936 and 1937, which refer to Mexican *hachas* and perhaps to ancient Peruvian monoliths.[106] Once again, as in his family groups, Moore generated in miniature plaster maquettes forms that would be realized in monumental stone or bronze, and he incorporated elements of small-scale Pre-Columbian sculptures into his imagery. Alan Wilkinson has suggested plausibly that the heads of both outer figures may be based on three-inch-high gold jaguar masks from the Moche or Chimú culture, which were illustrated in Heinrich Ubbelohde-Doering's *L'Art du vieux Pérou* in 1952.[107] Shaped from hammered sheet gold to form a hollow square feline head with holes for attachment to a base (probably a woven headband or shirt), these masks embody the sophisticated metallurgical tradition that developed as early as 500 B.C. on the north coast of Peru. The jaguar was a primary motif of ancient Peruvian art, serving from the early period onward as an emblem of power. The right-angled channels comprising the feline's eyes and cheeks and the groove forming its mouth, and their proportional relation to the whole, seem to be echoed in Moore's heads.

Another example of Moore's appropriation of ancient Peruvian imagery at this time is his bronze *Mother and Child* of 1953, for which he made a preparatory drawing in 1951 and a maquette in 1952. As Wilkinson has shown,[108] its source is a relief on a Chimú blackware pot illustrated in Ernst Fuhrmann's *Peru II*, which Moore owned.[109] Distinguished by their black color, polished sheen, and stirrup spouts (appliquéd with small animal figures), these mass-produced, mold-made vessels—which Gauguin had already admired—are decorated with mythological scenes in pressed relief (see page 67). This one depicts a struggle between two fantastic beings, the deity Ai Aipec in the guise of an anthropomorphic bird versus a sea monster. Moore focused on the latter figure, who clutches and threatens to devour Ai Aipec's serpent belt, and transformed it into a rather sinister version of the mother and child theme. The serpent head metamorphoses into a child with a gaping mouth straining toward the upright breast of its mother, whose serrated head, breast, and outstretched arm derive from the toothy open maw and the arm of the monster. Moore evidently had a special interest in this motif, since it reappears in two small bronzes of 1952, *Mother and Child: Corner Sculpture*, numbers 1 and 2.[110]

Moore's strange, angular, expressionistic image of a rapacious child assaulting its mother's breast makes overt the hidden content of some of his earliest images of infants aggressively sucking an isolated breast. It also reminds us that his 1920s infants were often based on Olmec were-jaguar babies whose essential feature is a snarling mouth. Erich Neumann has interpreted it as "a picture of the Terrible Mother, of the primal relationship fixed forever in its negative aspect," embodying the child's frustration by the denying, restraining mother.[111] As a unique rendition of a favorite theme, it thus suggests, in Freudian terms, the "return of the repressed"—revealing Moore's mother-hating side, and, finally, unmasking a possible psychological motive for his attraction to the aggressive aspects of Pre-Columbian art.

In all his years of referring to Pre-Columbian forms Moore never once traveled to their place of origin. Apparently, his experience of these forms out of context, in museums and reproductions, was sufficient for his purposes. Finally, however, on being awarded the sculpture prize at the second São Paulo Biennale—one of dozens of

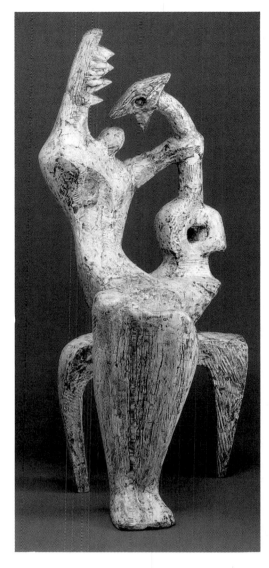

Henry Moore. Mother and Child. 1953. Plaster, 4¾ × 7⅛". Art Gallery of Ontario, Toronto, Gift of Henry Moore, 1973

OPPOSITE:
Jaguar masks. Moche or Chimú, North Coast, Peru, 200 B.C.–A.D. 600. Gold, height c. 3". Hamburgisches Museum für Völkerkunde, Hamburg, Germany

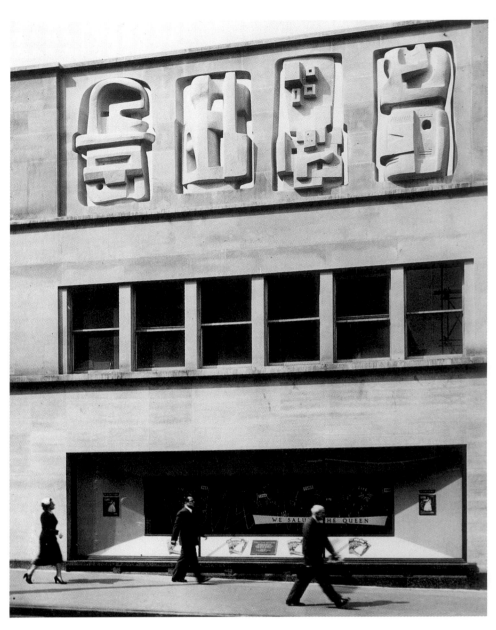

Henry Moore. Time-Life Screen. 1952–53.
Portland stone, length 26′6⅛″. Time-Life Building,
London, England

international prizes that followed on the heels of his triumph at the 1948 Venice Biennale—Moore traveled to Brazil and Mexico in 1953 and 1954, visiting several Pre-Columbian sites in Central Mexico and Yucatán. "When I went there I was tremendously impressed by the people," he commented in 1982. "It seemed to me that Mexican people lived on the ground, and I mean I saw them sitting there quite naturally, comfortably, all on the ground," he continued, linking this to his favorite theme of the reclining figure based on the chacmool.[112]

But it was too late for this visit to have any meaningful impact on Moore's work, since his innovative work now lay behind him. Though he continued to be productive for another thirty years until his death in 1986 at age eighty-eight, his output was mainly in his institutionalized role of modernist old master, recapitulating, with much assistance, old formulas with new materials, techniques, and textural effects (in increasingly bloated size and skewed scale).

Indeed, in his transformation from exceptional outsider to establishment celebrity, from Yorkshire rebel to national hero, Moore came to exemplify the bourgeois concept of individualism and free enterprise, of the self-creating artist making a world all by himself—with perhaps a little help from the Third World.[113] The perpetuation of this myth and its attendant denial of native art's intrinsic meaning continues apace. Edmund Carpenter suggests that, following on the heels of a highly popular, romantic account of the Eskimo, Canadian authorities in the 1950s promoted, as a solution to native unemployment, an Inuit art geared to the tourist trade.[114] An artist named James Houston, an admirer and student of Moore, helped implement this government policy by training native artists. And as a result, this new Eskimo style bears a more than coincidental resemblance to Moore's art.[115] Thus, in an ironic twist, Moore's

appropriation and translation of Pre-Columbian sculpture has now come full circle as the basis of a reconstituted Eskimo carving style with a not-so-hidden Western identity.

NOTES

1. This chapter was originally pubished in a different form as "Henry Moore and Pre-Columbian Art," *Res* 17/18 (Spring/Autumn 1989), pp. 158–97.

2. See John Glaves-Smith, "The Primitive, Objectivity and Modernity: Some Issues in British Sculpture in the 1920s," in S. Nairne and N. Serota, eds., *British Sculpture in the Twentieth Century* (Whitechapel Art Gallery, London, 1981), pp. 74–75.

3. Charles Harrison, "Sculpture and the New 'New Movement'," in S. Nairne and N. Serota, *op. cit.*, p. 103.

4. *Ibid.*, p. 104.

5. Cited in John Russell, *Henry Moore* (Baltimore, 1973), p. 23.

6. From an interview with Moore, *Horizon* 3, no. 2 (1960).

7. Cited in Philip James, ed., *Henry Moore on Sculpture* (London, 1966), p. 33.

8. Among the earliest acquisitions were Aztec carvings that had been in the provocative 1825 Mexican exhibition staged by William Bullock in London's Egyptian Hall, Piccadilly. This first European view of large-scale Aztec sculpture included casts of such major monuments as the Calendar Stone (found in 1790 under the Mexico City Cathedral), Stone of Tizoc, and the terrifying Coatlicue, which Bullock had taken during his Mexican travels, alongside botanical specimens, stuffed birds, and ancient and modern artifacts. The collection was given further impetus by the publication of Lord Kingsborough's lavish nine-volume encyclopedia, *Antiquities of Mexico* (1831–48), for which he had commissioned copies of all the Mexican codices in Europe, in hopes of proving that Mexico had been colonized by the lost tribes of Israel.

9. Appointed curator in the ethnographic department in 1902, he had by 1905 reinstalled the collection. His *Short Guide to the American Antiquities Collections in the British Museum* (1912) was followed by several excellent unofficial publications based on a card index of some 30,000 museum specimens, including *South American Archaeology* (1912), *Mexican Archaeology* (1914), *Central American and West Indian Archaeology* (1916), and *Maya and Mexican Art* (1927), all mainly illustrated with British Museum material. See J. H. Braunholtz, *Sir Hans Sloane and Ethnography* (London, 1970), p. 42.

Under Joyce's editorship, *Man*, the journal of the Royal Anthropological Institute, also became a quasi-official organ of the museum's ethnographic department. Joyce also wrote introductions to the catalogue of the Burlington Fine Arts Club's 1920 "Exhibition of Objects of Indigenous American Art"—an extensive display of ancient American objects from local private collections—and an illustrated edition of Prescott's popular *Conquest of Mexico* (1922).

10. Braunholtz, *op. cit.*, pp. 43–44.

11. Cited in James, *op. cit.*, p. 157. The Pre-Columbian material visible to Moore can be gleaned from a perusal of Joyce's various publications and their plates, as well as from the artist's own recollections and drawings.

12. Robert Wauchope, *They Found the Buried Cities* (Ann Arbor, 1977), pp. 241ff. See also Gregory Mason, *Silver Cities of Yucatan* (New York, 1927). Spinden, a noted art specialist and epigrapher, also wrote *A Study of Maya Art*, Memoirs of Peabody Museum of Archaeology and Ethnology 6 (Cambridge, Mass., 1913), and many articles on the Maya and New World origins.

13. In a May 19, 1923, article in the *London Illustrated News* on newly discovered Aztec mosaic masks in a Mexican cave, the running head was: "The so-called New World has antiquities of no less interest than those of the Old World, and the American archaeologists are busily opening up new fields of discovery in their own continent" (p. 864). In the space of two years (1923–24) Gann wrote more than a half-dozen articles on aspects of American archaeology, including reports of Mexican archaeologist Manuel Gamio's current excavations of pre-Aztec remains in the Pedregal section of Mexico City, the proto-Maya Tuxtla Statuette, his own excavations at Lubaantun and discovery of a Maya site on the Yucatán coast, which he called Chacmool, in honor of a giant statue inside one of its temples, and compared with that of Chichén Itzá (in two different articles).

14. Unlike the Derain, Aztec figures do not normally have their heads buried in their arms, though similar ancient West Mexican ceramic and Costa Rican stone representations of males often do. Derain probably saw examples of all these sculptures in the Trocadéro.

15. Paul Westheim (*Sculpture of Ancient Mexico* [New York, 1963], pp. 14–18) first defined the architectonic nature of Aztec sculpture in these terms.

16. Sidney Geist, *Brancusi, The Kiss* (New York, 1978), pp. 30–32. Geist suggests that Derain's sculpture was his response to the electrifying Salon d'Automne Gauguin retrospective in late 1906, a comprehensive display of the artist's paintings, wood and stone carvings, and ceramics. He characterizes it as a three-dimensional rendition of current Fauvist, especially Matissian, concerns but skirts the question of Pre-Columbian influence on both Derain and Brancusi: "Derain seems to have drawn heavily on an antecedent work [of his], itself the product of a series of influences." *Ibid.*, p. 100, n. 22. Yet the conspicuous Pre-Columbian influence on Gauguin's ceramics would logically have pointed these artists towards that tradition. Moreover, certain features of Brancusi's early sculptures, such as his figures' striated hair, as well as some of his later sculptures, particularly *The Gate of the Kiss*, 1938, strongly suggest that the artist had a firsthand awareness of ancient Mexican and Peruvian architectonic forms.

17. Donald Hall, "The Experience of Forms" (Profile of Henry Moore, 2 parts), *New Yorker* 41 (December 11 and 18, 1965), p. 102.

18. He explored the Leeds public library—where he encountered Fry's book—and Rutherston's extensive art library in Bradford, and in London, haunted the South Kensington Museum (now the Victoria and Albert) library.

19. James, *op. cit.*, p. 32.

20. For example, the inside cover of notebook no. 6, 1926, which reads: "Go to V&A Museum & get out Chinese Sculpture by Osvald Siren Volume 4—Plates . . . & Animals in Chinese Art BENN Brothers-publishers The Art of Old Peru-Lehmann . . . Ancient Egyptian Works of Art-Arthur Weigall . . . The Customs of Mankind Lilian Eichler." Cited in Leeds City Art Galleries, *Henry Moore, Early Carvings, 1920–1940* (Leeds, 1982), p. 24.

21. For further information, see Alan G. Wilkinson, *The Drawings of Henry Moore* (Courtauld Institute of Art, London, 1974; reprinted New York, 1984), p. 39, nn. 33 and 34; and Wilkinson, *The Drawings of Henry Moore* (Tate Gallery, London, 1977), p. 153, nn. 31 and 32. Both Fuhrmann books are inscribed: "Henry Spencer Moore 1923."

Moore also probably knew Herbert Kuhn's *Die Kunst der Primitiven* (1923), which contained Pre-Columbian art, as well as the 1922 illustrated edition of Prescott's *Conquest of Mexico*, with an introduction by Joyce.

22. Mainly found in notebooks no. 3 of 1922–24 and no. 6 of 1926, though notebooks nos. 2 (1921–22) and 4 (1925) also contain examples.

23. See Wilkinson, 1974 and 1977 *op. cit.* In his detailed examination of Moore's notebook drawings, Wilkinson reveals the comprehensiveness of Moore's art historical studies, ranging from Paleolithic to Post-Impressionist periods, from painting to sculpture, but favoring especially Egyptian, Sumerian, Cycladic, archaic Greek, Etruscan, and African, as well as ancient Mexican sculpture. He points out several drawings of Pre-Columbian objects that never got translated into sculptures, including two drawings of a whale (?) in notebook no. 4, derived from an Aztec carved bone illustrated in what he mistakenly identifies as pl. 99 of Ernst Fuhrmann's *Mexiko III* (Darmstadt, 1923) (there is no pl. 99 in Fuhrmann 1923); a drawing inscribed "Head of Christ in Alabaster/Mexican" from an unidentified source in notebook no. 6 (Wilkinson, 1977, *op. cit.*, p. 150); and four sketches of Peruvian objects, three of which appear in notebook no. 3: a Chimú mosaic earspool with a reversible design of two birds with a common body from the British Museum, two bird studies from a Moche pot from Chimbote, and a large study of two heads taken from the neck of a Moche bottle from Trujillo, reproduced in Fuhrmann's *Reich der Inka* (1922), pls. 51, 15. In each case Moore isolated the figurative elements and ignored the pot. There is also a copy of an Inka silver llama in notebook no. 6 copied from Walter Lehmann's *The Art of Old Peru* (1924), pl. 109 (Wilkinson, 1974, *op. cit.*, pp. 39–40). Wilkinson has ignored what is clearly another rendering of a Pre-Columbian object in notebook no. 2 (on the same page as the earliest sketches of the chacmool) from an unidentified source—a sketch of an iguana or lizard scaling another object, which appears to be either a *hacha* or an alabaster vessel.

24. David Mitchinson, *Henry Moore, Unpublished Drawings* (New York, 1976), p. xv.

25. These ideas were suggested to me by a reading of Susan Stewart, *On Longing* (Baltimore and London, 1984), pp. 89–92.

26. Henry Moore, *Henry Moore at the British Museum* (New York, 1981), p. 66.

27. Reproduced, for example, in Thomas A. Joyce, *Mexican Archaeology* (London, 1914), pl. v, and Fuhrmann, *Mexiko III*, *op cit.*, pl. 4.

The most extensive treatment of Moore's Pre-Columbian sources is by Wilkinson in: 1977, *op. cit.*; "Henry Moore's Reclining Woman," *Annual Bulletin* (National Gallery of Canada, Ottawa, 1979), pp. 33–54; and *Gauguin to Moore: Primitivism in Modern Sculpture* (Art Gallery of Ontario, Toronto, 1981). His discussion is most useful in documenting some of the material available to Moore; however, he fails to recognize many of Moore's Pre-Columbian sources.

28. For a documentation of this working method, see the discussion of Moore's creation of *Locking Piece*, based on an extended interview with the artist, in Hall, December 11, 1965, *op. cit.*

29. Since its publication more than eighty years ago, this sculpture has captivated many people, including Diego Rivera, who pictured it in one of his murals. Yet several Pre-Columbian experts have questioned its authenticity, citing the rarity of this pose in the stone medium—it is most common in painted codices—and its unusual "cabinet" size and carving technique.

30. Moore has stated, "From 1922 on I went once or twice a year to Paris—until 1932 or 1933 I didn't miss a year." Cited in Wilkinson, 1977, *op. cit.*, p. 15.

31. Reproduced in Walter Lehmann, *Altmexikanische Kunstgeschichte* (Berlin, 1922), pls. 25, 32, 33 and Thomas A. Joyce, *A Short Guide to the American Antiquities Collections in the British Museum* (London, 1912), fig. 7.

32. This sculpture is designated no. 35 in the five-volume Lund-Humphries catalogue raisonné of Henry Moore's sculpture; the prefix LH refers to this sequencing of Moore's work. See David Sylvester, ed., *Henry Moore: Volume One, Sculpture and Drawings, 1921–48 [Catalogue raisonné]* (Lund-Humphries, London, 1957); and Henry Moore, *Sculpture and Drawings, 1949–1959, Volume Two* (Lund-Humphries, London, 1965).

33. For example in Lehmann, 1922, *op. cit.*, figs. 25, 32, 33, 38. Jacob Epstein's portrait of Augustus John's son Romilly of 1905–07 (illustrated in Richard Buckle, *Jacob Epstein* [Cleveland, 1963], p. 22) shares this trait.

34. For example, *London Magazine* 24, no. 140, pp. 123–32. On Olmec altars, the lower half of the larger figures' bodies are obscured. On the other hand, Brancusi's *The Kiss* and certain painted and carved mid-fifteenth-century Florentine madonnas also provide pictorial precedents for half-length bodies.

35. 1922, *op. cit.*, fig. 16.

36. Particularly as reflected in Moore contemporary Leon Underwood's 1925–30 totemic carvings, e.g., *Totem to the Artist*.

37. For example, Joyce, on a visit to New York, saw a film on Maya ruins made by Blom at the Explorers

Club. Blom in turn visited the British Museum's Maudslay show in 1923 and was in contact with Maudslay. In England again in 1930, Blom visited Joyce, who was himself involved in the 1931 expedition to the Mexican Gulf Coast area, which he published in *Man*, 1931. See Robert L. Brunhouse, *Frans Blom, Maya Explorer* (Albuquerque, 1976).

38. Moore's respect for Dobson can be seen by the fact that he suggested him for the sculpture professorship at the Royal College of Art, which he himself was temporarily filling at this time. See also Roger Fry, "Mr. Frank Dobson's Sculpture," *Burlington Magazine*, April 1925, pp. 171–77.

39. See T. W. Earp, *Frank Dobson Sculptor* (London, 1945), pls. 3 and 14; and Kettle's Yard, "True and Pure Sculpture; Frank Dobson 1886–1963" (1981), fig. 29.

40. Illustrated respectively in S. Nairne and N. Serota, *op. cit.*, pp. 59, 76.

41. In an article entitled "The Sculpture of Frank Dobson" (*The Arts* 12, no. 6 [December 1927], pp. 305–10, Underwood praised Dobson's work by way of an aside about Altamira and the Dordogne.

42. Cited in W. J. Strachan, *Henry Moore: Animals* (London, 1983), p. 24.

43. Possibly inspired by Moore's animal sculptures based on Aztec works, American sculptor John Flannagan in the 1920s and 1930s produced a distinctive series of stone animals, often embedded in rocks. They draw on the Native American disposition to reveal the forms and forces inherent in nature by playing on an ambiguity between natural and cultural forms.

44. See Esther Pasztory, "Three Aztec Masks of the God Xipe," in Elizabeth H. Boone, ed., *Falsifications and Misreconstructions of Pre-Columbian Art* (Washington, D.C., 1980).

45. One such mask (LH 61) draws on aspects of the famous (severed) head of the Aztec goddess Coyolxauhqui—which looks a lot like the Xipe masks, and was also reproduced in Basler and Brummer's book (p. 86)—and Olmecoid colossal heads. Two additional masks of 1929 and 1930 (LH 64 and 77) are also apparently indebted to Teotihuacán masks reproduced in Basler and Brummer, (pp. 43ff.). In a similar vein is his 1928 *Mask* (LH 52), which recalls classic period Veracruz flat stone heads (*hachas*) associated with the Pre-Columbian ball game.

46. See Paul Westheim, *Sculpture of Ancient Mexico* (New York, 1963), pp. 15–19. Even the symbol-laden imperial cult objects reserved for Tenochtitlan's sacred precinct (e.g., the terrifying colossal Coatlicue covered with skulls and extruded hearts, reproduced in Joyce [1912])—which never interested Moore—adhere to the shape of the closed stone block.

47. The great Mayanist Maudslay himself described it as being marked by "a tendency to overelaboration," in Thomas A. Joyce's *Guide to the Maudslay Collection . . .* (London, 1923), p. 54.

48. At this time, all art outside the Western "great tradition" was perceived as part of the same primitive continuum. But Moore's reference to African, Cycladic, Egyptian, and archaic Greek sculpture was cursory as compared to Pre-Columbian art. See Wilkinson, 1984, *op. cit.*, for documentation of Moore's other non-Western sources.

49. Cited in Sylvester, 1957, *op. cit.*, p. xliv.

50. Cited in Leeds City Art Galleries, *op. cit.*, p. 23.

51. *Ibid.*

52. Geist, *op. cit.*, pp. 5–6.

53. "Another book [besides Fry] that I found a great help and an excitement was Ezra Pound's book on Gaudier-Brzeska," he said in 1961.

54. This was reprinted in Pound's *Gaudier Brzeska: A Memoir* (London, 1916), pp. 13, 35, from his essay in *Blast* and a letter to the editor of the *Egoist*, both 1914.

55. Cited in James, *op. cit.*, p. 37.

56. Cited in Sylvester, *op. cit.*, p. xliii.

57. Cited in Strachan, *op. cit.*, p. 16.

58. Cited in James, *op. cit.*, p. 50.

59. Harry T. Moore, ed., *The Collected Letters of D. H. Lawrence* (London, 1932), p. 677.

60. *Ibid.*, p. 763.

61. He characterized it as the phallic thrust of the sacrificial knife. See Benjamin Keen, *Aztec Image in Western Thought* (New Brunswick, N.J., 1971), pp. 553–57; and Hugh Honour, *The New Golden Land* (New York, 1975), p. 187.

62. Harry Moore, *op. cit.*, p. 744.

63. Cited in Richard Aldington, *Portrait of a Genius, But* (London, 1950), p. 273.

64. Cited in Wilkinson, 1981, *op. cit.*, p. 266.

65. See Hall, *op. cit.*, p. 102.

66. See Edmund Carpenter in his introduction to S. Williams, *In the Middle: The Eskimo Today* (Boston, 1983) for a clear statement of this position: "No one lives an 'elemental,' 'simple,' 'direct,' 'immediate,' life. People everywhere are pattern-makers and pattern perceivers; they live in symbolic worlds of their own creation."

67. Moore, 1981, *op. cit.*, p. 66.

68. The scholarship was expressly designed for the study of Italian old masters, and the Royal College of Art required its recipient to return with copies of Italian art in hand.

69. Russell, *op. cit.*, pp. 40–41.

70. Richard Shone, "Painting and Sculpture in the 1920s," in S. Nairne and N. Serota, *op. cit.*, pp. 83–90. Other popular themes of this ilk included Italian landscapes, mythological scenes, *fêtes galantes*, and Commedia del'Arte figures. But the true distillation of these was the massive female inspired by Renoir's sensuous late *Grandes Baigneuses*, Picasso's meditations on motherhood, and Maillol's *L'Action enchaînée*. Shone suggests that they represented a wish to return to certitude, order, and spirituality after the war's convulsions.

71. According to Shone (*op. cit.*, p. 85), there are striking similarities in pose and style between some of

Grant's drawings of sumptuous nudes, which appear more like sculptures than life drawings, and those of both Moore and Barbara Hepworth of this period.

72. Richard Cork, "Overhead Sculpture for the Underground Railway," in S. Nairne and N. Serota, op. cit., p. 91; and Cork, Art Beyond the Gallery in Early 20th Century England (New Haven and London, 1985), pp. 266ff.

73. When Holden asked Moore to participate, at Epstein's urging, the thirty-year-old sculptor was initially reluctant. He was torn between satisfaction at receiving a substantial public commission and misgivings about "the humiliating subservience of the sculptor to the architect" (James, op. cit., p. 97). Moore had learned very well the modernist lesson of the artwork's autonomy, but he needed the work since it would provide considerable exposure and revenue. His chief source of regular income was a teaching position, supplemented by the sale of his drawings, which until World War II outnumbered sculptures twenty to one (Wilkinson, 1977, op. cit., p. 17). As a sculptor he also faced economic constraints peculiar to his trade: the high cost of marble, stone, and seasoned wood (not to speak, for the moment, of bronze casting), as well as of handling, storing, and transporting bulky, heavy objects. (In 1925 Moore had joined the London Arts Association, which was founded as a self-help group to grapple with the financial, exhibition, and patronage problems confronting artists.) He seems, in fact, to have been entertaining the notion of architectural sculpture commissions since at least 1926, when he began to use reinforced concrete for sculptures. Once Moore was established as a bona-fide art star in the 1940s, large-scale public commissions keyed to architecture increasingly became his mainstays (although mainly in the round with strong separate identities, rather than reliefs).

74. Wilkinson, 1979, op. cit., pp. 76–77; Cork, 1981, op. cit., p. 97.

75. James, op. cit., pp. 40, 42. Herbert Read (Henry Moore [London, 1965], p. 72) corroborates the 1925 date, but makes the Trocadéro cast the connecting link. But in a 1950 letter to Professor Michael Coe (personal communication), he says he saw the chacmool figure "in a photo first in 1923." On another occasion he told David Sylvester that he saw an illustration of it in Lehmann's Altmexikanische Kunstgeschichte in 1927 and looked at the plaster cast at the Trocadéro only after completing the Leeds figure in 1929. See Wilkinson, 1979, op. cit., pp. 39–40.

76. See Wilkinson, 1981, op. cit., fig. 94. It occurs at the bottom of page 93 on the same page as a drawing of what is surely another Pre-Columbian object, resembling a classic Veracruz hacha carved in relief with a lizard, or perhaps an alabaster vessel with a superimposed lizard, such as one pictured in Lehmann, 1922, op. cit., pl. 19.

77. London Magazine 24, no. 140, pp. 123–32, and London Illustrated News, November 1 and 29, 1924.

Since Le Plongeon's discovery, 14 chacmools have been located at Chichén Itzá, and 12 at Tula, a related, probably contemporaneous, Toltec center in northern Mexico. There have also been isolated, dispersed finds at Quirigua (by Maudslay), and other Maya-area sites (in El Salvador, by Lehmann), even as far south as Costa Rica, as well as at later, Aztec-period sites, including Tenochtitlán, Tlaxcala, and Cempoala.

78. See Wilkinson, 1979, op. cit., p. 40. He also suggests that a naturalistic reclining nude on page 21 of notebook no. 5 (c. 1925–26), which foreshadows the Leeds Reclining Nude, may be derived in part from the chacmool.

79. C. Neve, Leon Underwood (London, 1974), pp. 107–8, pl. 63.

80. Cork (1985, op. cit., pp. 169–74) and Wilkinson (1979, op. cit., pp. 49–51) have traced the gradual evolution of the West Wind figure in Moore's series of preparatory sketches. The artist's deep involvement with the project is clear from the pains he took to perfect both the conception and execution of the image.

81. Wilkinson, 1979, op. cit., pp. 49–51.

82. Cited in ibid., p. 52.

83. David Sylvester (Henry Moore [London, 1968], p. 6) suggests that Moore's figure resembles Michelangelo's Medici Chapel Dawn and that he may have unconsciously derived this contrapposto effect from it.

Curiously, an anomalous chacmool from Chichén Itzá, called the Swimmer chacmool, has legs that assume the same sideways position as that of the Leeds Reclining Figure. See Mary Ellen Miller, "A Re-examination of the Mesoamerican Chacmool," Art Bulletin 47, no. 1 (March 1985), pp. 7–17, ill., p. 14.

84. Cited in Ionel Janiou, Henry Moore (Paris, 1968), pp. 28–29.

85. See, for an example of a dualistic head, Miguel Covarrubias, Pre-Columbian Art of Mexico and Central America (New York, 1957), pl. IV.

86. See Miller, op. cit., pp. 7–17; Joyce, 1914, op. cit., pp. 42, 138; Walter Lehmann, The History of Ancient Mexican Art (New York, 1922), p. 27; and Alfredo Cuellar, Tezcatzoncatl escultorico: El "Chac-Mool" dios mesoamericana del vino (Mexico City, 1981).

87. Honour, op. cit., pp. 84–117.

88. There are a small number of representations of reclining females known from northern South America, particularly the Moche culture in formative-period Peru, but they are exceptional and confined to the ceramic medium. The Moche version is a bowl at the bottom of which lies a supine female with a gaping vulva. Any fluid poured into the bowl runs down through the vulva and into a reservoir beneath it, so that when fluid is poured out, the vulva serves as spout. These vessels are thought to have a possibly humorous connotation but are devoid of any notions of availability, vulnerability, or tranquillity inherent in reclining female nudes in the West. See Paul H. Gebhard, "Sexual Motifs in Prehistoric Peruvian Ceramics," in Theodore Bowie et al., Studies in Erotic Art (New York and London, 1970), pp. 109–69, and fig. 54.

89. Benjamin Buchloh, "Figures of Authority, Ciphers of Regression," in Brian Wallis, ed., Art After Modernism: Rethinking Representation (New York, 1984), p. 121.

90. For illustrations, see Sylvester, 1957, op. cit., LH nos. 42, 96.

91. Wilkinson, 1979, op. cit., p. 55, n. 35.

92. Cited in Russell, 1973, op. cit., p. 48.

93. Cited in Wilkinson, 1979, *op. cit.*, p. 33.

94. See, for example, Epstein's *Elemental, Woman Possessed, Chimera, Adam,* and *Ecce Homo.*

95. Hall, *op. cit.*, p. 128. Epstein had amassed a large collection of primitive art by this time.

96. See Anna Greutzner, "The Surrealist Object and Surrealist Sculpture," in S. Nairne and N. Serota, *op. cit.*, pp. 121ff. See also Wilkinson, 1981, *op. cit.*, and "Henry Moore," in W. Rubin, ed., *Primitivism in 20th Century Art* (Museum of Modern Art, New York, 1984), pp. 595–612.

97. See Rosalind Krauss, "Giacometti's Primitivism," in Rubin, ed., *Primitivism in 20th Century Art* (Museum of Modern Art, New York, 1984), pp. 521–23, and pls. on pp. 513, 519, 529. Krauss suggests that the so-called gameboard pieces are especially radical because they decenter representation by conceiving of the work itself as a base that begins to fuse with its surroundings. The metaphoric nature of the forms also expands the work's spatial as well as temporal dimensions. She also sees the gameboard pieces as inextricably linked with Giacometti's primitivism.

98. Bataille's essay appeared in Jean Babelon et al., *L'Art précolombien. Cahiers de la république des lettres, des sciences, et des arts* 11 (Paris, 1928). Krauss, *op. cit.*, pp. 510–12.

99. Krauss (*op. cit.*, p. 512) maintains that the explicitly erotic and sadistic *Suspended Ball*—suggesting both cutting and caressing—has a wedge-shaped component recalling implements called *palmas* that are thought to have been worn by the players as protective devices. And the subsequent *Point to the Eye, Circuit,* and *No More Play* investigate sculpture itself as a ball court, playing field, or gameboard. She identifies Frans Blom's *The Maya Ball Game: Pok-ta-pok,* Middle American Papers (New Orleans, 1932), as a major source about the game at the time, noting that Blom gives dictionary definitions of the game that relate the game with death and emphasize the instrumentality of the players' naked buttocks in the game (the ball was kept aloft with their knees and buttocks)—*Nahuat ollama:* to play ball with buttocks.

100. See Mitchinson, "1930–1940," in Leeds Art Galleries, *Henry Moore: Early Carvings* (Leeds, 1984), p. 36.

101. See Barbara Braun, "Ball Game Paraphernalia in the Cotzumalhuapa Style," in *Baessler Archiv,* n. s. 25 (1977), pp. 426–27.

102. For an illustration, see Sylvester, 1957, *op. cit.*, pl. on p. 198.

103. Moore exhibited with the Surrealists during this period, participating in the International Surrealist Exhibition in London in 1936, the year he met Ernst. For an illustration of Ernst's painting, see John Russell, *Max Ernst* (New York, 1960), pl. 20.

104. See Gilbert Medioni and Marie-Therese Pinto, *Art in Ancient Mexico, Selected and Photographed from the Collection of Diego Rivera* (New York, 1941). The first major exhibition exclusively devoted to West Mexican art, based on Rivera's collection, was held in Mexico City in 1946.

105. See Alan R. Sawyer, *Mastercraftsmen of Ancient Peru* (New York, 1968), p. 12. In 1952, Sawyer points out, the Art Institute of Chicago exhibited an important Peruvian collection, well known from German publications, which became the basis of its Department of Primitive Art; in 1954, the Museum of Modern Art presented a traveling show called "Ancient Arts of the Andes"; and in 1955 Peru sent an exhibition of ancient, colonial, and modern Peruvian art to Mexico City and Toronto, followed by a larger show of the same type in Paris in 1957.

106. For example, *Mother and Child,* 1936 (Sylvester, 1957, *op. cit.*, no. 171), resembles any number of pan-Andean shaft figures representing warriors with shields from c. 500 B.C. to A.D. 500. See Barbara Braun, "Sources of the Cotzumalhuapa Style," *Baessler Archiv,* n. s. 26 (1978), pp. 191–95, figs. 38, 39. Moore might have seen such figures in books about ancient Peruvian art that were published in the 1930s.

107. Wilkinson, 1981, *op. cit.*, pp. 294–95.

108. *Ibid.*, p. 292.

109. Moore had referred to ancient Peruvian metalwork once before in a drawing of a silver Inka llama appearing on p. 30 of notebook no. 6, 1926. See Wilkinson, 1977, *op. cit.*, p. 150, and fig. 136.

110. See Moore, 1965, *op. cit.*, pls. 36, 37, for illlustrations. Other works of the late 1950s suggest that Moore was looking in the direction of ancient Peru for inspiration, particularly his "wall backgrounds" for bronze sculptures whose unusually textured surfaces recall those of Inka stone masonry.

111. Erich Neumann, *The Archetypal World of Henry Moore* (New York, 1959), p. 117.

112. Interview with Moore by Luis Roberto Vera, September 1982, in Peter Briggs, ed., *Maya Image in the Western World* (University of New Mexico Art Museum, Albuquerque, 1987), p. 41.

Very little information is available about Moore's Mexican trip. However, Mexican painter Alfonso Soto Soria executed a mural based on a Moore project at the experimental El Eco museum in Mexico City. It represents on a blank background a series of frontal, monumental skeletal figures, recalling both Pre-Columbian and modern Mexican folk art, linked together by intersecting lines.

113. For example, Russell (1973, *op. cit.*, p. 23) notes that Moore, in becoming the Yorkshire lad who rose to talk with the prime minister in front of the fire, embodied the notion "that a man was what he made himself." For an alternative view, see Griselda Pollock, "Art, Art School, Culture: Individualism after the Death of the Artist," *Block* 11, no. 1 (1985/86), pp. 10–13.

114. Edmund Carpenter, *Eskimo Realities* (New York, 1978), pp. 192–203.

115. According to Carpenter (*op. cit.*), these Eskimo carvings came into being in 1949 as a direct result of Houston's teaching and promotions under the auspices of the Canadian Handicraft Guild, and later, the government. Houston should be credited with helping to create a new art bringing much-needed financial assistance to Eskimos, but these carvings should not be represented falsely as traditional. Traditional Inuit art consisted of wood, bone, and ivory implements elaborated for social rituals, but the new souvenir art is carved out of stone and functions in a very different way. It is produced by competitive individuals for a cash economy, and its resemblance to Moore's sculptures is meant to enhance its mass marketability. See also Edmund Carpenter, *Oh, What a Blow That Phantom Gave Me!* (New York, 1973), pp. 103–5. For a different view, see Richard Anderson, *Art in Primitive Societies* (New Brunswick, N. J., 1979), pp. 174–79.

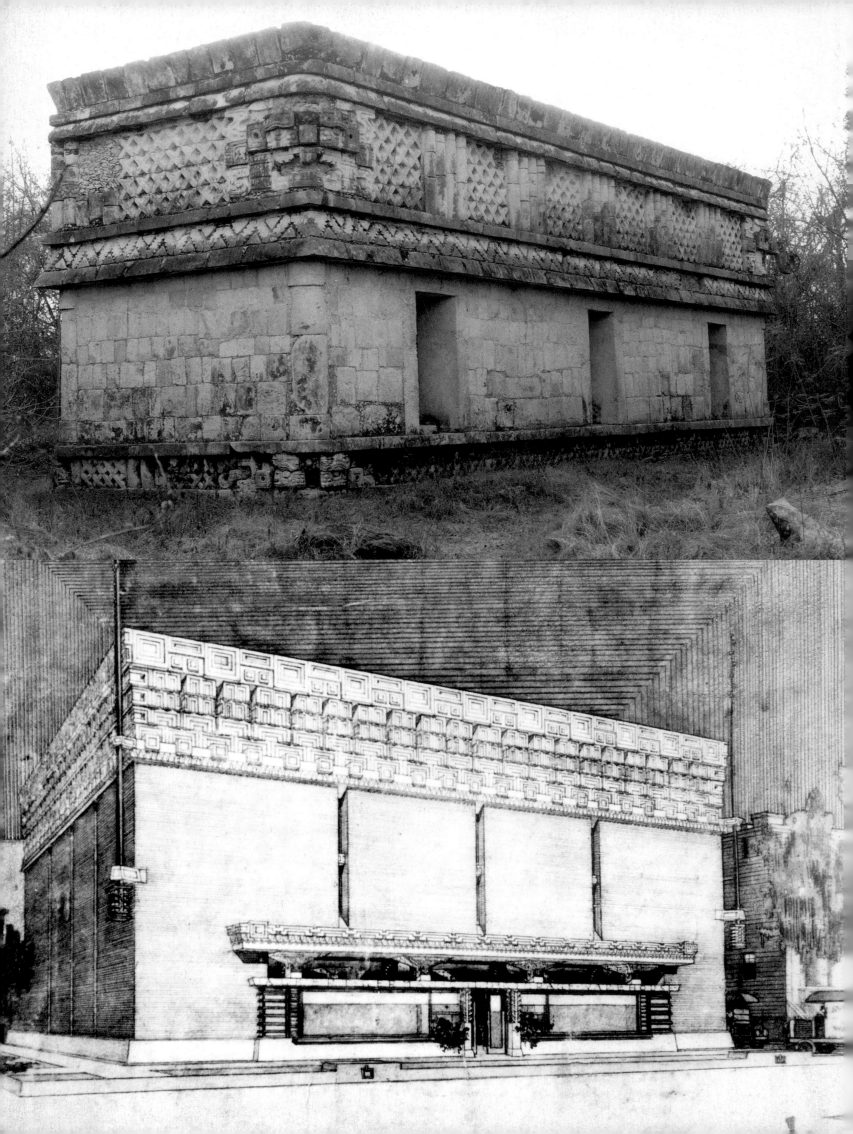

FRANK LLOYD WRIGHT: A VISION OF MAYA TEMPLES

rank Lloyd Wright, the leading American architect of the twentieth century, was a strange combination of the new and the old, of twentieth- and nineteenth-century notions. His work was a curious hybrid of insights bred of new technology and a romantic, mystical orientation toward a lost Eden, the cubist grid, and symbolic decoration.

He was a self-styled genius who nearly always denied any debt to outside influences. "There never was an exterior influence upon my work either foreign or native," he typically testified, adding, "as far as the Incas, Mayan, even the Japanese—all to me were but splendid confirmation."[1] He preferred to think of himself as a discoverer of universal truths about primordial geometric structures and proportions rather than as an imitator of the forms of primitive—nonindustrialized, non-Western—cultures that also embodied these visual laws. However, in a less guarded moment Wright acknowledged: "And those human nature-cultures of the red man, lost in backward stretch of time, almost beyond our horizon—the Maya, the Indian, we may learn from them."[2]

Indeed, the evidence indicates that Pre-Columbian architecture did far more than merely confirm his inspiration. He was in fact always well informed about vanguard intellectual and aesthetic issues and well aware of significant contemporary archaeological investigations of ancient cities. Although he never traveled in Mexico or Central America, he was constantly alert to Pre-Columbian architecture and its achievements. Wright learned about Pre-Columbian architecture very early and referred to it in every phase of his long and extraordinary career, from his earliest Oak Park period in the late nineteenth century to the creation of the Guggenheim Museum in the 1940s. It is true that Pre-Columbian sources played a dominant role only in the period from 1910 to 1930, when he was operating in a context that favored their usage. And they were not, of course, the only influences on his work, the standard list of which includes the kindergarten blocks of the nineteeth-century German educational reformer Friedrich Froebel, the inspiration of Wright's mentor Louis Sullivan, and the arts of Japan; recent additions to the list include the Aesthetic movement and the Vienna Secession. Without denying Wright's genius, individuality, or ability to absorb and transform lessons from others, it is possible now to see that he was profoundly aware of and influenced by the new art and archaeology of his time and that his use of modular geometry overlaid by symbolic decoration and impelled by romantic and mystical notions owed a great deal to the Pre-Columbian architecture with which he was so familar.

EARLY YEARS

Wright testifed to a childhood infatuation with Pre-Columbian architecture: "I remember how, as a boy, primitive American architecture, Toltec, Aztec, Mayan, Inca, stirred my wonder, excited my wishful admiration."[3] But his first serious encounter with it was in the late 1880s in the context of the Chicago School of architecture and the Aesthetic movement, which upheld a mélange of exotic forms as surface decorative elements.[4] In 1887, after studying civil engineering at the University of Wisconsin for a few years, Wright found work in Chicago as a draftsman for Lyman Silsbee, a practitioner of a conventional form of picturesque domestic architecture. In a short time, however, he joined the prominent firm of Adler and Sullivan, which was developing a progressive form of architecture suitable for a modern industrial city—tall buildings that would efficiently accommodate downtown commercial and office space.[5]

Apart from his contribution to the development of the skyscraper, Sullivan was known for the extraordinary use of ornament inspired by nature and exotic sources in his buildings. Wright soon became Sullivan's disciple. Concentrating his practice on domestic buildings and following his mentor's lead, he began looking outside the classical Renaissance tradition for new models. French architectural theorist Eugène Viollet-le-Duc's *Habitation of Man* and Owen Jones's *The Grammar of Ornament*, which promoted the uses of the primitive and exotic as a means of arriving at new forms,

were basic references for the Chicago School.[6] Wright studied the works of both men, pronouncing Viollet-le-Duc's *Dictionnaire raisonné* "the only sensible book on architecture."[7] Through Viollet-le-Duc he would have come to know the work of French photographer-explorer Désiré Charnay, since Viollet-le-Duc had written the introduction to Charnay's *Ancient Cities of the New World*. Based on Charnay's expedition to Mexico and Central America from 1857 to 1860 under the aegis of Napoleon III, the book reproduced the first successful photographs of Pre-Columbian architecture (using the new glass-plate-negative process), capturing the awesome monumentality of such sites as Uxmal, Yaxchilán, Palenque, and Mitla.

It is certain Wright was also acquainted with the popular books of two other prominent French antiquarians, Charles Etienne Brasseur de Bourbourg and Augustus Le Plongeon, including the latter's *Queen Moo and the Egyptian Sphinx*, which framed numerous plans, drawings, engravings, and photographs of indigenous architecture with fanciful interpretations of Pre-Columbian culture.[8] Their mystical speculations regarding cultural diffusion and lost continents have been thoroughly discredited by modern scientific archaeology, but they had considerable credibility with a lay audience at the time and for many years afterward.

About Wright's knowledge of the lavishly illustrated travel books by John Lloyd Stephens and Frederick Catherwood there can be no question. *Incidents of Travel in Central America, Chiapas and Yucatan* and *Incidents of Travel in Yucatan* were best-selling accounts of two extensive expeditions they undertook in the Maya heartland; they contain many accurate engravings, lithographs, and photographs of ruins seen through a romantic filter.[9] Wright had another early connection to Pre-Columbian architecture through Bruce Price, an architect he admired, who in 1885 had designed the Tuxedo, New York, home of Pierre Lorillard with reference to Pre-Columbian forms. (Lorillard was an enthusiast of ancient America who had sponsored Charnay's 1880 expedition to Mexico as well as Le Plongeon's expeditions to Yucatán.)[10] One further channel of this interest in Pre-Columbian art was probably the Arts and Crafts movement in upstate New York, exemplified by Gustav Stickley, which upheld the simplicity and purity of regional and vernacular traditions of handcrafted decorative arts as a counter to the depredations of industrial production.[11]

Wright's most intensive and direct exposure to Pre-Columbian architecture took place in 1893 during his many visits to the World's Columbian Exposition in Chicago, where he worked on Adler and Sullivan's Transportation Building.[12] The fair was dominated by a conservative eastern establishment that repudiated the progressive Chicago School by adopting a Neoclassical aesthetic idiom for the main buildings. Wright, however, ignored this standard and fastened instead on the fair's romantic and exotic aspects as a means of achieving an appropriate form with which to embody the culture of the New World, especially on the examples of Japanese and Pre-Columbian architecture that could be seen there.[13] Prominent Japanese buildings included the Nippon Tea house and the official exhibit of the imperial Japanese government, a replica of a wooden temple of the Fujiwara period known as the Ho-ho-den. The display of pre-Hispanic architecture was relegated to the rear of the fairgrounds in the anthropological section reserved for the representation of the customs and arts of native peoples, but its elaborateness was in keeping with the general theme of the exposition, which was a celebration of the accomplishments of four hundred years of American progress since Pre-Columbian times.[14]

Frederick Putnam, director of the anthropology exhibits at the fair as well as of Harvard's Peabody Museum, had arranged full-size plaster casts of Indian ruins around the exterior of the Anthropology Building (replete with vegetation simulating the trees and bushes rooted in these ruins *in situ*). These included major monuments of the Puuc style of Maya architecture (c. A.D. 700–1000): the great portal of Labná and three structures from Uxmal—the central portion of the Serpent House, two sections of the Nunnery, and the corbel-vaulted (closed) portal from the Governor's House—as well as a large monolith and several steles from Petén Maya sites. They had been prepared expressly for the exposition by Edward Thompson, American consul to Mérida and amateur antiquarian who spent many years exploring and excavating ruins in Yucatán (until he was finally evicted from Chichén Itzá during the Mexican Revolution for dredging and looting the treasure of its sacred cenote for the Peabody Museum).

The Anthropology Building contained a sizable exhibition of Maya artifacts and

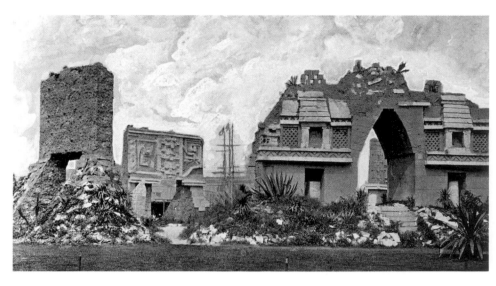

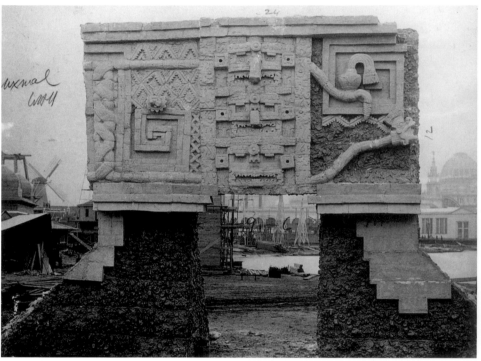

reliefs, as well as 162 large photographs of recently discovered ruins in Mexico and Central America. Taken by Alfred Maudslay and Teobert Maler, who had systematically explored and documented the Maya area since the early 1880s, they pointed up the new application of technology to the study of archaeology. Maudslay's large, meticulously prepared pictures, which were shot head-on and gently lighted, clarified every detail of structures at Copán, Quiriguá, Tikal, Yaxchilán, Palenque, and Chichén Itzá, while Maler's pictures of more obscure Yucatecan ruins, such as Iximche, Sayil, Labana, Xixhmol, Tsits, and Hochob, which were shot with a raking light, dramatically accentuated the overall light-and-dark patterns of the facade decoration. Thus, visitors to the anthropological exhibit had an opportunity to experience the monumental scale, iconographic complexity, and exotic settings of these Maya buildings in considerable depth, through both casts and photographs.[15] They also would have got the message (propounded by the Peabody) that the Maya of the classical period was the only ancient indigenous culture worthy of consideration by high-minded patrons and aesthetes.

Following the fair, the Pre-Columbian artifacts, including the plaster casts, were acquired by Chicago's new Field Columbian Museum, which displayed selected exhibits from the exposition. Thus, Wright had an opportunity to examine them at his leisure, together with Maudslay's and Maler's photographs, which were soon reproduced in a number of publications.[16] The proximity of the Field Museum undoubtedly drew Wright's attention to its curator, William Henry Holmes, whose *Archaeological Studies among the Ancient Cities of Mexico* was the first systematic archaeological treatment of

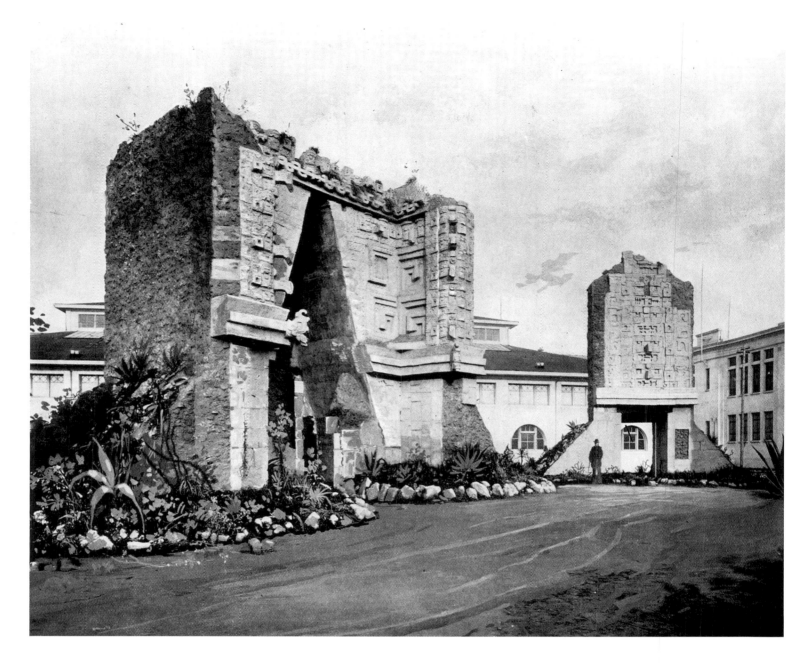

ancient American architecture as a distinct subject. Paying particular attention to the graphic presentation of masonry and construction, it contains meticulous renderings of plans, elevations, facades, and panoramic views of Pre-Columbian cities—which a trained architect could easily translate and emulate—while also reconstructing the life and times of their creators.[17] In the following decades, additional data on ancient Maya building design and technique were available to Wright in the proliferating archaeological literature on the subject, including the excellent publications of Maler, Alfred Tozzer, and Herbert Spinden.[18]

Though Wright was exposed to and began to assimilate Japanese and Pre-Columbian architecture at the same time and valorized them in the same terms—as elemental, indigenous, and natural in form and material and as a counter to the decadent, artificial, classicizing Beaux Arts style[19]—the full impact of ancient American architecture on his designs was delayed. In his early Oak Park years he appropriated an eclectic mixture of Shingle, Palladian, Queen Anne, and exotic styles in his domestic designs. The Charnley and Winslow houses, for example, were characterized by a blockiness, solidity, and cubic massing that traditionally have been attributed to Wright's exposure to Froebel's experimental kindergarten toys known as "Gifts and Occupations," a set of geometric blocks (spheres, cubes, cylinders) and basic craft activities that were the centerpiece of his progressive pedagogical theory,[20] and more recently to his adherence to a popular theory of composition called Pure Design that emphasized circles, lines, squares, and polygons.[21] But these traits also reflect the compact cubic shapes, frontality, and verticality of the Maya temples from Uxmal and

PAGE 142, ABOVE:
Alfred P. Maudslay. Casa de Monjas (the Nunnery, eastern face of wing), Chichén Itzá, Yucatán, Mexico. In Biologia Centrali-Americana, 1889–1902, vol, 3, pl. 15. Carbon print, 32½ × 25¼". The Brooklyn Museum Library Collection

PAGE 142, BELOW:
Teobert Maler. Temple 33, Yaxchilán, Chiapas, Mexico. Maya, 8th century. Photograph: 1900, from a 4 × 5" glass plate. Peabody Museum of Archaeology and Ethnology, Harvard University, Cambridge

PAGE 143, ABOVE:
Frank Lloyd Wright. Charnley House, Chicago, Illinois. 1891. Frank Lloyd Wright Archives, Scottsdale, Arizona

PAGE 143, BELOW
Frank Lloyd Wright. Winslow House, River Forest, Illinois. 1893–94. The Frank Lloyd Wright Archives, Scottsdale, Arizona

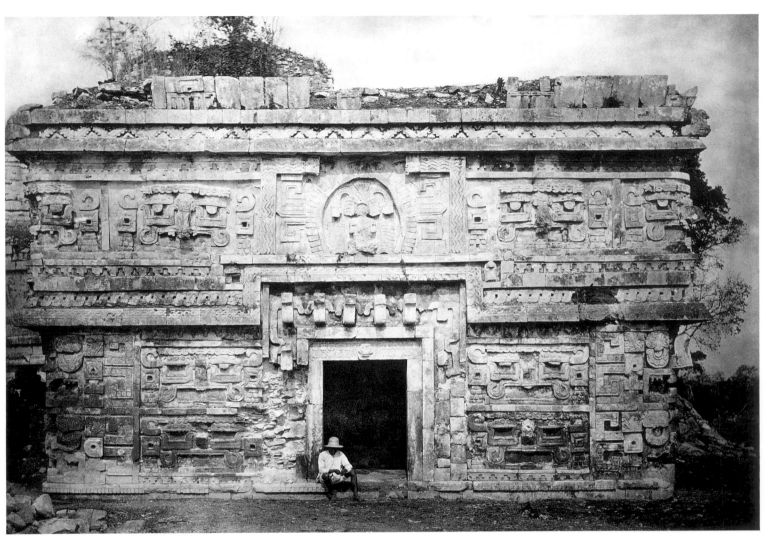

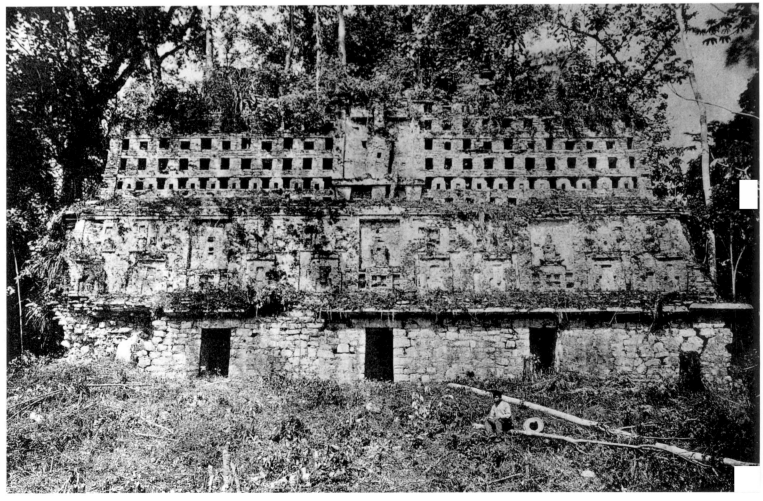

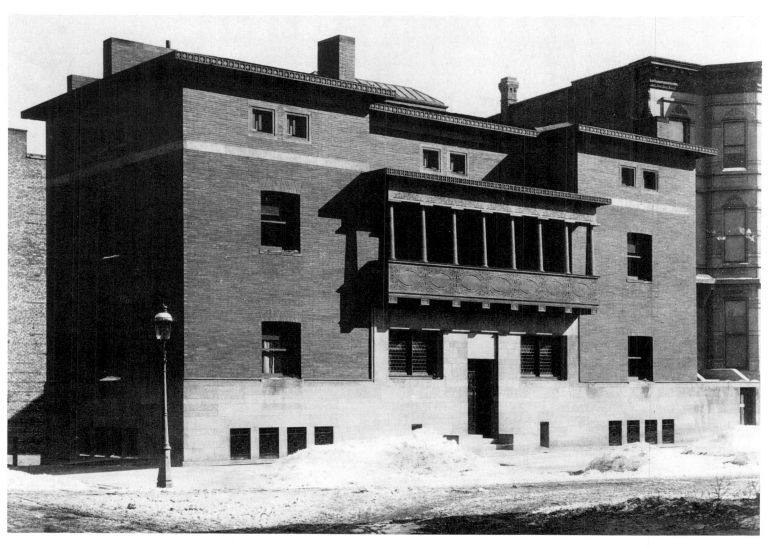

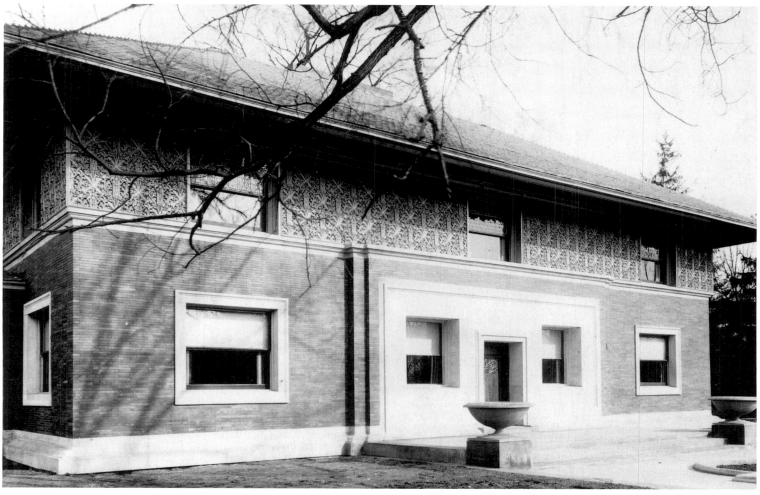

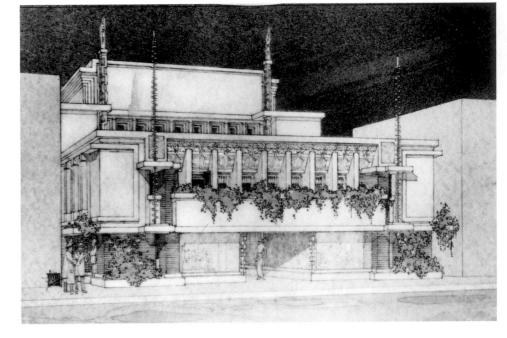

Frank Lloyd Wright. Kehl Dance Academy, Madison, Wisconsin. 1912. Drawing, 15×21". The Frank Lloyd Wright Archives, Scottsdale, Arizona

William Holmes's illustration of mosaic patterns adorning buildings at Mitla, Oaxaca, Mexico. From Fieldiana: Anthropology, 1895, vol. 1, fig. 84. The New York Public Library

Chichén Itzá that were replicated at the fair.[22] Moreover, minor surface details of these houses—exterior decorative moldings, stripping, coursing, and interior capitals—appear to derive from Puuc-style architecture.[23] Thus the Winslow house seems to allude to Pre-Columbian monuments in the masklike configuration around its front door, the division of its facade into a decorative upper band (covered with Turkish-inspired designs) and plain lower surface, as well as in the capitals of the columns in its hallway screen. After 1895, however, this influence receded from view as the Prairie houses became more deeply affected by the stylized forms, economy, and directness of Japanese prints and the elongated asymmetrical plans, low-pitched, overhanging roofs, and rectangularly divided walls typifying Japanese buildings.[24]

Not until the second decade of the new century did Wright turn to Pre-Columbian ideas of form in a major way, only after he had exhausted the Prairie style and experienced profound personal and professional dislocations. Between 1909 and 1914, he left his wife for another woman and exchanged his suburban Oak Park existence for that of a peripatetic aesthete. He also sojourned in Europe on the occasion of the publication of the Wasmuth Album of his work in Germany, where he was exposed to European primitivism. Finally, he endured the tragic fire and murder of his second wife at his Taliesin, Wisconsin, retreat, and the ensuing scandal.

The turmoil in Wright's life happened to coincide with the advent of a new movement favoring the revival of indigenous architectural styles, and this conjunction of events apparently rekindled Wright's longstanding interest in Pre-Columbian architecture. He now turned to ancient Mesoamerican buildings as prototypes for a series of experimental designs using new materials, paying particular attention to their architectural sculpture as a model for integrating ornament into the structure of his buildings.[25]

In the early years of the decade Wright's interest in Pre-Columbian forms was confined mainly to architectural ornamentation. His first overt use of ancient indigenous motifs appears in the Kehl Dance Academy in Madison, Wisconsin, an unrealized project of 1912, which incorporates, between the piers of its second-floor porch, a fret design that adorns many Puuc-style buildings, such as the facade of the Governor's Palace and the western range of the Nunnery at Uxmal (replicated at the World's Columbian Exposition in Chicago). The corner posts on the third level of this building are also adorned with a zigzag pattern topped by wedge-shaped stones, which probably refer to the stylizations of serpents common to Maya architectural sculpture in Yucatán. Examples include a portion of the Nunnery facade that was replicated at the Chicago fair and up-ended serpent columns found at Chichén Itzá (which were often reproduced as isolated forms).[26] These zigzag patterns further recall the conventionalized serpents, clouds, and waves that comprise the ornamental mosaic friezes on Mixtec buildings at Mitla, which Wright could have studied in Holmes's precise illustrations in *Archaeological Studies among the Ancient Cities of Mexico*.[27]

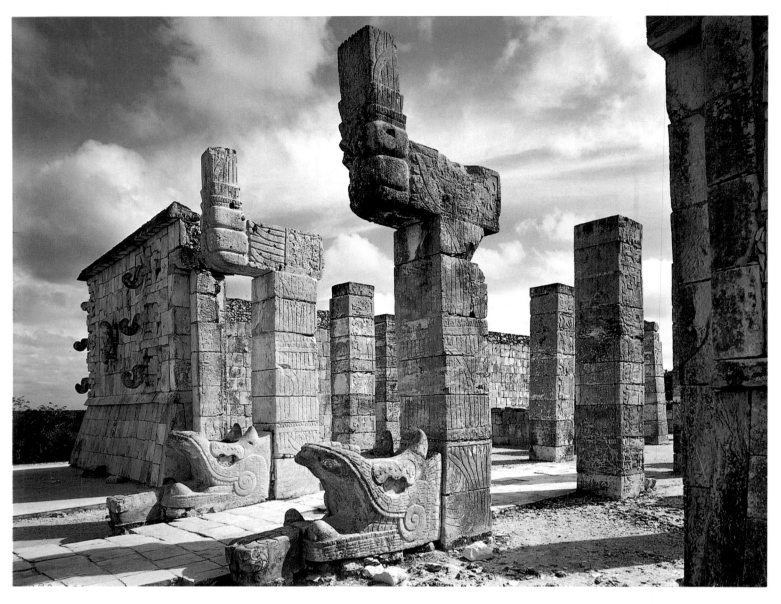

Upended feathered serpent columns, entrance, Temple of the Warriors, Chichén Itzá, Yucatán, Mexico. Toltec-Maya, 1000–1200

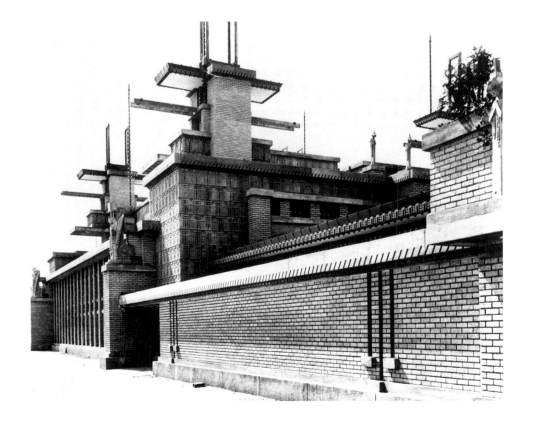

Frank Lloyd Wright. View of giant concrete finials, Midway Gardens, Chicago, Illinois. 1914. Demolished. The Frank Lloyd Wright Archives, Scottsdale, Arizona

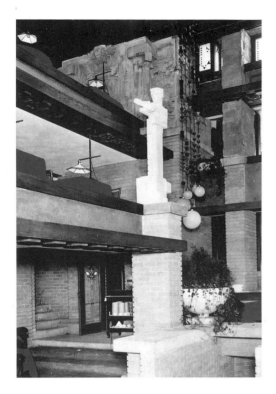

Frank Lloyd Wright. Dining area (with balcony relief visible at top), Midway Gardens, Chicago, Illinois. 1914. Demolished. The Frank Lloyd Wright Archives, Scottsdale, Arizona

The ornamental systems of a number of Wright's projects of these years pay homage to the geometricized architectural decoration of ancient Mexico, revealing his intense appreciation of its rigorous and complex manipulation of shapes and patterns abstracted from nature. In the Midway Gardens of 1914, an open-air Chicago music hall and restaurant, he turned to Maya forms not only for motifs that would enhance the exotic Arabian Nights atmosphere he wanted to achieve but also to learn how to integrate figural, symbolic, and architectonic forms into an organic whole. He was convinced that the conformity of such forms to a grid was expressive of the machine age, because it made possible their production with modern materials and mechanical techniques.[28] He also attributed a metaphysical power to conventionalized figural representations, and this notion may have been reinforced by an awareness of the symbolism of Maya and Mexican designs that had been advanced by many interpreters of Pre-Columbian culture.[29]

Scattered throughout the Midway Gardens complex were sculptural decorations inspired by pre-Hispanic forms. They include semiabstract three-dimensional forms, such as the great concrete finials at the corners of the winter garden, which recall in a general way the monoliths with reticulated profiles that served as guardian or standard-bearer figures, or space and time markers on the plazas and pyramids of Maya and Mexican cities. A large relief at the end of one of the top dining balconies in the indoor restaurant specifically refers to the relief from the Temple of the Cross at Palenque, which was frequently reproduced in the archaeological literature. Both images represent centralized heads flanked by tall figures juxtaposed with rectangular forms.[30] A frieze on a ledge of the F. C. Bogk House in Milwaukee, Wisconsin, 1916, shows Wright's application of similar Maya models to domestic designs of the period. It features a centralized head with a conventionalized beard surrounded by rectilinear forms and is derived from a combination of details on Puuc facades and Petén reliefs, which Wright may have studied in Spinden's *A Study of Maya Art.*[31]

At Midway Gardens, the key instance of Wright's dependence on Pre-Columbian forms is the first appearance of his special, precast-concrete decorated blocks, which were elaborated with abstract geometric patterns in layered planes inspired by Maya and Mixtec ornaments. He called them textile blocks to distinguish them from

Relief from the Temple of the Cross, Palenque, Chiapas, Mexico. Maya, 600–800. After Alfred P. Maudslay, in Kubler, Studies in Classic Maya Iconography, *1969*

Frank Lloyd Wright. Frieze unit, F. C. Bogk
House, Milwaukee, Wisconsin. 1916.
The Frank Lloyd Wright Archives,
Scottsdale, Arizona

Puuc Maya–style facade mosaic, east building, the
Nunnery quadrangle at Uxmal, Yucatán, Mexico,
700–1000

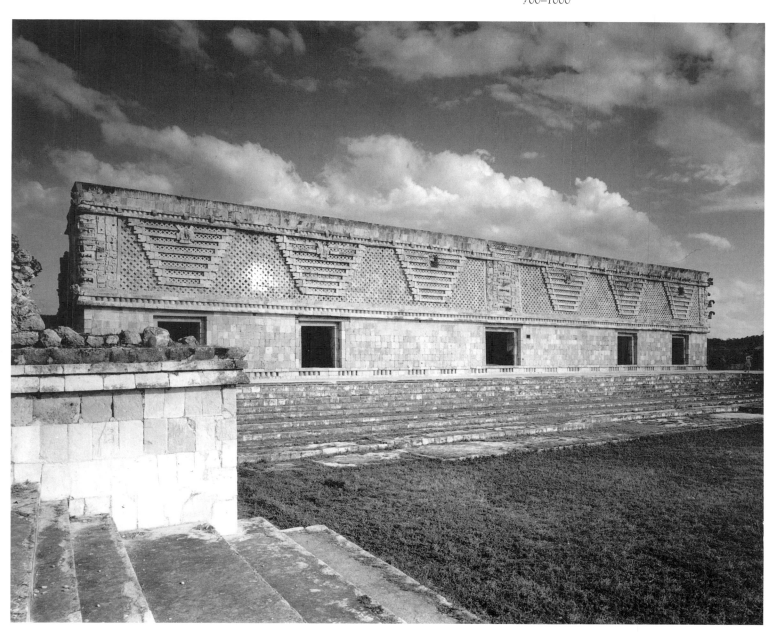

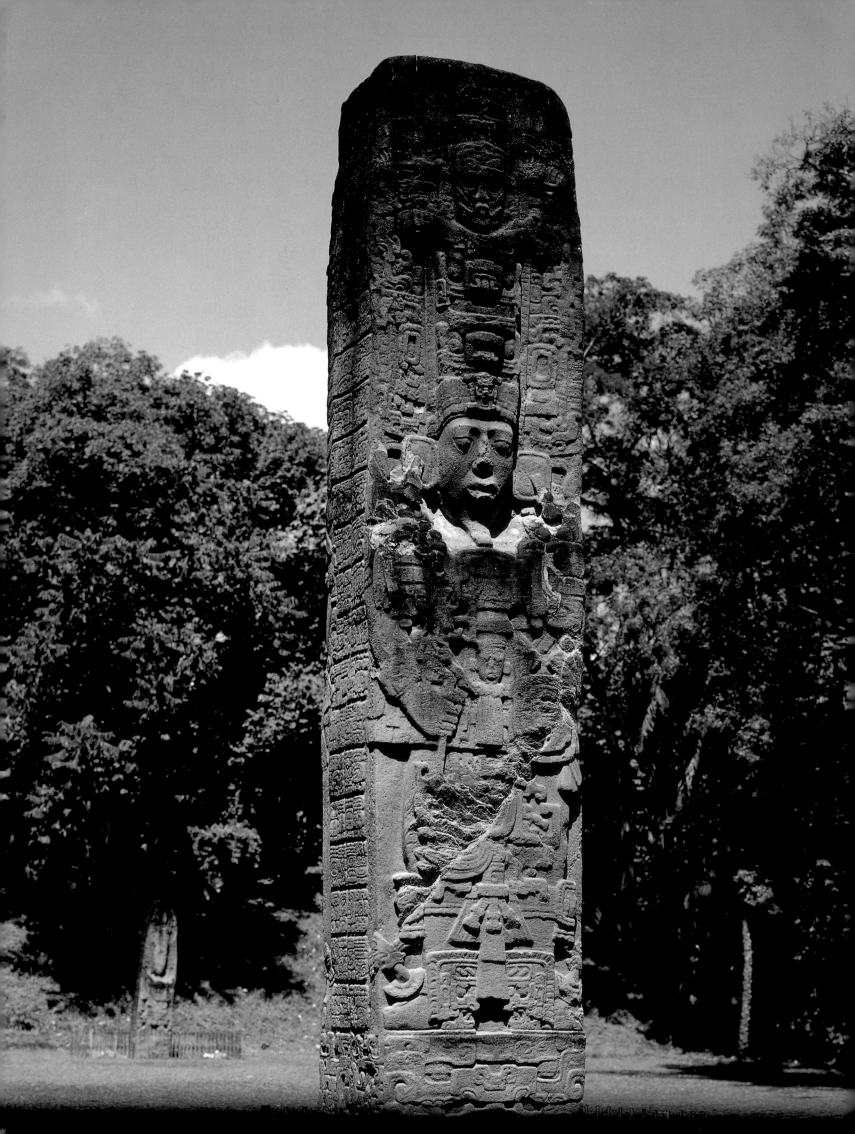

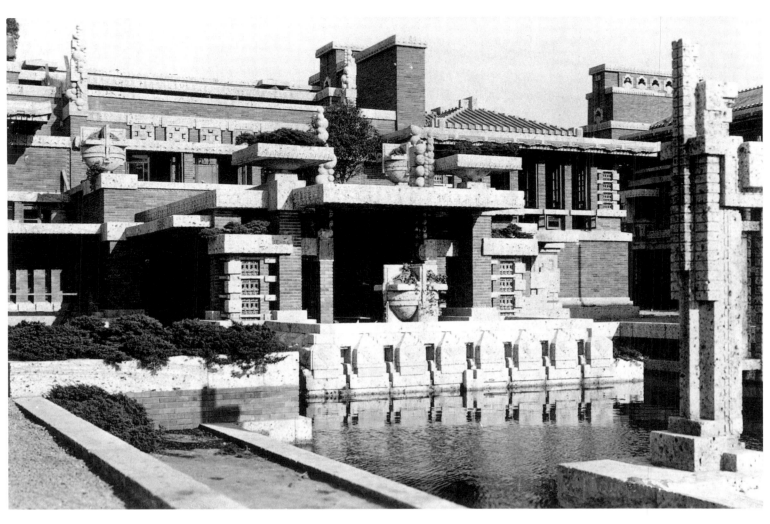

ordinary prefabricated building blocks and maybe to allude to the origin of their ancient prototypes in textile art—an idea suggested by Holmes and other Pre-Columbian experts.[32] That Wright resorted to Maya models at the time he began to experiment with concrete as a modern material may be no coincidence, since the Maya regularly employed concrete or lime cement (faced with a veneer of thin limestone or stucco) as a building material. With concrete he could create smooth or textured surfaces and could convey sculptural volumes resembling those of Maya architecture.[33] At Midway Gardens Wright used these blocks over a masonry foundation, but in the 1920s he developed them into a system for constructing entire walls covered with lively rectilinear patterns on their interior and exterior surfaces—like weaving in concrete, he said[34]—which became the hallmark of his Los Angeles houses. The interior and exterior of the Imperial Hotel in Tokyo, a huge contemporaneous project that occupied Wright from 1911 to 1922, was also articulated with geometricized ornament resembling the concrete decorations and machine-made blocks of Midway Gardens, but these were created by handwrought chiseling of tufa-like stone and interwoven with the building's brick and concrete shell.[35]

The most striking example of Wright's Pre-Columbian-inspired buildings of this period is the A. D. German Warehouse in Richland Center, Wisconsin (page 136), designed in 1915 as storage space for commodities and constructed between 1917 and 1920. Here, for the first time, the overall configuration of Wright's building is Pre-Columbian, specifically recalling both the Temple of the Two Lintels (page 136) and the Red House (also known as Chichán-Chob) at Chichén Itzá.[36] All three structures are large rectangular blocks with facades pierced by three narrow vertical openings and divided into a decorated upper band and an undecorated lower zone. Since the warehouse required few windows and large blank walls to fulfill its function, it lent itself to an adaptation of these Maya models. But the interior space of Wright's building, which is based on more conventional sources, bears no relation to the Maya floor plans with their long and narrow rooms.

To establish the warehouse's highly decorated coursing, Wright continued to experiment with concrete, in this case using standardized precast-concrete blocks based

Frank Lloyd Wright. Imperial Hotel, Tokyo, Japan. 1915. Demolished. The Frank Lloyd Wright Archives, Scottsdale, Arizona

OPPOSITE:

Stele E (south side), Quiriguá, Guatemala. Maya, 8th century. Sandstone, height c. 8′6″

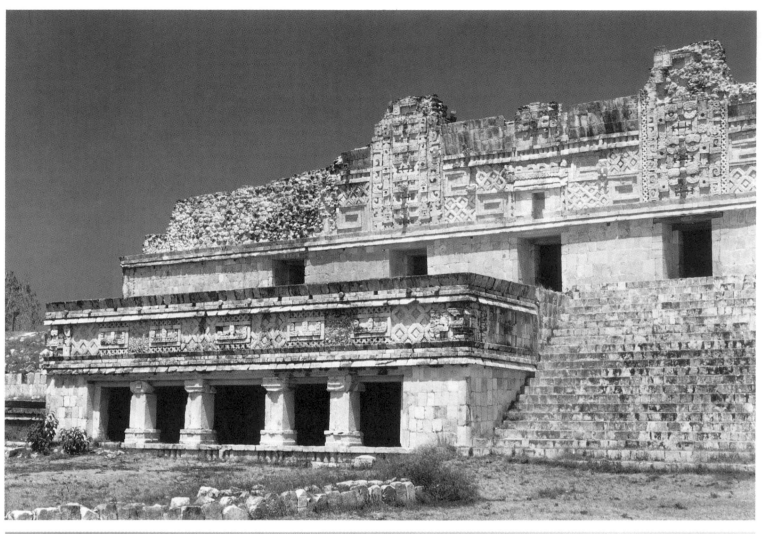

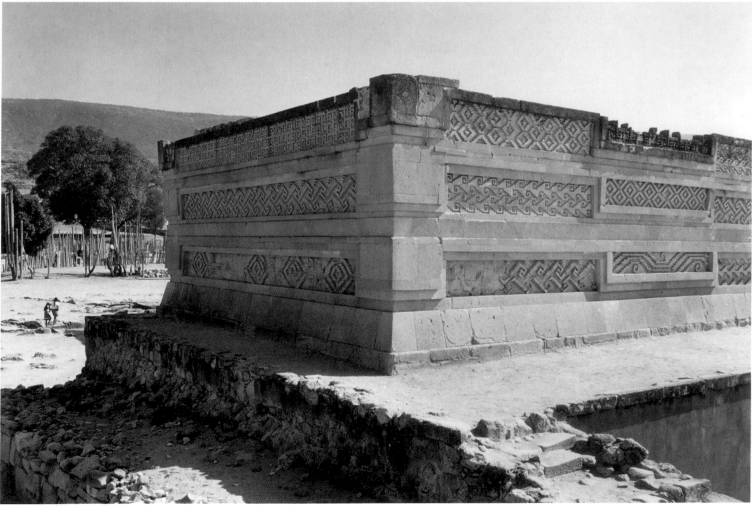

on a regular grid and filled with squares within squares. He may have abstracted their pattern from the upper zones of these same Chichén temples, which consist of lattices and frets set with stone columns or masks. His frieze, however, more closely resembles the horizontal geometric mosaic panels bordering the exterior of buildings at Mitla, which were decorated with meanders of small cut stones inlaid and fitted together with great precision. The outward cant of the warehouse frieze and the cornice above its doorway also echo those of buildings at Mitla. At the same time, however, the gargoyle-like projections on the corners of the warehouse (like the flagpole brackets on the Kehl Dance Academy) derive from the protruding hooked tongues of Maya rain deities called Chacs, which adorn Puuc-style buildings at Uxmal and Chichén. Thus, Wright was culling and combining a variety of motifs from the architecture of different Pre-Columbian cultures, not just the Maya, and creatively adapting them to his own purposes. At this time, his appropriation of pre-Hispanic models was confined to their overall configuration and ornamentation; it did not extend to the composition of interior spaces, which he based on more conventional sources.

MAYA REVIVAL HOUSES

Between 1916 and 1922 Wright spent most of his time in Japan, supervising the construction of the Imperial Hotel, but he nevertheless accepted a commission from Aline Barnsdall, a Chicago oil heiress and theater enthusiast, to build an elaborate complex on a hill she had purchased in Hollywood, California; it was to be an artists' colony consisting of a residence for herself, an experimental theater, artists' apartments and studios, shops, and smaller houses. (The only realized designs in this grandiose project were the main residence and two smaller houses.) Barnsdall's house, which Wright characterized as a "holiday adventure in American Romanza," was his first domestic design to fully exploit Pre-Columbian sources. And he evidently considered it an important design; he devoted several pages to it in his autobiography, despite the fact that he was unable to give it his full attention.[37]

Wright conceived of Barnsdall's house as a temple commanding the top of a terraced hill, surrounded by other buildings and strands of olive trees, with sweeping views in different directions of the city, near and far mountains, and the Pacific Ocean. Once again, as in the German Warehouse, he adapted the shape of a Maya temple for his building, but this time he was guided by a different style of Maya architecture. The steeply canted roof of the living room pavilion dominates the facade and seems to echo the shape and color of distant mountain slopes. It derives from the mansard-like roof profiles of Maya temples in the western Petén at the sites of Yaxchilán and Palenque, such as the Temple of the Sun at Palenque, rather than the flat rooflines of Yucatecan Maya structures, which are still evident in the building's wings. The piers supporting this roof also resemble those of the porch of this Palenque temple. Another Wright-designed residence of this period, the Tazaemon Yamamura house in Ashiya, Japan, has a similar steeply pitched roof, topped by a roofcomb-like form, which even more closely resembles Petén Maya models. By the same token, the notion of a temple that is apparently growing out of a hilly elevation and is closely oriented to the natural forms of the landscape and loosely linked on different levels to nearby structures and platforms by plazas and causeways recalls Maya site planning in the hilly jungle terrain of the Petén more than the flat plain of Yucatán. The excellent photographs of Petén structures by Maler, Maudslay, and Tozzer, which the Peabody Museum had recently published, may have inspired Wright's combination of these elements in his design for Barnsdall's house.

Petén Maya forms are also echoed in the main ornamental motif of the house, a stylized design based on the hollyhock, Barnsdall's favorite flower, which gives the house its name. Like the conventionalized designs Wright used to adorn Midway Gardens and the Bogk house, it has a hieratic form consisting of a central upright flanked by regularly spaced rectangular modules, and it too may have been inspired by the many examples of geometrically stylized natural forms illustrated in Spinden's A Study of Maya Art. He cast these abstracted hollyhocks in concrete and used them as a means of integrating the whole design, applying them to the exterior on decorative friezes, piers, and finials on the facade, inner courtyard, parapets, and rooftop terraces,

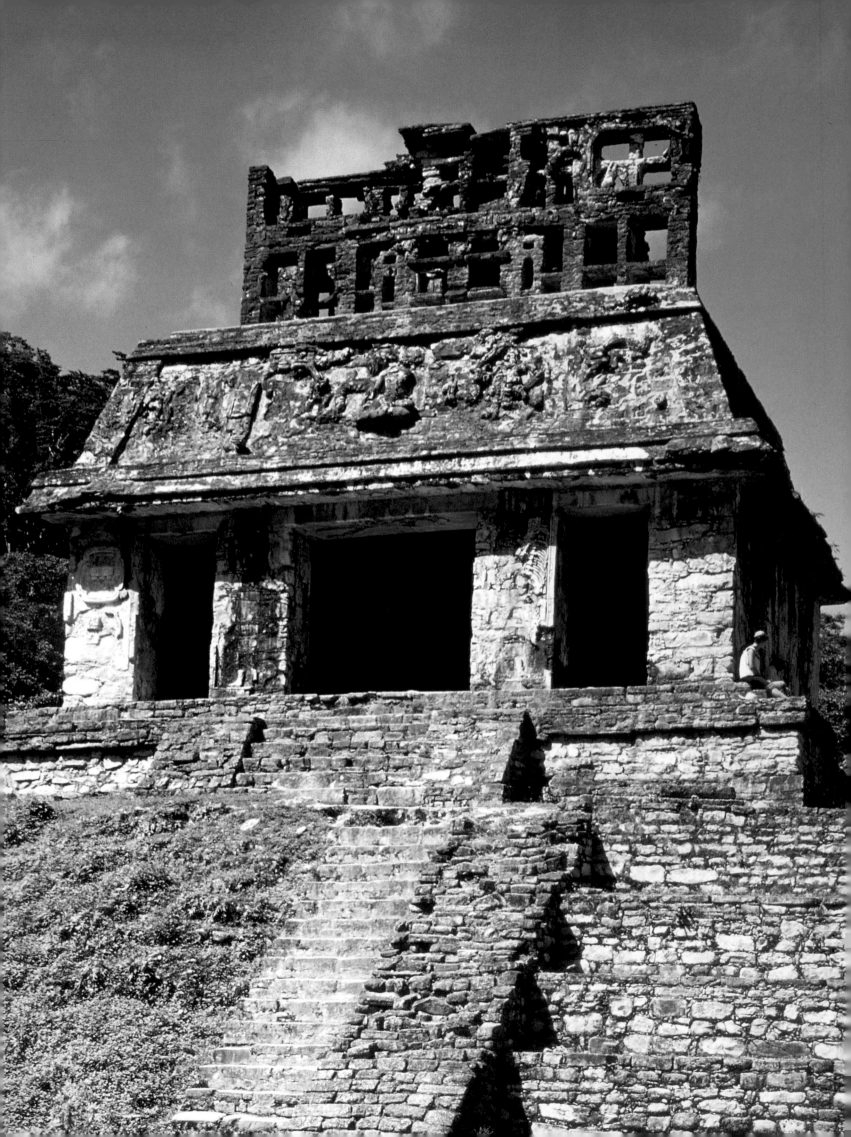

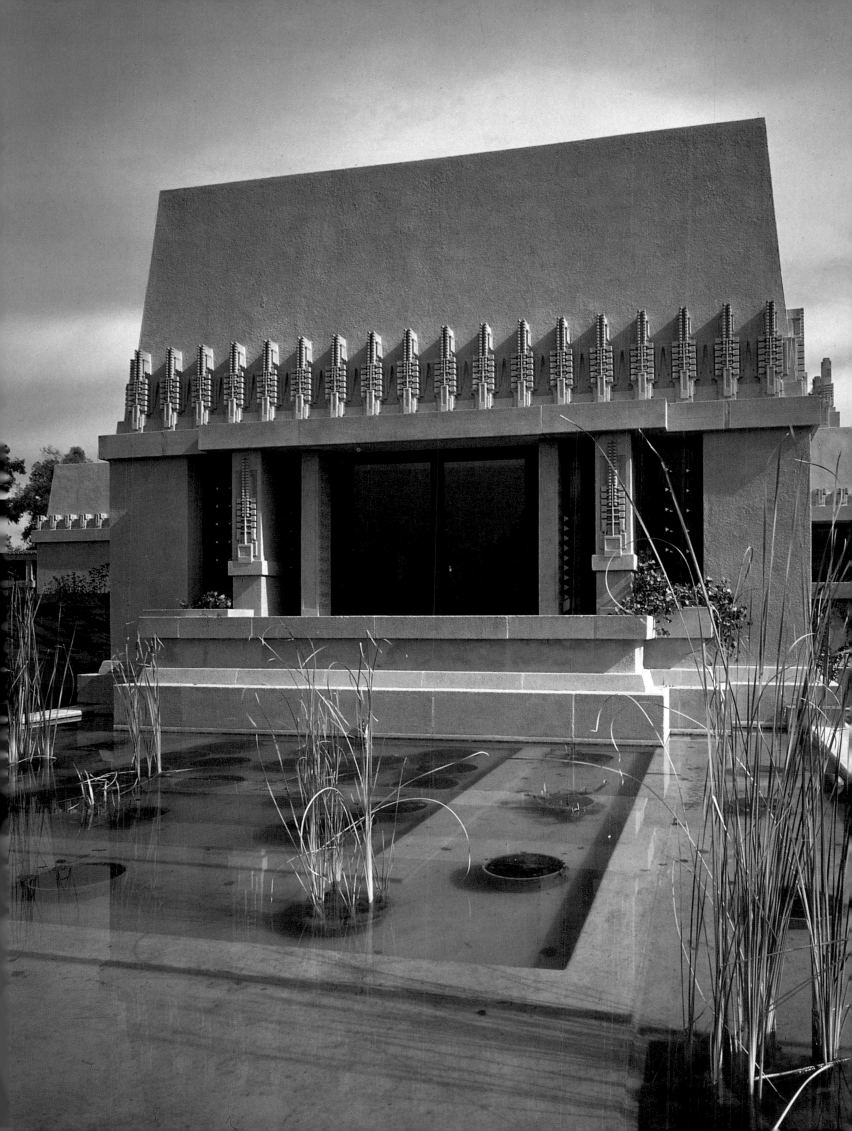

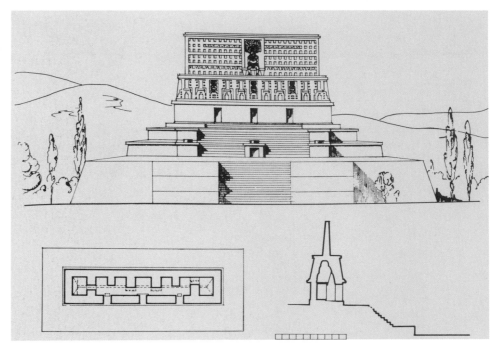

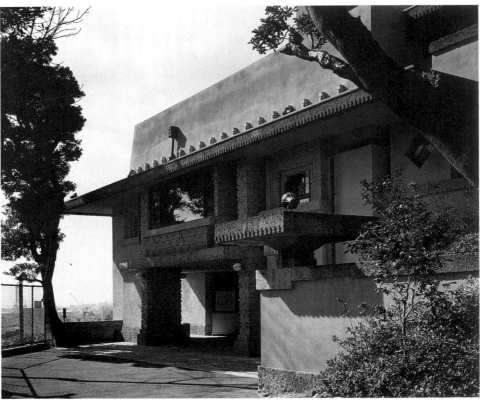

and to the interior as surface details on windows, walls, and floor coverings. Like them,
Wright intended the building to be constructed entirely of poured concrete, but
instead he used a combination of conventional wood framing, hollow structural tile,
and stucco with concrete poured over it to produce a smooth monolithic mass that
resembles Petén Maya architecture in both form and color.[38]

The interior of Hollyhock House carries out the exoticism of the exterior and its
pointed relation to the powerful natural forces defining the southern California
landscape. Wright adapted the complex plan from his earlier use of a Beaux Arts
cruciform plan, organizing it around an open courtyard, with the major axis going
through the loggia and living room and a secondary axis through the music room and
library.[39] The courtyard, which was intended as an outdoor theater, suggests the
ceremonial courts within Maya palace precincts, such as the famous one at Palenque.
A focal point of the plan is the fireplace, which is set at the juncture of the major and
secondary axes, diagonally opposite the entrance. The fireplace or hearth always carries
the main iconographical weight of Wright's houses, and Hollyhock House is no

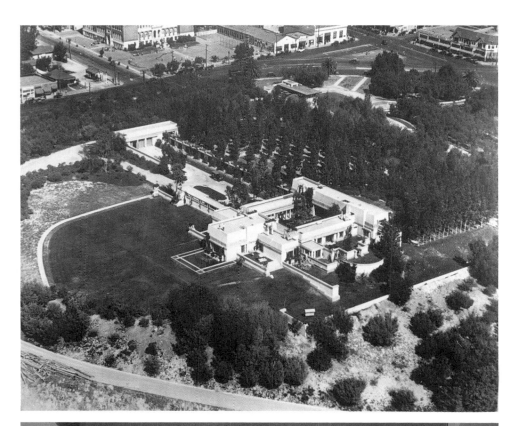

Frank Lloyd Wright. Aerial view, Aline Barnsdall (Hollyhock) House, Hollywood, California. 1920. The Frank Lloyd Wright Archives, Scottsdale, Arizona

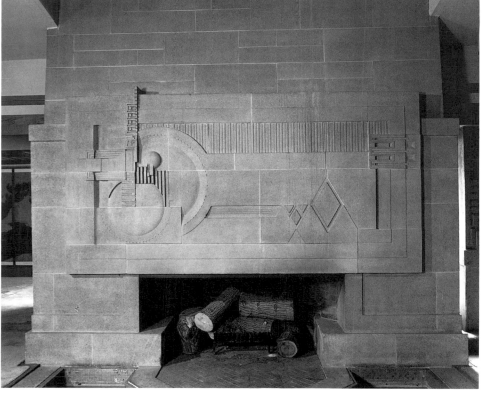

Frank Lloyd Wright. Living-room fireplace, Aline Barnsdall (Hollyhock) House, Hollywood, California. 1920

exception.[40] Constructed of cast-concrete blocks, it projects a third of the way into the room and rests under a skylight in a pool of water that flows from a stream in the courtyard. Embracing all the natural elements, it rises between the earth and the sky, like an *axis mundi* connecting a lower, earthy, and watery world and a higher, light-filled realm.[41]

On its mantel is a complex, narrative relief incorporating, in an asymmetrical composition, primary geometric forms that seem both mechanical and organic, as well as large and small versions of the abstracted hollyhock motif in profile. From the entrance across the room, the big hollyhock on the left-hand side suggests a regal figure looking out over a vast, receding landscape—an evocation of Aline Barnsdall surveying her domain (in his autobiography, Wright characterized the estate as her queendom). On a more abstract level, the iconography of the mantel symbolizes a

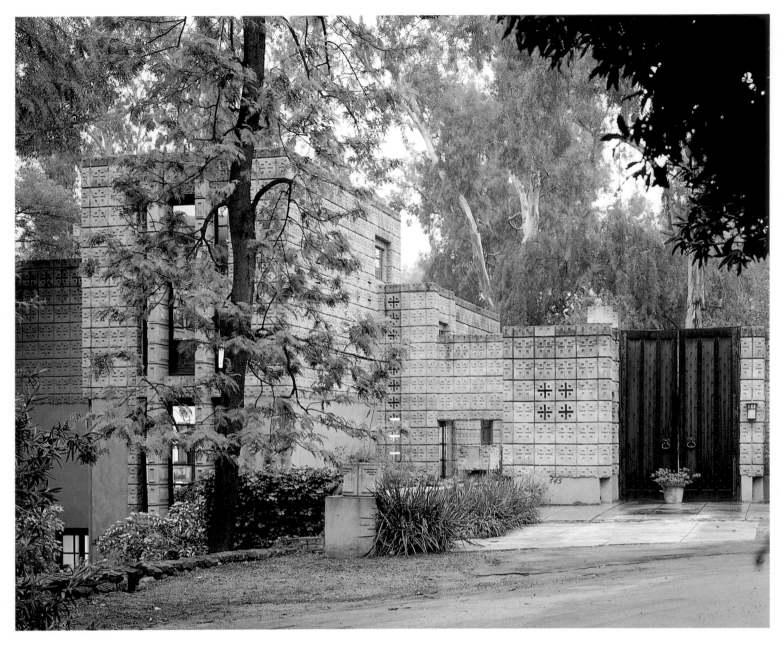

Frank Lloyd Wright. Rear facade, Alice Millard
House, Pasadena, California. 1923

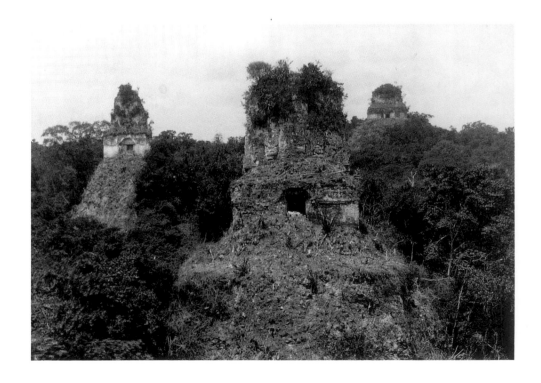

Teobert Maler. Photograph of Tikal, Guatemala,
showing temple site before excavation. The Peabody
Museum of Archaeology and Ethnology, Harvard
University, Cambridge

cosmic drama of cyclical change in nature: Circular forms on the left set up a recurrent rhythmic movement in the composition, which echoes the natural cycle of the water and sky circulating around and above the hearth.[42] Wright probably meant to evoke indigenous myths involving natural cycles and cataclysmic change, since during his stay at the Barnsdall estate in 1923 he wrote an essay articulating a theory of seismic convulsions in the Pacific rim, mentioning the cities of Los Angeles, San Francisco, and Tokyo (where he had just completed his earthquake-proof Imperial Hotel).[43] He may well have been thinking about the cataclysmic destruction of Atlantis, which was first recounted by Brasseur de Bourbourg, reiterated by Le Plongeon, and recently revived by other authors,[44] or about the Aztec myth of the creation and destruction of five suns or world epochs—the last culminating in an earthquake—which was an ideological mainstay of the ongoing social and cultural experiments in Mexico.[45] In this sense, Hollyhock House emerges as Wright's formal and symbolic response to these eruptive elemental forces, with a heavy debt to Pre-Columbian conceptions.[46]

Wright's translation of Maya forms in his buildings is usually regarded as an effort to create a truly indigenous American architecture based on native forms.[47] But it was one thing for him to use Maya-inspired forms in the German Warehouse in rural Wisconsin and quite another in the Hollyhock House in southern California, a region with an ancient pre-European past, which was formerly inhabited by Mexicans. There was, moreover, a local historicist style already firmly in place in the area.[48] Ever since the 1915 Panama-California International Exposition in San Diego, which had promoted a regional Spanish Colonial Revival as a defensive reaction to East Coast traditions, the new southern California elites had adopted the style of the early colonial missions with tile roofs and stuccoed walls as the local architectural standard. It responded to their architectural needs with a reassuringly familiar vernacular style, which also identified them with the first aristocratic Spanish conquerors who settled the area. As Gebhard has explained, Wright's revival of the Maya style in Los Angeles was an offshoot of this development, a deliberate attempt to surpass an acclaimed regional historicism by going back to an even more distant and exotic local past.[49] The monumentality and elaborate ornamentation of the Maya models—less domestic and more flamboyant than the popular neo-Spanish style—was also well suited to the extravagant life-style generated by the booming new movie industry.[50] Wright's adaptation of ancient American models on the West Coast also served to reaffirm his longstanding personal articles of faith: It emphasized his independence from Europe—especially apt during the epoch of World War I—and presented an appearance of being organic in relation to the local physical and climatic environment. In this way, the Peabody's exaltation of the Maya as the Greeks of the New World, befitting the attention of America's upper crust, which Wright first encountered at the great Chicago Exposition, found further expression in his hands in southern California.

TEXTILE-BLOCK HOUSES

Following the completion of Hollyhock House, Wright continued to mine this fancifully exotic regional architectural vein in 1923 and 1924, building four more residences in Los Angeles that were self-consciously based on Pre-Columbian models. Known as textile-block houses, they are calculated representations of romantic Maya ruins characterized by cubical massing, intricately patterned stonelike surfaces with chiaroscuro effects, and dramatic siting on foliated hilltops or ravines.[51] In designing them, however, Wright had a more serious intention than besting the local vernacular tradition; he saw them not only as art but as a force for human betterment. His hope was to develop a standardized system of construction appropriate for the machine age, one that would be efficient and economical but also integrally ornamental. It would demonstrate the possibility of using ordinary, inexpensive materials to build well-designed houses expressive of spiritual values. Their surfaces would be malleable to any design and would become "a living thing of beauty like textured trees," and the houses themselves would become "nothing less than a distinctly genuine expression of California life in terms of modern industry and American opportunity."[52]

The system he devised joined textured cast-concrete slabs—like the ones in Midway

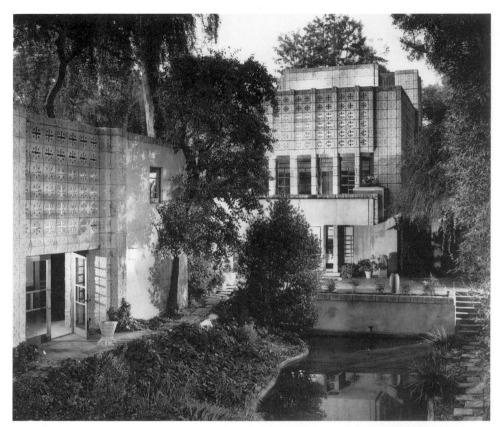

Frank Lloyd Wright. Street facade, Alice Millard House, Pasadena, California. 1923

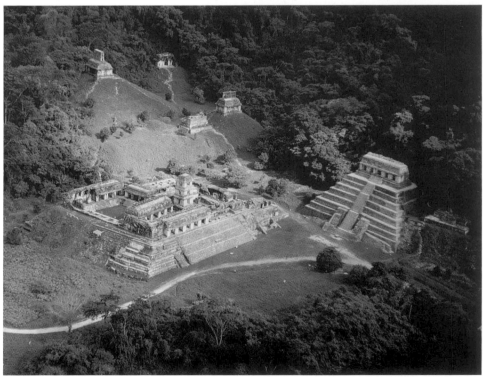

Palenque, Chiapas, Mexico. Maya, 600–800. Aerial view from the northwest showing (in left foreground) the Palace; (right) the Temple of the Inscriptions; (left rear) the Temple of the Cross, the Temple of the Foliated Cross, Temple 14, and the Temple of the Sun. Pre-Columbian Art Research Institute, San Francisco

Gardens that were based on the geometric mosaic decoration of Puuc Maya and Mixtec structures—with steel joints. It consisted of two parallel rows of four-inch-thick blocks separated by a hollow space, tied together at intervals both horizontally and vertically by a steel reinforcing rod. The units provided two continuous exposed surfaces, as well as insulation, and could be used for exterior and interior walls, floors, and partitions. In this way the structure and the surface of the building were woven together to create a literal building fabric, like the warp and weft of a textile.[53] Some blocks had smooth facing, others had (sometimes perforated) patterns based on geometric or conventionalized plant forms, which were molded in high relief to reflect and refract brilliant sunlight, like those of their ancient forebears.[54] Though Wright remained terribly proud of his revolutionary construction technique, his hope that it would be practical and economical was confounded by many unresolved technical problems and contradicted by his elitist patrons' desire for luxury housing.[55]

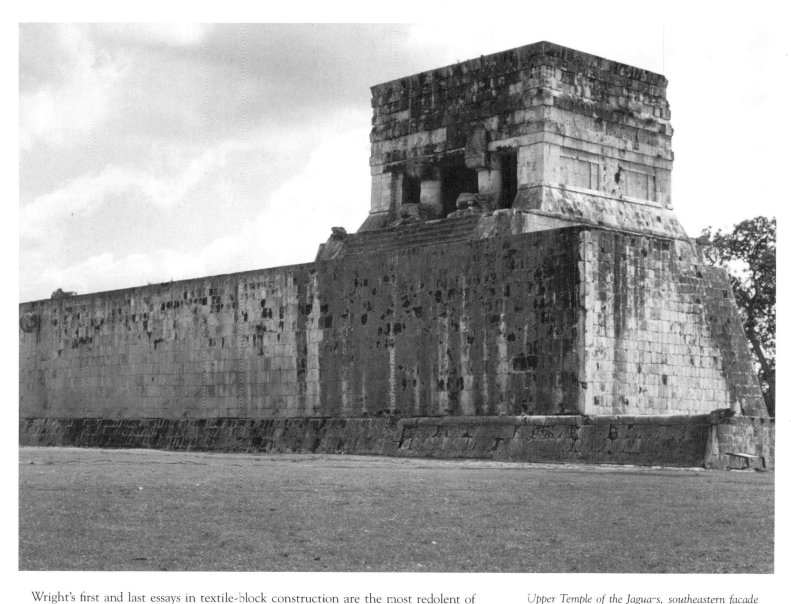

Wright's first and last essays in textile-block construction are the most redolent of ancient indigenous architecture. The house he designed in Pasadena in 1923 for Alice Millard, a transplanted Chicagoan (like Barnsdall) and former client, was his first—and probably most successful—effort. Smaller in scale and lighter in feeling than the other textile-block houses, it was dubbed La Miniatura by its owner, who intended it to be a studio-house that would accommodate her extensive book collection rather than be a full-scale home. Once the terrace walls, roof gardens, and balconies were added to the original design, however, the house was no longer so modest. Framed by two tall eucalyptus trees, the building rises three stories within a low ravine and overlooks a sunken garden and pond. Its intensely vertical format, surface play of light and shadow, and intimate relation to the landscape evoke Petén Maya ruins such as Temple III at Tikal, particularly in the romantic renderings by Catherwood. The approach through a sequence of changing levels and a paved court also appears to echo Maya site planning.

Once again, Wright synthesized and transformed culturally diverse pre-Hispanic formal concepts for one design. The cantilevered upper balcony of La Miniatura, with its tall French doors separated by piers, suggests a typical feature of Toltec-Maya architecture in Yucatán: upper temples with colonnaded porches, such as that of the Temple of the Jaguars on the ball court at Chichén or of the Temple of the Diving God at Tulum.[56] At the same time, the building's block pattern, which consists of a sunken, equal-armed cross at the center of a symmetrical pattern of overlapping squares, derives from the mosaic friezes on Mitla palaces, which were illustrated in Holmes's *Archaeological Studies among the Ancient Cities of Mexico*.[57] Wright used it all over the exterior and on the main interior space, a two-story living room with a wall of glass doors on the first level and perforated patterned blocks on the second. The latter was doubtless inspired by a spectacular interior hall in the Palace of the Columns at Mitla, whose entire upper surface is covered with geometric mosaics. In addition,

Upper Temple of the Jaguars, southeastern facade overlooking the Ball Court, Chichén Itzá, Yucatán, Mexico. Toltec-Maya, 1000–1200

PAGE 160:
Frank Lloyd Wright. Living room, Alice Millard House, Pasadena, California. 1923. Frank Lloyd Wright Archives, Scottsdale, Arizona

PAGE 161, ABOVE:
Interior of the Great Hall, Palace of the Columns. Mitla, Oaxaca, Mexico. Mixtec, 1200–1521

PAGE 161, BELOW:
Frank Lloyd Wright. Facade, Charles Ennis House, Los Angeles, California. 1923

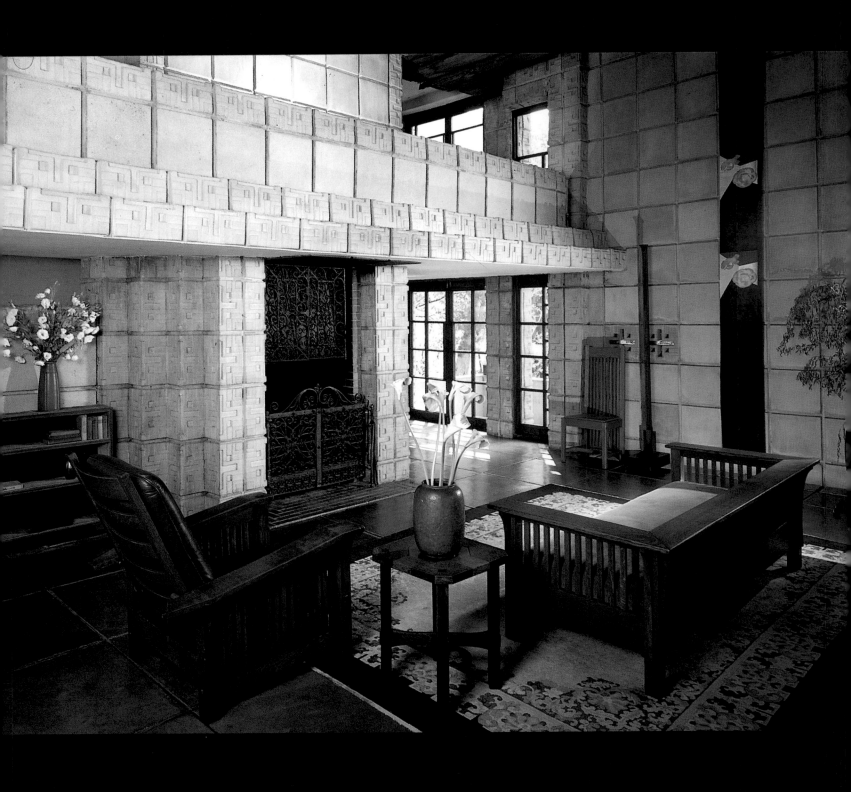

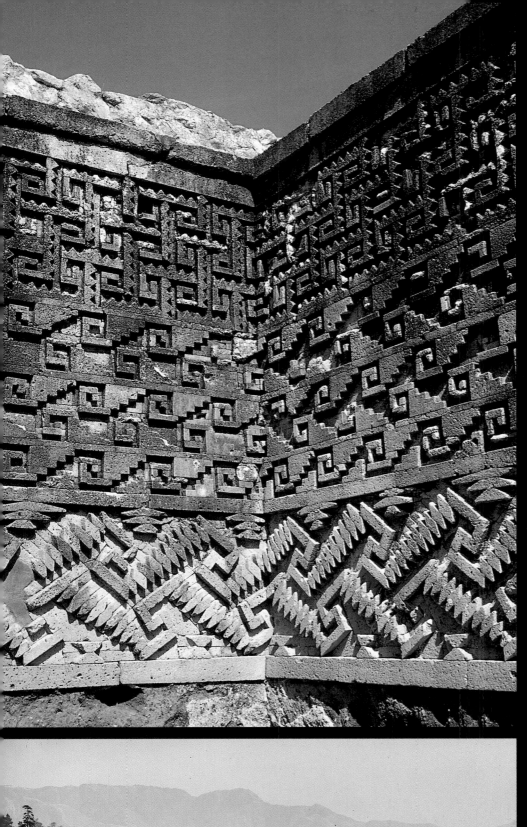
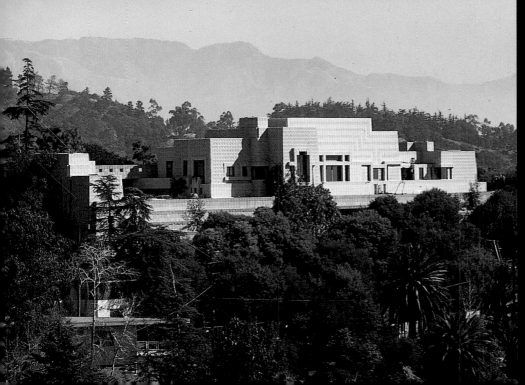

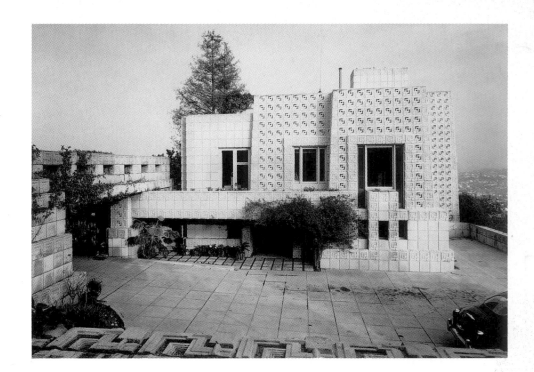

Frank Lloyd Wright. Exterior court, Charles Ennis House. 1923. Los Angeles, California

the interior courts of several structures at Mitla were decorated with bands of mosaics.

Of the remaining three textile-block houses, those built for John Storer and Samuel Freeman in the Hollywood hills are structurally more adventurous than the Millard house. Although their volumetric sculptural form, stonelike textured surfaces, and dramatic siting invest them with the aura of ancient American ruins, they depart very far from specific pre-Hispanic models. On the other hand, the textile-block house that Wright designed for Charles Ennis in 1924 was more directly indebted to Pre-Columbian models, perhaps because Ennis himself was a Maya enthusiast.

Resting on gigantic retaining walls, the massive Ennis House aggressively dominates a ridge at the base of the Santa Monica mountains and is visible from below for miles. The exterior recombines stylistic features of culturally diverse Pre-Columbian sources. Alternating bands of smooth and textured concrete block derive from the facades and interior courts of Mitla palaces. The battered outer walls and assembled vertical massing of the house and parapets, which appear to extend the hill on which it is built, were modeled after the agglutinated temples atop huge artificial acropolises at Maya sites, such as Tikal and Yaxchilán. At the same time, the horizontally stepped and sharply rectangular profile suggests a source in the more compact and severe pyramid platforms characteristic of the Mexican highlands. The fortress-like effect of the whole is intensified by the house's orientation away from the street.

Once inside the gates, however, the temple-fortress illusion recedes. The house itself is a large rambling affair characterized by a low, horizontal massing reminiscent of the palaces at Mitla.[58] On the exterior, deep perspectives of bright, broad, paved terraces and contrastingly dark, shadowed porticos and stairwells recall the intersection of wide ceremonial plazas with recessed doorways and tombs at pre-Hispanic sites, such as Monte Albán, Mitla, and Chichén Itzá. Inside, deeply patterned, inwardly sloping block walls and long receding hallways evoke the narrow, oddly angled corbel-vaulted corridors of Petén Maya residences, such as the Palace at Palenque, while rows of textile-block piers echo the relief-covered colonnades of the Temple of the Warriors at Chichén Itzá. The progression of shapes within the house—a constrained entryway leads to a highlighted "greeting area" of intersecting planes, which opens onto an eighty-foot-long hallway leading to the master bedroom, followed by a spacious, twenty-six-foot-high living room and then an intimately scaled dining room—also recall the erratically proportioned spatial sequences of many Maya sites.[59] The aggregation of these peculiar visual features, all of them transmutations of typical Pre-Columbian architectural traits, creates a surreal atmosphere of mystery and foreboding both inside and outside the house.

The Ennis House, moreover, is equipped with Maya-inspired detailing, including an ornamental iron gate and ironwork doors and windows punctuated with Maya hieroglyphs, both authentic and invented: A panel depicting a Maya ruler hangs over

OPPOSITE:
Frank Lloyd Wright. Hall leading to the master bedroom, Charles Ennis House. 1923. Los Angeles, California

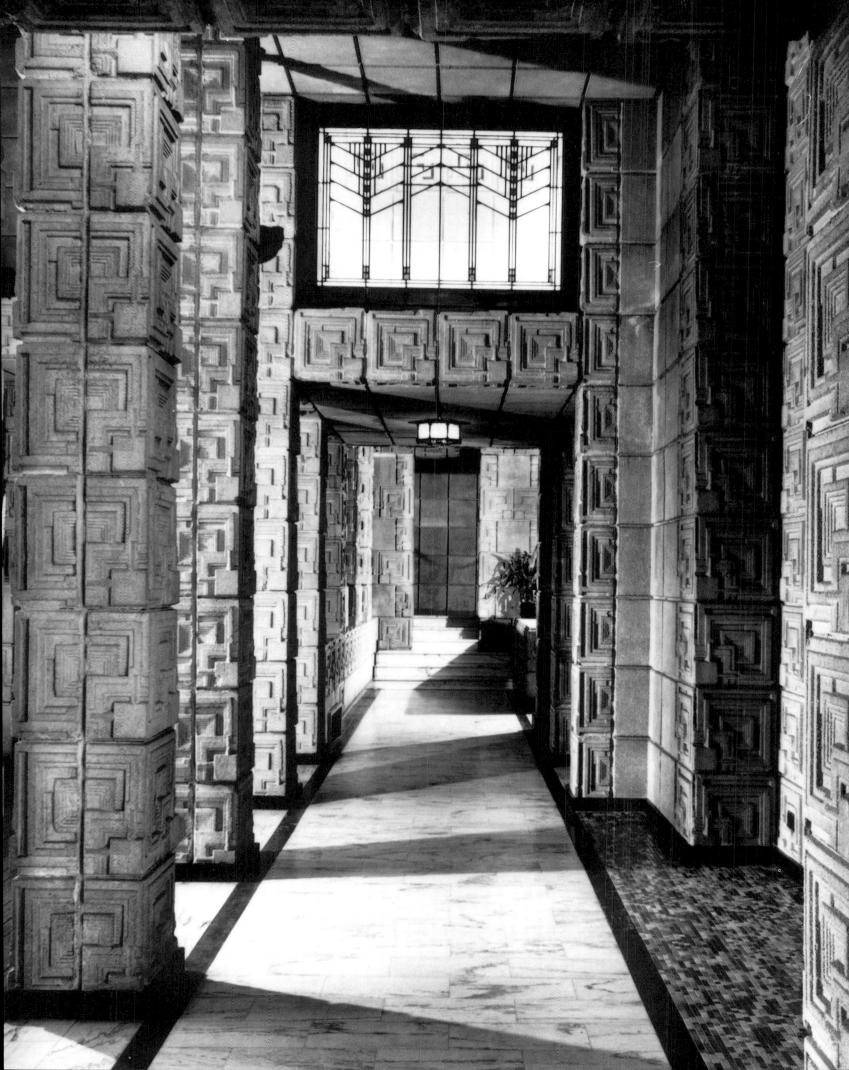

Interior corridor of the Palace at Palenque,
Chiapas, Mexico. Maya, 600–800. Pre-
Columbian Art Research Institute, San Francisco

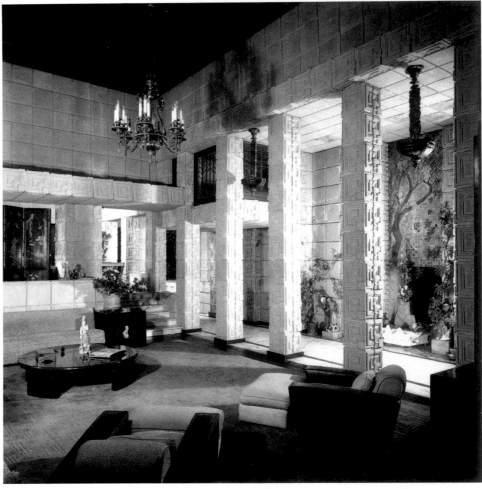

Frank Lloyd Wright. Detail of interior piers,
Charles Ennis House, Los Ángeles, California.
1923

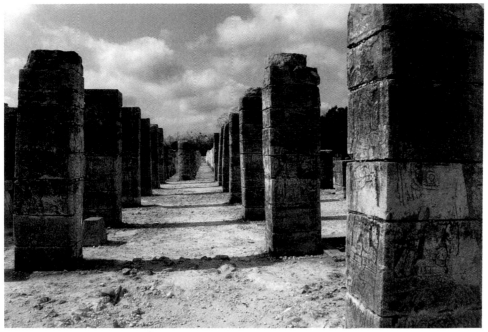

Sculptured columns in the Colonnade (facing south), Temple of the Warriors, Chichén Itzá, Yucatán, Mexico. Toltec-Maya, 1000–1200

LEFT:
Frank Lloyd Wright. Main gates with elements (on rectangular panels) derived from Maya hieroglyphs, Charles Ennis House, Los Angeles, California. 1923

BELOW:
Frank Lloyd Wright. Doheny Ranch Project, Los Angeles, California. 1923. Perspective drawing. Frank Lloyd Wright Archives, Scottsdale, Arizona

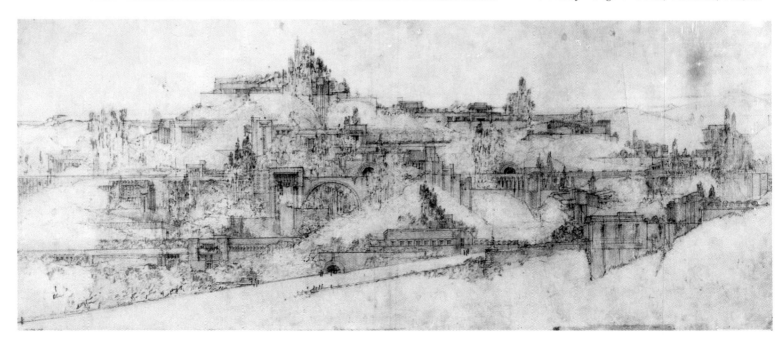

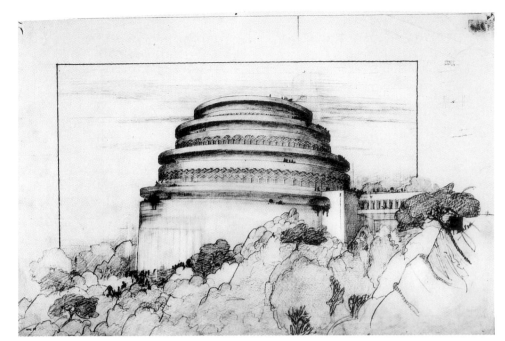

Frank Lloyd Wright. Gordon Strong Planetarium,
Sugar Loaf Mountain, Maryland. 1925. Drawing.
Frank Lloyd Wright Archives, Scottsdale, Arizona

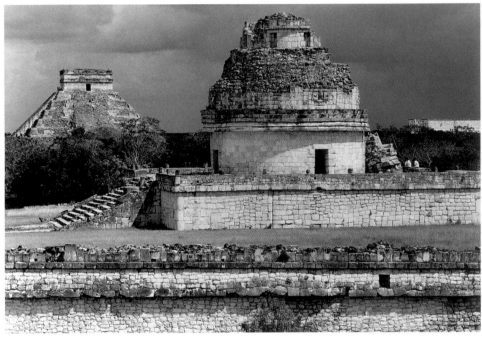

Observatory, Chichén Itzá, Yucatán, Mexico.
Toltec-Maya, 1000–1200

the dining room fireplace; incised Maya motifs decorate door pulls and light-switch plates; and Maya-derived designs cover ceramic tiles in the bathrooms.[60] These decorative touches were probably ordered by the owner rather than the architect, though they are incorporated in Wright's personal designs.[61]

An examination of some of Wright's unexecuted projects of the 1920s underscores the extent of his dependency on pre-Hispanic architecture and its insistent linkage with his visionary conceptions. One of the most imaginative was the Doheny Ranch project, an enormous real-estate development, commissioned by oil magnate Edward Doheny, consisting of a multilevel complex of concrete-block buildings, terraces, roadways, arches, and landscaping in the Sierra Madre. Its concrete-block mountainside villas were manifestly beholden to Pre-Columbian models and led directly to the Los Angeles textile-block houses. A design for the cabin of a Lake Tahoe resort project, calling for an inverted pyramidal structure and corbeled masonry and clapboard siding, also refers to Pre-Columbian architecture.[62] The Gordon Strong Planetarium was designed as a tourist attraction for a mountaintop in Maryland. A great advocate of the automobile for the future course of America, Wright called it the "Automobile Objective" project and centered it on an imposing spiral auto ramp, which was undoubtedly inspired by the spiral interior ramp of the Observatory at Chichén Itzá.[63] He also drew its heavy, compact base and inverted conical profile from the massive platform and circular plan of the same Pre-Columbian structure. Thus Wright consistently turned to ancient indigenous architecture as a vocabulary for his

most innovative designs, fusing stylizations of pre-Hispanic forms and a faith in new technology and materials into an articulation of his idea of the landscape of the future. While he failed to realize these projects at the time he conceived them, he was able to resuscitate many of them in slightly altered form later on.

THE MAYA REVIVAL STYLE

Wright's interest in reconstituting Pre-Columbian architecture prefigured a full-fledged Maya Revival style in southern California and elsewhere in the United States during the late 1920s and early 1930s, when several notable architects employed pre-Hispanic building motifs as a general source for a new modern American architecture derived from non-European models.[64] They fastened mainly on the angularity, repetitiveness, and abstraction of these ancient motifs as a means of responding in an American idiom to the great Parisian Art Deco Exposition of 1925 ("Exposition internationale des arts décoratifs et industriels modernes"), which promoted exoticism, geometricized ornament, and shiny new materials as the quintessential machine-age design. Unlike Wright, who had assertively denied Pre-Columbian influence on his work, these architects openly avowed it.

The proponents of the Maya Revival style encompassed a broad spectrum of professional tendencies; their ranks included vanguard architects like Wright's son Lloyd, establishment conservatives like Alfred C. Bossom, and fringe figures like Robert Stacy Judd. They designed all manner of private and public buildings— residences, hotels, shops, cinemas, skyscrapers, churches, civic centers—with a Pre-Columbian inflection. The style even spawned a handbook setting out an ornamental vocabulary for the style.

George Oakley Totten's *Maya Architecture* (1926) codified different versions of about a dozen Pre-Columbian architectural elements—friezes, columns, corbeled arches—for ready application to traditional plans so that modern architects might use them in the same way they use eighteenth-century Neoclassical orders. The book's incantatory dedication invokes the death of the Maya race and its reawakening and future preservation in the hands of a young and vigorous people of the North. The introduction, not surprisingly, hails the comparable efforts of Manuel Gamio and the Mexican Renaissance to discover Aztec art and culture and to develop a new national art based on this heritage.

Lloyd Wright's work was an extension of that of his father, to whom he remained close all his life and whose ideas and goals he embraced wholeheartedly. He has recalled that his father's efforts to establish a link and a continuity with indigenous American architecture, especially that of the Pueblo cultures of the American Southwest and the Pre-Columbian civilizations in Mexico and Guatemala, go back as early as the Oak Park years. Unlike his father, however, Lloyd Wright has not hesitated to declare his own interest in conveying the spirit of the American Indian in his buildings.[65]

After collaborating on the Barnes complex and supervising the construction of several of his father's textile-block houses, Lloyd Wright became a passionate devotee of Pre-Columbian architecture, and he executed several Maya-inspired buildings of his own. The most intriguing is the John Sowden House, 1926, in Los Angeles, whose striking entrance and interior court walls are flamboyant adaptations of Yucatecan Maya temple portals framed by stylized serpent-maw motifs, like that of the Chenes site of Hochob, which has extravagant volutes extending across the entire width of its central mass. The interior court of the Sowden House also contains Toltec-Maya-derived pillars and Maya-like steles (which recall the sculptured piers in the Midway Gardens). Lloyd Wright's use of curtains rather than doors to make the court's exterior and interior spaces continuous probably also derives from pre-Hispanic precedents.

In 1924 and 1925, the younger Wright designed a shell for the Hollywood Bowl whose angled panels and stepped surfaces simulated an ancient Mexican pyramid. But his Lake Arrowhead Hotel and Bungalows project, c. 1927–28, was the most specifically Pre-Columbian of his works.[66] The main building is a bridge that spans a canyon with a stream running through a corbel-vaulted tunnel reminiscent of vaulted passageways in the Governor's Palace and the Nunnery at Uxmal. It has a row of high

PAGE 168, ABOVE:
Lloyd Wright. Interior court, John Sowden House, Los Angeles, California. 1926

PAGE 168, BELOW:
House of the Doves, Uxmal, Yucatán, Mexico. Puuc Maya, 700–1000

PAGE 169, ABOVE:
Replica of Temple at Hochob, Campeche, Mexico. Chenes style, Maya, 600–900. Museo Nacional de Antropología, Mexico City

PAGE 169, BELOW:
James Miller and Timothy Pflueger. Lobby, 450 Sutter Street (The Medical Building). 1930. San Francisco, California

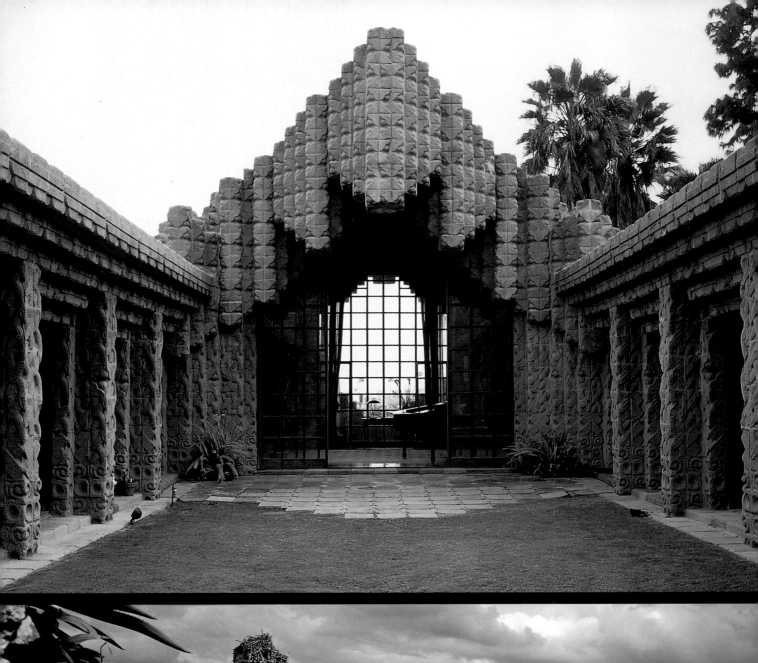

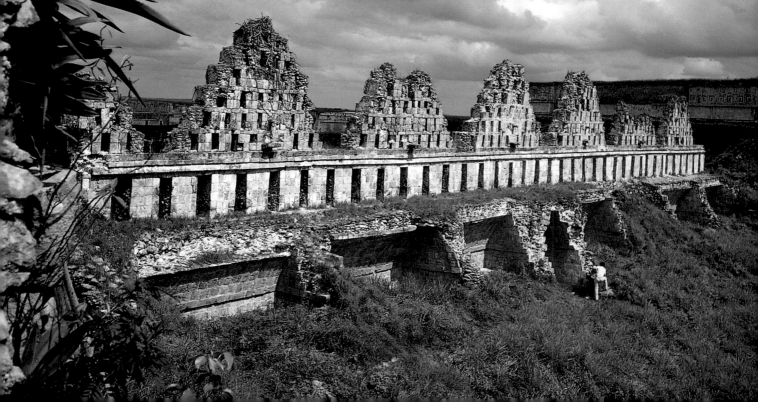

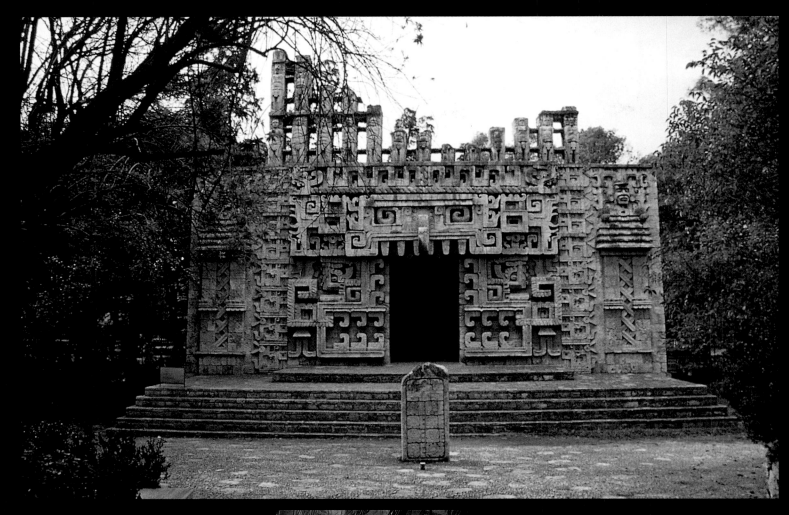
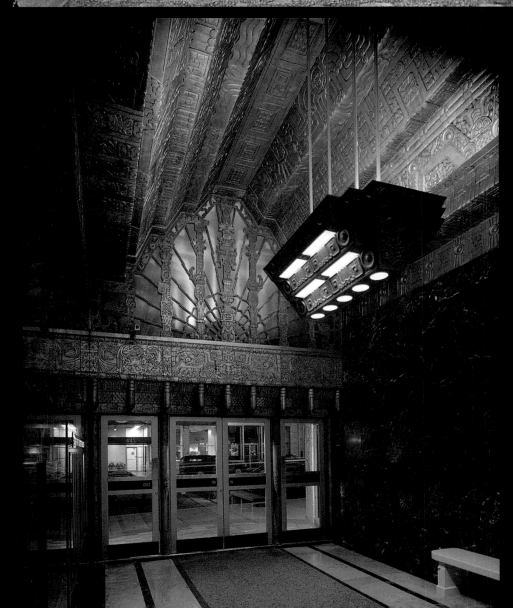

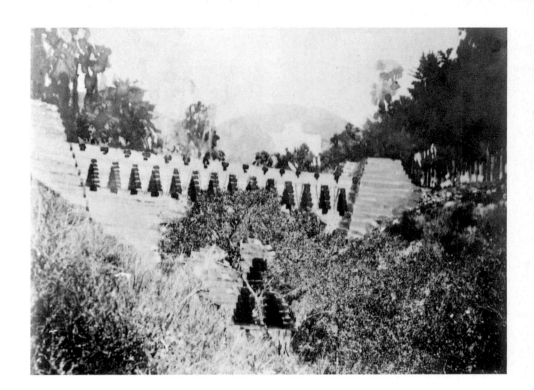

corbel-vaulted windows and glass doors that open onto a terrace terminated on either end by truncated pyramidal platforms. This conception was undoubtedly inspired by an unusual structure at Uxmal known as the House of the Doves, which has an elaborately crested central wall consisting of a series of pillars surmounted by nine triangular sections (resembling church bellfries) with pigeonholes in them (hence the name), and which also ends in a pyramid platform.

After a trip to Mexico in 1921, Bossom, a British architect with a successful Beaux Arts practice in the United States, began applying Pre-Columbian motifs to his Art Deco skyscrapers. In *An Architectural Pilgrimage in Old Mexico*, he wrote, "Not to visit Mexico is not to know the Western Hemisphere. Not to have viewed the monuments of its romantic past is not to sense the inner meaning of American tradition . . . ," and he suggested that a great American national style could be built upon Maya architecture.[67] In another book he illustrated a Tikal temple opposite one of his own skyscrapers, noting that the ornament on the latter was based on primitive American motifs like those used by the Maya of Guatemala nearly two thousand years earlier.[68]

In a similar vein in 1930, San Francisco's leading Art Deco architects, James Miller and Timothy Pflueger, built a skyscraper at 450 Sutter Street whose elaborate decorative scheme is based on Maya art. In this case, however, they focused on the baroque figurative, rather than the geometric abstract, aspect of the ancient style. The ornate gilt lobby—including the portal, spandrels, ceiling, grillwork, elevators, and floor—is completely covered with florid Maya-style scrollwork and imagery, while an upper-story suite is adorned with Maya-inspired murals.

The most fascinating proponent of the Maya Revival style was Robert B. Stacy Judd, an eccentric English-born, California-based architect whose work might be characterized as a regional Pop variant of Art Deco. His best known design is the Monrovia Community Hotel of 1925, built as a tourist attraction to fortify the real-estate development of this Los Angeles exurb. An ardent admirer of Pre-Columbian art and architecture, Stacy Judd fashioned the hotel's exterior ornament and interior decor after Maya designs (on a basically Spanish Colonial plan), but he called it the Aztec Hotel because he thought it was a catchier name.

The building's stucco facade is punctuated by a decorative layer of thick, cutout shapes—curlicues, dots, dashes—which suggest a kind of shorthand version of Maya architectural decoration in carved stone or modeled plaster. Some of the curvilinear motifs recall Maya calendric hieroglyphs associated with the Petén, but the volutes, bifurcated corner designs, and rows of small bamboo-like pilasters derive from architectural sculpture on the facades of temples at Labná, Uxmal, and Hochob in Yucatán. Naturalistic images on buildings at Uxmal and Hochob, including huts and human or deity figures, probably suggested the abstracted stepped pyramid and figure

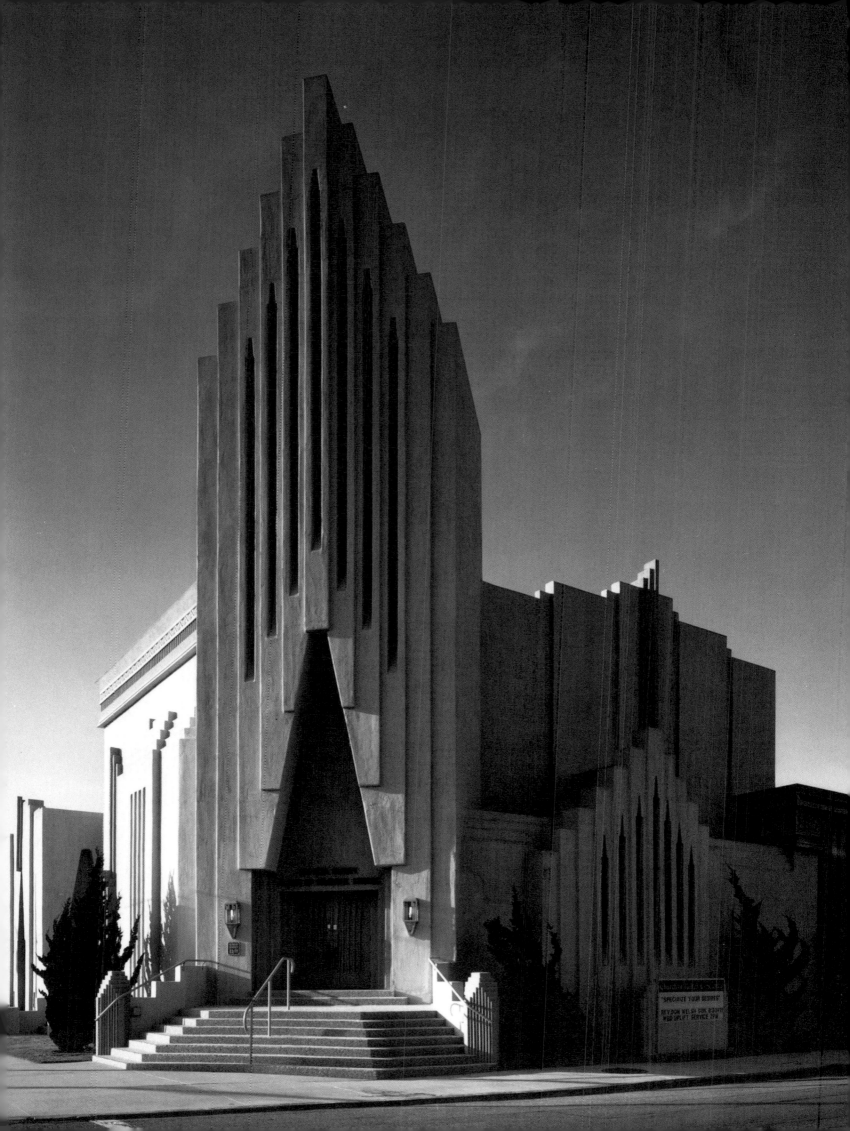

on the main corner of the U-shaped building. "As it is not entirely clear what the exact reason was for the peculiar medley of carved pieces, cubes, and the many quaint shapes forming some of the Mayan panels, I did not duplicate any particular original panel of the temples but assembled the curious units to my own fancy," wrote Stacy Judd, explaining his relation to his sources in an essay on Maya architecture.[69] In the hotel's handsomely appointed interior, Maya- and Mixtec-inspired geometric patterns and palette are painted, stenciled, and carved on pillars, doorway frames, wainscotting, chandeliers, electric fixtures, floors, ceilings, and furniture. Murals adorning the hotel foyer, lobby, and dining room refer vaguely to Maya myths and deities; they also reflect an awareness of the contemporaneous activity of the Mexican muralists.[70]

By far the most successful of Stacy Judd's Maya Revival designs was the First Baptist Church of Ventura, 1928–30, an architectural gem whose gracefully proportioned exterior and interior are perfectly integrated. The main entrance is capped by a corbeled arch and set within a central tower that is stepped like a Pre-Columbian pyramid, while the moldings on the side facades are decorated with an amalgam of Chenes and Puuc Maya–style motifs. The Pre-Columbian ornamental detailing on the exterior is echoed on the interior in the shapes of the windows, doors, balcony railings, grillwork, and the decoration of the altar.

Stacy Judd traveled extensively in Mexico and Central America, and he wrote and lectured widely on Pre-Columbian art and architecture.[71] Before his travels, he applied Pre-Columbian motifs to his buildings as a free style of decoration, but afterwards he moved closer to his sources, faithfully replicating Maya interior space and ornamental detailing. In the Beverly Hills mansion he designed for his friend, battery magnate T. A. Willard, for example, the public rooms actually had corbel-vaulted ceilings and simulated feathered-serpent columns from Chichén Itzá. The design was also informed by the knowledge and taste of the client. Willard had personally visited Mexico and written a book commemorating the romantic exploits of his friend Edward H. Thompson, the Peabody archaeologist-adventurer who had supplied the plaster casts for the great Chicago Exposition and who later dredged a vast treasure from the sacred well at Chichén Itzá.[72]

Unlike most of the Maya Revival architects, for whom the style was a passing fancy, Stacy Judd remained committed to it throughout his career. In later years he turned his attention increasingly to the design of religious-cult structures, which lent themselves to the style, including the Church of Jesus Christ of Latter-day Saints in Mexico City, 1934, a Los Angeles center for theosophy called the Philosophical Research Society, 1935, 1950, and a Masonic Temple in North Hollywood, 1951. Another preoccupation was the design of a utopian community called Enchanted Boundary, 1944–55, an unrealized theme park of Native American architectural styles.

Robert Stacy Judd. Recreation room, T. A. Willard House, Beverly Hills, California. 1929. Drawing. University of California, Santa Barbara, Architectural Drawing Collection

OPPOSITE, ABOVE:

Temple (Palace group), Labná, Yucatán, Mexico. Puuc Maya, 700–900

OPPOSITE, BELOW:

Robert Stacy Judd. The Aztec Hotel, Monrovia, California. 1925

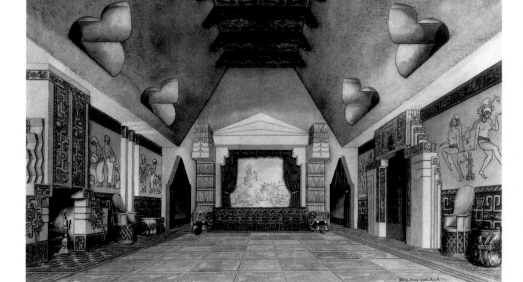

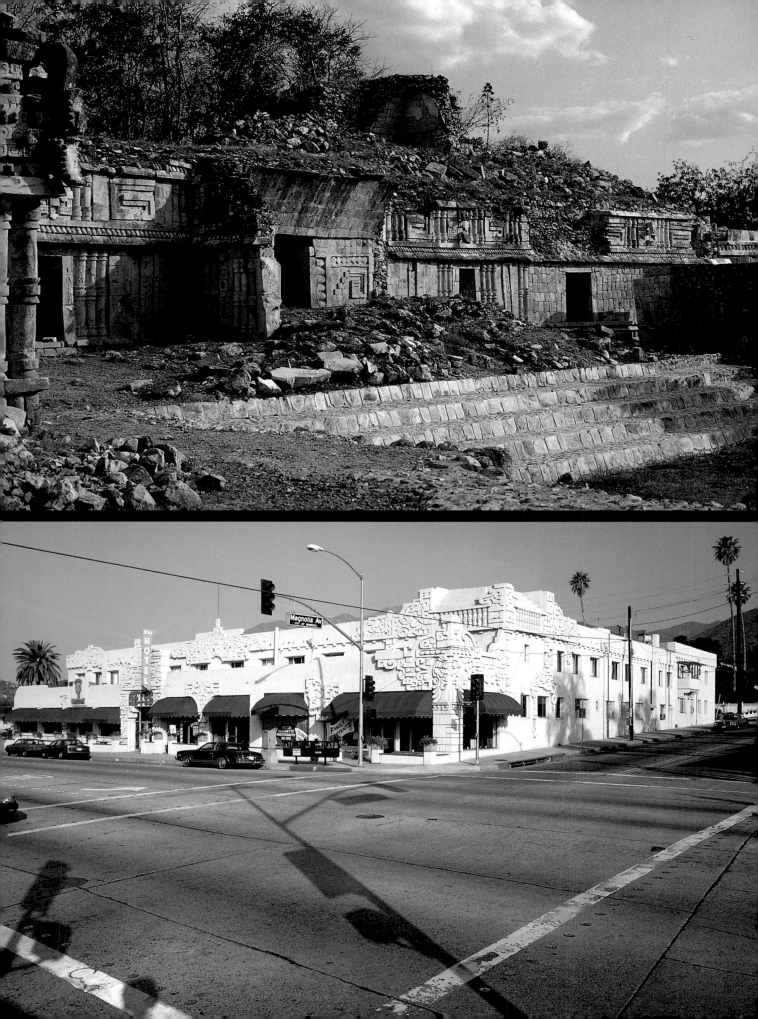

More flamboyant and whimsical than Frank Lloyd Wright's Maya-inspired buildings, Stacy Judd's designs represent a kitsch variant of Wright's high-style primitivizing, as Gebhard has noted. But these architects' relation to their pre-Hispanic sources was remarkably similar. Equally inspired by romantic nineteenth-century accounts and twentieth-century archaeological investigations, they believed that a reconstituted Maya style would foster the growth of an indigenous American architecture. And in southern California they found an environment that was historically, climatically, economically, and culturally auspicious to such an enterprise. For both Wright and Stacy Judd, Pre-Columbian motifs became a ready-made vocabulary to be appropriated and synthesized without regard to historical accuracy or cultural context. Thus the most famous ancient cultures, the Maya and Aztec, became encompassing labels for every kind of Pre-Columbian inspiration in their designs.

Stacy Judd's production, by its fringe nature, can illuminate some of the impulses behind Wright's embrace of Pre-Columbian forms that have been obscured by mainstream analyses of the master's work. Stacy Judd was unbound by modernist protocols about the primacy of pure form in art and could freely celebrate his attraction to the mythic content and associations he located in Maya architecture. To the Maya, Stacy Judd wrote, "architectural design was religious symbolism just as it was for every ancient people."[73] This symbolism was charged with occult energy and mystically linked to a kind of universal oversoul. "To my comparatively lay mind," he wrote in 1926, "the remarkable resemblance of details in Maya art to the recognized styles of ancient architecture seems to be conclusive of either borrowed principles or point to a common origin."[74] His book *Atlantis, Mother of Empires* (1939) recapitulated Le Plongeon's diffusionist, neo-Platonic explanations of the similarities between Maya and Egyptian pyramids, calendars, and hieroglyphs, Easter Island statues, and other mysterious ancient phenomena; they were the result of a common origin in a lost, sunken continent. Such speculations helped explain the otherwise unaccountable engineering, architectural, and mathematical feats of what were deemed uncivilized indigenous races. They also dovetailed with the worldview of the many mystical cults that had a wide currency during the turbulent 1920s and 1930s—Rosicrucianism, Mormonism, Freemasonry, the philosopher-magus Georgi Gurdjieff's Institute for the Harmonious Development of Man, to name a few.[75] Theosophical thought embedded in Pythagorean number mysticism underlies many of these cults, and the Maya obsession with numeration, evident in their calendrics and architecture, was viewed by them as a materialization of Divine Numerical Logic. (It should be recalled that Wright's third wife, Ogilvanna [whom he courted in 1924 and married in 1928] was a disciple of Gurdjieff.)

Wright too believed that Maya designs embodied a spiritual value that would invest his buildings with a mystico-religious dimension and imbue them with an ancient pantheistic vision.[76] In his 1912 essay *The Japanese Print: An Interpretation* he revealed the enormous importance he gave to the symbolism of geometry: "There is a psychic correlation between the geometry of form and our associated ideas which constitutes its symbolic value. There resides a certain 'spell power' in any geometric form which seems more or less a mystery, and is, as we say, the soul of the thing."[77] According to Wright, Japanese and other "primitive" artists who simplified and conventionalized natural forms were capable of grasping the underlying geometric structure of form and of sensing its symbolic meaning. In so doing they got to the hidden core of reality based on mathematical laws, which Wright related to Plato's conception of the "eternal idea of the thing." The conventionalized forms of these primitive cultures were in perfect harmony with their environment and their social and political structures. Modern civilization had to find an equivalent, Wright felt, and the artist who could find the forms of an indigenous American art would lead the way to a revitalized society.[78]

Implicit in Wright's Maya-inspired designs is the notion of a quick fix of ancient indigenous wisdom as an antidote to a rampant American materialism and utilitarianism, notwithstanding his advocacy of new materials and technology. On the surface, mysticism and technology appear to be antithetical, but on closer examination they have much in common: Both ideologies embrace the utopian notion that they are capable of reconciling all social conflict and assert that human beings are Promethean and can accomplish anything.[79] Like Diego Rivera, Wright harbored both a disposition toward a mystical pantheism and a reverence for technological power.

WRIGHT'S LATE WORK

The Depression brought an end to the southern California Maya Revival style and a halt to Wright's conspicuous appropriation of pre-Hispanic formal concepts.[80] But Wright never ceased drawing inspiration from Pre-Columbian architecture; the difference now was that he was able to integrate this influence more fully into his structures. In 1927 he returned to Chicago to practice, and during the early 1930s he became involved with a number of utopian projects informed by the notion that art and architecture in a benevolent environment could remedy social maladies and improve individual life by themselves. They included the establishment in 1932 of the Taliesin Fellowship at Spring Green, Wisconsin—modeled after Wright's earlier Oak Park studio as well as Arts and Crafts colonies, the Bauhaus, and Gurdjieff's Institute—with the aim of developing an indigenous cultural expression in a master-apprentice situation,[81] and in 1935 of Broadacre City, a planned community with low-density, middle-class suburban housing that was developed by the fellowship but never executed. Both were conceived as hierarchical systems ruled by an autocratic master-architect.

Out of his plan for Broadacre City Wright developed his Usonian houses (the name is a play on USA) of the late 1930s and 1940s, prefabricated, affordable middle-class housing that was the apotheosis of the textile-block houses of the 1920s. Their technological innovations, including the use of a geometrical grid and sandwich walls, and, sometimes, concrete-block construction, evolved from Wright's structural experimentation in Los Angeles. They also have the cubical compactness, inapproachable facades (facing away from the street), and close association with site of the textile-block houses.[82]

Another major project of the late 1930s, the design of Florida Southern College in Lakeland, was an outgrowth of the textile-block houses; its pierced and patterned concrete-block construction bows to both Maya and Mixtec precedents. Wright probably considered that the Pre-Columbian idiom was as appropriate to the semitropical climate and the Indian and Hispanic ancestry of Florida as of southern California and consonant as well with his client's vision of the school as a great educational temple. "You will see in these buildings now standing at Florida Southern College the sentiment of a true educational saga along the cultural lines of an indigenous architecture for our own country," Wright said.[83]

Taliesin West, the third major undertaking of these years, was designed as the winter headquarters for Wright's fellowship in the desert outside Scottsdale, Arizona. It is aesthetically linked to Florida Southern College by its long horizontal axes punctuated by strong diagonals and series of walkways and terraces[84] and by being

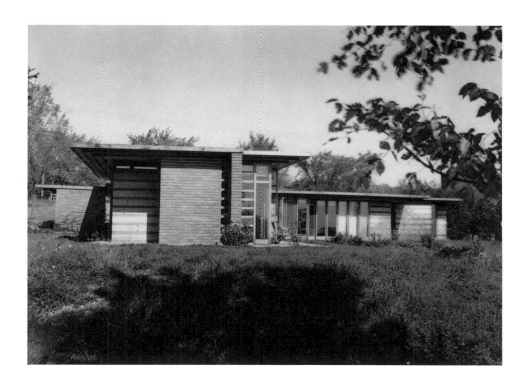

Frank Lloyd Wright. The Herbert Jacobs House, Madison, Wisconsin. 1937

PAGE 176:
Frank Lloyd Wright. Florida Southern College, Lakeland, Florida. 1938

PAGE 177:
Frank Lloyd Wright. View of talud-tablero walls and monument with Mixtec greca motif, Taliesin West, Scottsdale, Arizona. 1937

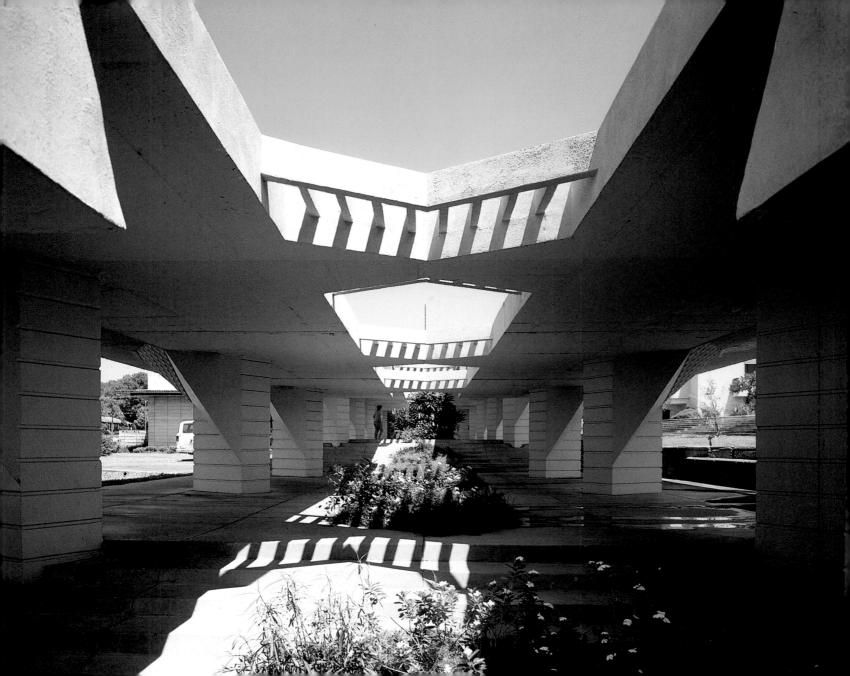

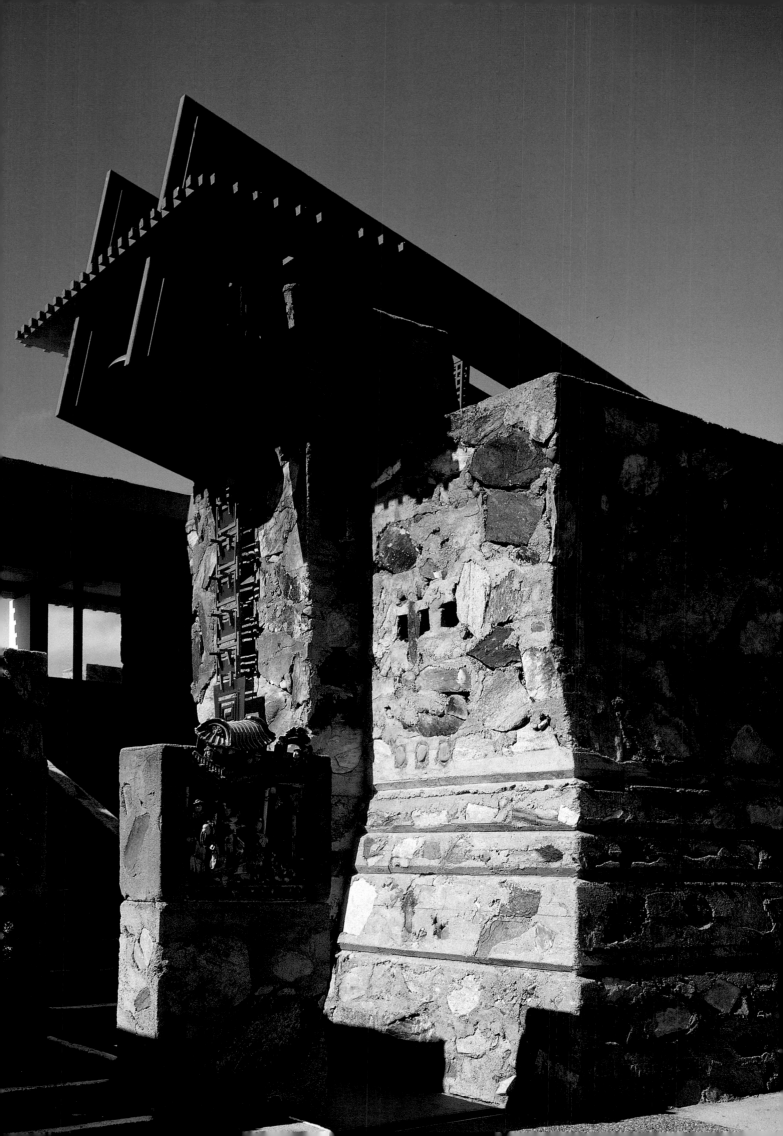

Frank Lloyd Wright. Solomon R. Guggenheim Museum, New York. 1943

Frank Lloyd Wright's signature emblem, known as the Taliesin Fellowship Square. The Taliesin Fellowship Square is a registered trademark belonging to the Frank Lloyd Wright Foundation. The Frank Lloyd Wright Foundation grants permission to Harry N. Abrams, Inc., to use the mark in this book. The Frank Lloyd Wright Archives, Scottsdale, Arizona

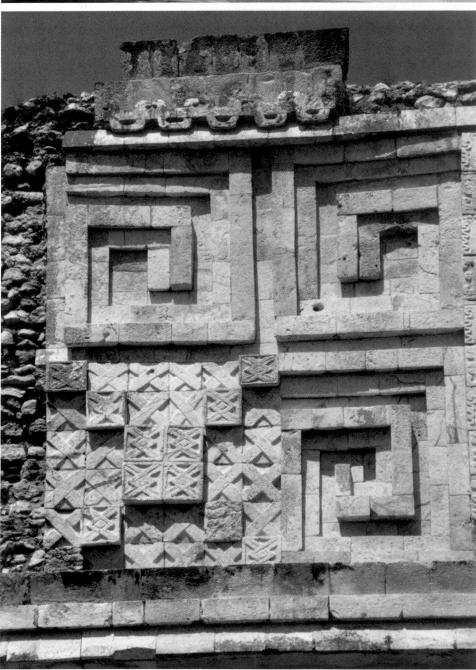

Governor's Palace (detail showing motifs that inspired Wright's signature emblem), Uxmal, Yucatán, Mexico. Puuc Maya, 700–1000

informed by Pre-Columbian architecture. In this instance, however, Wright focused mainly on highland Mexican rather than Maya models. The rough-hewn stone surfaces, strong, sweeping lines, low-lying forms, *talud-tablero* walls (incorporating a sloping base and a rectangular panel), and even a monumental sculpture near the entrance to the complex recall in a generalized way characteristic traits of Teotihuacán, Zapotec, and especially Aztec architecture.

Among Wright's later works, the Guggenheim Museum in New York, which he described as a temple to human creativity (and worked on from 1943 to 1959), is the most resonant of Pre-Columbian architecture. Composed of a large spiral ramp around a central domed space resting on an enormous platform with rounded edges, it is modeled after the Chichén Itzá Observatory as transmuted through the Strong Planetarium project of 1924. Wright had finally internalized the lessons of pre-Hispanic architecture. In the great plasticity of the thick poured concrete and the expressive flow of the swelling space, he realized its essentially sculptural nature while ignoring its surface ornamentation. In 1953, he came closest to acknowledging it as a continuous source of inspiration when he wrote (in response to the first article examining the relationship of his work to pre-Hispanic forms): "Had I not loved and comprehended Pre-Columbian architecture as the primitive basis of world architecture, I could not now build as I build with understanding of all architecture. Only with that understanding could I have shaped my buildings as they are."[85] At around this time Wright also expressed his identification with Pre-Columbian architecture by adopting as his signature emblem on the title pages of his autobiographical books and on stationery letterheads, as well as on sculptures at the entrance to Taliesin West, one of the most prominent motifs in Pre-Columbian art, the Maya volute or Mixteca greca, which adorns the palaces of Uxmal and Mitla.[86]

In the end, it is clear that Wright drew on Maya and Mexican forms both for aesthetic and symbolic ornament and, to a lesser extent, for structural ideas and materials. Some critics have been perplexed by this aspect of his production and embarrassed by his unmodernist use of surface decoration and his mystical dimension, preferring to see his buildings always as the expression of an individual creative imagination. They have construed his work of the 1910s and 1920s as regressive and elitist, but in fact it has been seen as linked to his most visionary and democratic conceptions. It is necessary to look further, not only to place this work in the social nexus of the California revival styles but to acknowledge the extent to which this greatest American architect of the twentieth century carried the form and spirit of Pre-Columbian architecture into the modern era.

NOTES

1. Frank Lloyd Wright, *A Testament* (New York, 1957), p. 205. The full citation reads: "There never was exterior influence upon my work either foreign or native, other than that of *lieber meister* [Louis Sullivan], Denkmar Adler, John Roebling, Whitman and Emerson, and the great poets worldwide. My work is original not only in fact but in spiritual fiber . . . as far as the Incas, the Mayans, even the Japanese—all to me were splendid confirmation."

2. Frank Lloyd Wright, *Modern Architecture: Being the Kahn Lectures for 1930* (Princeton, 1931), p. 4.

3. *Ibid.*, p. 11. Wright was born in Richland Center, Wisconsin, in June 1869 to William Cary Wright, an itinerant music master turned preacher and Anna Lloyd Jones, a determined and aggressive woman. His parents soon moved to Weymouth, Massachusetts, where they raised him in a transcendentalist atmosphere until returning to Wisconsin in 1880.

4. See Doreen Burke et al., eds., *In Pursuit of Beauty: Americans and the Aesthetic Movement* (The Metropolitan Museum of Art, New York, 1987).

5. There is a vast literature on Wright. The basic references I have used include Henry Russell Hitchcock, *In the Nature of Materials: The Buildings of Frank Lloyd Wright 1887–1941* (New York, 1942); Grant Carpenter Manson, *Frank Lloyd Wright to 1910* (New York, 1958); Vincent Scully, *Frank Lloyd Wright* (New York, 1960); and Robert C. Twombly, *Frank Lloyd Wright: His Life and His Architecture* (New York, 1979). There is also a considerable literature on the subject of Wright and Pre-Columbian architecture. Dimitri Tselos, "Exotic Influences in the Architecture of Frank Lloyd Wright," *Magazine of Art* 47 (April 1953), pp. 160–69, 184, was the seminal article on the subject. Other valuable articles include Gabriel Weisberg, "Frank Lloyd Wright and Pre-Columbian Art—The Background for His Architecture," *Art Quarterly* 30 (Spring 1967), pp. 40–51; Dimitri Tselos, "Frank Lloyd Wright and World Architecture," *Journal of the Society of Architectural Historians* 28 (March 1969), pp. 58–72; Kathryn Smith, "Frank Lloyd Wright, Hollyhock House and Olive Hill, 1914–1924," *Journal of the Society of Architectural Historians* 38 (March 1979), pp. 15–33; and Neil Levine, "Hollyhock House and the Romance of Southern California," *Art in*

America 71 (January 1983), pp. 150–65. Two invaluable books covering the subject are Marjorie Ingle, *Mayan Revival Style: Art Deco Mayan Fantasy* (Salt Lake City, 1984) and David Gebhard, *Romanza: The California Architecture of Frank Lloyd Wright* (San Francisco, 1989). Important unpublished sources include Frederick W. Peterson, *Primitivism in Modern American Art* (Ph.D. dissertation, University of Minnesota, 1961); Terry R. Kirk, "The Sources of Pre-Columbian Influences in the Architecture of Frank Lloyd Wright" (M.A. Thesis, Columbia University, 1986); and Anthony M. Alofsin, *Frank Lloyd Wright: The Lessons of Europe, 1910–22* (Ph.D. dissertation, Columbia University, 1989). I have found Peterson's dissertation especially helpful in focusing on this issue.

6. Peterson, *op. cit.*, pp. 15, 152, 157–60. According to Peterson, prominent Chicago School architect William le Baron Jenney presented a lecture series at the University of Chicago (published in the journal *Inland Architecture*, 1883–84), which promoted Viollet-le-Duc's theories on primitive architecture as a means of addressing the building problems of a modern industrial city. At the same time, another important Chicago School architect, John Root, discussed the need for an instinctual and natural style, citing as models a temple at Palenque and the Acropolis in Athens.

7. Cited in Alofsin, *op. cit.*, p. 4. Viollet-le-Duc's ideas about the uses of the primitive and the relationship between nature and architecture had a profound impact on Wright. He always upheld the Platonic notion of the existence of a higher logical order structuring all natural creations, which had to be discovered and applied to human creation. See Narciso Menocal, "Frank Lloyd Wright and the Question of Style," *Journal of Decorative and Propaganda Arts* 2 (Summer/Fall 1986), p. 5.

8. Brasseur spent a number of years in the Maya region and wrote a four-volume *Histoire des nations civilisées du Mexique et de l'Amérique centrale* (1856), which was well received by scholars at the time, though his later writings positing diffusionist theories were condemned as speculative. Brasseur interpreted the Maya Codex Tro-Cortesianus and other native manuscripts as describing a large ancient continent extending across the Atlantic, ruled by Queen Moo and King Ra Mu, which was destroyed in a great cataclysm, except for the part occupied by the Maya, which was miraculously restored in a later geological upheaval. Ignatius Donnelly's *Atlantis: The Antediluvian World* (1882 and subsequent editions) popularized these notions.

Le Plongeon, a freemason and adventurer, was a skilled professional photographer and recorder of information from his wide travels in Mexico, Central and South America. His theories about the land of Moo were favorably received by admirers of Pre-Columbian culture at the time and were kept alive by James Churchward's highly popular accounts in *The Lost Continent of Mu, Motherland of Man* (1926), *The Children of Mu* (1931), *The Sacred Symbols of Mu* (1938), etc. See Ingle, *op. cit.*, pp. 76–79; and Lawrence Desmond and Phyllis Messenger, *A Dream of Maya: Augustus and Alice Le Plongeon in Nineteenth Century Yucatan* (Albuquerque, 1988).

9. By the time of their second visit, photography had been invented, and Catherwood took daguerreotypes at Copán as the basis for his engravings. Many other travel books about Mexico and Central America were written during the mid- and late nineteenth century. See Weisberg, *op. cit.*, pp. 41–42, for further titles.

Architects customarily acquired vast libraries, and Wright was no exception. According to his son Lloyd Wright, Wright's library had a copy of Stephens and Catherwood, Herbert Spinden's *A Study of Maya Art*, and several Smithsonian publications on the Maya and Mexico. Since Wright's original library was burned in the fire at Taliesin in 1914, there is no record of his holdings in the early years. (Professor David Gebhard, University of California, Santa Barbara, personal communication, September 1987.)

10. Scully (*op. cit.*, note 35) speculated about the possibility of Maya influence on Wright's early work through his connection with Pierre Lorillard at the time Wright was working on projects in Buffalo. See also James Kornwolf, "American Architecture and the Aesthetic Movement," in Burke et al., *op. cit.*, p. 376; and Kirk, *op. cit.*, p. 37, note 12.

Lorillard began patronizing Le Plongeon's expeditions in 1880 and was interested in going on an expedition to Tulum with him, though this proved politically untenable at the time. Le Plongeon dedicated his second major work on the Maya, *Sacred Mysteries among the Mayas and Quichés. 11,500 Years Ago*, to Lorillard in gratitude for his financial assistance. See Desmond and Messenger, *op. cit.*, p. 58.

11. David Gebhard, personal communication, September 1987.

12. Manson (*op. cit.*, p. 34) states: "It is safe to say that Wright made scores of trips to the Fair grounds in Jackson Park both before and after turnstiles were in operation. It was a journey of only twenty minutes on the special trains of the Illinois Central."

13. Wright was acquainted with Japanese as well as Pre-Columbian forms before his visit to the fair; Japanese prints and Oriental art were already being collected in vanguard Chicago circles. Wright himself began to amass an important collection of Japanese prints after the turn of the century. See Manson, *op. cit.*, pp. 34–35.

14. See Robert Rydell, *All the World's a Fair: Visions of Empire at American International Expositions, 1876–1916* (Chicago and London, 1984), pp. 55–57. Frederick Putnam, director of Harvard's Peabody Museum of Archaeology and Ethnology, and his assistants Franz Boas and Joseph Jastrow focused on the ethnological display of living American Indians (realistic groupings of costumed manikins in their original settings and demonstrating their crafts, customs, and ceremonies), while the Smithsonian Institution—the U.S. National Museum and the Bureau of American Ethnology—contributed separate displays of the culture of extinct "tribes," including William Henry Holmes's exhibition of his archaeological research in Mexico and Otis Mason's exhibit reflecting native American culture at the time of Columbus. Rydell makes the point that the exhibitions of Indian life served to illustrate the inevitable triumph of white civilization (embodied in the Beaux Arts architecture of the White City) over the Indian nations, who were represented either as savages or in need of government agencies.

15. Information from Diana Fane, "Maudslay and Maler," lecture presented at the Americas Society, New York, October 1986.

16. Maudslay's photographs were published in a special supplement of Godman and Slavin's multivolume

Biologia Centrali-Americana (1889–1902). Maler's photographs appeared in the journal *Globus* in 1895 and 1902; in several Peabody Museum publications after 1897, e.g., "Explorations in the Department of Petén, Guatemala: Tikal," *Memoirs, Peabody Museum of Archaeology and Ethnology* 5, no. 1 (1911); and in an *Atlas of Mexico and Central America*, which he marketed himself.

17. See H.E.D. Pollock, "Sources and Methods in the Study of Maya Architecture," in Clarence L. Hay et al., eds., *The Maya and Their Neighbors: Essays on Middle American Anthropology and Archaeology* (New York, 1940), p. 191.

18. It would be surprising if Wright had not consulted Tozzer's *Tikal* (1911), and Spinden's *A Study of Maya Art* (1913), soon after they were published. See Pollock, *op. cit.*, for other important sources.

19. Wright had rejected an offer by one of his clients of an expense-paid study in Paris at the École des Beaux Arts, followed by two years at the American Academy in Rome. See Frank Lloyd Wright, *An Autobiography* (New York, 1932; repr. 1977), pp. 149–52.

"Japanese art," he commented, "was nearer to the earth and a more indigenous product of native conditions of life and work, therefore more nearly modern as I saw it, than European civilization alive or dead" (*ibid.*, p. 194). In his book, *The Future of Architecture* (New York, 1953), pp. 52–53, Wright wrote, "The Mayan is probably an elemental architecture, greater than anything remaining on record anywhere . . . a grand simplicity of concept and form—a kinship of elemental nature and natural forms of the material."

20. See Ellen Lupton and J. Abbott Miller, *The ABCs of △□○: The Bauhaus and Design Theory* (Cooper Union, New York, 1991), p. 10. The Gifts and Occupations were introduced in a highly ordered sequence suggesting increasingly complex geometries that were intended to mirror the child's physical and mental development: They began with a simple sphere at the age of two months and ended at age six with an entire set of geometric forms. Froebel believed that this progressively richer vocabulary of forms would enable the child to more easily form representations of the objective world.

21. See Menocal, *op. cit.*, pp. 4–19. This theory was akin to other Platonic systems of design popular at this time, like the Golden Section. Cf. Rivera's and Torres-García's use of similar systems in designing their pictures.

22. Kirk, *op. cit.*, pp. 5–6. Kirk compares the foyer of the Charnley house and the project for a Village Bank, 1894, with the plan of the Temple of the Sun at Palenque.

23. Tselos, 1953, *op. cit.*, pp. 164–65; and 1969, *op. cit.*, pp. 58–59. He relates most of these features to the Nunnery buildings at Chichén and Uxmal.

24. Tselos, 1953, *op. cit.*, pp. 162–63.

25. See Alofsin, *op. cit.*, pp. vi, 136, 155, 241–42, and *passim*. Alofsin argues that Wright's experimentation with new motifs during the teens and twenties is attributable to his search for pure, universal geometric forms and an awareness of European primitivizing. Moreover, he substitutes for Pre-Columbian influence on Wright's work of the twenties the impact of Vienna Secession architects using Near Eastern forms and the work of Viennese sculptors Franz Metzner and Emile Simandl.

26. Weisberg (*op. cit.*, p. 49) notes that the zigzag pattern symbolizes the coils of a serpent and suggests that it derives from the facade of the Nunnery at Uxmal which encompasses both a coiled serpent and a fret. But the freestanding feathered-serpent columns (which no longer support roofs) atop temples at Chichén Itzá are the more likely source. Wright's use of a standard may in itself refer to the standards commonly associated with Maya and Mexican structures. Weisberg further suggests that the configuration of the second, porchlike floor of the Kehl Dance Academy, and the recessed third floor of this building, may reflect that of the first and second stages of the Temple of the Frescoes at Tulum, as illustrated by Catherwood.

27. William H. Holmes (*Archaeological Studies among the Ancient Cities of Mexico* [Chicago, 1895–97], p. 250) suggested that the geometric motifs on the mosaic panels on the buildings at Mitla were symbolic and derived from markings on the body of a serpent deity. See also Rosemary Sharp, "Chacs and Chiefs: The Iconology of Mosaic Stone Sculpture in Pre-Conquest Yucatán, Mexico," *Studies in Pre-Columbian Art & Archaeology* 24 (Washington, D.C., 1981), pp. 9–10.

28. Like many other artists of the period, Wright saw the machine as an invincible force and as a forerunner of democracy. See his "Art and Craft of the Machine," *Brush and Pencil* 8 (May 1901).

29. See Alofsin, *op. cit.*, pp. 171–72, citing Wright's 1912 essay *The Japanese Print: An Interpretation* (Chicago; repr. New York, 1967). Wright saw a mystical force in the symbolic power of geometry—he called it "spell power"—which could be harnessed by the artist to transform society. And in the primitive and exotic he found a confirmation of his intention to conventionalize, geometricize, and spiritualize form.

30. Tselos, 1969, *op. cit.*, pp. 59–60 and figs. 5 and 6.

31. See Tselos, 1953, *op. cit.*, pp. 16–18; and Alofsin, *op. cit.*, pp. 250ff.

32. In discussing the mosaic patterns at Mitla, Holmes (*op. cit.*, p. 249) noted that the same elements—meander, diamond, s-shape, and angular hook—occur in the textile and ceramic arts of many of the more cultured American nations.

33. See David Gebhard, *Lloyd Wright* (catalog for an exhibition, the Art Galleries of the University of California, Santa Barbara, November 23 to December 22, 1971), p. 32.

34. "Concrete is a plastic material—susceptible to the impression of the imagination. I saw a kind of weaving coming out of it. Why not weave a new kind of building?" Wright wrote in *An Autobiography*, p. 258.

35. David B. Stewart, *The Making of a Modern Japanese Architecture: 1868 to the Present* (Tokyo and New York, 1987), p. 79.

36. Scully, *op. cit.*, p. 24; Alofsin, *op. cit.*, p. 244.

37. Wright, *An Autobiography*, pp. 243–57. The actual on-site supervision of the construction was directed by R. M. Schindler, who also designed the two small residences. Richard Neutra designed a wading pool and pergola, and Wright's son Lloyd was responsible for the landscaping. In 1927 Aline Barnsdall deeded her property to the City of Los Angeles, and it is now open to the public.

38. Gebhard, 1989, *op. cit.*, p. 14.

39. *Ibid.*, pp. 3, 14. Gebhard points out that Wright's adherence to the traditional cruciform plan in the Barnsdall House reveals his hidden reliance on the classical forms which he openly repudiated.

40. Neil Levine, "Landscape into Architecture: Frank Lloyd Wright's Hollyhock House and the Romance of Southern California, *AA Files* 3 (January 1983), p. 35.

41. *Ibid.*

42. *Ibid.*, p. 36. According to Levine, Wright's son Lloyd explained the scene as depicting Aline Barnsdall as an enthroned Indian princess contemplating her desert *mesas*. He suggests that the scene also recalls the synthesis of cosmic forces represented in Navajo sandpaintings (known to Wright at this time)—ground drawings beneath the smoke hole of a hogan containing an elongated figure of a rainbow guardian surrounding a field on three sides. The curative purpose of the sandpaintings corresponded with Barnsdall's assertion that she commissioned the house to give stability to her rootless life. Levine's iconographic interpretation of the fireplace does not refer specifically to Pre-Columbian notions.

43. Frank Lloyd Wright, *Experimenting with Human Lives* (Olive Hill, 1923). Cited in Levine, *AA Files*, p. 37.

44. Le Plongeon had written and lectured about his theories of seismology from 1870 on. See Desmond and Messenger, *op. cit.*, p. 11. He had also discovered a relief on the lintel of a building called Akab Dzib at Chichén Itzá, which he interpreted as a description of the seismic destruction of Atlantis and claimed as a validation of Brasseur's decipherment of the Maya Codex Tro-Cortesianus as referring to this event. See Ingle, *op. cit.*, pp. 77–78. It is also possible that Wright was thinking of Le Plongeon's story of Queen Moo and the Mayas when he characterized Barnsdall as queen of the domain of Olive Hill.

45. Barnsdall had radical political sympathies and was a leading light of the vanguard artistic community in Los Angeles in the 1920s, which included Dorothy Parker, Tina Modotti, and other individuals who were closely in touch with cultural and political events in Mexico.

46. Scholars have also assigned Pre-Columbian sources to parts of the unrealized design for the Barnsdall theater, an innovative structure in the same complex. Tselos (1953, *op. cit.*, p. 166 and fig. 14) suggests that the theater's cubiform mass, elaborate cornices, and projecting block were inspired by the east end of the Nunnery at Chichén Itzá. Alofsin (*op. cit.*, p. 249) indicates that the building's rich ornamentation contained figural references to feathered Aztec figures.

47. This assumption is based on statements Wright made in his Wasmuth Album essay and in other places. According to Alofsin (*op. cit.*, p. 246), Wright "believed that the original architecture of a culture should provide the sources for 'the organically true' forms of the culture, and, once found, they would transform the life of the members of that culture." See also Lloyd Wright's account of his father's interest in indigenous architecture in Gebhard, 1971, *op. cit.*, p. 32.

48. See Gebhard, 1989, *op. cit.*, p. 2.

49. *Ibid.*, p. 3.

50. As Levine points out (*AA Files*, pp. 22, 31, and *Art in America*, pp. 153, 156), fantastically ornamented pre-Hispanic buildings also provided an appropriate visual expression of Hollywood as the land of fantasy and enchantment, which it had already become by this time. Extravagant and exotic sets for D. W. Griffith's film epics, such as *Intolerance*, remained standing in lots all over Hollywood, some of them just a few blocks from the Barnsdall House, whose own luxuriousness exemplifies the romance of Hollywood in the 1920s.

51. Gebhard, 1989, *op. cit.*, p. 4.

52. Quotes from Wright, *An Autobiography*, p. 265. Wright (*ibid.*, p. 251) said he was attending to a "voice within" crying for the recognition of the machine as the normal tool of the modern age. See also Edgar Tafel, *Apprentice to Genius: Years with Frank Lloyd Wright* (New York, 1978), p. 125.

A local precedent for Wright's system was Irving Gill's ingenious concrete architecture, e.g., the Walter Dodge House in Los Angeles (1914–15), which was based on Californian vernacular traditions, keyed to its climatic conditions, and concerned with structural economy and functional efficiency. See Marcus Whiffen and Frederick Koeper, *American Architecture: 1860–1976* (Cambridge, Mass., 1981), p. 318.

53. See Gebhard, 1989, *op. cit.*, p. 20; and Alofsin, *op. cit.*, p. 275.

54. In most cases, Wright used patterned and plain blocks in combination with one another. Each house was given at least one unique block pattern. And to make the houses seem organic to the locale through their color and texture, he employed sand from the site of each of the houses for the concrete mix. Gebhard (1989, *op. cit.*, p. 20) reports that one drawback of this process was that it was impossible to wash impurities out of the local sand, and consequently the blocks have been unstable over time.

55. This system proved less simple and easy to put together than Wright imagined, since each house required many different molds for blocks that needed to accommodate special functions—corners, jambs, caps, bases, columns, spandrels, windows—and for plain and textured blocks. The blocks were also unduly affected by the weather, becoming streaked on their surfaces, and they could not accommodate utilities easily. See Tafel, *op. cit.*, p. 126.

56. Wright had used this format before in some of his early Chicago houses and in the Unity Temple, but it assumes a decidely Pre-Columbian complexion in this context.

57. Tselos (1969, *op. cit.*, p. 67) identifies this motif as a Maya kan cross or Venus sign, which symbolized the four corners of the world in the classic period and turquoise, water, and fertility in the postclassic period.

58. Gebhard, 1989, *op. cit.*, p. 26.

59. Ingle, *op. cit.*, pp. 16–17. She characterizes the building as a mysterious Pre-Columbian castle of Oz.

60. *Ibid.*

61. *Ibid.*

62. See Tselos (1953, *op. cit.*, p. 166) for a discussion. The forms here also suggest tepees and boats.

63. Weisberg (*op. cit.*, p. 50, fig. 10) suggests instead that its source was a rendering of a Circular Watchtower in Oaxaca, which was reproduced in a Smithsonian publication of 1856.

There was also a skyscraper apartment-house project for St. Marks-in-the Bowery Church, New York, 1929, an offspring of the Maya-inspired project for the National Life Insurance Company in Chicago of 1924. See Twombly, *op. cit.*, pp. 200–201, for a discussion of some of these unexecuted projects.

64. See Ingle, *op. cit.*; Gebhard, Review of Marcus Whiffen and Carla Breeze, *Pueblo Deco, the Art Deco Architecture of the Southwest* and M. Ingle, *Mayan Revival Style: Art Deco Mayan Fantasy* in *Journal of the Society of Architectural Historians* 45, no. 3 (September 1986), pp. 313–14; Bevis Hillier, *Style of the Century* (New York, 1983), pp. 76–78; and E. Bradford Burns, "The Maya Imprint on Los Angeles," *Americas*, nos. 11–12 (November–December 1981).

65. Gebhard, 1971, *op. cit.*, pp. 16, 31–32.

66. *Ibid.*, p. 35.

67. Hillier, *op. cit.*, pp. 76–77. See also Dennis Sharp, *Alfred C. Bossom's American Architecture, 1903–1926* (London, 1984), pp. 29–32.

68. Cited in Hillier, *op. cit.*, p. 76.

69. Robert Stacy Judd, "Maya Architecture." *Pacific Coast Architect* 30. no. 5 (November 1926), p. 31.

70. Stacy Judd described the foyer and lobby murals as representing the Kingdom of Darkness featuring the god and goddess of death, the Sun God blessing the crops, and the god of lust (which he placed adjacent to the ladies' room). Allegorical murals in the main dining room represent the "progress in commerce and art of the Maya and hispanic races" and the transition from the Indian to the white races on this continent. See Leslie Burton Blades, "Maya Architecture and a Modern Architect," *The Home Builder* 4, no. 5 (May 1926), pp. 6–8, 26.

71. He published accounts of his travels in a book titled *The Ancient Mayas: Adventures in the Jungle of Yucatán* (1934) and articles in the journal *Architectural Engineer*. He also produced two plays and poetry on the subject of the Maya.

72. See Barbara Braun, "Sex, Death and Science at the Sacred Well," *Village Voice* (February 26, 1985), pp. 48–49, for an account of Thompson's exploits and Willard's book, *The City of the Sacred Well* of 1926.

73. Cited in Blades, *op. cit.*, p. 6.

74. Stacy Judd, 1926, *op. cit.*, p. 27.

75. See Ingle, *op. cit.*, pp. 76–79.

76. See Peterson, *op. cit.*, pp. 171–76; and Alofsin, *op. cit.*, pp. 170–74, 253, and *passim*.

77. Wright, 1912, *op. cit.*, pp. 15–16.

78. Alofsin, *op. cit.*, pp. 173–75.

79. See Alvin Gouldner, *The Dialectic of Ideology and Technology* (New York, 1976), pp. 260–61.

80. His last-realized use of the textile-block construction characterizing his Los Angeles houses was in the design of the Arizona Biltmore Hotel, 1929, an Art Deco structure employing Maya motifs. Wright acted as a consultant to the architect, and his hand is most discernible in the cottages surrounding the main building. See Brendan Gill, *Many Masks: A Life of Frank Lloyd Wright* (New York, 1987), p. 307.

81. See Twombly, *op. cit.*, pp. 212–20, for a discussion of the fellowship and its relationship to Gurdjieff's notions.

82. Innovations included a foundation and a floor that were a single concrete slab; a roof that was a monolithic plane supported by a minumum number of ready-made walls; radiant heating; and a prefabricated interior. See Twombly, *op. cit.*, pp. 240–74; and Bruce Pfeiffer and Gerald Nordland, *Frank Lloyd Wright, In the Realm of Ideas* (Carbondale, Ill., 1988).

83. Cited in Pfeiffer and Nordland, *op. cit.*, p. 97.

84. Gill, *op. cit.*, pp. 398–99.

85. Cited in Tselos, 1969, *op. cit.*, p. 72, who explained that this statement, which was typed on Taliesin stationery but unsigned and undated, was sent to Robert Goldwater, editor of *The Magazine of Art* in response to its publication of Tselos, 1953. *op. cit.*, the first serious discussion of Wright's exotic sources.

86. Tselos (1953, *op. cit.*, p. 184) notes that Wright merged this sign with the solid red square that he had used as an autographic device for most of his professional career. Kirk (*op. cit.*, p. 35) identifies it as the sign of eternity—a double helix in Cartesian coordinates—which symbolizes the aboriginal conflation of space and time.

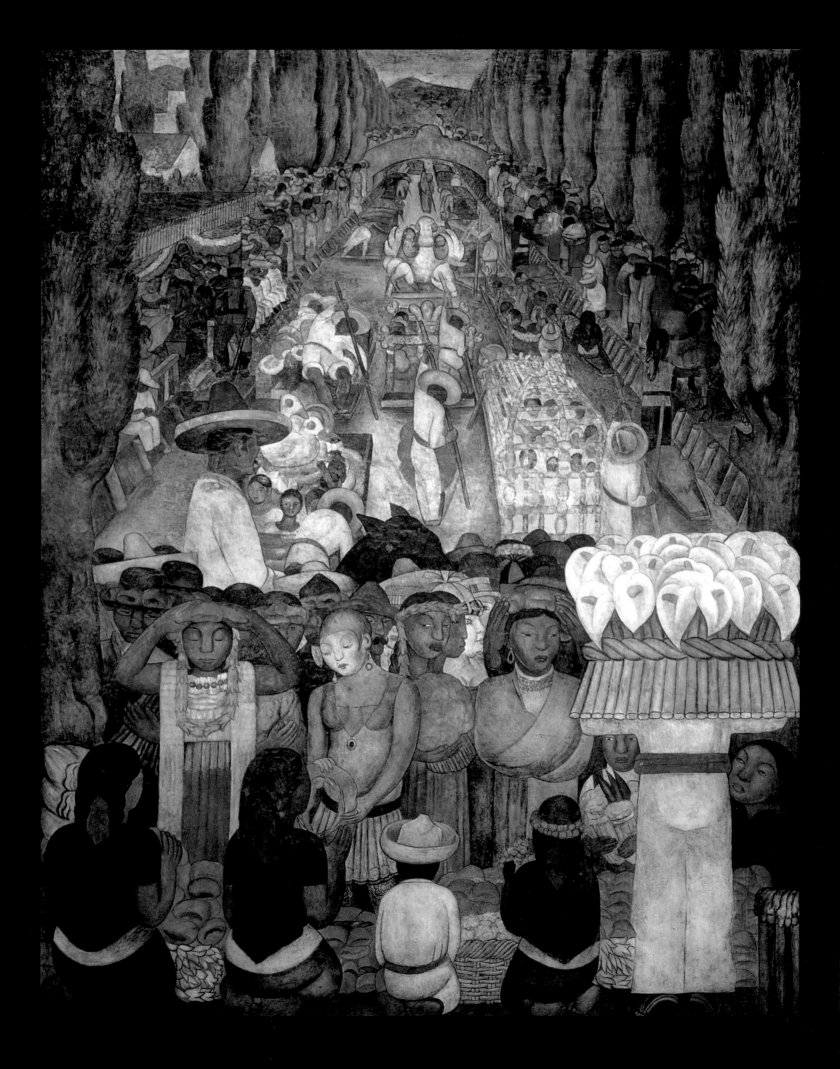

DIEGO RIVERA: HERITAGE AND POLITICS

Devuelvo al pueblo lo que de la herencia artística de sus ancestros pude rescatar (I give back to my people that which they can rescue from the artistic legacy of their ancestors).

DIEGO RIVERA, portal inscription, Anahuacalli

Like Henry Moore, Frank Lloyd Wright, and Joaquín Torres-García, each in his way, Diego Rivera used Pre-Columbian sources as both a rejection of established values and an affirmation of national identity.[1] Unlike his colleagues, however, Rivera's primitivizing was part of a larger sociopolitical program known as the Mexican Renaissance—a reassertion of Mexico's indigenous political, cultural, and artistic traditions after four hundred years of colonial subjugation—which was a product of the Mexican Revolution of 1910–20. This dovetailing of nationalist and artistic revivals made Rivera's appropriation of primitive sources unique; he used it as an explicit sign of political affiliation to promote explicitly revolutionary purposes. His decision to use these sources in the service of realistic rather than abstract ends further distinguishes his primitivizing from that of most twentieth-century artists. Instead of appropriating the primitive as a historicist means of facilitating communication within a modernist abstract framework, he used it to construct a mythic past whose effectiveness could be experienced in the present.[2] Like his fellow Latin American Torres-García, Rivera considered himself rooted in the ancient indigenous culture, and he was intent on using Pre-Columbian art as the basis of an autonomous and identifiably American aesthetic, independent of that of Europe.

Although he renounced abstraction, Rivera did not abandon vanguardism, nor did he reject the lessons of Cubism—especially its underlying geometry, planarity, constricted space, tilted perspective, and simultaneity. He embraced the notion of a return to Pre-Columbian roots while studying modern art in Europe, as an extension of modernist primitivizing, and in many ways his primitivizing is comparable to that of other modernists. Like the formalists, he appropriated Pre-Columbian morphology, imitating ancient styles and motifs, and like the Surrealists he adapted primitive conceptions and myths. Also like many European modernists who admired the primitive, he did not hesitate to collect examples of primitive art. Unlike them, however, he consciously intended to reverse the normal procedure in which the European assimilates the primitive by having the primitive absorb the European, so that modern art would feed into the native tradition.[3] By thus favoring indigenous over alien idioms, he felt he was rejecting the foreign colonization of Mexico.[4]

Rivera was more directly in touch with his sources than most modernist primitivizers. Aztec sites were visible in the Mexican landscape; extensive collections of ancient monuments and art were on hand in Mexican museums; and millions of Nahuatl speakers lived in Mexico. In Europe the primitive and folk elements were quite separate from one another—the primitive an exotic product of distant lands, the folk element something native and local. But in the minds of many of the key figures in the Mexican Renaissance, the folk and primitive elements were indivisible, one a survival of the other.

Rivera was also far better informed about the primitive than his European contemporaries. Ongoing anthropological and archaeological investigations in Mexico, which had been stimulated by the Mexican Renaissance, became a perpetual source of inspiration and a framework for his encounter with Mexico's past and present. This context has been almost completely ignored in previous discussions of Rivera's appreciation and use of ancient Mexican art, including those of Antonio Rodriguez, Stanton Catlin, Betty Ann Brown, Francis O'Connor, and Beatriz de la Fuente, which must form the basis for any further study.[5] Equally neglected is the role of Rivera's vast personal collection of Pre-Columbian art, which is not only an index of the ancient Mexican art he knew and admired but also a measure of how he experienced and evaluated Pre-Columbian art and culture. These neglected aspects of Rivera's primitivism, and the way these kinds of representations of Pre-Columbian art and culture came to define the subject for him, are ripe for exploration.

PAGE 184:
Diego Rivera. Flower Festival. 1923–28. Fresco. Court of the Fiestas, Ministry of Public Education, Mexico City

ARCHAEOLOGY AND THE SEARCH
FOR A NEW ART

The overthrow of the thirty-five-year Porfirio Díaz regime in 1911 and the reshaping of Mexican society after civil war and political revolution provided the Mexican vanguard with a mission to produce a new art for a new society.[6] The collapse of the Porfiriate signaled the end of Spanish Creole domination of Mexico, which had denied its Indian heritage, and the installation of Mestizo (the mixed Indian and Creole majority) control of the society. Newly appointed government officials, such as José Vasconcelos, minister of education, established vast programs designed to foster national pride in a previously scorned Indian heritage and to disseminate a new cultural identity for disenfranchised Indians and Mestizos. Education for the masses, as well as music, dance, poetry, literature, architecture, and mural painting, were intrinsic parts of this cultural revival.[7] It also sought to rediscover—and to salvage—specific forms of culturally marginalized art, including *pulqueria* painting, popular subjects on the walls of working-class bars; *retablos* and *ex votos*, paintings giving thanks for miraculous cures or good fortune that were mounted in large quantities on church walls; traditional portraiture and broadsheets; and folk art in general.[8]

Archaeological investigations of pre-Hispanic Mexican civilization provided an essential means of revindicating the Indian and salvaging the indigenous past. Although the Porfiriate had financed some archaeological activity, chiefly the collection of monuments and description of sites (for international expositions) and publication of ancient chronicles and codices,[9] Mexican archaeology before the Revolution had been dominated by foreign scholars, such as Ernst Forstemann, William Holmes, Alfred Maudslay, Eduard Seler,[10] and Alfred Tozzer, who conducted the most energetic and systematic investigations of ancient sites, hieroglyphics, and codices. Archaeology achieved official status for the first time only in 1917, when the distinguished archaeologist and anthropologist Manuel Gamio established Mexico's Department of Anthropology, which was soon followed by the Department of Pre-Hispanic Monuments (today the Instituto Nacional de Antropología y Historia, known as INAH), regional archaeological institutes, and an archaeological publishing program, which included journals, monographs, and reissued chronicles.[11]

Rivera had gone to study painting in Europe in 1907.[12] After a year in Spain, he settled in Paris until 1921, except for a brief return to Mexico in 1910 and a few trips abroad. Fully entrenched in the vanguard Parisian circle of Picasso, Gertrude Stein, Apollinaire, Ilya Ehrenburg, Sergey Diaghilev, and others, he was by late 1913 a supremely accomplished Cubist, investing Cubist formulas with a heightened chromatic, narrative, and emotional intensity. *Zapatista Landscape*, for example, contains connotational references to Mexican landscape elements, colors, textures, and costumes. Its incorporation of a rifle, cartridge belt, and *Zapatista* sombrero also reveals the artist's emerging political commitment to the Mexican Revolution.

Together with David Alfaro Siqueiros, who was also studying in Europe, Rivera soon became convinced that there was a need for a new, figurative art that would be based on Mexican nationalism, Marxism-Leninism, and a revival of indigenous aesthetic traditions without, however, ignoring avant-garde attitudes and the lessons of Cubism. Siqueiros articulated the notion of returning to Pre-Columbian roots as an extension of vanguard primitivizing in his 1921 Barcelona manifesto: "We must come closer to the works of the ancient settlers of our vales, Indian painters and sculptors, Mayan, Aztec, Inca. . . . Our climatological identification with them will help us assimilate the constructive vigor of their work. Their clear elemental knowledge of nature can be our starting point."[13] Anticipating his return to Mexico to participate in the postrevolutionary artistic resurgence and also the possibility of mural painting, Rivera traveled to Italy in 1920 for seventeen months to study Etruscan, Byzantine, and Renaissance art, focusing particularly on the Renaissance revival of the native Italian classical heritage in fresco painting.[14]

After returning home in 1921, Rivera joined the Communist party and, with Javier Guerrero and Siqueiros, founded the Syndicate of Technical Workers, Painters, and Sculptors (and its incendiary broadsheet, *El Machete*). Their manifesto proclaimed their intention to produce, in collaboration with carpenters and plasterers, ideological art for the masses in the form of monumental public murals that would forward the

aims of the Revolution by raising the collective consciousness of the people and mobilizing them to action. It upheld the native art tradition as a model for a socialist art: "The art of the Mexican people is the most important and vital spiritual manifestation in the world today, and its Indian traditions lie at its very heart. It is great precisely because it is of the people and therefore collective."[15]

Shortly after his return home Rivera declared his interest in Pre-Columbian art as a major means of carrying out these aims: "The search that European artists further with such intensity ends here in Mexico, in the abundant realization of our national art. I could tell you much concerning the progress to be made by a painter, a sculptor, an artist, if he observes, analyzes, studies Mayan, Aztec, or Toltec art, none of which falls short of any other art, in my opinion."[16] He soon began a serious study of ancient and popular Mexican art in codices, chronicles, and collections, as well as on trips to ancient sites and indigenous communities in the Yucatán peninsula and the isthmus of Tehuantepec, which were sponsored by Vasconcelos to acquaint artists with Mexico's heritage.

To a significant extent, the muralists' relation to Pre-Columbian art and archaeology was framed by the investigations of contemporary archaeologists working in Mexico. Francisco Goitia, one of the important precursors of the muralists, worked as an illustrator in the Teotihuacán Valley, sketching Indians and artifacts as part of Gamio's great ethnographic and archaeological research project;[17] Adolf Best Maugard was Franz Boas's draftsman in his Valley of Mexico excavations;[18] and Jean Charlot was employed by the Carnegie Institution in Yucatán, rendering pre-Hispanic murals and illustrating excavation reports at Chichén Itzá.[19] Although Rivera did not actually collaborate with archaeologists, his approach to pre-Hispanic culture was keyed to the investigations of the preeminent Mexican archaeologists of the day, Gamio and Alfonso Caso, who, as passionate indigenists, translated into scientific terms the Revolution's spiritual awareness of the grandeur of its native tradition.[20]

In 1917, Gamio, the first Mexican archaeologist to be trained (by Boas) in the new scientific methods of field excavation, unearthed sensational remains of an archaic culture beneath more complex strata at a site in the Valley of Mexico called Azcapotzalco. These findings refuted the claims of Anglo-American archaeologists— Thomas Joyce, Sylvanus Morley, Herbert Spinden—that the Maya civilization was more ancient than, and altogether superior to, the Mexican.[21] In the same year, Gamio conducted large-scale stratigraphic excavations at the spectacular urban site of Teotihuacán, which provided a clearer view of the second stage of the history of the pre-Hispanic world and also revealed the remarkable Temple of Quetzalcoatl. Gamio conceived of archaeology as a great synthesizing science. His monumental 1922 study of the Teotihuacán Valley, La Población del Valle de Teotihuacán, which was illustrated by Goitia, encompasses geographic, biological, linguistic, ethnographic, and religious phenomena in all periods of Mexican history. This widely influential work, which was intended to foster the integration of backward Indians into the new national unity, was an apparently self-conscious reflection of Friar Bernardino de Sahagún's sixteenth-century Florentine Codex: General History of the Things of New Spain (Codex Fiorentino. Historia General de las Cosas de Nueva España). Sahagún's encyclopedic, illustrated chronicle of Aztec society was designed to promote Indian integration into a new socioeconomic system.[22] Gamio was also a key figure in the reevaluation of ancient Mexican art. His book Forjando Patria (1916) enjoined his countrymen to regard previously despised Aztec artifacts aesthetically, saturate themselves in aboriginal history, myths, cosmogony, and philosophy, and use visual culture as a means of unifying the national consciousness.[23]

Caso (also a lawyer) was trained by Hermann Beyer, a student of the great German iconographer Eduard Seler. Caso's investigations, which combined a study of the ancient chronicles with archaeological data, centered on Aztec religion and cosmology and on Zapotec ruins and calendric inscriptions.[24] Excavating at Monte Albán from 1930 on, he provided a time sequence for the Oaxaca Valley that distinguished the (previously conflated) Zapotec and Mixtec styles and unearthed some spectacular finds. As holder of a prestigious university chair of archaeology, and as director of INAH, Caso also became the chief explicator of every major monument that was excavated in Mexico.

Typology and stratigraphy enabled Gamio and Caso to replace the earlier emphasis

Diego Rivera. Zapatista Landscape—The Guerrilla. 1915. Oil on canvas, 56¾ × 48⅜". Museo Nacional de Arte, Mexico City

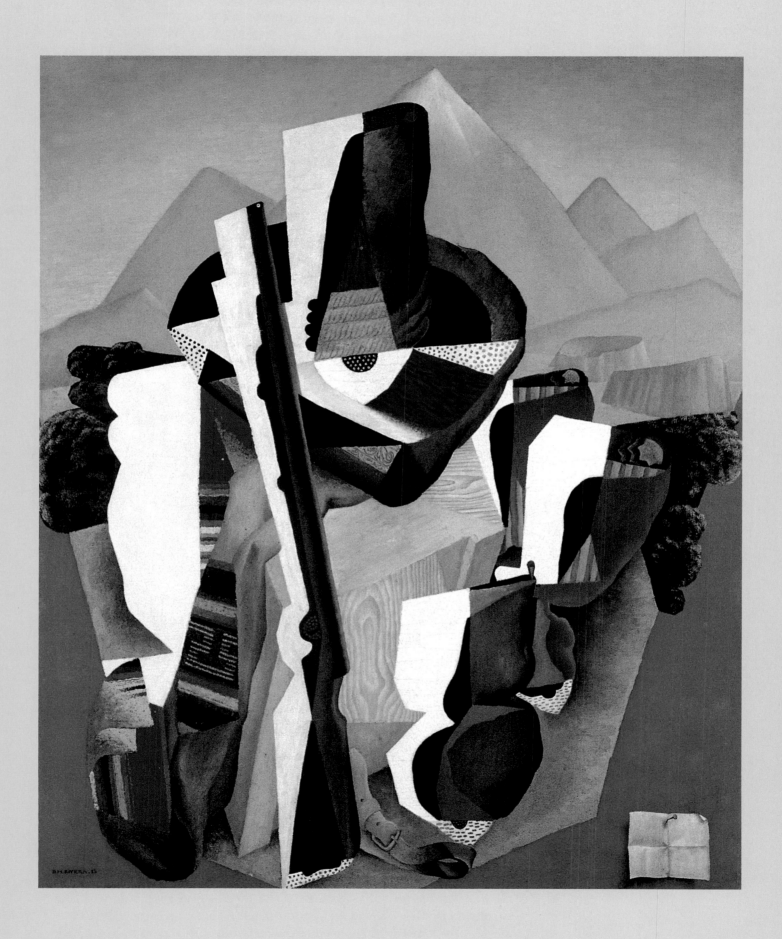

on collection and description of archaeological finds with a new definition of the expressive form and evolution of each regional culture.[25] Like previous investigators, however, they remained more interested in the imaginative rather than the practical reality of ancient Mexico, explaining it in religious and mythic rather than social and political terms. They never questioned the archaeological record with regard to cultural change or complexity, nor were they interested in retrieving the culturally specific function and context of ancient artifacts—issues that preoccupied a later generation of archaeologists. Despite their adherence to scientific methods, they renounced the positivism of the Díaz regime, which was based on Auguste Comte's doctrine of social progress through technology, in favor of advancing the goals of the Mexican Revolution in imaginative terms by transforming the past into present relevance; their interpretations of the archaeological record invariably supported indigenist and nationalist claims. Gamio's study of pre-Hispanic agriculture in the Teotihuacán Valley affirmed the notion of Pre-Conquest communalism as the historical basis of Zapata's land reform; Caso's interpretations upheld the continuity between ancient and popular Mexican beliefs and the cultural supremacy of Central Mexico over other regions.[26]

Rivera's links with Gamio and Caso can be traced to his association with *Mexican Folkways* magazine, which helped popularize these intellectuals' attitudes during the 1920s by celebrating indigenous forms and promoting a revival of popular arts as a means of fostering a new national unity. (Gamio served as advisor and Rivera as art director of the bilingual magazine.) Gamio's essay in the first issue urged that the study of folklore be not an end in itself but a means to meliorate Indian and Mestizo poverty and backwardness while preserving their cultural heritage.[27] This was to be accomplished, it was clear, by the reeducation of the elite sectors of Mexican society about native traditions. Rivera, Jean Charlot, Caso, Eduardo Noguera, Anita Brenner, Roberto Montenegro, Tina Modotti, Carlos Mérida, William Spratling, Carlton Beals, René d'Harnoncourt, Robert Redfield, and Miguel Covarrubias were contributors.

The magazine depicted Indian life as a colorful pageant of rituals, costumes, dancing, music, decorations, and customs and explored different facets of indigenous culture, for example, masks as an expression of ancient and popular magico-religious beliefs, or religious and secular festivals as a throwback to Aztec festivals celebrating the months of the solar year.[28] It characterized the Indian peasant as a natural artist, though backward, superstitious, and downtrodden. In an appreciation of *retablos* and *ex votos*, for example, Rivera asserted that the modern Mexican Indian was "an incorrigible creator of beauty," who by sheer native intuition converted foreign models (Hispanic paintings of saints and martyrs) into something genuinely Mexican. At other times he spoke about the inherent artistry of ancient Indians, indicating that he conflated the two.[29] The decadent yet vibrant indigenous majority—an idealized collective entity, lacking specific identity—was incapable of fending for itself and must be taken in hand by sympathetic new authorities.[30]

In breaking new ground in the appreciation of a marginalized population and culture, the magazine trod lightly, wishing only to extol what had been previously despised. It ignored the complexity of the issues it raised and disdained dissenting views, such as that of José Clemente Orozco, who charged that it was wrong to idealize earlier indigenous cultures and to attribute to the Indian objects of folk art that were the product of a fusion of ancient and Spanish models.[31] It also refused to consider that ancient and modern Mexican forms might be discontinuous, that is, that crucial documentation for the Pre-Columbian period was missing, surviving forms were fragmentary at best and unlikely to resemble Aztec originals, and ceremonies recorded by the chroniclers were only a memory at the time.

1923–30: THE NATIONALIST MURALS

Rivera wanted to revive the genre of history painting in public spaces by providing pictures for the illiterate indigenous population that would support the Mexican Revolution and put art at the center of communal life, where it had not been for centuries. Under government sponsorship, he undertook a vast pictorial reconstruction of Mexican life and Pre-Columbian history in a series of murals in national buildings, executed between 1921 and 1930. His first mural, on the stage of the Bolívar

Amphitheater in the National Preparatory School (Escuela Nacional Preparatoria), 1921–22, was clearly a transitional effort; he was feeling his way from his Cubist easel pictures to didactic, realistic wall painting. Painted in encaustic and conceived as a religious allegory, *Creation*, which was part of a larger mural program (devised by Vasconcelos) on the theme of evolution, is a pastiche of familiar Renaissance frescoes and Byzantine mosaics; it represents the Trinity flanked by personified virtues and natural elements. The only indigenist components are the Mestizo features and clothing of two female figures and a swarthy male figure emerging from a volcano in the center of the composition.

The artist's first sustained indigenist expression was the decoration of the Ministry of Public Education (Secretaría de Educación Pública), seat of a new federal education system designed to coordinate and implement teaching activities in primary, secondary, and professional schools throughout the country—the heart of Vasconcelos's plan to integrate the Indian and Mestizo population into mainstream national life. Organized according to the architecture (a three-story, neocolonial, convent-style building divided into two patioed parts), the murals rise in three tiers on open corridors surrounding courtyards.[32] In its initial stages the Secretaría project was an elaboration of Vasconcelos's notion of human evolution in nationalistic and *mestizaje* terms, but it soon developed into a more militant, Marxist expression of Mexican history and culture. Rivera began painting a series of murals in early 1923, with the assistance of Guerrero, Charlot, and Amado de la Cueva, whom he soon replaced with lesser lights. By the time it was completed in 1928, the cycle consisted of an astounding 235 panels (116 of them major frescoes) covering a total area of 15,000 square feet, and Rivera had firmly established his signature style and his reputation as the premier Mexican muralist.

The encyclopedic scope of this project, which attempts a synthesis of the entire social, cultural, and regional fabric of the Mexican nation—landscapes, work, celebrations, struggles—takes its cue from Gamio's comprehensive study of the Teotihuacán Valley, and its ultimate model, the Florentine Codex, Sahagún's panoramic portrait of indigenous life. Following Gamio, Rivera hoped to construct a new native cosmos that would give voice to the disinherited sectors of Mexican society and to do so by becoming saturated in Aztec history, myth, religion and art, as well as the folk environment and popular longings.[33]

Rivera's immersion in ancient forms began with an (unsuccessful) attempt to imitate a pre-Hispanic fresco technique based on an ancient Indian recipe (using nopal cactus juice as a binder), which Guerrero had developed from a study of the murals at Teotihuacán.[34] Next, in order to populate his Mexican cosmos, Rivera created instantly recognizable and distinguishable protagonists. Anglo, Creole, and Mestizo soldiers, priests, politicians, landowners, and businessmen appear as they do in contemporary or period portraits, photographs, and prints, or as caricatures. Following Siqueiros's lead, however, he invented a new physical type for the previously unrepresented Indian peasants and workers (except for nineteenth-century "*costumbrista*" depictions of picturesque Indians), which he modeled after Aztec stone sculptures and, to a lesser extent, ancient West Mexican terra-cotta figures.[35] These Indians replicate the proportions, physiognomy, and even the hairstyles of Aztec representations of naturalistic, nude, or simply dressed male figures who are usually identified as *macehuales*, the plebian freemen who formed the base of the pyramidal structure of Aztec society.[36] The Aztec figures have broad, flat heads and cheeks; low foreheads; snub noses; short necks; rounded, gently stooping shoulders; unmuscled limbs; and expressive hand gestures; and their heads, hands, and feet are disproportionately large in relation to their slender, short bodies. Standing figures have their weight distributed equally on both feet; seated figures are shown with their arms hugging their knees. Rivera also adopted, as an image of the quintessential Indian peon, a hunched figure bearing a burden on its back (often with a forehead tumpline), which derives from both West Mexican ceramic and Aztec stone representations of porters, the humblest members of Aztec society.[37]

Rivera was probably aware that European modernists had admired similar Pre-Columbian sculptures—that, for example, André Derain had based his 1907 *Crouching Figure* on a squatting *macehual* and that Henry Moore was imitating similar figures in his sculpture at this time. Unlike these modernists, however, Rivera had no wish to

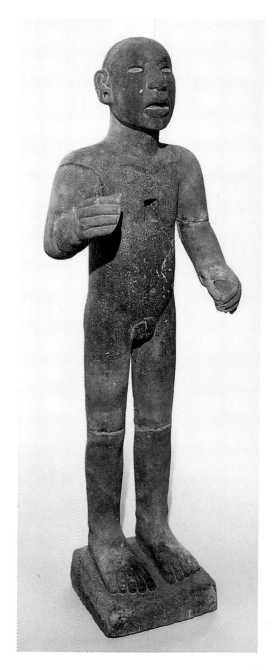

Standing man (Macehual). Aztec, 1350–1521. Stone, height 43¼". Peabody Museum of Natural History, Yale University, New Haven

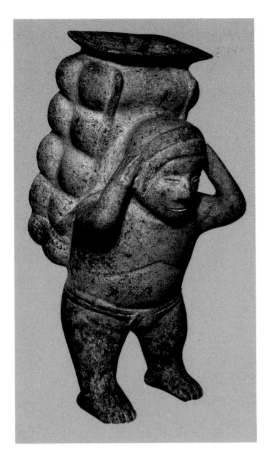

Burden Bearer. Jalisco, Mexico. 250 B.C.–A.D. 250. Terra-cotta. Diego Rivera Museum, Mexico City

transform Aztec morphology into semiabstract terms. He inserted his Aztec-inspired figures into the Renaissance spatial system the modernists eschewed, often using the bulky, solid shapes of these figures as baffles leading into the picture space. (At other times, however, he used a flatly patterned, Post-Impressionist space that was closer to their ken.) And where Derain and Moore adopted the impassive demeanor of Aztec sculptures to further formalist imperatives, Rivera was more interested in its expressive meaning. He has often been criticized for rendering Indians with uninflected personalities and a passive and submissive manner, as compared to his Anglo, Creole, and Mestizo types who register energy and emotion.[38] But their passivity and resignation can be explained as Rivera's expression of Aztec religious concepts, as recounted by Sahagún, specifically the idea of a compact between Aztec men and their gods, which holds that man was created by the sacrifice of the gods and must reciprocate by sacrificing his own life in order to nourish them with human blood and hearts. The listlessness of the Aztec *macehual*—and of the contemporary Indian who is conflated with him—is thus traceable to their ancient role as fodder for the sun.[39] Even Rivera's representations of the militant Indian revolutionary hero and martyr Emiliano Zapata seem to conform to this essentializing interpretation of the Indian peasant and his ancestors.

The extent to which Rivera honored ancient myths and meanings in his Secretaría cycle is further demonstrated in the Court of the Fiestas, begun in 1924, whose theme is the popular secular and religious festivals of the Mexican people. Although often dismissed as purely picturesque and folkloristic decoration, these fiesta scenes have deeper meaning. Rivera's focus on native festivals coincided with Vasconcelos's promotion of them as a way of diffusing the arts throughout Mexico and with *Mexican Folkways'* strategies for representing native culture. Rivera's intention was to redefine them as indigenous, rather than colonized, events, by evoking their origins in the ritualized social existence of ancient Mexicans, which was centered on the elaborate calendric celebrations of "flower, song, and sacrifice" so carefully described by Sahagún.

Diego Rivera. The Great City of Tenochtitlán (detail, figure of a porter). 1945. Fresco. Patio Corridor, The National Palace, Mexico City

Diego Rivera. Agrarian Leader Zapata *(based on Rivera's "Revolt" panel, Palace of Cortés, Cuernavaca, Mexico). 1931. Fresco (movable panel), 93¾ × 74". Collection, The Museum of Modern Art, New York, Abby Aldrich Rockefeller Fund (1631.40)*

The mural representing the Pascolera deer dance, for example, emphasizes the continuity between ancient and modern-day Mexican festivals in which dancing played a major part, since it was considered one of the most authentically pre-Hispanic of Mexican regional dances.[40] Celebrated by Yaqui Indians of the northwestern sierra, it revolved around a pantomime in which a dancer disguised as a deer and two or more so-called *pascola* dancers enact scenes of the hunt, such as a coyote killing a deer. Rivera modeled the dancers' costumes on those of modern-day ritualists but based their dance movements on the postures of small ceramic figurines of dancers from Teotihuacán, which Gamio had excavated and published in 1922. In addition, the masked dancers evoke ancient Mexican masking traditions—a favorite indigenist theme first explored by Caso in a 1924 article in *Mexican Folkways*, which begins with a description of Yaqui deer-dance masks.[41] Rivera's keen interest in indigenous masks is evident elsewhere in the Secretaría cycle and extends throughout his career.[42] One of his last murals, a mosaic on the facade of the Insurgentes Theater, links ancient masquerades—personified by terra-cotta dancers from Tlatilco—with the performing arts in contemporary Mexico.[43]

Additional Fiesta court murals that call attention to pre-Hispanic survivals in indigenous rituals include the representation of the flower festival of Santa Anita (page 184), which is celebrated in the lakeside district of Xochimilco, a southern suburb of Mexico City famous for its "floating gardens" (*chinampas*). Here, Indian women carrying babies and flowers wear garlands with tassels hanging down the sides of their faces, recalling the headbands of Aztec fertility goddesses who presided over harvest festivals in which flowers were important.[44] The ancient resonance of the flower-fertility theme is also underscored in a fresco in the stairwell of the Labor courtyard

Diego Rivera. Pascolera Deer Dance. 1923–28. Fresco. Court of the Fiestas, Ministry of Public Education, Mexico City

Dancing figurines. Teotihuacán, Mexico, 300–600. Terra-cotta, average height appr. 4″. Diego Rivera Museum, Mexico City

OPPOSITE:
Diego Rivera. A Popular History of Mexico. 1953. Mosaic, c. 41′9″ × 139′. Insurgentes Theater, Mexico City

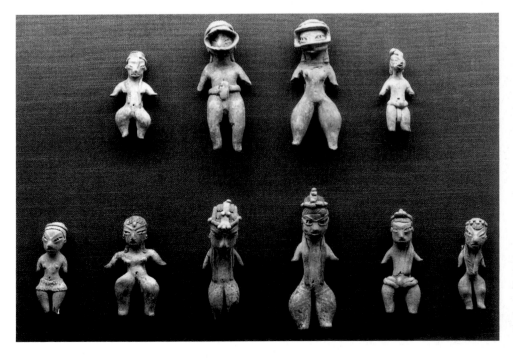

Female figurines, some with masks. Tlatilco, Mexico, 1000–500 B.C. Terra-cotta, average height appr. 4″. Diego Rivera Museum, Mexico City

HECTOR BONILLA
Actuando presenta a
IGNACIO LOPEZ TARSO El VESTIDOR HECTOR BONILLA
Actuando presenta a
IGNACIO LOPEZ TARSO

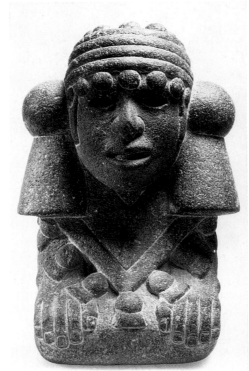

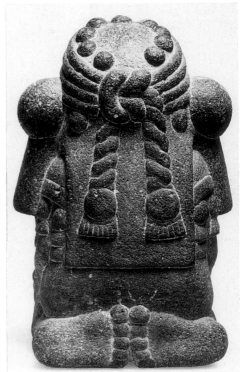

Goddess with tassled headdress, front and rear views. Aztec, 1350–1521. Basalt, height 11¾". Museum für Völkerkunde, Basel

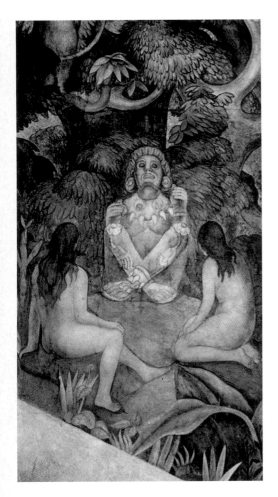

Diego Rivera. Detail of central section of stairway mural between first and second floors. 1923–28. Fresco. Labor Courtyard, Ministry of Public Education, Mexico City

OPPOSITE:
Xochipilli, Aztec god of flowers. 1350–1521. Stone, height 45¼". Museo Nacional de Antropología, Mexico City

that replicates the famous cult statue of Xochipilli, the Aztec god of flowers and sensuality (minus his platform), situating it within a lush pre-Hispanic tropical landscape reminiscent of Gauguin's Tahitian paradise.[45]

On the opposite wall of the Fiesta court Rivera depicted the popular Mexican festival of the dead, the Day of the Dead (el Día de los Muertos, an official national holiday celebrated on November 2), in three murals that again assert the agrarian roots of the native population by contrasting the urban and rural celebrations of the holiday.[46] His vision of the urban festival is chaotic, showing a drunken crowd of merrymakers watching a street performance by musician calaveras, skulls or skeletal figures (inspired by the great Mexican satirist José Guadalupe Posada). Its flatly patterned, tightly packed format, filled with action and incident, is meant to reflect the occidental notion of death as an "impenetrable abyss," in Rivera's words.[47] By contrast, his representations of the rural Day of the Dead, which show colorfully decorated graves and a table laid with feast offerings, are calm and symmetrical compositions, by which Rivera meant to affirm the respectful indigenous attitude toward death as something both inevitable and life engendering.[48] Once again, they bring to mind Aztec festivals dedicated to the dead, which, according to the chroniclers, were both solemn and gay.[49]

Heeding Gamio's injunctions about transforming the past into present relevance, Rivera seized on Aztec dualistic philosophy as a structuring device for his monumental nationalist murals. More specifically, he identified the positive connotation of death among the Aztecs and indigenous peasants as the central metaphor of Mexican civilization, and he incorporated the Aztec notion of transformation—that is, the creation of new life through the destruction of the old and the confrontation, and alternation, of irreconcilably opposed forces (life and death, day and night, light and dark, wet and dry)—into the scheme of his major projects of the 1920s. To account for the seasonal renewal of nature, both ancient and modern-day Mexican agriculturalists used a sexual metaphor involving the mythic sun deity who dies in the sexual encounter with the fertility goddess and is reborn in the form of maize. Another major Aztec metaphor for transformation was death as a result of armed combat. The disappearance of the sun at night was described as a battle between the forces of light and dark in which the sun died and was reborn each morning after successfully fighting the night. Aztec human sacrifice was thus a reenactment of the deity's death and rebirth.[50]

It is precisely this idea of death as a dynamic agent, as opposed to the static Western notion of death as an absence of life, that Rivera saw as the distinguishing

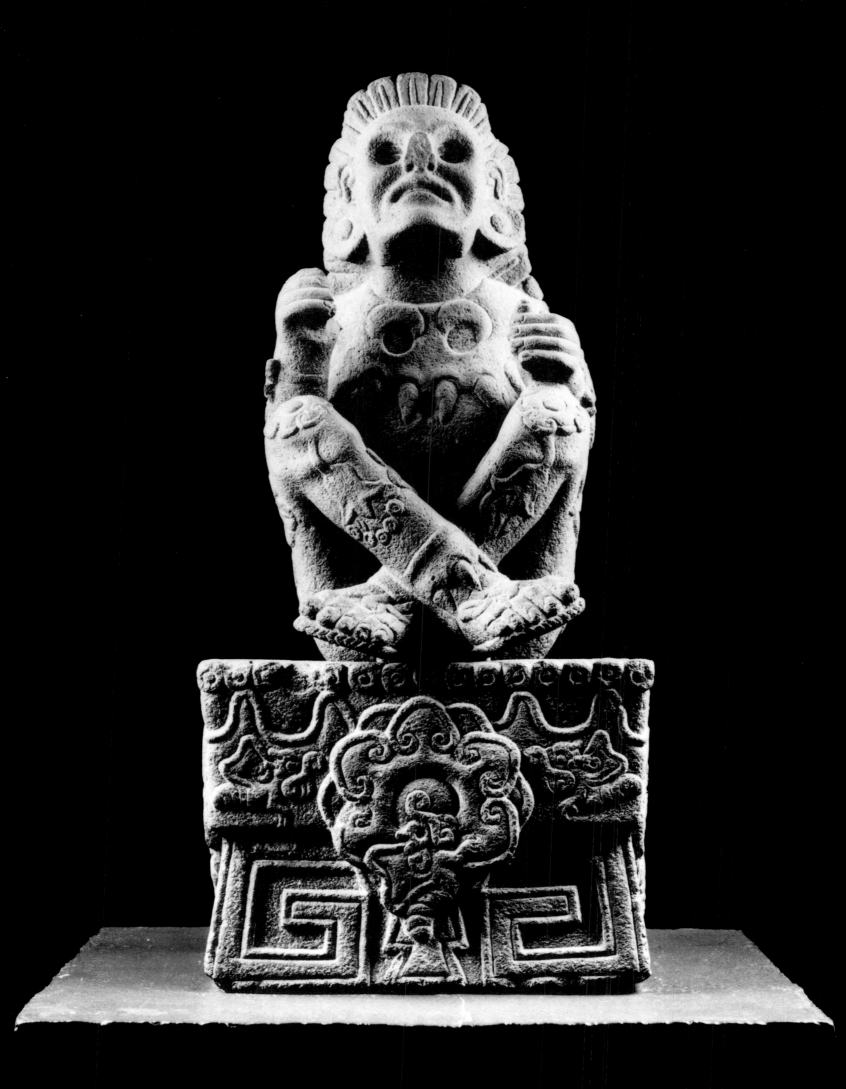

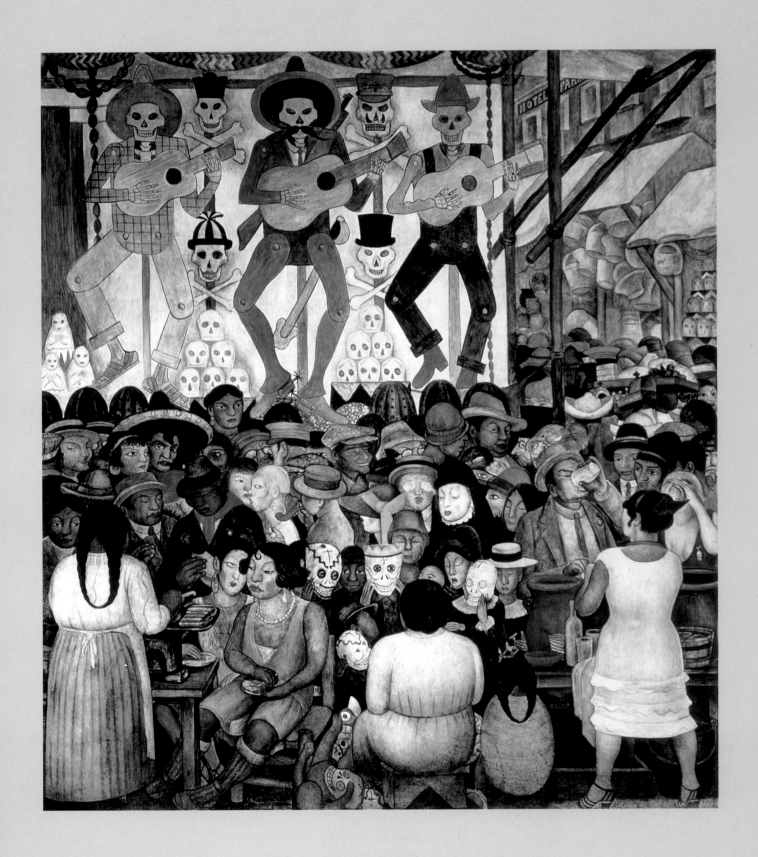

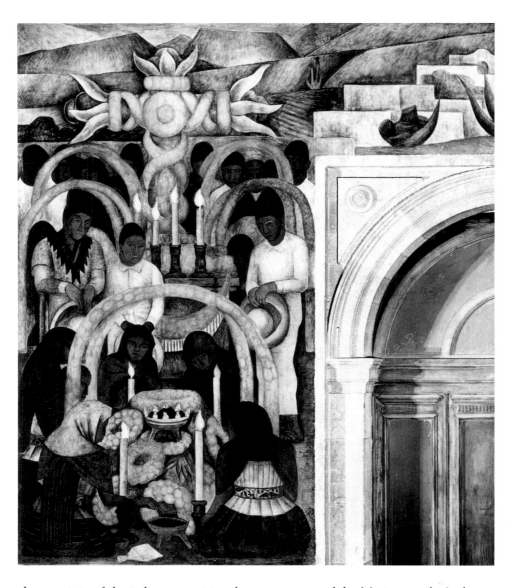

characteristic of the indigenous spirit—the very essence of the Mexican soul. And as
an indigenist, he identified strongly with it, often representing his own likeness in
relation to it. He pictured himself in the urban Day of the Dead scene below the right-
hand *calavera* (who wears Rivera's habitual costume of workers' overalls), and again,
much later, at the center of his Hotel Prado mural, 1947, in the guise of a child
holding the hand of a female *calavera,* who is metaphorically his mother, the source of
life, as well as the embodiment of the Mexican spirit. Dressed, like Posada's *Catarina
calavera,* as a stylish, late-nineteenth-century bourgeois woman, she wears a boa made
of a feathered serpent (mythic incarnation of Quetzalcoatl), and on her backbone is
inscribed the Aztec emblem of death generating life and movement, called the *ollin*
sign, which is also featured as an emblematic device in an upper floor of the
Secretaría.[51] The Pre-Columbian art collection that Rivera amassed and the museum
he designed and built to house it articulates the same notion of transformative death as
the central metaphor of Mexican culture.

Rivera explored these Aztec concepts of dynamic opposition and metamorphosis
more fully in his extraordinary frescoes of 1924–27 in the chapel (now an auditorium)
of the new agricultural college in Chapingo. They address the central issue of the
Mexican Revolution, the land reform demanded by Zapata—specifically, the
expropriation of haciendas to give peasants parcels of land (*ejidos*) to work
communally—that was generally understood as a return to the communal agrarian
organization of pre-Hispanic times. On either side of the chapel he developed a
thematic opposition between the notions of natural and social transformation of the
land. The entryway establishes the pattern with representations of the shrouded corpses
of the revolutionary heroes, Zapata and Otilio Montaño, buried beneath a fruitful
cornfield on the south wall, and a group of militant peasants spreading the seeds of the
revolution on the north. Here, Rivera has equated the Aztec myth of the death of the
maize god after a sexual encounter with the earth goddess with the martyred Mexican

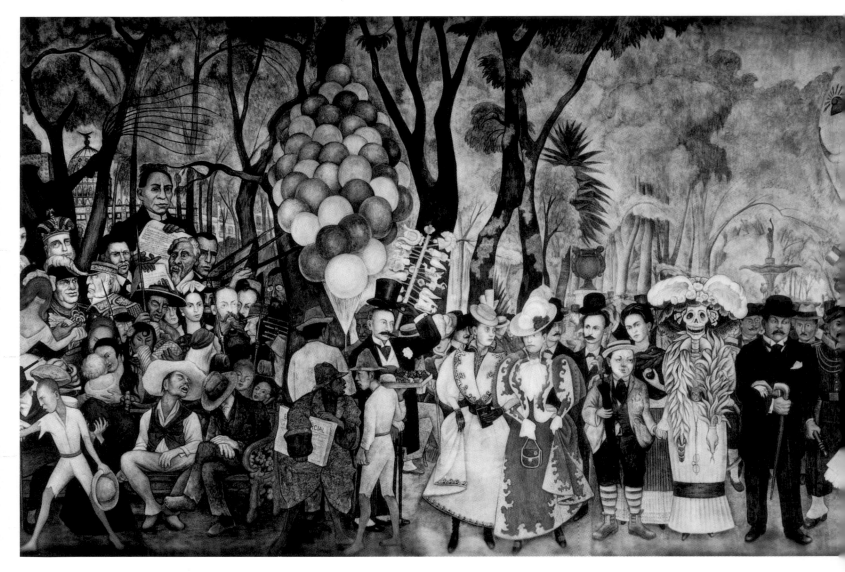

Diego Rivera. Dream of a Sunday Afternoon in
the Alameda *(central section). 1947–48. Fresco.
Hotel del Prado, Mexico City*

José Guadalupe Posada. Catarina calavera
(Calavera of the Female Dandy). *c. 1910. Detail
from a zinc linocut poster, overall 37¼ × 27½",
detail 14⅛ × 20⅛". The Art Institute of Chicago,
Prints and Drawings Department Purchase Fund,
RO8070*

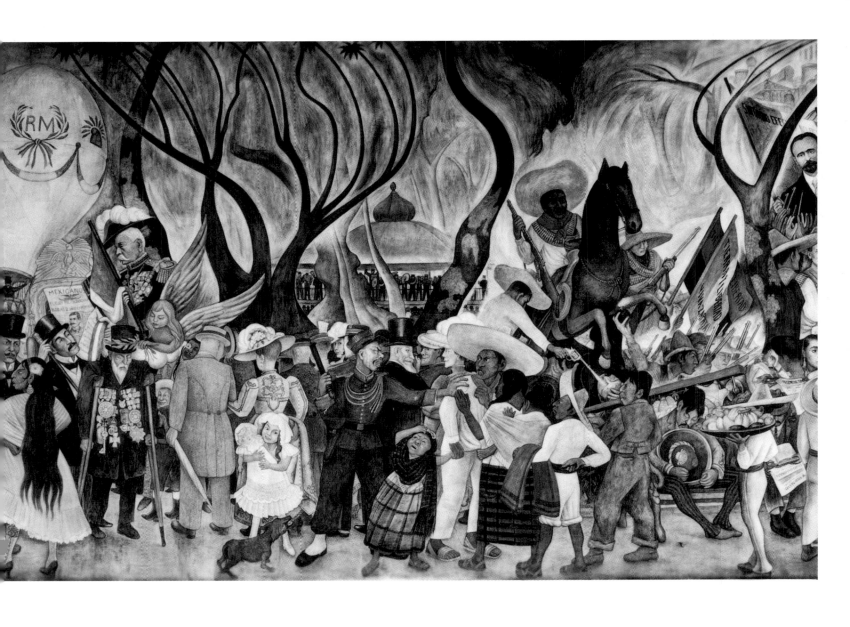

Quetzalcoatl, feathered serpent deity. Aztec, c. 1500. Stone, height 20⅛". Museo Missionario Etnologico, Musei Vaticani, Vatican City

PAGE 202:
Diego Rivera. Blood of the Revolutionary Martyrs Fertilizing the Earth (Zapata and Montaño). 1926–27. Fresco. Chapel, Autonomous University, Chapingo, Mexico

PAGE 203:
Diego Rivera. Overview of chapel. 1926–27. Fresco. Chapel, Autonomous University, Chapingo, Mexico

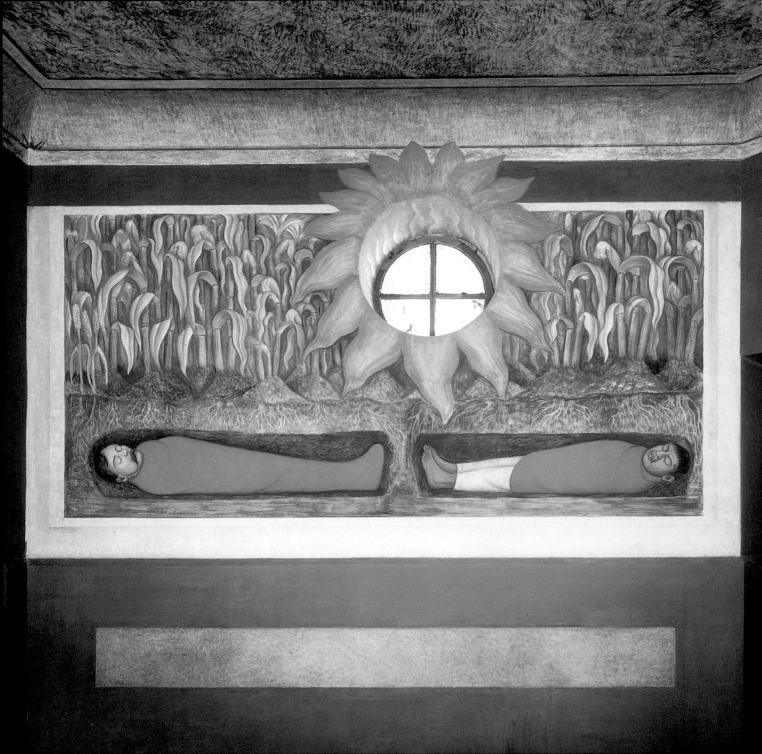

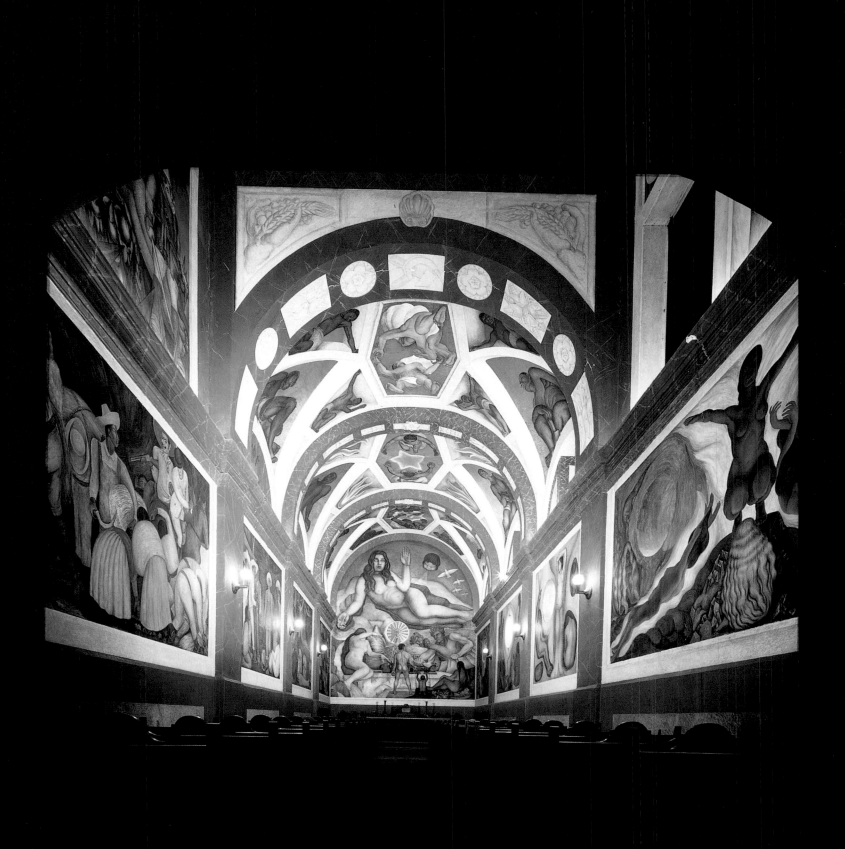

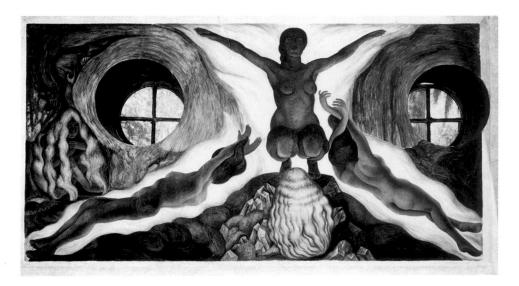

Diego Rivera. Natural Evolution (Subterranean Forces). *1926–27. Fresco. Chapel, Autonomous University, Chapingo, Mexico*

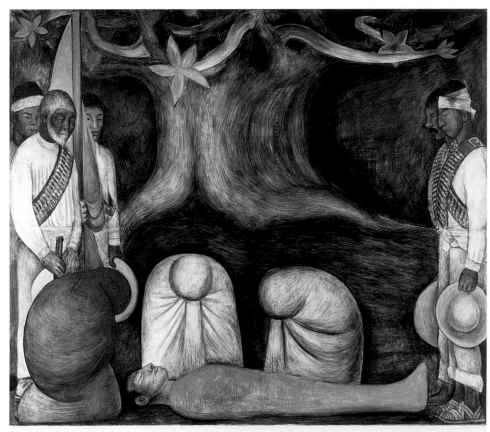

Diego Rivera. Continuous Renewal of the Revolutionary Struggle. *1926–27. Fresco. Chapel, Autonomous University, Chapingo, Mexico*

heroes of the Revolution. Just as the Aztec god is required to die in order to be reborn in the form of maize, Rivera asserts, so the agrarian revolution requires the sacrifice of its leaders in order to grow.

In the nave, representations of the stages of human and plant evolution—growth of embryos, germination of seedlings, flowering of plants[52]—on the south wall, are paired with images of the stages of revolution, on the north—exploitation, agitation, armed struggle, reorganization. The former are associated with the fertility and awesomeness of the mothering earth and with light; the latter relate to Zapata's commitment to violent land reform and to darkness. Both sides contain Pre-Columbian allusions: a kneeling female clutching maize who is modeled after Aztec icons of the corn goddess, Tonantzin, on the right; and a dead revolutionary under a conspicuously flowering tree, on the left. The vision of the natural transformation of the land culminates in the seasonal harvest and that of social transformation in the flowering of the revolutionary struggle, with soldier, worker, and peasant distributing food to the multitudes.

The chapel's apsidal wall resolves the two sides in a huge mural representing a voluptuous reclining figure symbolizing the fertile earth (a portrait of Rivera's pregnant wife, Lupe Marín) attended by personified natural elements, which signifies the

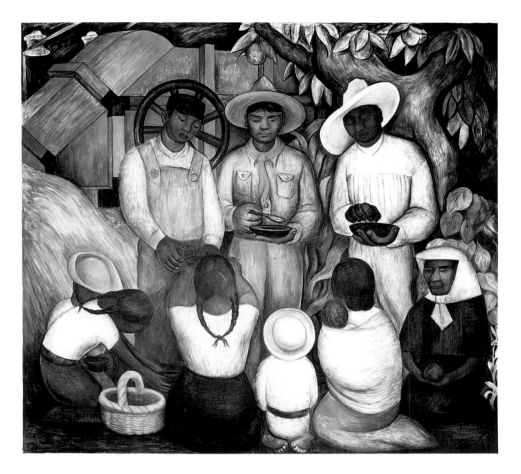

Diego Rivera. The Distribution of Food to the
Multitudes. 1926–27. Fresco. Chapel,
Autonomous University, Chapingo, Mexico

harmony between humankind and nature once both have been liberated from the
bondage of selfish interests.[53] (Here, the Aztec philosophy of a never-ending cyclical
war of opposing forces is superceded by the Marxian dialectical law of the unity of
opposites.) Rivera has thus evoked the Aztec metaphor of transformation through the
regenerative processes of nature to assert the moral force behind the Revolution,
representing Zapata's demands for land reform not only as an inevitable and natural
course but also as a reclamation of the ancient rights of Indian peasants whose maize
crops had sustained Mexico from the earliest time.

Rivera's next big commission was for a series of murals in the National Palace, the
seat of government built over the ruins of the palace of Moctezuma II, adjacent to the
main ceremonial precinct of Tenochtitlán, the Aztec capital. He used this historically
significant site to set before the Mexican people a sweeping vision of their entire
history, from the pre-Hispanic period to the present, which would teach them about
their newly recognized native origins and mobilize them to action within a political
movement (the contending forces in the Revolution had just organized a central
political party).[54] He began painting in 1929 and worked on the project in three
stages over the next twenty years without ever completing it. Among the most
ambitious and complex paintings in world art history, the murals also represent the
grand summation of Rivera's Pre-Columbian research.

Rivera visualized the immense central stairway wall and adjacent panels (1929–30
and 1935) as a huge triptych representing Mexican history from the fall of
Teotihuacán to the postrevolutionary reconstruction. The centrifugally organized
composition—inspired by Baroque religious art—begins on the right-hand wall with a
mythic vision of the Pre-Columbian epoch. Its focal point is the pale-faced culture
hero Quetzalcoatl, beneficent ruler-priest of Cholula, who was humiliated and banished
by the Toltecs but who promised to return, a prophecy that ostensibly led Moctezuma
to accept Cortés as his second coming. Framed by a pyramid-temple (resembling the
Pyramid of the Sun at Teotihuacán), he sits among his acolytes, imparting the
peaceable arts and crafts of civilization—maize cultivation, stele carving, textile
weaving, ceramics, painting, stone carving, music making, ceremonial dancing.
Opposite these creative workers, slaves build a pyramid, supervised by an elite eagle
knight. Below them, a class conflict rages between Aztec rulers and ruled—this is an
idealized but dialectical construction of the pre-Hispanic past.

PAGES 206–7:
Diego Rivera. The History of Mexico: From the
Fall of Teotihuacán to the Future. Stairway
murals: south wall (above left), north wall (above
right), central section (below right and far right),
detail of central section (below left). 1935. Fresco.
National Palace, Mexico City

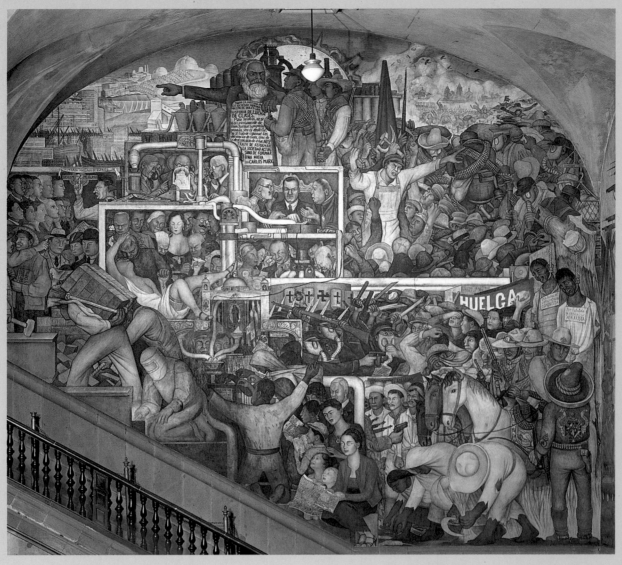

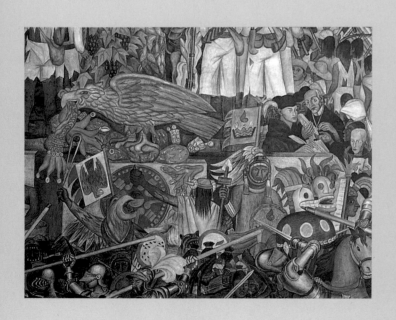

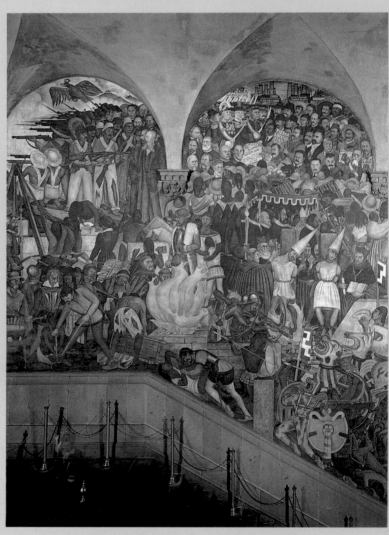

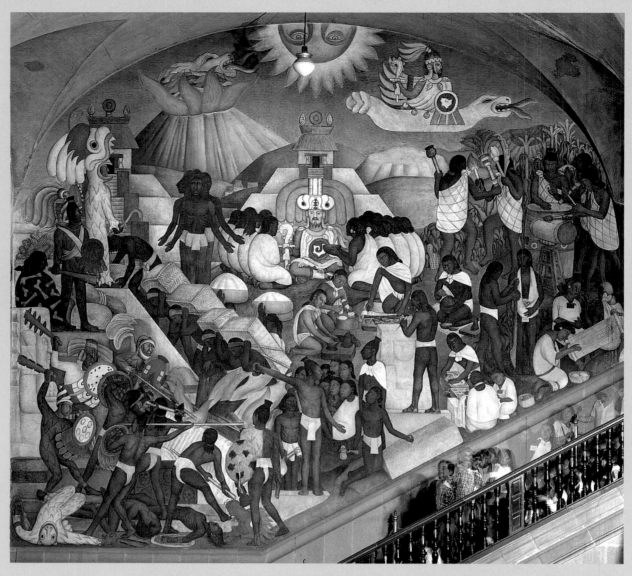

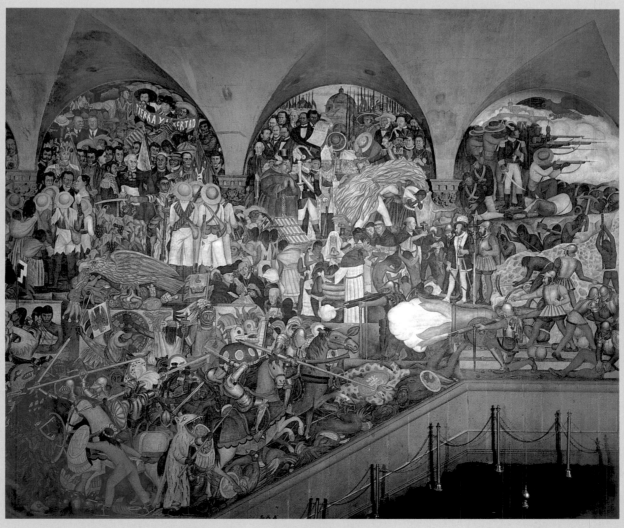

Women grinding corn and weaving. From the Codex Mendoza. c. 1541–42. Illuminated manuscript, 12⅞ × 9″. Bodleian Library, Oxford

In the sky above, the deified Quetzalcoatl, after his expulsion from Tula, sails toward the east on a feathered-serpent raft—an allusion to his transformation into the planet Venus.[55] The volcano surmounted by an *ollin* sign also links Quetzalcoatl with the Aztec myth of the creation and destruction of four suns, which holds that the Aztecs were living in a fifth world to be destroyed by earthquake on the date "four movement." The inverted sun at the very top of the composition predicts the coming of a new world, presumably the epoch of Karl Marx, who is pictured as the modern equivalent of Quetzalcoatl in a contemporary Mexican context on the left side of the stairwell.[56]

This depiction of ancient Mexico shows the extraordinary range of the artist's archaeological research and demonstrates his amazing synthesizing powers. His major pictorial sources were illustrated codices from the post-Conquest period, particularly the Lienzo de Tlaxcala, the Codex Mendoza, the Codex Telleriano-Remensis,[57] which were produced under Spanish patronage by native scribes to supply the Viceregal government with a wide range of information about Aztec culture, and illustrations from sixteenth-century chronicles, especially Sahagún's Florentine Codex and *Primeros Memoriales*, and Friar Diego Durán's *Historia de las Indias de Nueva España*.[58] But Rivera combined these with visual references to Aztec reliefs and Toltec-Maya murals.

yepolinhq̃ mexica

Ruler surrounded by subjects. Page 48 from a facsimile of the Lienzo de Tlaxcala. c. 1550. Painting on cloth. Museo Nacional de Antropología, Mexico City

The conception of a ruler surrounded by his subjects was probably suggested by illustrations in the Lienzo de Tlaxcala; and that of the creative workers surely derives from pages in the Codex Mendoza. The eagle knight, however, is based partly on codex illustrations and a well-known sculpture of an eagle knight (which Gamio upheld as the epitome of Aztec realism). The figure of a fair-haired ruler wearing a feathered headdress combines an illustration from Durán with relief representations on a famous Aztec stone container (now in Hamburg) or on a cliff face in Toluca.[59] And, finally, the deity figure on a serpent raft, the inverted sun, the battle scene, and other details are indebted to Toltec-Maya murals on the Upper Temple of the Jaguars at Chichén Itzá,[60] in conjunction with illustrations from the Florentine Codex.

Rivera continued the history of ancient Mexico on the lower section of the gigantic central stairway wall with a representation of the Spanish conquest of Tenochtitlán, which pitted Aztec knights against the Spanish conquistadors.[61] This historical battle was immediately preceded by another between Cortés, with his Indian allies from Tlaxcala and Texcoco, and Aztec-ruled Cuernavaca. Rivera painted both battles during the same period, one in the National Palace and the other in the Cortés Palace in Cuernavaca, as part of a mural on the history of the state of Morelos and used the same ancient sources for both.[62] Many of the costume elements and poses of the Indian warriors and Spanish soldiers are composites of illustrations of Conquest battles in the Lienzo de Tlaxcala and of ritual combat in the Florentine and Mendoza codices, as Catlin has observed.[63] They are combined with references to Uccello's fifteenth-century frescoes of battles, which Rivera drew in Italy. The most striking elements in both battle scenes are outsized Aztec battle standards—wooden effigies or symbols of deities constructed on a scaffolding supported by poles and carried aloft by ranking warriors to frighten enemies—and flags with Indian heraldic signs, which Rivera adopted from the Lienzo and the Codex Mendoza.

The focal point of the National Palace stairway mural, and of the entire triptych, is an image of an eagle on a cactus, the emblem of the Aztec state. Rivera took this important ancient motif from the back of a famous Aztec monument, the Temple of the Sacred Warfare (*Teocalli de la Guerra Sagrada*), which was uncovered in the foundation of the National Palace in 1926 (after its initial discovery and reburial in 1831). This temple model symbolized the Aztec capital and probably functioned as Moctezuma's throne. Its complex iconography (covering every surface but the bottom)

Head of an eagle knight. Aztec, 1350–1521. Stone, 12⅝ × 11¹³/₁₆". Museo Nacional de Antropología, Mexico City

Temple of the Jaguars, Chichén Itzá, Yucatán, Mexico. Copy of south-wall mural by Adela C. Breton, 1904–6. Peabody Museum, Harvard University, Cambridge

Quetzalcoatl. From the Florentine Codex, Med. Palat. 218, folio 10 verso. 1575–80. Illuminated manuscript. Biblioteca Medicea Laurenziana, Florence

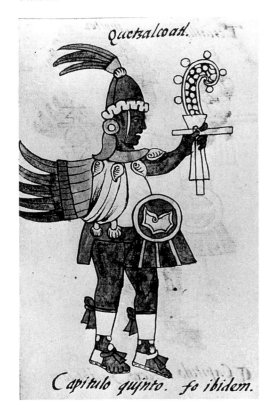

Tlaxcalan warriors and Spanish officers battling Mexicans. From a fascimile of the Lienzo de Tlaxcala. c. 1550. Painting on cloth. Museo Nacional de Antropología, Mexico City

Diego Rivera. Battle of the Aztecs and Spaniards. *1930. Fresco, Palace of Cortés, Cuernavaca, Mexico*

Ritual combat between eagle knight and prisoner. From the Florentine Codex, Med. Palat. 218, folio 180 recto. c. 1575–80. Illuminated manuscript. Biblioteca Medicea Laurenziana, Florence

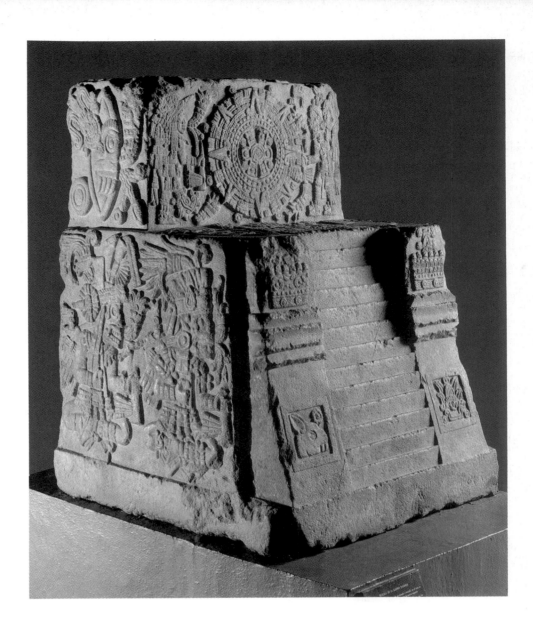

Temple Stone. Aztec, Tenochtitlán, Mexico. c. 1507. Stone, 47¼ × 36¼ × 39″. Museo Nacional de Antropología, Mexico City

records the New Fire ceremony of 1507 celebrating the Aztecs' glorious past and future and represents the Méxica of Tenochtitlán as the legitimate power in the Valley of Mexico.[64]

A relief at the top of the temple model depicts the Aztec war deity Huitzilopochtli and Moctezuma II flanking a solar disk. On the sides, seated deities draw penitential blood from their loins to help support the legitimate ruler. The eagle perched on a nopal cactus on the back is part of the Aztec origin myth involving the tribe's migration through the desert until the appearance of an eagle on a cactus with a serpent in its mouth, identifying their new home. But instead of a serpent, the eagle here has a speech scroll, which signifies sacred warfare (called the Atl Tlachinolli glyph). Every figure on the monument also emits this war cry, consisting of streams of water and fire.

In 1926 Caso wrote a monograph about this monument, describing its iconography and interpreting its meaning with reference to the codices and chronicles. He focused on the Aztec symbol of the eagle and cactus, which he characterized as the essence of the cult of Huitzilopochtli. The eagle, Caso explained, is a manifestation of the sun, who as a young warrior is born each morning from the womb of the old earth goddess Coatlicue and dies each evening. In order for him to rise again and illuminate the world, he must engage in divine combat with his brothers the stars and his sister the moon, and his sustenance requires human blood provided by his chosen people, the Aztecs. The cactus is the tree of sacrifice, whose red fruit (human hearts) nourishes him on his flight. War for the Aztecs thus became a necessary religious ritual defining the very meaning of their existence, and the sacred warfare glyph was its symbol.[65]

Rivera's vision of the Aztec state emblem faithfully follows Caso's interpretation, rendering the sacred warfare glyph in the eagle's mouth and the sacrificial hearts

OPPOSITE:

Eagle on a cactus (back of Temple Stone). Museo Nacional de Antropología, Mexico City

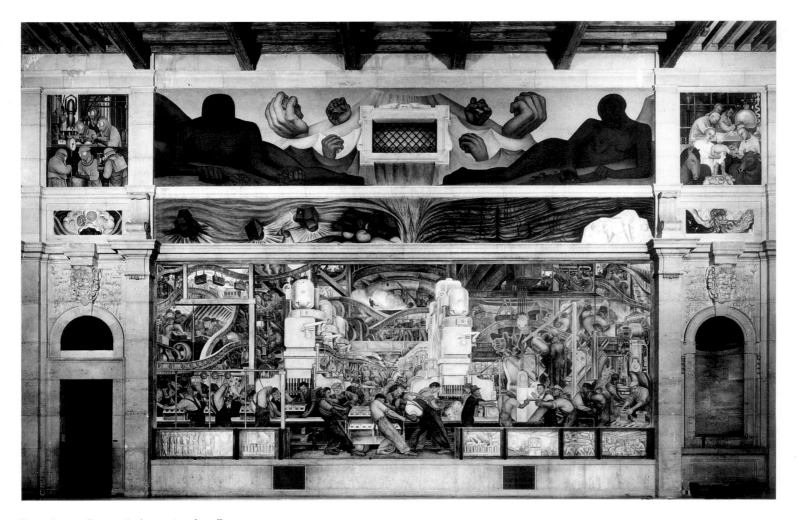

Diego Rivera. Detroit Industry (north wall).
1932–33. Fresco. The Detroit Institute of Arts,
Founders Society, Purchase, Edsel B. Ford Fund
and Gift of Edsel B. Ford

(cactus fruit) in its claws, and even the flowers and pistils on the cactus fruit, which Caso decoded as an allusion to the Aztecs' "flowery wars," waged to capture sacrificial victims for the sun. Beneath the emblem, Rivera also incorporated the two figures flanking a sun disk on the front of the monument, and a large sacred warfare glyph. The flanking figure in an eagle costume, whom Caso identified as Huitzilopochtli, appears in Rivera's mural as an eagle knight. However, in his monograph Caso failed to establish the identity of the other figure—whom we now know is Moctezuma II— though he compared its peculiar plumed headdress with that worn by the Aztecs' nomadic ancestors in an illustration in Diego Durán's atlas.[66] Rivera followed suit by obscuring the identity of this figure, whose back is to the viewer, and representing him as a priest in the same peculiar headdress raising a freshly sacrificed (cactus fruit) heart to the sun disk—thereby underscoring the monument's message of warfare and blood sacrifice as a means of fueling the sun and maintaining the Aztec state.

In this mural, as at Chapingo, Rivera employed a Pre-Columbian transformation metaphor to advance the moral force of the Mexican Revolution. He evoked as the centerpiece of an imaginative recreation of the history of Mexico the Aztec metaphor of death by armed combat, which was associated with the Aztec origin myth involving the tribal deity who had to be nourished by the continual sacrifice of foreign war captives in "flowery wars." Just as the Aztecs went to battle out of necessity, to nourish their sun god and to maintain a unified state, Rivera suggests, so have modern Mexicans had to fight wars of resistance to foreign domination: the battle of Tenochtitlán against Cortés, nineteenth-century wars of liberation, and the bloody twentieth-century revolution (alluded to in the mural's lunettes). And so should they be prepared to struggle against imperialism in the future (as the raised hand of Marx testifies in the left-hand panel). The final, self-conscious analogy Rivera has drawn is that between the Temple of the Sacred Warfare, a monument glorifying the history of the Aztec state, and his own monumental mural commemorating the past achievements of the Mexican nation and promoting its future.

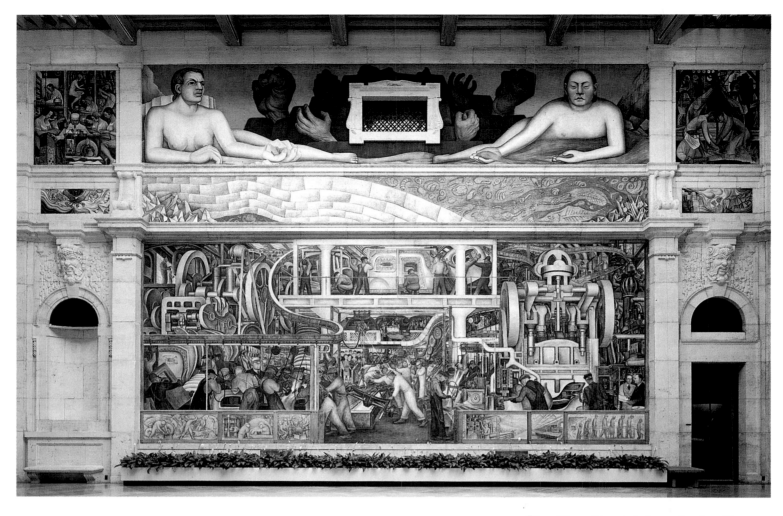

Diego Rivera. Detroit Industry (south wall). 1932–33. Fresco. The Detroit Institute of Arts, Founders Society, Purchase, Edsel B. Ford Fund and Gift of Edsel B. Ford

THE 1930S AND BEYOND: TECHNOLOGY SPEAKS

No longer exclusively nationalistic in character but still highly political, Rivera's post-1930 murals continued to promote the revolutionary notion of workers building a new world; however, their focus shifted from armed battle to technology as the workers' best means of controlling the natural and social order.[67] Because Mexican government patronage for murals had all but dried up during the later, repressive years of Plutarco Calles's political ascendancy (1929–34), Rivera (and his fellow muralists) turned to elite and corporate sponsors in the United States for financial assistance and critical approval.[68] The United States provided a new, international arena in which to spread the message of communism, but its special attraction was its industrial and technological might. Like the Russians, Rivera viewed the United States in schizophrenic terms, as an imperialist enemy (embodying the last stage of capitalism) and as the most advanced form of society (the wave of the future), which should be emulated in Mexico.[69] For their part, Rivera's U.S. patrons were willing to ignore the ideology of such a world-famous artist if his services could lend them credibility during the difficult Depression period.[70]

Among Rivera's U.S. projects, only his murals for the Detroit Institute of Art, 1932–33, and San Francisco's Golden Gate International Exposition of 1940 allude in important ways to Pre-Columbian art. Rivera's decoration of the Detroit Institute's Neoclassical courtyard celebrated the organizational skills and productive powers of modern capitalism as exemplified by the vast Ford Motor Company industrial complex, the world's first fully integrated automobile manufacturing and distribution center. The project is dominated by two enormous, opposing panels depicting the industrial production process. The north wall illustrates the construction of automobile engines, including drilling for iron ore and the operation of blast furnaces, foundries, conveyor belts, gear inspections, and so on. The south wall shows the manufacture of car chassis and features two huge stamping-press machines.

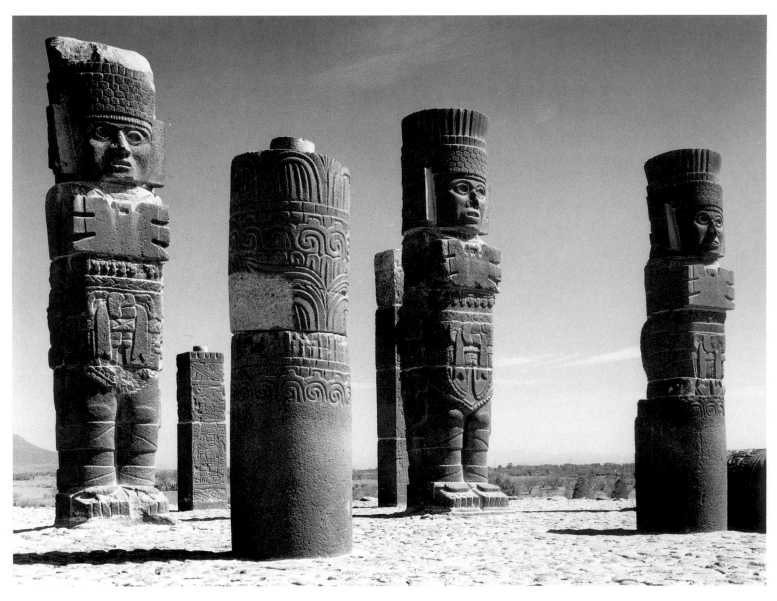

Colossal Atlantean warriors atop Pyramid B, Tula, Hidalgo, Mexico. Toltec, 1000–1200. Stone, height c. 15'

Once again, Rivera organized his subject matter—the technological processes at Ford's River Rouge Plant—on the basis of Aztec dualistic philosophy and metaphoric expression, as he had at Chapingo. Francis O'Connor suggests convincingly that the northern mural, representing the manufacture of the automobile's interior force, symbolizes the dark, unconscious dimension of the industrial process; the southern mural, representing the manufacture of the car's exterior, symbolizes the light, conscious aspects of the subject.[71] In the upper registers, giant reclining nude figures symbolizing the four races and the earth's resources reinforce this dichotomy. In the north mural, allegorical figures representing the "primitive" black and red races flank a volcano (analogous to the blast furnace below) covered with disembodied hands extracting raw materials from the depths of the earth. On the south, figures symbolizing the white and yellow races flank a Pre-Columbian pyramid studded with expressively gesticulating—not grasping—hands.

Disguised Pre-Columbian "deities" preside over the contrasting technological processes depicted in the lower registers: on the north, overscaled spindles (related to engine blocks) recall giant, blocky Toltec Atlantean figures—architectonic representations of ancestral warriors with round heads, flat chests, and striated aprons—that once supported a temple roof atop a pyramid at Tula; on the south, huge stamping presses resemble the muscular, dynamic forms of the monstrous cult image of Coatlicue, the Aztec earth-fertility-death goddess and mother of Huitzilopochtli. Rivera has translated the colossal figure of the goddess (discovered in 1790 in the Aztec ceremonial precinct and reinterred because of its fearful aspect) into an anthropomorphic machine: the intertwined serpents of Coatlicue's skirt (which give her her name) have become pistons and valves; their fangs, parts of the machinery.[72]

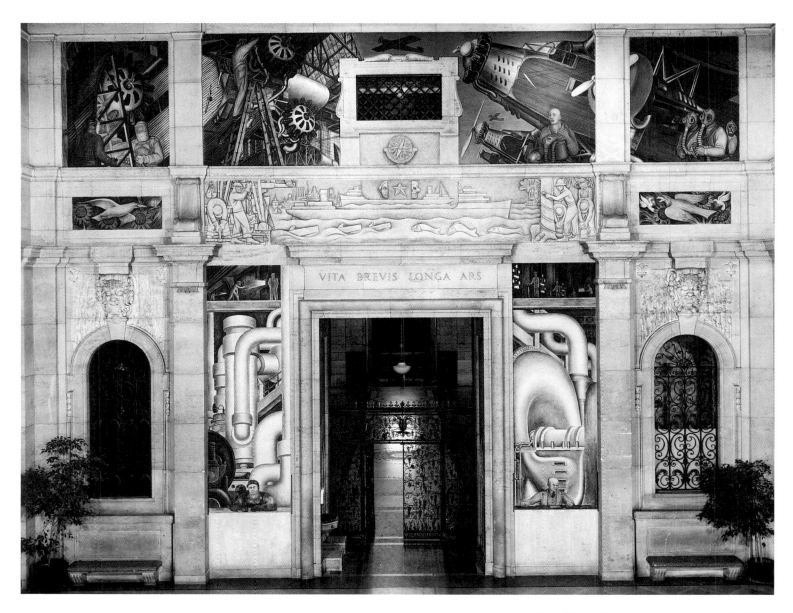

Diego Rivera. Detroit Industry (west wall). 1932–33. Fresco. The Detroit Institute of Arts, Founders Society, Purchase, Edsel B. Ford Fund and Gift of Edsel B. Ford

Rivera may even have intended the staunch Atlanteans to signify guardian spirits, dignifying and protecting the workers, in the same way they may once have functioned in the Toltec temple interior, and the terrifying Coatlicue, avatar of Aztec dualism, to embody the workers' vulnerability to malign exterior forces.[73] Although these Pre-Columbian effigies make an odd couple—they were created in disparate cultures and time periods as different kinds of signifiers—Rivera was probably thinking of the frequently paired Aztec deities depicted in the codices, or quite possibly of the famous pair of stone idols from Cozcotlan, Puebla, in the National Museum, which represent Coatlicue (see page 29) and a male deity, perhaps a fire god.[74]

The dualistic spirit of the goddess Coatlicue hovers over the entire enterprise. Her hand gestures of repelling or giving (the necklace of hands and hearts above a death's-head belt) are metaphors for her powers of life and death, which are echoed in the disembodied hands of the upper registers. (Her clawed hands and feet and the two serpents substituting for her head emblematize her association with the earth and its voracious and regenerative aspects.) Her dualistic principle is echoed further in the bisected human head—half alive, half skull—of the transportation mural on the west wall, which delineates the constructive and destructive applications of technology (civilian or military) and nature (peaceful or predatory). This duality is reiterated elsewhere, for example, in panels at the top right and left of the north wall depicting the positive and negative applications of science (immunology versus the manufacture of gas bombs) and nature (healthy human embryo versus cells suffocated by poison gas).

Where previously Rivera had used only the more naturalistic Pre-Columbian icons—Xochipilli, Quetzalcoatl, Xilonen—as models, he now refers to this more abstract and

217

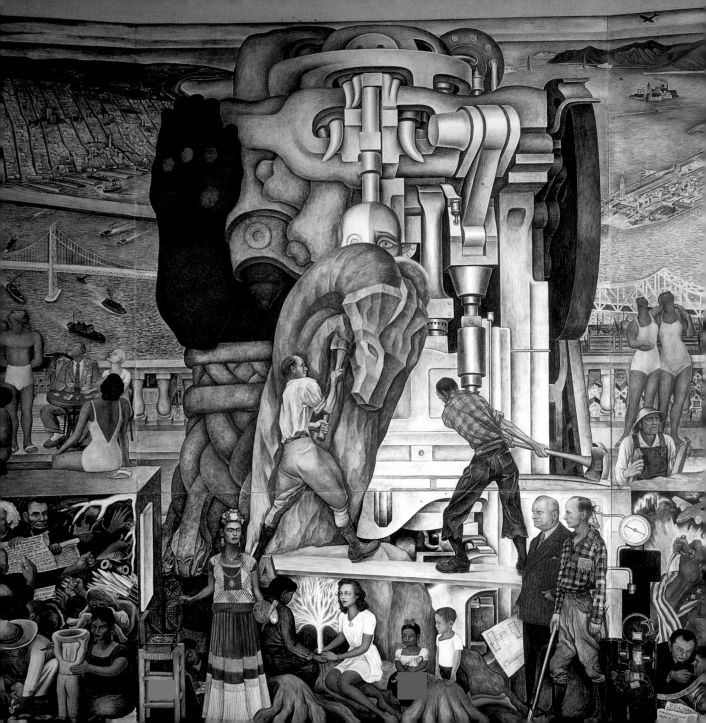

terrifying image of an Aztec deity (which Gamio and other indigenists had repudiated for its monstrosity) as a fitting analogue of the modern machine. For him, they are both supreme embodiments of natural forces. "I felt that in the society of the future, as already, to some extent, that of the present, man and machine would be as important as air, water, and the light of the sun," he wrote of his Detroit murals.[75] Scientific and technological power serves as the secularized equivalent of the unlimited potency and cosmic unification once provided by ancient religion.[76] Technology, Rivera proposes, has irrevocably altered the human relationship to nature; rationality has replaced superstition as a means of mastering the material world. In the Pre-Columbian era, priests sacrificed human hearts atop pyramids to sustain the sun; in the modern era, laborers offer up raw materials to be transformed into fuel for the new superpowers, machines.[77] No longer a power in its own right, nature is simply an object of utility for humankind.

Rivera attributed to technology a formal as well as substantive power. Modern machinery was for him as aesthetically convincing as Aztec sculpture, and modern engineers the equals of ancient pre-Hispanic artists. "Your engineers are your great artists," he declared in the United States. "These highways are the most beautiful things I have seen. . . . In all the constructions of man's past, pyramids, Roman roads and aqueducts, cathedrals and palaces, there is nothing to equal these. Out of them and the machine will issue the style of tomorrow."[78] The mural titled *Pan-American Unity*, which he painted for San Francisco's Golden Gate Exposition to promote the notion of a progressive Pan-American culture, conveys this idea clearly. Its fused images of the Aztec death goddess and the Detroit stamping press, each occupying half of a bilaterally divided figure, represent the synthesis of the artistic genius of the ancient south and the technology of the modern north: a marriage of "the plumed serpent and the conveyor belt," in Rivera's words.[79] Here, the great Coatlicue functions primarily as a signifier of the aesthetic prowess of Native Americans, but she also reflects the Aztec notion of death creating life, which Rivera idealized as the essential Mexican spirit.

Rivera's career in the United States came to an abrupt halt when he antagonized his capitalist sponsors by refusing to alter his mural scheme for the lobby of the RCA

Oxomoca and Cipactonal, first created couple, patrons of sustenance and origins. From a facsimile of the Codex Borbonicus, p. 21 (portion). Mexico City, preconquest or early colonial. Screenfold manuscript, panel 15⅜ × 15½"

OPPOSITE:

Diego Rivera. Pan-American Unity (central section). 1940. Fresco. City College of San Francisco

building in the new Rockefeller Center complex; he would not accede to their demand that he expunge the agitational portrait of Lenin from his celebration of the new industrial worker, and the mural was destroyed. In 1934 he returned to Mexico with renewed prospects of mural commissions in a changing political climate. He reproduced his RCA building mural in the Palace of Fine Arts (Palacio de Bellas Artes) in Mexico City and resumed work on his stairway murals in the National Palace (Palacio Nacional), but between 1937 and 1942 he received no public commissions. In his later Mexican murals, Rivera reverted to Mexican historical themes and to the bold evocation of Pre-Columbian archaeology that characterize his earlier work, often combining these old devices with his new reverence for modern technology. His reassertion of native roots may have been an effort to resist the new cosmopolitanism and rapid internationalization (or re-colonization) of Mexico during the postwar period, as Catlin argues.[80] But that reassertion sometimes comes across as a nostalgic yearning for a primitive agrarian world, a regressive impulse that summons pre-Hispanic forms in an antiquarian spirit. The murals still promote national unity and historic identity but mainly as agents of a social meliorism, rather than revolutionism, which corresponds with the altered Mexican and worldwide sociopolitical landscape. The late-period compositions are also generally less inventive, their forms more descriptive, than those of previous efforts.

Rivera's most interesting murals of this period, for the Río Lerma water system, 1951, and the Hospital de la Raza, 1953–54, both in Mexico City, celebrate ancient and modern indigenous methods of harnessing nature for a better society. As he did in Detroit, Rivera promotes the notion of technology as a secular equivalent of a Pre-Columbian deity, but he appropriates new imagery from the iconography of different pre-Hispanic cults: For solar and earth deities he substitutes the gods of rain and healing (whose cults are related to those of the earth deities), as befitting structures dedicated to water usage and medicine.

The Río Lerma waterworks in Chapultepec Park tap underground mountain sources of the Lerma River to provide water for a district of Mexico City. The large complex, begun in 1943 and completed in 1951, was designed not only to function as a water-distribution system but also to serve educational, artistic, and recreational purposes. Rivera's contribution to the project included murals in the main distribution tank within the pumping station of the water system (in Spanish called the *carcamo*, which translates as either the "concave womb" of an animal or a "tunnel"), and a huge mosaic relief in an adjacent exterior fountain.[81] His chosen theme is water as both a force of nature and a requirement for human life.

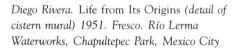

Diego Rivera. Life from Its Origins *(detail of cistern mural) 1951. Fresco. Río Lerma Waterworks, Chapultepec Park, Mexico City*

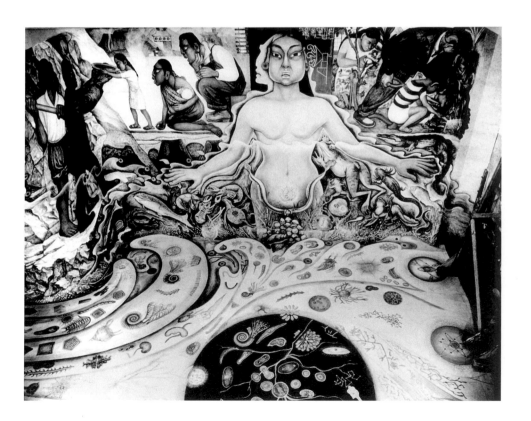

Diego Rivera. Beneficent Hands of Nature
Bestow the Gift of Water (detail of cistern
mural). 1951. Fresco. Río Lerma Waterworks,
Chapultepec Park, Mexico City

PAGE 222:
Tlaloc effigy vessel. Aztec, Tenochtitlán, Mexico.
Clay, 13¾ × 12¾". Protecto Templo Mayor,
Mexico City
This vessel, discovered recently in excavations of
the Templo Mayor in Mexico City, is similar to the
forms that were available to Rivera.

Chalchiuhtlicue, "She of the Jade Skirts."
Teotihuacán, Mexico, 300–600. Stone, height
10'6". Museo Nacional de Antropología, Mexico
City

Rivera painted the murals inside the cistern of the pumping station in an
experimental medium (unsuccessfully) designed to preserve them in the flowing water.
Entitled *Mexico Puts an End to Its Thirst* and *Life from Its Origins*, they trace
contrasting notions of natural evolution and social transformation in a scheme that is
familiar from Chapingo and Detroit—in this case pitting engineering skills against
nature's fecundity. Life is shown beginning at the bottom of the water tank with
myriad small aquatic forms—amoebae and crustaceans—and developing into more
advanced forms in the water flowing on either side of the tank, out of which emerge
an enormous multiracial creator couple. The masked female, with a baby embryo inside
her belly, and frogs and crustaceans springing from her outstretched hands, is yet
another of Rivera's fulsome fertility goddesses. The other walls are occupied by a giant
pair of bountiful hands from which water flows into the cistern, and, opposite them,
portraits of the project's twenty-four directors, engineers, and workers—the actual
technicians responsible for the tunnel—including those who died while constructing it.

Rivera's goddess was inspired by Mesoamerica's earliest cult images of a water-fertility
goddess with frontal pose and outstretched arms found at Teotihuacán (c. A.D. 300–
600), perhaps in combination with later, more generalized representations of this
goddess, who is associated with mountains and streams.[82] Her face resembles that of
many Teotihuacán figures and masks, with its flat planes, deep-set, almond-shaped
eyes, open, downturned mouth, and flanged ears with round ear spools. To the right of
her face is the sign for temple structure, adorned with disks symbolizing the rain god
Tlaloc, which is a convention of Aztec codices.[83] Though she is far more naturalistic
than the great hieratic basalt water goddess Chalchiuhtlicue—"she of the jade skirts,"
consort of Tlaloc—which was found near the Pyramid of the Moon at Teotihuacán,

PAGE 223, TOP TO BOTTOM:
The Paradise of Tlaloc. Teotihuacán, Mexico, 300–600. Reproduction of fresco from Tepantitla compound. Museo Nacional de Antropología, Mexico City

Bestowing hands, Portico 11, Tetitla, Teotihuacán, Mexico, 300–600. Fresco

Diego Rivera. Water fountain depicting the rain god Tlaloc. 1951. Mosaic. Río Lerma Waterworks, Chapultepec Park, Mexico City

Life/death mask. Tlatilco, Mexico. 1000–500 B.C. Terra-cotta. Museo Nacional de Antropología, Mexico City

OPPOSITE, ABOVE:
Diego Rivera. The People's Demand for Better Health. 1953. Fresco. Hospital de la Raza, Mexico City

OPPOSITE, BELOW:
Tlazolteotl, goddess of filth, sin, and adultery. From a facsimile of the Codex Borbonicus, p. 13 (portion). Mexico City, preconquest or early colonial. Screenfold manuscript, panel 15⅜ × 15½"

the wavy pattern of water around her recalls that on the latter's skirt, and their bilaterally symmetrical poses and angular shapes are similar.

However, Rivera's major source is undoubtedly the so-called Tlalocan mural from the Tepantitla palace compound at Teotihuacán, which Caso published shortly after its discovery in 1942 in an article that has since become the standard interpretation of the mural complex.[84] In the upper (tablero) portion of the wall, a frontal deity with extended arms, probably a water-fertility goddess like the monumental Chalchiuhtlicue, issues water droplets from her hands and sprouts a great tree from her head. The hands of a flanking pair of acolytes bestow abundant offerings that merge with the flowing water beneath them, which is filled with hundreds of tiny aquatic creatures. The sloping lower portion of the wall (talud) depicts a flowering landscape with dozens of exuberant little figures cavorting gaily in streams of water flowing from a mountain.

Caso interpreted the deity figure as the Aztec rain god Tlaloc accompanied by his priests and the scene of watery abundance below as the paradise of Tlaloc, afterworld of eternal springtime reserved for those who die by drowning. And Rivera clearly conceived of the Lerma murals in terms of those at Tepantitla, as mediated by Caso, incorporating into the Lerma iconography the deity figure, flowing water, aquatic creatures, and even the notion of death by drowning in the images of the workers who died during the construction of the waterworks.

The recurrent images of bestowing hands at Tepantitla, and in many other Teotihuacán murals, shed light on Rivera's lifelong fascination with expressive hands, which he may have valued as signifiers of the meeting point between human beings and the material world,[85] or simply as metaphors for elemental or intellectual forces. The huge disembodied hands in the Lerma mural join the ranks of the giant creating, rousing, grasping, instructing, indicating, protecting, and destroying hands that are a prominent feature of his murals, from the Preparatoria to Detroit. While visually akin to European models from Michelangelo to Rodin, they are conceptually related to the gesturing hands in Pre-Columbian art, which function as important bearers of meaning in Maya hieroglyphs, Aztec sculptures, and Teotihuacán murals.[86] Curiously, Henry Moore's sculptures betray a similar awareness of the significance of hand gestures in Pre-Columbian art, and their hands derive from a similar concatenation of Renaissance and Aztec sources.

Outside the Lerma pumping station, a vast mosaic relief sculpture (made of plastic resin pigments), part of a fountain adorned with undulating serpents and fishes, depicts the Aztec rain god Tlaloc, who is associated with flowing water. Rivera's use of the mosaic medium was a deliberate evocation and revival of the lapidary art of the Aztecs and Mixtecs (perhaps filtered through Antonio Gaudí's mosaic decorations in Barcelona).[87] And one of his sources for the grotesque split-faced head of Tlaloc was surely the famous Aztec turquoise mosaic mask representing Tlaloc, which is in the British Museum and thought to be part of Moctezuma's gift to Cortés, as described by Sahagún.[88] The trunklike braided nose (consisting of twined serpents), thick, everted lip (resembling a mustache), and toothy mouth of the turquoise mask are similar to Rivera's head. But, as was often the case, Rivera probably fashioned the deity's head from a number of pre-Hispanic sources, including goggle-eyed and fanged-mouth terra-cotta and stone effigies of Tlaloc. For the striding pose of the god, he appropriated the running posture of many deities in Aztec manuscripts, for example, the image of Quetzalcoatl in the Codex Borbonicus (page 24)[89]—one of his favorite pre-Hispanic sources during later years—and in colossal Aztec reliefs. The great circular relief depicting the moon goddess Coyolxauhqui, which was recently unearthed in the Templo Mayor excavations, is a striking example. Rivera's Tlaloc is extremely foreshortened when seen from the ground, suggesting that it might best be viewed from the air like certain Pre-Columbian earthworks, such as the great Serpent Mound of the Hopewell Culture in southern Ohio or the Nazca lines etched in the Peruvian desert, as if their makers intended them as gigantic propitiatory offerings to be seen by supernatural forces in the sky. This remarkable Lerma fountain thus looks back to ancient Pre-Columbian earthworks and ahead to earth sculptures of the 1970s, such as Robert Smithson's Spiral Jetty, which also fuse mythical and scientific, especially evolutionary and ecological, concerns in a site-specific context.

As usual, the particular expressivity of Rivera's project relates closely to the social and historical significance, as well as the function, of the site it occupies. Now a part

los q̃ naçih aqui on fin do
mon te lillo fea a uâ de mocyx

Female figure covered with sores. Ixtlan del Río style, Nayarit, Mexico, 200 B.C.–A.D. 500. Clay with red slip and black, white, and yellow painted decoration, 10½ × 8½ × 5″. Los Angeles County Museum of Art, the Proctor Stafford Collection, Museum purchase with Balch funds (M.86.296.113)

OPPOSITE:
Frida Kahlo. My Birth. 1932. Oil on metal, 12 × 13¾″. Private Collection, U.S.A.

Vase showing figure administering an enema. Maya, 600–900. Terra-cotta

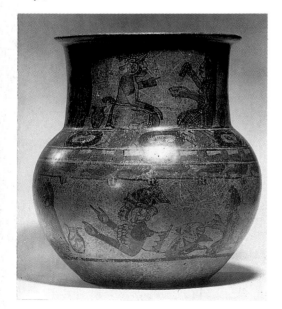

of a park with museums, zoos, and playgrounds, the waterworks are built over the ancient site of Chapultepec, which was the sacred mountain shrine of the Aztec ruler, a hill on the western shore of Lake Texcoco adorned with gardens, temples, palaces, and cliff reliefs, including a recently excavated sculpture of Tlaloc.[90] Chapultepec, signifying "grasshopper hill" in Nahuatl, had ancient importance as the site of the first Aztec settlement in the Valley of Mexico. Its springs, which skillful Aztec engineering had channeled through aqueducts to supply fresh water to Tenochtitlán, were also a priceless natural treasure. Thus, Rivera's depiction of the ancient water god and goddess within a modern hydraulic system on an Aztec site dedicated to the same purpose resonates with historical meaning; it commemorates the capacities and skills of the Aztec order and celebrates the continuities between the old and new Mexicos.

Like the Lerma project, Rivera's mural for the national Hospital de la Raza, a health facility for the indigenous population, commemorates ancient and modern Mexican technical capabilities. Titled *The People's Demand for Better Health*, it explores ancient Mexican healing practices as precursors of modern scientific medicine and advocates public-health services for all Mexicans.[91] Once again, the mural is dominated by a huge image of a Pre-Columbian fertility goddess: Tlazolteotl, Aztec goddess of dirt, debauchery—thus confessor goddess—and childbirth, who is also an avatar of Toci ("our grandmother"), described by Sahagún as the goddess worshipped by Pre-Columbian physicians, curers, and midwives.[92] Rivera quoted this image directly from a page in the Codex Borbonicus, in which the goddess is wearing a conical hat, cotton headdress, and flayed human skin; she squats as a child emerges from her spread legs. Rivera also replicated the only known stone representation of Tlazolteotl, a small-scale sculpture at Dumbarton Oaks (page 100), which is shown swinging from a tree limb at the right. No longer an allegorical figure, the goddess stands for herself in the Aztec pantheon. Directly beneath her is a panel illustrating the enormous variety of medicinal plants administered by Aztec sorcerer-curers, which Rivera carefully transcribed from a facsimile of a colonial herbarium known as the Codex Badiano.[93]

The dualistic mask below is a signal that the mural is organized on the familiar basis of the Aztec polarities and the theme of death and rebirth. Modeled after a famous life/death mask found at Tlatilco (c. 1000 B.C.), it is set between confronting (feathered and scaled) serpents, which recall the border imagery of Teotihuacán murals and Aztec reliefs. The rotating sun and moon above and framing lateral yellow and red trees further reinforce this duality. The right side of the bifurcated composition portrays the world of Pre-Columbian medicine; the left, the world of modern Mexican medicine. With the aid of archaeological material from different regional cultures and periods, principally West Mexican and Maya, Rivera reconstructed the pre-Hispanic healing arts—surgical and herbal treatment of eye, intestinal, skin, orthopedic, and vascular diseases, and, most prominently, as the special province of Tlazolteotl, childbirth—beneath representations of the main temples of Tenochtitlán (implying that they are all Aztec practices). Presiding over them is a large figure of a priest wearing the vestments of Tlazolteotl, as she is portrayed in the Borbonicus, while each medical practitioner wears a headdress associated with Toci as she is depicted in Sahagún's Florentine Codex.[94]

Frida Kahlo, Rivera's second wife, had already adapted the image of the Aztec goddess of parturition in her 1932 painting *My Birth*, but she used it in a strikingly different manner than her husband. Rivera copied the ancient form intact and combined it with many other images in different styles to make an uplifting public statement about ancient and modern Mexican medicine; she assimilated the iconic power of Tlazolteotl into her subjective realm, while also presenting a mythic Mexican history.[95] Her small-scale, intimate painting explores her personal physical and emotional suffering—a miscarriage in Detroit, a disfiguring childhood accident, the recent death of her mother—at the same time as it underscores her relationship to her Mexican Catholic and Pre-Columbian roots. While conceived in the format of the *ex voto* paintings she collected, which graphically depict an illness or disaster, invoke the intercession of a portrayed saint, and inscribe a thank offering, *My Birth* ironically denies the possibility of amelioration: It depicts Kahlo's birthmother's head shrouded, as in death, below a portrait of a Mater Dolorosa whose throat is cut and above a blank inscription.

The literal transcription of Pre-Columbian forms in Rivera's Hospital de la Raza

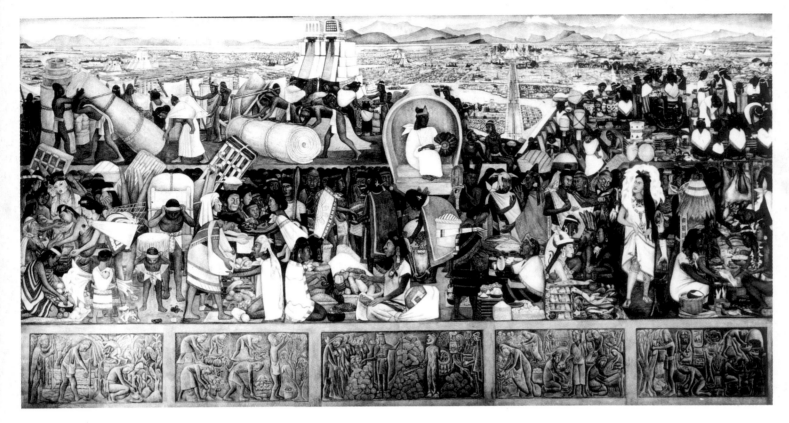

Diego Rivera. *The Great City of Tenochtitlán. 1945. Fresco. Patio Corridor, The National Palace, Mexico City*

mural proudly hails both the heritage and the possible resurgence of the indigenous crowds who pass before it. Rivera appropriated Pre-Columbian forms in similar wholesale fashion for the purpose of dramatizing ancient Mexican achievements in the patio corridor murals of the National Palace (adjacent to his stairway frescoes), which he painted intermittently between 1945 and 1951 but never completed. Unlike the juxtaposed pre-Hispanic and modern figures in the la Raza mural, however, the patio corridor murals are arranged conventionally in a sequence and are devoid of clashing stylistic elements. This absence of dialectical contrasts flattens the murals and makes clear how important the tension between the mythic and the human is to the vitality of Rivera's work.

Jaguar figurine with wheels. Nopiloa, 300–900. Terra-cotta, length 7⅛". Museo de Antropología, Universidad Veracruzana, Jalapa, Mexico

RIGHT:
Harlot. From the Florentine Codex, Med. Palat. 220, folio 41 verso. c. 1575–80. Illuminated manuscript. Biblioteca Medicea Laurenziana, Florence

OPPOSITE:
Scene depicting costumes awarded to warriors who took captives, showing a figure wearing an Aztec manta. Page from the Codex Mendoza, Ms. Arch. Seld. A. 1, folio 64 recto (EW1684). c. 1541–52. Illuminated manuscript, 12⅞ × 9". The Bodleian Library, Oxford

Aztec corn goddess (at lower left). From a facsimile of the Codex Borbonicus, p. 31. Mexico City, preconquest or early colonial. Screenfold manuscript, panel 15⅜ × 15½"

Diego Rivera. The Huastec Civilization. 1950. Fresco. Patio Corridor, The National Palace, Mexico City

Diego Rivera. The Tarascan Civilization. 1942. Fresco. Patio Corridor, The National Palace, Mexico City

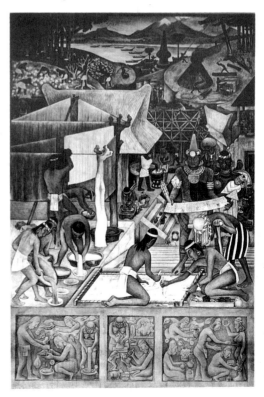

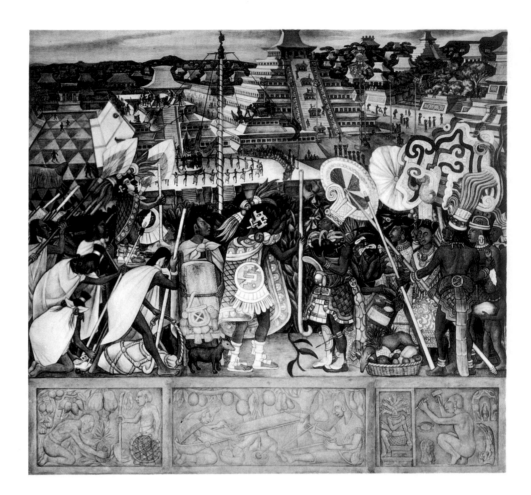

Diego Rivera. The Totonac Civilization. 1950.
Fresco. Patio Corridor, The National Palace,
Mexico City

Yiacatecuhtli, god of merchants. From the
Florentine Codex, Med. Palat. 218, folio 12 recto.
c. 1575–80. Illuminated manuscript. Biblioteca
Medicea Laurenziana, Florence

The nine dioramas of ancient Mexican civilization include representations of several regional cultures, native industries (rubber, cocoa, and maguey), and the arrival of Cortés, each with a grisaille predella panel.[96] Rivera based this synopticon of ancient Mexico's contributions to world culture on his usual prodigious research culled from Caso's publications and advice, Sahagún's Florentine Codex, and surviving monuments and manuscripts. He also used his ever-expanding personal collection of Pre-Columbian art as an inventory of forms.

The largest and most compelling patio corridor mural depicts the Aztec capital, Tenochtitlán. The background consists of a sweeping aerial panorama of the canal-crossed island, with its distant twin-templed ceremonial center, set within the lakebed of the Valley of Mexico, surrounded by majestic snow-covered peaks.[97] The tip-tilted foreground presents a market day in the great plaza of Tlatelolco, Tenochtitlán's twin city, with its own looming twin pyramids, which Bernal Díaz del Castillo and Cortés celebrated. In the center, a royal steward, wearing the peaked turquoise crown of the Aztec nobility and carrying an elegant feather fan, oversees the rich and varied commerce from a litter. A profusion of fantastic goods from all over the Aztec empire—foodstuffs, herbal medicines, ceramics, woven mats—are laid out for sale or barter by colorfully attired persons, whose costumes derive from codex illustrations. Incidents and curiosities based on Pre-Columbian art fill the bustling scene: business transactions recall classic Veracruz or Aztec reliefs representing two conversing figures in profile; a little flower girl pulls a wheeled ceramic toy like those found in Veracruz sites; a two-faced woman is modeled after split-faced figurines from preclassic Tlatilco. Below, grisaille panels depict the human labor that produces the market—maize cultivation, bean and fruit harvesting, tribute counting, cotton gathering and weaving, and food processing.

Everything is available in this world of material abundance, even the wares of an erotic, tattooed prostitute. Aztec girls were warned about becoming gaudily dressed prostitutes prowling the markets, and boys were instructed to stay away from their enticing ways.[98] The conception of the figure probably derives from an illustration of a harlot with gaudy clothing and disheveled hair in the Florentine Codex, but the face encased in calla lilies resembles that of Frida Kahlo in her self-portraits. She is a

signifier of the pleasures of the flesh; the dismembered human arm for sale beside her, of its agonies—human sacrifice or cannibalism. By highlighting the prostitute and framing her with a dismembered arm and a bare-breasted sorcerer, with their pejorative connotations, Rivera acknowledged some of the negative aspects of Aztec society while at the same time glamorizing them. Four additional panels portray the arts and industries of regional cultures, focusing on their principal contributions to the Aztec economy as represented by the Tlatelolco market. Here, Rivera was probably guided by the Aztec tribute lists in manuscripts, such as the *Matrícula de Tributos*, and by the chroniclers' accounts.[99] Ignoring the Maya region, Rivera depicted only the Mexicanized cultures near the Central Plateau—the Huastec, Zapotec, Tarascan, and Totonac—whom the Aztecs conquered during the rule of Moctezuma I. He conveyed the expressive style of each by means of the anthropological criteria—racial characteristics, material and intellectual culture, economic situation, environment, and biological conditions—first outlined by Gamio in his study of the Teotihuacán Valley.[100]

The conquered Huastec region became the Aztecs' chief source of maize. Thus, the Huastec panel emphasizes maize cultivation, which is protected by an image of the Aztec corn goddess taken from the Codex Borbonicus. (The predella panel underscores the fact that maize was the staff of life in the Pre-Columbian world by representing the primordial creator couple, who are patrons of sustenance and origins, also copied from the Borbonicus.) The Tarascan panel features textile dyeing, and the Zapotec panel the Mixtec gold- and feather-working prized by the Aztec nobility (and the Spanish conquistadors). Rivera's conception of the goldworking is indebted to Caso's 1932 excavation of a spectacular horde of gold jewelry from a royal tomb on Monte Albán that had been reused by the Mixtecs in the late postclassic period; his depiction of the metalworking process is based on illustrations in the Florentine Codex.[101] Finally, the Totonac panel portrays the Gulf Coast region as the hub of Aztec mercantile activity: Aztec merchants (*pochteca*), represented by both an idol and an impersonator of Yiacatecuhtli, god of merchants, quoted from the Florentine Codex, meet with Totonac chiefs, copied from reliefs on the ball court of El Tajín. In the background, Rivera carefully reconstructed this site, famous for its Pyramid of the Niches, ball courts, and *volador* ceremony involving eagle dancers suspended from a high pole,

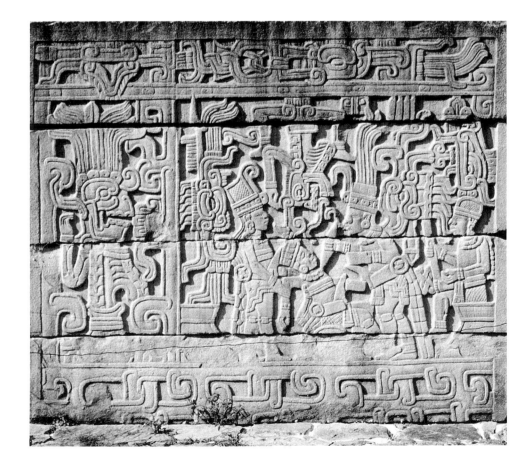

Ball-court relief (northeast panel). Totonac, El Tajín, Veracruz, Mexico, 500–900. Stone. Pre-Columbian Art Research Institute, San Francisco

Pottery house with group of people. Nayarit, West Mexico, 250 B.C.–A.D. 250. Terra-cotta with black and white painted decoration, 9 × 13". National Museum of the American Indian, New York, Smithsonian Institution

whose survival into the twentieth century had been featured in *Mexican Folkways*.[102]

Art historians have faulted the fanciful antiquarianism of this construction of Pre-Columbian culture, in which images from disparate times and places in the Mesoamerican universe are combined and conflated. Betty Ann Brown for example, has noted that the Tarascan mural dominated by textile-dyeing activity juxtaposes an Aztec codex (held by a priestly figure directing the craftsmen's efforts) with a figure of a woman and child based on preclassic Nayarit-style terra-cottas, while pitched-roof houses derived from West Mexican narrative ceramics are set within a typical Central Mexican landscape of snowcapped volcanoes.[103]

A more serious, although related, criticism involves Rivera's idealization of the Pre-Columbian world; in his zeal to make it attractive, he made it seem idyllic. This is revealed clearly in the different ways he represented the Aztecs in the first and the Spanish in the last patio corridor mural. Both portray cultural epochs identified as much with colonial oppression as with civilization.[104] Yet, while the Spanish in the last mural are vilified in no uncertain terms—Cortés is horribly deformed, his brutish soldiers engage in torture and pillage, the Indians are enslaved—there is no hint in the Tenochtitlán panel of the Aztec imperialism and exploitation that made the Tlatelolco market possible. A substantial percentage of the food staples and artisanal wares displayed in the market in such abundance were amassed as harsh tribute, not voluntary contributions; they were the products of subjugated districts and conquered territories.[105] Rivera chose to neglect this exploitation and cruelty in his representation of the pre-Hispanic past while he magnified it in his depiction of the Spanish colonial world.

This idealization of the Aztecs colors all the nationalist murals. Rivera glossed over the exploitation, fanaticism, and hieraticism that were intrinsic to the maintenance of a unified state in Aztec times: in his celebration of ancient native festivals, which were so formalized that even the slightest deviation was severely punished; in his advocacy of the notion of a return to an agrarian communalism of the Aztecs that had ceased to exist during their reign; in his evocation of the exotic costumes and body ornaments of the Aztecs, which were the subject of strict sumptuary laws; and in his call for a renewal of the Aztec state, which was grounded in authoritarianism and militarism, in the new Mexican nation.

Rivera further failed to recognize that the monstrous deity images he used in the Detroit, Lerma, and Hospital de la Raza murals expressed Aztec power relations as well as philosophic concepts about natural forces. Many of the Pre-Columbian notions he embraced were formulated after the mid-fifteenth century, when Aztec sociopolitical organization was based on significant class exploitation and the agrarian subsistence economy depended on territorial expansionism. The monolithic Coatlicue is a product of the imperial Aztec state, which validated itself by representing its indivisible connection with the sacred universe through ancient cults addressed to natural phenomena. Her gruesome imagery reinforced the state's demands for bloodthirsty sacrifice and violent death, which it needed for the integration of conquered peoples into its society.[106]

Rivera's idealization of the pre-Hispanic past is indissoluble from his utopianism about the future. And his failure to situate the ancient Mesoamerican world in its historical context makes transparent his positivist and mechanistic view of history. His murals promote a future that would be based on technology and communism and embedded in indigenous traditions. In his celebration of technology in the Detroit murals, he compared the powers of the earth goddess Coatlicue in the old order to that of science in the new. But as he refused to recognize the hierarchical aspects of the Aztec deity images, so he failed to acknowledge that technocracy is restricted by the interests of the power elites of the modern bureaucracy.[107] The Detroit murals contain no overt reference to the striking Ford workers being shot down at the very moment he was painting them. U.S. auto workers end up having the same hierarchical relation to U.S. technocracy as Aztec *macehuales* had to Aztec deities: Both are integrated into a vast (mechanized or cosmic) system "to the point that they become anonymous organic connectors within the relentless rhythms and needs of a geometric whole."[108] Similarly, in advocating inter-American solidarity in his Golden Gate Exposition mural, Rivera ignored the fact that U.S. power would necessarily dominate any Pan-American union.

RIVERA'S COLLECTION:
KEEPING THE FLAME ALIVE

Rivera's collection of Pre-Columbian art was constructed in the same spirit of didactic and fanciful antiquarianism and displays the same reverence for—and license to appropriate and decontextualize—Pre-Columbian art and culture seen in the patio corridor murals in the National Palace.

Like many modern European and North American artists and collectors, Rivera felt entitled to amass a collection of primitive art as a form of appreciation and homage but also as a means of protecting and salvaging a fast-disappearing culture.[109] What mainly distinguished his collection from others—apart from its intensive focus on Pre-Columbian art and its gargantuan size—were the nationalist and instrumental imperatives of Mexican indigenism that informed it. With the intention to affirm and disseminate the value of native art traditions and benefit his fellow countrymen, he created a museum to house his collection, which he called Anahuacalli (house of the Valley of Mexico, in Nahuatl), and eventually donated it to the state. Its portal is inscribed (in Spanish): "I give back to my people that which they can rescue from the artistic legacy of their ancestors."

Rivera embraced the task of collecting with the same voracious appetite and herculean energy that informed all his activities. Precise information about his collecting practices is difficult to obtain. People in the know are guarded in their comments, because, as collector and Rivera intimate Frederick Field observes, collecting Pre-Columbian art was always regarded in Mexico as "an activity on the edge of legality, and a subjective issue dependent on who you were and what connections you had."[110] Rivera claimed to have had a passionate interest in Pre-Columbian sculpture from the time he was a youngster, and he recalled that he would purchase small pieces with a few centavos at the Sunday market in Mexico City. At first, he said, the historian Alfredo Chavero and his painting teacher at the Academy of San Carlos, Felix Parra, who were both early enthusiasts of Pre-Columbian art, encouraged him in this pursuit; and after his return from Europe, so did Carlos Mérida, who was working with him on the Preparatoria murals.[111] But his serious collecting really only began around 1930, when he devoted whatever spare cash he had to it. In fact, Frida Kahlo often complained that he neglected his financial responsibilities in order to feed his passion for pre-Hispanic art.[112] Once the word spread that Rivera was collecting in a big way, dealers and runners constantly approached him with objects for his consideration, and he seems to have turned nothing down. Among his circle of friends, Miguel Covarrubias, Roberto Montenegro, and Moisés Sáenz also accumulated extensive Pre-Columbian holdings, but Rivera's became the largest private collection in Mexico, officially numbering 59,400 objects.[113]

Important archaeological discoveries in the Valley of Mexico and western Mexico in the 1930s greatly stimulated Rivera's collecting. During the western expansion of Mexico City, an ancient cemetery discovered in 1936 beneath a huge brickworks at Tlatilco yielded quantities of early and middle preclassic ceramic figurines, masks, pots, vases, *sellos* (stamps), as well as pyrite, bone, jade, and serpentine objects that had been deposited as grave offerings. Rivera and Covarrubias went there frequently in search of objects, and, later on, Covarrubias also officially excavated the site, publishing an elaborate reconstruction of the culture of its early inhabitants.[114] By all accounts, Rivera was one of the best customers of the local laborers and *huaqueros* (grave robbers), buying caseloads of objects without even inspecting their contents.[115] One of his major suppliers was the village butcher, who would set aside many cartons-worth of material for him.[116] There was competition as well as cooperation among these collegial collectors, including a good deal of swapping of objects, as they sorted and refined their Pre-Columbian holdings.[117]

Accounting for his passion for the art of Tlatilco, Rivera declared: "Surely the Maya in their best moments attained an insuperable fineness and elegance. But the art of Tlatilco, throughout its evolution, attained a degree of character and imagination higher than the Maya."[118] Enchanted by the female fertility figurines, he marveled at the ingenuity of the ancient artists who individualized each one with tiny inflections of the clay. The well-endowed "pretty lady" type he linked with the earth goddess and female love[119] and characterized the fantastic split-faced type as either a "sculptural

Anahuacalli (the Diego Rivera Museum), Mexico City. 1943–55

Twin pyramid, Tenayuca, Mexico. Aztec, 1350–1521

Anahuacalli, eastern elevation

rendition of rhythmic dance movement, or a portrait of an earthly thing elevated to a supernatural plane."[120] Both types are incorporated in his later murals for the Insurgentes Theater and the National Palace.

West Mexican material came to the fore through Hans-Dietrich Disselhoff's field reconnaissance of Colima shaft tombs in 1932, which furnished detailed descriptions and drawings and mapped the location of tombs; Eduardo Noguera's discovery in 1938 of tombs at El Opeño in northwestern Michoacán that were earlier than the tombs farther west and clearly linked with them; and a great deal of surreptitious digging in Nayarit, Jalisco, Colima, and Guerrero. By 1941 Rivera had already acquired enough West Mexican material to fill a book, which was published by Oxford University Press. *Art in Ancient Mexico* contained photographs of selected objects from his collection and helped establish a fashion for collecting terra-cottas from Colima, Nayarit, and Jalisco in the United States and abroad.[121] Then, in 1946, the first major exhibition exclusively devoted to ancient West Mexican art, based on Rivera's collection, was held at the Palace of Fine Arts in Mexico City.

Rivera cherished the formal inventiveness, exoticism, and frank expression of death and sex of Tlatilco and West Mexican objects, the same traits that many modernist artists located in the primitive. But he must have found their mortuary character, which ratified the importance of the ancient Mexican cult of the dead, as attractive as their extraordinary plastic and expressive power and the invaluable ethnographic information they provided. And he undoubtedly viewed their celebration of both the gaiety and terror of Mexican life as a manifestation of the dualism at the core of ancient Mexican religion and cosmology. The fact that they were stylistically and culturally related, as both Salvador Toscano and Covarrubias affirmed,[122] was also evidence to him of the superiority of highland Mexican over Maya civilization.

It was during the early years of Lázaro Cárdenas's presidency (1934–40) that Rivera began seriously to entertain the notion of Pre-Columbian art and archaeology as a great national resource that could energize the Mexican national identity, rather like the raw materials beneath Mexico's surface that could be used to fuel technology. Like Mexican oil reserves, Pre-Columbian art had to be protected against foreign depredation—mainly by rich North American institutions and collectors—and the way to do this, Rivera felt, was through nationalization, just as Cárdenas had nationalized the holdings of foreign oil companies in 1938. Accordingly, in 1943 Rivera set about creating a museum with which he could personally transform his collection into an empowering vehicle for his countrymen by teaching them about their heritage. And in 1955, just two years before his death, he entrusted it to them, appointing his longtime mentor, archaeologist Alfonso Caso, as advisor to the collection and building. In making this grand gesture Rivera surely saw himself single-handedly fulfilling Gamio's 1916 call in *Forjando Patria* for the aesthetic recognition of Pre-Columbian artifacts.

Typically, Rivera positioned himself at the center of this project by controlling every facet of the museum's design and construction and by incorporating within it what he hoped would be (but never was) a working studio. His conception was a totalizing one, integrating the museum's site, facade, plan, and interior decor with its function, and having all its parts contribute to the expression of his idea. He situated it in the southern outskirts of Mexico City, near Coyoacán, in the village of San Juan Tepetlapa, on an ancient volcanic lava bed, not far from the oldest pyramid in the Valley of Mexico at Cuicuilco. The site occupies about twelve acres, and originally Rivera thought of it as a City of the Arts, consisting of a museum (and storage unit), an open-air theater, library, exhibition, concert halls, and popular-handicrafts workshops, but this ambitious plan was never realized.

The four-story structure, which was designed by Juan O'Gorman after Rivera's

Anahuacalli, corbel-vaulted interior stairway

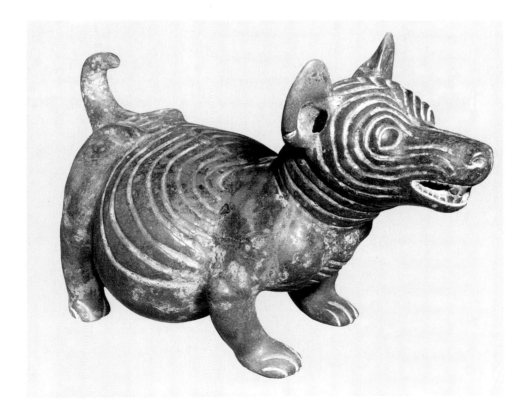

Wrinkled "ixcuintli" dog. Colima, West Mexico, 250 B.C.–A.D. 250. Red polished clay. Diego Rivera Museum, Mexico City
Dogs had a special mortuary significance in ancient Mexico.

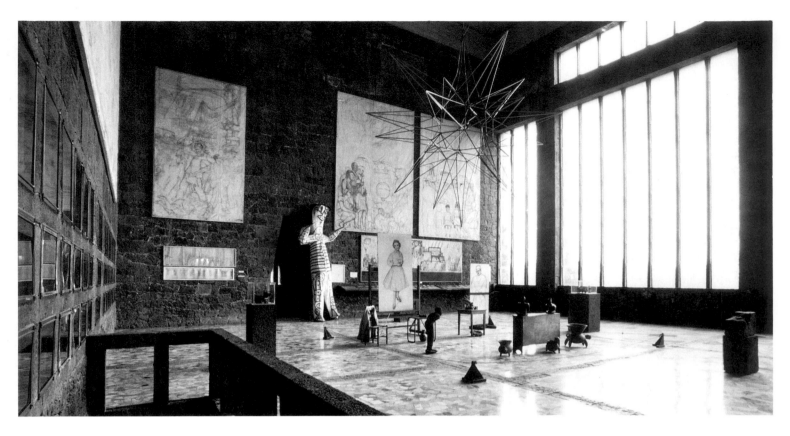

Diego Rivera's studio at Anahuacalli. The Diego
Rivera Museum, Mexico City

*Coatlicue, ceiling decoration at Anahuacalli.
Mosaic. Diego Rivera Museum, Mexico City*

drawings and plans,[123] was built of irregularly shaped lava rocks taken from the
surrounding beds, to match the locale and the many Aztec artifacts it would contain.
Rivera's conceit was to have an Aztec-style pyramid-temple housing his Pre-Columbian
art collection, just as he had previously erected a pyramid with a thatch roof in the
backyard of the Casa Azul, Frida Kahlo's family home at Coyoacán, for the same
purpose. Starkly silhouetted against an expansive Aztec-style plaza, it is a bizarre
synthesis of distinctive Mexican and European architectural traits. The forbidding
facade has thick battered walls whose sharp rectangular profiles and proportions
resemble those of pyramids at Teotihuacán and Aztec sites; window niches that recall
the decorative features of the pyramids of El Tajín; and Toltec-inspired ornamental
details, such as attached columns and jutting serpent heads. However, its huge slab
doors and the slit openings in its massive walls lend it the aspect of a medieval
European fortress that seems only to lack a moat and drawbridge—an effect that
suggests Rivera imagined the civilization of the Aztecs as closely resembling that of the
Middle Ages.

In conformity with the exterior, the building's interior is a highly theatrical amalgam
of various pre-Hispanic architectural elements, and its prevailing tonality is heavy,
somber, and severe. It has Maya-style corbel-vaulted ceilings and doorways, stairwells
constructed of unfaced volcanic rock slabs, oddly shaped rooms, dark interior
passageways, erratic openings for light sources, and water from a sacred cenote[124]
running under the walls to form shallow fountains in the arid ground outside. Brightly
colored mosaic ceilings (recalling those at Ravenna, Italy) enliven the gloomy,
cryptlike rooms on the lower floors. They depict familiar Aztec glyphs, deities, and
myths—the Aztec death goddess Coatlicue in the entryway, Tlaloc, the four suns, *ollin*
(for movement and earthquake), fertility, and death signs—as well as personal and
political emblems—a serpent emitting a speech scroll with the glyph for *toad* (Frida
Kahlo's nickname for Rivera), the Nahuatl symbol of his birthdate, disembodied hands
raising hammer and sickle, a dove of peace. Visitors move from darkness to light, from
an elemental to an ethereal plane, as they ascend the pyramid to Rivera's huge,
brightly lit studio with its polished marble floors and large glass windows offering
panoramic views of the surrounding area. Higher still, there is a roof terrace lined with
Toltec and Aztec sculptures and architectural decorations.

As an example of primitivizing architecture, Anahuacalli can be compared with the
Maya Revival style buildings that were designed in the United States in the 1920s and
1930s. It is especially reminiscent of Frank Lloyd Wright's Los Angeles textile-block

Fertility goddesses. Teotihuacán, Mexico. 450–750. Terra-cotta plaques. Diego Rivera Museum, Mexico City

houses, particularly the Charles Ennis House (see pages 161–64), which are insistently related to their sites and self-consciously evoke the verticality and blocklike rectangularity of certain Maya and Mixtec buildings, the stepped profiles of Aztec architecture, and even, on the interior, the strange sequence of changing spaces, levels,

Altar-like installation of Aztec idols, Anahuacalli. Diego Rivera Museum, Mexico City

and dramatic light and dark contrasts of several Pre-Columbian sites. In some ways, Anahuacalli also resembles Taliesin West, Wright's headquarters in the Arizona desert (see page 177), which, with its rough-hewn stone surfaces, strong, angled lines, and *talud-tablero* walls, refers in a generalized way to highland Mexican architecture.

Though these modern masters' notions of pre-Hispanic architecture were perhaps not so far apart, Rivera was uniquely concerned about its ethnographic meaning. Anahuacalli is often characterized as a strange museum-pyramid-tomb, and it truly evokes nothing so much as a mausoleum. In fact, Rivera meant the building to be a concrete embodiment of the idea of death that he had located as the central metaphor of Mexican civilization in the 1920s, even down to situating the museum on a dead lava bed. The dark, cryptlike lower chambers of the museum symbolize the lower world of the dead and the light-filled upper stories the land of the living, like some Nayarit clay two-story house groups. And the transformation from death to life implicit in the Aztec concept is enacted in the visitor's transition from the groundfloor entrance to the upper levels. The situation of Rivera's bright, broad studio in the higher reaches of the pyramid suggests further that the death of ancient Mexican civilization gave birth to Rivera's genius, which carries it on in modern times. Thus, despite its nationalist premises, Anahuacalli was, like Rivera's indigenist murals, an intensely personal expression; it represented ancient American culture through the filter of the artist's romantic yearning for a primitive agrarian world and located the artist at the center of that world.

Each section of the museum is designed differently to display Rivera's cherished objects to best advantage. The two thousand objects on view are mainly grouped by region and theme, though sometimes by culture or chronology.[125] In accord with indigenist ideology, the collection focuses on objects from the Mexicanized cultural areas of Mesoamerica—the Valley of Mexico, West Mexico, northern and central Veracruz, and Oaxaca—and ignores the Maya region. It contains many fine examples of stone and ceramic objects representing the Mezcala, Zapotec, Mixtec, Toltec, and Gulf Coast cultures—for example, ball-game implements and clay figurines from classic-period Veracruz. Not surprisingly, however, its strongest components are Western and Central Mexican objects—which were among the primary Pre-Columbian sources for the murals—including huge numbers of terra-cotta anthropomorphic and zoomorphic figures, narrative scenes of village life, and containers from Colima, Nayarit, and Jalisco, as well as numerous solid and hollow clay figurines and vessels from Tlatilco. Teotihuacán is well represented by quantities of early clay figurines of animated dancers, and later mass-produced plaques representing fertility goddesses, stone masks, old fire gods, and tripod cylinder vessels. Among the abundant examples of Aztec art are many small, crudely carved stone and clay cult images—female deities, seated old gods, effigy vessels of Tlaloc, temple models—which were placed in shrines throughout late postclassic Central Mexico or used by peasants for personal worship.

Twenty exotically named rooms are devoted to, say, earth deities, rain gods, or objects from Teotihuacán and coordinated with thematically appropriate mosaic decoration, so that, for example, a mosaic representing the Aztec *ollin* sign adorns a room containing stone and clay sculptures of the old fire god and earth shaker. Rivera referred to his Pre-Columbian objects as *ídolos* and displayed many of them in this spirit, mounted as icons on altar-like shelves in darkened rooms that dramatize their ancient function as objects of veneration and terror. On the other hand, he represented the lighter side of the duality with West Mexican terra-cotta figures, as embodiments of the sensual and quotidian realms, and displayed them at eye level in well-lit glass cases encouraging aesthetic contemplation of their plastic form.[126] The museum thus vacillates between conflicting conceptions of Pre-Columbian objects as both archaeological and aesthetic matter, to be viewed contextually and decontextually.[127]

Rivera's construction of ancient Mexican art depends on this choice of objects. He selected predominantly small, cabinet-sized objects made of humble materials (clay and rough stone) that were often, in later periods, provincial versions, lacking the skilled execution of urban imperial works. Redolent of the earth, they also underscore a favorite theme of the murals: the elemental quality of indigenous art and culture. They are evocative of the life of common pre-Hispanic people: their daily round of work, prayer, and play. One of the few large freestanding statues on display, a representation

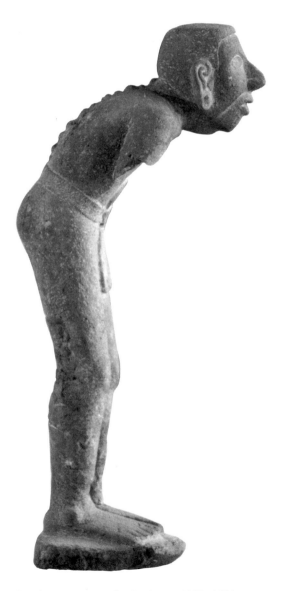

Standing man (Macehual). Aztec, 1350–1521. Stone, height c. 3'6". Diego Rivera Museum, Mexico City

of an Aztec *macehual*, underscores this overall emphasis on the art and life of common people. Eschewing large monuments, including frescoes, and the sumptuary items of gold, turquoise, or featherwork associated with the pre-Hispanic elite, the collection projects the idea that great size and precious material are not integral components of fine art; and the corollary that a society need not be rich to produce great art.

This emphasis is surely also a calculated indictment of capitalist values as they were expressed in North American collections of Pre-Columbian art, such as those of Robert Woods Bliss or Nelson Rockefeller, which focus exclusively on extraordinary, precious, and monumental items. In effect, the objects in Rivera's collection are projected as ancient equivalents of modern Mexican popular and folk art. Rivera's San Angel studio (which has recently been opened to the public) embodies the same idea. It is indiscriminately crammed with both ancient and popular Mexican artifacts: old and new masks from Guerrero, preclassic and postclassic ceramics from the Central Plateau, modern folk toys, and the walls and ceiling are hung with wire skeletons and huge papier-mâché Judas figures from street festivals. Rivera strongly identified with these popular figures, which also adorn his studio at Anahuacalli, together with his childhood drawings and cartoons for murals. Indeed, Rivera's voluminous collection of popular Mexican art is housed on the grounds of Anahuacalli in a long, low building alongside the museum. It is opened to the public only once a year in November, on the occasion of a big celebration honoring the Mexican Day of the Dead in which the popular street figures are unveiled.

This linkage of Pre-Columbian and Mexican popular and folk art, which harks back to the ideology of indigenism and the pages of *Mexican Folkways* magazine, is manifest in many Mexican and North American collections put together during the modernist period, including those of Covarrubias, Donald Cordry, William Spratling, and Nelson Rockefeller. These individuals took their cue about collecting the primitive from modernism's universalist ideology and complementary collagist technique—first perfected by Gauguin in his Tahitian paintings—that gave them license to range freely in their appropriations across widely disparate cultures, to mix and match fragments and collapse myths and images originating in different times and spaces, in order to create personal visions of exotic attractiveness. At his ranch near Taxco, William Spratling, for example, fancifully displayed his pre-Hispanic collection by placing marvelous jewels in the open hands of Totonac figures arranged in vibrantly colored niches illuminated by daylight filtered through domes.[128]

In the end, Rivera's appropriation of Pre-Columbian objects was not very different from Spratling's or Rockefeller's. It is rooted in a paternalistic sense of entitlement to personally salvage, accumulate, assimilate, define, dispose, and hand down the Pre-Columbian artistic heritage, and to package it in a self-aggrandizing monument. Rivera was of course intent on telling a different story with this material than they were—one that imagined a mythic past that would inspire the Mexican masses in the creation of a new nation. But just as Spratling translated his Pre-Columbian objects into signifiers of the importance of antiquarian silverworking, Rivera mystified the connotation of pre-Hispanic art and culture for his own ends. He represented the ancient (and the modern) indigenous world as a static entity, governed by an unchanging cosmic-religious unity in which Aztec myths and mores could be freely projected onto all other—even the earliest—Mexican cultures. Moreover, by equating pre-Hispanic and popular Mexican art in this context, and omitting from view the sumptuary and monumental objects of the Aztecs and their predecessors, he deprived ancient Mexican art and culture of another vital dimension: He glossed over the class differences and power relations of Pre-Columbian society and the exploitation and hieraticism that were intrinsic to the maintenance of a unified state in Aztec times, just as he had done in his patio corridor and nationalist murals. This static and one-dimensional view of pre-Hispanic art and culture is underscored by Anahuacalli's unchanging exhibition and by its physical isolation and inaccessibility, which, in a sense surely not intended by the maestro, enhance the association of death and Pre-Columbian culture: The objects seem to be embalmed in the building as a lifeless national treasure. There is, finally, in both the capitalist and Marxist representations of Pre-Columbian culture a similar (though by no means identical) occlusion of the historical relation of power in the collectors' acquisition of their pieces,[129] including the wrenching of these objects from the ground by *huaqueros*.[130]

But it is easy enough, with hindsight, to be harshly critical of Rivera's ideas and practices from the perspective of changed attitudes towards archaeological artifacts. In all fairness, his particular truths about these objects—his elevation of aesthetic appreciation of native artifacts and nationalist imperatives over authenticity and historical accuracy—were constituted at a particular moment in history. He took his cue about the ethnographic meaning of pre-Hispanic art from the practice of Mexican archaeology in the 1920s and 1930s, which was invested in typology, chronology, and iconography, not in reconstructing the specific life of ancient indigenous people through a careful examination of context, and which was itself imbued with an indigenist ideology that translated a knowledge of pre-Hispanic culture into concepts that could sustain a new nation. In many publications, Caso stressed the cosmic-religious unity of Mesoamerica, interpreting Zapotec urns and Teotihuacán frescoes in the light of Aztec myths, and downplayed the authoritarianism and militarism of these regimes. Furthermore, just as Rivera had boldy shunned the ambiguities of modernist abstraction in favor of overtly communicating his ideas in realistic terms in his murals, so in his representation of the pre-Hispanic past at Anahuacalli he had simplified the picture and laid himself open for criticism in a way that Rockefeller's collection did not.

Finally, however, the force of Rivera's imaginative recreation of Mexican life in his murals cannot be disputed, despite the contradictions inherent in his political thinking and artistic practice. His titanic achievement does indeed represent the great fulfillment of Gamio's call for the aesthetic recognition of Pre-Columbian art. He made it a larger and more central historical fact than it had been before and shifted it further into Western consciousness. And, as the mark of a great master, he changed forever the way we see it.

NOTES

1. A portion of this chapter was presented as a paper, "Diego Rivera's Collection: Pre-Columbian Art as a Political and Artistic Legacy," in a symposium held at Dumbarton Oaks, October 1990, and published in Elizabeth H. Boone, ed., Collecting the Pre-Columbian Past (Washington, D.C., 1993), pp. 251–70.

2. Laura Molvey and Peter Wollen, Frida Kahlo and Tina Modotti (Whitechapel Art Gallery, London, 1982), pp. 19–20. I am indebted to Molvey and Wollen for clarifying my ideas about Rivera's work in the context of the Mexican Renaissance. Their essay particularly enhanced my understanding of the convergence of the political and artistic avant-garde in Mexico, and the manner in which modernism, popular historicism, and mythic nationalism came together in Rivera's—as well as Frida Kahlo's—work.

3. Ibid., p. 12.

4. See Diego Rivera, "Retablos: The True and Only Pictoric Expression of Mexican People," Mexican Folkways 1, no. 3 (October–November 1925), pp. 7–12. In this essay Rivera discusses native folk art and, by implication, his own work, in these terms.

5. See Antonio Rodriguez, Diego Rivera (Colección Anahuac de arte mexicano) (Mexico City, 1948), and A History of Mexican Mural Painting (London, 1969); Stanton Catlin, "Political Iconography in the Diego Rivera Frescoes at Cuernavaca, Mexico," in Henry A. Millon and Linda Nochlin, eds., Art and Architecture in the Service of Politics (Cambridge, 1978), pp. 194–215; Betty Ann Brown, "The Past Idealized: Diego Rivera's Use of Pre-Columbian Imagery," in Detroit Institute of the Arts, Diego Rivera: A Retrospective (New York and London, 1986), pp. 139–57; Francis O'Connor, "An Iconographic Interpretation of Diego Rivera's Detroit Industry Murals in Terms of Their Orientation to the Cardinal Points of the Compass," in ibid., pp. 215–35; and Beatriz de la Fuente, "El arte prehispánico y la pintura mural de Diego Rivera," in Instituto Nacional de Bellas Artes, Diego Rivera Hoy (Mexico City, 1986), pp. 89–101.

6. Mulvey and Wollen, op. cit., p. 8. They point out the similar roles of the Mexican and Russian avant-garde of the 1920s vis-à-vis the revolutions in these countries.

7. This revival was as much philosophical as political, with roots in a reformist intellectual society, the Ateneo de la Juventud (Atheneum of Youth), founded and led by Vasconcelos for the purpose of replacing Porfirian positivism, which was based on Auguste Comte's theories of material progress, with an idealist classical humanism fused with indigenous virtues. After the revolution, Vasconcelos's philosophy evolved into a mystical vitalism, blending visionary notions of Mexican nationalism, cosmic man, will, destiny, and art. See Mulvey and Wollen, op. cit., p. 12; and David Rockfort, Murals of Diego Rivera (London, 1987), p. 22.

8. Mulvey and Wollen, op. cit., p. 19, point out that ex voto painting was essentially a nineteenth-century style in decline, while pulqueria painting and popular prints still existed during the 1920s, although, with the exception of self-conscious revivals by artists, they were becoming extinct. See Jean Charlot, An Artist on Art, vol. 2 (Honolulu, 1972); Anita Brenner, Idols behind Altars (Boston, 1929); and Hayden Herrera, Frida, A Biography of Frida Kahlo (New York, 1983).

9. The most active Mexican Pre-Columbianists were Francisco Paso y Troncoso and Antonio Peñafiel. The chronicles published at this time included those of Friar Diego Durán, Historia de las Indias de Nueva España (1867–80); Fernando de Alvarado Tezozomoc, Crónica Mexicana (1878); Friar Toribio Motolinía, Memoriales (1903); Francisco J. Clavijero, Historia Antigua de México (1868); and Friar Bernardino de Sahagún, Codex

Fiorentino. Historia General de las Cosas de Nueva España (1907–09). See Ignacio Bernal, *A History of Mexican Archaeology: The Vanished Civilizations of Middle America* (London, 1980), chap. 7.

10. German scholar Eduard Seler (1849–1922) was the outstanding explicator of ancient Mexican culture, publishing numerous essays on Aztec cosmology and iconography based on his careful study of codices, his own translations of Nahuatl texts, and archaeological explorations. One of his important German students, Herman Beyer, settled in Mexico, where he edited *El México Antiguo*, a journal of Pre-Columbian research. Seler also became the first director of a short-lived International School of American Ethnology and Archaeology in Mexico City, which was founded in 1911 with the backing of the Mexican, U.S., French, and Prussian governments, as well as Columbia, Harvard, and the University of Pennsylvania. He was succeeded by Franz Boas, Jorge Engerrand, Alfred Tozzer, and, finally, Manuel Gamio, who had studied at the school under Seler and Boas.

11. These included the journals *Ethnos* (1920), edited by Gamio, and *Revista Mexicana de Estudios Históricos* (1927), edited by Alfonso Caso and Manuel Toussaint; major monographs by Gamio (*La Población del Valle de Teotihuacán* [Mexico City, 1922]) and Ignacio Marquina (*Estudio arquitectónico comparativo de los monumentos arqueológicos de México* [Mexico City, 1928]) and reissued chronicles by Clavijero and Sahagún.

12. Rivera was born in Guanajuato, Mexico, in December 1886. In 1892 his family moved to Mexico City, where he studied art on scholarship in the Academy of San Carlos from 1896 to 1905 in a course emphasizing technical expertise, especially perspective, geometry, the Golden Section, and study from nature. His teachers included Felix Parra, a conventional academic painter who admired Pre-Columbian sculpture and introduced it to Rivera; the landscapist José Maria Velasco; Santiago Rebull, a follower of Ingres; and Gerardo Murillo Cornadó [Dr. Atl], who promoted an interest in indigenous subjects. In 1906 Rivera was awarded a modest four-year state scholarship to study in Europe.

13. It was published in *Vida Americana* 1 (May 1921)—the first and only number of this journal. In 1919 Siqueiros visited Rivera in Paris, and they discussed the Mexican Revolution and the social role of art. It is also worth noting that the Modern Gallery in Paris held an "Exhibition of Paintings by Diego M. Rivera and Mexican Pre-Conquest Art" in October 1916. See Laurance P. Hurlburt, "Diego Rivera (1886–1957): A Chronology of His Art, Life and Times," in Detroit Institute of Arts, *Diego Rivera: A Retrospective* (New York and London. 1986), p. 45.

14. Florence Arquin (*Diego Rivera: The Shaping of an Artist, 1889–1921* [Norman, Okla., 1971], pp. 113–43) notes that Rivera particularly admired Giotto, Uccello, Ambrogio and Pietro Lorenzetti, Piero, Raphael, Signorelli, and Michelangelo for their use of classical myth, realism, and humanism to evoke pride in the ancient Italian past. Bernard Myers (*Mexican Painting in Our Time* [New York, 1956], p. 34) suggests that Rivera also absorbed postwar Neoclassicizing tendencies in Italy.

15. Cited in Dawn Ades, *Art in Latin America: The Modern Era 1820–1980* (New Haven and London, 1989), pp. 153–54, 324.

16. Cited in Charlot, 1972, *op. cit.*, p. 36.

17. Goitia had direct contact with the Revolution as a recording artist to a Pancho Villa group in the north during the years 1912 to 1917. At this time he also produced naturalistic scenes depicting the pathos of everyday Mexican life, which anticipated the more socially conscious perspective developed by the muralists in the 1920s. See Myers, *op. cit.*, p. 13; and The Metropolitan Museum of Art, *Mexico: Splendors of Thirty Centuries* (New York, 1990), pp. 566–75.

18. Best Maugard was hired by Boas to make thousands of drawings of pots, when Boas was digging with Gamio in the Valley of Mexico in an effort to establish a chronology for Mexican archaeology. From this project Maugard developed an art alphabet for educating children. See Rockfort, *op. cit.*, p. 25. An "Album de Coleccines Arqueológicas," selected and arranged by Boas, illustrated by Best, with text by Gamio, was published by the Museum of Anthropology in 1921–22.

19. From 1926 to 1929 Charlot worked as a copyist for Sylvanus Morley and the Carnegie Institution of Washington at Chichén Itzá. He contributed renderings of murals and excavation reports to publications on the Temple of Warriors at Chichén Itzá and on the Maya site of Coba. See Earl Morris, Jean Charlot, and Ann Morris, *The Temple of the Warriors at Chichén Itzá, Yucatán*, Carnegie Institution of Washington, pub. no. 406 (Washington, D.C., 1931), and J. E. Thompson, H.E.D. Pollock, and J. Charlot, *A Preliminary Study of the Ruins of Cobá, Quintana Roo, Mexico*, Carnegie Institution of Washington, pub. no. 424 (Washington, D.C., 1932).

Charlot had become acquainted with Pre-Columbian art in his native Paris before joining the muralists in Mexico. In his book *Mexican Mural Renaissance* (New Haven, 1963), pp. 9–10, he attested: "My rattles and hornbooks were the idols and Mexican manuscripts from my uncle Eugene Goupil's collection. They were also my ABC of modern art. . . . Just having known *calli*, the Aztec hieroglyph that signifies 'house'—a cube of space contained in a cube of adobe—watered down the angular landscapes of Braque and Derain into little more than a mild departure from impressionism. The flat colors of the codices, with raw chromas paired in refined discord, could pass as the goal toward which Matisse of 'Music' and 'Dance' took his first hesitant steps."

20. Myers, *op. cit.*, p. 14, referring to Gamio.

21. See Herbert J. Spinden, *A Study of Maya Art*, Memoirs of the Peabody Museum of Archaeology and Ethnology 6 (Cambridge, Mass., 1913); Thomas A. Joyce, *Mexican Archaeology* (London, 1914) and *Maya and Mexican Art* (London, 1927); and Carnegie Institution of Washington excavation reports on Uaxactun, Chichén Itzá, and Copán by Sylvanus G. Morley et al. These investigations sustained the nineteenth-century Anglo-American passion for the Maya, who were deemed the superior American Indians and called "the Greeks of the New World." Recently, British Americanist Norman Hammond has reasserted these claims for the greater antiquity of the Maya as a result of his excavations in Belize. See, e.g., Hammond, "The Earliest Maya," *Scientific American* 236, no. 3 (1977), pp. 116–33.

22. From 1547 to 1575 Sahagún compiled a number of manuscripts on native customs, using illustrations

drawn by natives and information collected from elders and recorded in Nahuatl. They include the *Primeros Memoriales* and the *Manuscrito de Tlatelolco*, published as the *Codices Matritenses del Real Palacio*, and the *Codex Fiorentino*, his final work. See Friar Bernardino de Sahagún, *Florentine Codex: General History of the Things of New Spain*, translated and edited by Arthur Anderson and Charles Dibble (Santa Fe, 1950–82).

23. In a chapter on pre-Hispanic art in *Forjando Patria* (Mexico City, 1916, pp. 69–79) Gamio distinguished between naturalistic and grotesque types of sculptures, and privileged the classical simplicity of the former, exemplified by the head of an eagle knight, over the formal confusion of the latter, represented by the goddess Coatlicue. See Miguel Leon-Portilla, *Aztec Thought and Culture* (Norman, Okla., 1963), p. 213; Benjamin Keen, *The Aztec Image in Western Thought* (New Brunswick, N.J., 1971), pp. 514–30; and Ades, *op. cit.*, pp. 198–200.

24. See Alfonso Caso, *Estelas Zapotecas* (Mexico City, 1928) and *La religión de los Aztecas* (Mexico City, 1936).

25. See Gordon Willey and Jeremy Sabloff, *A History of American Archaeology* (San Francisco, 1980), pp. 88–91 and *passim*.

26. For example, in a discussion of the ancient Mexican Parcheese-like game called *patolli* Caso ("Un Antiguo Juego Mexicano: El Patoli," in *El México Antiguo*, II, 1924–27) turned to the chronicles to describe and illustrate the game; pointed to its survival in present-day Puebla; linked it with both the ritual and solar calendars of the Aztecs; and suggested that it was played in propitiation of the gods of the sun, *pulque* (native alcoholic drink), and games. In his pathbreaking studies of Mixtec codices, Caso also consistently interpreted Mixtec iconography in terms of Aztec beliefs (Nancy Troike, personal communication, September 1992). See also John B. Glass and Donald Robertson, "A Census of Native Middle American Pictorial Manuscripts," in Howard F. Cline, ed., *Handbook of Middle American Indians*, vol. 14 (Austin, 1975), pp. 81–252.

27. Gamio, "The Utilitarian Aspect of Folklore," *Mexican Folkways* 1, no. 1 (June–July 1925), pp. 6–8. Gamio contrasted simple provincial with complex urban societies, stressed the backwardness of the Indian and Mestizo majority—"the true ancestors of the ancient Mexicans"—and urged its incorporation into the advanced minority sector, without the loss of its folkloric customs and "valuable natural inclinations." To further scientific progress, he asserted, "It is indispensable to analyze and to know their diverse and peculiar modes of thinking. . . . A magazine like this one, therefore, devoted to make known the thousand mysterious and fantastic paths through which flow the ideas of those Mexicans who . . . still remain in backward cultural stages, deserves all our appreciation and enthusiastic praise" (*ibid.*, p. 7).

28. Great emphasis was placed on fiestas, which were characterized as pagan, pre-Hispanic phenomena superficially overlain by Hispanic Christian practices; though having names and costumes of saints and demons, their protagonists preserve basic attributes of ancient gods of war, rain, and corn. A great deal of information was available about ancient festivals consisting of dances, theatrical performances, poetic recitations, and feasts ending with the death of a sacrifical victim, because Conquest-period Spaniards were fascinated by the Aztec rituals of the months of the solar year and had them recorded and illustrated, most completely and reliably by Sahagún.

29. See Rivera, 1925, *op. cit.*, p. 9: "The Mexican Indian [is] he who suffers because he has communicated with the stars, because he has found the supreme beauty in plumage and paints, the power and form in mountain and rock and sculpture and architecture. It is his native intuition that saves his soul and his self-respect, which, in spite of the nightmare of enemies within and without, makes him over and beyond his martyrdom, inevitably, incurably, and incorrigibly a creator of beauty." See also Rivera, cited in Alfredo Cardona Peña, *El Monstruo en su Laberinto: Conversaciónes con Diego Rivera* (Mexico City, 1980), p. 139: "In the prehispanic world everything in the life of the people was artistic, from the palaces and temples (which were monumental works of sculpture) and magnificent frescoes, that today astonish all who contemplate them in the jungle, to the most mundane pottery, children's toys and corn-grinding stones. Everything was a work of art, and, 99 percent of the time, a masterwork" (trans. author).

30. A specific example of this paternalism was Gamio's effort to stimulate the craft production of the native community in the Teotihuacán Valley from the top down and the outside. See Rubin de la Borbolla, "Observaciones sobre el arte popular mexicano," in *Homenaje al Dr. Manuel Gamio* (Mexico City, 1956), p. 449.

31. For Orozco's view of indigenism as romantic claptrap, see Museum of Modern Art Oxford, *!Orozco! 1883–1949* (Oxford, 1980), pp. 34, 46. He did not participate in the magazine, but it printed his objection to its interpretation of one of his frescoes as lacking sympathy with indigenism. See José Clemente Orozco, "A Correction," *Mexican Folkways* 5, no. 1 (January–March 1929), p. 8–9.

32. The smaller Court of Labor depicts, on ground level, manual and industrial labor characteristic of various Mexican regions; the second level, intellectual labor; and the third, arts and sciences and the heroes of the Revolution. A stairwell in the labor courtyard depicts Mexican landscape scenes and the evolution of the country's political and social life. The larger Court of Fiestas embraces on separate levels the themes of popular Mexican religious and political festivals; escutcheons of the Mexican states; and *corridos* (popular ballads) of the agrarian and proletarian revolutions—allegories of good and evil in which popular heroes take up arms against the oppressors of the peasants and workers.

33. Rivera wrote: "I try to be . . . a condensor of the struggles of the longings of the masses and transmitter of a synthesis of their desires, and to serve as an organizer of their consciousness and to help their social organization." Cited in Instituto Nacional de Bellas Artes, *op. cit.*, p. 108 (trans. author).

34. Charlot, 1972, *op. cit.*, p. 341; Rockfort, *op. cit.*, p. 25. According to Charlot, Guerrero made several trips to the site of Teotihuacán, the ancient highland capital of the classic period (thirty miles north of Mexico City) to match his experiments in fresco technique at the Secretaría with ancient Mexican processes. But the use of nopal sap to prime the walls resulted in many technical problems, and the project soon had to be abandoned.

35. In his penny engravings accompanying the *corridos*, José Guadalupe Posada was the first person to visualize the Mexican lower orders, but without reference to ancient sources. Catlin (1978, *op. cit.*, p. 210)

first suggested that Aztec sculpture "was a fundamental source in the evolution of Rivera's stylized norm applied to indigenous subjects." According to Myers (op. cit., p. 53), Siqueiros had already turned to such models in an unfinished fresco, *Burial of a Worker*, 1922–24, in the National Preparatory School, in which the heads of the workers carrying the coffin are derived from Aztec sculpture.

36. Some of these figures represent standard bearers who were positioned on temples holding flags and banners. Often nude or simply dressed, they may also have been costumed in ceremonial masks, capes, skirts, and jewels for different ritual occasions, at which times they would be impersonators of appropriate deities. See Richard F. Townsend, "State and Cosmos in the Art of Tenochtitlán," *Studies in Pre-Columbian Art & Archaeology* (Washington, D.C., 1979), p. 23; and Esther Pasztory, *Aztec Art* (New York, 1983), p. 228.

37. The dark skin color of Rivera's Indians derives not from the uniform gray of Aztec stone sculptures (which retain only fugitive traces of their original bright color) but from the earth- and sand-colored tonalities of West Mexican ceramics. Rivera dressed his Indians in popular native costumes: men in unbleached cotton suits, palm-leaf sombreros, and sandals; barefoot women in more vivid costumes—wrap-around skirts, pointed capelets (*quexquemetl*), and shapeless, square-neck, sleeveless blouses (*huipil*)—that survive from pre-Hispanic times.

38. Rivera further differentiated between Anglos and Indians by surrounding the former with artificial, mechanical forms and the latter with organic forms. Also, Rivera's figures of Anglo and Mestizo men are generally taller, broader, and more angular, while natives are shorter and rounder, rather like the distinction between Maya and Mexican ethnics in the murals at Chichén Itzá, which Charlot apparently adapted for Spaniards and Indians in his Preparatoria mural depicting the Conquest.

39. See Caso, *El Teocalli de la Guerra Sagrada* (Mexico City, 1927); 1936, op. cit.; and *The Aztecs, People of the Sun* (Norman, Okla., 1958). The gods' self-sacrifice for the sake of humanity is illustrated by the Aztec creation myth, which, according to Sahagún, (1950–82, op. cit., bk. 7, pp. 3–8), describes how, after the destruction of Teotihuacán, the Aztecs got together at a great bonfire to create a new world. They bickered among themselves as to which god would throw himself into the fire to create a new sun, and finally a poor syphilitic god, who had nothing to lose, jumped into the fire and became the sun. After this another god jumped in and became the moon, and then they all followed suit in order to make the sun move.

George Kubler ("The Cycle of Life and Death in Metropolitan Aztec Sculpture" [1943], in Thomas Reese, ed., *Studies in Ancient American and European Art: The Collected Essays of George Kubler*, [New Haven and London, 1985], pp. 219–25) observed how lacking in animation and vitality are Aztec representations of *macehuales*, as compared with the more dynamic and vital Aztec sculptural images of flora and fauna, and he explained their passivity and resignation as an expression of this central tenet of Aztec cosmology.

40. See Frances Toor, *A Treasury of Mexican Folkways* (New York, 1947), pp. 331–33. Toor, an American expatriate, was the editor of *Mexican Folkways* magazine.

41. Alfonso Caso, "The Use of Masks among the Ancient Mexicans," *Mexican Folkways* 5, no. 3 (July–September 1929), pp. 111–13. This was one of the first scholarly efforts to recognize that masks played an important role in Aztec society.

42. Rivera's use of ancient masks in the Secretaría cycle is also visible in representations of masked dancers with shields, Indian faces modeled after Teotihuacán masks, and masks of the rain god Tlaloc employed as decorative devices. Another expression of Rivera's interest in Mexican masks was his lifelong passion for the papier-mâché Judas figures used in Lenten and Easter festivals throughout Mexico, which he kept beside him in all his studios and often depicted in paintings.

43. As Brown (op. cit., p. 152) notes, of all Rivera's works this mosaic on a facade of a centralized building visible to passersby seems most directly linked with present-day popular art, such as Chicano murals. The huge mask of a female that dominates the composition derives, curiously, from a temple facade in Katmandu.

44. These goddesses include Cihuacoatl (patroness of Xochimilco), Xilonen, Coatlicue, Tonantzin, and Xochiquetzal, goddess of flowers, sensuality, and drunkenness and patroness of feasting, music, dances, games, and crafts. According to Sahagún (1950–82, op. cit., bk. 2, p. 14), Cihuacoatl presided over a July harvest festival in which lords adorned themselves with garlands of flowers instead of jewels and feathers. Rivera's inclusion of a single, overtly sexual Anglo female (a tourist?) in the scene contrasts the modesty of the Indian with the vulgarity of Anglo women and also suggests the infiltration of urban values into a traditional, indigenous context.

For Rivera, Indians and flowers were synonymous. In an essay on *pulqueria* paintings in *Mexican Folkways* 2, no. 7 (June–July 1926), pp. 7–12, he remarked that flowers always adorn even the humblest Indian hut, and he explained this as an aspect of the Indians' natural artistry and love of color.

45. See especially Gauguin's *There Is the Marae* and *Where Do We Come From? What Are We? Where Are We Going?* with Tiki-like idols inserted into a natural setting. Gauguin's influence on Rivera, especially with regard to the expression of the mysteries of female sexuality and procreation, has often been overlooked. Rivera's apparent reference to the Douanier Rousseau's foliage in this mural is ironic, since Rousseau claimed to have visited Mexico and to have been inspired by its tropical fauna and flora, although there is no proof that he was ever there.

46. Indigenist ideology stressed this urban-rural cleavage in Mexican society, juxtaposing the values of individuality, education, and complexity on the one hand, with those of community, custom, and simplicity on the other. See Robert Redfield, *Mexican Folkways* 5, no. 1 (January–March 1929), pp. 30–34; and M. Gamio, *La Población del Valle de Teotihuacán* (Mexico City, 1922).

47. Cited in Bertrand Wolfe, *The Fabulous Life of Diego Rivera* (New York, 1963), p. 147.

48. *Ibid.* Indigenists stressed the ancient roots of the popular fascination with death, citing as antecedents the Pre-Columbian ball game ending in the beheading of the captain of the losing team; the myth in which Quetzalcoatl created humanity by retrieving his ancestors' bones from the underworld and spilling his own

blood on them; Aztec festivals dedicated to the dead, human sacrifice, skull racks (*tzompantli*), and skeletal representations of the god of death *Mictlantecuhtli*. See, for example, Frances Toor, "The Festival of the Dead," *Mexican Folkways* 1, no. 3 (October–November 1925), pp. 17–22. However, the Spanish are also responsible for the emphasis on death in Mexican culture. They introduced the figure of death in their allegorical Christian morality plays, which are still performed all over the country.

49. Friar Diego Durán, for example, noted that the ninth month was dedicated to the small feast of the dead involving children and was essentially a happy occasion, while the tenth month involving the grown-up dead was a solemn ceremony in which human beings were sacrificed on a sacrificial stone laid with abundant offerings. See Eduardo Matos Moctezuma, "Conception of Death in Mexico: The Spanish Conquest," *Artes de México*, no. 145, año xviii (1971), p. 89.

50. Pasztory, *op. cit.*, pp. 56–58.

51. Following both Renaissance and Pre-Columbian fresco traditions, Rivera paid great attention to decorative devices as elements carrying themes throughout the entire architectural space. Among such devices in the Secretaría are many pre-Hispanic elements, including Nahuatl words and motifs such as the great serpent from the pyramid of Xochicalco, Tlaloc masks, and glyphs signifying water, fire, and movement. The use of pre-Hispanic emblems as architectural decoration is also highly developed in his murals at the agricultural college at Chapingo, where Maya architectural decorations adorn frescoes in the entryway to the administration building, as well as those at Cuernavaca. But the extent of Rivera's appreciation of the ancient meaning of Pre-Columbian cultural forms is revealed more fully in his integration of pre-Hispanic concepts within the fabric of his murals.

52. Rivera's evocation of the origins of life, primordial organisms, and biological growth here and elsewhere is embedded in evolutionary and archaeological premises and in a primitivist search for fundamentals.

53. See O'Connor, *op. cit.*, pp. 216–20; and Stanton Catlin, "Mural Census," in Detroit Institute of Art, *Diego Rivera: A Retrospective* (New York and London, 1986), p. 256.

54. See Rockfort, *op. cit.*, pp. 58, 100, n. The PNR (National Party of the Revolution), which soon became PRI (Institutional Party of the Revolution), was formed as the instrument of national government and remained unchallenged until 1989, when Cuahtemoc Cárdenas ran a nearly successful campaign against the PRI candidate.

55. In this aspect he is called Tlahuizcalpantecuhtli, the Lord of the House of Aurora, and is usually pictured as a warrior—as he is here—rather than as a pacifist ruler-priest, and he is linked with the creation myth of the fifth sun.

56. Just as he did with the rural and urban death festivals in the Secretaría's Court of Fiestas, here Rivera set up a formal contrast between the indigenous world of Quetzalcoatl, which is a vision of tranquillity and balance, and the modern world of Marx, which is pictured as a chaotic jumble.

57. The Lienzo is an early colonial painted cloth (c. 1550) in the National Museum of Anthropology, Mexico, containing eighty-six conquest scenes of European manufacture. Most of the scenes are of battles and show indigenous and Spanish warriors. The Spaniards are depicted sympathetically, together with their Tlaxcalan allies, who ultimately joined Cortés in combat against their old enemies, the Aztecs. The Codex Mendoza (c. 1541–42), in the Bodleian Library, Oxford, was commissioned by the Spanish Viceroy Antonio de Mendoza for Charles V and treats Aztec history, tributes, and ethnography. The Codex Telleriano-Remensis in the Bibliothèque Nationale, Paris, is a composite document compiled in Central Mexico (c. 1562–63) containing three major sections on the Aztec calendar and divinatory and historical traditions, which are illustrated in several native styles with Spanish annotations. See Howard F. Cline, ed., "Guide to Ethnohistorical Sources," part 3, *Handbook of Middle American Indians*, vol. 14 (Austin, 1975), for a thorough survey and census of native pictorial manuscripts. See also Elizabeth H. Boone, "Painted Manuscripts," in The Metropolitan Museum of Art, *Mexico: Splendors of Thirty Centuries* (New York, 1990), pp. 268–79.

58. A few of the codices were visible in the Mexican National Museum, and many had been published in facsimile form in Lord Kingsborough's *Antiquities of Mexico* (1831–46). Brown (*op. cit.*, p. 140) asserts that Rivera used mainly the illustrations from the chronicles and colonial codices as a source for his nationalist work and suggests that he may have favored them over pre-Conquest sources because they were more accessible and employed the conventions of the European tradition he knew so well.

59. It is not clear whether Rivera had access to the Acatzingo relief in Toluca, but the Aztec box was reproduced by Seler in 1904. See Pasztory, *op. cit.*, pp. 257–58. There are many relief images in the Aztec canon depicting profile figures seated in tailor fashion, including those on the sides of the monument known as the Temple of the Sacred Warfare (see below).

60. The murals of the Upper Temple of the Jaguars were copied for Alfred Maudslay by Adela Breton in 1904–06. They are thought to depict the Toltec conquest of Maya Chichén Itzá, within a context of celestial cycles and the victory of Venus, the night, and stars over the sun and the day. There are a number of motif correspondences between Rivera's murals and these, particularly representations of feathered-serpent boats, round shields, thatch huts, and an inverted sun at the top of the composition. See Clemency Coggins, *The Cenote of Sacrifice* (Austin and London, 1984), pp. 157–65.

61. Higher up on the central wall are lunettes representing subsequent episodes in Mexican history, including the Reform, the reign of General Díaz, the execution of Emperor Maximilian, and the war with the United States. The central panel depicts the famous Jesuit priest Miguel Hidalgo and National Independence, and, above this, there is a representation of the Revolution of 1910–20 capped by an image of Zapata.

62. Commissioned by U.S. Ambassador Dwight Morrow in 1929 as a gift to Mexico and completed in 1931, the Cuernavaca mural covers three walls of a second-floor patio of the sixteenth-century palace. Catlin ("Some Sources and Uses of Pre-Columbian Art in the Cuernavaca Frescos of Diego Rivera," *Proceedings of the 35th International Congress of Americanists* [Mexico City, 1964], pp. 439–49; 1978, *op. cit.*;

and 1986, *op. cit.*, p. 270) has studied its Pre-Columbian sources in depth. He cites as major sources the Lienzo de Tlaxcala and Matrículo de Tributos, which Rivera saw in the National Museum; facsimiles of the Codex Mendoza, Codex Vaticanus, and Codex Telleriano-Remensis which were published in Lord Kingsborough's *Antiquities of Mexico*, Sahagún's illustrated chronicles, Seler's *Gesammelte Abhandlungen*, as well as pre-Hispanic architecture, sculpture, and mural painting. Beatriz de la Fuente (*op. cit.*) asserts that these battle scenes embody one of three major Pre-Columbian themes in Rivera's work, the others being daily work and deity images.

63. Catlin (1964, *op. cit.*, pp. 441–45) points out that Rivera has taken many costume elements and poses of the Spanish officers from the Lienzo and that he gives the flat, relatively unmodeled Lienzo figures a greater plasticity by combining them with the more realistic, three-dimensional, and active drawings of armored soldiers in the Florentine Codex.

64. See Pasztory, *op. cit.*, pp. 165–69, for an explanation of the significance of the Temple Stone. See also Ramón Mena, "Votive Monument of Motecuhzoma Xocoyotzin," *Mexican Folkways* 2, no. 3 (August–September 1926) pp. 32–42; and Caso, 1927, *op. cit.*

65. Pasztory, *op. cit.*; Caso, 1927, *op. cit.*, and Caso, 1958, *op. cit.*, pp. 14–15.

66. See Diego Durán, *Book of the Gods and Rites, and the Ancient Calendar* (Norman, Okla., 1971).

67. Rivera's earlier references to technology were subsumed in an agrarian context. The machines he introduced into the apsidal mural at Chapingo, for example, are overwhelmed by the dark-skinned earth-mother figure. But a more insistent reference to technology enters the Cuernavaca murals of 1929–30 in the pointed juxtaposition of the Spaniards' iron weapons, steel armor, and horse mounts with the Indians' primarily ritualistic military paraphernalia (frightening masks, standards, and emblems) and their lack of animals for draft or transport. Rivera's exaggerated post-1930s reverence for technology may in fact be partly attributable to his awareness of Mexico's long, painful history of deficient technology.

68. During the late twenties, Rivera was more successful in getting government support for his murals than his colleagues. In addition, in 1929 Ambassador Morrow commissioned Rivera to paint a mural in the Cortés Palace in Cuernavaca as a token of the new U.S. "Good Will" policy toward Latin America. However, most of the painting Rivera produced was on a small scale, including many panel paintings, portraits, book illustrations, and watercolors, in order to supplement his income. In 1931 he illustrated an unpublished translation of the great Quiché Maya epic, the *Popol Vuh*, with drawings and watercolors, which make use of Maya sources. See Detroit Institute of Art, *op. cit.*, figs. 152 and 358.

69. The Russians worshiped Frederick Winslow Taylor's rationalization of the production system (via time-and-motion studies of the labor process) but despised the social system it served. Radu Stern made this point in "American Models for Socialist Goals: Amerikanizm and the Russian Avant-Garde in the 1920s," paper delivered in a session titled "Americanisme," College Art Association Annual Meeting, San Francisco, February 1989.

70. Terry Smith ("A Modern Form of Patronage? Diego Rivera's Detroit Institute of Arts Mural: Cooption and Controversy," paper delivered in a session titled "New Approaches to American Patronage," College Art Association Annual Meeting, Houston, February 1988) suggested that Ford and Rockefeller were probably attempting to popularize their domains and manipulate public opinion in their use of Rivera to decorate their walls, while Rivera went along with them in order to get his own message across in an international arena.

71. O'Connor (*op. cit.*, pp. 222–29) sees the Detroit iconography as an elaboration of the symbolic program Rivera articulated at Chapingo, which incorporated Pre-Columbian myths. He argues that Rivera organized his murals in accord with pre-Hispanic directional symbolism and its associated deities, but he fails to clearly relate the images Rivera invoked to the directions and ignores the fact that they are of different orders.

72. Rivera was not the first Mexican painter to seize upon the image of Coatlicue as a centerpiece for a mural. Saturnino Herran, a prominent member of the classicizing Ateneo de la Juventud group of artists and writers founded by Vasconcelos, depicted the goddess in the central panel of his unrealized mural project *Our Gods* (1914–18) for the new Teatro Nacional (now the Palacio de Bellas Artes) in Mexico City. However, Herran's is an old-fashioned Symbolist rendition of the Aztec idol. In his study for the mural, groups of idealized Indians and Spaniards worshipfully flank the colossal statue, which is subtly superimposed with an image of the crucified Christ, signifying the fusion of the indigenous and European races. See Metropolitan Museum of Art, *op. cit.*, pp. 581–84.

73. Such as the Ford guards shooting striking workers at the Rouge plants, according to O'Connor, *op. cit.*, p. 229.

74. For an identification of this deity couple, see Henry Nicholson and Rainer Berger, "Two Aztec Wood Idols: Iconographic and Chronologic Analysis," *Studies in Pre-Columbian Art and Archaeology* 5 (Washington, D.C., 1968), p. 23; and Pasztory, *op. cit.*, p. 212.

75. Cited in Rockfort, *op. cit.*, p. 67.

76. Alvin Gouldner, *The Dialectic of Ideology and Technology* (New York, 1976), pp. 251–61. Science and technology become panaceas, so that all problems seem to ultimately capitulate to their power.

77. See Linda Downs, "Los frescos de La Industria de Detroit: Una interpretación de la tecnológia moderna," in Instituto Nacional de Bellas Artes, *op. cit.*, pp. 241–42.

78. Cited in Wolfe, *op. cit.*, p. 277. The notion that machinery is the art of the modern age was pervasive in the art and design of the 1920s, for example, in Purism, Léger's painting, and in Art Deco objects.

79. Cited in Terry Smith, *Making the Modern: The Visual Imagery of Modernity, USA, 1908–1939* (Ph.D. dissertation, University of Sydney, 1985), p. 161, n. 31.

80. Catlin, 1986, *op. cit.*, pp. 323–34.

81. Forming part of the complex are water storage tanks or reservoirs that are surrounded by Aztec-style mosaic reliefs representing undulating serpents, which Rivera also designed. There is also a replica of the relief-carved pyramid at the ancient Mexican site of Xochicalco.

82. For example, the Toltec image of a goddess at Cerro de la Malinche. See Pasztory, *op. cit.*, pp. 127 and 132.

83. Brown, *op. cit.*, p. 142.

84. Alfonso Caso, "El paraiso terrenal en Teotihuacán," *Cuadernos americanos* 1, no. 6, (1942). A modern stele in front of the entrance to the Lerma pumping station also seems to echo the style and decoration of this Teotihuacán mural complex.

85. See Guy Brett, "The Mural Style of Diego Rivera," *Block* 4 (1981), p. 29.

86. Samuel Martí (*Manos Simbólicas* [Mexico, 1971]) compared the hands in Pre-Columbian art with the mudras of Indian and Far Eastern art, suggesting a trans-Pacific connection between them. Such a comparison was probably not lost on Rivera.

87. In 1938 Caso singled out a mosaic shield from Chichén Itzá as one of thirteen masterpieces of Mexican archaeology in the National Museum.

88. See Marshall Saville, "Turquoise Mosaic Art in Ancient Mexico," Museum of the American Indian, Heye Foundation, *Contributions* 6 (New York, 1922), pp. 13–14.

89. The Codex Borbonicus (in the Bibliothèque de l'Assemblée Nationale, Paris) may have been written before the Conquest but not later than 1541. It concerned the sacred calendar and religious ceremonies of the Aztecs. Many of the calendric deities in the first section of the manuscript assume this running posture. Rivera could have seen this manuscript during his sojourn in Paris, and he could also have consulted a facsimile edition published by E. T. Hamy in Paris in 1899. Until recently, scholars accepted it as an authentic Pre-Columbian document, and no doubt Rivera considered it as such. See Brown, *op. cit.*, p. 142, and n. 9, p. 230.

90. See Pasztory, *op. cit.*, pp. 127–28. The architectural and sculptural remains on this hill were destroyed by order of Bishop Zumarraga in 1539, and in succeeding centuries by the erection of a viceregal palace and by vandals using explosives. According to Pasztory (*ibid.*), comparable mountain shrines in the Valley of Mexico at Tula and Tetzcotzingo have cliff reliefs representing Aztec maize-water-earth goddesses.

91. Rivera was himself ailing at this time and traveled to Moscow for an operation. However, he had explored the theme of ancient and modern medicine before in murals in the Ministry of Health and Welfare (1929–30) and the National Cardiology Institute (1943). Brown (*op. cit.*, p. 153) points out that a small grisaille in the latter depicts a Pre-Columbian Indian man curing a reclining female with leaves dipped into a container. Above her torso Rivera inscribed the legend: "Mexican medicine before the Christian Era, the use of Yoloxochitl [the "heart flower" plant] for the cure of heart ailments."

92. Brown, *op. cit.*, p. 153.

93. Codex Badiano (in the Vatican Library), written in Nahuatl in 1552, contains approximately 184 colored drawings of plants and herbs used in pre-Hispanic medicine.

94. Brown (*op. cit.*, p. 154) points out that the priest figure is portrayed in the exact position of a priest who faces an image of the goddess Toci on p. 30 of the Borbonicus.

95. Mulvey and Wollen, *op. cit.*, pp. 15, 19–20.

96. According to Catlin (1986, *op. cit.*, p. 263), Rivera originally planned to continue the sequence from the ninth panel, depicting Cortés, around all four sides of the open corridor to meet up with the panel to the left of the stairway fresco presided over by Marx, thereby linking the indigenous past with a socialist future.

97. Brown (*op. cit.*, pp. 145–46) provides a good description of this mural.

98. Pasztory, *op. cit.*, p. 68.

99. The Matrícula, a pictorial record of tributes rendered by the empire, forms one part of the Codex Mendoza. On the bottom of each page of this book is a place glyph of the individual city offering tribute, and the tribute in mantles, cloths, military costumes, shields, jewels, and foodstuffs is arranged in rows above it, with specific quantities indicated by symbols over the objects. Tribute was sent to Tenochtitlán every eighty days. See Pasztory, *op. cit.*, pp. 205–8; Durán, 1964, *op. cit.*, pp. 127–31, 208; and Bernal Díaz del Castillo, *The Discovery and Conquest of New Spain* (New York, 1956), pp. 227–28.

100. Gamio, 1922, *op. cit.*, and "The Sequence of Cultures in Mexico," *American Anthropologist* 26 (1924), pp. 307–22.

101. See Caso, "Reading the Riddle of Ancient Jewels," *Natural History* 32 (1932), pp. 464–80; and Caso, "Monte Albán, Richest Archeological Find in America," *National Geographic* (October 1932), pp. 487–512.

102. The banner carried by the Totonac chiefs is derived from the interlace scrolls on the ball-court reliefs. The smiling Totonac woman is taken from smiling face figurines unearthed at Remojadas, Veracruz. In the *volador* ceremony four eagle dancers tied by ropes to a small platform at the top of a wooden pillar twirl downward in thirteen turns that commemorate the fifty-two-year cycle. See Caso, "Notes on Ancient Games," *Mexican Folkways* 7, no. 2 (April–June 1932), pp. 56–60; and Toor, 1947, *op. cit.*, p. 331.

103. Brown, *op. cit.*, pp. 145–52, 155. Brown also deplores the fact that Rivera drew his pre-Hispanic sources mainly from elite rather than peasant art and depicted the life of extraordinary aristocrats rather than that of ordinary commoners.

104. Rockfort, *op. cit.*, p. 82.

105. Shifra Goldman, *Contemporary Mexican Painting in a Time of Change* (Austin, 1977), p. 114; and Brown, *op. cit.*, p. 155. See also Cecelia Klein, "Masking Empire," *Art History* 9, no. 2 (June 1986), pp. 136, 157. According to Klein, artisanal work, such as masks, functioned fully in this system as tribute and future tribute. It represented and facilitated one group's appropriation of the goods and services of at least one other, and ultimately legitimized the state's aggressive behavior.

106. Townsend, *op. cit.*, p. 22.

107. See Gouldner, *op. cit.*, pp. 260–61; and Ida Rodriguez-Pampolini, "Rivera's Concept of History," Detroit Institute of Arts, *op. cit.*, p. 137.

108. O'Connor, *op. cit.*, p. 229, referring to the workers in Detroit.

109. Notable European modernists who had a passionate interest in primitive art and appropriated it in their own work were the Surrealists Max Ernst and André Breton, avowed leftists who accumulated large, impressive collections and ended up becoming connoisseurs of primitive art. See, for a discussion of the Surrealists' collections of primitive art, Barbara Braun, "Art from the Land of the Savages, or Surrealists in the New World," *Boston Review* 13 (October 1988), pp. 5–6, 18–19.

110. Personal communication, July 1990.

111. Cardona Peña, *op. cit.*, p. 89. Rivera said that Mérida had sold him a marvelous Olmec jadeite mask when he needed money.

112. See Wolfe, *op. cit.*, pp. 372–23; and Herrera, *op. cit.*, p. 313 and *passim*.

113. See *Diego Rivera Museum-Anahuacalli* (Mexico City, 1970); and "Anahuacalli: Museo Diego Rivera" (Essays by Carlos Pellicer, Ruth Rivera, and Dolores Olmeda de Olvera), *Artes de México*, no. 64/65, año xii (1965), p. 34.

114. For an account of Covarrubias's Pre-Columbian collection and his various publications on Pre-Columbian art, as well as his manifold activities as caricaturist, illustrator, painter, and anthropologist, see Lucia García-Noriega y Nieto, ed., *Miguel Covarrubias Homenaje* (Centro Cultural Arte Contemporáneo, Mexico City, 1987).

115. García-Noriega y Nieto, *op. cit.*, p. 179.

116. Frederick V. Field, personal communication, July 1990.

117. One observer (Jeanette Pepper Bello, personal communication, June 1990) recalls an instance in which Rivera recognized that he possessed the missing head of a Tlatilco hunchback figure in Covarrubias's collection and immediately offered it to him.

118. Cardona Peña, *op. cit.*, pp. 108–9. All quotes from this source translated from the Spanish by the author.

119. "Sappho could not have expressed anything better to symbolize her preference for the consummate grace and beauty and intelligence that Plato spoke of in relation to the purely feminine love emotion." Cited in Cardona Peña, *op. cit.*, p. 109.

120. Cited in Cardona Peña, *op. cit.*, p. 111. "However you view it," Rivera concluded, "[whether] through the lens of aesthetic fantasy or scientific hypothesis or optically, or in the integration of all of these, the art of Tlatilco, whose plastic strength embodies profound human emotion, is without doubt one of the highest, strongest, most original expressions of human art."

121. Gilbert Medioni and Marie-Therese Pinto, *Art in Ancient Mexico: Selected and Photographed from the Collection of Diego Rivera* (New York, 1941). The fashion for West Mexican material was pursued most avidly in the United States on the West Coast by members of the movie colony, such as the actor Charles Laughton, who had an important collection. For its impact on the art of Henry Moore at this time, see pp. 124–27.

122. Hasso von Winning, *The Shaft Tomb Figures of West Mexico*, Southwest Museum Papers 24 (Los Angeles, 1974), pp. 2–4.

123. Like many artists of his generation, Rivera conceived of architecture as the highest form of art, and he pictured himself as an architect in a section of the Secretaría murals. He had also designed and constructed twin houses and studios in San Angel for himself and his wife Frida Kahlo.

124. A natural water hole in the northern Yucatán peninsula formed by the collapse of the limestone surface, which was the principal water source in this area in pre-Hispanic times. The Sacred Cenote at Chichén Itzá is the best-known example.

125. The catalogue mentions ample storerooms for 55,000 plus objects, and presumably the remaining 57,400 objects in Rivera's Pre-Columbian collection are stored there.

126. The paucity of wall texts and labels throughout the museum and the general absence of information about the objects—the only catalog was published in conjunction with the 1968 Olympics—also encourages an aesthetic reading of them.

127. The presentation of Pre-Columbian objects follows the pattern established by Herbert Spinden in the Brooklyn Museum, the 1939 San Francisco Exposition, René d'Harnoncourt's 1941 Museum of Modern Art (MoMA) exhibition of Indian art, and the MoMA "Exhibition of Twenty Centuries of American Art," organized by Alfonso Caso. These shows also had a nationalist thrust—to promote native American art and link it with the United States.

128. García-Noriega y Nieto, *op. cit.*, pp. 50–51. After he moved from New Orleans to Taxco in 1929, Spratling began collecting pre-Hispanic art. Together with Covarrubias and several antique dealers, he formed a group for exchanging objects. Three museums became the ultimate beneficiaries of his extensive collections of pre-Hispanic, Colonial, and modern Mexican popular and decorative art: the Arts and Sciences University Museum at the National Autonomous University of Mexico, the Regional Museum of the city of Taxco, and the National Museum of Anthropology in Mexico City.

129. See James Clifford, *The Predicament of Culture: Twentieth-Century Ethnography, Literature and Art* (Cambridge, Mass., 1988), p. 220. Clifford's chapter "On Collecting Art and Culture" stimulated many of my thoughts on Rivera's collection.

130. Though none of the objects in his collection have an archaeological provenance, Rivera railed against looters. "It is urgent to end the looting which is destroying our precious earth," he declared, adding, "for beauty's sake, not for knowledge" (Cardona Peña, *op. cit.*, p. 108). It did not matter to Rivera that decontextualized objects deprived archaeologists of precise information about their ancient meaning and function, only that native artisanry was appreciated and preserved in Mexico. He was also unconcerned that by validating, say, West Mexican ceramics, he was promoting further collecting which promoted further looting; and that, having created a demand for these objects in the international antiquities market, he also encouraged their forging. But Rivera could no more foresee the deleterious consequences of his collecting than the exploiters of fossil fuels for technology could predict environmental depredations.

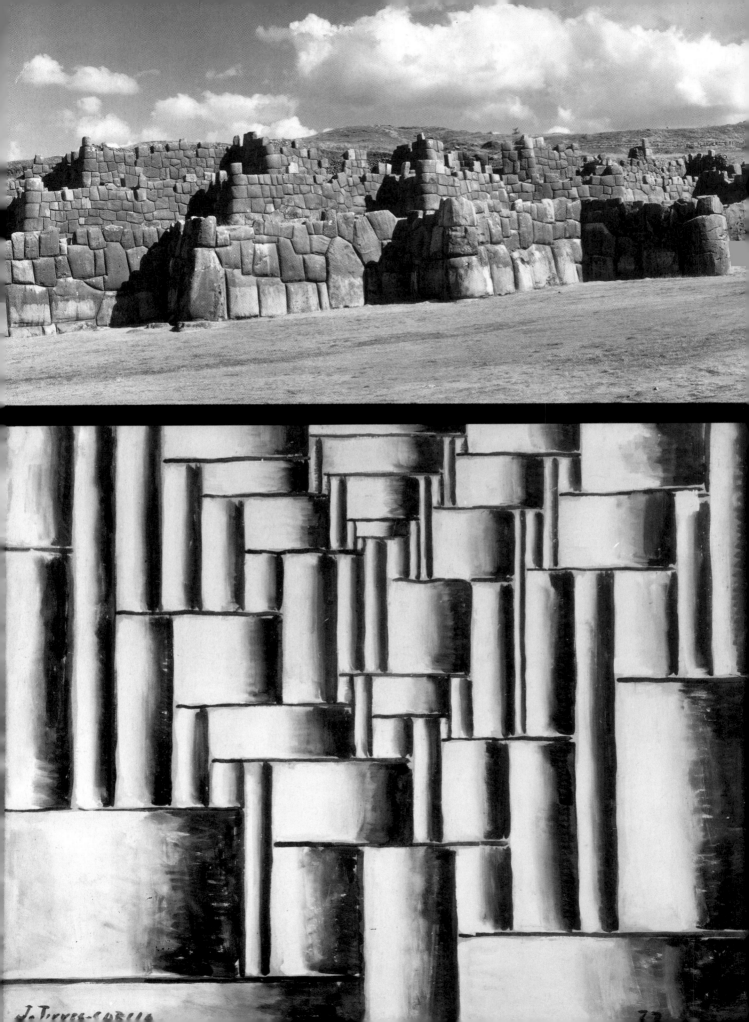

J. Torres-García

JOAQUIN TORRES-GARCIA: THE ALCHEMICAL GRID

oaquín Torres-García was a Uruguayan artist whose work embraces the rationality of Constructivism and the romance of Surrealism with Pre-Columbian art. Like his fellow Latin American Diego Rivera, he was committed to a revival of Pre-Columbian forms but in the service of modernist abstraction, based on idealist rather than materialist precepts, and on universalist rather than nationalist notions. Torres-García's stylistic inconsistency and his mysticism and dogmatism have helped to obscure his extraordinary achievement in North America and Europe—where he is often treated as a provincial—even though he has been enormously influential for Latin American artists.[1]

A man of prodigious energy and plastic facility, Torres-García embraced several art movements in many countries, before arriving, after the age of fifty, at his signature style. With a few exceptions, the art literature glosses over his long apprenticeship in Spain—where he emigrated with his family at age 17 in 1891[2]—in favor of concentrating on his conjunction with De Stijl Constructivism in Paris and his subsequent career in Uruguay. But his earlier career in Barcelona, which shaped his skills and perspective, provides a basis for penetrating his complex identity.

Driven by a new industrial economy (based on textiles) in the hands of an ascendant bourgeoisie, Barcelona in the early years of the twentieth century was intent on becoming modern and cosmopolitan while also preserving the local Catalan language and culture that distinguished it from the relatively undeveloped remainder of Spain.[3] The city's art scene was dominated by two successive aesthetic movements: Modernismo—a local version of Art Nouveau, with a Symbolist and anarchist complexion—and Noucentisme, meaning "1900s style," a classicizing modernism representing a return to rationality and political order. Both styles were associated with broader Catalan cultural and political imperatives and identified with the revival of local traditions.

Until around 1908, Torres-García aligned himself with the Modernistas, while practicing a form of Art Nouveau illustration,[4] at which time he shifted his allegiance to the Noucentista camp and his art practice to the decoration of churches, public buildings, and private houses. His morally uplifting allegorical murals depicted robust classical figures in idyllic pastoral settings, rendered with a pastel palette and linear style that was indebted as much to Italian Quattrocento painting as to Arnold Böcklin and Puvis de Chavannes.[5] By 1911 Torres-García was already acclaimed for his Noucentista murals and was given a prestigious commission by Enric Prat de la Riba, influential leader of the Catalan provincial government, to paint in the town hall a cycle celebrating Catalan regionalism.[6]

During these years Torres-García established an ambitious program of complementary painting, teaching, and writing, which became a lifelong pattern. He gave lessons to private pupils—including his future wife, the aristocratic Manolita Piña de Rubies. He also served as instructor at a progressive children's school in neighboring Tarasa[7] and founded a school of decoration to link painting closely with architecture in the service of Catalan nationalism. At the same time, he wrote several polemical articles and books, including Notes sobre art (1913) and Diàlegs (1915), which elaborated his neo-Platonic vision of art and hailed the classical Mediterranean revival as an appropriate instrument to foster Catalan nationalism, while reviling the alien French and German traditions.[8] These pronouncements defining his moral and aesthetic positions at a given moment were manifestations of Torres-García's acute urge to communicate, instruct, argue, proselytize, and to promote himself, and they placed him at the center of art world discourse wherever he resided. By the end of his life he had published twenty-one books and more than a hundred articles—most of which have never been translated into English.[9]

The Catalan painter and dealer Josep Dalmau began exhibiting Torres-García's work in 1912, the same year he organized a group show of Albert Gleizes, Fernand Léger, Jean Metzinger, Marie Laurencin, Marcel Duchamp, and Juan Gris, as well as exhibitions of futurist paintings and the poet Guillaume Apollinaire's calligrammes.[10] Torres-García responded positively to this form of Cubism, which translated Picasso's and Braque's formal innovations into something that could be incorporated into the

PAGE 250, ABOVE:
View of zigzag platforms at the giant Inka "fortress" of Sacsahuamán, Cuzco, Peru. 15th century

PAGE 250, BELOW:
Joaquín Torres-García. Abstract Tubular Composition. 1937. Tempera on board, 31⅞ × 39¾". Collection Bernard Chappard, New York

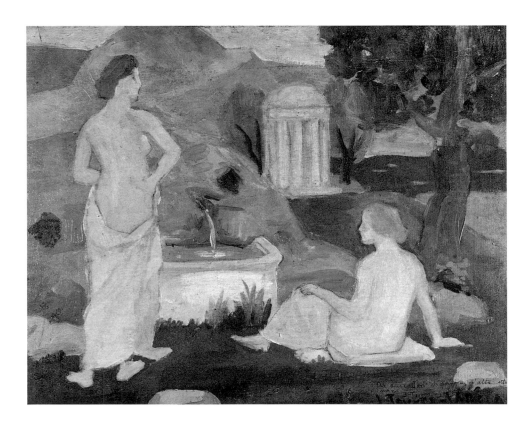

Joaquín Torres-García. Arcadian Scene. *1912.
Oil on canvas, 14½ × 19¼". Whereabouts
unknown*

local classicizing and moralizing style.[11] However, its impact on his work is not visible
until 1916, when he set aside his Mediterranean classicism (except in his murals) in
favor of a form of futurist dynamism (called Vibrationism) introduced to him by fellow
Uruguayan Rafael Perez Barradas.[12]

Torres-García articulated his passionate conversion to modernism in *El
descubrimiento de sí mismo*, 1916; a manifesto of Vibrationism, written in collaboration
with Barradas, 1917; and in a series of journal articles on *evolucionismo.* "Nothing
that has already been realized can be of any use to us," he wrote, adding, "Our motto
must be individualism, the here and now, inter-nationalism."[13] Representations of
workers and construction sites in one of his murals suggest that he flirted with the
leftist causes espoused by most modernists in this year of the Russian Revolution and
the syndicalist strike in Barcelona.[14] But the fact that Torres-García was still painting
Neoclassical allegories in the town hall demonstrates his readiness to entertain at the
same time apparently contradictory painting styles and ideologies.

Torres-García expressed his dedication to the new autonomous art in a series of
drawings and paintings from 1917 to 1919 that embrace the aesthetic concerns of
Gleizes, Italian Futurism, and Apollinaire's verbal-visual fusion. Mainly Barcelona
street scenes, they convey the tempo of urban commerce and suggest the sounds,
sights, and motions of Barcelona's rapid modernization, using flat, shifting planes,
changes of viewpoint, and linkages between words, numbers, and images to break
down clear distinctions between figures, objects, and setting.[15] Yet, even as he is
commenting on the multiplicity and chaos of modern life, Torres-García's affinity for
order, balance, and proportion is evident in the tightly woven geometric construction
of alternating vertical and horizontal forms punctuated at regular intervals with dark
and light accents. Collage-like drawings that synthesize the bustling street life plainly
reveal this underlying gridded organization—their space is partitioned into clear-cut
(though irregular) rectangular compartments filled with fragmentary human,
architectural, and mechanical elements—and strikingly anticipate the Constructivist
framework of Torres-García's mature style. The crucial difference is that the objects
within the compartments of the earlier pictures are illusionistic—their fragmentation is
allied to a Futurist form of illustration—whereas the Neo-Plastic scaffolding of the
later works is embedded with signs. It took Torres-García another ten years of advances
and retreats, of experimentation and assimilation of modernist ideas to transform these
connotational elements into abstract terms.

The missing ingredient in Torres-García's early modernist efforts was the ideogram,
which he eventually derived from a study of primitive and Pre-Columbian art. Yet even

253

Joaquín Torres-García. Barcelona Drawing #25. 1917. Ink on paper, 4¾ × 8⅛″. Private Collection

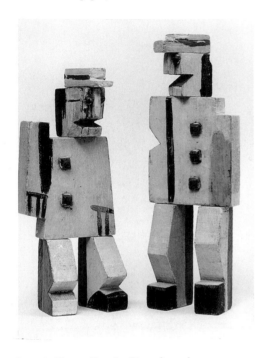

Joaquín Torres-García. Carved wooden toys. 1919. Painted wood. Private Collection, New York

though its influence had not yet penetrated his painting, Torres-García was certainly aware of primitive and naive art at this time. For one thing, he had in his possession a well-known book extolling the aesthetic value of primitive art: Ernst Grosse's *The Origins of Art* (1903), published in Barcelona as *Los comienzos del arte* in 1906.[16] Like many other theorists of the period, Grosse was searching for the roots of art, though his interpretation of the primitive is distinguished from that of Carl Einstein or Roger Fry in that Grosse stresses the social as well as the formal character of primitive art. For another, the foreign vanguard artists in Dalmau's circle—particularly Apollinaire, who was a student of African, Oceanic, and Native American art, and who was engaged in a search for the primitive roots of language and writing—were alert to primitivist concerns.

Torres-García's ingenious carved wooden toys, an important facet of his activity in Barcelona, embody an active interest in the playful and naive, which were always bracketed with the primitive in the first decades of the century. These are whimsical, caricatural images of men, women, animals, and vehicles (automobiles, trains, boats, wagons). Constructed of simple, semigeometric, brightly painted modular components, the individual images can be assembled in a variety of compact forms. The artist also created larger groups, such as a couple with a dog or a miniature village. Torres-García, who was familiar with woodcarving from observing his father's Montevideo lumberyard and carpentry shop, began to make the toys in 1916, around the time of his conversion to modernism, and their geometric reductionism and interchangeable parts seem to echo Cubist notions of form.[17] He intended them for the amusement of his own children and as educational aids to tap the "intuitive vision" and "most pure and real aesthetic imagination" of his young art students at the progressive Mont d'Or school. From the start he also seems to have entertained the hope of making money out of them.[18] Although he took pains to separate them from his art practice, he considered them important enough to exhibit in December 1918 at the Dalmau Gallery together with his first modernist efforts and to write a catalogue essay detailing his pedagogical interest in them.[19] Once again, it was a number of years (in the late 1920s) before Torres-García was able to integrate his passion for constructed toys with his modernist efforts. But the physical directness of these forms, their tactile, handcrafted quality, informs his work in every medium from the start.

Discouraged by the withdrawal of official patronage from his murals as a result of a change in government, offended by the hostile public reaction to the radically changed style of his easel paintings, and concerned about supporting his wife and three children, Torres-García left Barcelona for a locale that promised to be more hospitable to his new work and his toys. Vanguard artists in the Dalmau circle trumpeted New York as the ultramodern city of the future (and, paradoxically, as an outpost of the primitive and naive). "The US is the country for me . . . ! Gigantic, dynamic, free, with an abundance of activity and machines!" Torres-García wrote Barradas in January 1920.[20] Thus, with nothing to lose and much to gain, Torres-García and his family departed for New York in July 1920.

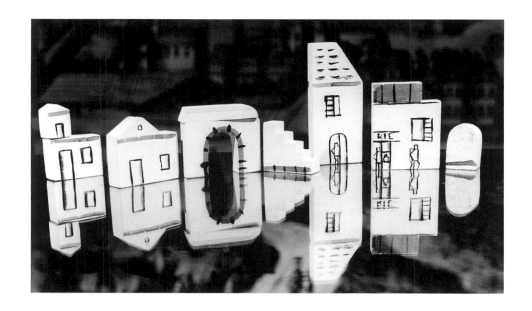

Joaquín Torres-García. Village. 1928. Painted
wood with graphic elements. Private Collection

At first he found New York exciting; his Catalan friends were on hand; he met a
number of sympathetic artists, including Jean Xceron, Walter Pach, John Graham,
Joseph Stella, Marcel Duchamp, and the musician Edgard Varèse; he had several
articles translated and published in *The World*; and his work was well received by local
patrons Katherine Dreier, founder of Société Anonyme, and Gertrude Vanderbilt
Whitney. The latter also encouraged his toymaking, twice exhibiting his paintings and
toys at the Whitney Studio Club and founding with him the Artists Toy Club in
1922. Torres-García's New York cityscapes (page 257) became an extension and
ratification of his earlier modernist efforts, substituting skyscrapers for the picturesque,
smaller-scale buildings of Barcelona. They are more loosely organized, flatter, and more
dynamic; their orthogonal compartmentalization functions more structurally; and they
contain more graphic and verbal notations and a greater variety of mechanized traffic.

But New York failed to live up to Torres-García's inflated expectations of it. Despite
a warm reception in many quarters, he was unable to support his family from the sale
of either his painting or his toys, and he was unsuccessful in soliciting commissions for
murals, theatrical designs, stained glass windows, or even advertisements.[21] Thus, in
July 1922, the disillusioned exile returned to a familiar Mediterranean environment,
which he hoped might also prove more congenial to his toy-manufacturing schemes.
For the next four years he and his family led a peripatetic existence in Italy—Genoa,
Cascina, Fiesole, Livorno (where a fourth child and second son was born)—and on
the French Riviera in Villefranche-sur-Mer. Through all these divagations Torres-
García continued to paint his favorite mix of urban and port scenes and Synthetic
Cubist still lifes. In 1924 he also reverted to his former mural style, once again
decorating villa walls with classicizing subjects. Then, in June 1926, the favorable
response to his modernist efforts in an exhibition of both painting styles that friends
arranged in Paris encouraged Torres-García to channel his energies in that direction
and to engage directly with Parisian modernism at its source.

In September 1926 Torres-García entered a Parisian art world in upheaval, feverishly
repudiating the materialist and rationalist excesses of Western civilization in the
aftermath of the devastation of World War I. Cubist and Dadaist initiatives were now
polarized between two camps: geometric abstractionists hoping to transcend the
phenomenal world by expressing its essence through an ideal geometry; and Surrealists
seeking to liberate images and processes of the human subconscious—the one referring
to a higher metaphysical order, the other to a primordial disorder.[22] Their enthusiasm
for *arts primitifs* of the previous decade was further fueled by the postwar
disillusionment and new fascination with the colonies. Both camps regarded the
elevation of the primitive as an important means of undermining established artistic
categories. Surrealists, following Apollinaire's lead, invoked the romance of the
primitive release of repressed instinctual drives. Purists and Neo-Plasticists, on the
other hand, gravitated to the reductivist principles and concrete simplicities of the
primitive.[23]

In psychological and practical terms, Paris for Torres-García meant starting over at

Joaquín Torres-García. Structure. 1927.
Ink on paper, 3⅜ × 4⅛". Private Collection

Joaquín Torres-García. Drawing for a monument.
1928. Ink on paper, 4½ × 4". Private Collection

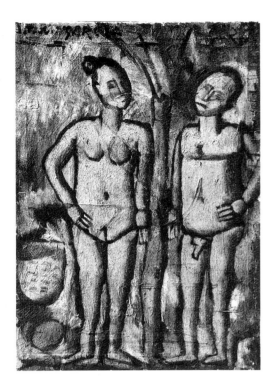

Joaquín Torres-García. Two Primitive Figures. 1928. Oil on canvas, 18⅛ × 13″. Museo Torres-García, Montevideo, Uruguay

OPPOSITE:
Joaquín Torres-García. New York City—Bird's Eye View. c. 1920. Gouache on cardboard, coated light gray, 13⁵⁄₁₆ × 19⅛″. Yale University Art Gallery, New Haven, Connecticut, Gift of Collection Société Anonyme

Joaquín Torres-García. Mask. 1928. Oil on canvas, 20⅛ × 15⅜″. Private Collection

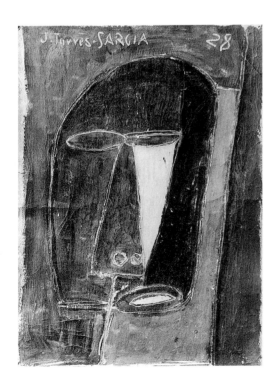

age fifty-two, proving his artistic mettle anew, and improving his bleak financial situation.[24] At first he shared a studio with the much younger Jean Hélion, who introduced him to the artistic milieu and to his first Paris dealer, George Byne. (Hélion also befriended Torres-García's adolescent son Augusto, who often accompanied him on outings to the Marché aux Puces in search of primitive artifacts.) Torres-García resumed an old friendship with Julio Gonzalez, joining a circle of Spanish artists, poets, and musicians that included Edgard Varèse and Luis Fernandez. The latter, a Freemason, initiated Torres-García's interest in occultism and spiritual transcendence, including medieval symbology, Cabalism, and Pythagorean number mysticism involving notions that the world soul and celestial bodies are ruled by number and that numerical values proper to musical consonance are derived from the music of the spheres. This esoteric knowledge proved very attractive to Torres-García, who was probably predisposed to it through his prior experience with neo-Platonic philosophy and progressive education (whose leading light was theosophist Rudolf Steiner).

During 1927 and 1928 Torres-García's receptivity to these crosscurrents—the magical power of numbers and symbols, Surrealist and Constructivist doctrines, and the primitive—produced a creative explosion in his art. His first overtly primitivizing paintings are a series from 1928 of whimsical, geometrically simplified, robust nudes on the theme of Adam and Eve that were based mainly on West African sculptures— Senufo and Bambara figures—with heads inspired by Coptic painting. The pots, baskets, and other implements in these paintings attest to a close inspection of all kinds of primitive artifacts. (Similar objects reappear in graphic form in his mature Constructivist pictures.) These canvases represent a dramatic departure from previous efforts and seem, with their heavy impasto, bright color, dark outlines, and strong stylizations, to be alternative versions of the stately pastel nudes of his classicizing murals. Their playful, ridiculous, and erotic cast suggests an engagement with Surrealist imperatives about recovering the unconscious and instinctual in art. Up until that point Torres-García had confined his expression of the instinctual to his toys, which he continued to make and, for the first time, to paint with schematic graphic elements (page 255) that reflected a new interest in children's drawings.[25]

Another group of primitivizing paintings, based on West African, possibly Fang, models, explore a very different structure and spirit. The frontal images are built of very flat, superimposed planes, outlines are looser, and colors are restricted to black, brown, and white, suggesting experimentation with positive-negative spatial concepts. The rhythmic patterns of these paintings evoke jazz, in terms of the contemporary understanding of nègre as embracing Afro-American music, tribal masks, voodoo, passion, and freedom. In both primitivizing series, Torres-García was involved with translating three-dimensional artifacts into two-dimensional plastic terms, but he would soon move on to explore other areas of the primitive that were intrinsically flattened and patterned.

The frontality, flatness, and geometry of these paintings point to Torres-García's concurrent investigation of a more direct kind of pictorial space opened up by the Neo-Plasticists—abstract geometric construction. The first indication of this tendency occurs in drawings from 1927 to 1929 (page 255) that employ a pure plastic conception and an orthogonal grid. They appear to have been arrived at intuitively, however, unlike the more systematically constructed wooden reliefs and paintings he executed after becoming fully initiated into the Neo-Plasticist aesthetic through his friendship with Theodore van Doesburg. Neo-Plasticist doctrine upheld art as an ideated reality that should translate a universal harmony through formally balanced elements and that should be free of all extra-artistic references and individual expression.[26] It proposed that the underlying geometric order in nature must be discovered and revealed by the artist in compositions consisting of right-angle relationships and the three primary colors, along with white, black, and gray. And it promoted theosophic notions deriving from Madame Blavatsky about the mystical properties of certain geometric forms and numerical progressions, including the Golden Section, the mathematical formula for establishing "divine" harmonic proportions on the painting surface.[27] In practice, Neo-Plasticism meant the resolution of the figure-ground dichotomy inherent in the Western pictorial tradition since the Renaissance: lines, forms, and colors residing on and activating a unified field.

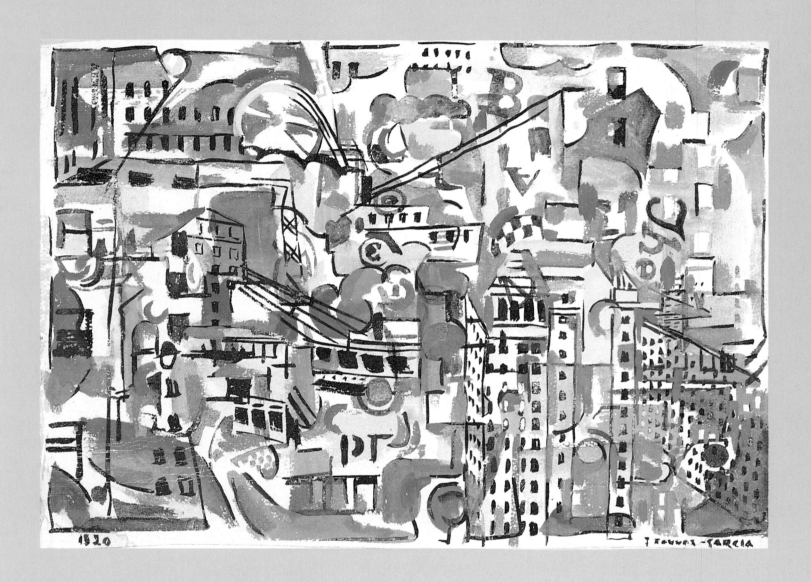

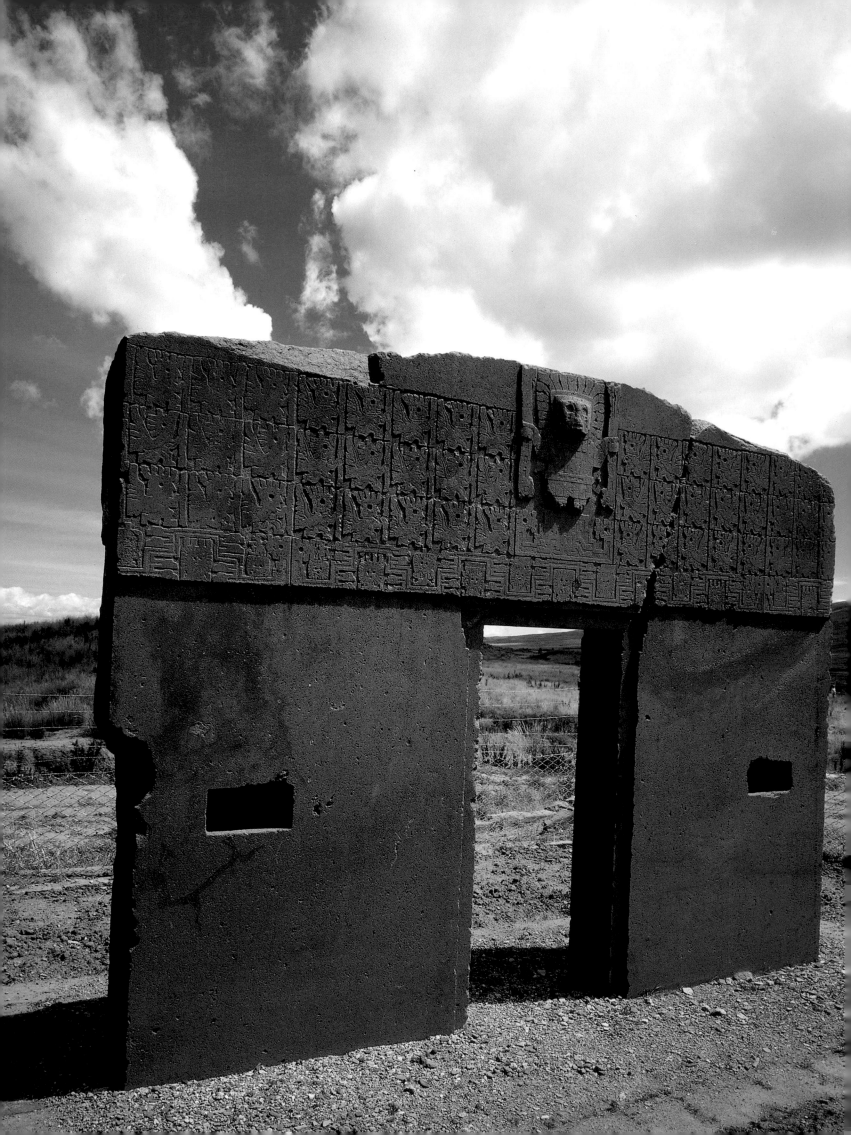

At this same juncture, Torres-García connected with Pre-Columbian art, experiencing it as both a ratification of and a source of motifs for, the development of his personal Constructivist aesthetic. He had ample opportunity to study it in the flurry of exhibitions and articles prompted by the Surrealists' new enthusiasm for Native American art.[28] In July 1928 Torres-García attended a vast Pre-Columbian exposition at the Louvre's Pavillon du Marsan of the Musée des Arts Décoratifs, which included an astonishing 1,246 objects from North, Central, and South America culled from European and Latin American institutional and private collections. Organized by Alfred Metraux and Georges Henri Rivière, *Les Arts anciens de l'Amérique*[29] marked the acceptance of Pre-Columbian forms into the high-art pantheon (more than a decade after African art had achieved that distinction). It was the first French exhibition to treat Native American artifacts aesthetically, stressing their stylistic rather than ethnographic identity, grouping them in terms of form and decoration, and taking their inherent beauty into account.

Torres-García was also exposed to Pre-Columbian art in a more direct and personal way. In 1928, through his friendship with Paul Rivet, the director of the Trocadéro, he got his son Augusto a job rendering an inventory of the Nazca ceramics in its collections.[30] These grave offerings, dating from around 200 B.C. to A.D. 600, exemplify the flat, schematic, polychrome style of southern Peruvian art (in contrast to the realistic, sculptural, and monochromatic artistic tradition of the north). And a stunning archaeological discovery in the Paracas peninsula of southern Peru must have lent a special excitement to Augusto's task. In 1927 Julio Tello had unearthed a cemetery filled with 429 mummies wrapped in bundles of extravagantly decorated textiles[31] whose designs are closely related to Nazca pots. Augusto's job also gave him access to the entire primitive collection at the Trocadéro, which he recalls his father visited frequently during this period, admiring above all its Nazca pottery, Peruvian textiles, and North American Indian painted hides.

Architecture was the governing metaphor of 1920s art, encoding the lessons of order, clarity, and purity advanced by every form of modernist Constructivism. Thus it was quite natural that Torres-García was also attracted to the Trocadéro's cast of the Gateway of the Sun at Tiwanaku (in the entryway to the Peruvian exhibit since the Universal Exposition of 1878). Originally the doorway to a major temple, this monolith is carved in low relief with a frieze of figures and designs that would become the leitmotiv of south Peruvian and Bolivian art of the Middle Horizon period (c. A.D. 600–1000). Torres-García based a number of his Constructivist drawings of 1927 to 1929 on the Gateway of the Sun and on Inka masonry.[32] A painting of 1930 was also partially inspired by the Tiwanaku monolith. In these drawings, Torres-García employed Andean masonry in much the same way that Piet Mondrian had used Parisian buildings in his pathbreaking Facades series of 1914, extracting horizontal and vertical lines through a process of simplification and purification to arrive at an abstract essence.

Torres-García also referred to Andean architecture in his more strictly constructed wooden reliefs of 1929 to 1930, which employ the Golden Section and, occasionally, primary colors. Like the Inka walls he must have seen in photographs of, for example, Sacsahuamán, the giant fortress outside Cuzco (page 250), many of Torres-García's reliefs are monochromatic, retaining the natural color of the material from which they are made and relying on textural variations for their effect. The heavy shadows cast by the beveled edges of the huge stones and the trapezoidal doorways of Inka buildings are echoed in the reliefs as well as in the later series of black, gray, and white abstractions of the mid-to-late-1930s (page 250) that expand upon the earlier drawings based on Andean architecture. It is abundantly clear that Torres-García imagined these Inka walls as a form of ancient Constructivism—a kind of "natural" geometry—obeying the laws of orthogonals and tectonics, as César Paternosto has suggested.[33] They also sustain the Constructivist notion of basing art on fundamentals in the sense that, as glacial boulders, they were primeval matter.[34]

Probably the earliest instance of Torres-García's incorporation of pictographs within the Constructivist grid—the basis of his signature style—occurs in these reliefs. Since they are evidently extensions of his wooden toys (which he had already painted with graphic elements), it appears that he was able finally to integrate figuration and abstraction by joining two kinds of forms sharing a childlike character, which was

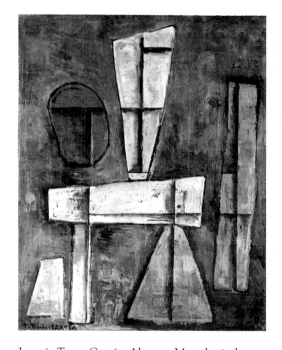

Joaquín Torres-García. Abstract Metaphysical Forms. 1930. Oil on canvas, 57½ × 44⅞". Private Collection

OPPOSITE:
The Gateway of the Sun. Tiwanaku, Bolivia, c. 700

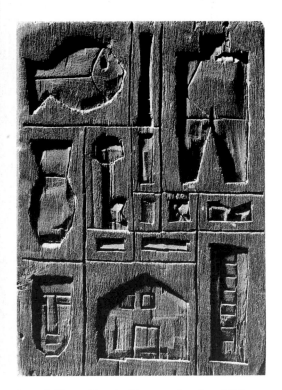

Joaquín Torres-García. *Constructive Art.* 1930. *Incised wood, 6⁵⁄₁₆ × 4⁵⁄₁₆". Museo Torres-García, Montevideo*

commonly equated with the originary and the primitive at the time. His commitment to toymaking and to children's art had taken him to the same place as the Constructivist search for simplicity and fundamental principles: to the grid as a basis for overall structure and to pictograms as the archetypal expression of the basic constituents of life.

After some experimentation Torres-García translated this dualistic conception into plastic terms in his painting. At first he divided the canvas into Constructivist planes of limited colors defined by a system of vertical and horizontal lines that are superimposed with schematic figural and landscape elements. By the end of 1929, after he had become personally acquainted with Mondrian, he transformed the ground into a unified field of a single tone and related the graphic elements to the gridded structure rather than to each other in terms of landscape or still life.[35] He ended up, in 1930, by presenting each graphic notation in an individual rectangular compartment, which was sometimes shaded to produce an illusion of depth, as if it were embedded in a shallow relief. He described the process in *Historia de mi vida* (1939):

The difficulty lies in this: if he composes a painting only with abstract forms, either geometric or irregular, what was he to do if he wanted to express something that would refer to concrete things? Because if he tries to put together both things (as he will do, hundreds of times), nature loses and so does plastic construction. But one day he thinks: to the abstract element there must

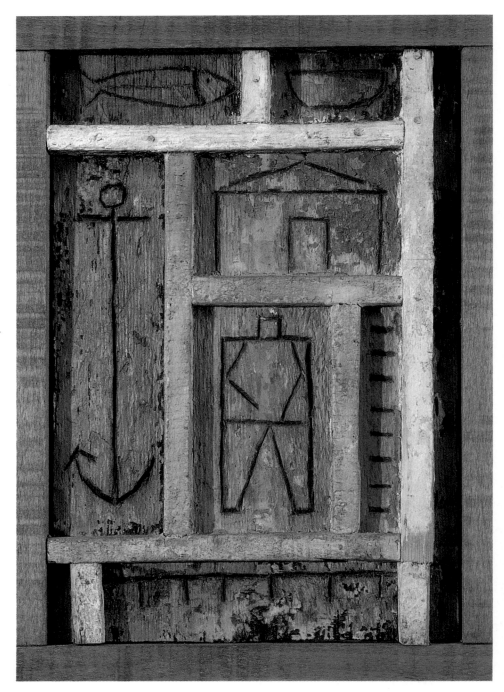

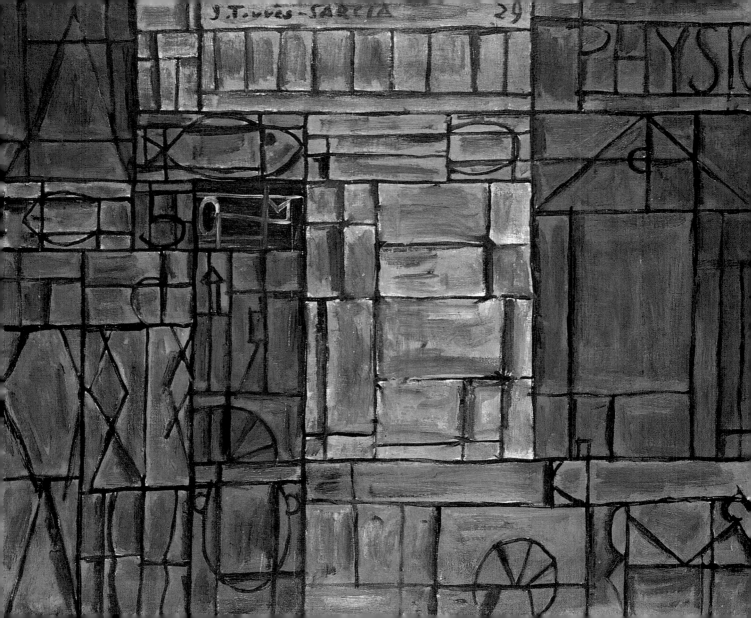

Crustacean and stylized snake. Huaca Prieta,
Peru, 3000–2000 B.C. *Reconstructed textile*

always correspond a referred idea of a thing, something also abstract. What can this be? In order to be represented graphically, it must be either the written name of a thing, or a schematic image, as little apparently real as possible, such as a sign. And he does. In the construction divided into rectangles as if it were a wall of stones he puts into each of the compartments the drawing of a thing. And there it is! It must be that.[36]

The same concept was apprehendable in all kinds of Peruvian artifacts decorated with flat designs—textiles, ceramics, as well as reliefs, including, of course, the Gateway of the Sun—because they embody stylistic conventions dictated by the weaving process: A schematization based on verticals and horizontals developed in response to the warp and weft of the threads as they crossed each other. The earliest known Peruvian artifacts are textiles decorated with images of supernatural cult animals, such as an eagle, snake, or crab from the site of Huaca Prieta in the Chicama Valley, which became prototypes of flat Peruvian design. Their stylistic traits—bilateral symmetry, split representation, rhythmic repetition, polar opposition, and modular composition in horizontal registers—were reproduced in other mediums even when there was no structural necessity for them.[37]

By 1930, Torres-García had developed most of his repertory of pictograms. Many of them can be identified as normative visual forms derived from his personal experience[38] or as generalized symbols of nature. Others are familiar astrological or zodiacal signs, letters, and numbers with directional or magical significance.[39] The artist also appropriated a number of his schematic motifs from Egyptian hieroglyphs, Greek geometric pottery, North American Indian painted hides and petroglyphs (tepees and thunderbirds), Pre-Columbian art (masks, architecture, pottery forms and decorations, textile designs), prehistoric cave painting, and children's drawings.

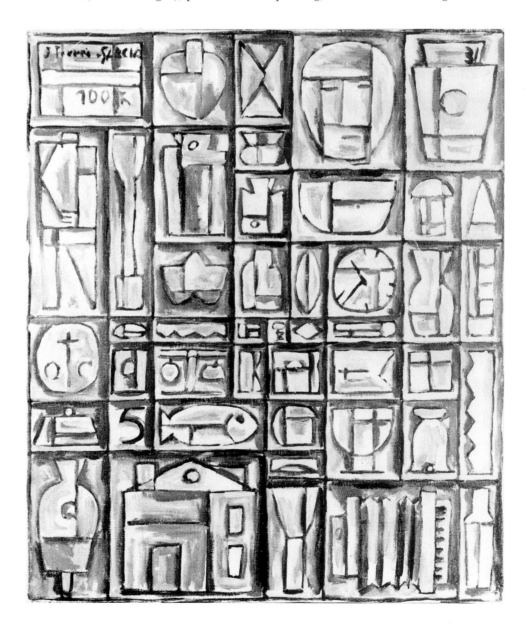

Joaquín Torres-García. Composition. 1931.
Oil on canvas, 25½ × 21½". Private Collection

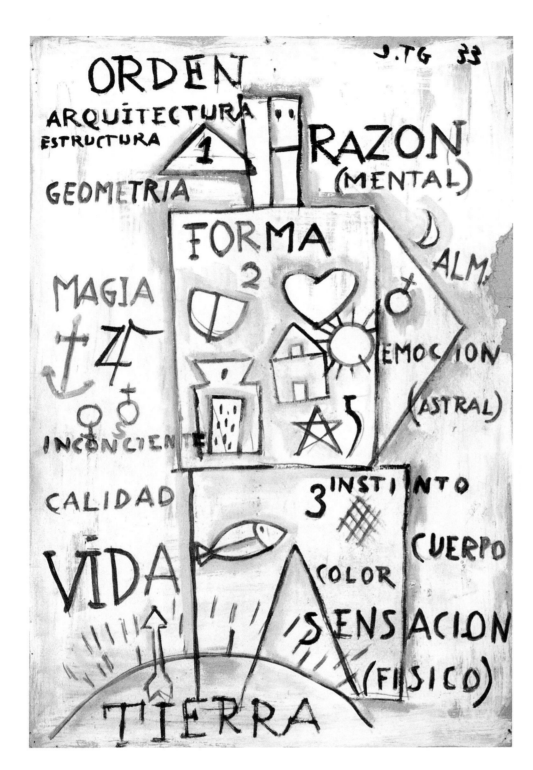

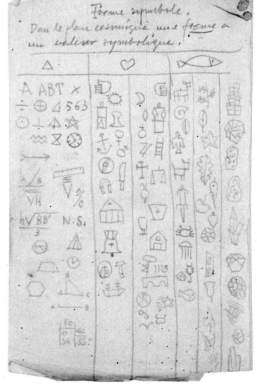

However, the interpretive keys provided by the artist, which divide the symbols into mental, moral, and material categories,[40] suggest that all the signs, and their relative size, combination, and sequence, have private connotations. The painting *Cosmic Composition with Abstract Man*, 1933, spells out the system's hierarchical order, which implies a progression to an ideal state: Signs of earth occupy the lower register, emotion and spirit the middle, and reason above. It is clear that the artist assigned each form a symbolic value within the cosmic plan that guided his thinking—so that, for example, a ruler always signifies the Golden Section, or a ladder, spiritual ascension—and that each Constructivist painting simulates a cosmic totality or universe by juxtaposing elements from all three realms. Hence Universal Constructivism, the name he gave his painting system, is doubly universal, in terms of its Neo-Plasticist construction and its language of signs.

Torres-García's effort to extract a universal sign system from a broad range of cultural and personal contexts was deeply embedded in a neo-Platonist and mystical ideology. In particular, it conforms to a metaphysical theory of sign-types that goes back to Plato in the *Cratylus*, which proposes that hieroglyphs constitute the only

Joaquín Torres-García. Construction with Serpentine Forms. 1931. Oil on wood, 16⅛ × 12″. Private Collection

OPPOSITE:

Joaquín Torres-García. Construction with Strange Figures. 1931. Oil on canvas, 35 × 21¼″. Private Collection

PAGE 266:

Polychrome urn decorated with design of a masked figure. Nazca, South Coast, Peru, 100–500. Ceramic. National Museum of the American Indian, New York, Smithsonian Institution

PAGE 267:

Joaquín Torres-García. Symmetrical Composition in Red and White. 1932. Oil on canvas, 50 × 34¼″. Collection Mr. and Mrs. Meredith Long

"natural" and truthful form of human expression.[41] In *The Tradition of Abstract Man* (1938), Torres-García wrote of the sign:

Any primitive culture progresses along that line. Its art, always geometric in expression, is a ritual, something sacred. Such is the problem the artist today must face; this too is the wish revealed in modern artistic expression. Raising the term "structure" to a universal plane, we can determine that the sign is something natural, and so can grasp the essence of this point of incidence between the living and the abstract. And this would be the best explanation of what we understand by Constructive Art.[42]

Many of the magical symbols, astrological signs, and numerical formulas in Torres-García's repertory are commonly featured in hermetic and theosophical tracts. These tracts also regularly refer to the very same ancient civilizations (Egypt, Greek, and Native American) to which he turned for geometric and graphic symbols. Like many mystical modernists, Torres-García was steeped in theosophy and saw himself as a visionary artist who intuitively divined these symbols and synthesized them in his work, channeling the essential message of myth to humankind.[43] The notion of reintegrating man into his archetypal self is codified in one of his central pedagogical tenets, the rule of abstract harmony (*La Regla Abstracta*) and in *The Tradition of Abstract Man*.[44]

The paintings of late 1931 to 1932 testify that Torres-García was intently examining Nazca ceramics.[45] Many have a flat decorative patterning, a palette of earth reds, yellows, and browns, and a symmetrical and hieratic organization. Compare, for example, a Nazca polychrome vase with the central figure in *Construction with Strange Figures*, 1931, or the mouth mask, trophy head (magic talisman-like scalps in which the power of defeated enemies was thought to reside) markings, and caricatural profile heads on another pot with elements in *Construction with Serpentine Forms*, 1931. The symmetrical organization and color distribution of many late Nazca and Tiwanaku ceramics are also echoed in such paintings as *Symmetrical Composition in Red and White*, 1932.

What has been overlooked in previous assessments of the influence of Nazca ceramics on Torres-García's pictures, however, is that, beyond individual motifs, color scheme, and hieratic organization, their impact on Torres-García probably extends to the construction of his pictographic system. In other words, he sought in Nazca art not only obvious formal elements but the structural principles underlying the forms. Scholars had shown that the flat designs on Nazca pots were never merely decorative; they had the character of magical formulas and prayers to be conveyed by the dead to gods and demons, and they functioned as metaphoric signs that were coordinated in a

Drum in the shape of an otter. Early Nazca culture, South Coast, Peru, c. A.D. 100. Ceramic. Whereabouts unknown

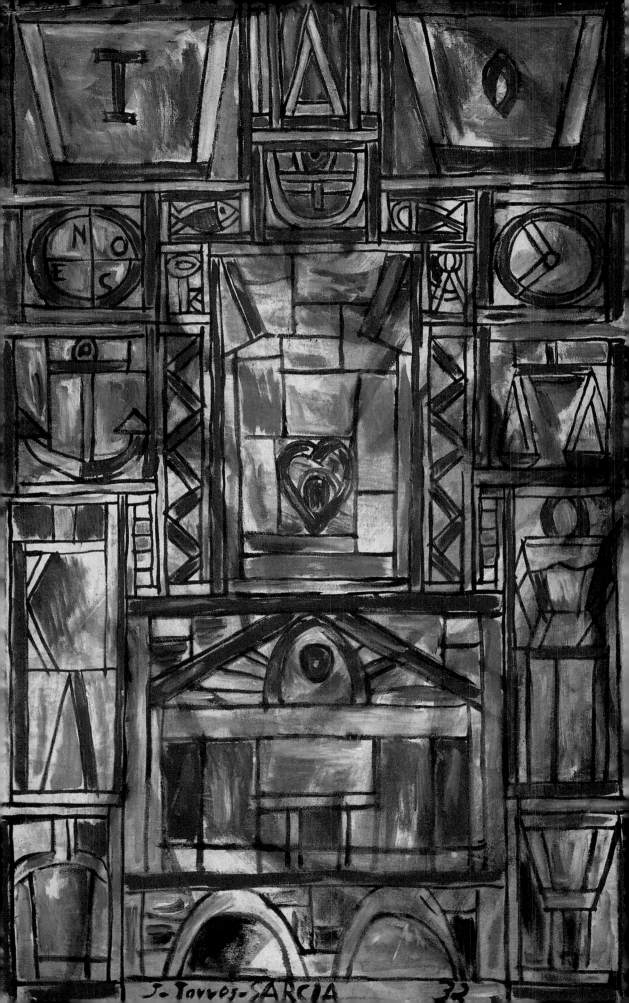

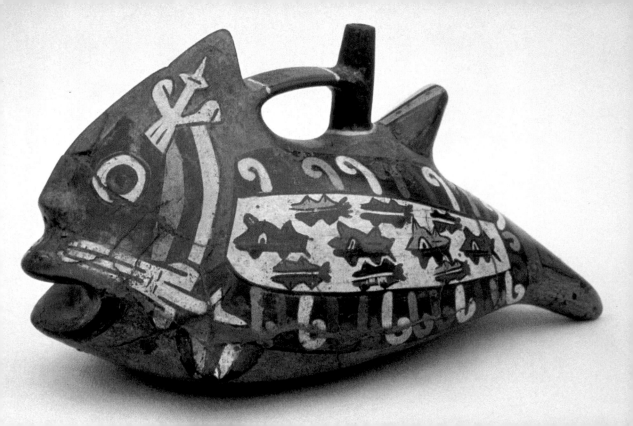

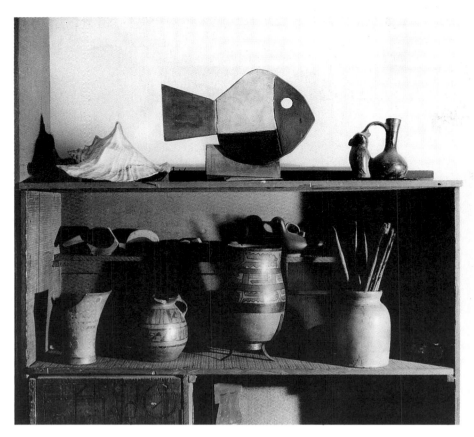

OPPOSITE:
Single-spout bottle in the form of a fish. Early Nazca culture, South Coast, Peru, c. A.D. 100. Polychrome baked clay, length appr. 9". Museo Nacional de Arqueología y Antropología, Lima

Interior of Torres-García's studio with objects from his collection of Pre-Columbian ceramic art and his own sculpture (see fish at top center)

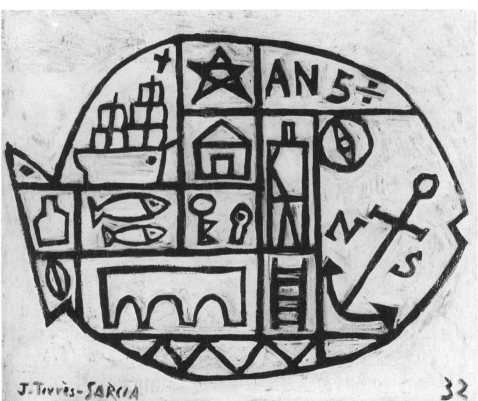

J. Torrès-GARCIA 32

Joaquín Torres-García. Untitled (Fish). 1932. Oil on canvas, 21 × 25½". Private Collection

hierarchical system of interrelated themes (animals and plants, warfare and agriculture, religious and mythical subjects) reflecting a native cosmology, that is, like a hieroglyphic writing system.[46]

It seems likely that Torres-García located an originary, "natural" writing system in Nazca iconography, one faithful to the imperatives of neo-Platonic theory, and that he proceeded to model his personal symbolic system after it, organizing his signs into natural, cultural, and spiritual spheres and relating them to one another diagrammatically, in the manner of Nazca iconography. And though he probably intended them to be comprehensible, for the most part they elude our grasp today, remaining wrapped in mystery, like the symbols on Nazca ceramics. While emitting clues to the artist's intended meaning, the pictograms serve mainly as an extraordinary

PAGE 270:
Paul Klee. A Leaf from the Book of Cities. 1928. Engraving on crayon base on paper and wood, 16¾ × 12⅜". Oeffentliche Kunstsammlung Basel, Kunstmuseum

PAGE 271:
Paul Klee. Clown. 1929. Oil on canvas, 26⅜ × 19⅝". Private Collection, St. Louis

1928 N6 ein Blatt aus dem Städtebuch Klee

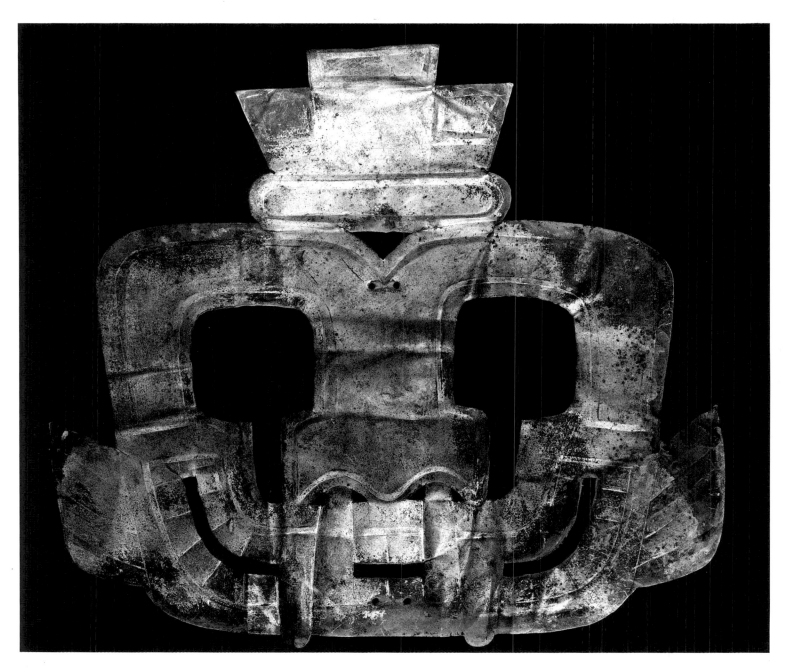

visual counterpoint within the overall pattern of the paintings, whose burnished color, crusty surfaces, and obvious debt to ancient forms lend them an archaic and archaeological cast.

Torres-García's symbolic system is the most personal aspect of his art, but he was not alone in his desire to fuse abstraction and figuration in the interest of expressing a cosmic totality. In many ways his efforts resemble that of Paul Klee, another artist with a history of involvement with children's drawings, primitive textile design, metaphysical ideas, and Constructivism. Klee's patterned canvases of the late 1920s, such as *A Leaf from the Book of Cities*, 1928, or *Tree Nursery*, 1929, display hieroglyphic forms suspended on rhythmically divided, often boxlike, surfaces, and a strong tactility that encourages archaeological associations with runic stones or inscriptions on papyrus (Klee visited Egypt in 1928 and 1929). Throughout the 1920s there was ample opportunity to see Klee's art in Paris, which he visited in 1928, and where he was the darling of the Surrealists, who accorded him honorary membership in their group.[47]

A comparison between a number of Torres-García's paintings of masks from 1928 to 1931 and Klee's pictures of masks and clowns suggests that this resemblance is not entirely coincidental. Klee himself, particularly in his late, darkly intense paintings (after 1938), demonstrated a sustained interest in both the style and iconography of ancient Peruvian woven and painted textiles, metal masks, and even stone reliefs. The affinity of these mystically inclined painters of graphic abstractions for flat, linear, orthogonal Pre-Columbian forms is indicative of a kinship between this tendency in modernist painting and this strain of pre-Hispanic art.[48]

Puma head, feline mask. Chavínoid, Pachacamac, Peru. Hammered silver, height 8". Courtesy Department of Library Services, American Museum of Natural History, New York

OPPOSITE:
Paul Klee. Moon Goddess of the Barbarians (Luna der Barbaren). *1939. Gouache on paper mounted on board, 12¾ × 8¼". Private Collection*

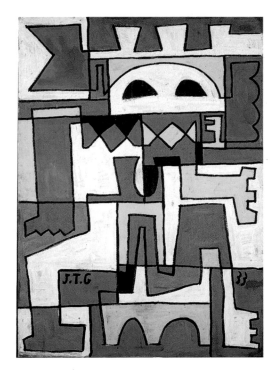

Joaquín Torres-García. Assembled Animist Form.
1933. Tempera on board, 39⅜ × 29½". Collection
Fayez Sarofim

Torres-García presented his personal fusion of abstraction and figuration as an alternative to a Neo-Plasticist aesthetic that he considered too austere and life-denying. He was not prepared to jettison humanist subject matter—what he referred to as his metaphysics—in favor of pure abstraction, even though his friends Van Doesburg and Hélion vehemently disapproved.[49] Ever the polemicist, Torres-García joined forces with the critic Michel Seuphor to advance his aesthetic position. Together, in 1929, they founded *Cercle et Carré* [Circle and Square], the short-lived Constructivist association that admitted imagery into its formulation. In 1930 they published three issues of a journal by the same name and organized a major exhibition of the association's membership, which included eighty prominent abstract artists, including Mondrian, Wassily Kandinsky, Hans Arp, Kurt Schwitters, and Georges Vantongerloo. But just as Torres-García was apparently on the verge of becoming an internationally recognized abstract painter, the Parisian art market collapsed in the Depression, and he was obliged to leave Paris with his family in 1933 for a teaching prospect in Madrid (which failed to materialize). Although Madrid proved to be professionally and financially disappointing, the eighteen months he spent there were artistically rewarding. They enabled him to solidify and refine his personal Constructivist system and deepen his connection with Pre-Columbian art.[50]

A series of paintings with a new formal approach executed in late 1933 reveals the artist shifting his attention from Nazca ceramic decoration to closely related textile designs from Paracas, which Tello had recently unearthed to great fanfare. In *Assembled Animist Form*, 1933, the image seems freed from the grid, but in fact symbol and grid are integrated by means of a wandering, orthogonal line that interlocks the large anthropomorphic figure, flat color planes, and positive/negative spaces. (The Neo-Plasticist color scheme is intensified with a special varnish.) The figure in this painting partially recalls a curious composite creature called the Oculate Being—a frontal anthropomorphic feline with prominent eyes, jagged appendages (snakes and trophy-heads), and clawlike hands and feet—which is the focal image of many Paracas fabrics. Though the same hybrid creature occurs on Paracas and Nazca pottery, it has a more complex presence in the textile medium as a result of the stylization imposed by the warp and weft patterning. Later-period textiles from Tiwanaku and Wari (c. A.D. 600–1000) extend this stylization to the point of abstraction. Taking as their point of departure the profile winged attendants of the central deity on the Gate of the Sun, they transpose individual elements—weeping eye, mouth, nose, hand-held staff, running legs, wings—into kaleidoscopic flat patterns of paired elements arranged in rectilinear registers. Examples of such textiles were visible in the Madrid archaeological museum and in many publications about ancient Peruvian textiles that were inspired by Tello's finds.[51]

In April 1934, after forty years abroad, Torres-García returned to Uruguay with his family, determined to put his European years behind him and to initiate a new phase in his career. *Historia de mi vida*, an autobiographical account of his life up to 1934, marks a deliberate closure and a new beginning. Torres-García was now prepared to make an art suitable to the Latin American experience. "I believe the age of colonialism and imports is over (now I'm talking about what we call culture), so away with anyone who speaks, in literary terms, a language other than our own *natural language* (I don't say *criollo*), be they writers, painters, or composers! If they didn't learn the lesson of Europe when they should have, too bad for them, because the moment has passed," he declared.[52] What he had in mind was the establishment of a regional art tradition, a School of the South, that would promote modernism with nativist roots, linking the art of today (Constructivism) with the art of yesterday (prehistoric Indian form). In the context of Uruguay, he argued, Pre-Columbian art had greater meaning than in Europe and should take on new significance as a local basis for a truly national, contemporary artistic expression. Thus, upon his return to Montevideo, Torres-García's involvement with Pre-Columbian art became more deliberate and was rationalized as part of the formation of a self-consciously Latin American art.

He was also surely aware of the indigenist movement in Peru during the late twenties and thirties, especially of the ideas promulgated by the writer José Carlos Mariátegui, founder of the Peruvian Socialist Party and the vanguard journal *Amauta* (signifying "wise man" in Quechua). Mariátegui modeled his party after the Inka *ayllu* (a pre-Conquest social unit based on reciprocal obligations and communal land) rather than

OPPOSITE, ABOVE:
Mantle with shaman figures. Paracas Peninsula, Peru, A.D. 0–100. Plain weave with stem-stitch embroidery, 55⅞ × 94⅞". Courtesy Museum of Fine Arts, Boston, William A. Paine Fund

OPPOSITE, BELOW:
Detail of a burial blanket depicting the "Oculate Being." Paracas Peninsula, Peru, 200 B.C.–A.D. 200. Cotton embroidered with alpaca wool, detail 7⅛ × 6¼". The Textile Museum, Washington, D.C.

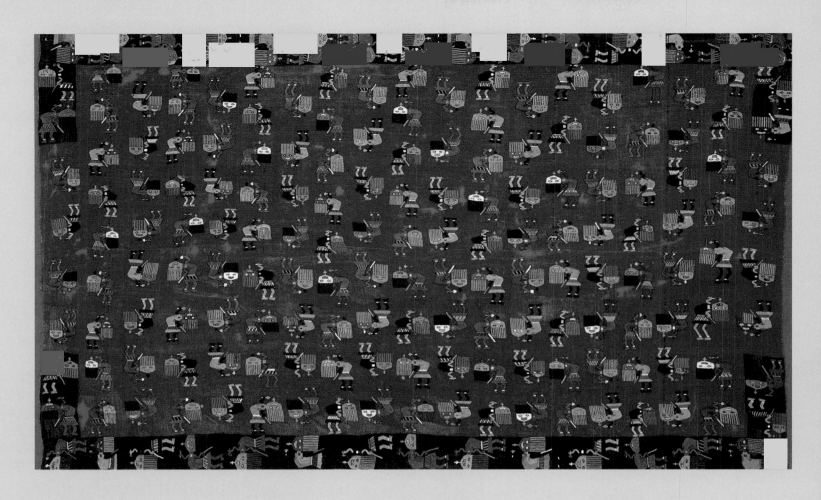

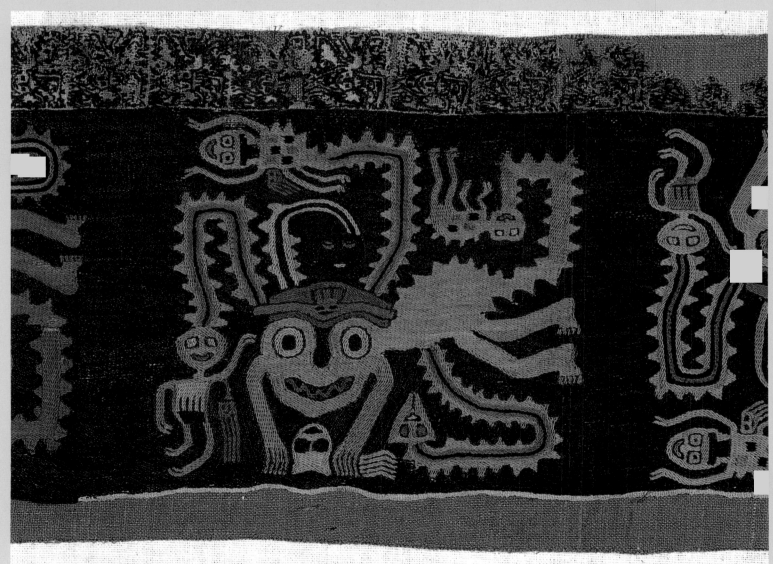

European socialism, and it was supported by many artists and writers who shared his ideas and contributed to his review.[53] Although Torres-García dreamed of a very different, more cosmopolitan, form of art and culture for Uruguay, he must have taken heart from this revival of ancient indigenous traditions in neighboring Peru.

The Uruguayan political economy of the 1930s, a utopian welfare state with an internationalist and Pan-American foreign policy, seemed to provide an auspicious climate for the fulfillment of Torres-García's vision. José Batlle y Ordóñez, the president who dominated the country from 1903 until 1929, pioneered a form of economic nationalism that promoted social justice, labor reform, and extensive public works at the same time as it supported foreign investments to spur economic growth. This policy accorded with Uruguay's traditional role as a buffer between the warring Brazilian and Argentinian states and with the universalist and radical-socialist sympathies of the urban middle class, composed mainly of recent immigrants from southern Europe, that was the political base of Batlle's Colorado party.[54] By 1930 per capita income in Uruguay was the second highest in South America after Argentina, and even though Uruguay was suffering from the effects of the Depression under the benevolent dictatorship of General Gabriel Terra at the time of Torres-García's return, Uruguayans still regarded themselves as progressive Utopians in comparison with their neighbors.[55]

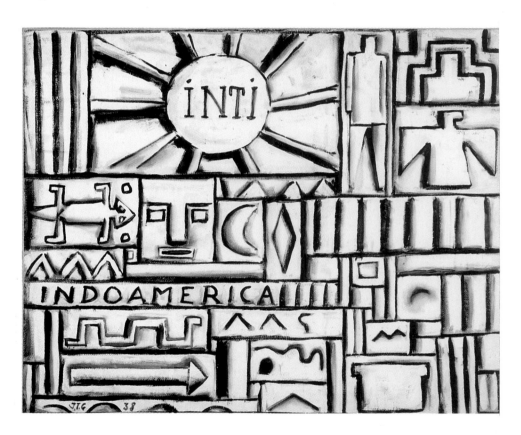

Joaquín Torres-García. Construction in Black and White (INTI). *1938. Tempera on board, 31⅛ × 40″. Private Collection*

Torres-García recognized the importance of a social base and of favorable political and economic indicators to the establishment of a new regional art movement. In his manifesto for the School of the South he wrote: "So, if we compare how things are in Uruguay today, with what they used to be, we find an enormous difference. And that is what gives us a different angle on things, it is what creates a different mentality; the Uruguay of today . . . things are on the move."[56] Similar conditions had obtained in Catalonia twenty years earlier, when the new self-consciously regional style known as *Noucentisme* was instituted in Barcelona as part of a drive toward the modernization and industrialization of that backward country. In effect, then, Torres-García was reinventing the notion of a new classicism as an alternative art of the southlands, rooted in ancient indigenous tradition and linked with an optimistic modernization, only this time in terms of Universal Constructivism, Pre-Columbian art, and Pan-Americanism.[57]

But Uruguay's cultural condition failed to support Torres-García's initiatives; the country was still artistically conservative and provincial. To rectify this situation, he

devoted the next few years to refining his system of Universal Constructivism, honing his knowledge of Pre-Columbian art and culture, and proselytizing his ideas. He founded the Asociación de Arte Constructivo (AAC) in 1935 as a platform for his activities, published a book outlining his theories (*Estructura*, 1935), developed a training program based on his philosophy, including his repertory of signs, and on ancient indigenous art, and started the periodical *Círculo y Cuadrado* in 1936, modeled after the aborted one in Paris. He soon gathered around him a group of acolytes and charged them with the mission (inspired by De Stijl ideals as well as notions of Pre-Columbian and medieval art practice) to produce the new art collectively and anonymously and to transform the aesthetic sensibility and physical environment of Montevideo. Later, in 1944, Torres-García would form a working studio (*Taller*) to further this program within a community-based system of intensive pedagogy and collective work. Like the Bauhaus, the Taller Torres-García (TTG) embraced the

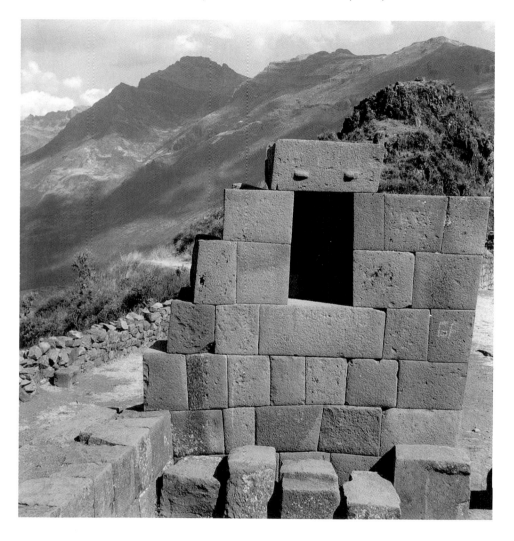

Portion of a wall from Inka mountain fortress, Pisak, Peru. c. 1500

notion of the unification of the arts through architecture and the abolition of the distinction between art and artisanry but, as the Arts and Crafts movement had done, ignored the issue of modern technology. Members executed commissions to decorate public buildings, such as the 1944 murals in the Saint Bois Hospital; created furniture, stained glass, and ceramics, as well as painting and sculpture (all unsigned, except by the master); and published a review called *Removedor* [Paint Remover]. Torres-García also encouraged his disciples to collect and live with Pre-Columbian art and to visit Pre-Columbian sites, though he himself acquired only a few objects and never traveled to Peru.[58]

The heavily francophile and classicizing cultural tradition in Uruguay also did not encourage a revival of Pre-Columbian art. The local Indian population (the Charruas) had never been very large—there was scant material evidence of a pre-Hispanic presence—and had long since been absorbed into the predominantly European society.[59] Torres-García, in any case, was not concerned with actual Indians or their folk art; his neo-Platonic theories about the "natural" condition of Andean artifacts

PAGE 278:
Fragment of poncho with highly stylized feline design, Tiwanaku, Bolivia, 6th–9th century. Wool, tapestry weave, 40¾ × 19⅞". The Metropolitan Museum of Art, The Michael C. Rockefeller Memorial Collection, Bequest of Nelson A. Rockefeller, 1979

PAGE 279:
Joaquín Torres-García. Indo-America. 1941. Oil on animal hide, 39 × 33½". Private Collection, New York

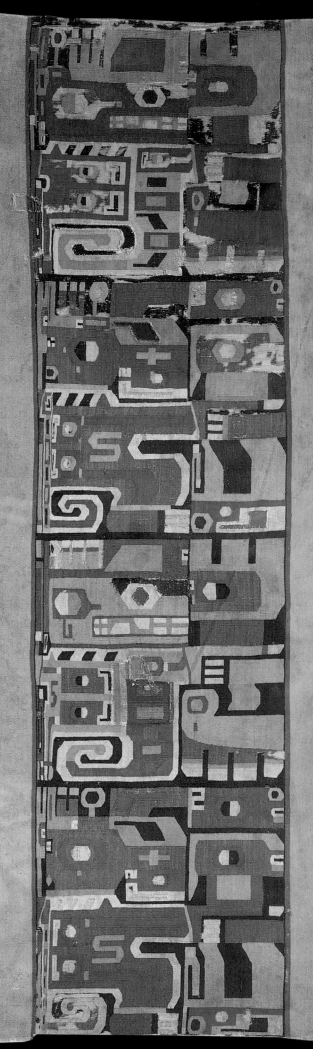

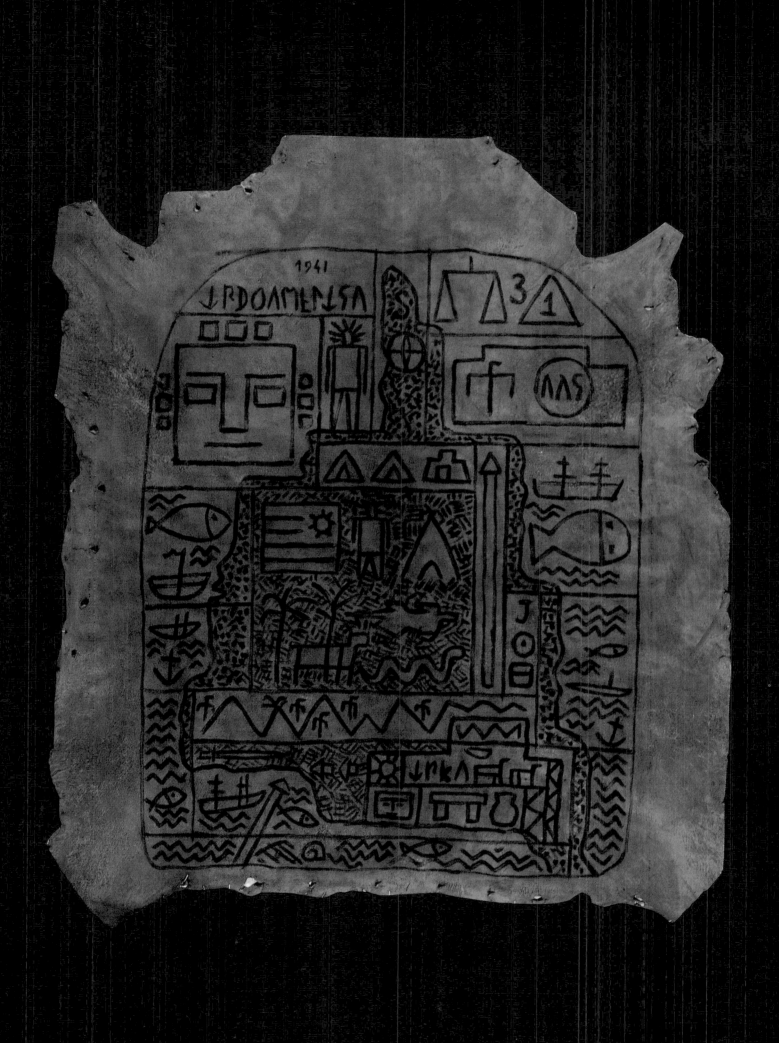

even implied that the ancient Indians who created them were lesser beings. Instead, his interest lay in incorporating indigenous into high art.

However different the perspective and aims of the concurrent indigenous revival in nearby Peru, heartland of the Inka civilization, the archaeological research and exploration it stimulated provided support for Torres-García's efforts. Following his remarkable finds in Paracas, Tello's book *Antiguo Peru: Primera epoca* of 1929 for the first time proclaimed the indigenous origins of ancient Peruvian civilization, locating them in the Chavín culture of the northern highlands (c. 900–200 B.C.), and rebutting Max Uhle's theory of an external, Central American origin. Here was an ancient precedent for Torres-García's idea of creating a homegrown regional art tradition.

The national celebration of the quatrocentenary of the foundation of Spanish Cuzco by Francisco Pizarro in 1534 brought further attention to Peruvian archaeology. Among the first Inka sites to be explored systematically were the megalithic stoneworks of Sacsahuamán, and spectacular altiplano ruins at Kenko, Ollantaytambo, and Pisak (page 277).[60] Further afield, archaeologists made important discoveries from pre-Inkaic periods: stone sculpture and ceramics at the site of Pukara in Bolivia, and a great gold and silver horde at Lambayeque on the north coast. These finds were broadcast in newly established archaeological journals, such as *Wirakocha* and *Revista del Museo Nacional*, and in more popular venues. They arrived on the heels of Max Uhle's 1930 report of his excavations of the Inka holy of holies, the Temple of the Sun in Cuzco, and Hiram Bingham's account of his three expeditions to Machu Picchu, the famous so-called lost city of the Inkas.[61] There can be no question that Torres-García avidly followed these developments in American archaeology; his newspaper clippings of dozens of articles on Machu Picchu, Pisak, Kenko, and other sites have been preserved by his widow.[62]

Torres-García also scoured the ethnographic literature for information about ancient Andean culture. From the colonial-period chronicles of Garcilaso de la Vega, Cieza de Leon, and Felipe Guamán Poma de Ayala (published in Spanish for the first time in 1936) and articles on Inka society, religion, and myth by Tello, Luis Valcarcel, Arthur Posnansky, and other investigators, he extracted certain ideas about Inka social structure and cosmology, which he set forth in *Metafísica de la Prehistoria Indoamericana* (1939).[63] For Torres-García the Inka world was a "natural" model that conformed to the neo-Platonic ideal, and Inka art was the ancient realization of his objectives; they confirmed all his theories and provided a firm basis for them in reality, he said. The three major Inka deities, the Sun (Inti), the Earth (Pachamama), and the remote power who mediates between gods and humans (Wirakocha),[64] corresponded to the Pythagorean trinity of the organic, inorganic, and spiritual light of the universe, or the material, moral, and mental triad that Torres-García upheld in his *The Tradition of Abstract Man* and symbol system. Paintings from these years often feature upended or inverted triangles, the number three, and the words INTI, Pachamama, and Wirakocha, and a series of three sculptures (intended to be shown together) also materialize this mystical trinity. According to Torres-García, this theogony had generated Inka state communalism. It also spawned Inka art and architecture based on geometric principles, which corresponded with the art of the "great constructivist epochs" that Torres-García venerated and, of course, with Universal Constructivism.

Torres-García located the emblem of this perfect integration of Inka religion, social structure, and art in the so-called Intiwatana stones at Pisak, Machu Picchu, and Kenko, prominent gnomons situated on elevated clearings and enclosed by circular walls. Valcarcel characterized the one at Pisak as a solar observatory, explaining that the shadow it projected of the sun in its daily and yearly round could be measured to determine the agricultural calendar, as well as the solstices and equinoxes, and that this had been verified by modern astronomers.[65] Torres-García described the Intiwatana in precisely the same terms but emphasized their function as vehicles for sun worship and crop regulation and their geometric form, and thus their participation in the cosmic, religious, scientific, practical, and aesthetic aspects of the lives of the ancient inhabitants.[66] Inka forms, therefore, accorded with the universal principles of unity that had been shattered by modern materialistic society and could be used as a means of restoring that unity: Torres-García and his followers, through their willpower, could incorporate this art into the great constructivist tradition of the ages, and revindicate it in modern-day South America.

Illustration from a facsimile of the chronicle of Felipe Guamán Poma de Ayala, El Primer Nueva Cronica y Buen Govierno. *16th-century manuscript*

After Thomas Norton. Hermetic Scheme of the Universe. 1749. Engraving. Musaeum Hermeticum, Frankfurt

OPPOSITE:
Joaquín Torres-García. Sculptural Trinity. 1942–44. Painted wood. From left to right: Padre INTI, 1944, 44⅝ × 12⅜"; Pachamana, 1944, 29⅞ × 34⅝"; Idea, 1942, 43¾ × 4⅜". Private Collection, New York

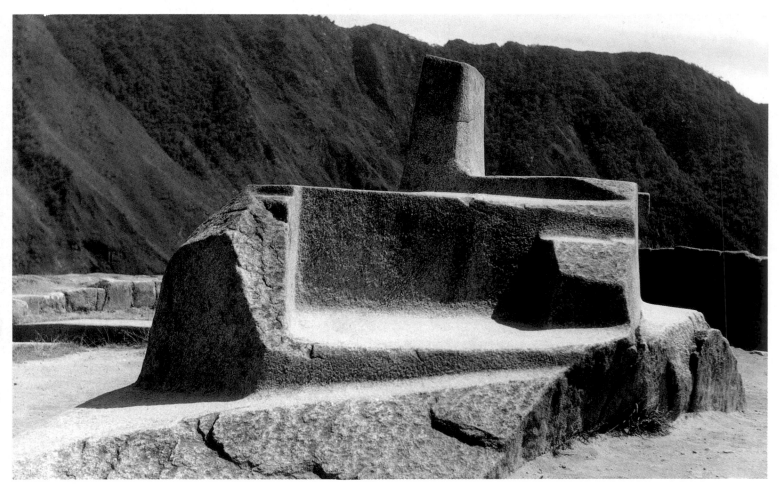

Intiwatana stone, Machu Picchu, Peru. Inka,
c. 1500

Joaquín Torres-García. Cosmic Monument. 1938.
Granite. Rodó Park, Montevideo, Uruguay

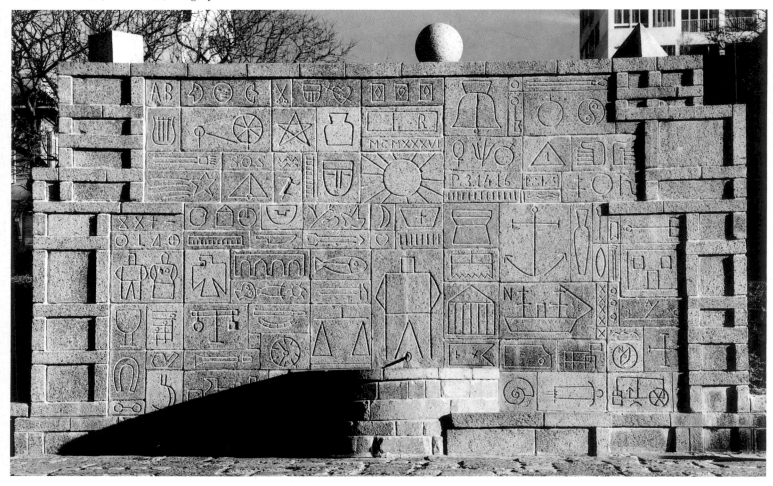

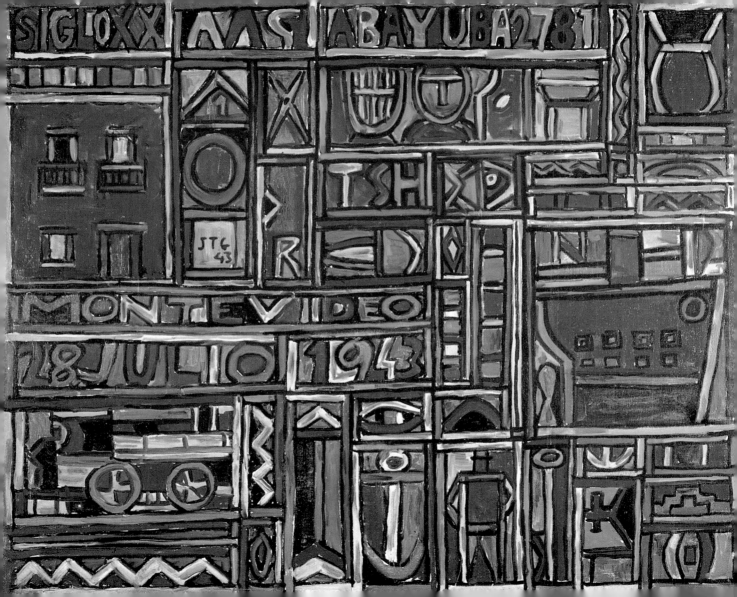

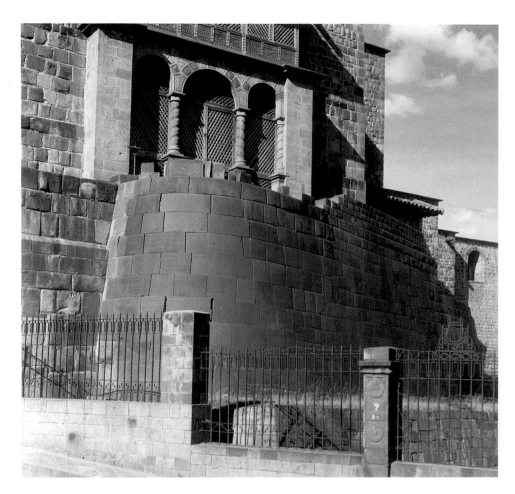

Temple of the Sun (Coricancha), Cuzco, Peru. Inka, c. 1500

It should come as no surprise that the particular notions of the Inka world upon which Torres-García fastened—the state as a utopian socialist entity, the Intiwatana as astronomical observatory, and a Pan-American cultural substratum extending from Tiwanaku to Yucatán—originated in late-nineteenth-century investigations, such as Charles Wiener's *Pérou et Bolivie* (1880), which sought confirmation in the New World of occult theories involving "natural" systems of writing, calendrics, government, and cultural diffusion. Though these concepts continue to exert broad popular appeal today, modern scientific archaeology has rejected them in favor of explanations that characterize the Inka state as totalitarian rather than socialist; the Intiwatana as *usnu* or sacred forms that were manifestations of Inka animistic cults rather than solar observation posts;[67] and the coincidence of traits in widely disparate cultures as independent inventions.

Torres-García's monumental relief in Montevideo's Rodó Park, an incised stone slab framed by ladder-like orthogonal forms, surmounted by solid geometric shapes, and fronted by a curved fountain, marks the apotheosis of Pre-Columbian art in his work. He turned this commission for a public sculpture commemorating an important Uruguayan intellectual figure, José Enrique Rodó, into a monument to the new tradition he meant to establish, using it to communicate his vision of filling the vast spaces of the South American continent with "a big idea," a spiritual message involving Constructivist principles, symbolism, and the resuscitation of an anonymous, collective, native American art.[68] Rodó's widely acclaimed essay, *Ariel*, of 1900, was a conservative appeal to Hispanic Americans to uphold the Spanish humanist tradition, which he traced back to classical antiquity. Torres-García shared his reverence for the Greco-Roman tradition but hoped to incorporate within a conception of South American culture the indigenous Indian legacy that Rodó had ignored.[69]

The Rodó relief represents a deliberate effort on Torres-García's part to root Universal Constructivism within a more archaic native tradition than that of the Inka, in affirmation of Tello's designation of Chavín as the "mother culture" of Peru. In *Metafísica* he attests: "In truth, the most solid and finely worked sculptures are attributed to the pre-Inkaic cultures. It was at that time that the Indian enjoyed full liberty. And that culture was the great Chavín culture, the apogee of the local culture."[70] A flat, champlevé relief from a late phase of Chavín art (c. 400–200 B.C.), known as the Raimondi Stele, can be pinpointed as the major source of Torres-García's

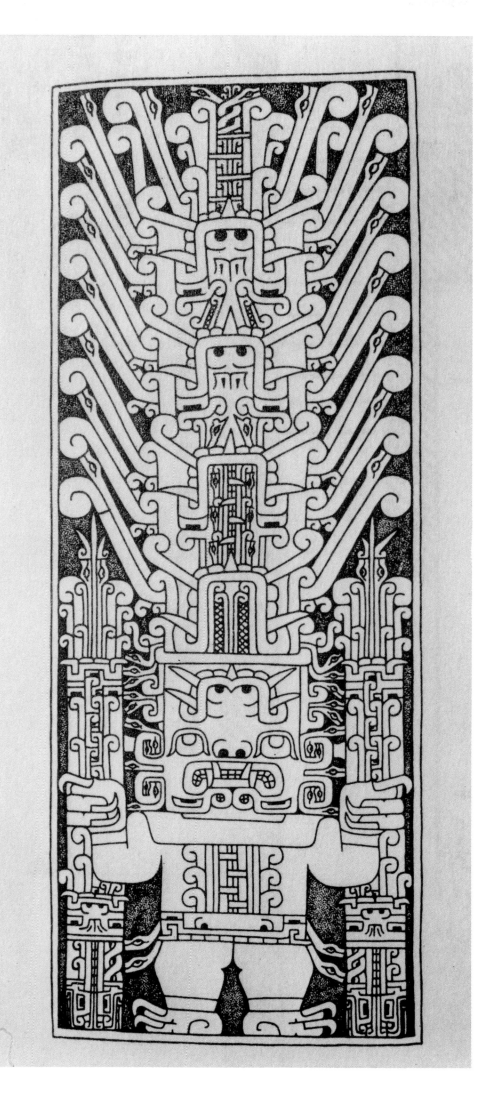

Drawing of the Raimondi Stele. Chavín de Huántar, Peru, 400–200 B.C.

Joaquín Torres-García. Diego Velázquez. 1939. Oil on canvas, 18½ × 13¾". Museo Torres-García, Montevideo, Uruguay

Rodó monument.[71] The central figure, an anthropomorphic, staff-holding jaguar with a very tall headdress, is schematized into a rigidly gridded format determined by the rectangular frame. Its bilaterally symmetrical headdress is a composite of reduplicated and split representations of fangs, eyes, and feathers. The rhythmic juxtaposition and recombination of positive and negative elements create an almost abstract composition, which can be read in different directions. The focal point of Torres-García's own bilaterally symmetrical composition is a sign of the sun with rays set within a comparable system of interrelated signs, which also express an eternal dialogue between the microcosm and macrocosm. In all likelihood, Torres-García had seen Peruvian archaeologist Jorge Meulle's important study of the Raimondi Stele, which drew attention to its identity with the central figure on the Gateway of the Sun at Tiwanaku and suggested that both represented the rayed Sun God.[72]

The Rodó monument also contains a number of references to Inka art and architecture. The rectangular stone facing and the semicircular shape of the fountain in front of the relief recall the smooth coursing and curved wall of the Coricancha (Qorikancha), the great Temple of the Sun in Cuzco. The sundial-like shadow cast by the fountain suggests that of the Intiwatana, while its function as a water source, and its attached bench, evoke Inka *huacas* (wak'a), the hallowed places where religious rites were performed, which often took the form of natural rocks, springs, and seats. Capping everything are the basic Constructivist building blocks—a three-dimensional cube, sphere, and triangle—which are also Pythagorean symbols for truth, perfection, and creative synthesis.

After the failure of his Rodó monument to generate a groundswell of public support for his theories, a disillusioned Torres-García began to come to terms with the fact that his dream of a transcendent art of shared myth and universal language had ceased to be credible. Political events in Europe, including the Spanish Civil War and the rise of fascism in Germany, contributed to this realization. With the appearance in Uruguay of unmistakable signs of economic stagnation and social fragmentation, the utopian dream was also unraveling at home.[73] Abandoning the notion of unifying all the arts under one aesthetic rationality, Torres-García now admitted two different kinds of painting into his lexicon—Universal Constructivism and a form of Synthetic-Cubist figuration—landscapes, still lifes, and portraits grounded in an abstract geometric structure and tonalism, as he explained in his book, *La Recuperación del Objeto*.[74]

In 1939, Torres-García initiated a strange series of portraits of great figures from the European past, concurrently with his Universal Constructivist paintings. The portraits are recognizable but deformed images of famous historical figures such as Raphael, Velázquez, Cézanne, Mozart, Rabelais, and Napoleon, based partly on visual evidence and partly on occult theory.[75] European precedents for these paintings include a late series of portraits of legendary heroes by Velázquez, one of the painters Torres-García most admired. But he also found Pre-Columbian models in the realistic strain of ancient Andean art, most notably Moche portrait jars (see pages 75–76), which he had previously ignored. They depict by means of caricatural exaggeration and distortion the distinctive physiognomies of important chiefs and other notables who lived on the north coast of Peru in c. A.D. 1–700. And they were the subject of much scholarly and popular attention at this time, including Rafael Larco Hoyle's *Los Mochicas* and articles in local newspapers as well as in *Removedor*, the review published by the Taller.[76]

In conclusion, two phases of the master's involvement with Pre-Columbian art can be distinguished, before and after his return to Uruguay in 1934, and in both he embraced it with his characteristic intensity and dedicated study. In Paris Torres-García immediately gravitated to the flat, pictorial southern tradition of ancient Andean forms in its lithic, ceramic, and textile variants, which he deemed a direct, unmediated, and universal means of communication and an embodiment of the neo-Platonic ideal. Upon his return to Montevideo, Torres-García's involvement with Pre-Columbian art became more deliberate and was rationalized as part of the formation of a self-consciously Latin American art. He kept abreast of archaeological developments, studied the ethnological literature, and articulated his ideas about ancient Andean art forms in various writings. In accord with the developing scholarly discourse, Torres-García finally also admitted aspects of the geometricized naturalism of northern Peru into his lexicon of cherished Pre-Columbian forms.

Despite his herculean efforts to create a new synthesis of metaphysics and abstraction with a determinedly Latin American foundation and to extend the influence of "the big idea" by way of his Taller, the complexity of his vision died with him in 1949. Though the Taller continued to operate for a time, it could not survive without his presiding genius and, after several years of diminished activity, closed its doors in 1963. Many of the artist's followers, including his two painter sons, Augusto and Horacio, reached the conclusion that metaphysics and abstraction could not be fused and that Universal Constructivism was a unique, untransmissible style, and they went their separate aesthetic ways. The geometric abstraction he inspired in later generations of South American artists was, after all, only one aspect of Universal Constructivism and one facet of his genius. Even so, it was firmly imprinted with the aesthetic values of the ancient indigenous past. His attempts to draw a full range of philosophic, social, and aesthetic formulas from the ancient Andean art and culture he so revered were the most ambitious and wide-ranging made by any twentieth-century artist.

NOTES

1. In the absence of a catalogue raisonné of Torres-García's work, an evaluation of his production is a difficult task. The first serious English-language treatment of the artist was a catalogue by Daniel Robbins, *Joaquín Torres-García: 1874–1949* (The Solomon R. Guggenheim Museum, New York, 1970), which presented a comprehensive picture of Torres-García's paintings, toys, wooden reliefs, and sculptures. Barbara Duncan and Susan Bradford's *Joaquín Torres-García 1874–1949: Chronology and Catalogue of the Family Collection* (Austin, 1974) is a carefully documented presentation of Torres-García's life and work. The most instructive source to date is Margit Rowell's catalogue essay, "Order and Symbol: the European and American Sources of Torres-García's Constructivism," in Hayward Gallery, *Torres-García: Grid-pattern-sign* (London, 1985). However, Rowell omits a good deal of Torres-García's production from consideration and downplays the content of his art in order to lend it a formal coherence it does not actually possess. Her discussion of the influence of Pre-Columbian art on the artist is intelligent but superficial. More recently, another catalogue by Holliday T. Day et al., *Art of the Fantastic: Latin America, 1920–1987* (Indianapolis, 1987), contains useful but brief essays on Torres-García and provides a context for his work.

Among Spanish-language sources Enric Jardi's *Torres-García* (Barcelona, 1974) (trans. by Kenneth Lyons) is especially good on the artist's early years, and Mario H. Gradowczyk's *Joaquín Torres-García* (Buenos Aires, 1985) is important for its examination of Torres-García's symbolism. While not exclusively about Torres-García, César Paternosto's *Piedra abstracta* (Mexico and Buenos Aires, 1989) is the first book to offer an in-depth consideration of the impact of Inka architecture on his work.

2. Torres-García was born in July 1874 in Montevideo to a Catalan father and Uruguayan mother. During his youth the port city of Montevideo was a prosperous cosmopolitan center with a francophile culture. However, in 1891, a recession generated by a beef-market crisis prompted his father, a proprietor of a general store with a carpentry shop and lumber yard, to return to his native Catalonia. Settling at first in a village near Barcelona, Torres-García senior joined his brother's cording business and then moved to the Catalan capital, where he was employed as a furniture maker. Young Torres-García soon began a course of study in the Barcelona Academy of Fine Arts and the Baixas Academy.

3. See Hayward Gallery, *Homage to Barcelona, The City and Its Art, 1888–1936* (London, 1985-86), for a documentation of the artistic revival and regionalist stirrings permeating the city at this time.

4. Between 1896 and 1901 Torres-García worked mainly as a graphic designer, illustrating vignettes for periodicals, broadsheets, and posters in the style of Lautrec, Steinlen, Mucha, and Ramón Casas. As a member since 1893 of a conservative Catholic artists association modeled after a medieval guild, the Circle of San Lluc, he had learned about Platonic philosophy and made important social contacts, including artists in the circle of Picasso and Sunyer at the Quatre Gats café, and the architect Antonio Gaudí, who hired him to work on stained glass windows for the Sagrada Familia cathedral from 1904 to 1906.

5. Torres-García's important commissions included six great canvases for the chapel of the Holy Sacrament, Church of San Agustí, Barcelona, and fresco cycles for the Church of the Divine Shepherdess in Sarria and the Council Chamber in Barcelona. In 1910 he also decorated the ceiling of the Uruguayan Pavilion at the Universal Exposition in Brussels.

Many of these early murals have been destroyed or overpainted. Other lamentable losses of the artist's work include late mural paintings destroyed in a fire at the Museo de Arte Moderno, Río de Janeiro, in 1978. Fortunately, Torres-García was a most prolific artist.

6. This huge commission to decorate the Salon of San Jordi in the Town Hall called for frescoes representing a golden pastoral age and life and death cycles, as well as stained glass windows like those Torres-García had created for Gaudí. In preparation, Torres-García traveled to Italy and Switzerland on a stipend to study fresco techniques. He executed the murals between 1913 and 1917 but never completed them; his commission was revoked as a result of negative official response and a volatile political climate. Overpainted in 1925, the murals have recently been restored and hung in a room in the Palace of "La Generalitat" in Barcelona.

7. His first son, Augusto, was born here, and three other children soon followed. Torres-García gave them all classical names.

8. Jardi, *op. cit.*, p. 42; Hayward Gallery, 1985–86, *op. cit.*, p. 181. The habit of evoking polarities that Torres-García developed in his early polemical writings became a lifelong pattern. The oppositions North/South, Paris/Mediterranean, international/indigenous, city/country, Surrealism/Constructivism, romanticism/rationalism recur in his thinking, even as he strove to reconcile them.

9. Most of his essays are compiled in *Universalismo constructivo*, vols. 1 and 2 (Madrid, 1984). Additional writings include *Historia de mi vida* (Montevideo, 1939), an autobiography covering the years until 1934, various illustrated "artists books"—progenitors of the contemporary kind—and numerous catalogue texts, uncollected articles, and manifestos. Translations of the manifestos "The Southern School" (1935) and *The Tradition of Abstract Man* (1938) have been published, respectively, in Dawn Ades, *Art in Latin America: The Modern Era, 1820–1980* (New Haven and London, 1989), pp. 320–22, and Hayward Gallery, 1985, *op. cit.*, pp. 105–11.

10. During World War I, a number of these vanguard Parisians took refuge in Barcelona (Spain was neutral) and congregated at Dalmau's gallery. Their little colony, including Sonia and Robert Delaunay, Gleizes, Laurencin (Apollinaire's mistress) and Francis Picabia (who shuttled between the Catalan capital, New York, and Zurich), promoted a form of literary and connotational cubism allied to Apollinaire's visual poetry experiments. Picabia published the latter in his "391" magazine (distributed by Dalmau), a Barcelona extension of Stieglitz's experimental "291" in New York. These provincial centers reacted similarly to vanguard aesthetic developments in metropolitan Paris; Dalmau and Stieglitz each organized similar exhibitions of primitive, naive, and contemporary art, featuring Duchamp, Gleizes, and Picabia.

11. Gleizes, who upheld broader, often urban, subject matter and opposed an exclusively formalist approach, was especially well received in his solo show at Dalmau's gallery in 1916.

12. Barradas settled in Barcelona in 1916 after coming in contact with Filippo Marinetti in Milan. He used cubist lines and planes to create equivalents for the energy of machines and the excitement of urban life, calling his painting Vibrationism. In 1917, Torres-García joined forces with Barradas to contribute texts and drawings in this new style to vanguard journals such as *Art Voltaic* and *Un enemic del poble* (March 1917–May 1919), the latter founded by proletarian poet and Vibrationism champion Joan Salvat-Papasseit. See Hayward Gallery, 1985-86, *op. cit.*, pp. 181, 199, and fig. 210.

13. Hayward Gallery, 1985–86, *op. cit.*, p. 199.

14. Torres-García's wife Manolita sympathized with the Bolshevists from this time on, while Torres-García himself remained resolutely apolitical, maintaining that art and politics do not mix. (Personal communication, Cecelia Buzio de Torres-García.) An essay on the Mexican Muralists in *Universalismo constructivo* (*op. cit.*) confirms this insistence on a separation of art and politics.

15. See, for example, *Figura con paisaje de la ciudad* in Jardi, *op. cit.*, fig. 127.

16. Torres-García's annotated copy is still in his family's library in Montevideo. Thanks to Cecelia Buzio de Torres-García, I have had the opportunity to examine this copy. Marginal pencil markings and notes suggest that he was especially interested in Grosse's discussion of ornamental primitive art, particularly geometric patterns (some of which he cut out of the book). He also marked passages defining rhythmic repetition as the unifying principal of aboriginal forms of decoration and passages comparing children's art and the drawings of Eskimos and Australian aboriginals.

17. Torres-García shared his involvement with toys with other modernists in his ken, such as Joan Miró, who collected folkloric toys from Mallorca, and incorporated images of toys in such paintings as *Still Life with Toy Horse* of 1918. Lionel Feininger also made wooden toys for his children, while Picasso and Leger incorporated puppet-like elements in their ballet spectacles, such as *Parade* (which was performed in Barcelona in 1917).

18. He employed a form of mass production in manufacturing them, outlining the forms on multiple blocks of wood, having them cut with a mechanical saw, and then painting the components with the assistance of his wife and children. An attempt to set up an export business fizzled when a partnership formed with a carpenter for this purpose dissolved in a dispute over finances.

19. In the catalogue titled (in Catalan) "Joguines d'art," he wrote: "The child needs to learn to play, thus the toy must exist as an exercise of multiple experiences and activities, discoveries and rewards, consciousness of things and of the self. . . . The toy should be something fantastic . . . but should never be grotesque . . ." (transl. author). Throughout the essay, Torres-García referred to the instinctual nature of the aesthetic impulse, echoing the theories of Grosse and Apollinaire that linked the childlike with the primitive, and art with play, and saw "simple" societies as the lost childhood of a decadent Western civilization.

Torres-García's conception of his toys was curiously similar to that of Hopi and Zuni kachinas, the small, brightly painted, geometrically simplified wooden dolls of supernatural figures and their dancer impersonators that were used by these North American Indians as instructional objects for children. He might have seen reproductions of kachinas in Bureau of American Ethnology publications; other modern artists were certainly conscious of their charms. In his paintings of 1908 Emile Nolde replicated kachinas from the Museum für Völkerkunde in Berlin, and from the 1920s on, Surrealists like Max Ernst and André Breton collected these Indian dolls with fanatic devotion.

20. Cited in Nelly Perazzo, "Constructivism and Geometric Abstraction," in Luis R. Cancel et al., *The Latin American Spirit: Art and Artists in the U.S., 1920–1970* (New York, 1988), p. 107.

Walt Whitman was venerated as the quintessential voice of this dynamic, democratic New World. And the poet's Catalan biographer and translator, C. Montoliu, was Torres-García's friend who was already living in New York. The well-oiled network of vanguard information and exchanges between the two provincial art centers, which was fostered by Dalmau and Alfred Stieglitz, was perhaps an added incentive for the move.

21. There are New York notebooks filled with sketches that seem proto-Pop in their deadpan rendition of commercial household products and domestic services.

22. Rowell, *op. cit.*, p. 9.

23. See Robert Goldwater, *Primitivism in Modern Art* (Cambridge, Mass., and London, 1986), pp. 164, 171.

24. His meager income derived from occasional sales of his wife's jewelry and his toys to the Galleries Lafayette and other department stores.

25. He also executed a series of childlike drawings in 1927, around the time that he began to paint the toys with graphic elements. The exhibition of his own children's drawings at the Dalmau Gallery in Barcelona (December 5–20, 1929) corresponded with this interest.

26. Rowell, *op. cit.*, p. 11; see also pp. 12–13 for a fine account of Neo-Plasticism and the way in which it facilitated Torres-García's swift progression toward his own brand of Constructivism.

27. Essentially, the Golden Section involves the ratio of a divided line or a part to the whole, so that the smaller part is to the larger part as the larger part is to the whole. For a detailed explanation of this principle as applied to painting, see Ramón Favela, *Diego Rivera: The Cubist Years* (Phoenix, 1984), pp. 18–19, and note 32.

According to Augusto Torres-García, Luis Fernandez probably introduced his father to the Golden Section as an aspect of esoteric knowledge of all kinds. On joint visits to medieval churches in Paris, Fernandez would decipher the arcane iconography of the sculptural ornaments and point out the hidden arithmetical laws governing them. See Rowell, *op. cit.*, p. 12.

28. André Breton, Paul Elouard, and Max Ernst were actively collecting primitive and Pre-Columbian art, and Tristan Tzara and Georges Bataille were publishing essays about it. See Tristan Tzara, "A propos de l'art pré-Colombien," *Cahiers d'Art* 4 (1928), pp. 170–72; and Jean Babelon et al., *L'Art précolombien* (Paris, 1928).

29. Musée des Arts Décoratifs, *Les Arts anciens de l'Amérique*, catalogue ed. by Alfred Metraux and Georges Rivière (Paris, 1928). Raoul d'Harcourt, an expert on Peruvian ceramics and textiles (whose personal collection provided most of the show's 260 items from Peru and Bolivia), wrote the introduction.

30. Augusto may have been working on the treasure trove of Nazca ceramics that explorer Paul Berthon collected for the Trocadéro shortly after 1900. See Paul Berthon, *Étude sur le précolombien du Bas Pérou* (Paris, 1911). Nazca material was receiving a great deal of attention from Americanists at this time, for example: A. L. Kroeber and A. Gayton, "The Uhle Pottery Collections from Nazca," *Publications in American Archaeology and Ethnology, University of California* 21, no. 3 (1924) and 24, no. 1 (1927).

31. It received worldwide attention in the press, and special exhibitions for the display of the textiles were organized in Peru and Europe. See Julio Tello, *Antiguo Peru* (Lima, 1929 and 1959), p. 10; William McGovern, *Jungle Paths and Inca Ruins* (New York, 1927); and Jane Dwyer, "Chronology and Iconography of Paracas Style Textiles," in A. Rowe, E. Benson, and A. Schaffer, eds., *The Junius B. Bird Pre-Columbian Textile Conference* (Washington, D.C., 1979), p. 106.

32. César Paternosto, "Escultura incaica y arte constructivo," *Artinf*, no. 46–47, año viii, (June–July 1984), pp. 24–25. See also Paternosto, 1989, *op. cit.*, pp. 169–70; Rowell, *op. cit.*, p. 15; and Ades, *op. cit.*, p. 144.

33. Paternosto, 1989, *op. cit.*, pp. 166–72.

34. Frederick Peterson, *Primitivism and Modern American Art* (Ph.D. dissertation, University of Minnesota, 1961), p. 81 and *passim*.

35. Rowell, *op. cit.*, p. 16.

36. Torres-García, *Historia de mi vida*, *op. cit.*, pp. 268–69, cited in Robbins, *op. cit.*, pp. 22–23.

37. For example, when embroidery was introduced into Paracas textiles, thereby permitting a deviation from this geometric mode, the figures still retain their angularity and are still defined by a series of parallel lines. See Dwyer, *op. cit.*, p. 109.

38. The rope, caliper, awl, sextant, hammer, and ladder are probably associated with childhood memories of his father's cordmaking and carpentry; the big ship, porthole, smokestack, anchor, telescope, helmwheel, chain, and compass with Montevideo's heavy maritime activity. Other signs are from Torres-García's adult experience in the studio—palette, paintbrush, ruler, oil lamp, window, knife, bottle.

39. These appear more frequently in paintings executed after Torres-García's return to Uruguay. They include the letter "N" for North America (when it appears at the bottom of a canvas upside down, it signifies a world upside down), the word "SUD" for south, mystical numbers, e.g., 5 signfying the ideal pentagram, AAC (for Asociación de Arte Constructivo), or TTG (for the Taller Torres-García), along with an invented language with which he signs his name.

40. In the interpretive key, under the sign of a triangle representing the realm of higher reason and creative activity there are mathematical and Pythagorean symbols and instruments for the measurement of time and space, such as a sextant, compass, and ruler; under the sign of a heart representing the realm of human emotions, beliefs, and values, there are oppositional symbols evoking dualities: male/female, sun/moon, active/passive, religious/secular, etc.; and under the sign of a fish representing the earthly environment there are symbols of the animal, mineral, and vegetable world: plants, water, birds, etc.

41. See W.J.T. Mitchell, *Iconology: Image, Text, Ideology* (Chicago and London, 1986), pp. 75–94.

42. Cited in Ades (her translation), *op. cit.*, p. 147.

43. Peterson, *op. cit.*, p. 82.

44. Gradowczyk (*op. cit.*, pp. 54–57) has argued that Torres-García's symbols are a didactic means of furthering a transcendental unity. Otherwise, the literature generally suppresses the artist's mysticism and messianism, presumably in the interest of securing his recognition as a progressive, formalist modernist according to the paradigm adumbrated by art critic Clement Greenberg.

45. Robbins (*op. cit.*, p. 25) and Rowell (*op. cit.*, p. 17) have pointed this out.

46. See Max Uhle, "The Nazca Pottery Of Ancient Peru," *Davenport Academy of Sciences, Proceedings* 13 (1914), pp. 1–16; Eduard Seler, "Die buntbemalten Gefässe von Nasca," *Gesammelte Abhandlungen* 4 (1923), pp. 169–338; Kroeber and Gayton, *op. cit.*; Eugenio Yacoveleff in a series of articles identifying many of the animals, plant forms, and deities on the pots in the journals *Wirakocha* and *Revista del Museo Nacional* (1931 and 1932); and Luis Valcarcel, "El gato de agua, sus representaciones en Pucara y Nazca," *Revista del Museo Nacional* (1932). It is quite possible that Torres-García was familiar with some of these articles.

See also, for a recent explanation of Nazca signs, Richard F. Townsend, "Deciphering the Nazca World: Ceramic Images from Ancient Peru," *Museum Studies of the Chicago Art Institute* 11, no. 2 (Spring 1985), pp. 122–37.

47. Torres-García never acknowledged Klee's importance to his own work, but he did see paintings by Klee in the great Parisian collection of Alphonse Kahn (personal communication, Cecelia Buzio de Torres). And in an article about Pre-Columbian art (*Círculo y Cuadrado*, May 1936) he suggested that Klee's most beautiful creations are comparable to the plastic conceptions of ancient Peruvian painted textiles. Xul Solar (Alejandro Solari), an Argentinian contemporary of Torres-García who also incorporated pictograms and Pre-Columbian mythology in his paintings, has openly avowed Klee's influence.

48. Like Torres-García and Klee, French Surrealist Victor Brauner made use of Pre-Columbian pictograms, not to invent a symbolic sign system but to project psychosexual desires, private obsessions, and personal myths as well as to evoke the supernatural. He modeled his gridded paintings of the 1930s dealing with metamorphosis on Mixtec pictographic codices in which heavily outlined, brightly colored, mythico-historical figures establish a gridlike pattern on the page. He also combined these sources with the aggregated signs of Paracas Necropolis embroideries in his decorative encaustic paintings of the following decades.

49. "Geometry is one thing, humanity is another; their mixture is at once anti-mathematic and anti-human," Hélion declared. Cited in Rowell, *op. cit.*, p. 13.

Colleagues who had also taken a stand against militant abstraction, refusing to be polarized in the Constructivist or Surrealist camps, included Julio Gonzalez and Amédée Ozenfant. And as before, the activities of Torres-García's son Augusto were a bellwether for his father's compelling interests and affiliations. In the late 1920s, Augusto studied drawing with Ozenfant and assisted Gonzalez in his sculpture studio.

50. Rowell (*op. cit.*, p. 14) asserts that Torres-García spent a great deal of time in Madrid at the archaeological museum, where he studied Pre-Columbian and other kinds of prehistoric artifacts from a new, more scientific—ethnographic and anthropological—perspective. Here he developed a more "structured and coherent" theory of art based on cultural and formal evolution, with particular reference to Paleolithic, Neolithic, and Bronze ages, and a special affinity for celtlike female idols from Bronze Age Spain.

51. Among them were articles in archaeological journals by Julio Tello, A. L. Kroeber, A. Gayton, Rebecca Carrion Cachot, and Raoul d'Harcourt, an early connoisseur and collector (most of the Peruvian and Bolivian material in the big 1928 Pre-Columbian exhibition in Paris was his) who wrote the authoritative *Textiles of Ancient Peru and their Techniques*. See, for example, Rebecca Carrion Cachot, "La indumentaria en la antigua cultura de Paracas," *Wirakocha* 1, no. 1 (1931).

52. Cited by Ades, *op. cit.*, pp. 144 and 320, in her translation of Torres-García's 1935 manifesto, "The Southern School."

53. Ades, *op. cit.*, p. 203. José Sabogal was the premier exponent of indigenist painting in Peru at this time, and he had many followers. As a contributor to Mariátegui's journal, he was more interested in cultural than social issues and wrote articles promoting a revival of popular and traditional arts and crafts in Peru.

54. Arthur Whitaker, *The U.S. and the Southern Cone: Argentina, Chile and Uruguay* (Cambridge, Mass., 1976), p. 52.

55. *Ibid.*, pp. 119–20; and Holliday T. Day, "J. Torres-García, 1874–1949," in Day et al., *op. cit.*, pp. 79–80.

56. Ades, *op. cit.*, p. 321.

57. He may even have conceived the germ of these ideas while he was still in Barcelona. In December 1915, after reading *Ariel* (1900) by the Uruguayan José Enrique Rodó, he began a correspondence with the author, in which he declared, "I am a Uruguayan, residing for the past twenty years in this beautiful Mediterranean town. I studied here, I consider this my second country." But, he continued, it was his duty to channel his efforts towards Uruguay. "Our country has progressed a lot in the past twenty years, but I ask myself if there is still something to be done in the art field." (Letter provided by Cecelia Buzio de Torres.) It should be recalled that David Alfaro Siqueiros, whose *Vida americana* (1921) propounded the formation of an art for the New World, was in Barcelona at this time.

58. Among his followers, Francisco Matto acquired an outstanding collection, which is presently housed in a small museum in Montevideo. In the late 1940s a group of Taller members made a pilgrimage to Peru to visit ancient pre-Hispanic sites and collections.

59. An 1835 census showed that out of a population of 128,000, 3,500 were Negroes (mostly slaves), 800 mulattos, 580 Indians, and the rest, 123,000, white. After 1835 the European element increased rapidly with foreign immigration from Italy, Spain, and France. See Whitaker, *op. cit.*, p. 45.

60. These excavations were conducted by Luis Valcarcel, director of the Peruvian National Museum and a prolific popularizer of archaeology. See L. Valcarcel, *Sajsawan redescubierto, y primer informe sobre los trabajos arqueologicos* (1934); *Ancient Peruvian Art* (Lima, 1937); and *The Latest Archaeological Discoveries in Peru* (1938), which was published in the special Discovery series of the National Museum of Lima. Valcarcel also contributed articles to *Círculo y Cuadrado* and Taller Torres-García publications.

61. Max Uhle, "El Templo del Sol de los Incas en Cuzco," *Proceedings of the Twenty-third International Congress of Americanists* (New York, 1930), pp. 291–95; Hiram Bingham, *Machu Picchu, a Citadel of the Incas. Report of the Explorations and Excavations Made in 1911, 1912 and 1915 under the Auspices of Yale University and the National Geographic Society*, Memoirs of the National Geographic Society and Yale University (New Haven, 1930).

62. Thanks to Cecelia Buzio de Torres, I have had the opportunity to peruse this file. It shows that Torres-García was interested in current excavations in Central America at the Maya sites of Copán, Quirigua, and Chichén Itzá, and at Teotihuacán in Mexico, and also, to a lesser extent, in developments in Old World archaeology. There exists, in addition, a preserved file of his photo clippings, which contains many pictures of Pre-Columbian sites and objects.

63. *Metafísica* (Publicaciónes de la Asociación de Arte Constructivo, Montevideo, n.d.) contains numerous citations from authoritative texts, but few are credited and none documented. Exceptions include references to Valcarcel, Posnansky, and one or two other authors. Valcarcel's *Historia de la cultura antigua del Peru*, 2 vols. (Lima, 1943–49) and Posnansky's *El pasado prehispánico del Gran Peru* (La Paz, 1940) summarize their contributions to the literature. Both authors gave credence to the diffusionist notion of an ancient Pan-American cultural substratum.

64. See Torres-García, *Metafísica, op. cit.*, pp. 29–30. Here he calls Inti by the name Pachacamac. Not only was the Inka pantheon trinitarian, but there were three elements (water, earth, and fire), three kingdoms, and the sun and lightning each had three aspects.

65. Luis Valcarcel, "An Almost Unknown Inca Stronghold Now Fully Revealed: The Great Mountain-Citadel of Pisak, with Its Ramparts, Houses, Gardens, and Turreted Forts Overhanging a 1500 ft. Precipice," in *The Latest Archeological Discoveries in Peru*, Discovery series 1 (Lima, 1938), n.p. Oftentimes, Valcarcel compared features of Inka ruins with ancient Egyptian pyramids and sculptures in much the same way that Torres-García does in *Metafísica* and elsewhere.

66. In *Metafísica, op. cit.*, pp. 43ff., Torres-García explained their function as a kind of hitching post for the sun when it reached its zenith in the southern sky, which was also the day of the great new year's sun festival of Inti-Raimi. He concluded that the ancient Peruvians could only have arrived at this great plastic realization if they had possessed geometrical rules and sacred measures, such as the Golden Mean, and that therefore they were great calculators and geometricians.

67. See, for a current explanation of the Intiwatana, Graziano Gasparini and Luise Margolies, *Inca Architecture*, trans. by Patricia J. Lyon (Bloomington, Ind., 1980), pp. 266–67, 271.

68. See Joaquín Torres-García, *Escritos: Selección analítica y prólogo: Juan Flo* (Montevideo, 1974), pp. 128–29, for the artist's statement about the need to make large monuments, like those in Egypt, to fill the great desert and vast spaces of the South American continent: "to fill space with a big idea."

69. See Day et al., *op. cit.*, pp. 78–80.

70. *Metafísica*, p. 25 (trans. author). There was much for Torres-García to admire in the geometrically stylized religious and symbolic art of Chavín, which, as he noted, so closely resembled his own efforts: "The constructive-geometric art based on the law of frontality and on numerical rhythm has a perfect identity with pre-Inkaic (above all with the archaic Chavín culture) and various forms of Indian America, and for that reason can be incorporated within the great tradition." Cited in Zola Díaz Peluffo, *Ideas fundamentales de Torres-García* (Montevideo, 1982), p. 139 (trans. author).

71. The Raimondi Stele is more elaborate and complex than earlier Chavín reliefs, which are characterized by simple frontal or profile silhouettes of men, jaguars, and condors (some of whose body parts are replaced by the fangs, eyes, canines, claws, nostrils, and wings of mythical animals) and modest geometric decorations; ornament proliferates beyond the organic silhouette of the figure, and every body part contains metaphoric substitutions and peripheral complications. See Henri Stierlin, *Art of the Incas and Its Origins* (New York, 1984), pp. 68–76; and George Kubler, *The Art and Architecture of Ancient America* (2d ed., Harmondsworth and Baltimore, 1975), p. 256.

72. Jorge Muelle, "Filogenia de la Estele Raimondi," *Revista del Museo Nacional* 6, no. 1 (1937), pp. 135–50. Muelle's stress on the relationship between the Raimondi Stele and late Nazca ceramic decoration would have interested Torres-García a great deal.

73. Whitaker (*op. cit.*, p. 259) explains this situation in terms of Uruguay's declining economic productivity stemming from a long-term neglect of the agrarian sector and a mounting dependency on the world meat market, as well as an overloaded government payroll.

74. Torres-García, *La recuperación del objeto*, 2 vols. (Montevideo, 1952); and see Torres-García, *Escritos, op. cit.*, pp. 115–17.

75. Their peculiar physiognomies may be the result of an overzealous application of the principle of the Golden Section. It is possible, as Gradowczyk has suggested (*op. cit.*, p. 73), that Torres-García intended his portrait gallery as a means of invoking the spirituality of great men during a parlous time.

76. See Rafael Larco Hoyle, *Los Mochicas*, 2 vols. (Lima, 1938–39). One such *Removedor* article was written by Argentinian archaeologist Antonio Serrano. A clipping of a newspaper article about Moche portrait jars is preserved in a file in the possession of the artist's widow.

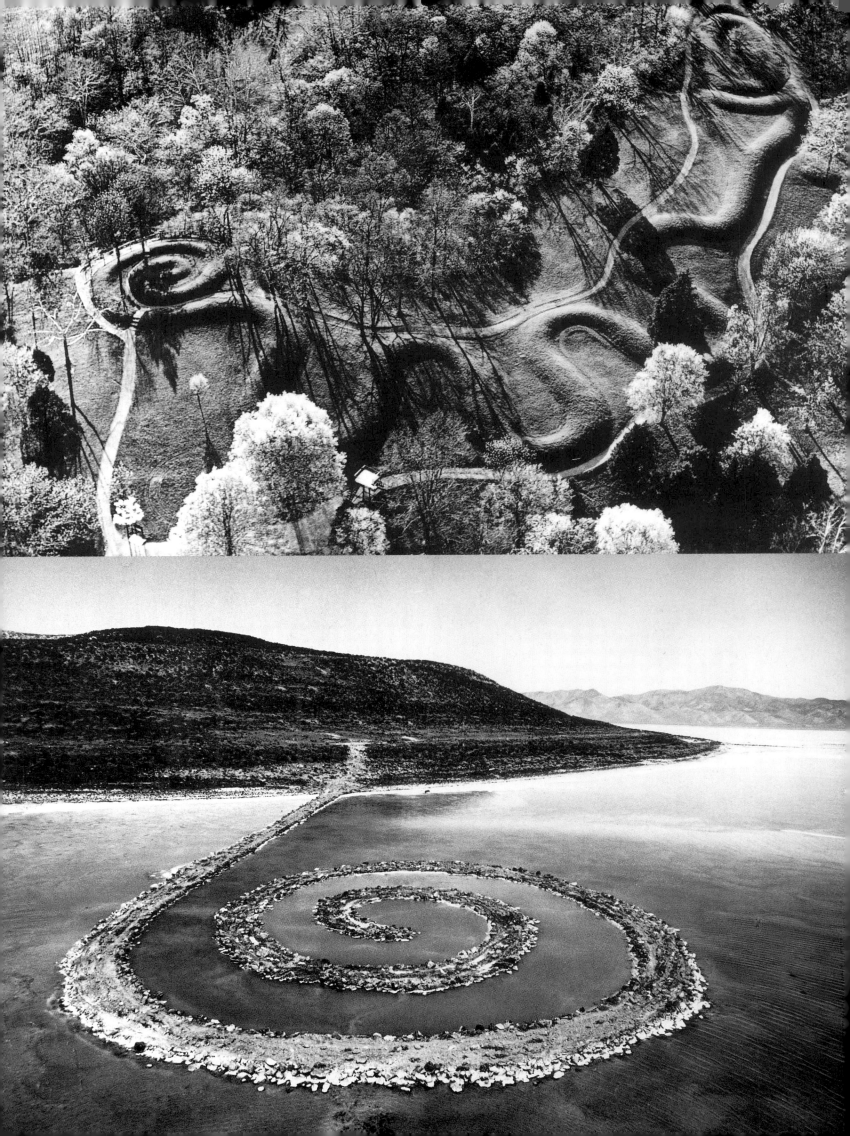

PRE-COLUMBIAN ART AND MODERNISM:
THE SHIFTING GROUND

With the exception of Gauguin, the great precursor of modernist primitivism, the individuals in question, Rivera, Moore, Wright, and Torres-García, produced their most important work during the heyday of modernism in the 1920s and 1930s, in the wake of the radical formal and social democratic experimentation of the early years of the century, and at a time when Pre-Columbian art became generally recognized as aesthetically worthy. They experienced Pre-Columbian art in the same shifting terms with which it has been perceived since Darwin. On the one hand, like all art outside the Western "great tradition," it was seen to be part of the great primitive continuum that included African, Cycladic, Egyptian, archaic Greek, Islamic, even Japanese art. Moreover, its association with cannibalism and human sacrifice aligned it with the supposedly unmediated expression of savages. On the other hand, pre-Hispanic art was viewed as a product of a courtly and statist culture whose densely populated cities, great temples, palaces, and calendrics showed it to belong to a higher rung of civilization.

These artists' assimilation of Pre-Columbiana was just one example of the remarkable receptivity to new currents and the extraordinary powers of creative synthesis that define their genius. They were as well informed about archaeological discoveries in the Americas as they were about vanguard modernist developments, keeping in touch through archaeological reports and magazine and newspaper accounts of expeditions. For the most part, their relationship to the Pre-Columbian sources they appropriated was a distant one. They derived information about ancient American objects indirectly, from book and magazine reproductions and visits to museums, private collections, and universal expositions. At the same time, however, they viewed these decontextualized objects as exemplars or extensions of Pre-Columbian cultures.

Only rarely, however, was their interest in Pre-Columbian forms grounded in an ethnographic knowledge. The great exceptions were, of course, the Latin Americans. Rivera and Torres-García had a special and more immediate relationship to Pre-Columbian culture as a result of living in spatial proximity both to pre-Hispanic remains and, perhaps more significantly, to nationalist revival movements that placed a high value on ancient indigenous civilizations. Rivera's ethnographic knowledge of Pre-Columbian cultures was unsurpassed among these modern artists. Uniquely, he experienced pre-Hispanic art in its original locale on visits to ancient Mexican and Yucatecan ruins, and he maintained a close personal association with the leading archaeologists of his day who were continually refining knowledge about ancient America. Torres-García also kept abreast of archaeological developments, studied the ethnological literature, and articulated his ideas about ancient Andean forms in various writings, most notably in *Metafísica de la Prehistoria Indoamericana*. As an expression of their aesthetic appreciation of ancient American forms, both artists collected them. Torres-García accumulated a small number of Pre-Columbian objects, while Rivera amassed a huge personal collection that he eventually donated to the state.

Gauguin also had a more direct connection with Pre-Columbiana, one that was conditioned by the entwined nature of his life and art. His understanding of ancient Peruvian art resonated with memories of his childhood sojourn in Lima, Peruvian ancestry, and both his mother's and guardian's Pre-Columbian collections. Like Moore and Wright, however, Gauguin was not interested in detailed ethnographic information about Pre-Columbian forms. He derived a meaning for them mainly from popular and sensationalist sources, which traded freely on the West's racist, sexist, mystical, and utopian projections of the primitive.

Whatever the extent of these artists' knowledge of the Pre-Columbian world, their appropriation of its material culture was conditioned by the universalist credo and collagist techniques of modernism. Their method was uniformly one of bricolage: culling and combining a variety of pre-Hispanic styles and motifs, piecing together fragments of forms and myths, irrespective of cultural or ethnic boundaries, and creatively adapting them to their own aesthetic strategies. Intent on making something new out of these borrowed designs, they were unconcerned with historical accuracy, even when leaning heavily on archaeological data. Rivera, for example, conflated the

regional aesthetic traditions of Pre-Columbian civilization, mixing West Mexican, Veracruz, Aztec, and even Maya styles in his murals depicting Pre-Columbian life. Their art is something that lives in the imagination rather than in historical fact.

THE SPELL OF PRIMITIVISM

To a greater or lesser extent, each of these artists, Gauguin, Rivera, Wright, Moore, and Torres-García, felt alienated from himself and from the dominant culture of his respective country and fastened on primitive and Pre-Columbian art as a means of critiquing or halting the fragmentation and social dislocations of the postindustrial world. In this sense, the Pre-Columbian was synonymous with the primitive, representing the original or natural state preceding the corruptions of civilization— innocent of repressed sexuality, distorted economic life, sanctimonious religious beliefs, human estrangement from nature—and also a projection of a more desirable future. Art had the power to set troubled matters in the world aright, they believed, and the artist was capable of reconstituting a lost unity in culture by changing and revitalizing art and the times.[1] (Once their reputations were secure, however, these artists invariably moved from seeing primitivism as a means of challenging traditional values to a position of upholding them.) Thus, many of the ideas these artists located in Pre-Columbian forms cannot be differentiated from the generalized primitivism of the period, which involved a yearning for and fear of the repressed areas—sexuality, violence, death—of an overly rationalized Western culture, as well as spiritual questions centering on the primordial relationship of human beings to nature, the life cycle, and the cosmos. Through the Pre-Columbian primitive these men enacted dramas of selfhood, consciousness, sexuality, and the path of civilization, each finding in it what they were looking for, while often framing it in terms of a traditional dualism.[2]

Gauguin's primitivizing paved the way for the others in myriad ways. It included, besides his appropriation of primitive forms, his idealization of primitive lifeways, fascination with primitive myths and languages, attention to colonial adventure literature, such as Alphonse Pinart's many articles on his New World travels, and an embrace of diffusionist explanations for the coincidence of traits in far-flung primitive cultures. However, his association of the female and the exotic primitive with sexuality, procreation, and death was especially seminal. Many of the themes and preoccupations of the Tahitian and Marquesan years found preliminary expression in his little-known ceramics. Inspired by a style of ancient Peruvian (Moche) pottery whose iconography is saturated with sex and death, they amplified this imagery to express personal obsessions with dangerous sexual impulses that violated rigid Western norms. In many ceramics, wood sculptures, and prints of the late 1880s a woman is the specter of lover and mother at the same time, visualized as seductive and deadly, generative and maternal. In his Parisian work she is a dangerous white woman intertwined with a wild beast, often a serpent or swan; in the tropics she is dark skinned, submissive, and compliant, a metaphor for luxuriant nature. Gauguin's testamentary painting *Where Do We Come From? What Are We? Where Are We Going?* summarizes many of these ideas.

Rivera followed Gauguin closely in his relation to the Pre-Columbian as primitive, adding a Mexican nativist and Marxist polemical spin to a more generalized primitivism. His Symbolist evocation of the mysteries of female sexuality in the chapel of the agricultural college at Chapingo, for example, uses women to represent the life cycle—fertility, gestation, birth—on one wall, and equates this with the stages of the Mexican peasant revolution on the opposite wall. The culminating image in the chapel's apse fuses both in the form of a swarthy and voluptuous yet sturdy and proud reclining female (his pregnant wife, Lupe) as the personification of nature and the primitive native race. In another Gauguinesque early mural in the Secretaría, Rivera portrayed an Edenic early stage of Mexico's history as a luxuriant jungle landscape peopled by compliant nude females attending an exotic icon, substituting for a Tahitian god a famous statue of Xochipilli, the Aztec flower deity.

Like Gauguin in his mummy-inspired and wraithlike images of females, Rivera attached enormous importance to the idea of death in the Pre-Columbian primitive, consistently linking it with the female. On the basis of the Aztec myth of the sun god

who dies in a sexual encounter or in battle and is reborn, he located the notion of death and transformation as the central metaphor in Mexican culture, and in his later murals he incorporated the image of the Aztec earth goddess Coatlicue as the personification of this idea. For Rivera, the Aztec conception of transformative death was a correlative of the Marxist ideology of a transformative politics.

For Moore as well, the Pre-Columbian offered a fascination with baser instincts and psychic energies as a way of countering Western hyperrationality. It assumed a complicated gender subtext in which the female and the primitive are perceived as attractive and dangerous Others. He employed a fiercely masculinist rhetoric—evoking potency, hardness, sharpness—in addressing the subject of pre-Hispanic art at the same time as he consistently translated male-gendered pre-Hispanic images into females. Thus the Aztec image of a seated man who becomes in his hands a woman giving birth and the Toltec chacmool whom he transformed into a recumbent female express adoration and fury toward the maternal figure who is made available to the male gaze with its erotic potential and capacity to violate.

As a paradigm of the modernist preoccupation with the question of play that was usually bracketed with the primitive, the Pre-Columbian ball game captivated Rivera, Moore, Giacometti, and many Surrealists. Their interest in the ball game was both formal and conceptual, encompassing the shapes of enigmatic stone sculptures associated with the game—yokes, *hachas*, *palmas*—as well as notions of the game as a contest between life and death and a metaphor for the play of cosmic forces and the celestial round. Rivera imaginatively recreated the game in his illustrations for the *Popol Vuh*, the Maya Quiché epic in which hero twins play ball against the lords of the underworld. The severed limbs and ball-like forms of Moore's abstract sculptures of the early 1930s depend heavily on Giacometti's metaphorical "gameboard" pieces that self-consciously evoke Georges Bataille's interpretation of the ball game, stressing the erotic and sado-masochistic aspects of the ritual: the ball bouncing off players' buttocks and human dismemberment. Moore also appropriated the flat, axe-shaped forms of *hachas* in various Heads of the late thirties. Even Frank Lloyd Wright looked to the ball game to the extent that he often imitated the pillared porch and inverted serpent columns on the Upper Temple of the Jaguars overlooking the great ball court at Chichén Itzá.

THE SEARCH FOR ROOTS

The search for origins as a means of resolving personal, artistic, social, and political problems led to Pre-Columbian as often as to other primitivist models. Peripatetic and culturally estranged during much of their adult lives, Gauguin and Torres-García invested the Pre-Columbian with a nostalgic yearning for their childhood origins in Latin America, using the metaphor of finding a home as a structuring pattern within primitivism.[3] Gauguin's quest for primitive settings led him to Central America, which became the first tropical landscape to engage his senses and creative imagination. Later, when he moved to Tahiti, he imagined that he was recovering his childhood roots in the Pacific rim, just as Torres-García returned to the landscape of his youth in Uruguay to promote a Universal Constructivism that was grounded in ancient Peruvian form and meaning. Wright was another uprooted youth who experienced a condition of exile throughout much of his adult life. Although he never ventured to primitive locales, he immersed himself from an early age in books about remote and exotic times and places—the medieval period, ancient Egyptian and Pre-Columbian civilizations.

Gauguin, Torres-García, and Wright sought artistic solutions in a return to first principles and primordial structures in the Pre-Columbian primitive. Gauguin examined Maya hieroglyphic inscriptions as a key to an originary, natural language. In much the same way, Torres-García studied Nazca iconography as a basis for his signature ideographic system. In his case, however, the quasi-alchemical development of a new visual language was also related to a search for a new, decolonized identity for South America.[4] Torres-García's and Wright's involvement with progressive education, children's toys, and the basic shapes and volumes of geometry—triangles, squares, circles—corresponded with their efforts to find a primordial visual structure in ancient American forms. While Torres-García articulated his project in terms of both

universalist fundamentals of form and nativist structures, Wright's rhetoric suppressed the latter in favor of the former.

The Pre-Columbian primitive offered the possibility of a radically different, unalienated world in which human beings, nature, and the cosmos were fully integrated.[5] Gauguin had idealized preindustrial peasants and dreamed of a utopian community of like-minded artists in the tropics. Rivera identified strongly with Mexican Indian peasants and their popular arts, which he believed to be derived from ancient indigenous forms, and he strove to adopt the new Mexican art to the old. Torres-García hoped to resurrect pre-Hispanic arts and crafts practices and traditions in his Taller Torres-García, but unlike Rivera, he was not interested in the popular arts of South American Indians (who were, in any case, extinct in Uruguay) and wanted to incorporate Pre-Columbian art into the Western high-art canon.

The longing for a return to a primitive, unalienated collectivity echoed in these artists' efforts to extend their art into a total environment as well as in their attempts to revive ancient craft traditions, both a legacy of Arts and Crafts movement theories. Inspired by Pre-Columbian and other primitive models, Gauguin ornamented the interior and exterior of his studios and houses with wood carvings, hand-modeled pottery, embroidered textiles, and murals; Rivera designed wood carvings, the interiors and exteriors of buildings, and architectural sculpture; Torres-García hand-decorated his studio and home, made frames for his paintings, wooden constructions, furniture, ceramics, stained glass, and decorative murals; Wright presided over the ornamental detailing and even designed the furnishings of many of his buildings; and Moore, insisting on "truth to materials," experimented with the expressive possibilities of many different kinds of stone and wood.

In the context of Latin American indigenist revivals and social transformations, Rivera and Torres-García found an alternative model for a new social order in the preindustrial communalism of ancient America, respectively envisioning a restored Aztec empire based on an ancient agrarian communism in Mexico and a reconstituted socialist Inka polity in Uruguay. They also invested ancient American myths explaining the creation and destruction of the cosmos with new meanings to support the remaking of the Mexican and Uruguayan social orders. Like them, Wright was preoccupied with myths of primitive origins and apocalyptic destructions, which he also linked to an alternative vision of the United States—one that would restore the body and self to a relation of full and easy harmony with nature and the cosmos—which he articulated in his unrealized project for Broadacre City. Paradoxically, however, while these artists all yearned for an idealized harmonious and equitable primitive existence, they also insisted on the supremacy of the creative individual and invariably reprocessed the primitive Other as a sign and symbol of the self, thereby ultimately reaffirming the very conditions they sought to deny.

THE SIGNIFICANCE OF THE GRID

Striving to achieve an underlying unity in the structure of their work, Torres-García, Wright, Moore, and, to a certain extent, Rivera revealed a distinctively Pre-Columbian kind of primitivism, in which form was a determining factor in their advocacy of native American over other primitive models. Following on the heels of the radical formal experimentation of the prewar years, each of these artists adhered to a gridded form that was promoted by Cubism and adapted by many vanguard modernist artists as an emblem of aesthetic purity, origins, and autonomy.[6] In arriving at a unified geometric structure, they focused on the geometric abstraction inherent in Pre-Columbian tectonic forms—pyramids, squares, grecas, stepped frets—which was seen as ancient confirmation of and model for a modernist gridded form. The artifacts that most appealed to them derived from an assortment of ancient American cultures, which, though widely separated in time and space, nevertheless uniformly encompassed an architectonic discipline and reductive geometric form, especially Mexican highland monumental sculpture and architecture, Yucatecan Maya (Puuc) and Mixtec buildings, and the woven textiles and Inka walls of the southern Peruvian highlands.

Moore related primarily to the ancient stone-carving tradition of the Mexican

highlands, which he located in the severe, angular, rough-hewn volcanic stone monuments of the Aztec, Toltec, Teotihuacán, Mezcala, and Olmec cultures (and interpreted as an expression of masculine values). He distilled from the art of these disparate cultures certain shared basic formal traits, which give them a broad stylistic unity: blocklike form, smooth unadorned planes, rhythmic equilibrium, and hard stone materials. The sculptor's semiabstract carved animals, masks, and seated and reclining figures, which conventionalize naturalistic forms into a cubic geometric structure, are profoundly indebted to these sources, as are such signature traits of his sculpture as the twisted, upright head of every reclining figure that ultimately derives from the Toltec-Maya chacmool. While continuing to adhere to a Pre-Columbian-inspired blocky format in his later work, Moore also discovered in the art of ancient Veracruz, Guatemala, and West Mexico the means to enliven his figures through textural effects, perforations, exaggerated gestures, and anatomical distortions. Ever the eclectic researcher, he also uncovered new formal models in ancient Peruvian monoliths, metalwork, and ceramics.

Wright's interest in Pre-Columbian forms encompassed the Mexican and the Maya. The ornamental systems of a number of his projects of the 1910s and 1920s pay homage to the geometricized architectural decoration of highland Mexico, revealing his intense appreciation of its rigorous and complex manipulation of shapes and patterns abstracted from nature. His Los Angeles houses freely combine and fully exploit the geometric mosaic facades, blocky masses, and reticulated profiles of Mixtec and Puuc Maya temples and palaces to arrive at cubically compact structures, dramatically pierced and patterned concrete-block construction, and a close association between building and site. During this period Wright also turned to Petén Maya narrative reliefs as a model for integrating geometricized figural and symbolic forms into an organically unified architectonic whole. Maya architecture and planning also supplied him with interesting formal solutions to problems of massing, roofing, interior and exterior spacing, sequencing, and decoration (as well as romantic landscaping effects).

Wright consistently turned to pre-Hispanic architecture for ideas for his most innovative and visionary designs. In these often unrealized projects, he articulated his idea of the landscape of the future by fusing stylizations of ancient geometric structures and a faith in new technology and materials. The Guggenheim Museum was one of these successful efforts. Some of his later projects, such as Taliesin West, evoke facets of a Pre-Columbian building tradition he had not previously explored: the rough-hewn stone surfaces, strong, sweeping lines, low-lying forms, and *talud-tablero* walls of Teotihuacán, Zapotec, and especially Aztec architecture of the Mexican highlands.

Torres-García gravitated to the flat, schematic, pictorial tradition of southern Peruvian art in its lithic, ceramic, and textile variants. His gridded drawings, wooden reliefs, and Constructivist paintings of the late 1920s contain references to ancient Andean architectonic forms, including the Gate of the Sun at Tiwanaku and the textiles that ultimately determined their strict geometry, which he interpreted as primordial visual structures ratifying Mondrian's Neo-Plasticism. In an effort to fuse metaphysics, symbolic figuration, and visual abstraction, Torres-García arrived at his signature style, Universal Constructivism, by incorporating pictographs modeled after the sign system of Nazca ceramics within a gridded structure.

After his return to Uruguay, as part of the formation of a self-consciously Latin American art, Torres-García made a deliberate effort to root Universal Constructivism in the tectonic forms of the Inka and more archaic Chavín; his culminating visual statement, a gridded, symbol-laden relief in Montevideo's Rodó Park, was modeled after major monuments of both cultures. Finally, after recognizing that his dream of a universally shared symbolic abstract language could not be realized, Torres-García admitted representation back into his art and along with it an appreciation of the geometricized naturalism of ancient Peru. He modeled his strange, realistic late portraits of historical figures on the same Moche portrait vessels that Gauguin had appropriated in his self-portrait jars.

Rivera had repudiated modernist abstraction in favor of a realism that could be understood by the masses, but he organized his mural compositions on the basis of an abstract geometric structure of interlocking, cubically flattened volumetric forms, and a shallow, tightly controlled space deriving from Synthetic Cubism. His major Pre-Columbian models accommodate this design scheme; they are the tight, hard, plastic

forms of Aztec and West Mexican sculptures, whose (angular or rounded) geometric stylization Moore also admired and imitated. The caricatural aspects of Jalisco, Colima, and Nayarit terra-cotta figures—their anatomical distortions, schematic sharpness, exaggerated postures, and playful inventiveness—particularly appealed to Rivera as expressive devices for his paintings, in much the same way that Moche ceramic sculptures had served Gauguin and Torres-García.

The one major pre-Hispanic art tradition these artists consistently ignored was, curiously, the most highly esteemed in the West: the Classic Maya style of the lowland rainforests of southern Mexico and northern Guatemala, characterized by the florid curvilinear decoration of monumental architectural sculpture, small jades, and painted pottery. They rejected this ornate, predominantly narrative art of elegant, extravagantly voluted reliefs and refined calligraphic lines because it was at odds with the self-contained and self-referential geometry of the grid and because it was too visually similar to some of the forms favored by the discredited Western classical tradition. In Rivera's case, elevating Mexican over Maya forms was also a means of ratifying the nationalistic and anticolonialist imperatives of the Mexican Renaissance. Despite its neglect by these modernists, however, this elegant Maya scrollwork style was resurrected as ornamentation applied to everything from skyscraper facades and lobbies to fixtures in the Maya Revival decorative art style, which in many ways continued the Art Nouveau aesthetic.

The appropriation of the tectonic strain of pre-Hispanic art was nearly always accompanied by a mystical construction of Pre-Columbian culture. As Rosalind Krauss points out, the grid for many artists was the staircase to the Universal—to Being, Mind, Spirit—to the spiritual.[7] This was particularly applicable to visionary artists like Torres-García and Wright, who used modular geometry as a specific discipline and figural-symbolic decoration to express metaphysical notions. They experienced elemental geometric forms as the incarnation of a Platonic or divine numerical order, whose mysterious "spell power," in Wright's words, could be harnessed to transform society.

Wright believed that the conventionalized natural forms in Japanese and other "primitive" art embodied both a geometric structure and symbolic meaning and harmonized perfectly with their social, political, and physical environment. Modern civilization had to find an equivalent, he felt, and the great artist who could find the forms of an indigenous American art would lead the way to a revitalized society.[8] For Torres-García the Inka world was a "natural" model that conformed to the neo-Platonic ideal, and Inka art was the ancient realization of his own objectives: Its forms accorded with the universal principles of unity—the Pythagorean trinity of the organic, inorganic, and spiritual light of the universe—that had been shattered by materialistic society and could be used as a means of restoring that unity. Even a determined materialist like Rivera did not entirely escape this mystification of pre-Hispanic geometric form: He found the Golden Section in many Teotihuacán artifacts and Pythagorean proportions in other indigenous forms, imbuing them with a kind of mystical vitalism.

Numerous esoteric investigations of Pre-Columbian civilization in the nineteenth century supported the idealist notion that the geometrical forms of ancient America were intensifications of organic models. Charles Wiener's *Pérou et Bolivie*, for example, sought confirmation in the New World of occult theories involving "natural" writing systems, calendrics, government, and cultural diffusion involving notions of lost civilizations and sunken continents. This occult lore focused especially on the inexplicable achievements of the Maya: hieroglyphic writing, numeration, calendrics, and astronomy (manifested in cosmically aligned pyramids). During the socially turbulent 1920s and 1930s Augustus Le Plongeon's and James Churchward's popular treatments of the sacred mysteries of the Maya dovetailed neatly with the worldview of the many mystical cults and secret societies that had gained wide currency.[9] Rosicrucianism, Mormonism, Freemasonry, Georgi Gurdjieff's Institute for the Harmonious Development of Man, to name a few, promoted theosophical thinking embedded in Pythagorean number mysticism and viewed the Maya obsession with numeration as a materialization of divine numerical laws.

Astonishingly, these mystical constructions of Pre-Columbiana continue to be entirely credible to many intelligent people. They surfaced recently in the bestselling

books of Erich Von Daniken, such as *Chariots of the Gods?*,[10] which explained the Nazca lines etched in the Peruvian desert and other apparently extraordinary achievements of Pre-Columbian civilization as the handiwork of aliens from outer space, and just a few years ago in José Arguelles's prediction of an apocalyptic "harmonic convergence" in 1989, based on his interpretation of the calendrical reckonings of the Maya. The breadth and depth of this reponse to Pre-Columbiana surely has to do with questions that have been posed since the first Western encounter with the Aztecs at the time of the Conquest about the origins and nature of New World civilizations, which have proven so disruptive to religious and social Darwinist orthodoxies. They are inevitably linked with the search for answers to the imponderables of life and the ineffable. Thus, despite the fact that scientific social theory and archaeology have succeeded in discrediting or dismissing many of the more fantastical explanations of Pre-Columbian culture, the romantic aura of the mysterious, magical, and otherworldly always attaches to its material remains. Together with tectonic form, these mystical and mythic dimensions are distinguishing features of the popular and aesthetic reception of Pre-Columbian art and archaeology in the West.

THE PRE-COLUMBIAN AS A STATIST CULTURE

The Pre-Columbian architectonic forms celebrated by twentieth-century artists as confirming the modernist grid also served to confirm Pre-Columbian civilization in the status of embryonic high culture. It is recognized that the Pre-Columbian universe encompassed many relatively simple sociocultural entities ("chiefdoms," "tribes") of an uncontestable antiquity and religious nature (that produced small-scale sculptures, ceramics, and metallurgy of considerable aesthetic interest). Nevertheless, statehood and civilization are popularly associated with Pre-Columbian art in the West not only because of the presence of writing and calendrics but especially because of the monumental public works and imposing architectural and sculptural ruins primarily identified with the large-scale, complex, stratified societies of the Maya, Toltec, and Aztec in Mesoamerica and the Inka in Peru.[11]

This association of Pre-Columbian civilization with statism had artistic and political ramifications. Its high-culture status and alignment with civilized societies made Pre-Columbiana spiritually attractive to artists like Moore, Wright, Torres-García, and Rivera, who were equally receptive to the transcendental religious beliefs, Victorian moralizing, and hierarchical evolutionary classifications of the nineteenth century and to the secular ideology and relativist anthropology of twentieth-century science. It also appealed to the traditionalist and conservative aesthetic tendencies of each of these artists, who were still tied to the Greco-Roman classical tradition of the academies in which they had been trained. Their (often hidden) disposition to classical form also prompted them to turn to Renaissance sources in conjunction with Pre-Columbian models, even while they loudly repudiated Neoclassical and Beaux Arts artistic conventions.

Wright's use of pre-Hispanic sources rarely extended to the composition of the interior spaces or floor plans of his houses, which he based on different, often more conventional, sources. The Maya-inspired Barnsdall House, for example, adheres to the traditional cruciform plan. After a trip to Italy early in his career, Moore's conflicting loyalties to both the classical ideal and Pre-Columbian orthogonal forms paralyzed for a time his will to work; he was able to resolve this conflict and resume work by honoring both traditions in his sculpture. Rivera assiduously studied the murals of Giotto, Uccello, Piero, and Michelangelo in Italy before returning home to participate in the Mexican Renaissance, and he modeled his application of pre-Hispanic forms to further the Revolution after their use of classical myth, realism, and humanism to evoke pride in the ancient Italian past. Like Moore, Rivera transformed Aztec-inspired figures into semiabstract terms, inserting them into visual systems inspired by both Neoclassical and Cubist spatial systems. Torres-García's affinity for order, balance, and proportion was evident in his classicizing allegorical murals in Barcelona as much as in the Neo-Plastic scaffolding of his later work. He always maintained a reverence for the Greco-Roman and humanist tradition and hoped to incorporate within a conception of South American art an indigenous Indian legacy and the classical heritage. In this sense,

therefore, Pre-Columbian architectonic form was double-edged; it equally confirmed the Cubist grid and the classical order of the Renaissance, the modern and the traditional.

REVIVALISM AND ITS MOTIVES

The conviction that monumental forms and great architectural ruins are the expression of great states was also conducive to Pre-Columbian art figuring prominently in revival styles of a nationalist and anticolonialist complexion on the American continent and its relevance to certain European nationalist imperatives. In Mexico, Peru, and California during the 1920s and 1930s, revival styles featuring pre-Hispanic forms were embedded in the construction of a new national or regional identity and the rejection of a colonial status. In Europe immediately following World War II, Pre-Columbian-inspired public monuments were used as emblems of the postwar restoration of one nation's power. These associations serve to represent another important distinction between Pre-Columbian and other forms of the primitive in Western eyes; the primitive occasioned mainly individualistic, not collectivist, social expression.

The Mexican Renaissance following the Revolution of 1910–20 had a far-reaching impact in the Americas. In *Forjando Patria* and *La Población del Valle de Teotihuacán*, Manuel Gamio helped provide it with a theoretical basis. He appealed to Mexicans to rediscover and preserve indigenous art and to develop a new national art, independent of that of Europe, that was based on the great native heritage, using ancient motifs adapted to the requirements of modern aesthetic judgment. In addition, Gamio promoted a revival of popular arts and crafts as a vehicle for revitalizing the indigenous population and fostering a new national unity. Although it was predicated on a populist revival of archaic and local folk art traditions in combination with new cosmopolitan elements, the Mexican Renaissance provided a reformist means for a rising Mestizo bourgeoisie to signify their social supremacy and to maintain conservative cultural values while at the same time being modern and progressive. In this context, Rivera almost single-handedly fulfilled Gamio's call for the aesthetic recognition of Pre-Columbian art in his great nationalist mural cycles and in his mammoth collection of Pre-Columbian art that is housed in the museum he designed and donated to the state (Anahuacalli).

Gamio's injunctions and the example of the Mexican Renaissance resonated in the United States in the Maya Revival style in architecture and decorative arts during the 1920s and 1930s, which encouraged the reassertion of an identifiably American art style that was unaccountable to European standards, in this case, Parisian Art Deco. After the Panama-California International Exposition in San Diego (1915) promoting the expansion of U.S. economic interests in Latin America along with a renewal of Hispanic and Mexican regional artistic traditions, southern California became the heartland of the Maya Revival style. An exotic offshoot of the broader, self-consciously vernacular, Spanish architectural revival style, it was based on the identification of adventurous patrons with ancient aristocratic elites and keyed to the theatrical opulence and fantasy of the burgeoning movie colony. Wright's Los Angeles "Maya style" residences, which were inspired as much by Mixtec as by Maya sources, had the cachet of an association with the elegant, intellectual, and peaceable "Greeks of the New World," an interpretation of the Maya fostered by Harvard's Peabody Museum ever since the World's Columbian Exposition in 1893. (In the national revival style south of the border, on the other hand, Mexican elites identified exclusively with the more down-to-earth and militaristic Aztecs.) The full-blown Maya Revival–style designs of Robert Stacy Judd were more flamboyant and whimsical than Wright's buildings; they serviced the emergent business interests (tourism, real estate) and unconventional religions of southern California, representing a kitsch variant of Wright's high-style primitivizing.

After returning to Montevideo in the mid-1930s, Torres-García dedicated himself to the task of forging a new autochthonous, regional art tradition, the School of the South, that would promote modernism with nativist roots, linking Constructivism, prehistoric Indian forms and motifs, and cosmic symbolism. He drew on many precedents for his project. In Barcelona he was a leading light of *Noucentisme*, a

modern idiom that revived ancient Mediterranean stylistic traditions in combination with cosmopolitan forms, and he was acquainted with Siqueiros when the latter was preparing his manifesto for a new Mexican art based on ancient native American roots for *Vida Americana*. He also had before him the immediate example of the Peruvian indigenist revival spearheaded by José Carlos Mariátegui, which was dedicated to the struggle for Indian land tenure and supported the vanguard review *Amauta*.

Torres-García's revivalist project, however, differed from the Mexican and Peruvian revivals in significant ways. While it was premised on a nationalist transformation involving Uruguay's utopian socialist state and on the collectivist activity of the artists' association and workshop founded by Torres-García, it did not involve social protest and lacked institutional support. Moreover, Torres-García rejected any connection with local indigenism or folk art in favor of implanting universalist and vanguard modernist values in what he thought of as the blank cultural slate of the New World. He took upon himself the superhuman task of single-handedly creating an artistic theory and practice, inventing a new symbolic language for an entire region, and assimilating universalist (Constructivist) abstraction within distinctive local expressions of form, while at the same time devising and enforcing a pedagogical system to implement these inherently contradictory ideas. What made this hegemonic task impossible was the underdeveloped cultural condition and colonial status of Latin America.[12]

Although less immediately apparent, Moore's relation to Pre-Columbian monumental art traditions was also contingent on notions of a nationalist revival. In this case, however, the connection was indirect, having to do less with the intentions than with the uses of Moore's art. After World War II and the popular and critical triumph of his Underground shelter drawings, Moore received many commissions for public monuments from the British establishment: church, state (through the Arts Council), corporations, and museums. To fulfill his institutionalized role of Britain's modernist old master, Moore once again turned to familiar (and some new) Pre-Columbian models for (mostly open-air) monumental state and corporate symbols, often recapitulating old formulae with new materials, techniques, and textural effects in bloated size. And at the same time as Moore's champions, including the dean of English art critics, Sir Herbert Read, celebrated these sculptures for their infusion of vitality into archetypal forms, the Fine Arts Department of the British Council was subsidizing their worldwide distribution as ambassadorial emblems of Britain's continuing artistic and political relevance.

PRE-COLUMBIAN PRIMITIVIZING IN THE POST-MODERN PERIOD

In the period after 1945 new generations of artists have continued to appropriate Pre-Columbian forms in the footsteps of Gauguin, Moore, Wright, Torres-García, and Rivera. They have, however, practiced a differently inflected primitivism in a context of changed global economies and sociopolitical structures.

Since World War II the ascendancy of multinational capitalism and the decolonization of the Third World have conditioned a relation to the Pre-Columbian primitive in which the utopianism, the faith in art and science, and the fervid nationalism marking the high-modernist version have become increasingly suspect. Especially since the late 1960s, a new generation of middle-class, college-educated, and well-traveled artists began to think about art in conceptual rather than concrete terms. The Pre-Columbian primitive for the first time has been constituted ironically, parodistically, historically, and anthropologically with respect to reified categories of natives and others; assumptions about artistic and cultural originality, purity, and authenticity; and issues of race, gender, and power.[13] Sophisticated contemporary artists no longer regard Pre-Columbian artifacts in museums and reproductions as exemplars of pre-Hispanic cultures but rather as decontextualized objects pertaining to fictional (ethnographic, archaeological, aesthetic) discourses. They also incorporate images of these artifacts into rhetorical or allegorical statements that deconstruct old myths about them and challenge the religious, nationalist, imperialist, and sexist agendas with which they have been entwined since the Conquest.

Yet more similarities exist in the modernist and Post-Modernist views of the

primitive than we might imagine. The non-Western world is still a field of projection for our deepest fears and strongest desires about power, sex, death, and destruction and is often still conceived as existing outside history in a timeless "ethnographic present," and the same myths (of origination, apocalypse, paradise) are still imposed on it as in the earlier period. The West still seems to need the primitive as a preconditon and supplement to its sense of self and to create heightened versions of the primitive as nightmare or utopian dream.[14] However, there is now a general recognition of a need for dialogue with so-called primitive cultures and a new willingness to understand culture in processual, rather than fixed, terms. There is, for example, a new awareness of the millions of surviving Maya, Nahuatl, Quechua, and Aymara speakers living today in Guatemala, Mexico, Peru, and Bolivia, who, despite their marginalized existence and colonized condition, continue to create beautiful objects that are part of rich, ongoing traditions, though they are often still classified as folk or tourist art.

The Legacy of Joaquín Torres-García

Torres-García's legacy fusing Constructivist abstraction, cosmic symbolism, and Pre-Columbian art has extended far and wide in South and North America. In Uruguay the Asociación de Arte Constructivo and, later, the Taller Torres-García served as a training ground and platform for the practice of Universal Constructivism through which Torres-García proselytized his ideas with formidable energy and skill for fifteen years. Among members of the Taller during the 1940s and 1950s, Gonzalo Fonseca, Francisco Matto, and Julio Alpuy carried on his fusion of Pre-Columbian motifs, enigmatic symbolism, and Constructivist abstraction. However, they were able to realize the master's ideas in their own terms only after moving to New York in the 1960s.[15] During the same period Torres-García's theory and practice attracted artists in neighboring Argentina, including Carmelo Arden Quin, Alfredo Hlito, and Juan Mele, who actively pursued his Constructivist aesthetic—although not his symbol system—in the Arturo, Concrete art, and Madi groups, spawning a strain of geometric abstraction throughout South America that is still flourishing.

An outstanding Torres-García disciple in the next generation is César Paternosto, an Argentine artist who has chosen to live in New York. During the 1970s, when Paternosto and his compatriot Alejandro Puente were working in a minimalist syntax in Argentina, they were attracted to Torres-García's notions of an aboriginal, indigenous Constructivism as a precursor to modernist geometric abstraction and as an emblem of identity for Latin American artists continuing a local aesthetic tradition.[16] Ever since Paternosto first visited the Inka ruins around Cuzco in 1977, he has been obsessed by ancient Peruvian tectonic art and the theories of Torres-García. Reaffirming the master's notion that metaphysical ideas inhere in geometric form, Paternosto attests that the rhythmic protruberances and concavities in the austere planar forms of Inka stonework embody a system of signs. He projects the same idea in his work: A series of monochromatic paintings with Quechua titles in the late 1970s embody nearly imperceptible signs; a later series more boldly depicts symbolic Andean geometric forms in patterns derived from Nazca, Tiwanaku, and Inka textiles. Their subtly modulated coloration evokes the tonality of the landscape and ancient artifacts of Peru. Paternosto's most recent shaped canvases incorporating their structured supports, such as *Cruz de Sur*, 1992, are Constructivist in every sense and have themselves become iconic objects that pay homage to the spirit of Torres-García and to ancient Peruvian symbolic forms.

In North America in the 1940s and 1950s Josef and Anni Albers's dedication to a Constructivist aesthetic (as a result of their long association with the Bauhaus) and passion for Pre-Columbian forms paralleled but was entirely independent of that of Torres-García. They departed Europe for the American continent around the same time he did, accepting an offer to teach in the United States at Black Mountain College in North Carolina. Soon after their arrival in 1934 the Alberses traveled to Mexico and immediately developed an aesthetic appreciation of Pre-Columbian artifacts. They made thirteen subsequent trips in the following decades during which they amassed an important collection of more than one thousand Pre-Columbian miniatures, mostly clay figurines from the preclassic villages of Tlatilco, Chupícuaro, and western Mexico—that also captivated Rivera—which appealed to them on the

Josef Albers. To Monte Albán. 1942. Zinc lithograph, 13¾ × 10½". Josef Albers Foundation

Anni Albers. Untitled wall hanging. 1925. 50 × 38". Die Neue Sammlung, Staatliches Museum für Anglewandte Kunste, Munich

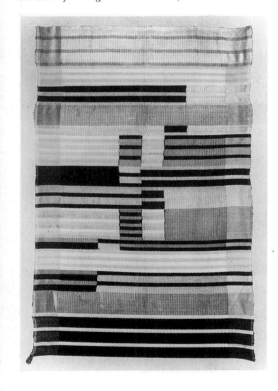

OPPOSITE:

César Paternosto. Cruz del Sur (Southern Cross). 1992. Acrylic emulsion and marble powder on canvas, 66 × 53". Collection the artist

basis of their technical proficiency, rich plastic rhythms, and visual inventiveness. Josef Albers was particularly fascinated with the many subtle variations on a single theme he found in Chupícuaro figurines, which he correlated with his own exploration of serial imagery and repetition.[17]

Josef Albers's paintings and graphics and Anni Albers's weavings also contain formal and associational references to pre-Hispanic forms. While totally abstract, Josef Albers's *Graphic Tectonic* series of lithographs and several oil paintings evoke the presence of ancient Mesoamerican architecture through their orthogonal structure, pyramidal forms, evocative color, and titles, such as *To Monte Albán* or *To Mitla*, suggesting the artist's experience of specific archaeological sites. Their floating geometry also communicates his mystical relation to the awesome and otherworldly aspects of ancient American art. The titles of Anni Albers's textile designs are also redolent of ancient Mexico, but their techniques, such as the use of tapestry and gauze, and the proportions and rhythms of their gridded patterns convey a stronger relationship with the ancient Peruvian weaving tradition. Her craft orientation also underscores the strong appeal of nonmonumental forms of Pre-Columbian art—pottery, textiles, jewelry—for modern designers who appreciate their mastery of materials and the vitality of their conventions.

In New York during the same period, American abstract artists in the circle of A. E. Gallatin, such as Charles Shaw, Burgoyne Diller, Jean Xceron, Carl Holty, and Balcomb Green (many of whom were involved with the *Cercle et Carré* group in Paris that was founded by Torres-García and Michel Seuphor) were familiar with Torres-García's geometric abstractions, which were exhibited in Gallatin's gallery (later Museum) of Living Art at New York University. However, it was among first-generation Abstract Expressionists, including Adolph Gottlieb, Barnett Newman, and Louise Nevelson, that Torres-García's fusion of the Cubist grid and Surrealist fantasy in the interests of forging an indigenous expression found special favor, although this fact has often been (deliberately) obscured in the art literature.[18]

In a series of pictographic paintings from 1941 to 1951, Gottlieb followed Torres-García's precedent by filling the compartments of an irregularly (rather than rigidly) gridded format with rounded (rather than angular) ideograms inspired mainly by North American Indian (rather than ancient Peruvian) forms, which he also saw as a universal language emanating from the recesses of the human mind (or the Jungian Collective Unconscious) as it is revealed in primitive forms of writing.[19] However, Gottlieb's attitude toward pictographs differed from Torres-García's; he saw them as leading to the psychic liberation and self-realization of the artist and perhaps also as a means of evoking and redeeming the horrors of World War II,[20] rather than as the expression of the collective identity of an American hemisphere that Torres-García intended.

There is a greater correspondence between the visual systems, theories, and histories of Torres-García and Alfred Jensen, an artist linked with the next generation of Color Field painting[21] who incorporated numbers, letters, and signs into his gridded structures. After leaving his native Guatemala at the age of seven to reside with relatives in Denmark, the peripatetic Jensen lived in Guatemala, California, and all over Europe before finally settling in New York in 1951. Like Torres-García's, his art is rooted in Pythagorean mathematical and geometric formulas that he identified with spiritual power and associated with Pre-Columbian architecture, hieroglyphs, and cosmology. In keeping with his background, Jensen related quite naturally to ancient Maya forms, favoring the gridded plans of Maya pyramids and Maya calendrics and numeration, which he discovered in J. Eric Thompson's *Maya Hieroglyphic Writing* soon after its publication in 1950. Equally informed by a curious combination of the simple and complex, irrational and rational, local and international, Jensen and Torres-García, after half a lifetime's apprenticeship, each arrived at his autographic style through a mystical synthesis of these contradictory elements.

The materialist, handcrafted character of their work is strikingly similar: Its carefully measured yet eccentric gridded scaffolding always conveys the obsessive presence of a human hand. Each component is simplified and isolated, given a discrete identity and clarity; color is endowed with a plastic simplicity and directness and a disquieting luminosity. These are abstractions with a pronounced tangibility and physical integrity, which, in tension with the felt presence of the metaphysical ideas propelling them,

Adolph Gottlieb. Nostalgia for Atlantis. 1944.
Oil on canvas, 20×25″. Copyright 1980 Adolph
and Esther Gottlieb Foundation, Inc.

OPPOSITE:
Louise Nevelson. Sky Cathedral—Moon
Garden + One. 1957–60. Wood painted black,
9′1″ × 10′10″ × 1′7″ (without base). Courtesy The
Pace Gallery, New York

PAGE 308:
Alfred Jensen. Uaxactun. 1964. Oil on canvas,
50¼″ × 50¼″. The Solomon R. Guggenheim
Museum, New York

PAGE 309:
Alfred Jensen. Sun Rises Twice, Periods III, IV
(two sections of a four-section mural). 1973. Oil
on canvas, 8 × 16′. Hirschhorn Museum and
Sculpture Garden, Washington, D.C.

exude a kind of mysterious poetry. Here, in this mastery of the concrete and the ideal, and in the intense focus on the thing itself, is where both artists' love of Pre-Columbian artifacts can be experienced most keenly.

Torres-García's and Jensen's shared experience of forcible uprooting and long years of exile may help to account for the similarity of their production. They were doubly alienated in the sense of being separated from conventional society by their oppositional modernist position and from a true sociopolitical identity by their colonial heritage. Implicit in the heavy dose of Pre-Columbian primitivism they injected into their art is a return to fundamentals that is both a critique of the present and a nostalgic longing for the restoration of ancient values as well as for a transcendent world where time and place are suspended and spiritual values reign.[22]

The Legacy of Frank Lloyd Wright

The legacy of Wright's appropriation of Pre-Columbian forms reverberates in many areas of the visual arts, including not only the obvious one of architecture but sculpture and scenic design as well. Wright's investigations of the orthogonal patterns on the facades of Puuc Maya and Mixtec buildings in his Los Angeles textile-block houses, together with Torres-García's paintings and constructions of frontal pictographic signs fitted into shallow boxlike spaces provided important precedents for Louise Nevelson's signature wooden constructions, in which analogues of Pre-Columbian stonework bind an improvisational collagist aesthetic. In works such as Sky Cathedral, Nevelson also exploited the inherent theatricality and romantic aura of Maya architectonic sculpture that Wright had tapped in the exaggerated light and dark contrasts, stark geometry, and dramatic settings of his Los Angeles residences.

Nevelson was introduced to Pre-Columbian art by her close friend Diego Rivera,[23] whom she assisted on the New Workers School murals in 1933 (painted immediately after the Rockefeller Center mural debacle). Her interest in it was revived in the late 1940s through her association with the émigré Surrealist Wolfgang Paalen, editor of Dyn magazine and proponent of Maya and Northwest Coast art, and with members of the Indian Space school, including Will Barnet, Peter Busa, and Steve Wheeler, who explored the form and iconography of native American art as a means of integrating formalist and Surrealist concerns in their paintings. Then, after two trips to ancient sites in Mexico and Central America in 1950 and 1951 ignited her interest in Maya monuments, she began to seriously engage Pre-Columbian art in her work. (There were six subsequent visits.) Immediately following her first trip to Mexico and Yucatán

she visited the American Museum of Natural History's Pre-Columbian installation, where she encountered the plaster casts of giant Maya steles from Quirigua, Guatemala. These monuments inspired her to return to Central America only a few months after her first trip in order to experience them *in situ*. She was oddly disappointed by the real thing, however, preferring the plaster replicas and artificial lights of the museum over the actual, decaying monuments in their jungle locale, she said.[24]

The impact of these trips is first felt in a series of semiabstract etchings of 1952 to 1955 that contain many references to the tropical rainforest and archaeological sites, including a murky, mysterious black tonality and imagery and titles evoking the ancient majesty of Maya kings and queens. Nevelson's breakthrough columns, wall reliefs, and environments of the second half of the decade, announcing her mature style, continued to summon her experience of Maya monumental sculpture in these terms, as titles such as *Black Majesty* and *Royal Voyage* suggest. Through the tension between her freewheeling collage and calculated geometry, and the monumentality, uniform color, dramatic lighting, and muteness of her forms, she produced a metaphor of the archaeological mystique. This phantom Maya-Mexican architecture celebrated the irrational sphere in an overrationalized society and mirrored the mystical awe of Indian culture expressed by contemporaneous "beat" poets, writers, and artists. At the same time, it constructed a mythology of Maya royalty into which Nevelson self-consciously projected her own persona as well as her ambition to power through her sculptures: her dreams of art-world stardom and royal stature.[25]

Nevelson's framing of the Maya with a royal metaphor coincided, rather curiously, with a pathbreaking discovery made by Mayanist Tatiana Proskouriakoff revealing that historical kings and queens were actually represented on Maya steles. Since the 1930s Proskouriakoff had worked as an architectural draftswoman for the venerable Carnegie Institution of Washington and was noted for her watercolor reconstructions of Maya temples and palaces, which imagined their original pristine state as being all covered with white plaster. She later turned her attention to a study of Maya iconography and epigraphy. In a remarkable 1960 article in *American Antiquity*,[26] she proved that thirty-five dated monuments from Piedras Negras were arranged sequentially in groups that celebrated events in the lifetime of a ruler—royal accessions, marriages, births, military victories; the figures on classic Maya reliefs were not mythical deities or priests, as had previously been supposed, but dynastic rulers. She also underscored the importance of matrilineal descent in Maya dynastic history by identifying many of the hieroglyphic signs for the personal names and titles of royal females.[27]

Proskouriakoff's discovery stimulated great advances in the decipherment of Maya hieroglyphs, so that thirty years later the dynastic records of many sites have been worked out and as many as 90 percent of the glyphs are translated. In 1986 a flamboyant exhibition and accompanying book, *The Blood of Kings*, organized and written by Linda Schele and Mary Miller for the Kimbell Art Museum in Fort Worth, interpreted the Maya world on the basis of their synthesis of the new epigraphic information as a series of kingly societies primarily preoccupied with royal lineage, ritual bloodletting, and bloody warfare. This well-publicized show overturned, indeed reversed, the old notion that the Maya world was a peaceful theocracy preoccupied with time-keeping and astronomy and personalized Maya kings by attaching recognizable names and events to them (while ignoring the thoughts and customs of the majority of the population whose affairs were not recorded in glyphs). At the same time, however, the show reinforced the construction of the Maya fostered by the Peabody Museum in the late nineteenth century that the classic period Maya culture was the most civilized and literate among American Indian cultures, and one worthy of devotion by discriminating, upscale Americans.[28] In this sense, Nevelson's approach to the Maya both continues and anticipates a major ideological strain of Maya art history, archaeology, and epigraphy.

As a trained architect who apprenticed to Wright for two years, Tony Smith was aware of the master's embrace of Pre-Columbian forms and like him recognized the reductive geometry inherent in the basic formal vocabulary of Pre-Columbian sites—steles, pyramids, platforms, plazas, pathways—and the way in which these unvarying elements were organized into practical and symbolic systems. However, he focused on aspects of this tradition that accommodated his minimalist and conceptualist sculptural

syntax: cool, detached, reductive, mathematically predictable (though optically
ambiguous), industrially fabricated geometric forms, such as polyhedrons and
tetrahedrons, with a clear-cut overall image that would change in interaction with the
spectator. He intended his monumental, quasi-mathematical sculptures to pose
questions about the distinction (or lack of same) between fabricated objects and art
and about technology's impact on the landscape. But Smith differed from other
minimalist sculptors in the same way that Jensen departed from his Color Field
colleagues: He subscribed to quasi-mystical mathematical theories intended to give his
(associatively titled) architectural sculptures a spiritual resonance. Smith was also
deeply interested in art historian George Kubler's theories concerning formal sequences
and families of artifacts articulated in *The Shape of Time* (1962), which derive from
American archaeology as well as formalist art history and represent a pivotal link
between Pre-Columbian discourse and minimalist art.

Smith modeled his gigantic works on archetypal Mexican and Andean architectural
plans, ornaments, and sculptures, using these elements as prototypes, much like
polyhedrons and other geometric forms. With an architect's eye he perused
characteristic ornamental details—patterned profiles, cornices, balustrades, benches,
and sunken courts—of structures at Mexican highland sites such as Teotihuacán,
Monte Albán, and Tenayuca, many of which he visited, as well as Inka sites such as
Machu Picchu. He also studied pre-Hispanic sculpture, especially Aztec zoomorphs, to
help shape his art. The huge minimalist *Snake Is Out* of 1962, for example, translates
Aztec serpent representations into minimalist abstraction. Mathias Goeritz, a catalytic
German Post-Modern artist living in Mexico, achieved a similar fusion of Aztec
architectural sculpture and minimalism in works such as *The Serpent*, 1953,[29] which
was installed in the experimental El Eco museum in Mexico City and may have been
known to Smith.

Wright's Maya-inspired buildings have also provided important models for scenic designers. The expressionistic theatricality of the Charles Ennis House in Los Angeles, for example, has come to epitomize a familiar strain of Hollywood fantasy. Several Hollywood directors have used its strange interior spaces, deeply patterned, overbearing rooms and corridors as film sets to establish a mood of otherworldly menace and impending violence in cinematic visions of the clash of alien cultures. William Castle's *The House on Haunted Hill*, 1958, a horror movie starring Vincent Price, was the first film to use this locale. More recently, Ridley Scott's *Blade Runner*, 1982, a science-fiction film involving aliens on the lam in Los Angeles in the year 2019, and *Black Rain*, 1989, a violent cop-and-robber caper pitting corrupt American law enforcers against a terrifying Japanese gang in contemporary Tokyo, each employed the master bedroom of the Ennis House as the strange, luxurious lair of an exotic protagonist.

Blade Runner also encompasses another facet of Wright's Pre-Columbian-inspired designs: their visionary expression of utopian technological preoccupations, which set designer Sydney Mead transposed into Scott's dystopian view of the modern world. For one set he adapted the master's most futuristic project of the 1920s, an unrealized thirty-two-story skyscraper for the National Life Insurance Company in Chicago consisting of four towers set on an axial spine with cantilevered floors and copper and glass hung walls, which is derived from steeply vertical Petén Maya temples in Guatemala and embellished with textile block patterns based on Mixtec and Puuc Maya range buildings. The film's mise en scène was also beholden to an unrealized design for a "City of the Future" by Wright's collaborator and son, Lloyd Wright, who in fact worked independently as an architect and set designer in the 1920s. *Blade Runner* sets also incorporated futuristic stylizations of the Templo Mayor, the great twin pyramidal temples in the heart of the ceremonial precinct of the Aztec capital of Tenochtitlán, once again embellished with Mayoid surface designs, as well as distillations of the great pyramids at Teotihuacán in receding perspective.

The Legacy of Henry Moore

Henry Moore's appropriation of Pre-Columbian art has resonated widely on the American continent, stimulating some important original voices and spawning many imitators of his stone-and-wood carving style and his example of relating monumental forms to a (natural or cultivated) landscape.

John Flannagan, a sculptor who conceived of himself as a direct carver revealing the forms and forces inherent in nature, produced a distinctive series of stone animals during the 1930s, often embedded in rocks, which draw heavily on Aztec representations of serpents and other animals that play on the ambiguity between natural and cultural forms, as well as on Moore's similarly inspired animal sculptures. During this same period, Louise Nevelson, a close friend of Flannagan's wife, who shared her enthusiasm for modern dance, was imitating Moore's chacmool-inspired reclining figures in plaster and terra-cotta.

Flannagan settled in Woodstock, an artist's colony in upstate New York whose beautiful Catskill-mountain setting inspires a strong feeling for nature among its inhabitants. In the same locale, Harvey Fite, another artist dependent on Moore's example, carved semiabstract wood and stone figurative sculptures and planted them in open-air contexts. Fite is best known, however, for his imposing *Opus 40*, 1939–76, a huge earthwork consisting of stone terraces and ramps spiraling up to a jagged monolith that was fashioned entirely from an abandoned stone quarry on the artist's property. (The title alludes to its arduous and time-consuming process of realization.) Immediately before embarking on *Opus 40*, Fite had spent several months in Honduras in the employ of the Carnegie Institution, restoring the great stone structures at the classic Maya site of Copán.

In an ironic though hardly unusual twist, Henry Moore's Pre-Columbian-inspired sculptures and principles of direct carving have come full circle as the basis of a reconstituted Eskimo carving style geared to the tourist trade. During the 1950s under the aegis of James Houston, an artist who was an admirer and student of Moore, and Canadian governmental authorities desirous of solving the problem of native unemployment, Inuit artists in Canada fashioned a new art form that successfully expresses their own vision while emulating Moore's sculptural conventions. Traditional

Inuit art consisted of wooden, bone, and ivory implements elaborated for social rituals, but the new souvenir art is carved out of stone by competitive individuals functioning in Western systems of sales and display. The story of modern Inuit art is by no means unique; in the aftermath of Euroamerican colonialism, many other non-Western cultures have applied the European forms and techniques that dominate the global visual discourse to their own ends.[30]

The Legacy of Diego Rivera

In Mexico, Rivera's primitivizing was carried on well into the 1950s and 1960s by Rufino Tamayo, a Zapotec Indian who identified strongly with the Pre-Columbian tradition, amassed an extensive collection of Pre-Columbian art (which he donated to his native state of Oaxaca), and used West Mexican terra-cottas and, occasionally, Aztec sculptures as sources for his paintings with indigenous themes, in combination with the colors and forms of popular folk art. However, Tamayo rejected populist muralism in favor of easel painting that served a modernist expressive semiabstraction and asserted an internationalist rather than a nationalist identity.[31] Tamayo's universalist and individualist stance foreshadowed the attitudes of younger generations of Mexican artists whose work represented a complete rupture with the indigenism of the Mexican Renaissance. They included abstractionists such as Vincente Rojo, Gunther Gerszo, and Lilia Carrillo, who came of age in the 1950s, and *Los interioristas*, the figurative painters and graphic artists of the 1960s, such as Arnold Belkin, Francisco Icaza, and José Luis Cuevas, whose expressively distorted, neohumanist, and apolitical creations were indebted to Orozco's art.

The more recent generation of Mexican painters of the 1980s turned inward once again to embrace the indigenous heritage by incorporating specific images of some of the Mexican School painters of the 1920s and 1930s and reviving Pre-Columbian art and popular craft traditions in decidedly cosmopolitan and Post-Modern terms. The introspective figurative art of Nahum Zenil, Julio Galán, Rocio Maldonado, Adolfo Patiño, and others is an ironic, playful, and dramatic expression of private experience couched in terms of a collective Mexican cultural identity; it represents a tendency corresponding with the new privatization of culture in Mexico in which corporate art patronage has replaced government sponsorship. A number of these artists address issues of gender, sexual preference, ambiguity, and tension in their work and pay homage to and sometimes quote Frida Kahlo's canvases that employ masking devices, dreams, and popular devotional imagery to explore personal concerns, rather than honoring Rivera's public statements.[32]

In the United States between 1930 and 1934 *los tres grandes*, Rivera, Siqueiros, and Orozco, introduced the notion of muralism as a means of restoring national heritage and pride through federal funding of artists during a time of social reconstruction that became the Works Progress Administration (WPA) policy during the Depression. These great painters were tremendously influential among young, socially conscious North American artists of the American Scene and Social Realist schools during the 1930s and continued to have an enormous impact on the Abstract Expressionists of the 1940s, especially on artists like Jackson Pollock, who had direct contact with them. They offered a distinctive, energetic, and monumental American version of modern art using local roots in combination with cubist innovations and directed attention to the importance of Indian art and myth, in addition to exerting stylistic and iconographic influences on particular artists.

Rivera's impact also extended (though less immediately) to the land artists of the late 1960s, such as Robert Smithson and Michael Heizer, who took Tony Smith's minimalist ethos out of the gallery and urban environments and into remote outdoor settings, returning to elemental forms and materials by engaging the landscape directly. Like Smith, Smithson used metaphor and symbol in his art and manipulated Pre-Columbian form ideas on a huge scale in an expanded field. But instead of reducing art to essence, Smithson was interested in magnifying its realm to include new concepts of space, time, mobility, ecology, and mental projection, as well as social and scientific concerns. It is in this sense, encompassing the notion of incorporating modern Western art into the primitive domain, that Smithson may be said to follow Rivera's example.

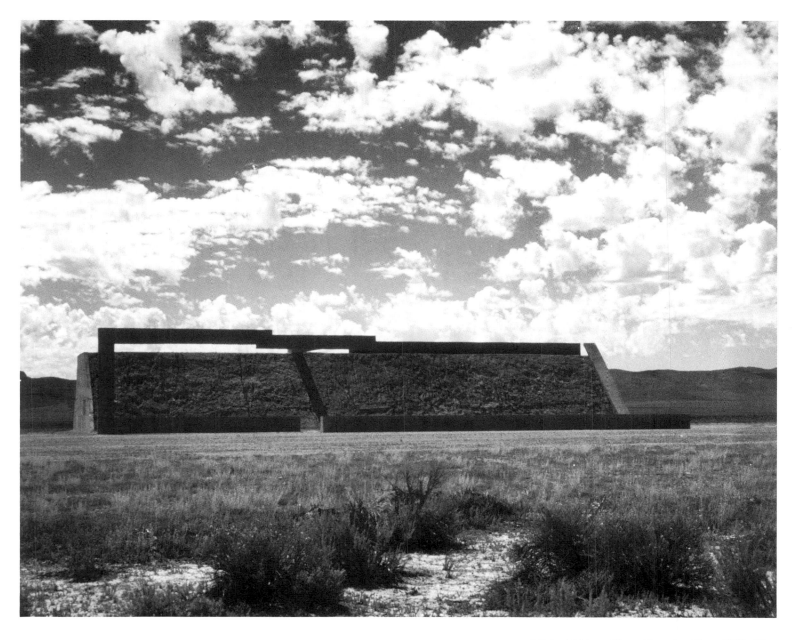

Michael Heizer. City—Complex One. 1972–76. Earth mound with concrete framing, height 23½', width 140½'. South Central Nevada, Collection of the artist and Virginia Dwan

Like Rivera, Smithson was immersed in the social sciences and natural history, especially anthropology and geology, and in dialectical thinking. He was also well versed in Pre-Columbian art and myth (he wrote about Mexican mythology) from travels in Mexico and assiduous study. His embrace of the notion of collapsing systems (entropy) even recalls Rivera's affirmation of the Aztec concept of transformative death and world cataclysm. While Rivera worshiped modern archaeology and technology and converted them into art, however, Smithson was skeptical about optimistic science and attempted to subvert academic anthropological methodology in his work through the parodistic appropriation of museum dioramas and maps.

Smithson explored areas of pre-Hispanic art and culture in every phase of his brief career: The isolated shapes of his early minimalist sculptures suggested primary units—spiral, pyramid, corbel vault, stepped form—of ancient American art; the pathbreaking *Site/Non-Site* series installed piles of despised materials (rocks, salt) in patterns recalling Pre-Columbian site plans; the *Mirror Displacement* performance pieces referred to Maya myths and numeration; and the large-scale earthworks, such as the *Spiral Jetty* in the Great Salt Lake in Utah, imprinted monumental, symbolic, spiral-serpent imagery onto the landscape in imitation of a widespread Pre-Columbian practice visible in the Nazca lines etched in the southern Peruvian desert and the great Serpent Mound of the Hopewell culture in southern Ohio (page 292).

Like Rivera in his late projects, especially the Río Lerma waterworks in Chapultepec Park, with its enormous mosaic image of the Aztec water deity Tlaloc that cannot be visually grasped from the ground, and Anahuacalli, the Pre-Columbian museum he designed and built on an ancient lava bed, Smithson was involved in the reclamation

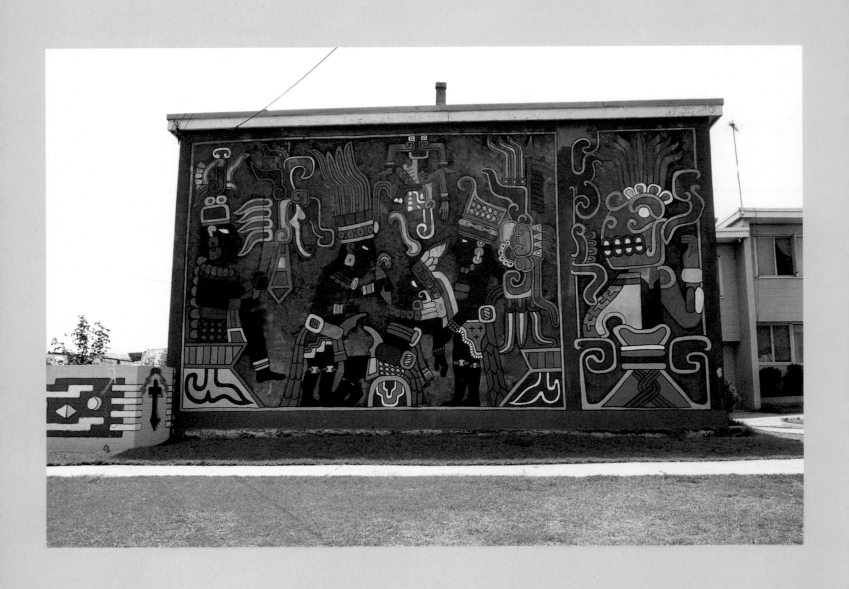

of ancient sites as public recreation areas and the restoration of their prehistoric, mythic, and cosmic significance. Smithson's projects differed from Rivera's, however, in their ecological concerns and ironic commentary on romantic notions of the landscape. The fusion of scientific and primitive astronomy, evidenced by Smithson's attention to the physical alignment of his earthworks with the cosmos and the effects of time on them, as well as their sites' prehistoric and mythic dimensions, parallels the concerns of archaeoastronomy. A discipline that emerged at the same time as land art, it combines a study of Pre-Columbian archaeology and ethnology with modern astronomy by focusing on the design and orientation of ancient sites and ceremonial structures.[33]

Smithson's later land-reclamation proposals were never realized, but Michael Heizer pursued his ideas in works such as *Effigy Tumuli*, giant earth mounds in the shape of water animals located on a toxic strip mine on an Illinois plateau overlooking a river. They evoke Pre-Columbian earthworks, such as the Ohio Serpent Mound and artificial plateaus shaped like totemic animals constructed by the ancient Olmec culture of Mesoamerica. More than that of any other land artist, Heizer's work is self-consciously informed by a knowledge of Pre-Columbian archaeology, owing to an exposure to his archaeologist father Robert Heizer's excavations, which included an investigation of the Olmec site of La Venta (with a special interest in ancient earth- and stone-moving techniques).

Two of Heizer's major earthworks, *Double Negative* and *Complex One*, attest to his personal experience of Pre-Columbian monuments. The latter consists of a long horizontal mound of earth with a rectangular base and sloping front. It embodies a concrete framing device that the artist has explained as a deliberate reference to the concrete serpent banding on the sloping benches of the great ball court at Chichén Itzá.[34] Heizer intended *Complex One* to be the first of a group of earthworks to be called *City*, which would cover three square miles of the Nevada desert. The scale and grandiosity of these projects also suggest that the artist was reaching for the kind of immortality that archaeology confers on the rulers who erected their ancient models.[35]

Today, the example of Rivera's appropriation of Pre-Columbian art continues to resound in the work of Chicano artists who are reasserting their Mexican ethnic identity and heritage as a colonized group within the United States. Beginning with mural painting in Chicago in the mid-1960s inspired by political issues such as farm workers' rights and immigration policies, Chicano art quickly spread to urban centers throughout the country, taking hold through the 1980s especially in areas of the West and Southwest that have the largest concentration of Mexican-Americans. Like Mexican School painting of the 1920s and 1930s, Chicano art is archaizing and romantic in character and upholds the ethos of Indian culture as an alternative to European values.[36] To affirm their ethnic identity and distinguish themselves from the dominant Anglo culture, many Chicano artists have revived iconic images of Pre-Columbian and popular Mexican culture featured in Rivera's indigenist murals, such as the earth goddess Coatlicue/Tonantzin (often syncretistically fused with the figure of Mexico's patron saint, the Virgin of Guadalupe); the Day of the Dead; and the eagle, serpent, and cactus emblem of the Aztec state. A good example is a mural quoting the sacrificial scene depicted on the north ball court of El Tajín, a classic Veracruz site, one of many murals painted in the 1980s by resident gangs on the walls of the Estrada Courts, a Chicano housing project in East Los Angeles.

The Legacy of Paul Gauguin

The production of two contemporary California ceramists, Ken Price and David Gilhooly, returns us full circle to the earliest manifestation of modernist Pre-Columbian primitivizing. These artists have confirmed Gauguin's insight of the 1880s about Pre-Columbian pottery as the bearer of vital form, beliefs, and myths, and ratified his refusal of artistic hierarchies that consign pottery to the category of a humble craft with a predetermined function. In their work, pottery is no longer a decorative art but a full-fledged fine-art form, the equivalent of sculpture.

Such a profound attitudinal change was only possible in the "lowbrow" cultural climate of California, not in high-style New York. The new sculptural expression merging art and craft as Gauguin envisioned it developed during the late 1950s in Los

David Gilhooly. Mao Tse Toad. 1976. Glazed earthenware, 32 × 19". Collection the artist

OPPOSITE:
Charles W. Felix and the VNE Cobras. The Sacrifice Wall. 1974. Day-Glo paints. Estrada Court, East Los Angeles
This mural is a replica of the relief on the north ball court at El Tajín, a classic Veracruz site.

Angeles. Under the dynamic tutelage of Peter Voulkos at the Otis Art Institute, a group of studio potters were stimulated by the example of Picasso's pottery, Dada and Surrealist attitudes, and especially Abstract Expressionism's stress on process and the unconscious to address problems of perception, scale, and psychology in the ceramic medium. Their search for a new ceramic aesthetic quite naturally led to an exploration of Pre-Columbian and other rich ethnographic ceramic traditions. Two distinct schools emerged that represented different sensibilities: southern California formalist, exemplified by Ken Price's abstract ceramics, on the one hand; and San Francisco Funk, typified by David Gilhooly's realistic style, on the other.[37]

Price's mature work, like that of Smith and Smithson, represents a shift from an Abstract Expressionist involvement with the artist's experience to a focus on the viewer's experience through the object's material presence. He composes his meticulously executed, brightly glazed ovoid or angular forms in Conceptualist terms and uses industrial materials. Pre-Columbian sources have been conspicuous in his work since 1968, when he began to incorporate animal imagery with cup shapes in imitation of pottery from the Monte Albán and Mixtec cultures of ancient Oaxaca. He parodistically displayed these pieces in vitrines, like biological or ethnographic specimens.

Price's move from Los Angeles to Taos, New Mexico, in 1971 signaled a new geometricized Constructivist style involving the cup format that continued to draw on the same ancient southern Mexican ceramic tradition. Concurrently, he began a series of large-scale environmental installations called *Happy's Curios*, 1972–77, consisting of highly stylized jars and plates openly inspired by North American Indian, Pre-Columbian, and Mexican folk pottery, which are set in contexts recalling the sleazy curio shops and roadside altars in Tijuana, a border town in Mexico, very near the United States. This juxtaposition of primitivizing and popular marginal forms directly addressed the contradictions inhering in distinctions of art versus craft, forcing the viewer to confront them. *Happy's Curios* is thus a work of art about the art of ceramics that ironically comments on its social and economic status as a commodity. However, it is unclear whether Price is arguing for an equation of high and low art or merely for the enhanced respectability of his own medium.

Gilhooly's low-fired earthenware sculptures radically depart from the kind of formalist high-fire stoneware produced by Price in embracing narration, fantasy, visual puns, and Surrealist juxtapositions, and custom-fitting technical procedures to

narrative intentions. In the 1960s he began to make frogs and has since developed in a mock-anthropological vein an entire frog civilization, which has mythic, symbolic, and satiric dimensions. Its major protagonists are revisionist versions of male and female deities in Pre-Columbian and other ancient myths whose activities focus on food production and transformation. Gilhooly has closely studied the narrative-art traditions of ancient America, particularly the Chavín style of Peru and the classic period Maya of Mesoamerica, which equally encompass the kinds of visual puns, games, and ideographs he favors. He has also drawn upon the non-high-style pre-Hispanic pottery traditions of Amazon Basin "chiefdoms," such as the ceramic effigies of the Marajoara and Santarem cultures of Brazil and Paraguay. His complex strategy of appropriation employs Pre-Columbian and other primitivist imagery in combination with lowbrow forms from overlooked fringes of contemporary culture, including advertising, television, and especially Disneyesque cartoons that have already absorbed Pre-Columbian morphology. He collapses the distinction between high and low by transforming ceramic practice into something new, rather than by elevating it to the same level as painting and sculpture.

Thus, the art of Price and Gilhooly not only reveals the continuity of modernist interest in Pre-Columbian material culture from Gauguin to the present but also underscores the way in which attitudes toward these sources and perceptions about the nature of art have changed during the past century.

FINAL THOUGHTS

Indeed, a major lesson of this narrative of the history of the reception of Pre-Columbian artifacts in the West since the Conquest is that they do not have stable or immutable identities; their meanings have shifted within particular cultures in different historical contexts.[38] They had meanings before the Conquest, which archaeologists and art historians have attempted to penetrate, and since the Conquest the history of colonial contact has provided an overriding context for them. However, within that framework their meaning has also changed as they have become objectifications of Western curiosity, skepticism, romantic yearning, attachment to nature, nationalism, and aesthetic fashion in the succeeding five centuries. One constant, however, has been the persistent aura of mystery that attaches to ancient American material culture through all the changes in the perception of these objects.

Seeing Pre-Columbian art through the eyes of modern masters rather than archaeologically expands our understanding of both the pre-Hispanic and modern visual traditions. By highlighting monumental architecture and sculpture as major achievements of ancient American civilization, such a viewpoint reveals the importance of Pre-Columbian architectonic form, which at once ratified the gridded aesthetic of Cubism, confirmed the civilized status of the ancient American world, and licensed the use of ancient American art as a nationalistic emblem in the modern world. These artists' attention to particular pre-Hispanic models further reveals formal similarities between far-flung Pre-Columbian styles in ways not always apparent through a cultural historical approach.

Finally, such a study demonstrates the many ways, philosophical and aesthetic, that cross-cultural borrowing can be crucial to the creative efforts of artists, sometimes consciously, often unconsciously. The influences that have helped shape the work of many contemporary artists are much broader than is commonly supposed; this book is a first attempt to document a series of such influences that have been generally overlooked.

NOTES

1. This chapter is indebted to James Clifford's (*The Predicament of Culture: Twentieth-Century Ethnography, Literature and Art* [Cambridge,Mass., 1988]) and Marianna Torgovnick's (*Gone Primitive: Savage Intellects, Modern Lives* [Chicago, 1990]) studies exploring the issue of primitivism, which have sharpened my general ideas about it. I have also found useful insights about the issue of the colonial appropriation of primitive artifacts in Nicholas Thomas, *Entangled Objects: Exchange, Material Culture and Colonialism in the Pacific* (Cambridge, Mass. and London, 1991); and about colonialism and literature in Terry Eagleton,

"Nationalism: Irony and Commitment," in Terry Eagleton, Fredric Jameson, and Edward Said, *Nationalism, Colonialism, and Literature* (Minneapolis, 1990), pp. 23–42; and Edward W. Said, "Yeats and Decolonization," in Eagleton, Jameson, and Said, *op. cit.*, pp. 69–95.

2. Torgovnick (*op. cit.*, pp. 173–74) has formulated this idea with respect to twentieth-century writers, including Joseph Conrad, D. H. Lawrence, Sigmund Freud, and Claude Lévi-Strauss. She points out that they conceived of the primitive as alternately male or female, sympathetic or frightening, delectable or deadly.

3. For a discussion of the notion of origins and homelessness in relation to the primitive, see Torgovnick, *op. cit.*, pp. 185–90.

4. See Said, *op. cit.*, p. 79.

5. See Torgovnick, *op. cit.*, pp. 168–71.

6. According to Rosalind Krauss (*The Originality of the Avant-Garde and Other Modernist Myths* [Cambridge, Mass. and London, 1987], pp. 9, 158–62), the structural properties of the grid include an absolute stasis; a lack of hierarchy, center, and inflection, and thus an antireferential character; a hostility to narrative, which promotes silence; a disinterested structure, which is impervious both to time and incident; an image of originary purity and the origins of art; a zero ground beyond which there is no further model, or referent, or text. In addition, the grid is also associated with science or logic via physiological optics.

7. *Ibid.*, p. 10.

8. Anthony Alofsin, *Frank Lloyd Wright: The Lessons of Europe, 1910–22* (Ph.D. dissertation, Columbia University, 1989), pp. 173–75.

9. See Marjorie Ingle, *The Mayan Revival Style: Art Deco Mayan Fantasy* (Salt Lake City, 1984), pp. 76–79.

10. Erich Von Daniken, *Chariots of the Gods?* (New York, 1969) and several sequels.

11. The monumental architecture and sculpture of Tikal, Chichén Itzá, Tenochtitlán, and Sacsahuamán functioned primarily as geometric symbols of the awesome power of gods and rulers, and as legitimators of authority and rank. Buildings served as stage sets for ceremonies of state, steles commemorated important events in the lives of rulers, colossal statues projected the awesome cosmic power of deities. However, even the sumptuary items of ruling classes, including ceremonial and military objects, various accoutrements, jewelry, and clothing, often carried similar geometric symbols of authority, e.g., they were woven into the shirts of Inka rulers and the armor of Aztec warriors.

12. See Eagleton, *op. cit.*, p. 32.

13. See Thomas, *op. cit.*, p. 189; Torgovnick, *op. cit.*, note 18, p. 253; and Hal Foster "Re: Post." in Brian Wallis, ed., *Art After Modernism: Rethinking Representation* (New York and Boston, 1984), pp. 189–203.

14. Torgovnick, *op. cit.*, pp. 187, 246–47; and James Clifford, "Of Other Peoples: Beyond the 'Salvage' Paradigm," in Hal Foster, ed., *Discussions in Contemporary Culture, Number One* (Seattle, 1987), pp. 121–31.

15. For an account of the legacy of the Taller, see Mari Carmen Ramirez, "La Escuela del Sur: El legado del Taller Torres-García en el arte latinoamericano," in Museo Nacional Centro de Arte Reina Sofia, *La Escuela del Sur: El Taller Torres-García y su Legado* (Madrid, 1991).

16. Ramirez, *op. cit.*, pp. 134–35.

17. Karl Taube, *The Albers Collection of Pre-Columbian Art* (New York, 1988), pp. 9–12 (preface by Nicholas Fox Weber).

18. Until recently, a nationalistic construction of the history of the New York School suppressed its indebtedness to supposedly provincial Latin American artists, including Torres-García and the Mexican muralists, in the interests of asserting the postwar supremacy of the United States in the field of modern art.

Among the Abstract Expressionists, Barnett Newman was the most knowledgeable about Pre-Columbian art. In 1944, with the cooperation of the American Museum of Natural History, he organized the exhibition *Pre-Columbian Stone Sculpture* at the Wakefield Gallery in New York. In his catalogue introduction Newman argued for an aesthetic rather than ethnographic reception of Pre-Columbian artifacts and stressed their spiritual dimension.

19. Kirk Varnedoe, "Abstract Expressionism," in W. Rubin, ed., *Primitivism in 20th Century Art* (The Museum of Modern Art, New York, 1984), p. 632.

20. Stephen Polcari ("Adolph Gottlieb's Allegorical Epic of World War II," *Art Journal* 47, no. 3 [Fall 1988], pp. 203–6) argues that Gottlieb's pictographic paintings, and Abstract Expressionism in general, was a public art addressed to social concerns and historical experience relating to the war rather than a private, subjective art.

21. For a discussion of the Color Field painters' relationship to Pre-Columbian art, especially their appreciation of ancient Andean textiles, see Barbara Braun, "Technique and Meaning: The Example of Andean Textiles," *Artforum* 16, no. 4 (December 1977), pp. 38–43.

22. See Frederick W. Peterson, *Primitivism in Modern American Art* (Ph.D. dissertation, University of Minnesota, 1961), p. 81.

23. See Louise Nevelson, Interview with Barbara Braun, 1983, Oral History Program, Archives of American Art; and Barbara Braun, "PW Interviews: Louise Nevelson," *Publishers Weekly* (December 16, 1983), pp. 76–77.

24. Laurie Lisle, *Nevelson: A Passionate Life* (New York, London, Toronto, Sydney, Tokyo, 1990), p. 171.

25. See Laurie Wilson, "Bride of the Black Moon: An Iconographic Study of the Work of Louise Nevelson," *Arts* 54 (May 1980), pp. 141–43.

26. Tatiana Proskouriakoff, "Historical Implications of a Pattern of Dates at Piedras Negras, Guatemala," *American Antiquity* 25, no. 4 (1960), pp. 454–75.

27. Michael Coe, *The Maya*, 4th ed. (New York, 1987), p. 184; and Michael Coe, *Breaking the Maya Code* (New York and London, 1992), pp. 167–92.

28. See Cecelia Klein's thoughtful review, "Mayamania: 'The Blood of Kings' in Retrospect," *Art Journal* 47, no. 1 (Spring 1988), pp. 42–46.

29. See Dawn Ades, *Art in Latin America: The Modern Era, 1820–1980* (New Haven and London, 1989), p. 277, and fig. 12.62.

30. See Cecelia Klein, "Editor's Statement: Depictions of the Dispossessed," *Art Journal* 49, no. 2 (Summer 1990), pp. 106–9. Klein makes the important qualifying point that it is not the pictorial language but the degree of control these dispossessed cultures have over the production, distribution, and representation of their images that ultimately determines the effectiveness of these efforts.

31. For a discussion of Tamayo's indigenism, see Barbara Braun, "Rufino Tamayo: Indigenous or Cosmopolitan Painter?" *Art Criticism* 1, no. 4 (1981), pp. 52–67.

32. Edward Sullivan, "Rejecting Dependency: Atavism and Innovation in Mexican Painting of the 1980s," paper delivered at the annual meeting of the College Art Association, San Francisco, 1989.

33. See Anthony Aveni, ed., *Archaeoastronomy in Pre-Columbian America* (Austin, 1975); and *Native American Astronomy* (Austin, 1977). The practice of both land art and archaeoastronomy was permeated with 1970s fate-of-the-earth preoccupations and tended to ignore ancient and modern social relations.

34. See Elizabeth Baker, "Artworks on the Land," *Art in America* 64 (January–February 1976), p. 94; and John Beardsley, *Probing the Earth: Contemporary Land Projects* (The Hirshhorn Museum and Sculpture Garden, Smithsonian Institution, Washington, D.C., 1977), pp. 40–45.

35. For this insight I am grateful to the observations of Diane Parker, a student in a graduate seminar on "Primitivism in Modern Art, Some Unexplored Issues" that I conducted at the State University of New York at Stony Brook in the spring semester, 1988.

36. See Shifra Goldman, "The Iconography of Chicano Self-Determination: Race, Ethnicity, and Class," *Art Journal* 49, no. 2 (Summer 1990), p. 168 and *passim*.

37. See Richard Marshall and Suzanne Foley, *Ceramic Sculpture: Six Artists* (Whitney Museum of American Art, New York, 1981), pp. 10–37, 70–72, 104–6.

38. See Thomas, *op. cit.*, pp. 187–89, 205–8, and *passim* for a cogent statement of this idea that has helped frame this discussion.

SELECTED BIBLIOGRAPHY

DOCUMENTARY SOURCES

Babelon, Jean, Georges Bataille, Alfred Metraux, et al. *L'Art précolombien*. Cahiers de la République des lettres, des sciences, et des arts, no. 11. Paris, 1928.

Bell, Clive. *Art*. London, 1914.

Basler, Adolphe, and Ernst Brummer. *L'Art précolombien*. Paris, 1928.

Bingham, Hiram. *Machu Picchu, a Citadel of the Incas. Report of the Explorations and Excavations Made in 1911, 1912 and 1915 under the Auspices of Yale University and the National Geographic Society*. Memoirs of the National Geographic Society and Yale University. New Haven, 1930.

Blom, Frans. *The Maya Ball Game: Pok-ta-pok*. Tulane University Middle American Research Papers, no. 4. New Orleans, 1932.

Blom, Frans, and Oliver La Farge. *Tribes and Temples*. Tulane University Middle American Research Papers, no. 1. New Orleans, 1926–27.

Brasseur du Bourbourg, Charles Etienne. *Histoire des nations civilisées du Mexique et de l'Amérique centrale*. 4 vols. Paris, 1859.

Burlington Fine Arts Club. *Catalogue of an Exhibition of Objects of Indigenous American Art*. London, 1920.

Catherwood, Frederick. *Views of Ancient Monuments in Central America, Chiapas, and Yucatan*. London, 1844.

Charnay, Désiré. *Ancient Cities of the New World: Being the Voyages and Explorations in Mexico and Central America of 1857–1882*. New York, 1887.

Churchward, James. *The Lost Continent of Mu, Motherland of Man*. New York, 1926.

———. *The Sacred Symbols of Mu*. New York, 1938.

Demmin, Auguste. *Guide de l'amateur faïences et porcelaines*. Paris, 1867.

———. *Histoire de la ceramique*. Paris, 1875.

Díaz del Castillo, Bernal. *The Discovery and Conquest of Mexico*. Translated by A. P. Maudslay. New York, 1956.

Donnelly, Ignatius. *Atlantis: The Antediluvian World*. New York, 1882.

Durán, Friar Diego de. *Historia de las Indias de Nueva Espana e islas de la tierra firme*. Edited by Angel Garibay Kintana. Mexico City, 1967.

———. *Book of the Gods and Rites, and the Ancient Calendar*. Norman, Okla., 1971.

Exposition internationale des arts décoratifs et industriels modernes. Catalogue general officiel. Ministère du Commerce et de l'Industrie des Postes et des Télégraphes. Paris, 1925.

Fry, Roger. *Vision and Design*. London, 1920.

Fuhrmann, Ernst. *Reich der Inka*. Darmstadt, 1922.

———. *Mexiko III*. Darmstadt, 1923.

Gamio, Manuel. *Forjando Patria*. Mexico City, 1916.

———. *La Población del Valle de Teotihuacán*. 3 vols. Mexico City, 1922.

Gann, Thomas. *Mystery Cities*. London, 1925.

Garcilaso de la Vega, El Inca. *Royal Commentaries of the Incas and General History of Peru*. Translated by H. V. Livermore. Austin, 1966.

Grosse, Ernst. *The Origins of Art*. London, 1903.

Guamán Poma de Ayala, Felipe. *El Primer Nueva Cronica y Buen Govierno*. Translated by J. L. Urioste. Edited by J. V. Murra and R. Adorno. Mexico City, 1980.

Hamy, E. T. *La Galerie Américaine de Musée d'Ethnographie du Trocadéro*. 2 vols. Paris, 1897.

———. *Décades Américanae: Mémoires d'archéologie et d'ethnographie américaines*. Paris, 1898.

Holmes, William Henry. *Archaeological Studies Among the Ancient Cities of Mexico*. Field Columbian Museum Anthropological Series, 1, no. 1. Chicago, 1895–97.

Humboldt, Alexander. *Vues des cordillères et monuments des peuples indigènes de l'Amérique*. Paris and London, 1810.

Jones, Owen. *The Grammar of Ornament*. London, 1856; New York, 1880.

Joyce, Thomas A. *A Short Guide to the American Antiquities in the British Museum*. London, 1912.

———. *Mexican Archaeology*. London, 1914.

———. *British Museum Guide to the Maudslay Collection of Maya Sculptures from Central America*. London, 1923.

———. *Maya and Mexican Art*. London, 1927.

Kingsborough, Lord (Edward King). *Antiquities of Mexico, Comprising Facsimiles of Ancient Mexican Paintings and Hieroglyphs*. 9 vols. London, 1831–48.

Kuhn, Herbert. *Die Kunst der Primitiven*. Munich, 1923.

Landa, Diego de. *Relacion de las cosas de Yucatan*. Translated and Edited by A. M. Tozzer. Memoirs of the Peabody Museum of Archaeology and Ethnology, no. 18. Cambridge, Mass., 1941.

Le Plongeon, Augustus. *Sacred Mysteries among the Mayas and Quichés, 11,500 Years Ago*. New York, 1886.

——. *Queen Moo and the Egyptian Sphinx*. New York, 1896.

Lehmann, Walter. *Altmexicanische Kunstgeschichte*. Berlin, 1922.

——. *Kunstgeschichte das Alten Peru*. Berlin, 1924.

Maudslay, Alfred P. *Biologia Centrali-Americana: Archaeology*. Edited by Frederick DuCane, William Godman, and Osbert Slavin. 5 vols. London, 1889–1902.

Mexican Folkways 1, no. 1 (June–July 1925)—8, no. 2 (April–May 1933).

Musée des Arts Décoratifs. *Les Arts anciens de l'Amérique: Exposition organisée du Musée des Arts Décoratifs*. Palais du Louvre, Pavillon du Marsan. Paris, 1928.

Prescott, William. *History of the Conquest of Mexico*. London, 1843.

——. *History of the Conquest of Peru*. New York, 1847.

Recinos, Adrian, Delia Goetz, and Sylvanus Morley. *Popol Vuh: The Sacred Book of the Ancient Quiche Maya*. Norman, Okla., 1950.

Rodó, José Enrique. *Ariel*. 1900. Rev. ed. Cambridge, 1967.

Sahagún, Friar Bernardino de. *Florentine Codex: General History of the Things of New Spain*. Translation from the Nahuatl by Arthur J. O. Anderson and Charles E. Dibble. Santa Fe, 1950–82.

Soldi, Emile. *Les Arts méconnus: Les Nouveaux musées du Trocadéro*. Paris, 1881.

Spinden, Herbert. *A Study of Maya Art: Its Subject Matter and Historical Development*. Memoirs of the Peabody Museum of Archaeology and Ethnology, no. 6. Cambridge, Mass., 1913.

Squier, Ephraim G. *Nicaragua: Its People, Scenery, Monuments, and the Proposed Interoceanic Canal*. New York, 1852.

——. *Peru: Incidents of Travel and Exploration in the Land of the Incas*. New York, 1877.

Stacy Judd, Robert. *The Ancient Mayas: Adventures in the Jungle of Yucatan*. Los Angeles, 1934.

Stephens, John Lloyd. *Incidents of Travel in Central America, Chiapas, and Yucatan*. 2 vols. New York, 1841.

——. *Incidents of Travel in Yucatan*. 2 vols. New York, 1843.

Totten, George Oakley. *Maya Architecture*. Washington, D.C., 1926.

Viollet-le-Duc, Eugène. *Histoire de l'habitation humaine depuis les temps préhistoriques jusqu'à nos jours*. Paris, 1875.

Von Daniken, Erich. *Chariot of the Gods?* New York, 1969.

Waldeck, Jean Frédéric de. *Monuments anciens du Mexique et du Yucatan*. Paris, 1866.

Wiener, Charles. *Pérou et Bolivie: Récit de voyage suivi d'études archéologiques et ethnographiques et des langues des populations indiennes*. Paris, 1880.

GENERAL/CULTURAL HISTORY

Anderson, Richard. *Art in Primitive Societies*. Englewood Cliffs, N.J., 1979.

Bernal, Ignacio. *A History of Mexican Archaeology: The Vanished Civilizations of Middle America*. London, 1980.

Boone, Elizabeth H., ed. *Collecting the Pre-Columbian Past*. A Symposium at Dumbarton Oaks, October 6 and 7, 1990. Washington, D.C., 1993.

Braun, Barbara. "The Michael C. Rockefeller Wing: Art Not Anthropology." *Art News* 81, no. 3 (March 1982): 78–82.

——. "Sex, Death|and Science at the Sacred Well." *Village Voice* (February 26, 1985): 48–49.

——. "Cowboys and Indians: The History and Fate of the Museum of the American Indian." *Village Voice* (April 8, 1986): 30–40.

Braunholtz, H. J. *Sir Hans Sloane and Ethnography*. London, 1970.

Brenner, Anita. *Idols Behind Altars*. Boston, 1929.

Briggs, Peter, ed. *Maya Image in the Western World*. University of New Mexico Art Museum, Albuquerque, 1987.

Brunhouse, Robert L. *In Search of the Maya*. New York, 1974.

——. *Frans Blom, Maya Explorer*. Albuquerque, 1976.

Burke, Doreen, et al. *In Pursuit of Beauty: Americans and the Aesthetic Movement*. The Metropolitan Museum of Art, New York, 1986.

Carpenter, Edmund. *Eskimo Realities*. New York, 1978.

Chiappelli, Fredi, ed. *First Images of America: The Impact of the New World on the Old*. 2 vols. Berkeley, Los Angeles, and London, 1976.

Clifford, James. *The Predicament of Culture: Twentieth Century Ethnography, Literature, and Art*. Cambridge, Mass., and London, 1988.

——. "Of Other Peoples: Beyond the 'Savage' Paradigm." In *Discussions in Contemporary Culture, Number One*, edited by Hal Foster, 121–31. Seattle, 1987.

Desmond, Lawrence G., and Phyllis M. Messenger. *A Dream of Maya: Augustus and Alice Le Plongeon in Nineteenth Century Yucatan*. Albuquerque, 1988.

Eagleton, Terry, Frederic Jameson, and Edward Said. *Nationalism, Colonialism, and Literature*. Minneapolis, 1990.

Evett, Elisa. "Late Nineteenth Century European Critical Response to Japanese Art: Primitivist Leanings." *Art History* 6, no. 1 (March 1983): 82–106.

Fagan, Brian. *Clash of Cultures*. New York, 1984.

Gouldner, Alvin. *The Dialectic of Ideology and Technology*. New York, 1976.

Heyerdahl, Thor. *American Indians in the Pacific*. London, 1952.

———. *Sea Routes to Polynesia*. London, 1968.

Hogden, Margaret. *Early Anthropology in the Sixteenth and Seventeenth Centuries*. Philadelphia, 1964.

Honour, Hugh. *The New Golden Land: European Images of America from the Discoveries to the Present Time*. New York, 1975.

Keen, Benjamin. *The Aztec Image in Western Thought*. New Brunswick, N.J., 1971.

Klein, Cecelia. "Editor's Statement, Depictions of the Dispossessed." *Art Journal* 49, no. 2 (Summer 1990): 106–9.

Kubler, George. *The Shape of Time*. New Haven and London, 1962.

Lambourne, Lionel. *Utopian Craftsmen: The Arts and Crafts Movement from the Cotswolds to Chicago*. Salt Lake City, 1980.

Lears, Jackson. *No Place of Grace: Antimodernism and the Transformation of American Culture, 1880–1920*. New York, 1981.

The Metropolitan Museum of Art. *Mexico: Splendors of Thirty Centuries*. New York, 1990.

Mitchell, W. J. T. *Iconology, Image, Text, Ideology*. Chicago and London, 1986.

Newton, Douglas, et al. *Masterpieces of Primitive Art: The Nelson A. Rockefeller Collection*. New York, 1978.

Parmenter, Ross. *Explorer, Linguist, and Ethnologist: A Descriptive Bibliography of Alphonse Pinart*. Los Angeles, 1966.

Price, Sally. *Primitive Art in Civilized Places*. Chicago and London, 1989.

Roseberry, William. *Anthropologies and Histories*. New Brunswick and London, 1989.

Rydell, Robert. *All the World's a Fair*. Chicago and London, 1984.

Sabloff, Jeremy, ed. *Archaeology: Myth and Reality. Readings from Scientific American*. San Francisco, 1982.

Stewart, Susan. *On Longing*. Baltimore and London, 1984.

Stocking, George, Jr., ed. *Objects and Others: Essays on Museums and Material Culture*. Madison, Wis., 1985.

Todorov, Tzvetan. *The Conquest of America*. New York, 1984.

Thomas, Nicholas. *Entangled Objects: Exchange, Material Culture, and Colonialism in the Pacific*. Cambridge, Mass., and London, 1991.

Toor, Frances. *A Treasury of Mexican Folkways*. New York, 1947.

Torgovnick, Marianna. *Gone Primitive: Savage Intellects, Modern Lives*. Chicago, 1990.

Trachtenberg, Marvin. *The Incorporation of America: Culture and Society in the Gilded Age*. New York, 1982.

Wauchope, Robert. *They Found the Buried Cities*. Ann Arbor, Mich., 1977.

Whitaker, Arthur. *The U.S. and the Southern Cone: Argentina, Chile and Uruguay*. Cambridge, Mass., 1976.

PRE-COLUMBIAN ART AND ARCHAEOLOGY

Anton, Ferdinand. *Ancient Peruvian Textiles*. Translated by M. Heron. London, 1987.

Aveni, Anthony, ed. *Archaeoastronomy in Pre-Columbian America*. Austin, 1975.

Bennett, Wendell C. *Ancient Arts of the Andes*. The Museum of Modern Art, New York, 1954.

Boone, Elizabeth H., ed. *Falsifications and Misreconstructions of Pre-Columbian Art*. Dumbarton Oaks Conference Proceedings. Washington, D.C., 1980.

Braun, Barbara. "Technique and Meaning: The Example of Andean Textiles." *Artforum* 16, no. 4 (December 1977): 38–43.

———. "Ball Game Paraphernalia in the Cotzumalhuapa Style." *Baessler Archiv*, New Series 25 (1978): 421–57.

———. "Sources of the Cotzumalhuapa Style." *Baessler Archiv*, New Series 26 (1979): 159–232.

———. "The Serpent at Cotzumalhuapa." In *Pre-Columbian Art History: Selected Readings*, 2d ed., edited by A. Cordy-Collins, 55–82. Palo Alto, 1982.

———. "The Aztecs: Art and Sacrifice." *Art in America* (April 1984): 126–39.

———. "Art of the Incas." *Review: Latin American Literature and the Arts*, issue 34 (January–June 1985): 91–94.

———. "Chac's Revenge." *Art in America* (January 1986): 88–97.

Caso, Alfonso. *El Teocalli de la Guerra Sagrada*. Mexico City, 1927.

———. *Estelas Zapotecas*. Mexico, 1928.

———. "Reading the Riddle of Ancient Jewels." *Natural History* 32 (1932): 464–80.

———. *La Religion de los Aztecas*. Mexico, 1936.

———. "El paraiso terrenal en Teotihuacán." *Cuadernos Americanos* 1, no. 6 (1942).

————. *The Aztecs, People of the Sun.* Norman, Okla., 1958.

Cline, Howard F., ed. "Guide to Ethnohistorical Sources." *Handbook of Middle American Indians* 14. Austin, 1975.

Coe, Michael. *Mexico.* 3d ed. New York, 1984.

————. *The Maya.* 4th ed. New York, 1987.

————. *Breaking the Maya Code.* New York and London, 1992.

Coe, Michael, Dean Snow, and Elizabeth Benson. *Atlas of Ancient America.* New York and Oxford, 1986.

Covarrubias, Miguel. *Pre-Columbian Art of Mexico and Central America.* New York, 1957.

Diego Rivera Museum-Anahuacalli. Catalogue prepared by the Organizing Committee of the Games of the 19th Olympiad. Mexico City, 1970.

Donnan, Christopher. *Moche Art of Peru.* Los Angeles, 1978.

Easby, Elizabeth, and John Scott. *Before Cortés: Sculpture of Middle America.* The Metropolitan Museum of Art, New York, 1970.

Gasparini, Graziano, and Luise Margolies. *Inca Architecture.* Translated by P. J. Lyon. Bloomington, 1980.

Harcourt, Raoul d'. *Textiles of Ancient Peru and Their Techniques.* Edited by G. G. Denny and C. M. Osborne. Seattle, 1962.

Hay, Clarence L., et al. *The Maya and Their Neighbors: Essays on Middle American Anthropology and Archaeology.* New York, 1940.

Kan, Michael, Clement Meighan, and H. B. Nicholson. *Sculpture of Ancient West Mexico: Nayarit, Jalisco, Colima.* 1970. Reprint. Los Angeles County Museum of Art, 1989.

Keating, Richard W., ed. *Peruvian Prehistory.* Cambridge, New York, Portchester, Melbourne, Sydney, 1988.

Klein, Cecelia. "Masking Empire: The Material Effects of Masks in Aztec Mexico." *Art History* 9, no. 2 (June 1986): 136–57.

————. "Mayamania: 'The Blood of Kings' in Retrospect." *Art Journal* 47, no. 1 (Spring 1988): 42–46.

Kroeber, A. L., and A. Gayton. "The Uhle Pottery Collections from Nazca." *Publications in American Archaeology and Ethnology, University of California* 21, no. 3 (1924), and 24, no. 1 (1927).

Kubler, George. "The Cycle of Life and Death in Metropolitan Aztec Sculpture" (1943). In *Studies in Ancient American and European Art: The Collected Essays of George Kubler,* edited by Thomas Reese, 219–25. New Haven and London, 1985.

————. *The Art and Architecture of Ancient America.* 2d ed. Harmondsworth and Baltimore, 1975.

Larco Hoyle, Rafael. *Los Mochicas.* 2 vols. Lima, 1938–39.

Leon-Portilla, Miguel. *Aztec Thought and Culture.* Norman, Okla., 1963.

Medioni, Gilbert, and Marie-Thérèse Pinto. *Art in Ancient Mexico: Selected and Photographed from the Collection of Diego Rivera.* New York, 1941.

Miller, Mary. "The Mesoamerican Chacmool." *Art Bulletin* 62, no. 1 (March 1985): 7–17.

Morris, Craig. "Signs of Division, Symbols of Unity: Art in the Inka Empire," in *Circa 1492: Art in the Age of Exploration,* edited by Jay Levenson, 521–28. National Gallery of Art, Washington, D.C., 1991.

Morris, Earl, Jean Charlot, and Ann Morris. *The Temple of the Warriors at Chichén Itzá, Yucatán.* Carnegie Institution of Washington Publication 406. Washington, D.C., 1931.

Moseley, Michael. *The Incas and Their Ancestors: The Archaeology of Peru.* London, 1992.

Muelle, Jorge. "Filogenia de la Estela Raimondi." *Revista del Museo Nacional* 6, no. 1 (1937): 135–50.

Pasztory, Esther. *Aztec Art.* New York, 1983.

Posnansky, Arthur. *El Pasado Prehispanico del Gran Peru.* La Paz, 1940.

Proskouriakoff, Tatiana. "Historical Implications of a Pattern of Dates at Piedras Negras, Guatemala." *American Antiquity* 25, no. 4 (1960): 454–75.

Rowe, Anne, Elizabeth Benson, and Anne-Louise Schaffer, eds. *The Junius B. Bird Pre-Columbian Textile Conference.* Washington, D.C., 1979.

Saville, Marshall. "Turquoise Mosaic Art in Ancient Mexico." *Contributions* 6. Museum of the American Indian, Heye Foundation, New York, 1922.

Sawyer, Alan R. *Mastercraftsmen of Ancient Peru.* The Solomon Guggenheim Foundation, New York, 1968.

Schele, Linda, and Mary Miller. *The Blood of Kings: Dynasty and Ritual in Maya Art.* Kimbell Art Museum, Fort Worth, 1986.

Stierlin, Henri. *Art of the Incas.* New York, 1984.

Taube, Karl. *The Albers Collection of Pre-Columbian Art.* New York, 1988.

Tello, Julio. *Antiguo Peru.* 1929. Reprint. Lima, 1959.

Townsend, Richard F. "State and Cosmos in the Art of Tenochtitlán." *Dumbarton Oaks Studies in Pre-Columbian Art and Archaeology.* Washington, D.C., 1979.

————. "Deciphering the Nazca World: Ceramic Images from Ancient Peru." *Museum Studies of the Chicago Art Institute* 11, no. 2 (Spring 1985): 122–37.

Ubbelohde-Doering, Heinrich. *L'Art du vieux Pérou.* Paris, 1952.

Uhle, Max. "El Templo del Sol de los Incas en Cuzco." *Proceedings of the Twenty-third*

International Congress of Americanists, 291–95. New York, 1930.

Valcarcel, Luis. *Sajsawan redescubierto, y primer informe sobre los trabajos arqueologicos*. Lima, 1934.

———. *The Latest Archeological Discoveries in Peru*. Discovery Series 1. Lima, 1938.

———. *Historia de la Cultura Antigua del Peru*. 2 vols. Lima, 1943–49.

Von Winning, Hasso. *The Shaft Tomb Figures of West Mexico*. Southwest Museum Papers 24, Los Angeles, 1974.

Wauchope, Robert, ed. *Handbook of Middle American Indians*. 16 vols. Austin, 1965–84.

Westheim, Paul. *Sculpture of Ancient Mexico*. New York, 1963.

Willey, Gordon R., and Jeremy A. Sabloff. *A History of American Archaeology*. London and San Francisco, 1974.

MODERN ART

Ades, Dawn. *Art in Latin America: The Modern Era, 1820–1980*. New Haven and London, 1989.

Alofsin, Anthony M. *Frank Lloyd Wright: The Lessons of Europe, 1910–22*. Ph.D. dissertation, Columbia University, 1989.

Andersen, Wayne V. "Gauguin and a Peruvian Mummy." *Burlington Magazine* 109 (January–June 1967): 238–42.

———. *Gauguin's Paradise Lost*. New York, 1971.

Arquin, Florence. *Diego Rivera: The Shaping of an Artist, 1889–1921*. Norman, Okla., 1971.

Artes de Mexico. "Anahuacalli: Museo Diego Rivera." [Essays by Carlos Pellicer, Ruth Rivera, and Dolores Olmeda de Olvera.] *Artes de Mexico* 64/65 (año 12, 1965).

Beardsley, John. *Probing the Earth: Contemporary Land Projects*. The Hirshhorn Museum and Sculpture Garden, Smithsonian Institution. Washington, D.C., 1977.

Bodelson, Merete. *Gauguin Ceramics in Danish Collections*. Copenhagen, 1960.

———. *Gauguin's Ceramics: A Study in the Development of His Art*. London, 1964.

Braun, Barbara. "Rufino Tamayo: Indigenous or Cosmopolitan Painter?" *Art Criticism* 1, no. 4 (1981): 52–67.

———. "PW Interviews: Louise Nevelson." *Publishers Weekly* (December 16, 1983): 76–77.

———. "Paul Gauguin's Indian Identity: How Ancient Peruvian Pottery Inspired His Art." *Art History* 9, no. 1 (March 1986): 36–54.

———. *Form, Structure, Synthesis: The Paintings of Augusto Torres*. Santa Barbara Museum of Art, Santa Barbara, 1987.

———. "Art from the Land of Savages, or Surrealists in the New World." *Boston Review* 13 (October 1988): 5–6, 18–19.

———. "Henry Moore and Pre-Columbian Art." *Res: Journal of Anthropology and Aesthetics*, nos. 17/18 (Spring/Autumn 1989): 158–97.

Brooks, Van Wyck. *Paul Gauguin's Intimate Journals*. Bloomington, 1958.

Buchloh, Benjamin. "Figures of Authority, Ciphers of Regression." In *Art after Modernism: Rethinking Representation*. New York, 1984.

Cahill, Holger. *American Sources of Modern Art*. The Museum of Modern Art, New York, 1933.

Cancel, Luis R., et al. *The Latin American Spirit: Art and Artists in the United States, 1920–1970*. The Bronx Museum of Arts, New York, 1989.

Cardona Peña, Alfredo. *El Monstruo en su Laberinto: Conversaciones con Diego Rivera*. Mexico City, 1980.

Catlin, Stanton. "Some Sources and Uses of Pre-Columbian Art in the Cuernavaca Frescoes of Diego Rivera." *Proceedings of the 35th International Congress of Americanists*. Mexico, 1962, 439–49. Mexico City, 1964.

———. "Political Iconography in the Diego Rivera Frescoes at Cuernavaca, Mexico." In *Art and Architecture in the Service of Politics*, edited by Henry A. Millon and Linda Nochlin, 194–215. Cambridge, Mass., and London, 1978.

Charlot, Jean. *Mexican Mural Renaissance*. New Haven, 1963.

———. *An Artist on Art*. 2 vols. Honolulu, 1972.

Columbus Museum of Art. *Henry Moore, The Reclining Figure*. Columbus, 1984.

Cork, Richard. *Art Beyond the Galleries in Early 20th Century England*. New Haven and London, 1985.

Day, Holliday T., Hollister Sturges, et al. *Art of the Fantastic, Latin America, 1920–1987*. Indianapolis Museum of Art, 1987.

Detroit Institute of the Arts. *Diego Rivera: A Retrospective*. New York and London, 1986.

Duncan, Barbara, and Susan Bradford. *Joaquín Torres-García 1874–1949: Chronology and Catalogue of the Family Collection*. The University of Texas at Austin Art Museum, 1974.

Favéla, Ramon. *Diego Rivera: the Cubist Years*. Phoenix, 1984.

Fine Arts Society. *Christopher Dresser (1834–1904): Pottery, Glass, Metalwork*. London, 1972.

Foster, Hal. "The 'Primitive' Unconscious of Modern Art." *October* 34 (Fall 1985): 45–70.

García-Noriega y Nieto, Lucia. *Miguel Covarrubias Homenaje*. Centro Cultural Arte Contemporaneo, Mexico City, 1987.

———. "Mexican Silver: William Spratling and the Taxco Style." *The Journal of Decorative and*

Propaganda Arts 10 (Fall 1988): 42–53.

Gauguin, Paul. "Notes sur l'art à l'Exposition Universelle," parts 1 and 2. *Le Moderniste* (July 4 and 13, 1889): 84–86, 90–91.

Gebhard, David. *Romanza: The California Architecture of Frank Lloyd Wright.* San Francisco, 1989.

Geist, Sydney. *Brancusi, The Kiss.* New York, 1978.

Goldman, Shifra. *Contemporary Mexican Painting in a Time of Change.* Austin, 1977.

————. "The Iconography of Chicano Self-Determination: Race, Ethnicity, and Class." *Art Journal* 49, no. 2 (Summer 1990): 167–73.

Goldwater, Robert. *Primitivism in Modern Art.* 1938. Rev. and enlarged ed., Cambridge, Mass., and London, 1986.

Gradowyczk, Mario H. *Joaquín Torres García.* Buenos Aires, 1985.

Gray, Christopher. *Sculpture and Ceramics of Paul Gauguin.* Baltimore, 1963. Reprint. New York, 1980.

Guerin, Daniel, ed. *The Writings of a Savage: Paul Gauguin.* New York, 1978.

Hall, Donald. "The Experience of Forms (profile of Henry Moore, 2 parts)." *New Yorker* 41 (December 11 and 18, 1965): part 1, 66–68ff.; part 2, 59–60ff.

Hayward Gallery. *Torres-García: Grid-Pattern-Sign: Paris–Montevideo 1924–1944.* London, 1985.

————. *Homage to Barcelona: The City and Its Art, 1888–1936.* London, 1985–86.

Herrera, Hayden. *Frida: A Biography of Frida Kahlo.* New York, 1983.

Hillier, Bevis. *Art Deco of the 1920s and 1930s.* London, 1968.

————. *Style of the Century.* New York, 1983.

Hitchcock, Henry Russell. *In the Nature of Materials: The Buildings of Frank Lloyd Wright 1887–1941.* New York, 1942.

Ingle, Marjorie. *Mayan Revival Style: Art Deco Mayan Fantasy.* Salt Lake City, 1984.

Instituto Nacional de Bellas Artes. *Diego Rivera Hoy.* Mexico City, 1986.

James, Philip, ed. *Henry Moore on Sculpture.* London, 1966.

Janiou, Ionel. *Henry Moore.* Paris, 1968.

Jardi, Enric. *Torres García.* Translated by Kenneth Lyons. Barcelona, 1974.

Kirk, Terry R. "The Sources of Pre-Columbian Influences in the Architecture of Frank Lloyd Wright." MA thesis, Columbia University, 1986.

Krauss, Rosalind. *The Originality of the Avant-Garde and Other Modernist Myths.* Cambridge, Mass., and London, 1987.

Laude, Jean. *Arts primitifs dans les ateliers d'artistes.* Musée de l'Homme, Paris, 1967.

————. *La Peinture française (1905–14) et "l'art nègre."* Paris, 1968.

Leeds City Art Galleries. *Henry Moore, Early Carvings, 1920–1940.* Leeds, 1982.

Levine, Neil. "Hollyhock House and the Romance of Southern California." *Art in America* 71 (January 1983): 150–65.

Lisle, Laurie. *Nevelson: A Passionate Life.* New York, London, Toronto, Sydney, Tokyo, 1990.

Lupton, Ellen, and J. Abbott Miller. *The ABCs of △ □ ○: The Bauhaus and Design Theory.* The Cooper Union, New York, 1991.

Malingue, Maurice, ed. *Paul Gauguin: Letters to His Wife and Friends.* Translated by H. J. Stenning. London, 1946.

Manson, Grant Carpenter. *Frank Lloyd Wright to 1910.* New York, 1958.

Marshall, Richard, and Suzanne Foley. *Ceramic Sculpture: Six Artists.* Whitney Museum of American Art. New York, 1981.

Menocal, Narciso. "Frank Lloyd Wright and the Question of Style." *Journal of Decorative and Propaganda Arts* 2 (Summer/Fall 1986).

Mitchinson, David. *Henry Moore, Unpublished Drawings.* New York, 1976.

————. *Henry Moore Sculpture with Comments by the Artist.* New York, 1981.

Moore, Henry. *Sculpture and Drawings, 1949–1959, Volume Two* [catalogue raisonné]. London, 1965.

————. *Henry Moore at the British Museum.* New York, 1981.

Mulvey, Laura, and Peter Wollen. *Frida Kahlo and Tina Modotti.* Whitechapel Art Gallery, London, 1982.

Myers, Bernard. *Mexican Painting in Our Time.* New York, 1956.

The Museum of Modern Art and the Instituto de Antropología e Historia de Mexico. *Twenty Centuries of Mexican Art/20 Siglos de Arte Mexicano.* New York and Mexico City, 1940.

Museum of Modern Art, Oxford. *!Orozco! 1883–1949.* Oxford, 1980.

Nairne, Sandy, and Nicholas Serota, eds. *British Sculpture in the Twentieth Century.* Whitechapel Art Gallery, London, 1981.

The National Gallery of Art. *The Art of Paul Gauguin.* Washington, D.C., 1988.

Neumann, Erich. *The Archetypal World of Henry Moore.* New York, 1959.

Neve, C. *Leon Underwood.* London, 1974.

Orton, Fred, and Griselda Pollock. "Les Données Bretonnantes: La Prairie de la Representation." In *Modern Art and Modernism: A Critical Anthology*, edited by Frances Frascina and Charles Harrison, 285–304. London, 1982.

Paternosto, César. *Piedra Abstracta.* Mexico City and Buenos Aires, 1989.

Peluffo, Zola Díaz. *Ideas fundamentales de Torres-García.* Montevideo, 1982.

Peterson, Frederick W. *Primitivism in Modern American Art.* Ph.D. dissertation, University of Minnesota, 1961.

Pfeiffer, Bruce, and Gerald Nordland. *Frank Lloyd Wright: In the Realm of Ideas*. Carbondale, Ill., 1988.

Pollock, Griselda. "Stark Encounters: Modern Life and Urban Work in Van Gogh's Drawings of The Hague 1881–83." *Art History* 6, no. 3 (September 1983): 333–58.

Ramirez, Mari Carmen. "La escuela del Sur: El legado del Taller Torres-García en el arte latinoamericano." In *La Escuela del Sur: El Taller Torres-García y su Legado*. Museo Nacional Centro de Arte Reina Sofia, Madrid, 1991.

Read, Herbert. *Henry Moore*. 1934. Rev. ed. London, 1965.

Robbins, Daniel. *Joaquín Torres-García: 1874–1949*. The Solomon R. Guggenheim Museum, New York, 1970.

Rockfort, David. *Murals of Diego Rivera*. London, 1987.

Rodríguez, Antonio. *Diego Rivera (Coleccion Anahuac de arte Mexicano)*. Mexico City, 1948.
———. *A History of Mexican Mural Painting*. London, 1969.

Rubin, William, ed. *"Primitivism" in 20th Century Art: Affinity of the Tribal and the Modern*. 2 vols. The Museum of Modern Art, New York, 1984.

Russell, John. *Henry Moore, Stone and Wood Carvings*. Marlborough Gallery, New York, 1961.
———. *Henry Moore*. Baltimore, 1973.

Samaltanos, Katia. *Apollinaire, Catalyst for Primitivism, Picabia and Duchamp*. Ann Arbor, 1984.

Siqueiros, David. "Three Appeals for a Modern Direction to the New Generation of American Painters and Sculptors." *Vida Americana* 1, no. 1 (1921).

Scully, Vincent. *Frank Lloyd Wright*. New York, 1960.

Smith, Kathryn. "Frank Lloyd Wright, Hollyhock House and Olive Hill, 1914–1924." *Journal of the Society of Architectural Historians* 38 (March 1979): 15–33.

Smith, Terry. *Making the Modern: The Visual Imagery of Modernity, USA, 1908–1939*. Ph.D. dissertation, University of Sydney, 1985.

Stacy Judd, Robert. "Maya Architecture." *Pacific Coast Architect* 30, no. 5 (November 1926).

Stewart, David B. *The Making of a Modern Japanese Architecture: 1868 to the Present*. Tokyo and New York, 1987.

Strachan, W. J. *Henry Moore: Animals*. London, 1983.

Sylvester, David, ed. *Henry Moore: Volume One, Sculpture and Drawings, 1921–48* [catalogue raisonné]. London, 1957.
———. *Henry Moore*. The Arts Council of Great Britain, London, 1968.

Tafel, Edgar. *Apprentice to Genius: Years with Frank Lloyd Wright*. New York, 1978.

Torres-García, Joaquín. *Historia de mi vida*. Montevideo, 1939.
———. *The Tradition of Abstract Man*. Montevideo, 1938.
———. *Metafísica de la Prehistoria Indoamericana*. Montevideo, 1939.
———. *La recuperación del objeto*. 2 vols. Montevideo, 1952.
———. *Escritos: Selección analítica y prólogo: Juan Flo*. Montevideo, 1974.
———. *Universalismo constructivo*. 2 vols. Madrid, 1984.

Tselos, Dimitri. "Exotic Influences in the Architecture of Frank Lloyd Wright." *Magazine of Art* 47 (April 1953): 160–69, 184.
———. "Frank Lloyd Wright and World Architecture." *Journal of the Society of Architectural Historians* 28 (March 1969): 58–72.

Twombly, Robert C. *Frank Lloyd Wright: His Life and His Architecture*. New York, 1979.

University Museum. *Gauguin and Exotic Art*. University Museum, University of Pennsylvania, Philadelphia, 1969.

Wallis, Brian, ed. *Art After Modernism: Rethinking Representation*. New York and Boston, 1984.

Weisberg, Gabriel. "Frank Lloyd Wright and Pre-Columbian Art—The Background for His Architecture." *Art Quarterly* 30 (Spring 1967): 40–51.

Wentinck, Charles. *Modern and Primitive Art*. Oxford, 1979.

Whiffen, Marcus, and Frederick Koeper. *American Architecture: 1860–1976*. Cambridge, Mass., 1981.

Wilson, Laurie. "Bride of the Black Moon: An Iconographic Study of the Work of Louise Nevelson." *Arts* 54 (May 1980): 140–48.

Wilkinson, Alan G. *The Drawings of Henry Moore*. Tate Gallery, London, 1977.
———. "Henry Moore's Reclining Woman." *National Gallery of Canada, Ottawa, Annual Bulletin* (1979): 33–55.
———. *Gauguin to Moore: Primitivism in Modern Sculpture*. Art Gallery of Ontario, Toronto, 1981.

Wolfe, Bertrand. *The Fabulous Life of Diego Rivera*. New York, 1963.

World Cultures and Modern Art. The Encounter of 19th and 20th Century European Art and Music with Asia, Africa, Oceania, and Afro- and Indo-America. Catalogue by Manfred Schneckenburger et al. Exhibition on the occasion of the games of the 20th Olympiad. Munich, 1972.

Wright, Frank Lloyd. *The Japanese Print, an Interpretation*. Chicago, 1912. Reprint. New York, 1967.
———. *Modern Architecture, the Kahn Lectures for 1930*. Princeton, 1931.
———. *The Future of Architecture*. New York, 1953.
———. *A Testament*. New York, 1957.
———. *An Autobiography*. 1932. Reprint. New York, 1977.

INDEX

Pages in *italics* refer to captions and illustrations

The author and publisher wish to thank the libraries, museums, and private collectors who permitted the reproduction in black-and-white and color of paintings, prints, sculptures, and drawings from their collections. Photographs have been supplied by the following, whose courtesy is gratefully acknowledged. Numbers refer to page numbers.

Americas Society, Inc., New York: 281 above; The Ancient Art & Architecture Collection, Harrow-on-the-Hill, England: 113 below; Aquavella Galleries, NY: 77 below; Art Resource, NYC: 121 below; James Austin, Cambridge: 105; Dirk Bakker: 195, 196 below, 200–201 above, 202, 203, 204 above and below, 205, 206, 207, 211 above, 214, 215, 217, 223 below, 225 above, 230–31, 231 below right, 232 above; Bildarchiv Preussischer Kulterbesitz, Berlin: 75, 83; Lee Boltin Picture Library: 20; Barbara Braun, NYC: 98, 101 above, 104, 107, 108 middle left, 122 above, 255 middle and below, 285, 316; Manuel Alvarez Bravo: 220, 221 above; Hillel Burger: 210 above; Courtesy of CDS Gallery, New York: 269 below, 283; Daniella Chappard, NYC: 250 below, 279; Christie's Colour Library, London: 63; Christie's, New York: 272; Charles H. Coles: 273; Courtesy of The Paula Cooper Gallery, NYC: 311; D. James Dee, NYC: 254 middle, 259, 263 above, 264 above, 276, 280; Ursula Didoni: 60 above; Don Douglas, Moulin Photographic Studios, San Francisco: 169 below, 218; Roy M. Elkind, NYC: 305; Gabriel Figueroa-Flores: 224; Fotograf Ole Woldbye, Copenhagen: 57 below right, 74, 76 above; Jeffrey Jay Foxx, NYC: 26 above left and right, 29, 92 below, 102 above, 106 above, 117, 136 above, 150 above and below, 159, 161 above, 169 above, 173 above, 178 below, 189, 192 above, 194 middle and below, 210 below, 212, 223 above and middle, 228 middle, 236 all, 237 above and below, 238 above and below, 239 all, 240; Yukio Futagawa, Tokyo: 154 below, 175, 176; Irmard Groth: 102 below right; Carmelo Guadagno: 234; Pedro E. Guerrero, New Canaan: 175; David Heald: 308; Michael Heizer: 315; The Henry Moore Foundation, Much Hadham: 97, 99 above right, 103, 108 above and below left, 109 above, 113 above, 114, 121 above, 122 below, 124; Paul Hester, Houston: 274; Peter Horner: 196 above; Erroll Jackson, London: 106 below; Johns Hopkins University, The Special Collections, The Milton S. Eisenhower Library: 57 above and below left, 60 below, 61 below left and right, 62 above left, 65 right, 70 below, 72 above; Courtesy of The Josef Albers Foundation, Inc.: 304 above and below; Rollout Photograph © Justin Kerr, 1982: 226 below; Tony Linck, Fort Lee: 292 above; Régina Monfort: 257; Al Mozell, New York: 307; Michel Muller: 99 below; O. Nelson: 306; The New York Public Library: 141, 144 below; Oblagon, Los Angeles: 313 below; César Paternosto, NYC: 250 above, 277, 282 above, 284; Anthony Peres, Santa Barbara: 156 above, 158 above, 160, 163, 165 middle, 168 above, 171, 173 below; John M. Pflueger Architects, San Francisco: 41; Donato Pineider, Florence: 210 middle, 211 below, 228 below, 232 below; Eric Pollitzer, New York: 78; R.M.N., Paris: 81 above, 82 above; Rheinisches Bildarchiv, Cologne: 82 below; Dr. Merle Greene Robertson: 158 below, 164 above, 233; Dr. Alan R. Sawyer, Vancouver: 65 left, 72 below, 76 below, 264 below, 268; Bob Schalkwijk, Mexico City: 28, 184, 192 below, 194 above, 198, 199, 228 above; See Spot Run, Toronto: 317; Brian Seed & Associates, Skokie, Illinois: 130; Julius Shulman, Los Angeles: 153, 155 below, 161 below; Lee Stalsworth: 309; Ezra Stoller © Esto: 162, 164 below, 178 above; Soichi Sunami: 193; Wim Swaan, NY: 123 above, 145 above, 147 below, 148, 152, 166 below, 168 below, 216, 258; Testoni Studios, Montevideo: 255 above, 256, 260 above, 269 above, 282 below, 286; Richard Todd, Los Angeles: 62 above right and below; David Ulmer, St. Louis: 271; John Weber Gallery, New York: 292 below; Michel Zabé: 197, 209 below, 213, 222.

Illustration copyrights: © Mrs. Anni Albers: 304 below; © The Josef Albers Foundation, Inc.: 304 above; ARS, New York: 121 below, 270, 271, 272; © 1982 The Blade Runner Partnership. All Rights Reserved: 313 below; © The Pace Gallery, New York, Estate of Alfred Jensen: 309; © The Pace Gallery, New York, Estate of Louise Nevelson: 307; © John Weber Gallery, New York, Estate of Robert Smithson: 292 below; © 1942, 1962 The Frank Lloyd Wright Foundation: 136 below, 144 above, 165 below, 166 above, 313 above.